sci-fi
chronicles
a visual history of the galaxy's greatest science fiction

General Editor
Guy Haley

sci-fi
chronicles

a visual history of the galaxy's greatest science fiction

Foreword by
Stephen Baxter

FIREFLY BOOKS

A FIREFLY BOOK

Published by Firefly Books Ltd. 2014

First printing

Publisher Cataloging-in-Publication Data (U.S.)
A CIP record for this title is available from the Library of Congress

Library and Archives Canada Cataloguing in Publication
Sci-fi chronicles : a visual history of the galaxy's greatest science fiction / general editor Guy Haley ; foreword by Stephen Baxter.
Includes index.
ISBN 978-1-77085-264-8 (pbk.)
 1. Science fiction films--Encyclopedias. I. Haley, Guy, 1973-, Editor II. Title.
PN1995.9.S26S25 2014 791.43'615 C2014-901755-3

Published in the United States by
Firefly Books (U.S.) Inc.
P.O. Box 1338, Ellicott Station
Buffalo, New York 14205

Published in Canada by
Firefly Books Ltd.
50 Staples Avenue, Unit 1
Richmond Hill, Ontario L4B 0A7

Color separation by KHL ChromaGraphics Pte Ltd.
Printed in China by Midas Printing International Ltd

This book was designed and produced by
Quintessence Editions Ltd.
The Old Brewery
6 Blundell Street
London N7 9BH

Project Editor: Elspeth Beidas
Designers: Isabel Eeles, Josse Pickard,
 Damian Jaques
Editors: Henry Russell, Terry Burrows,
 Bruno MacDonald
Production Manager: Anna Pauletti
Editorial Director: Jane Laing
Publisher: Mark Fletcher

contents

foreword by stephen baxter

As a science fiction writer, probably the most common question I get asked is, "Why do you keep writing science fiction now that we're living in the future?" It's certainly true that many of the old dreams of science fiction have been fulfilled, or bypassed. And it does feel as if we're living through a time of accelerating change. But to imagine there is no role for science fiction today is to miss the point of the genre.

And if you want to know what that point is, this extraordinary book is your guide.

Science fiction has rarely been about the overt prediction of a definite future, but rather an expression of the tensions, anxieties and dreams of the present in which it is written. Science fiction is a response to change. This goes back to the genre's origins. The literature can be seen as an offshoot of older traditions such as tales of fantastic voyages, but — as shown here — authorities have traced the roots of the modern genre back to Mary Shelley's *Frankenstein* (1818), the work of Jules Verne and H.G. Wells in the 19th century, and to the American pulp-magazine revolution pioneered by Hugo Gernsback in the 1920s. What these disparate times have in common is that they were all points of flux, of change, scientific, technological or philosophical. In H.G. Wells' day the great shock of evolutionary theory was working its way through Victorian society, and so his classic novel *The Time Machine* (1895) is not really a futurological prediction of the year 802,701 AD, but an anguished meditation on the implications of Darwinism for late Victorian humanity.

Even as Wells was writing, however, new media, new ways of telling stories, were evolving. Wells himself was interested in the possibilities of cinema; *The Time Machine* has very visual sequences. From the beginning of the 20th century, science fiction has found visual expression through cinema, TV, gaming, comics and graphic novels, manga and other forms.

As the focus of our concerns has moved on, a whole variety of science fictional "futures" has been generated. If *Frankenstein* was a nightmare about the advance of science, this survey shows that the science fiction of the 1950s and 1960s heavily featured tales of apocalypse, like John Wyndham's *The Day of the Triffids* (1951) — but there were also wonderful dreams of what it means to be human in an inhabited universe, like Arthur C. Clarke's *2001: A Space Odyssey* (1968). In the 1980s the explosion of computing power led to "cyberpunk" fantasies like William Gibson's *Neuromancer* (1984): dreams of a transhuman future.

Of course as time progresses some material becomes outdated. Neil Armstrong's first footsteps on the Moon in 1969 made obsolete a whole library of science-fictional dreams of lunar exploration, but nobody would suggest expunging H.G. Wells' *The First Men in the Moon* (1901) from the canon; the fiction is what endures, not the science. So with time the fictional archive has got ever richer, deeper, more complex, and more cross-referential.

And that's where the graphic design of this book really scores. Accompanying the entry on *Frankenstein*, for example, you'll not only find a timeline of Shelley's book itself to guide you through the text, but also a timeline of the various reimaginings of the story from the first movie version in 1910 onwards, along with lavish illustrations, all the way up to Benedict Cumberbatch as the monster in Danny Boyle's 2011 stage version. *Frankenstein* is among 50 major works or creators to be given such spreads here.

Meanwhile, some individual and much-loved franchises like *Doctor Who* and *Star Trek* have already achieved decades of enduring success, and have spun off elaborate mythologies of their own, created by a multiplicity of hands professional and otherwise: extraordinary works of "metafiction," probably too extensive for any one individual to absorb. The ingenious design of the entries on around 25 of these franchises provides you with details of how the works have evolved with time, as well as with explorations of their fictional universes.

The graphic design of this book alone will provide you with content, context and comparison of the genre's most significant works. But at the heart of the book are of course the words of the many contributing scholars, and you'll find here expertly researched entries on science fiction auteurs from Gerry Anderson to J.G. Ballard.

The genre itself is undoubtedly still evolving, and today it's bigger than ever, with, as Haley shows in his later entries, *Avatar* (2009) having become the top-earning movie of all time, and franchises like *The Hunger Games* reworking old tropes for a new audience of young adults. Science fiction explores the consequence of change, then, but it is a way of dealing with change, of learning about it, of internalising it — not so much prophecy as a kind of mass therapy, perhaps. And history hasn't ended yet. In the dangerous and exciting centuries to come, we will need minds capable of coping with change more than ever before.

We need science fiction. We need to understand why it's important. And we need books like this one as guides to the rich legacy of the genre.

introduction by guy haley

Science fiction is arguably the most exciting genre of entertainment. No other form of storytelling shapes our culture as much, or is as popular. You may not think yourself a fan of science fiction, but consider the last movie you saw, or the last TV show, or the last video game you played. Whoever you are, some of your favorite entertainments will be listed in these pages.

Before starting work on this book, we had to ask ourselves a question: what is science fiction? Seemingly simple, but in reality the answer was hard to formulate. This is the definition we settled upon:

Science fiction is a member of a group of fictional genres whose narrative drive depends upon events, technologies, societies etc. that are impossible, unreal, or that are depicted as occurring at some time in the future, the past or in a world of secondary creation. These attributes vary widely in terms of actuality, likelihood, possibility and in the intent with which they are employed by the creator. The fundamental difference between science fiction and the other "fantastical genres" of fantasy and horror is this: the basis for the fiction is one of rationality. The sciences this rationality generates can be speculative, largely erroneous, or even impossible, but explanations are, nevertheless, generated through a materialistic worldview. The supernatural is not invoked (although in some settings might feature alongside SF trappings). Science fiction can be pure fantasy with bad science draped over it as a disguise — this is irrelevant, so long as the narrative geography is a nominally realistic geography, and is not one of magic. In this sense both the movies *Armageddon* (about a big asteroid hitting the Earth) and *Godzilla* (about a giant, atomically mutated lizard) are equally science fiction, even though the former is possible and the latter is not. They are both science fiction because the language used in both to frame the events is that of science.

There is a certain snobbery against science fiction. Mainstream critics will say that the likes of *Nineteen Eighty-Four*, *The Road*, or *Children of Men* are not science fiction. However, the criteria for saying so seems to be that they are "good art," and that "good art" cannot possibly be science fiction. Author Margaret Atwood once described the genre as "talking squids in space," despite herself writing little but science fiction. Why should she feel ashamed?

Science fiction's sheer broadness is chiefly to blame. It can revel in ridiculous escapism. *Power Rangers*, for example, is not "good art," although it is perfectly suited to entertaining small children.

A further issue is the grave error made regarding science fiction's relationship with the future. Despite appearances to the contrary, science fiction does not set out to predict, and its visions of the world to come date quickly. There have been a handful of examples of individual technologies being foreseen by science-fiction writers — no more. The impact of computers was almost completely overlooked by the writers of the early 20th century, for example. Science fiction is not predictive. "What if?" is its stock in trade.

It does, however, have an effect on the future.

Science fiction is a product of its time. The futures of the 1950s are those of atomic rockets and pipe-smoking engineers, those of the 1960s are replete with moonbases and free love, while worlds dreamt up in the 1980s are dominated by wicked corporations or scoured by nuclear apocalypse. But in being so parochial, SF fulfills a valuable function. Holding up a mirror to its present, it is consequently an image of its time. But it does not have to follow the rules of its time, and is often most fruitful when set in direct opposition to them. In this way, the very best science fiction has tremendous power. When Orwell wrote *Nineteen Eighty-Four*, the horrors of Stalinism were not widely accepted. H.G. Wells' Morlocks and Eloi are a damning indictment of the social divisions of the 1890s; the first inter-racial kiss on American screens was on *Star Trek*. Through exaggerated or simplified versions of our reality, science fiction opens our eyes to the truth of the world, and in doing so can even act as a preventative against disaster.

The wild, glorious visions of SF inspire real scientists. Often one hears scientists and technologists say, "I saw this in a science fiction show, and I wondered how I could make it work." *Star Trek* is particularly influential — you can thank it for your mobile phones, but also for ongoing research into teleportation and faster-than-light travel. In a similar vein, should we ever colonize another world, many of the problems of how we would survive there have already been examined by science fiction, while if we meet a sentient alien species, science fiction will have prepared us (as certain conspiracy theorists hold, deliberately) through numerous scenarios.

We will likewise be prepared if we find ourselves alone in the universe. In a secular society, science fiction provides room for the numinous; it is modern Western society's mental and spiritual gymnasium.

At other times, science fiction has acted as a smokescreen to dissent, giving a platform to writers to criticize repressive regimes.

The genre is not without its faults. It is almost certainly to blame for its own ghettoization. It can be exclusive and narrow-minded, being predominantly the product of male, Western minds. It can be shoddy, infantile and distracting. But even when it is, it is never less than entertaining, and is often beautiful.

As you probably appreciate, science fiction is a vast field, comprising many subgenres. We cannot possibly cover it all. Therefore, we have attempted to provide you with an overview, something that illustrates science fiction's history, breadth and influence. Any omissions are necessarily somewhat subjective, but sadly unavoidable.

Science fiction may not predict, but we will — that the scholars of the future will look back upon science fiction as a crucial part of 20th- and 21st-century culture. So, join us on our odyssey through this amazing genre's past and present, and feast your eyes on the myriad futures it has depicted.

how to use this book

Color-coded genres

Year of featured
subject's first key work

Awards won

Name of
featured subject

Key works

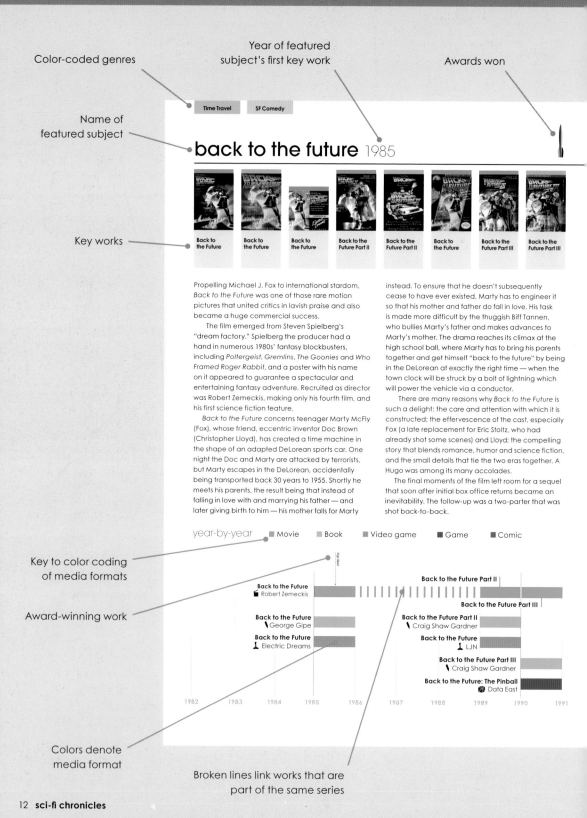

Time Travel SF Comedy

back to the future 1985

Back to
the Future

Back to
the Future

Back to
the Future

Back to the
Future Part II

Back to the
Future Part II

Back to
the Future

Back to the
Future Part III

Back to the
Future Part III

Propelling Michael J. Fox to international stardom, *Back to the Future* was one of those rare motion pictures that united critics in lavish praise and also became a huge commercial success.

The film emerged from Steven Spielberg's "dream factory." Spielberg the producer had a hand in numerous 1980s' fantasy blockbusters, including *Poltergeist, Gremlins, The Goonies* and *Who Framed Roger Rabbit*, and a poster with his name on it appeared to guarantee a spectacular and entertaining fantasy adventure. Recruited as director was Robert Zemeckis, making only his fourth film, and his first science fiction feature.

Back to the Future concerns teenager Marty McFly (Fox), whose friend, eccentric inventor Doc Brown (Christopher Lloyd), has created a time machine in the shape of an adapted DeLorean sports car. One night the Doc and Marty are attacked by terrorists, but Marty escapes in the DeLorean, accidentally being transported back 30 years to 1955. Shortly he meets his parents, the result being that instead of falling in love with and marrying his father — and later giving birth to him — his mother falls for Marty

instead. To ensure that he doesn't subsequently cease to have ever existed, Marty has to engineer it so that his mother and father do fall in love. His task is made more difficult by the thuggish Biff Tannen, who bullies Marty's father and makes advances to Marty's mother. The drama reaches its climax at the high school ball, where Marty has to bring his parents together and get himself "back to the future" by being in the DeLorean at exactly the right time — when the town clock will be struck by a bolt of lightning which will power the vehicle via a conductor.

There are many reasons why *Back to the Future* is such a delight: the care and attention with which it is constructed; the effervescence of the cast, especially Fox (a late replacement for Eric Stoltz, who had already shot some scenes) and Lloyd; the compelling story that blends romance, humor and science fiction, and the small details that tie the two eras together. A Hugo was among its many accolades.

The final moments of the film left room for a sequel that soon after initial box office returns became an inevitability. The follow-up was a two-parter that was shot back-to-back.

Key to color coding
of media formats

Award-winning work

Colors denote
media format

Broken lines link works that are
part of the same series

year-by-year ■ Movie ■ Book ■ Video game ■ Game ■ Comic

Back to the Future
Robert Zemeckis

Back to the Future Part II

Back to the Future Part III

Back to the Future
George Gipe

Back to the Future
Electric Dreams

Back to the Future Part II
Craig Shaw Gardner

Back to the Future
LJN

Back to the Future Part III
Craig Shaw Gardner

Back to the Future: The Pinball
Data East

1982 1983 1984 1985 1986 1987 1988 1989 1990 1991

SFWA
GRANDMASTER

Science Fiction and Fantasy
Writers of America Grandmaster

Hugo
Award

Nebula
Award

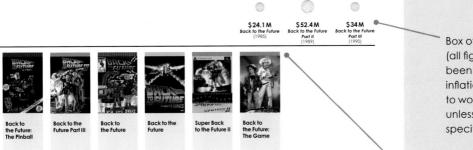

| $24.1M | $52.4M | $34M |
| Back to the Future (1985) | Back to the Future Part II (1989) | Back to the Future Part III (1990) |

Box office grosses (all figures have been adjusted for inflation and refer to worldwide totals unless otherwise specified)

Back to the Future: The Pinball

Back to the Future Part III

Back to the Future

Back to the Future

Super Back to the Future II

Back to the Future: The Game

Colors denote media format

Back to the Future Part II is set in three time zones. Marty and Doc first go forward to 2015 — replete with flying hoverboards and three-dimensional ads for *Jaws 19* — but inadvertently alter their past after Biff Tannen steals the DeLorean and takes it back to 1955 where he gives a sporting results almanac to his younger self. Through winning bets on sporting events, young Biff accumulates huge wealth which he parlays into a property empire and a brutal local power base. Consequently, the 1985 to which Marty returns is a nightmare of high crime, poverty and discontent. After realizing what has happened he goes back to 1955 to stop Biff from receiving the almanac.

Although slightly darker in tone than its predecessor, *Back to the Future Part II* is nevertheless a hugely enjoyable sequel that is often underrated (*Halliwell's Film Guide* didn't award it a single star). It is a film that takes the possibilities of time travel to the absolute max, delighting in the paradoxes that are thrown up as well as in Marty's thrilling efforts to change (or change back) the future. *The Encyclopedia of Science Fiction* notes: "It is perhaps the most sophisticated time-travel film ever made."

The third film in the series picks up where the second one left off. It sees the lead characters in yet another time zone, 1885, where Doc Brown has been living a quiet existence since the DeLorean took him there at the end of *Part II*. When Marty learns via a tombstone that his friend will be killed by an outlaw, he determines to go back and save him. He does so, but further complications ensue when Doc saves schoolteacher Clara Clayton from being killed in an accident, and then falls in love with her.

Although perhaps the least interesting part of the trilogy, *Back to the Future Part III* is an energetic romp that culminates in an exciting railroad set-piece. It's certainly the least science fictional of the trio, more like a good-humored Western for much of the time, not withstanding that railroad sequence, in which the train, pushing the DeLorean, has to reach a certain speed — 88 miles per hour (140 kph) — to ensure that the time machine can return to the present day.

Christopher Lloyd reprised the role of Doc Brown for television by appearing in brief live-action buffers of an animated series, entitled Back To The Future, which was produced by CBS in 1991 and 1992. **RL**

Contributor's initials

■ Animated TV series

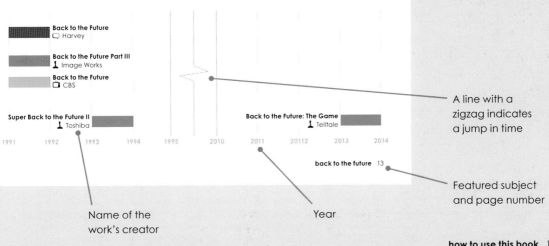

Back to the Future
▢ Harvey

Back to the Future Part III
⚊ Image Works

Back to the Future
▢ CBS

Super Back to the Future II
⚊ Toshiba

Back to the Future: The Game
⚊ Telltale

| 1991 | 1992 | 1993 | 1994 | 1995 | 2010 | 2011 | 20112 | 2013 | 2014 |

A line with a zigzag indicates a jump in time

back to the future 13

Featured subject and page number

Name of the work's creator

Year

how to use this book continued

Name of featured subject

Universe entries tell the "in-universe" history of the featured subject

Color denotes character

Key characters

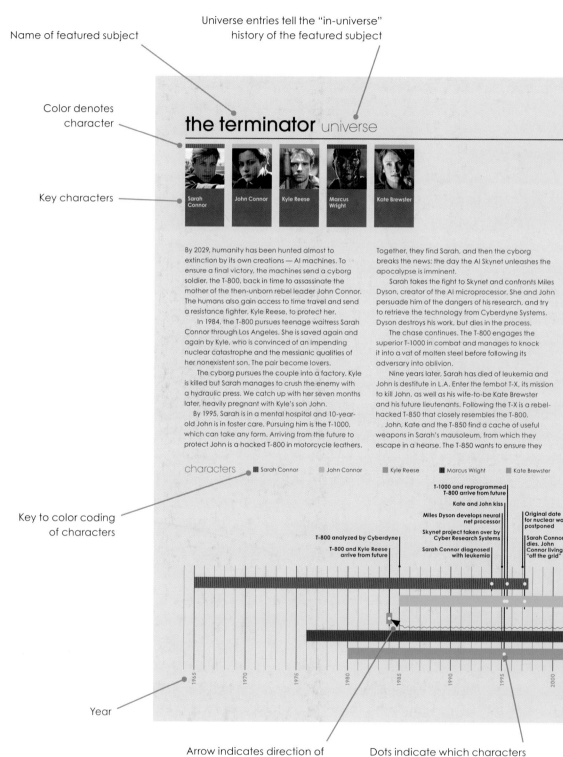

the terminator universe

Sarah Connor · John Connor · Kyle Reese · Marcus Wright · Kate Brewster

By 2029, humanity has been hunted almost to extinction by its own creations — AI machines. To ensure a final victory, the machines send a cyborg soldier, the T-800, back in time to assassinate the mother of the then-unborn rebel leader John Connor. The humans also gain access to time travel and send a resistance fighter, Kyle Reese, to protect her.

In 1984, the T-800 pursues teenage waitress Sarah Connor through Los Angeles. She is saved again and again by Kyle, who is convinced of an impending nuclear catastrophe and the messianic qualities of her nonexistent son. The pair become lovers.

The cyborg pursues the couple into a factory. Kyle is killed but Sarah manages to crush the enemy with a hydraulic press. We catch up with her seven months later, heavily pregnant with Kyle's son John.

By 1995, Sarah is in a mental hospital and 10-year-old John is in foster care. Pursuing him is the T-1000, which can take any form. Arriving from the future to protect John is a hacked T-800 in motorcycle leathers.

Together, they find Sarah, and then the cyborg breaks the news: the day the AI Skynet unleashes the apocalypse is imminent.

Sarah takes the fight to Skynet and confronts Miles Dyson, creator of the AI microprocessor. She and John persuade him of the dangers of his research, and try to retrieve the technology from Cyberdyne Systems. Dyson destroys his work, but dies in the process.

The chase continues. The T-800 engages the superior T-1000 in combat and manages to knock it into a vat of molten steel before following its adversary into oblivion.

Nine years later, Sarah has died of leukemia and John is destitute in L.A. Enter the fembot T-X, its mission to kill John, as well as his wife-to-be Kate Brewster and his future lieutenants. Following the T-X is a rebel-hacked T-850 that closely resembles the T-800.

John, Kate and the T-850 find a cache of useful weapons in Sarah's mausoleum, from which they escape in a hearse. The T-850 wants to ensure they

characters · Sarah Connor · John Connor · Kyle Reese · Marcus Wright · Kate Brewster

Key to color coding of characters

Year

Arrow indicates direction of time travel and date visited

Dots indicate which characters the key event relates to

survive the coming nuclear war; John intends to prevent it. The T-850 now reveals that it was sent by the older Kate in 2032.

Meanwhile, however, Kate's father Robert Brewster has taken over the Skynet project on behalf of the USAF and the trio are too late to prevent him activating the AI. Dying, Robert tells John to disable Skynet's system core at Crystal Peak in the Sierra Nevada. The T-X takes control of the T-850 and uses it as a weapon against John, but their protector shuts itself down. They travel to the mountains, pursued by the T-X, which is destroyed by the T-850's last remaining fuel cell.

But Crystal Peak does not contain the system core. Skynet is impossible to shut down; Judgment Day is upon them. In the nuclear war, much of humanity is wiped out. John takes over as leader of the survivors.

By 2018, Skynet dominates the Earth and John is fighting a losing battle when he discovers plans for a new kind of Terminator comprised of metal and organic tissue. A nuclear assault on the rebels leaves only two survivors: John and Marcus Wright, who saves a young Kyle Reese and a girl called Star from a T-600. Kyle and Star are soon taken prisoner.

At headquarters, John and General Ashdown plan to assault the Skynet base in San Francisco. An intercepted "kill list" reveals that John's death is second in priority to that of Kyle Reese, his father-to-be. Marcus is found to be a cyborg who believes himself to be human. John orders his destruction, but Marcus proves his loyalty by saving John's life from attacking hydrobots. John recruits him for the rescue of the prisoners.

It turns out that Marcus was created to lure John into Skynet's domain, where he will be killed.

Marcus removes his Skynet hardware and he and John fight a T-800. They destroy the Skynet base with Terminator fuel cells and are airlifted out. Marcus donates his own heart to save the dying John — and the war against the machines continues. **TH**

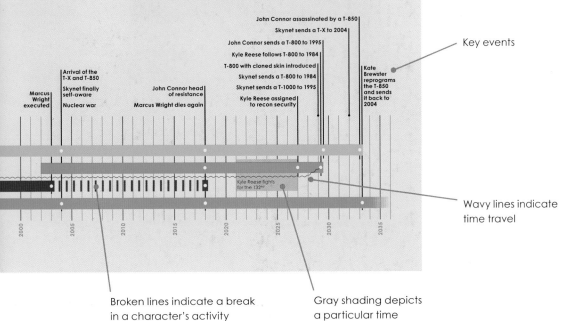

Key events

Wavy lines indicate time travel

Broken lines indicate a break in a character's activity

Gray shading depicts a particular time

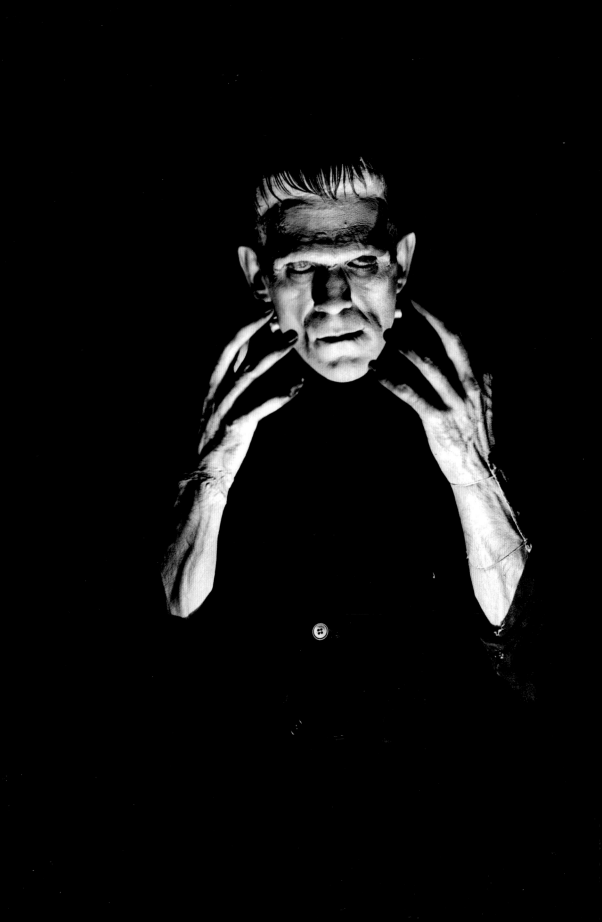

early science fiction:
the birth of a genre
1818–1925

frankenstein 1818

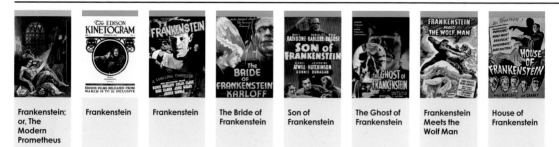

Frankenstein; or, The Modern Prometheus

Frankenstein

Frankenstein

The Bride of Frankenstein

Son of Frankenstein

The Ghost of Frankenstein

Frankenstein Meets the Wolf Man

House of Frankenstein

Frankenstein has its origins in the summer of 1816, the "Year without a Summer," when Lord Byron, Percy and Mary Shelley, Dr. John Polidori and others stayed at the Villa Diodati close to Lake Geneva. Owing to a volcanic winter caused by the eruption of Mount Tambora the year before, the weather was dreadful, and they whiled away the time telling one another ghost stories. Polidori produced a short story, *The Vampyre*, which was more influential initially and provided the impetus for the creation of the modern vampire myth, but it was the 19-year-old Mary who produced a novel that would come to be regarded as the first work of science fiction.

Shelley used the epistolary form, which had been popular in novels. She also drew on the conventions of Gothic literature, taking ideas of the horrific and the exploration of morals, and weaving them in with the Romantic love of nature and the valuing of pronounced emotions. In rooting her story in science she stepped away from the Gothic tradition. This is why *Frankenstein* has often been called the first true science fiction novel, even though it deals more with the consequences of the quest for knowledge than the mechanics of the science behind it.

The initial reception for the novel was mixed. Sir Walter Scott praised many things (although not the speed with which the creature acquired speech and literacy); other reviewers were less kind. The public, however, enjoyed it, and the book was a success; the first plays based on it were performed in the 1820s.

The first film version of *Frankenstein* was a 16-minute movie made by the Edison Company in 1910. The best-known version, however, was produced in the age of sound, directed by James Whale and released by Universal Pictures. They also produced many monster pictures in the 1930s and early 1940s, starting with *Dracula*. *Frankenstein* was released the same year, 1931. The visual style benefited from the wave of German film makers leaving Nazi Germany, who brought with them the stylized aesthetics of Expressionism. The use of dramatic shadows and unsettling angles added to the unnerving feel of Universal's monster movies.

Had he lived (and had MGM been willing to lend him to Universal), Lon Chaney Sr. — whose ability to transform himself was legendary — would have been a logical choice to play the creature. Instead, the role was offered to Bela Lugosi, who turned it down because it was not a speaking part. Boris Karloff took it on (although his name is omitted from the opening credits, replaced by an audience-teasing "?"), and became famous as the movie stormed the box office.

year-by-year ■ Book ■ Movie ■ Play

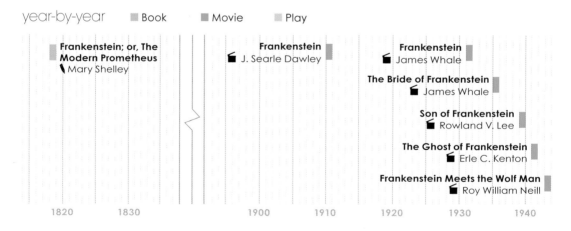

Frankenstein; or, The Modern Prometheus
Mary Shelley

Frankenstein
J. Searle Dawley

Frankenstein
James Whale

The Bride of Frankenstein
James Whale

Son of Frankenstein
Rowland V. Lee

The Ghost of Frankenstein
Erle C. Kenton

Frankenstein Meets the Wolf Man
Roy William Neill

1820 1830 1900 1910 1920 1930 1940

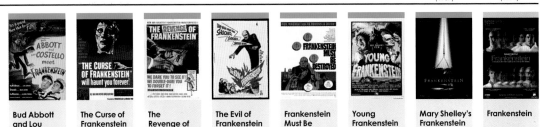

$184 M (U.S.)
Frankenstein
(1931)

$58 M (U.S.)
The Curse of
Frankenstein
(1957)

$176 M
Mary Shelley's
Frankenstein
(1994)

Bud Abbott and Lou Costello Meet Frankenstein

The Curse of Frankenstein

The Revenge of Frankenstein

The Evil of Frankenstein

Frankenstein Must Be Destroyed

Young Frankenstein

Mary Shelley's Frankenstein

Frankenstein

Frankenstein's immediate sequel was 1935's *The Bride of Frankenstein*, which begins with that long-ago gathering of friends in the Villa Diodati. Karloff again played the creature and James Whale directed. Elsa Lanchester played both Mary Shelley and the Bride.

The quality of the Universal films waned over time, and the *Frankenstein* franchise was no exception. *Son of Frankenstein*, *The Ghost of Frankenstein*, *House of Frankenstein* and *Frankenstein Meets the Wolf Man* were less successful than either of the Whale-directed films. By the end of the 1940s, monster movies were old hat, making them ripe for parody. Comic duo Abbott and Costello duly created *Bud Abbott and Lou Costello Meet Frankenstein* (1948), the first of their series of encounters with the Universal monster stable.

It took another continent, and a new generation, to restore shock to the Frankenstein story. In 1957, Hammer released *The Curse of Frankenstein*, starring Peter Cushing as Victor Frankenstein and Christopher Lee as the creature. Because the makeup used in the Universal films was copyright, Hammer's creature looks much more human than the square-headed 1930s version. Made on a modest budget, the film grossed $7 million in the United States and helped fuel Hammer's growth. Like Universal, they capitalized on the success of the first film with a number of

sequels. The ever-elegant Cushing played Victor Frankenstein for most of the series, becoming a star in the process. And while Hammer's output grew more exploitative and lower in quality over the decades, the *Frankenstein* cycle held up better than most.

The most recent film adaptation was *Mary Shelley's Frankenstein* (1994), directed by and starring Kenneth Branagh, with Robert De Niro as the creature. Although more faithful than most to the original story, it earned a poor critical reception.

Frankenstein later returned to the London stage, with Jonny Lee Miller and Benedict Cumberbatch alternating the roles of Victor and the creature in Danny Boyle's highly successful production.

Largely thanks to the success of the Universal movies, the idea of Frankenstein entered popular culture. Mel Brooks' film *Young Frankenstein* (1974) was a direct albeit comic homage, and the makeup Karloff wore inspired Herman Munster, but Shelley's novel has inspired many other works that have little in common with it. These include the 1957 film *I Was A Teenage Frankenstein* and the musical *The Rocky Horror Show* (made into a film in 1975). Authors as varied as Spike Milligan, Peter Ackroyd and Brian Aldiss have written books playing with Shelley's original ideas. Mary's creature won't die. **MM**

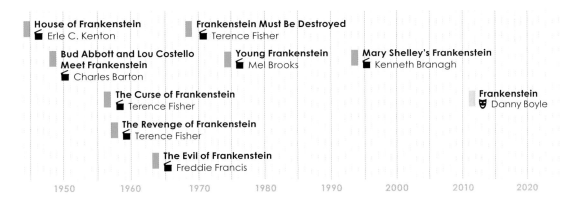

House of Frankenstein
Erle C. Kenton

Frankenstein Must Be Destroyed
Terence Fisher

Bud Abbott and Lou Costello Meet Frankenstein
Charles Barton

Young Frankenstein
Mel Brooks

Mary Shelley's Frankenstein
Kenneth Branagh

The Curse of Frankenstein
Terence Fisher

Frankenstein
Danny Boyle

The Revenge of Frankenstein
Terence Fisher

The Evil of Frankenstein
Freddie Francis

1950 1960 1970 1980 1990 2000 2010 2020

frankenstein universe

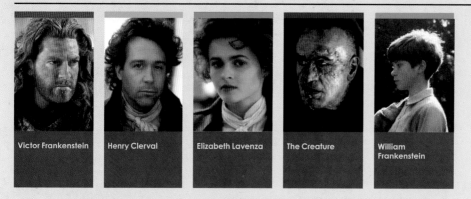

Victor Frankenstein Henry Clerval Elizabeth Lavenza The Creature William Frankenstein

Victor Frankenstein has an idyllic childhood, with one friend in particular, Henry Clerval. At 13, he finds a book by Cornelius Agrippa, an alchemist, and is enthralled by his writings. When he is 15, lightning blasts an oak near his home. His father then uses experiments to demonstrate the power of electricity.

At 17, as Victor prepares for university in Bavaria, his adopted sister Elizabeth falls ill. Mrs Frankenstein nurses her back to health, only to succumb to the disease herself.

Victor spends two years studying. Obsessed with finding the secret of life, he constructs a creature from body parts and revivifies it with electricity, but he is horrified by the result. Just as he falls into a brain fever, Clerval arrives and the creature escapes. Nursed by Henry for months, Victor recovers and spends another year at the university, but then decides to go home.

Meanwhile, the creature flees into a forest. It encounters people who hate it for its ugliness, and hides in a hovel next to a family, which it observes and thereby learns to speak and read. Then it discovers the identity of its maker from letters in the pockets of the clothes it wears.

The creature longs for companionship. One day, when the younger family members are out, it talks to their blind father. The children return and drive away the creature, who vows to have revenge on humans.

On his way to find his creator, the creature rescues a girl from drowning, only to be shot by a man who thinks it has attacked her. When the creature reaches Geneva, it encounters Victor's younger brother, William, in the woods, and hopes that an unprejudiced child could be its friend. Frightened, William tells the creature who his family is, hoping to scare it off. Enraged at the name of Frankenstein, the creature kills

characters ▮▮ Victor Frankenstein ▮ Henry Clerval ▮ Elizabeth Lavenza ▮ The Creature

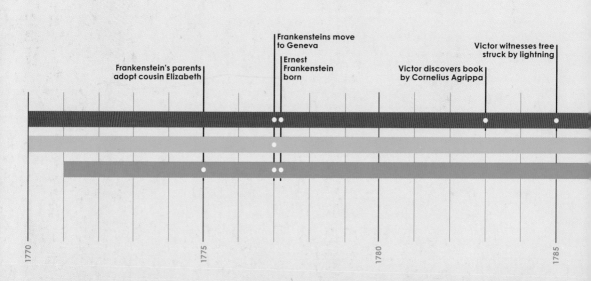

Frankensteins move to Geneva

Ernest Frankenstein born

Victor witnesses tree struck by lightning

Frankenstein's parents adopt cousin Elizabeth

Victor discovers book by Cornelius Agrippa

1770 1775 1780 1785

him. It takes a miniature portrait from him and, in spite, slips it into the pocket of a girl it finds sleeping.

Victor learns that William has been murdered. He returns home to find that Justine, a girl fostered by his mother, has been accused of the murder because she was found with the miniature. Although innocent, she confesses to the crime and is executed.

Victor believes the creature committed the crime. Tortured by guilt, he starts sailing and walking alone. High on a glacier near Chamonix, he encounters the creature once more. It promises to leave humans in peace if his creator will make it a mate.

Victor goes to England to do so, with Clerval. They travel north to Scotland, and Victor journeys on to Orkney alone. There, on a desolate island, he makes the creature's mate, but in fear of what evil might result he destroys it. Outraged, the creature threatens him, "I shall be with you on your wedding night."

Victor sails out to sea to dump the remains of the female creature. His boat drifts and he ends up in Ireland, where he is accused of murder. Shown the corpse of the victim, he sees it is Clerval, who has been strangled. Victor suffers another bout of brain fever.

When he recovers, and is proved to have been on Orkney at the time of the murder, Victor returns to Geneva. Believing the creature will kill him on his wedding night, he agrees to marry Elizabeth. He sends her to bed and waits for the creature to come to him. Come it does — only to strangle his bride instead.

Victor pursues the creature to the Arctic, where he is found near death on a floe by explorer Robert Walton. Taken aboard Walton's ship, Victor tells his story. But when the vessel becomes iced in, Victor sickens and dies. Walton enters his cabin to find the creature there. Its creator dead, it vows to destroy itself, and leaves. Walton sets sail for home. **MM**

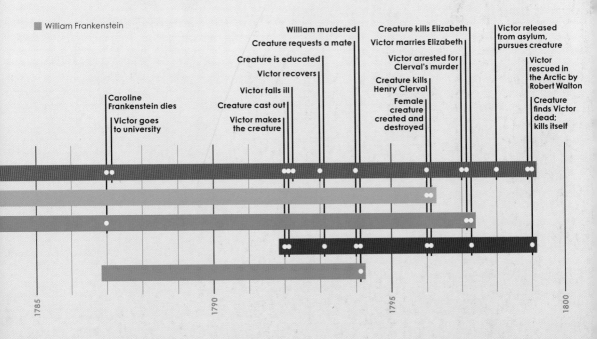

■ William Frankenstein

William murdered
Creature requests a mate
Creature is educated
Victor recovers
Victor falls ill
Creature cast out
Victor makes the creature

Caroline Frankenstein dies
Victor goes to university

Creature kills Elizabeth
Victor marries Elizabeth
Victor arrested for Clerval's murder
Creature kills Henry Clerval
Female creature created and destroyed

Victor released from asylum, pursues creature
Victor rescued in the Arctic by Robert Walton
Creature finds Victor dead; kills itself

1785 1790 1795 1800

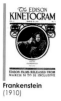

Frankenstein
(1910)

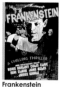

Frankenstein
(1931)

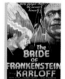

**The Bride of
Frankenstein**
(1935)

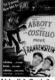

**Abbott & Costello
Meet Frankenstein**
(1948)

**Frankenstein Must
Be Destroyed**
(1969)

**Young
Frankenstein**
(1974)

**Mary Shelley's
Frankenstein**
(1994)

Frankenstein
(2011)

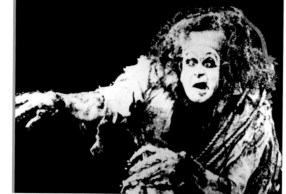

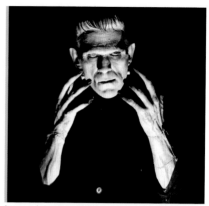

Charles Ogle was first to portray the creature on screen. He created the monster's look himself.

So uncomfortable was Boris Karloff's makeup that he joined the then-new Screen Actors Guild, founded to protect its members.

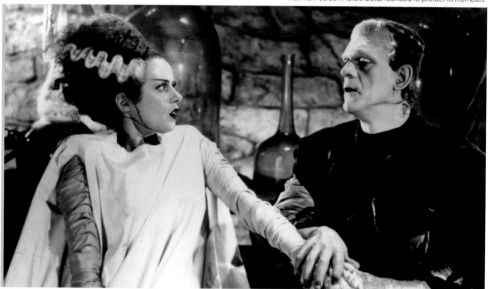

Elsa Lanchester portrayed both Mary Shelley and the bride. Shelley, said the actress, "did have this thing curdling inside of her, with a pretty exterior. She had fiends within. [Director] James Whale wanted to point that up." The bride became iconic, despite being on screen for barely 12 minutes.

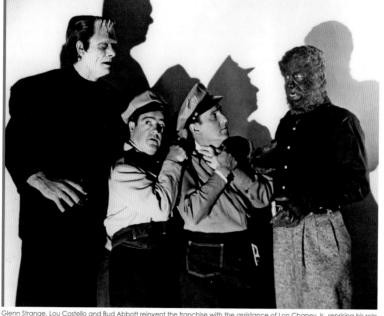

Glenn Strange, Lou Costello and Bud Abbott reinvent the franchise with the assistance of Lon Chaney Jr., reprising his role from 1941's *The Wolf Man*.

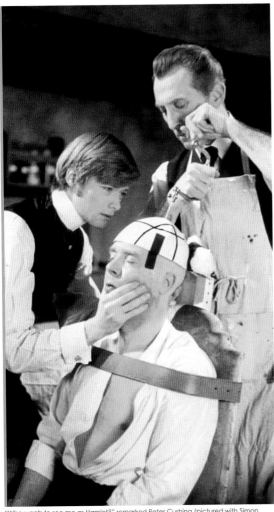

"Who wants to see me as Hamlet?" remarked Peter Cushing (pictured with Simon Ward and Freddie Jones). "Very few. But millions want to see me as Frankenstein."

Peter Boyle and Gene Wilder star in Mel Brooks' loving spoof **Young Frankenstein**. "My favorite movies," Brooks said, "have always been either Frankenstein or Fred Astaire."

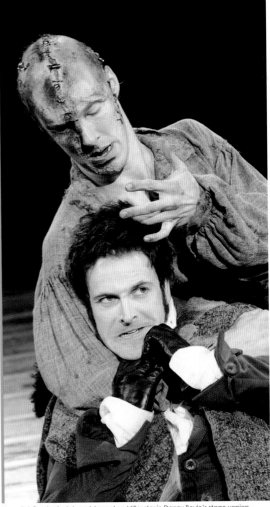

Robert De Niro and Kenneth Branagh brought Shelley's story back to life in 1994. "The subject has a Shakespearean scope and grandeur," Branagh told *Interview*.

Benedict Cumberbatch and Jonny Lee Miller star in Danny Boyle's stage version. *Frankenstein*, said Cumberbatch, is "ultimately a novel about bad parenting."

jules verne 1849

Journey to the Center of the Earth

From the Earth to the Moon

20,000 Leagues Under the Sea

Around the Moon

The Mysterious Island

Off on a Comet

The Begum's Millions

The Steam House

Today, Jules Verne and H.G. Wells are often seen as a pair, the founding fathers of science fiction, marking out thematic territory in a flurry of *fin-de-siècle* invention. But the two men were actually a generation apart — Verne's best work was produced while Wells was still at school.

Born in 1828, Verne was part of the movement of imaginative French literature that flourished in the mid-19th century; his contemporaries included Alexandre Dumas, Gustave Flaubert and Guy de Maupassant. Unlike Wells' prophetic warnings, much of Verne's work is bright, optimistic and thrilling.

Verne's father expected his son to follow him into the legal profession but, after arriving in Paris during the political upheavals of 1848, Jules started to make money from writing, first for the stage then for magazines. He developed a talent for rich, detailed descriptions of places he had never visited, based on careful scientific and geographical research in the Bibliothèque nationale.

In 1862, Verne met Pierre-Jules Hetzel, the publisher of Victor Hugo, Émile Zola and Honoré de Balzac. Hetzel planned a magazine that combined entertaining fiction with educational science. He rejected Verne's *Paris in the 20th Century* (which remained unpublished for 131 years) but accepted *Five Weeks in a Balloon*, the first of Verne's 54 *Voyages Extraordinaires*. For the next four decades, Verne would write at least one book a year, which Hetzel (and after 1886, his sons) would serialize, then publish in both lavish and cheap editions.

Verne admired Edgar Allan Poe, whose novel *The Narrative of Arthur Gordon Pym of Nantucket* touches on the "hollow Earth" theory. In 1864 Verne explored this theme in *Journey to the Center of the Earth* and eventually wrote his own sequel to Poe's tale, *Arthur Gordon Pym, An Antarctic Mystery*.

From the Earth to the Moon is Verne's most obviously science fictional novel and also his most influential, cited as inspiration by rocketry pioneers including Konstantin Tsiolkovsky, Robert Goddard and Hermann Oberth. The American Civil War had just ended and Verne envisaged — accurately, albeit 80 years too early and after the wrong war — that weapon makers whose skills were not currently required would redirect their attention to space travel. The novel tells how members of the Baltimore Gun Club design, build and fire a massive projectile to take three of them to the Moon (another theme explored by Poe). Jacques Offenbach adapted the story into an opera in 1875. This book ends after the missile is launched, but five years later Verne wrote a sequel, *Around the Moon*, in which the spacecraft returns safely to Earth. A little-known third outing for the Baltimore Gun Club is *The Purchase of the North Pole*, in which the members build inside Mount Kilimanjaro a cannon that is powerful enough to eliminate the Earth's axial tilt.

year-by-year ■ Book

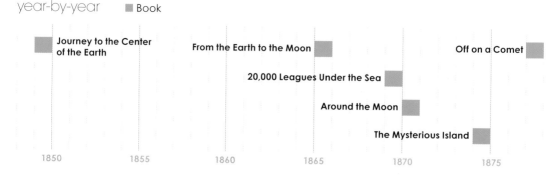

Journey to the Center of the Earth

From the Earth to the Moon

Off on a Comet

20,000 Leagues Under the Sea

Around the Moon

The Mysterious Island

1850 1855 1860 1865 1870 1875

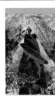

| Mathias Sandorf | Robur the Conqueror | The Purchase of the North Pole | Carpathian Castle | Propeller Island | Facing the Flag | Master of the World | Invasion of the Sea |

Verne's best-known and most adapted works are *20,000 Leagues Under the Sea* and the non-SF *Around the World in 80 Days*. In *The Mysterious Island* — a joint sequel to both *Leagues* and the non-SF *In Search of the Castaways* — Verne developed his method of treating what is now regarded as science fiction no differently from his regular adventure yarns.

Off on a Comet was Verne's most outlandish story, as a chunk of Planet Earth with 36 inhabitants is knocked into space by the glancing blow of a comet. Once past the initial, ridiculous premise (which is really not much sillier than that of Gerry Anderson's *Space: 1999*), Verne did his usual meticulous job of calculating the scientific phenomena which would be observed in such an event.

Verne's post-1871 work was influenced by the Franco-Prussian War, during which he served in the National Guard, and the technological advances in weaponry that he observed during the conflict. This is most apparent in *The Begum's Millions*, which features a war-mongering German dictator who builds a fortified town and a super-gun to fire gas-filled shells at an enemy city. Advanced weaponry and a heavily defended base also featured in *Mathias Sandorf*, long before such things became *de rigueur* for James Bond villains. The SF theme of *The Steam House* is more benign: the novel recounts a journey through India in a mobile building pulled by a steam-powered mechanical elephant.

Many of Verne's books featured balloons. *Robur the Conqueror* (aka *The Clipper of the Clouds*) reflected a contemporary scientific debate — stirred by the work of Otto Lilienthal — about whether these conveyances would eventually be supplanted by heavier-than-air vehicles. Robur, an aeronautical Captain Nemo, constructs a massive propeller-powered flying craft that he demonstrates but believes no nation should possess. He returned in a sequel, *Master of the World*. *Propeller Island* was set aboard a vast, artificial, floating millionaire's playground; *Facing the Flag* centered on another super-weapon; *Carpathian Castle* featured a holographic projector; and Verne's final novel, *Invasion of the Sea*, documented a massive civil engineering project to flood the Sahara Desert. Although Verne's popularity never waned during his lifetime, of his post-1880 output only the two Robur novels have cultural currency today.

Verne's works were widely translated but poor English versions sullied his reputation abroad for many years. A further eight *Voyages Extraordinaires* by "Jules Verne" were published posthumously, but these were partly or wholly written by Michel Verne and are considered apocryphal. Verne did, however, live long enough to see Georges Méliès adapt *From the Earth to the Moon* into the first ever classic science fiction film. Since then, there have been innumerable screen adaptations of his work. **MJS**

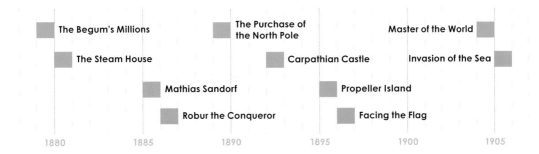

The Begum's Millions

The Steam House

Mathias Sandorf

Robur the Conqueror

The Purchase of the North Pole

Carpathian Castle

Propeller Island

Facing the Flag

Master of the World

Invasion of the Sea

1880 1885 1890 1895 1900 1905

journey to the center of the earth 1864

Journey to
the Center
of the Earth

Journey to
the Center
of the Earth

Journey to
the Center
of the Earth

Journey to
the Center
of the Earth

A Journey to
the Center
of the Earth

The Fabulous
Journey to
the Center of
the Earth

Journey to
the Center
of the Earth

Willy Fog 2

There are significant differences between the two best-known examples of "hollow Earth" science fiction. Where Edgar Rice Burroughs' *At the Earth's Core* (1914) and its sequels posit a literally hollow Earth — an empty sphere with life on the inside, gravity somehow reversed — Jules Verne's *Journey to the Center of the Earth* is concerned with deep caves and underground seas. Verne's work is more scientifically rigorous than Rice Burroughs' *Pelucidar* series, but no less fantastic.

The third of the *Voyages Extraordinaires*, *Journey to the Center of the Earth* is one of only a few works written by Verne that were originally published in book form without prior serialization. The story's main characters are the impulsive historian/scientist Professor Lidenbrock (differently spelled or renamed in various translations and adaptations) and his nephew Axel, a timid student who would like a quiet life with his sweetheart.

Lidenbrock is inspired by a cryptic message written by a (fictional) Icelandic alchemist named Saknussem to enter the bowels of the Earth through the crater of an extinct volcano and journey far underground. Guided by strong, honest hunter Hans, Axel and the Professor descend into a subterranean world of endless caverns.

After assorted caving adventures, the three men reach a vast, underground ocean populated by prehistoric beasts. They build a raft and find a land on the other side full of giant insects and 12-foot (3.6-m) tall ape-men. Blasting a rockfall that bars their way, they hold on tightly as their raft is sucked into a volcanic cavern and then shot out of the crater of a peak in Italy.

In *Journey*, Verne is still experimenting with his style. Most critics agree that far too much of the book is devoted to deciphering the message, whereas the giant subhumans and insects, which had no basis in contemporary science, are thoroughly atypical of the usually rigorous author. In later *Voyages*, Verne would find the real world to be quite *extraordinaire* enough without having to invent bizarre new species.

Yet the solid storytelling and straightforward characterization have long endeared *Journey* to readers and movie-makers. The film version directed by Henry Levin in 1959, starring James Mason and Pat Boone, remains the archetype and introduced the frequently copied idea of a nefarious rival explorer. A big-budget movie in 2008 starring Brendan Fraser was a hit and spawned a sequel (without Fraser) based on *Mysterious Island*, which in literary form was actually the sequel to *20,000 Leagues Under the Sea*.

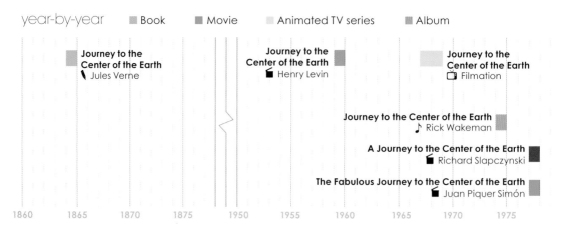

year-by-year ■ Book ■ Movie ▨ Animated TV series ▨ Album

Journey to the
Center of the Earth
\ Jules Verne

Journey to the
Center of the Earth
■ Henry Levin

Journey to the
Center of the Earth
▢ Filmation

Journey to the Center of the Earth
♪ Rick Wakeman

A Journey to the Center of the Earth
■ Richard Slapczynski

The Fabulous Journey to the Center of the Earth
■ Juan Piquer Simón

1860 1865 1870 1875 1950 1955 1960 1965 1970 1975

$266M
Journey to the
Centre of the Earth
(2008)

Journey to the Center of the Earth	Journey to the Center of the Earth	Journey to the Center of the Earth	Journey to the Center of the Earth	Journey to the Center of the Earth	Journey to the Center of the Earth	Journey to the Center of the Earth	Journey to the Center of the Earth

In between these two films came a curious Spanish version directed by Juan Piquer Simón and starring Kenneth More as Professor Otto Lindenbrock: *Viaje al Centro de la Tierra*, variously known in English as *Jules Verne's The Fabulous Journey to the Center of the Earth* and *Where Time Began*. Largely faithful to the novel, this rather dull 1976 movie's publicity promised much — including a giant gorilla, shamelessly modeled on that year's John Guillermin-directed remake of *King Kong* — which it ultimately failed to deliver. Simón also directed *Jules Verne's Mystery on Monster Island* (1981), a liberal adaptation of the author's 1882 monster-free castaway novel *L'École des Robinsons* (English title: *Godfrey Morgan*).

Prolific American B-movie director Albert Pyun referenced Verne in his 1988 feature *Alien from L.A.*, in which a waitress named Wanda Saknussem (played by supermodel Kathy Ireland) searches underground for her explorer father, Arnold, and eventually reaches the subterranean city of Atlantis. Pyun followed this with his own version of *Journey* that is partly a sequel to *Alien* and partly based on eight minutes of an unfinished 1986 Verne adaptation directed by Rusty Lemorande. The resulting confection of several conflicting styles satisfied no one and flopped at the box office.

On television, *Journey to the Center of the Earth* and *20,000 Leagues Under the Sea* formed the two halves of the second season of Spanish cartoon *Willy Fog*, the first season of which had been based on *Around the World in 80 Days*. A 1967 *Journey* animated series of 17 half-hour episodes incorporated elements from the 1959 film, whereas a 1993 TV movie and a 1999 mini-series both deviated massively from the source material, leaving little of the Verne original apart from the title and an underground adventure.

In 1974 rock musician Rick Wakeman recorded a live concept album, *Journey to the Centre of the Earth*, narrated by David Hemmings, which topped the British charts and spawned a belated sequel in 1999, *Return to the Centre of the Earth*, narrated by Patrick Stewart. A new recording of the original album was released in 2012, and in 2014 Wakeman toured a performance combining material from both albums, celebrating the 40th anniversary of his record and 150 years since the publication of Verne's novel.

In 1997 an audio theater group produced a dramatized version of *Journey*. Probably the most faithful adaptation of Verne's work is a Franco-Belgian animated feature released in 2001 – although it's not as much fun as the 1996 Canadian cartoon version, which adds a talking guinea pig to the mix. **MJS**

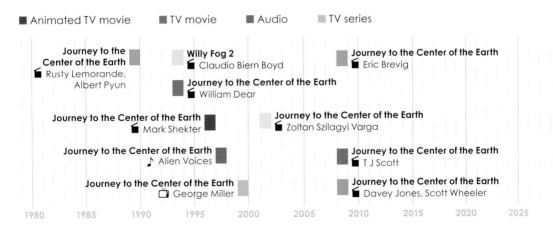

■ Animated TV movie ■ TV movie ■ Audio ■ TV series

Journey to the Center of the Earth
Rusty Lemorande, Albert Pyun

Journey to the Center of the Earth
Mark Shekter

Journey to the Center of the Earth
♪ Alien Voices

Journey to the Center of the Earth
George Miller

Willy Fog 2
Claudio Biern Boyd

Journey to the Center of the Earth
William Dear

Journey to the Center of the Earth
Zoltan Szilagyi Varga

Journey to the Center of the Earth
Eric Brevig

Journey to the Center of the Earth
T J Scott

Journey to the Center of the Earth
Davey Jones, Scott Wheeler

1980 1985 1990 1995 2000 2005 2010 2015 2020 2025

Journey to the
Center of the Earth
(1849)

Journey to the
Center of the Earth
(1959)

Journey to the
Center of the Earth
(2008)

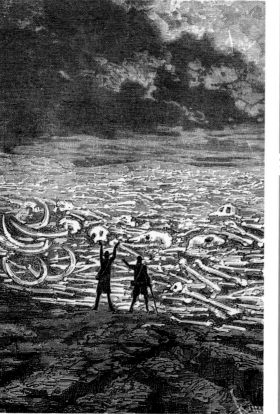

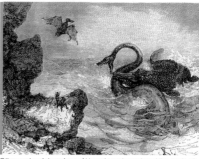

Other early print versions of Verne's work captured the perils of
the ocean . . .

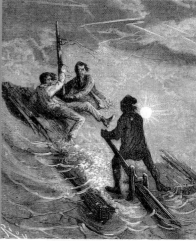

Illustration from an early French edition of Verne's *Journey to the Center of the Earth*.

. . . and the voyagers' relief at surviving them.

In the 1959 film version of *Journey to the Center of the Earth*, the part of student Alec McEwan was played by pop star Pat Boone.

A scene from *Journey to the Center of the Earth* (2008), directed by Eric Brevig.

The design of the raft in *Journey to the Center of the Earth* was plainly influenced by that of the *Kon-Tiki* on which Thor Heyerdahl had crossed the Pacific in 1947.

Stars of *Journey to the Center of the Earth*: (L–R) Josh Hutcherson, Brendan Fraser and Anita Briem.

Professor Trevor Anderson (Brendan Fraser) tries to outrun a Tyrannosaurus in *Journey to the Center of the Earth*.

20,000 leagues under the sea 1870

20,000 Leagues Under the Sea

The Mysterious Island

20,000 Leagues Under the Sea

20,000 Leagues Under the Sea

The Mysterious Island

20,000 Leagues Under the Sea

20,000 Leagues Under the Sea

Mysterious Island

The first primitive submarines were built during the 17th century, but it was not until the American Civil War in the 1860s that practical submersibles were developed. Jules Verne was inspired by them to create his most famous work of science fiction. Published in 1870 as the sixth of his *Voyages Extraordinaires*, *20,000 Leagues Under the Sea* was a huge success and has spawned numerous cinema and TV adaptations.

The story's protagonists are typically thin Vernian characters: an educated, upper-class man, marine biologist Professor Arronax; his loyal servant Conseil; and an honest, strong working-class man, harpoonist Ned Land. They join an expedition to hunt a sea monster that has been attacking shipping but which turns out to be a fabulously advanced submarine.

The *Nautilus* (named after a submarine built in France in 1800) is the invention of the mysterious Captain Nemo (Latin for "nobody"), who has rejected humankind since the death of his family and travels the oceans, combining scientific research with revenge attacks on shipping. Arronax, Conseil and Ned are rescued by Nemo, who treats them courteously but tells them that they can never leave the *Nautilus* because they would betray him. After a series of underwater adventures, the captives escape during an attack by a belligerent vessel.

Mixing detailed descriptions of exotic locales and marine life (researched in the Bibliothèque nationale) with fanciful inventions of his own, Verne created a scientific fairy tale. The highlight of the book (and of most adaptations) is a battle against a giant squid, a fabled creature properly documented by science for the first time in 1853. The core of the novel, however, is Nemo himself, one of Verne's most fascinating, charismatic and morally complex creations.

Verne had originally conceived Nemo as Polish but in the 1874 sequel, *The Mysterious Island*, the character is revealed as an Indian prince who fled his home after the unsuccessful Indian Rebellion of 1857. Set 16 years after *Leagues* but also (incompatibly) near the end of the Civil War, *The Mysterious Island* tells of five prisoners who escape a Confederate prison in a balloon and land on a remote Pacific atoll where they meet one of the main characters from another Verne novel, *In Search of the Castaways*. Some mysterious force is at hand on the island, providing the small colony with arms, tools and other help, and this is eventually revealed to be Captain Nemo. The island was his secret base, but now his crew is all dead and he lives alone aboard the *Nautilus*. At the end of the book Nemo dies, the island's central volcano explodes and the castaways are rescued just in time.

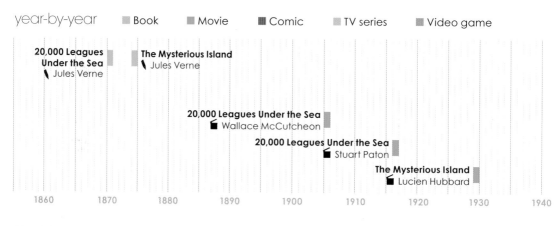

year-by-year ■ Book ■ Movie ■ Comic ■ TV series ■ Video game

20,000 Leagues Under the Sea
↖ Jules Verne

The Mysterious Island
↖ Jules Verne

20,000 Leagues Under the Sea
↖ Wallace McCutcheon

20,000 Leagues Under the Sea
↖ Stuart Paton

The Mysterious Island
↖ Lucien Hubbard

1860 1870 1880 1890 1900 1910 1920 1930 1940

| The Mysterious Island of Captain Nemo | The Other Log of Phileas Fogg | Kapitan Nemo | 20,000 Leagues Under the Sea | The League of Extraordinary Gentlemen | Return to Mysterious Island | Mysterious Island | Journey 2: The Mysterious Island |

It did not take long for film makers to see the potential of these books. Both novels were used as the basis for an ambitious silent feature in 1916. The most famous of the many versions of *Leagues* remains the live-action Disney film produced in 1954 (shortly after the novel's copyright expired), which features an iconic *Nautilus* design, strong performances — including James Mason as a definitive, if thoroughly non-Indian, Nemo — and a thrilling squid battle realized through massively complex special effects.

Over the years Nemo has also been played by such distinguished actors as Patrick Stewart, Michael Caine, Omar Sharif, José Ferrer and Herbert Lom. There have been several animated versions of both tales and there was a flurry of big-budget *Leagues* adaptations in the late 1990s, of which potentially the best, a magnificent steampunk prequel directed by Christophe Gans, was sadly never produced. *Mysterious Island* has also been frequently adapted, the best-known version being the 1961 movie which features stop-motion effects by Ray Harryhausen.

Because these books, like most Verne novels, are driven by incident rather than character, writers and film makers have had little problem in playing mix-and-match with them. The Russian mini-series *Kapitan Nemo* (1975) combines *Leagues* with *The Steam House*, a journey through India by steam-powered elephant, whereas *Journey 2: The Mysterious Island* (2012) is not only an adaptation of *Mysterious Island* and a sequel to *Journey to the Center of the Earth* but also incorporates Robert Louis Stevenson's *Treasure Island* and Jonathan Swift's *Gulliver's Travels* into its narrative. Meanwhile, Nemo had proved strong enough a character to survive transplantation into original stories by several other hands.

Philip José Farmer's novel *The Other Log of Phileas Fogg* (1973) combines Verne's *Around the World in 80 Days* with *Leagues* and *Mysterious Island*, resolving the inconsistencies between the last two while throwing Conan Doyle's Sherlock Holmes and Moriarty into the mix. Taking such crossover fiction to extremes, Alan Moore's comic-book series *The League of Extraordinary Gentlemen* (1999 onward) combines Nemo with other characters from Victorian fiction including H.G. Wells' Invisible Man, Stevenson's Dr. Jekyll and H. Rider Haggard's Allan Quartermain as a sort of steampunk superhero team. Kevin O'Neill's artwork correctly portrayed Nemo as an Indian Prince; Naseeruddin Shah played him in the critically panned 2003 film adaptation.

For those wanting to take a trip on a *Nautilus*, there are rides based on the 1954 film at the Disney amusement parks in Anaheim, California; Orlando, Florida; Paris, France and Tokyo, Japan. **MJS**

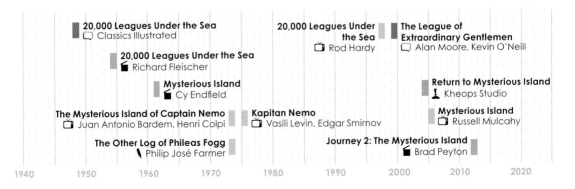

20,000 Leagues
Under the Sea
(1870)

The Mysterious
Island
(1929)

20,000 Leagues
Under the Sea
(1954)

Mysterious
Island
(1961)

Journey 2: The
Mysterious Island
(2012)

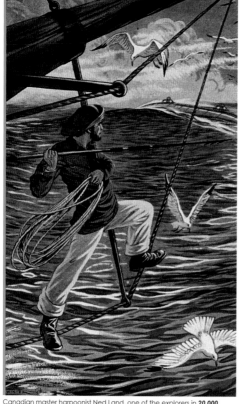

Canadian master harpoonist Ned Land, one of the explorers in *20,000 Leagues Under the Sea*.

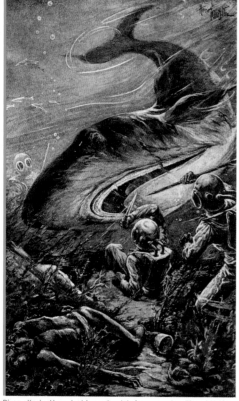

Divers attacked by a shark in a color plate from an early edition of *20,000 Leagues Under the Sea*.

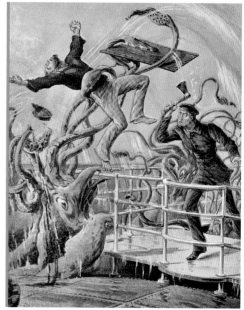

Tangling with the formidable giant squid.

Screen monsters have become more scary since *The Mysterious Island* (1929), directed by Lucien Hubbard . . .

. . . but the robots in the movie stand up much better to modern scrutiny.

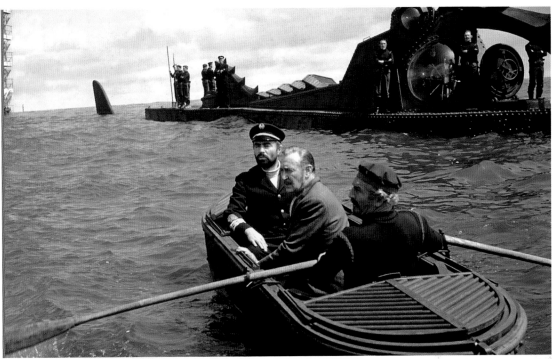

James Mason (L) starred as Captain Nemo in **20,000 Leagues Under the Sea** (1954), directed by Richard Fleischer.

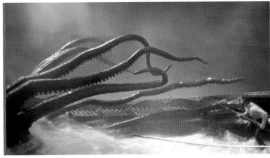

Mason versus squid in Fleischer's movie.

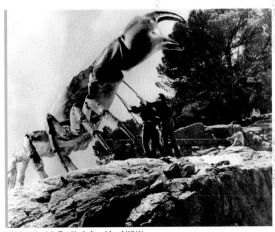

Lobster attack in **The Mysterious Island** (1961).

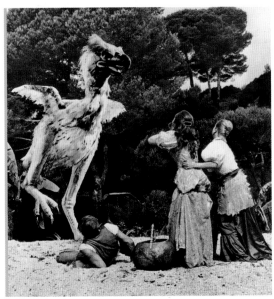

The castaways get the bird in **The Mysterious Island** (1961).

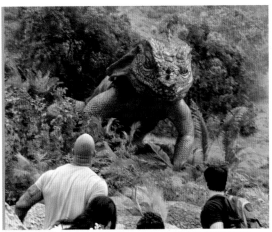

Journey 2: The Mysterious Island (2012) leavened jeopardy and thrills with humor.

kurd laßwitz 1871

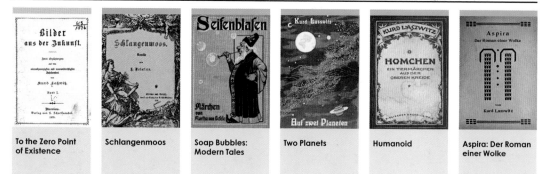

To the Zero Point of Existence

Schlangenmoos

Soap Bubbles: Modern Tales

Two Planets

Humanoid

Aspira: Der Roman einer Wolke

Known as "the father of German science fiction," Kurd Laßwitz (often rendered "Lasswitz" in English) was a physicist and mathematician whose literary works influenced scientists Wernher von Braun and Walter Hohmann in particular, as well as American science fiction in general through the writings of Hugo Gernsback. According to E.F. Bleiler in *Science in Fiction: The Early Years*: "Gernsback would have been saturated in Lasswitz's work, and Gernsback's theoretical position of technologically based liberalism and many of his little scientific crotchets resemble ideas in Lasswitz's work."

Laßwitz's first science fiction story was "To the Zero Point of Existence," a depiction of life on Earth in the year 2371. Typical of his subsequent writing, this was a work of extrapolative fiction. "Many inferences about the future can be drawn from the historical course of civilization and the present state of science; and analogy offers itself to fantasy as an ally," he wrote in his 1878 preface to *Bilder aus der Zukunft* (usually rendered in English as *Images from the Future*), which collected *Zero Point* with a second, similar novella.

Laßwitz's most famous work is *Auf Zwei Planeten* (*Two Planets*). Published in 1897, when the North Pole had not yet been reached by explorers, it tells of the discovery there of a Martian base.

The Mars depicted by Laßwitz closely follows Percival Lowell's idea of a planet criss-crossed by canals. (This belief, extrapolated erroneously from observations made by 19th-century astronomer Giovanni Schiaparelli, did much to fuel early science fiction's obsession with the Red Planet.) The Martians — who are physically similar to humans, apart from their larger, emotionally expressive eyes — come to Earth in search of water, which is running out on their planet. They fight the Earthmen to establish a protectorate, but parity is established between the two worlds and humankind then looks forward to a utopian future.

Steeped in contemporary scientific research even more deeply than the work of Jules Verne, Laßwitz is an early exponent of hard science fiction. His spaceships are powered by the "magic technology" of anti-gravity, but the details of transit between Earth and Mars, including the necessary course corrections and proper trajectories, remain accurate. However, his characterization is rather thinner than his knowledge of physics.

Laßwitz was a graduate of the universities of Breslau and Berlin, and spent his career teaching philosophy at the Gymnasium Ernestinum in Gotha. He also wrote experimental fairytales. An abridged version of *Two Planets* was published in 1971, but the work has never been fully published in English, and Laßwitz remains largely unknown outside his native Germany. **GH**

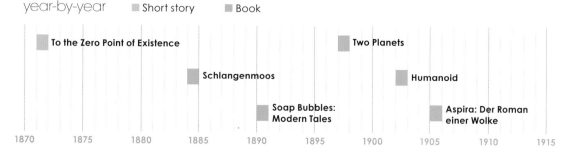

year-by-year ■ Short story ■ Book

To the Zero Point of Existence

Schlangenmoos

Soap Bubbles: Modern Tales

Two Planets

Humanoid

Aspira: Der Roman einer Wolke

1870　1875　1880　1885　1890　1895　1900　1905　1910　1915

a connecticut yankee in king arthur's court 1889

A Connecticut Yankee in King Arthur's Court

A Connecticut Yankee in King Arthur's Court

A Connecticut Yankee

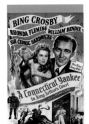

A Connecticut Yankee in King Arthur's Court

Bugs Bunny in King Arthur's Court

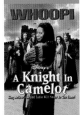

A Knight in Camelot

After decades wowing the world as a satirist, novelist and public performer — during his long career he created *The Adventures of Tom Sawyer*, *The Prince and the Pauper* and *Adventures of Huckleberry Finn* — 54-year-old Samuel Langhorne Clemens, known to millions of readers as Mark Twain, invented an entire subgenre of science fiction. There had been alternate histories and time travel tales before the 1890s, of course, but in terms of influence *A Connecticut Yankee in King Arthur's Court*, the story of a superintendent in a firearms factory who is knocked unconscious and wakes to find himself in sixth-century England, was greater than anything that preceded it.

Indeed, *A Connecticut Yankee*'s influence is the most notable thing about it. The novel is a rambunctious, satirical burlesque that has little plot or consistency of character. Hank Morgan, transported 1,300 years into the past, uses his (highly convenient) engineering skills and precise knowledge of historical eclipses to persuade King Arthur that he is a powerful magician whose talents dwarf those of Merlin, the court sorcerer. Hank is given free rein in the kingdom, and sets about introducing industry and democracy in an effort to reform all that he finds despicable about the past. He becomes friendly with Arthur, and easily outperforms Merlin; but the reactionary Catholic Church proves insurmountable. The novel climaxes with an apocalyptic insurrection, during which Hank wipes out thousands of nobles with electric shocks and drowning. Finally, phony magician Merlin inexplicably works his magic and plunges Hank into a deep sleep from which he reawakens back in the present day.

Twain is less concerned with time travel than with the implications of colliding the present with the past. The influence on such time travel stories as *The Terminator*, Robert A. Heinlein's "All You Zombies" and Kurt Vonnegut's *Slaughterhouse-Five* is therefore minimal. The book's real legacy is in L. Sprague de Camp's *Lest Darkness Fall* and in two series — S.M. Stirling's Nantucket and Eric Flint's 1632 — in which the journey back is merely a narrative device that sets up discussion of another topic. In *A Connecticut Yankee*, that other topic is American liberal imperialism. Hank Morgan is the first in a long line of time travelers who change the world, even though in this instance his experiment in democracy ends in disaster.

A Connecticut Yankee has been adapted numerous times — including into a stage musical, a Bugs Bunny cartoon and an episode of *The Transformers*. Sam Raimi's third *Evil Dead* film owes it a debt, as do Hartnell-era *Doctor Who*, *Bill and Ted's Excellent Adventure* and Leo Frankowski's hero Conrad Stargard. Almost every subsequent generation has created its own Yankee, from Bing Crosby in 1949 to Whoopi Goldberg in 1998. **TH**

year-by-year ▓ Book ▓ Movie ▐▌ Musical ▓ Animated short

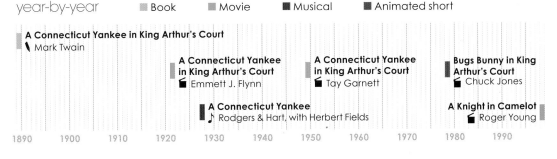

A Connecticut Yankee in King Arthur's Court
Mark Twain

A Connecticut Yankee in King Arthur's Court
Emmett J. Flynn

A Connecticut Yankee
♪ Rodgers & Hart, with Herbert Fields

A Connecticut Yankee in King Arthur's Court
Tay Garnett

Bugs Bunny in King Arthur's Court
Chuck Jones

A Knight in Camelot
Roger Young

1890 1900 1910 1920 1930 1940 1950 1960 1970 1980 1990

h.g. wells 1895

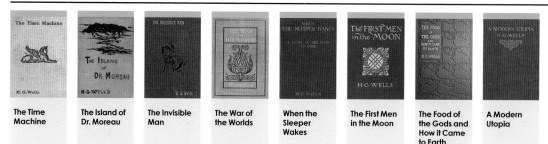

The Time Machine

The Island of Dr. Moreau

The Invisible Man

The War of the Worlds

When the Sleeper Wakes

The First Men in the Moon

The Food of the Gods and How it Came to Earth

A Modern Utopia

Acclaimed as one of the fathers of science fiction, Herbert George Wells published more than 50 novels during his lifetime (1866–1946), but his reputation as a science fiction writer is based mainly on the success of his earlier works.

Born in Bromley, Kent, England, in 1866, Wells came from a humble background: his father was a shopkeeper who boosted his income by playing professional cricket, while his mother was a domestic servant. Wells' education was somewhat erratic; he spent three years working as a draper's apprentice and a brief spell as a chemist's apprentice, as well as stints as a pupil-teacher at two schools, before winning a scholarship to the Normal School of Science (later the Royal College of Science).

His first marriage lasted only four years, and all his major works were published during his second marriage. The latter marriage was not easy for his wife Jane because Wells, a believer in free love, had several affairs and two illegitimate children.

Wells' first major novel, The Time Machine, published just before he reached the age of 30, was an immediate success. Like all his works it shows the influence of his early experiences and his interest in socialism as well as his scientific studies. In it, the Time Traveler (whose name the reader never learns) travels forward to the year 802,701, where he sees the eventual result of a divided society. The moneyed classes have evolved into the carefree, charming Eloi, the working classes into the brutish Morlocks. After further jumps through time to see the planet Earth in its dying stages, the Time Traveler returns to his own time.

In each of the three years that followed, Wells produced an equally influential novel: in 1896 came The Island of Dr. Moreau; The Invisible Man followed in 1897 and The War of the Worlds first appeared in 1898.

Although all these books are indisputably science fiction novels — and the ideas of time travel and alien invasion have continued to inspire science fiction writers right up to the present day — Wells, unlike Jules Verne, was more anxious to investigate morality in science and society than to explore what it might actually be possible for science to achieve. As he himself said, "Life is two things. Life is morality; life is adventure . . . Morality tells you what is right, and adventure moves you."

Wells' novels of the early 20th century were more realistic than his science fiction works of the 1890s. In his later writings, Wells became increasingly preoccupied with political ideas — the main characters in Kipps and The History of Mr. Polly, for example, both struggle against their place in society, allowing Wells to re-explore the experiences of his youth and to critique the British class system. His Ann Veronica explores a woman's right to choose her own lovers and lifestyle.

year-by-year ■ Book ■ Movie

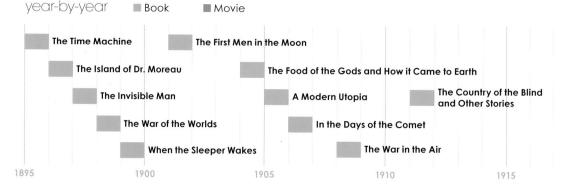

The Time Machine

The First Men in the Moon

The Island of Dr. Moreau

The Food of the Gods and How it Came to Earth

The Invisible Man

A Modern Utopia

The Country of the Blind and Other Stories

The War of the Worlds

In the Days of the Comet

When the Sleeper Wakes

The War in the Air

1895 1900 1905 1910 1915

| In the Days of the Comet | The War in the Air | The Country of the Blind and Other Stories | Men Like Gods | The Dream | The Shape of Things to Come | Things to Come | Star Begotten |

Nonetheless, certain themes persist throughout his oeuvre, and the most frequently recurrent of these is the notion that struggle is essential to human development. Its earliest statement is in *The Time Machine*, where it is asserted that "We should strive to welcome change and challenges, because they are what help us grow. With out them we grow weak." This conviction remains as strong as ever in his final works.

In addition to his novels, Wells published several volumes of nonfiction. In some of these, he outlined what he thought the future might bring. *Anticipations* was a big success when it was published in 1901; among the more accurate predictions therein were suburbanization and a unified Europe. His three-volume *The Outline of History* chronicled the past and also offered some predictions, including — controversially, for a work published less than two years after the end of the First World War — another major global conflict.

Not content merely to write about politics, Wells became actively involved in it. He was a firm believer in a global state. He was a member of the left-wing Fabian Society from 1903 to 1908, leaving after having failed to turn it from an intellectual talking shop into a larger, more active, political pressure group. In 1920 he met Lenin and Trotsky in the Soviet Union, but was disillusioned by what he saw in the recently established communist state. In 1922 and 1923 he stood unsuccessfully as a parliamentary candidate for the British Labour Party in the General Elections.

Wells' work, especially his key earlier novels, had a massive impact on film, television and radio. In 1936 he himself adapted *The Shape of Things to Come* for movie producer Alexander Korda, but it is the movies other people made of his novels, right from the earliest days of cinema, that enshrined his stories in the science fiction pantheon.

Georges Melies acknowledged Jules Verne as the inspiration of his *A Trip to the Moon* (1902), but many elements in the movie are clearly drawn from Wells' *The First Men in the Moon*. *The Invisible Man*, first filmed by an Italian company in 1916, became a staple of monster movies: James Whale directed a film version for Universal in 1933, and several sequels were made in the 1940s. *The Island of Dr. Moreau* has been filmed numerous times.

Of all Wells' books, however, *The War of the Worlds* has been adapted in the largest variety of ways, most notably in Orson Welles' 1938 U.S. radio play for the Mercury Theatre on the Air.

H.G. Wells himself has since entered popular culture, appearing as a character in television shows such as *Doctor Who* (the 1985 story "Timelash") and *Warehouse 13* (in which H.G. Wells is a woman), as well as in many other films, books and comics. **MM**

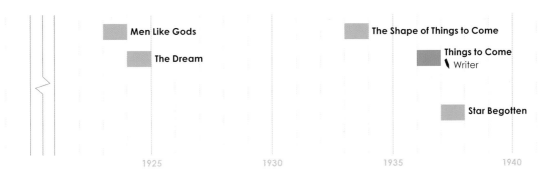

Men Like Gods

The Dream

The Shape of Things to Come

Things to Come
Writer

Star Begotten

1925 1930 1935 1940

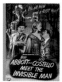

**Abbott and
Costello Meet
the Invisible Man**
(1951)

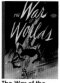

**The War of the
Worlds**
(1953)

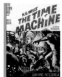

The Time Machine
(1960)

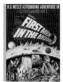

**First Men in the
Moon**
(1964)

**The Island of
Dr. Moreau**
(1977)

Hollow Man
(2000)

The Time Machine
(2002)

War of the Worlds
(2005)

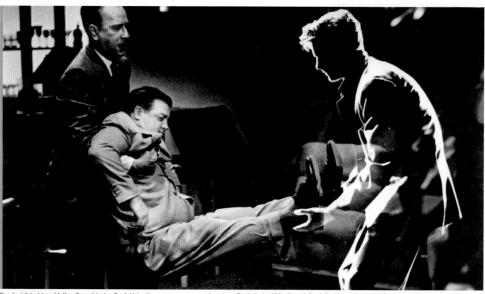

The Invisible Man (Arthur Franz) helps Bud Abbott move an unconscious Lou Costello in *Abbott and Costello Meet the Invisible Man*. In this version of the tale, the Invisible Man is Tommy Nelson, a boxer who has been framed for the murder of his manager.

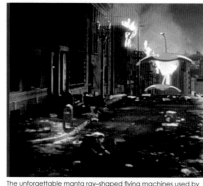

The unforgettable manta ray–shaped flying machines used by the Martian invaders in Byron Haskin's *The War of the Worlds*.

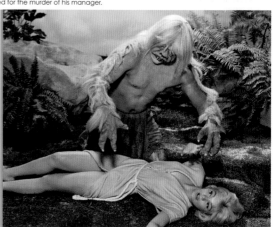

Yvette Mimieux and Wah Chang in George Pal's *The Time Machine* (1960). Chang was also responsible for the movie's special effects.

Edward Judd in Nathan H. Juran's *First Men in the Moon*, adapted for the screen by Nigel ("Quatermass") Kneale.

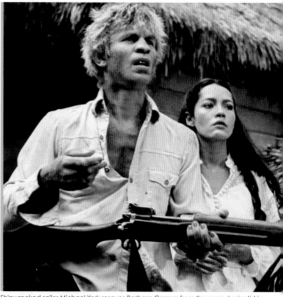

Shipwrecked sailor Michael York rescues Barbara Carrera from the crazed scientist in Don Taylor's *The Island of Dr. Moreau*.

Kevin Bacon in the title role of **Hollow Man** (2000), Paul Verhoeven's science fiction horror movie loosely based on H.G. Wells' *The Invisible Man*. Although panned by critics, the film grossed $190 million at the box office, more than twice what it cost to make.

The Time Machine (2002) was directed by H.G. Wells' great-grandson, Simon Wells.

A fearsome-looking morlock from the 2002 movie of **The Time Machine**.

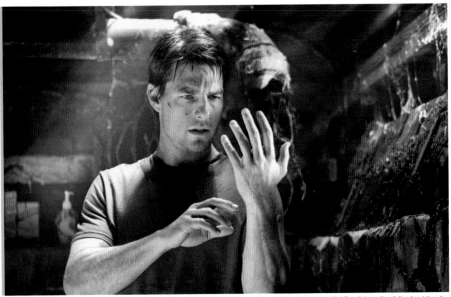
Tom Cruise as Ray Ferrier in Stephen Spielberg's **War of the Worlds** (2005). The movie was the pair's second Sci-Fi collaboration following *Minority Report* in 2002.

the time machine 1895

The Time Machine

The Return of the Time Machine

The Time Machine

The Time Machine

Time After Time

Time Machine II

The Time Ships

The Time Machine

In the most influential time travel story of all, a gentleman in Victorian London invents a machine that can transport the user to any point in the past or future. Early on in *The Time Machine* the unnamed Time Traveler is explaining to friends the rationale behind traveling through time into the future. They ask him why he had not sent his miniature machine into the past, and he replies: "If it traveled into the past it would have been visible when we came first into this room; and last Thursday when we were here; and the Thursday before that; and so forth!"

It is this rigorous logic and simplicity that perfectly encapsulate Wells as a storyteller. In one brief exchange he not only introduces and explains away a time travel paradox, but also provides a reason for his protagonist to be looking to the future, accelerating the story onward.

Like his Time Traveler, Wells was a forward thinker. His primary concerns were society and the shape of things to come. Throughout his work he preaches for a better and more just world, and this is seen clearly in *The Time Machine* as the lead character journeys further and further into the future, searching for that perfect time that he believes must be achievable, only to be confronted by horror. Karl Marx's Communism posited that equality will be attained only when technology can provide for everyone. The Time Traveler thinks he has found this when he catapults himself to the year AD 802,701 and discovers the beautiful Eloi living in a peaceful garden world.

But what appears to be a utopia is nothing of the sort. The Eloi prove to be vacuous and ignorant; worse, the Time Traveler discovers that they are merely cattle for the brutish yet technologically accomplished Morlocks who dwell beneath the surface.

The story is a gripping adventure, filled with fantastical creations. After the Time Traveler battles with the Morlocks, he heads further into the future. In a segment initially deleted, he sees mankind degenerate even more, and finally ends up at the very end of the Earth, where monstrous crabs lumber on a blood-red shore.

The novel made an immediate impact, and has since been adapted many times, most faithfully in the 1960 film directed by George Pal. It is referenced in the meta-adventure *Time after Time*, which depicts H.G. Wells himself chasing Jack the Ripper from Victorian London to 1970s San Francisco! In 2002 Simon Wells — H.G. Wells' great grandson — co-directed a remake of *The Time Machine*, which failed due to an ill-advised updating of the Victorian sensibilities of the original. Instead of using the simple spirit of scientific inquisitiveness and endeavor, the hero is given a tragic motivation that feels inauthentic.

There were time travel adventures before *The Time Machine*, but time travel science fiction was popularized by Wells. Without his Victorian page-turner there would be no *Star Trek*'s *City on the Edge of Forever* (1967), *Twelve Monkeys* (1995), Doctor Who (from 1963), *Primer* (2004) or any other work in the genre. **SW**

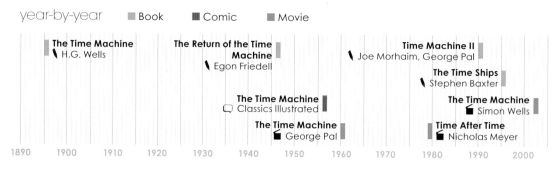

year-by-year ■ Book ■ Comic ■ Movie

the island of dr. moreau 1896

The Island of
Dr. Moreau

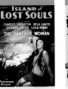

Island of Lost
Souls

Terror is a
Man

Mad Doctor
of Blood
Island

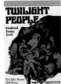

Night of the
Bloody Apes

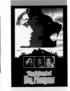

The Twilight
People

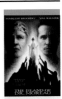

The Island of
Dr. Moreau

The Island of
Dr. Moreau

The Island of Dr. Moreau was H.G. Wells' third novel, and his most controversial. The work introduces Edward Prendick, a well-educated Englishman who finds himself shipwrecked on a mysterious island. There he meets the reclusive Dr. Moreau, a vivisectionist whose gruesome experiments have made him notorious in his native London. Prendick witnesses Moreau's latest project. Driven by the idea that the form of creatures is ultimately plastic, Moreau is attempting to create men from animals, reworking them through surgery. Although he believes he is nearing success, his collection of near-human animals are imperfect and prone to reverting to their animal natures. This race, disparagingly named "Beast Folk," become the surgeon's eventual undoing when Moreau is killed in a fight with one of his own creations. When Moreau's compound and boats are destroyed, Prendick finds himself marooned with the doctor's creatures, who become less and less human daily. His plans to build a raft are unsuccessful, but he eventually escapes. Back in civilization, he feigns amnesia when no one believes his story of Moreau's crimes against nature. In the end, he flees to the countryside, convinced that the people around him are about to revert to animal ways.

At a time of intense public debate about animal research, Wells makes plain his opposition to it. When Prendick hears the howls of a tortured puma, for example, Wells writes that the sound was "as if all the pain in the world had found a voice."

An obscure silent 1913 French film, *L'île d'épouvante* (*The Island of Terror*), was the first attempt at adapting the concerns of Wells' novel onto the cinema screen. Far better known, however, is 1932's Hollywood variant, *Island of Lost Souls*, directed by Erle C. Kenton and starring Charles Laughton and Bela Lugosi. This immaculately shot classic was banned outright in Britain for its depiction of Moreau's vivisection experiments. It would not be shown in that country until 1958 and, even then, only in heavily censored form.

Numerous B-movie shockers have evidenced a link to the Moreau story, including *Mad Doctor of Blood Island* (1968) and the Mexican "video nasty" *Night of the Bloody Apes* (1969). More interesting was *The Island of Dr. Moreau* (1977), directed by Don Taylor (*Escape from the Planet of the Apes*) and starring Burt Lancaster and Michael York. Despite taking numerous liberties with Wells' original premise, this pulp-horror opus from American International Pictures is well made with ambitious special effects.

Unfortunately, the next attempt at turning Wells' thought-provoking masterpiece into a Hollywood blockbuster was also the least interesting. *The Island of Dr. Moreau* (1996) became notorious when its original director, Richard Stanley (*Dust Devil*), was fired after reported clashes with its star, Val Kilmer. Stanley's replacement, John Frankenheimer, could do nothing to avert a disaster that damaged the reputations of all involved, even co-star Marlon Brando. **CW**

year-by-year ■ Book ■ Movie

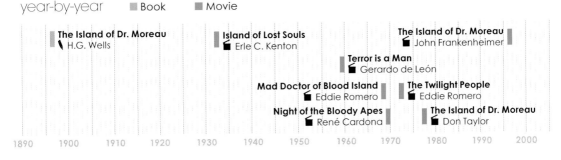

The Island of Dr. Moreau
H.G. Wells

Island of Lost Souls
Erle C. Kenton

Terror is a Man
Gerardo de León

Mad Doctor of Blood Island
Eddie Romero

Night of the Bloody Apes
René Cardona

The Twilight People
Eddie Romero

The Island of Dr. Moreau
Don Taylor

The Island of Dr. Moreau
John Frankenheimer

1890 1900 1910 1920 1930 1940 1950 1960 1970 1980 1990 2000

the war of the worlds 1898

The War of the Worlds

The War of the Worlds

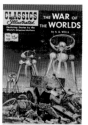

The War of the Worlds

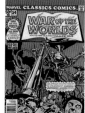

War of the Worlds

Jeff Wayne's Musical Version of The War of the Worlds

The War of the Worlds

By 1897, H.G. Wells had written three definitive works of science fiction, but this, his fourth novel, had an even greater impact. Combining his theories on evolution and Darwinism with the ideas of astronomers like Percival Lowell (who speculated in 1895 that the planet Mars could once have supported life), Wells depicted Britain, at that time the world's greatest power, coming under attack from a superior alien force.

The War of the Worlds is presented as a factual account of the arrival on Earth of metal cylinders fired from the planet Mars. The first cylinder crash-lands on Horsell Common near the English town of Woking (where Wells lived while writing the story), and opens to reveal monstrous Martians. These aliens construct tripod war machines armed with unstoppable heat rays, and use them in a campaign of destruction. Armies are wiped out, London is devastated. Humanity is finally saved when the Martians are destroyed by microbes and bacteria, to which the invaders have no immunity.

A vivid, bleak tale with minimal characterization, The War of the Worlds was one of many works of "invasion fiction" published at the end of the 19th century that dramatized concerns about growing international tensions by depicting attacks on Britain by foreign powers. But an invasion from space, rather than from overseas, took The War of the Worlds even further than these other books. In some ways, Wells' fantasy played as a dark allegory of imperialism, showing an alien force attacking Britain in much the same way as the British Empire had used its technological superiority to conquer other countries.

The image of towering tripod war machines was soon seared into the popular imagination. The War of the Worlds was hugely successful, and has since had a massive influence on the whole science fiction genre.

The fame of the work was increased by several adaptations, most notably that broadcast on October 30, 1938, courtesy of actor/director Orson Welles. Produced as a Halloween episode of the radio anthology show The Mercury Theatre on the Air, Welles updated the action to contemporary New York, and turned the first two-thirds of the adaptation into a news bulletin that presented the arrival of the Martians as if it was actually happening.

Famously, many listeners believed that what they were hearing was true. Some people reported smelling poison gas; others that they had seen flames

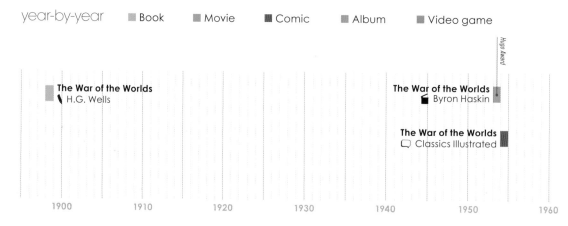

year-by-year ■ Book ■ Movie ■ Comic ■ Album ■ Video game

Hugo Award

The War of the Worlds
H.G. Wells

The War of the Worlds
Byron Haskin

The War of the Worlds
Classics Illustrated

1900 1910 1920 1930 1940 1950 1960

War of the Worlds

Jeff Wayne's The War of the Worlds

H.G. Wells' War of the Worlds

War of the Worlds

The War of the Worlds

War of the Worlds 2: The Next Wave

on the horizon; many prepared to flee their homes. Although the exact extent of this panic may have been exaggerated, and remains a matter of debate, the ensuing publicity — together with several copycat South American radio adaptations during the 1940s — made the original novel more famous than ever.

In 1953 the first Hollywood film adaptation took a looser approach to Wells' novel, again updating the action to the present day and adding a love story. Other changes included increased emphasis on the religious elements of the Martian defeat by the bacteria "that God in His wisdom had put upon this Earth," while the deadly tripods were changed into hovering craft that resembled manta rays.

Although the film was simplistic, its spectacular special effects won an Oscar, and inspired a TV sequel 35 years later. The two-season *War of the Worlds* show (1988–90) resurrected the invaders but made the action gorier and small-scale, thereby becoming less like the original and more like paranoid works such as *Invasion of the Body Snatchers*.

Strangely, one of the most faithful adaptations was a progressive rock concept album. Released in 1978, *Jeff Wayne's Musical Version of The War of the Worlds* preserved the Victorian setting, interspersing its music tracks with narration by Richard Burton and other performers, including rock singers David Essex and Phil Lynott. The album was a best seller for several decades, spawning regular re-releases, live tours, video games and DVDs. The album's lavish visuals (by Michael Trim, Geoff Taylor and Peter Goodfellow) are now for many definitive interpretations of the novel.

Several other movies entitled *The War of the Worlds* have appeared over the years, including an ambitious but doomed low-budget attempt at a faithful Victorian-era version. The most significant of these was Hollywood's second interpretation of the novel, directed by Steven Spielberg.

This 2005 version, again updated to the present day and with some altered plot elements, is a post-9/11 tale, making the alien assault on the United States even more violent and bleak than in the 1953 adaptation. It is, in the words of one critic, "tailor-made for audiences who have experienced the shock of an incomprehensible attack on home-soil."

Spielberg's movie struggles to balance traditional Hollywood storytelling with the novel's ending, but is faithful to the original in many ways. **SB**

■ TV series

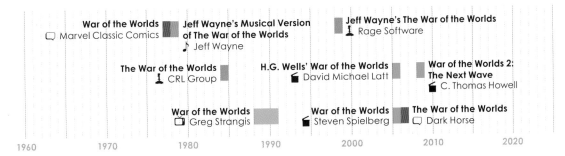

War of the Worlds
Marvel Classic Comics

Jeff Wayne's Musical Version of The War of the Worlds
Jeff Wayne

Jeff Wayne's The War of the Worlds
Rage Software

The War of the Worlds
CRL Group

H.G. Wells' War of the Worlds
David Michael Latt

War of the Worlds 2: The Next Wave
C. Thomas Howell

War of the Worlds
Greg Strangis

War of the Worlds
Steven Spielberg

The War of the Worlds
Dark Horse

1960 1970 1980 1990 2000 2010 2020

The War of the
Worlds (Radio
adaptation)
(1938)

The War of the
Worlds (1953)

War of the Worlds
(1977)

H.G. Wells' War of
the Worlds
(2005)

War of the Worlds
(2005)

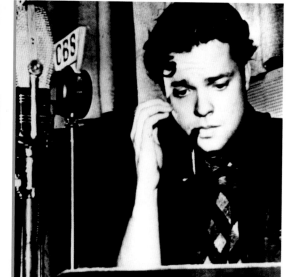

Orson Welles directed and narrated the 1938 CBS radio adaptation. The broadcast enhanced his reputation and helped convince RKO to back his movie *Citizen Kane*.

Welles' adaptation was so convincing that some people mistook it for a news item. (At least, that was the story with which the press ran; some historians are skeptical.)

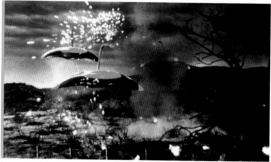

Byron Haskin's 1953 movie version updated the action and relocated it to California.

A Martian attack in Haskin's *The War of the Worlds*.

In Haskin's *War of the Worlds*, Ann Robinson is collared by an alien.

Artwork for Marvel's *Classic Comics* adaptation of *The War of the Worlds* was by Yong Montano and Dino Castrillo.

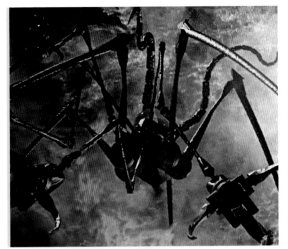
Alien craft in David Michael Latt's 2005 movie version.

Tom Cruise bathed in Martian light.

Tom Cruise starred in Steven Spielberg's 2005 blockbuster *War of the Worlds*.

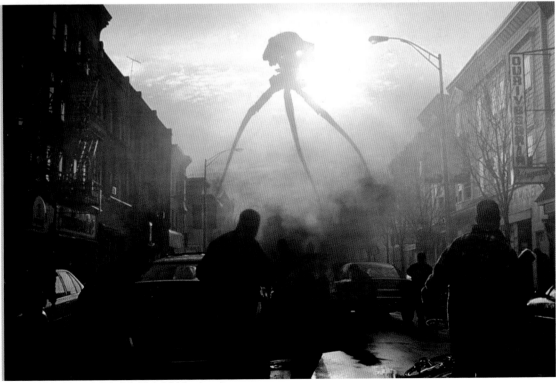
Extraterrestrial tripods lay waste to the United States in Spielberg's movie.

a trip to the moon 1902

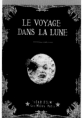

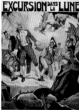

A Trip to the Moon

Excursion to the Moon

Regarded as the first proper science fiction film, *A Trip to the Moon* (*Le voyage dans la lune*) was pioneering filmmaker Georges Méliès' masterpiece. Shot over three months in 1902 at Méliès' own studio, behind his house in Montreuil in France, it was originally released in both black-and-white and color. For the latter version, every frame of film was hand-tinted.

Méliès had a keen interest in theatrical magic, and owned the Théâtre Robert-Houdin. He had been making films since 1896, initially short pieces showcasing optical illusions, then longer movies with fantastic storylines such as *Cinderella* (1899). He used his expertise in illusions to great effect in his movies, earning him the byname the "Cinemagician."

Drawing on the plots of both Jules Verne's and H.G. Wells' novels of lunar exploration, the 14-minute movie follows Professor Barbenfouillis, played by Méliès himself, as he persuades fellow astronomers to accompany him on his expedition, first showing them the workshops where his bullet-shaped rocket is being built. The rocket is fired out of a giant cannon (in the manner of Verne's spacecraft), and — in one of the most iconic images of cinema — lands right in the human-faced Moon's right eye. Memorable in black-and-white, the flood of scarlet blood in the colorized version makes the scene particularly striking.

The voyagers explore the Moon's surface, the Earth rises and they fall asleep. Personified constellations and planets appear in the sky above them, including Ursa Major, with a woman's face in every star, and Saturn, an angry old man. The Goddess of the Moon makes it snow, waking the explorers and driving them to shelter underground. It's a tropical place filled with waterfalls, mushrooms and aggressive Selenites (Moon men) who explode in a puff of smoke when attacked. Captured by the Selenites, the voyagers are taken to the King, whom they promptly explode. After that they're chased back to their rocket, climb inside, it's tipped off a ledge and plummets back to Earth, where it is rescued from the sea by a steamship.

Méliès himself acknowledged the influence of Verne's 1865 novel *From the Earth to the Moon*, in which the protagonists reach the Moon via a bullet-shaped capsule fired from a giant columbiad cannon. From Wells' 1901 novel *The First Men in the Moon* came the Selenites, a fecund landscape, capture, a chase and a return to Earth.

Although it was a hit in its day, Méliès didn't make much money from *A Trip to the Moon*. Early on a representative of the Edison Company illegally copied a reel in Europe; the pirated version was shown in the United States and none of the income it generated made its way back to Méliès. In 1908 a rival company, Pathé, brought out its own, incredibly similar, version of the story, again undermining Méliès' original.

Méliès suffered a series of setbacks in later life: bankruptcy, the commandeering of his studio during World War I for use as a hospital and the demolition of his theater to widen the street. In 1923 he burned his archive of movies. Although little of his work survives, *A Trip to the Moon* is still rightly celebrated today. **MM**

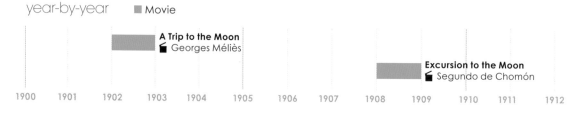

year-by-year ■ Movie

A Trip to the Moon
Georges Méliès

Excursion to the Moon
Segundo de Chomón

| 1900 | 1901 | 1902 | 1903 | 1904 | 1905 | 1906 | 1907 | 1908 | 1909 | 1910 | 1911 | 1912 |

altneuland 1902

Altneuland

In *Altneuland* (Old New Land) a young Jewish intellectual travels with a Prussian aristocrat to a remote Pacific island, stopping en route in Palestine to discover a sparsely-populated backwater of little interest. Twenty years later, the intrepid travelers return, this time finding a utopian paradise that has formed in their absence. This new state, settled by European Jews, is a flourishing democracy, but more than that it is filled with scientific marvels, and much of the book is given over to an extended tour of this "old new land."

In Altneuland, electricity rules. Power stations have been established; there are futuristic hover trains, electric boats and cars and, of course, electric lighting. Electric plows work the fields.

What differentiates *Altneuland* from all the other novels depicting ideal political states written around this time is that it made the great leap from the writer's imagination into reality.

The author, Theodor (Binyamin Ze'ev) Herzl, was born in 1860 in Budapest, then part of the Austro-Hungarian Empire. His parents were secular Jews. He studied law in Vienna before becoming a journalist. Later based in Paris, he covered the 1894 trial of Alfred Dreyfus, a French army officer of Jewish descent accused of treason. Although innocent, Dreyfus was sentenced to life imprisonment by a military tribunal that revealed deeply established anti-Semitism in France, and inspired the novelist Émile Zola to publish a famous attack on the judicial system in an open letter entitled "J'accuse" ("I Accuse").

It was during the Dreyfus Affair that Herzl first began to formulate his ideas about Jewish emancipation. A part of a widespread nationalist movement in Europe in the 19th century, Herzl became convinced of the need for a national homeland for the Jewish people. In 1896 he published a treatise, *Der Judenstaat* (*The Jewish State*), which attracted widespread attention. In 1897, Herzl convened the first Zionist Congress in Basel, Switzerland, and formed the Zionist Organization, thus giving birth to the Zionist movement. He visited Palestine in 1898, and for the rest of his life continued to lobby for a Jewish homeland, petitioning the Turkish Sultan, the German Kaiser and the British government (who offered the Jews a part of British East Africa, in what was known as "the Uganda Plan"). In 1948 the Zionist dream came true with the establishment of the state of Israel.

Altneuland is no literary masterpiece, but it is of unique historical significance for its contribution to the development of a Jewish state. A year after its first publication in German, it was translated into Hebrew under the title *Tel Aviv*, which means roughly "human-made structure around a spring."

In 1910, Tel Aviv was adopted as the name for the new city built by Jews on the eastern shore of the Mediterranean Sea.

Herzl died in 1904, while *Altneuland* was still a fantasy. Although today the book is little read, its ideas have influenced the modern world perhaps more than any other work of fiction. **LT**

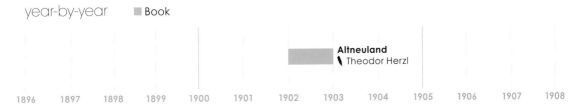

year-by-year ■ Book

Altneuland
❧ Theodor Herzl

| 1896 | 1897 | 1898 | 1899 | 1900 | 1901 | 1902 | 1903 | 1904 | 1905 | 1906 | 1907 | 1908 |

gullivar of mars 1905

Lieut. Gullivar Jones: His Vacation

Gullivar Jones, Warrior of Mars

The League of Extraordinary Gentlemen

Warriors of Mars

Edwin Lester Arnold grew up in Kent and India, worked as a journalist and published books about birds before writing his first adventure story in 1890. *The Wonderful Adventures of Phra the Phoenician* told of a soldier who witnessed various invasions and attempted invasions of England through his ability to go into and out of suspended animation. It flopped. *Lieut. Gullivar Jones: His Vacation* (later reprinted as *Gullivar of Mars*) was also a commercial failure at the time of publication, but it is now considered a minor landmark in the development of fantasy fiction, and especially the planetary romance sub-genre of science fiction.

Published between Percy Gregg's *Across the Zodiac* (1880) and Edgar Rice Burroughs' Barsoom series (from 1912), Arnold's novel tells of a modern Earth soldier whisked away to a fantastical Mars of strange creatures and alluring princesses, there to have adventures and become a hero.

Quite how much Arnold influenced Burroughs remains a topic of debate, but some similarities are clear. Jones is a U.S. Navy man who arrives on a savage, beautiful Mars by magic carpet — in a clear case of "be careful what you wish for," it takes him there when he foolishly blurts out his frustrations: "Oh, I wish I were anywhere but here, anywhere out of this redtape-ridden world of ours! I WISH I WERE IN THE PLANET MARS!"

And suddenly he is there, in a world packed with monsters, ape-men, beautiful copper-skinned maidens and decaying, decadent cities seemingly doomed through apathy to barbarian conquest,

and in desperate need of an outsider's two-fisted, proactive approach.

Less action-packed than Burroughs' John Carter tales, heaving with coincidences and with less variety in the strange civilizations that the often-bumbling hero encounters, *Gullivar of Mars* has always remained in Carter's shadow, but the occasional revival has kept the work from total obscurity.

Notably, in 1972, six issues of Marvel Comics' *Creatures on the Loose* updated the tale, turning Jones into a young Vietnam veteran whisked to a fantasy Mars. A clear effort to reproduce the popularity of the Conan the Barbarian comics of the time, the early issues, drawn by the great Gil Kane, show the clear potential in this world of tin bikinis and Rivers of the Dead. Whereas the book plods and frustrates in places, Marvel's version hit the ground running — Jones punches out his first red-skinned, long-tailed barbarian enemy on page four — and rarely lets up.

Subsequent comic series have shown versions of Jones that are closer to the original, notably *The League of Extraordinary Gentlemen: Volume Two* (2002–04) and the Dynamite Comics series *Warriors of Mars* (2012), which paired Jones with John Carter and blended their mythologies together.

Lieut. Gullivar Jones: His Vacation is not a great work, and it is clogged with purple prose and scientific implausibilities, but it is an influential one. If you can ignore the glib hero, the portrait it paints of a broken people, grown weak in their crumbling cities of ancient splendor, is haunting. **MB**

year-by-year ■ Book ■ Comic

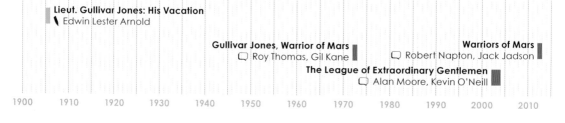

Lieut. Gullivar Jones: His Vacation
Edwin Lester Arnold

Gullivar Jones, Warrior of Mars
Roy Thomas, Gil Kane

Warriors of Mars
Robert Napton, Jack Jadson

The League of Extraordinary Gentlemen
Alan Moore, Kevin O'Neill

1900 1910 1920 1930 1940 1950 1960 1970 1980 1990 2000 2010

john carter of mars 1912

| Under the Moons of Mars | The Warlord of Mars | The Chessmen of Mars | Swords of Mars | Llana of Gathol | John Carter: Warlord of Mars | Princess of Mars | John Carter |

One of the first genuine SF adventure heroes, Edgar Rice Burroughs' iconic character John Carter of Mars made his first appearance in 1912, in the pages of The All-Story, a pulp magazine. Burroughs' first published work, A Princess of Mars (originally serialized as Under the Moons of Mars) was presented as a "found document" containing the recollections of American Civil War veteran John Carter. Somehow transported to the planet Mars, known to its inhabitants as Barsoom, Carter finds himself unexpectedly nimble in the red planet's low gravity. He undergoes a series of wild adventures among weird and terrifying creatures, while romancing the beautiful, red-skinned Martian princess Deja Thoris.

Burroughs' story was pulp adventure with an exotic sense of mystery and romance. The science fiction content often descended into dream-logic (especially Carter's journey to Mars via inadvertent astral projection), but the world of Barsoom was lush, attention-grabbing and evocative, and Burroughs captured a mix of energetic action and pulp poetry that wasn't bettered until Robert E. Howard's Conan stories in the 1930s.

Burroughs' first John Carter story was followed by a multitude of sequels that expanded the mythology of Barsoom in increasingly involved directions although largely keeping to the formula of action and romance laid down in A Princess of Mars. Burroughs worked through to the early 1940s on a series that expanded to 11 volumes. The Barsoom saga had an undeniable influence on the style and execution of pulp science fiction adventure, from the comic-book 1930s adventures of Flash Gordon, through to the tribal aliens of James Cameron's 2009 SF epic Avatar.

Yet although John Carter was influential, he made few appearances in other media, perhaps mainly because of the difficulty of realizing the lush fantasy of Barsoom. A series of animated John Carter shorts was briefly developed by Warner Brothers animator Bob Clampett in 1935–36, but got no further than a brief reel of test footage. Carter remained largely confined to the world of comic books, most notably in the 1977–79 Marvel series John Carter: Warlord of Mars (which featured artwork from future Batman writer/artist Frank Miller).

It took the rise of photo-realistic computer-generated imagery (CGI) to make a John Carter movie feasible. Several potential adaptations were developed, and one terrible low-budget version made it onto DVD as Princess of Mars in 2009. An ambitious big-budget interpretation finally arrived in 2012, with Pixar animator Andrew Stanton making his live-action directorial debut. Sadly, the $250 million John Carter was a box-office flop. It suffers from awkward storytelling and is too faithful to the source material, but at its best it does channel the energy and inventiveness of the original. However, its critical reception has made further John Carter movies extremely unlikely. **SB**

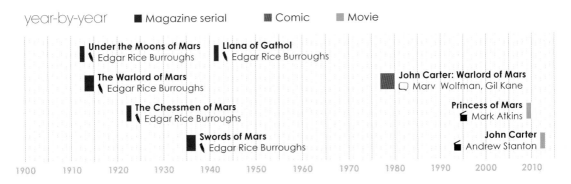

the lost world 1912

| The Lost World | The Poison Belt | The Lost World | The Land of Mist | The Lost World | The Lost World | The Lost World | King of the Lost World |

Although best known for his Sherlock Holmes tales, Sir Arthur Conan Doyle was also a prolific author of short stories and novels with fantastical themes. After Holmes, his most famous creation was Professor George Edward Challenger — a brilliant, bombastic scientist with "a bellowing, roaring, rumbling voice" and "the face and beard [of] an Assyrian bull" — who appeared in three novels and two short stories.

The first Challenger novel, *The Lost World* — an account of an expedition to South America — is the urtext of present-day dinosaur stories, and has influenced an entire subgenre of written, cinematic and comic-book science fiction.

Challenger believes he has evidence of an isolated prehistoric ecosystem atop an Amazonian plateau. He journeys there with ambitious journalist Edward Malone (who narrates), hunter/explorer Lord John Roxton and scientific rival Professor Summerlee.

Betrayal by a native bearer leaves the quartet stranded on the plateau where they encounter a range of dinosaurs and prehistoric mammals and birds. Savage ape-men capture some of the party, who are then rescued by primitive humans. Eventually Challenger and his companions escape the plateau and return to London with a captive pterodactyl as proof of their adventure.

In the first sequel, *The Poison Belt* (1913), Challenger gathers his three companions in a sealed room with tanks of oxygen as he predicts that the Earth will pass through a cloud of poisonous ether. Subsequently the quartet explore a devastated world, but after 24 hours the population revives as the ether effects prove only temporary. The final Challegner book, *The Land of Mist* (1926), reflected Conan Doyle's new interest in spiritualism, whereas the two short stories featured a drilling expedition to the Earth's core and a disintegration machine.

Meanwhile, Hollywood had woken up to the possibilities of *The Lost World*, astounding audiences in 1925 with a silent feature incorporating Willis "Obie" O'Brien's stop-motion effects and starring Wallace Beery. Obie later animated *King Kong* (1933), which owes an obvious debt to Conan Doyle's story.

The Lost World has since been adapted many times for film, television and radio with varying degrees of faithfulness and success. In lieu of expensive stop-motion, Irwin Allen's 1960 feature (starring Claude Rains) used lizards with stuck-on spines, with laughable results. John Rhys-Davies portrayed Challenger in a low-budget 1992 film, whereas Bob Hoskins took the lead role in a BBC mini-series featuring CGI created by the *Walking with Dinosaurs* team. Other actors to play Challenger include Patrick Bergin, Armin Shimerman, Basil Rathbone and Bill Paterson. In 2005 Bruce Boxleitner starred in a cheapie *King of the Lost World*. Most adaptations have included an invented female character to make up for the novel's entirely male cast. **MJS**

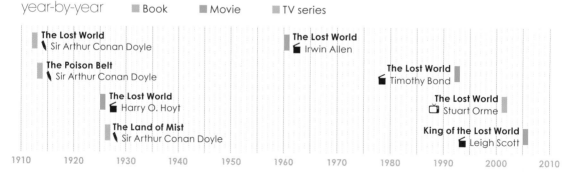

year-by-year ■ Book ■ Movie ■ TV series

The Lost World
\ Sir Arthur Conan Doyle

The Poison Belt
\ Sir Arthur Conan Doyle

The Lost World
◄ Harry O. Hoyt

The Land of Mist
\ Sir Arthur Conan Doyle

The Lost World
◄ Irwin Allen

The Lost World
◄ Timothy Bond

The Lost World
☐ Stuart Orme

King of the Lost World
◄ Leigh Scott

1910 1920 1930 1940 1950 1960 1970 1980 1990 2000 2010

tarzan 1912

Tarzan of
the Apes

Tarzan of
the Apes

Tarzan the
Untamed

Tarzan and
His Mate

Tarzan of
the Apes

Tarzan and
the Valley
of Gold

Greystoke:
The Legend
of Tarzan, Lord
of the Apes

Tarzan: The
Broadway
Musical

Tarzan is one of the most enduring and universally recognized of all the fantasy fiction heroes, an English Lord brought up by the Great Apes of Africa, and thus supremely equipped for adventures both within Western civilization and in the heart of the Dark Continent. He began in the pulp novels of the early years of the 20th century and has rarely been out of the limelight since, starring in 24 novels by his creator, Edgar Rice Burroughs, not to mention around 100 films.

Even more impressively, he's colonized just about every medium possible — radio, television, newspaper strips and video games — and become one of the most successful fictional characters ever created.

Some Tarzan adventures are straight survival tales of a feral child who grows up to battle external threats to his adoptive homeland. Others are fantasies of an Africa full of strange beasts such as the Mangani, the apes that bring up the young John Clayton, Lord Greystoke, which are clearly described as being different from gorillas.

Tarzan has greater abilities and more acute senses than any ordinary human — he can smell poachers up to a mile away, communicate with all species of animal and successfully wrestle crocodiles, sharks, rhinos, lions and even dinosaurs. His adventures take him to many strange places — lost cities of tiny men and talking gorillas, and lush Opar, an outpost of Atlantis where all the women are beautiful and there are riches in abundance.

The books established and defined the character of Tarzan, but most fans know their hero best from his wide-ranging adventures in the movies, where — after several silent films — a successful Tarzan franchise began in 1932 and continued through to the 1960s. Since then, there have been many revivals on both the big and small screens, often with some new contemporary twist. One such is 1984's *Greystoke: The Legend of Tarzan, Lord of the Apes*, which attempted to tell a low-key, realistic version of the original tale.

The definitive big-screen version of Tarzan, however, was in the dozen films made between 1932 and 1948 that starred former Olympic swimmer Johnny Weissmuller as a simple, pidgin-English-speaking "noble savage" version of the Ape Man. The best of these movies paired him with Maureen O'Sullivan as a lithe, lively and often scandalously clad version of his girlfriend Jane.

Though it can be hard to defend Tarzan from accusations of racism and sexism — the original books were very much products of their times — the core concept is surprisingly enduring, and the figure of a feral child-cum-nobleman, at home in two different worlds and yet comfortable in neither, seems as relevant to these eco-friendly times as ever. Few could find a film like *Tarzan and His Mate* (1934), the most sensual of the Weissmuller movies, or *Tarzan the Untamed* (1920), the best of the original novels, anything less than supreme entertainment. **MB**

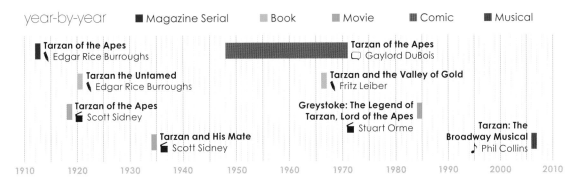

year-by-year ■ Magazine Serial ■ Book ■ Movie ■ Comic ■ Musical

Tarzan of the Apes
Edgar Rice Burroughs

Tarzan of the Apes
Gaylord DuBois

Tarzan the Untamed
Edgar Rice Burroughs

Tarzan and the Valley of Gold
Fritz Leiber

Tarzan of the Apes
Scott Sidney

Greystoke: The Legend of
Tarzan, Lord of the Apes
Stuart Orme

Tarzan and His Mate
Scott Sidney

Tarzan: The
Broadway Musical
Phil Collins

1910 1920 1930 1940 1950 1960 1970 1980 1990 2000 2010

h.p. lovecraft 1919

Dagon

The Hound

The Outsider

The Colour Out of Space

The Call of Cthulhu

The Dunwich Horror

The Silver Key

The Whisperer in the Darkness

Few 20th century authors have been more influential and less read than Howard Phillips Lovecraft (1890–1937). Lovecraft's fictional universe, Cthulhu Mythos, has had a far-reaching impact on popular culture: horror fiction's most successful practitioner, Stephen King, is heavily indebted to it, and it has gained new life in works of popular culture such as Joss Whedon's *Buffy the Vampire Slayer* and the Hellboy comic and movie franchise.

But Lovecraft's stolid prose and neurotic fantasizing have little appeal to most readers, and make the enduring significance of his work all the harder to fathom.

Lovecraft's early life was shaped by the mental illness of his father, Winfield Scott Lovecraft, a traveling salesman who suffered a severe mental breakdown in a Chicago hotel room. Raised by his mother, Sarah Susan Phillips Lovecraft, her two sisters and one elderly grandfather, Lovecraft would return repeatedly in his stories to the figure of the isolated male collapsing into psychosis. When his writing represented women at all, it was as figures of supernatural menace.

Lovecraft was a precocious linguistic prodigy who could recite poetry from the age of 3, but his early creativity was hindered by the death of his grandfather in 1904 and his mother's committal to a mental institution two years before her death in 1921.

Nonetheless Lovecraft displayed early talent as a writer of poetry and prose, and developed a network of literary correspondents who brought his work to public attention. Lovecraft's mature writing was inextricably linked with the genre of horror fiction, which was just emerging from the tradition of Gothic literature, and being shaped by such writers as Algernon Blackwood.

Lovecraft's first published story, "Dagon," appeared in Issue 11 of *The Vagrant* magazine in November 1919. It is a drug-addicted sailor's account of horrific events in World War I. This classic framing narrative was already common in horror fiction, and became the standard format for many of Lovecraft's stories. Although "Dagon" is not counted as part of the Cthulhu Mythos, it establishes many elements that featured prominently in Lovecraft's subsequent work, not least the "awakened" deity Dagon himself.

"Dagon" led Lovecraft into a mutually beneficial relationship with *Weird Tales*. First published in 1923, the magazine went on to define much of the modern horror, fantasy and science fiction genres and published work by Clark Ashton Smith, Robert Bloch, Robert E. Howard, Ray Bradbury, Fritz Leiber and Margaret St. Clair.

"The Call of Cthulhu" is the first of the Cthulhu Mythos stories, a term never used by Lovecraft himself

year-by-year ■ Short story ■ Book

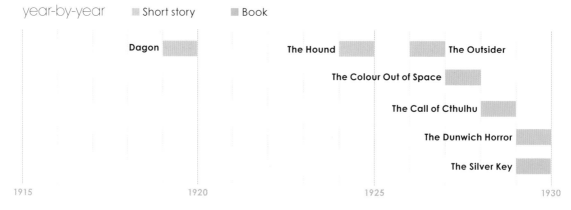

Dagon

The Hound The Outsider

The Colour Out of Space

The Call of Cthulhu

The Dunwich Horror

The Silver Key

1915 1920 1925 1930

| The Strange High House in the Mist | The Dreams in the Witch House | From Beyond | The Quest of Iranon | At the Mountains of Madness | The Shadow Over Innsmouth | The Case of Charles Dexter Ward | The Dream-Quest of Unknown Kadath |

but which was coined by his literary executor August Derleth. It begins with the discovery of a bas-relief sculpture among the papers of a deceased grand-uncle of the protagonist who then comes into conflict with a murderous cult of the ancient, god-like being Cthulhu. The story's New England setting, melange of occult imagery and obsession with non-Euclidean geometry put in place the key elements of the Cthulhu Mythos that would later be expanded upon by Lovecraft and a host of later creators.

"The Colour Out of Space" (1927), "The Dunwich Horror" (1929), "The Whisperer in Darkness" (1931) and 'The Dreams in the Witch House" (1933) continue the Cthulhu Mythos story cycle. Lovecraft again and again expressed his obsession with the implacable and incomprehensible nature of the cosmos, as represented in the slumbering forms of the "Ancient Ones," and the insanity that arises from attempting to understand the pure chaos of existence.

Among Lovecraft's other well-known stories are those that comprise the Dream Cycle, which introduced readers to Randolph Carter. Arguably Lovecraft's most memorable creation after Cthulhu itself, Carter is an alter ego of Lovecraft the author, and recurs in numerous stories. Bizarrely, perhaps Lovecraft's most famous "book" is *Necronomicon*, which is neither a novel nor a story but a magical tome

that is mentioned in so many of his own and others' works of fiction that it is widely credited as real (it isn't).

At the Mountains of Madness (1936) remains the most accomplished and complete of Lovecraft's later works, and the closest to a full novel in form if not in length. First serialized in *Astounding Stories* magazine before publication as a book, it details a scientific mission to Antarctica. The intense realism of the setting, contrasted with the horrific nature of the mission's discoveries, create a story that was described by Theodore Sturgeon as "more lucid than much of the master's works."

The Cthulhu Mythos has continued to be expanded by writers including Clive Barker and Neil Gaiman, and Lovecraftian horror has proliferated in books, films, television shows and video games. The cult role-playing game *Call of Cthulhu* (1981) is often credited with redirecting the attention of modern audiences to Lovecraft's legacy.

The work itself remains neglected, although the racist subtext of much of it has increasingly featured in critical discussions of representation in genre fiction. Yet its influence on the development of horror and science fiction is undeniable. H.P. Lovecraft established the genre as a space for the expression of humanity's deepest fears and neuroses, and of our feelings of powerlessness in the face of a chaotic universe. **DW**

The Call of Cthulhu
(1928)

The Haunted Palace
(1963)

The Dunwich Horror
(1970)

Re-Animator
(1985)

Bride of Re-Animator
(1985)

From Beyond
(1986)

In the Mouth of Madness
(1994)

The Call of Cthulhu
(2005)

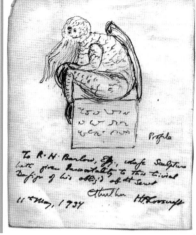

H.P. Lovecraft's original sketch of Cthulhu, which he described elsewhere as "a monster of vaguely anthropoid outline."

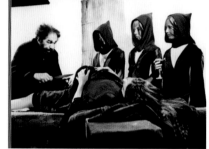

Ed Begley in *The Dunwich Horror* (1970). This was the Oscar-winning actor's last movie.

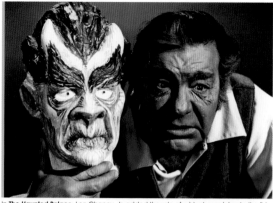

In *The Haunted Palace*, Lon Chaney, Jr. added the role of a black magician to the list of creepy characters he played in his long and distinguished movie career.

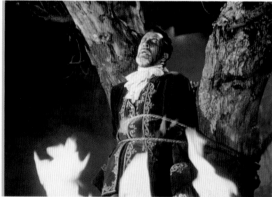

Vincent Price is burned at the stake in *The Haunted Palace*. Roger Corman's movie took its title from Edgar Allan Poe but its plot from the stories of H.P. Lovecraft.

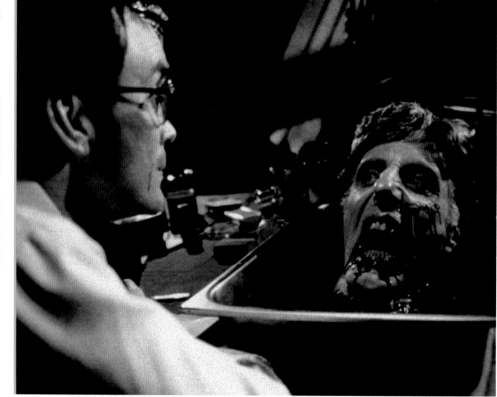

Jeffrey Combs (left) and David Gale in Stuart Gordon's gory comic horror film *Re-Animator* (1985).

Stuart Gordon's *From Beyond* (1986) is loosely based on the H.P. Lovecraft tale of the same name. It stars horror movie icon Jeffrey Combs.

Bride of Re-Animator (1990) was the second of several gleefully gory films starring Jeffrey Combs based on the 1922 short story "Herbert West – Reanimator."

Sam Neill in Roger Corman's *In the Mouth of Madness* (1994), whose title plays on two Lovecraft's tales, "The Shadow Over Innsmouth" and "At the Mountains of Madness."

In the Mouth of Madness concerns the search by insurance fraud investigator John Trent (Sam Neill) for best-selling horror novelist Sutter Cane.

2005's *The Call of Cthulhu* was the first film adaptation of Lovecraft's seminal story. A black and white silent movie, it was a surprise hit

the days of pulp:
the "golden age" of
science fiction

1920–50

karel čapek 1920

RUR: Rossum's Universal Robots | The Absolute at Large | The Macropoulos Secret | Krakatit | Adam the Creator | War with the Newts | The White Plague

Czech writer Karel Čapek is remembered today primarily for coining the word "robot," although it was actually his brother Josef who suggested the term, which is derived from the Czech *robota* meaning "servitude." Karel Čapek explored political and social ideas in fiction and nonfiction throughout the interwar period. He died just before the Nazi invasion of Czechoslovakia. Josef was not so fortunate; he died in a concentration camp.

RUR: Rossum's Universal Robots is a satirical play about a factory in which robots produce more robots. These are not mechanical automatons, which already existed in literature (for example Tik-Tok, introduced into L. Frank Baum's Oz stories in 1907) and to some extent in reality (mechanical, clockwork figures had long been manufactured), but artificial humans created by a biochemical process. Like Frankenstein's monster, the robots have no soul — although this is not a reflection of their blasphemous origins, merely a cost-saving measure. Their inventor, Rossum, sought to create new life but his nephew took control of the company and boosted its turnover by producing robots as quickly and cheaply as possible.

Set over several decades, the play documents how birth rates declined, humanity shrank and the robots revolted. Eventually only one human is left alive but he has no scientific training and cannot rediscover the secret of the robots' creation, even after being persuaded to dissect one. Hope finally emerges in two robots constructed with souls who fall in love and are renamed Adam and Eve.

Swiftly translated into English, the play was a critical and popular success but is now regarded as a curio. It has only been filmed once and most of the radio/TV adaptations are now more than 50 years old. Čapek's other stage works are: *The Insect Play* (a satirical fantasy about bugs); *The Macropoulos Secret* (a scientific formula conveys immortality; adapted as an opera by Čapek's countryman Leoš Janácek); *Adam the Creator* (an anarchist destroys humanity then tries to recreate it with limited success; co-written with Josef); and *The White Plague*, aka *Power and Glory* (a scientist bargains with fascist warmongers after discovering the cure for a virulent disease).

Karel Čapek's best-known novel is *War with the Newts*, a science fiction tale co-written with Josef with similar themes to *RUR*: a marine race of sentient but subservient creatures discovered in the Pacific is subjugated by humankind and subsequently revolts.

Čapek's other SF novels are *The Absolute at Large*, aka *Mass-Producing the Absolute* (atomic power accidentally releases uncontrolled holy power, causing unplanned miracles and a religious war), and *Krakatit* (documenting the psychological breakdown of the inventor of a super-powerful explosive).

Several of Karel Čapek's fantasy/supernatural short stories have been filmed, but the definitive screen adaptation of *RUR* is still awaited. **MJS**

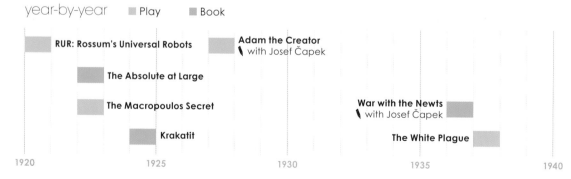

year-by-year ■ Play ■ Book

RUR: Rossum's Universal Robots / The Absolute at Large / The Macropoulos Secret / Krakatit / Adam the Creator with Josef Čapek / War with the Newts with Josef Čapek / The White Plague

1920 1925 1930 1935 1940

men like gods 1923

Men
Like Gods

H·G·WELLS

Men Like Gods

Men Like Gods by H.G. Wells is a thoroughly British science fiction experience. Its hero, Mr. Barnstaple, is an unassuming, well-meaning, middle-class Englishman. In need of a holiday, he takes off in his "Yellow Peril" car, navigates a country road, and finds himself suddenly and inexplicably in another world, perhaps even in another universe. Along with several other accidental arrivals, Mr. Barnstaple explores this seemingly perfect utopia, learning its history and customs, and setting off a clash of ideologies.

Written long after Wells' classics *The Time Machine*, *The War of the Worlds* and *The Island of Dr. Moreau*, *Men Like Gods*, in common with many of the author's late works, operates less like a novel and more like a thesis. It is Wells lecturing on the state of the world and how a utopian society could one day be realized.

The inhabitants of this imagined world are essentially the human race roughly 3,000 years in the future. When discussing their history with the earthlings they are able to look back sagely and reflect on all the mistakes they made during the time of their ignorance, which they call the "Ages of Confusion." Among their acknowledged errors were their failure to support and produce enough for all their fellow creatures, their maintenance of the few in comfort while the majority struggled, their preoccupation with consumption rather than production, their negligence in maintaining educational standards, their involvement in wars and their mismanagement of the ecosystem.

Mr. Barnstaple is a surrogate of Wells himself. He is thrilled and optimistic about this new, perfect world. To his mind, it is proof that all the selfless suffering of the artists, intellectuals and philosophers of his day with all be worthwhile in the end. Like Marx's Communism, it will work when the time is right.

Using William Morris' *News from Nowhere* as a reference, Wells' later explicitly states what is plainly his own view: "I had never thought before that socialism could exalt and ennoble the individual and individualism degrade him, but now I see plainly that here the thing is proved."

There is no question in the mind of Mr. Barnstaple — or indeed, by extension, that of Wells himself — that this utopia is better than Earth. Society is more important than the individual: the hero gives a passing thought to his family back home, wishing he could let them know that he was safe, but he never considers returning to them. He is like the Time Traveler in *The Time Machine*, who looks only to the future.

Men Like Gods is not as thrilling as the plots Wells created in his "scientific romances," but it is among his most personal and passionate works. Its themes run deep and its influence can subtly be found in a wide range of later works of science fiction. Aldous Huxley critiqued Wells' argument in *Brave New World*; as an innocent bystander in an adventure in space and time, Mr. Barnstaple prefigures Arthur Dent in Douglas Adams' *The Hitchhiker's Guide to the Galaxy*; Wells' utopians communicate through telepathy, decades before the trope became popular in science fiction; the hero siding with the alien race is the same dynamic as that used in *Avatar* (2009).

This is Wells at his most strident, most politically engaged. Many of its concerns remain valid almost a century after its original publication, with Wells once again proving himself a visionary. **SW**

year-by-year ■ Book

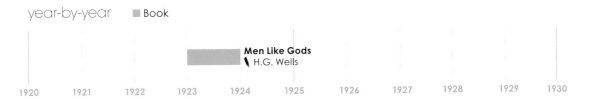

Men Like Gods
❨ H.G. Wells

1920 1921 1922 1923 1924 1925 1926 1927 1928 1929 1930

amazing stories 1926

Amazing Stories

Amazing Science Fiction

Amazing Science Fiction Stories

Amazing Stories

Amazing Science Fiction Stories

Amazing Stories

Amazing Stories was the world's first dedicated science fiction magazine. It was founded in 1926 by Hugo Gernsback and published in New York. One of the world's longest-running SF periodicals, it had various incarnations over the years, at least one of which survived into the early 21st century.

Relatively little is known of Hugo Gernsback's early life. He was born Hugo Gernsbacher in Luxembourg in 1884 to Jewish parents. At the age of 20 he emigrated to the United States, where he began to use the anglicized form of his family name.

He started out as a minor inventor. While trying to market his various creations, he imported radio parts from Europe. The commercial success of this enterprise enabled him to branch out into print publishing. In 1908 he founded *Modern Electric*, the world's first magazine devoted to electronics and radio, and in the following year he established the Wireless Association of America, for amateur radio enthusiasts, quickly attracting some 10,000 members. In 1913, Gernsback founded *The Electrical Experimenter* (later, *Science and Invention*), and it was here that he first began to publish short fiction.

Meanwhile, in 1911 Gernsback had published his own first novel, *Ralph 124C 41+*, as a 12-part serial in the pages of *Modern Electric*. The title is a perhaps

rather contrived play on words that represents: "One to foresee for one another." The work is an almost catalog-like view of a future that includes television, talking movies and space flight.

Gernsback's next work was *The Scientific Adventures of Baron Münchausen*, which appeared between 1915 and 1917. Thereafter he published an increasing number of scientifically-themed short stories and, in 1923, a special issue of *Science and Invention* dedicated to "Scientific Fiction."

In 1926, Gernsback brought out the first issue of a new magazine. *Amazing Stories* bore the subtitle "Scientifiction"—his name for the nascent genre. Sam Moskowitz, an SF historian, called the publication "the most important event in the entire history of science fiction." Writer and film maker James Gunn later asserted that "American science fiction is the base line against which all the other fantastic literatures in languages other than English must be measured. That is because science fiction, as informed readers recognize it today, began in New York City in 1926."

In reality, *Amazing Stories* did not exactly set the world on fire. The type of fiction chosen by Gernsback invariably favored scientific ideas over literary values. As a consequence, many of the stories were poorly written, even by the often less than demanding

year-by-year ■ Magazine ▨ Online

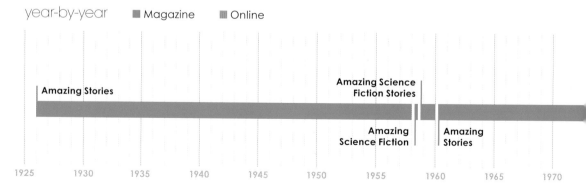

Amazing Stories

Amazing Science Fiction Stories

Amazing Science Fiction

Amazing Stories

1925 1930 1935 1940 1945 1950 1955 1960 1965 1970

Amazing Science
Fiction Stories
Combined with
Fantastic

Amazing Science
Fiction Stories
Combined with
Fantastic Stories

Amazing Stories

Amazing Stories

standards of other pulp magazines of the time. Nevertheless, Gernsback first published such notable SF authors as E.E. "Doc" Smith, Jack Williamson and Stanley G. Weinbaum.

Amazing Stories opened up a whole new sector of the pulp market. Gernsback began by reissuing classic stories by Jules Verne, Edgar Allan Poe and H.G. Wells, thus helping to codify the conventions of the genre that had become known as "scientific romance." More importantly, he helped to create SF fandom by publishing the letters (complete with addresses) of the readers who wrote to him.

Gernsback lost control of *Amazing Stories* in 1929 after a bankruptcy lawsuit. Undeterred, however, he then created two new magazines, *Science Wonder Stories* and *Air Wonder Stories*. The two titles would later combine to become *Thrilling Wonder Stories*.

In 1934 Gernsback created the first fan organization, The Science Fiction League, which soon established local chapters for fans in places as far away as Britain and Australia.

In 1936, Gernsback also lost control of his these creations. This time, he did not return to science fiction publishing for another 20 years. Meanwhile, although it could not be claimed that *Amazing Stories* went from strength to strength, it remained in print. The

title was acquired by Ziff-Davis Publications and in 1938 Raymond A. Palmer became editor. He focused on lively, action-adventure fiction, such as the work of Edgar Rice Burroughs, and in 1939 he published "Marooned Off Vesta," the first short story by 19-year-old Isaac Asimov.

Another major influence was Cele Goldsmith, who took over editorship of the magazine in 1958 and published early stories by Roger Zelazny and Ursula Le Guin. Other notable editors included the authors Harry Harrison, Barry N. Malzberg and Ted White between 1967 and 1969.

The magazine kept changing hands — and editors — in the following years, surviving into the 21st century in a short-lived incarnation under the auspices of Paizo Publishing. In 2011 the trademark was acquired by SF fan Steve Davidson, who has determined to keep the magazine going as an online publication. In one form or another, it seems, *Amazing Stories* is determined to march on.

Gernsback died in 1967. The Hugo Awards — given annually since 1953 by the World Science Fiction Convention for the best work in the genre — are named in his honor. In 1960, he himself received a special Hugo Award as "The Father of Magazine Science Fiction." **LT**

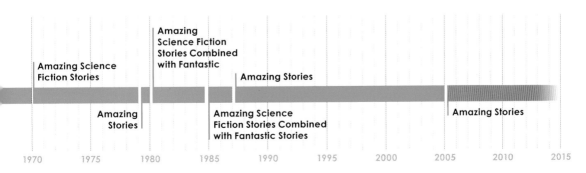

Amazing Science
Fiction Stories

Amazing
Stories

Amazing
Science Fiction
Stories Combined
with Fantastic

Amazing Stories

Amazing Science
Fiction Stories Combined
with Fantastic Stories

Amazing Stories

1970 1975 1980 1985 1990 1995 2000 2005 2010 2015

Amazing Stories
(1926–58)

**Amazing Science
Fiction Stories**
(1958–60)

**Amazing Science
Fiction Stories
Combined with
Fantastic Stories**
(1985–87)

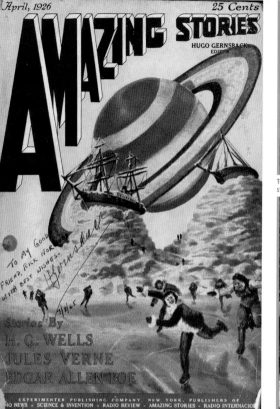

The first issue of **Amazing Stories** was published in April 1926. Inside, Gernsback proclaimed it to be "a *new* kind of fiction magazine ... a pioneer in its field in America."

The opening illustration sets the scene for Harold M. Sherman's story "All Aboard for the Moon" in **Amazing Stories**, April 1947.

"The Shaver Mystery" was written by Richard Sharpe Shaver, who claimed that most of its contents were true.

CHILDREN
OF
CHAOS

By IVAR JORGENSEN

*Born to an age of destruction
these Sons and Daughters of
Disaster said, "Stand back!
We'll show you how to
really blow this world into
stardust. Then you can
start over."*

SO OKAY, so maybe a guy
who lost his private in-
vestigator's license over a
little thing like libel *isn't* the
best guy to stumble over a
thing like the Kids. So maybe
the same guy—who had to
start selling brushes door-to-
door to keep on eating—*ain't*
the best guy to save the World.
So the hell what? So *somebody*
had to do it, and it just hap-
pened I knew Niles Pfizer
from when I was a private
eye, and he called me when he
found her body. So don't beef;
you still breathe regular, and
you don't have bombs sending
your house into the sky—with
you in it.

The glove—stuffed solid with coins—crashed against my skull like a sledge hammer.

"Children of Chaos" is credited to Ivar Jorgensen, a floating pseudonym used by numerous writers for the magazine.

CHILDREN OF CHAOS Mankind's Sins—Their Heritage

AMAZING

NOVEMBER 35¢ STORIES

THE LUNATIC PLANET
Does True Sanity Lie in Madness?

This cover illustration is by Edward Valigursky, who also designed the covers of novels by Isaac Asimov, Arthur C. Clarke and Ray Bradbury.

Amazing Science Fiction Stories May 1958. In his other life as an ad copywriter, Henry Slesar coined the term "coffee break."

Illustration opposite the opening page of Henry Hasse's "We're Friends, Now" in the April 1960 *Amazing Science Fiction Stories*.

They are drowning even now! The dirigible is fast breaking up! The engines and heavy structures have torn loose and sunk.

This dramatic image appeared in **Amazing Stories** shortly after the crash of the U.S. Navy dirigible USS *Macon* in 1935.

Soon to be a TV series . . .

SCIENCE FICTION $1.75 USA

AMAZING STORIES

Combined with FANTASTIC · Stories
K • 47734 • U.K.: 1.25 • JAN 1985

Andrew M. Greeley
Robert F. Young
Tanith Lee

A 1985 cover by Alex Schomberg, one of the most influential SF artists of all time.

metropolis 1927

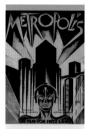

Metropolis

Metropolis

Metropolis

Metropolis

Metropolis

Metropolis

At the time of its release, *Metropolis* was the most expensive film ever made, a colossal boondoggle that almost bankrupted its German studio, UFA. Yet it survived, in its many versions, as a foundational text for its genre and its medium, both of which are incalculably indebted to it.

After the enormous success of his mythic two-part *Die Nibelungen*, Fritz Lang was probably the only director in Weimar Germany with the clout to realize a project of such magnitude. He planned it with his wife, Thea Von Harbou, who wrote the attendant novelization (which, incidentally, differs considerably from the film). Whether consciously or not, Lang and Von Harbou threw almost everything that excited them into the pot — the skyscraping cityscape of New York, the dying embers of German Expressionism, the bold new geometries of Art Deco, the competing influences of communism and fascism on Weimar Germany, Christian eschatology, robotics, romanticism and the ideas of Sigmund Freud.

The resulting film is just as easy to condemn as it is to praise. On the one hand, its plotting is a hot mess and its political allegory is at best naïve and at worst proto-fascist. But as a spectacle it is visionary — a triumph of editing, photography, set design and visual effects. Imagery such as the machine room transforming into a ravenous Sphinx, the burning Maria alchemically revealing herself as the beautiful

Maschinenmensch (machine human) and the Seven Deadly Sins coming to life, are formative moments in 20th-century culture.

The world of *Metropolis* is split into a privileged class of technocrats, whose children practice athletics and frolic in the pleasure gardens, and the enslaved workers, who toil thanklessly in the gothic bowels of the city. At the top of the "New Tower of Babel" sits Frederson (Alfred Abel), the Master of Metropolis, whose son Freder (Gustav Fröhlich) becomes our hero when he falls in love with Maria (Brigitte Helm), a saintly revolutionary leader who is secretly educating the workers.

Delving into the machinery beneath his feet in pursuit of true love, Freder is appalled to discover the life-threatening conditions of the workforce, and resolves to do something about it. But another chain of events is in motion — deranged scientist Rotwang (Rudolf Klein-Rogge), the former suitor of Freder's dead mother Hel, has created a robot duplicate of his lost love, onto whose face he transposes that of Maria. Frederson orders Rotwang to send the fake Maria into the catacombs, where she will disrupt the revolution. Rotwang wants to use his creation to ruin Frederson.

The stage is set for a desperate rebellion, as the false Maria leads the workers in an anarchic bacchanalia, destroying the machines and sweeping through Metropolis without purpose. Only Freder can

year-by-year ■ Movie ■ Book ■ Comic ■ Musical ■ Anime ■ Album

Metropolis
Fritz Lang

Metropolis
Thea Von Harbou

Metropolis
Osamu Tezuka

1925 1930 1935 1940 1945 1950 1955 1960 1965 1970

$17M (U.S.)
Metropolis
(1927)

$5M
Metropolis
(2002)

Metropolis **Metropolis** **Metropolis**

save the city, and the film's basic allegory is driven home repeatedly and decisively: "The mediator between brain and hand must be the heart."

At least, this is one version of what happens in *Metropolis*. The original cut of the film enjoyed only a short run in Berlin and an entirely different, and much shorter, version was released in the United States, rewritten by playwright Channing Pollock. All references to Freder's mother were removed, as was Frederson's terrifying henchman and a hefty amount of the last act. Fritz Lang's original *Metropolis*, meanwhile, vanished.

The history of the film is thus one of continued restoration, recutting and rescoring, as new and better materials have come to light, each interpretation spinning the story in a new direction. The most radical was the divisive Giorgio Moroder cut, assembled in 1984 with color tinting, subtitles, new effects and an entirely 1980s soundtrack by pop luminaries including Bonnie Tyler, Freddie Mercury and Adam Ant. It was not until 2008 and the discovery of a 16 mm negative copy in Buenos Aires that an almost complete version could be assembled, restoring over half an hour of footage unseen since 1927. Only a couple of scenes remain elusive. Although successive technicians and historians have spent 80 years reinventing *Metropolis*, we can now see as much of Lang's original cut as will ever be possible.

The film has three major legacies. The first is its inauguration of the science-fiction epic as, for better or worse, an enduring pipe dream for filmmakers with an eye on posterity. That *Metropolis* was not a blockbuster is neither here nor there; the legend of *Metropolis* has made it one, and everything from *2001: A Space Odyssey* (1968) to *Cloud Atlas* (2012) can be counted among its heirs.

The second is *Metropolis* itself. When the film was in production, New York had just overtaken London as the most populous urban center in the world, and thus became the model for future living. *Metropolis* embraced that vision (there is nothing outside the city in the film), and science fiction has been obsessed with vertical urbanity ever since — *Stand on Zanzibar*, *Make Room! Make Room!*, *High Rise*, *Dark City*, *Neuromancer* and especially *Blade Runner* are key novels and movies here.

The third and possibly most important legacy of *Metropolis* is its visual style. Fritz Lang's career successfully straddles the divide between the expressionism of his forbears in German cinema and the naturalism that he would go on to embrace in Hollywood. As neither one thing nor the other but rather a crucible of possibility, the film has become a key point of reference in visual art, not least in pop music, with Madonna, Queen and Nine Inch Nails all taking note of its power over the years. **TH**

Metropolis
(1926)

**Metropolis
(Giorgio Moroder)**
(1984)

Metropolis
(2001)

One of the original publicity posters for the consummate early work of German expressionistic cinema.

Lang's Tower of Babel was inspired by a famous painting of around 1563 by the Dutch artist Pieter Brueghel the Elder.

The rich men's athletics competition in **Metropolis** eerily foreshadow the 1936 Berlin Olympic Games.

Unable to hold a glass herself in her Maschinenmensch ("machine-human") costume, Brigitte Helm receives refreshment from a member of the film crew.

According to *The New York Times*, in Lang's **Metropolis** Brigitte Helm (seen here in the other half of her dual role, as Maria) "defined the unobtainable."

Brigitte Helm as Maria with some of the 25,000 extras who were used during the filming of Lang's **Metropolis**.

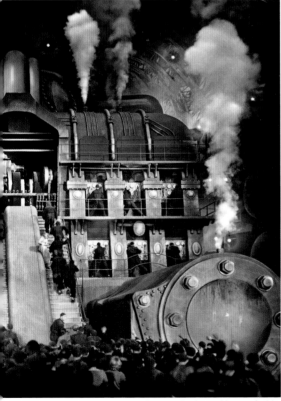

An underground factory, where the workers in **Metropolis** toil to provide power for the rich industrialists who live above the ground.

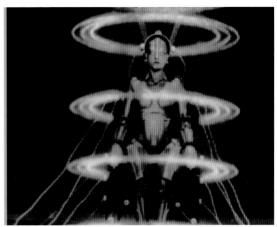

The 1984 recut of **Metropolis** by director Giorgio Moroder featured color tinting, subtitles and new effects. It was almost universally panned.

Some scenes in the Japanese **Metropolis** set cartoon characters against real or realistic backgrounds.

The 2001 **Metropolis** — directed by Japanese anime filmmaker Rintaro (Shigeyuki Hayashi) — is a loose adaptation of Lang's original rather than a remake.

buck rogers 1928

Armageddon 2419 AD

Buck Rogers in the 25th Century AD

Buck Rogers

Buck Rogers

Buck Rogers

Buck Rogers in the 25th Century

Buck Rogers: XXVC

Buck Rogers

In a career that coincided with the glory years of the American Century, Buck Rogers is one of the most important fictional space heroes. He helped to popularize science fiction through radio programs, movie serials and television series, and came to symbolize space exploration in the American consciousness: Daffy Duck cartoons parodied his adventures; anything unusual was castigated as "crazy Buck Rogers stuff," and "No bucks, no Buck Rogers" became an expression meaning that without financial support there's no progress.

The adventures of Anthony "Buck" Rogers began in the August 1928 issue of *Amazing Stories* magazine with "Armageddon 2419 AD," in which a First World War veteran working for a gas company is trapped in a Pennsylvania mine cave-in, falls into a state of suspended animation thanks to bizarre gases found there, and wakes nearly 500 years into the future. There he finds Americans fighting a guerrilla war against the Hans, an invading foreign power.

Creator Philip Francis Nowlan wrote a sequel to for publication the following year, by which time the John F. Dille Company had asked him to develop and modify the property for syndication as a newspaper comic strip — *Buck Rogers in the 25th Century*.

First appearing on January 7, 1929, the strip told a version of Armageddon 2419 AD, but with modifications: Rogers has a more dynamic first name, the date was changed to 2429, the Hans become a tribe of Mongols — making their Asian origins overt — and the supporting cast was widened. Joining freedom fighter Wilma Deering — the first person Buck meets and helps in both versions of the tale — were genius scientist Dr. Huer, friendly space pirate Black Barney and the evil Killer Kane and his lady, Ardala.

By 1932 Buck Rogers was a star of CBS — just as his newspaper strip had been the first science fiction series in that medium, so this was the original SF radio drama. Following a brief film subtitled "An Interplanetary Battle With the Tiger Men of Mars" that was shown at the 1933 World's Fair in Chicago, he became a star of the silver screen in a serial produced by Universal Studios, which reused sets, costumes, props and even the star, ex-Olympic swimmer Buster Crabbe from their previous serials based on Flash Gordon, Buck's great rival in competing newspaper syndicates. Universal's Buck Rogers suffers a balloon crash at the North Pole, then reawakens in a future America ruled by mobsters.

There have since been two TV series: a 1950 ABC offering with Eva Marie Saint as Wilma, and the camp 1979–81 version, with Gil Gerard as Rogers and a lycra-clad disco feel to its ruined future-Earth threatened by aliens from the planet Draconia. Books, games and comic books continue to appear regularly, but Buck Rogers remains in the shadow of Flash Gordon, who, although an imitator of Buck, has always enjoyed bigger-budget incarnations. **MB**

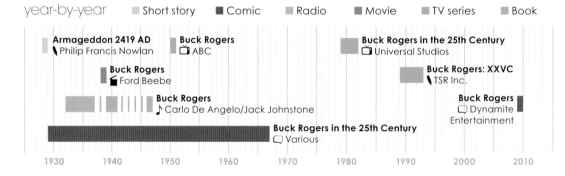

year-by-year ▓ Short story ▪ Comic ▓ Radio ▪ Movie ▪ TV series ▪ Book

Armageddon 2419 AD
\ Philip Francis Nowlan

Buck Rogers
☐ ABC

Buck Rogers in the 25th Century
☐ Universal Studios

Buck Rogers
🖐 Ford Beebe

Buck Rogers: XXVC
\ TSR Inc.

Buck Rogers
♪ Carlo De Angelo/Jack Johnstone

Buck Rogers
☐ Dynamite Entertainment

Buck Rogers in the 25th Century
☐ Various

1930 1940 1950 1960 1970 1980 1990 2000 2010

cordwainer smith 1928

War No. 81-Q	The Planet Buyer	The Boy Who Bought Old Earth	The Store of Heart's Desire	The Underpeople	Norstrilia

Cordwainer Smith was the pen name of Paul Linebarger, an American political scientist, East Asia scholar and specialist in psychological warfare who spent much of his early life in Europe, China and Japan. Thanks to his father's involvement in the 1911 Chinese Revolution, Linebarger was also the godson of Sun Yat-Sen, first president of the Republic of China, and his lifelong fascination with Chinese narrative structure gave his science fiction stories their unmistakable flavor.

A sensitive writer who used pseudonyms in order to maintain an air of mystery — his three non-SF novels were also written under pen names — Linebarger published his first story, "War No. 81-Q," at the age of 15, but it was the appearance of "Scanners Live in Vain" (his first Cordwainer Smith story) in 1950 that brought him serious attention. In 1975, the only full-length science fiction novel that was credited to him was released. A heavily revised combination of two previously published novellas, *Norstrilia* was a surreal far-future story that served as a cornerstone to one of the most enigmatic and distinctive SF future histories ever published.

The "Instrumentality of Mankind" saga consisted of this one novel and 26 short stories. Instrumentality stories had appeared at regular intervals until Linebarger's death in 1967, and some more appeared posthumously (including two tales completed by his wife, Genevieve Linebarger). The result was a unified future history of distinct and unforgettable oddness.

It depicted a period thousands of years in the future in which humanity, having traveled to the stars with the aid of near-autistic space pilots known as Scanners, has developed a massive civilization ruled by the priest-like Lords of the Instrumentality.

A slave-race of Underpeople has been created from genetically-engineered animals, and immortality is achieved by taking Stroon (a drug found only in the misshapen sheep of Old North Australia, or "Norstrilia"). Against this background, distinctive characters undergo strange adventures in stories including "The Lady Who Sailed The Soul," "The Crime and the Glory of Commander Suzdal" and "The Game of Rat and Dragon." Over time, the Instrumentality gradually evolves into a bland utopia where life loses its meaning, and only thousands of years later — through a process known as the Rediscovery of Man — is there any chance for a rebirth of the human race.

Acclaimed by Terry Pratchett, Stephen Baxter and Ursula Le Guin, the Cordwainer Smith stories are almost unique in science fiction because of their philosophical tone and their mythic strangeness.

The Instrumentality saga is filled with hints at an even larger, stranger universe, some details of which Linebarger may have planned to reveal, some of which were abandoned after he lost a notebook crammed with notes on his imaginary world. The Cordwainer Smith stories are little known outside the realm of literary SF, but remain among the clearest examples of the wonder, imagination and mystery that can be found in the best of the genre. **SB**

year-by-year ▨ Short story ▪ Book

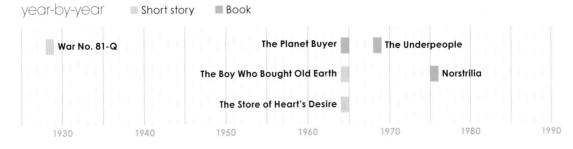

War No. 81-Q

The Planet Buyer

The Underpeople

The Boy Who Bought Old Earth

Norstrilia

The Store of Heart's Desire

1930 1940 1950 1960 1970 1980 1990

astounding stories 1930

| Astounding Stories of Super-Science | Astounding Stories | Astounding Stories of Super-Science | Astounding Science Fiction | Analog Astounding Science Fact and Fiction | Analog Science Fact and Fiction | Analog Science Fiction and Science Fact | Analog Science Fiction and Fact |

The world's oldest continually published science fiction magazine, *Astounding Stories of Super-Science* was launched in 1930 by publisher William Clayton. It attracted some of the most famous pulp writers because it paid contributors more than its main rival, *Amazing Stories*, whose owner, Hugo Gernsback, often never paid at all. Early issues featured mainly adventure stories with a fantastic element.

The magazine encountered financial trouble during the Depression, but was rescued in 1933 by Street & Smith, publisher of legendary pulp titles *Doc Savage* and *The Shadow*. Under F. Orlin Tremaine's editorship, *Astounding Stories* deliberately set out to include works with original ideas: it serialized H.P. Lovecraft's *At the Mountains of Madness* and stories by Jack Williamson and L. Sprague de Camp. By 1934 it was the leading U.S. science fiction magazine.

Publications of this kind proliferated in the late 1930s, but *Astounding*'s high standards enabled it to remain the market leader. Under John W. Campbell's editorship, it printed the first stories by several writers who would become prominent in the SF genre. These included "Black Destroyer" by A.E. van Vogt (1939), "Lifeline" by Robert Heinlein (1939) and "Trends," the second story by Isaac Asimov. All three writers became regular contributors, with Asimov's "Foundation" stories and three of Heinlein's novels appearing in its pages. In the 1940s, Arthur C. Clarke and Samuel Youd, under the name Christopher Youd, made their published debuts in *Astounding Stories*.

Astounding continued to support these writers after they had become established. Its reputation attracted authors who had been working for other pulps, such as L. Ron Hubbard and E.E. "Doc" Smith. *Amazing Stories* had serialized the latter's first Lensman stories but *Astounding* serialized the sequels.

In the 1950s, the launch of rival publications and a growing market for paperback books reduced *Astounding*'s circulation. In 1959 Condé Nast bought out Street & Smith, and changed the name of the magazine to *Analog Science Fact & Fiction*. Campbell remained as editor, and notable stories published during this time included Anne McCaffrey's first Pern story, "Weyr Search," and two works by Frank Herbert, "Dune World" and "The Prophet of Dune," which formed the basis of his novel *Dune*.

After Campbell's death in 1971, Condé Nast appointed Ben Bova as his successor. Bova did not plan to stay in the job for long, but remained at the magazine until 1978, winning the Hugo Award for Best Professional Editor five times. Before leaving, he recommended Stanley Schmidt as his replacement. Schmidt remained in the job after the magazine was sold on, first to Davis Publications, and then to Dell Magazines. Despite the changes in ownership and a further name change in 1992 to *Analog Science Fiction & Fact*, the magazine has continued to print works by writers who were or would become SF stalwarts, such as Lois McMaster Bujold, Greg Bear and David Brin. **MM**

year-by-year ■ Magazine

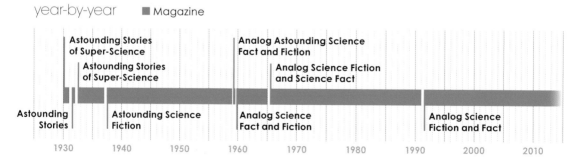

| Astounding Stories of Super-Science | Analog Astounding Science Fact and Fiction |
| Astounding Stories of Super-Science | Analog Science Fiction and Science Fact |

| Astounding Stories | Astounding Science Fiction | Analog Science Fact and Fiction | Analog Science Fiction and Fact |

1930 1940 1950 1960 1970 1980 1990 2000 2010

olaf stapledon 1930

Last and
First Men

Last Men
in London

Star Maker

Nebula
Maker
and Four
Encounters

Olaf Stapledon's novel, *Last and First Men,* is an extensive future history detailing the rise and fall of multiple human species throughout the Solar System over the course of two billion years. H.G. Wells had briefly touched upon far future history in *The Time Machine* (1895), but the scope and level of detail that Stapledon invested in his work were unprecedented.

Last and First Men begins with a future history of humankind, from The First Men (contemporary society) who survive until a vast explosion 100,000 years in the future renders much of Earth uninhabitable. The 35 surviving humans diverge into two competing species, and there follows a cyclical progression of species who rise up and decline for various reasons: by their own error; as a consequence of natural disaster; or after being overthrown by artificial species that they created to serve them.

Some of the societies described are cruel, some are savage and others are enlightened. Their treatment of extraterrestrials is consistently bad: the Second Men declare war on the Martians and exterminate them; when the inner Solar System faces immolation by the Sun, the Fifth Men flee the dying Earth and resettle on Venus, but by their efforts to terraform their new planet they annihilate the aquatic natives.

Yet through all the cycles of decline and regeneration, humankind maintains an upward evolutionary trajectory. After protracted periods of near-bestial existence, new generations of sentient beings arise. The Last Men are the eighteenth civilization, who, unable to escape the death of the Sun, seed the galaxy with biological material and broadcast their story back to their earliest forebears.

Last and First Men originates many ideas that were to later become commonplace in the genre, including terraforming, conglomerate "superminds," deliberate panspermia and genetic engineering. Later, Stapledon was the first to write about what became known as "Dyson spheres" (artificial satellites that can capture most or all of a star's energy). Freeman Dyson, for whom they were subsequently named, has stated that they should be called "Stapledon spheres."

The novel is ultimately optimistic, because it repeatedly shows the triumph of humankind's better nature over its baser instincts. It is thus like a secular version of the Omega Point, the term used by French Jesuit Pierre Teilhard de Chardin (1881–1955) to describe the maximum level of complexity and consciousness toward which he believed the universe was evolving.

Stapledon's later works included a sequel, *Last Men in London* (1932); *Star Maker* (1937), which covers the entire history of the universe and references *Last and First Men,* and the posthumously published *Nebula Maker and Four Encounters* (1976).

Stapledon was a philosopher who used science fiction to spread his ideas. His work inspired Arthur C. Clarke, among others. C.S. Lewis admired Stapledon but was alarmed by the "amorality" of *Last and First Men* and wrote *The Space Trilogy* as a rebuttal. **GH**

year-by-year ■ Book

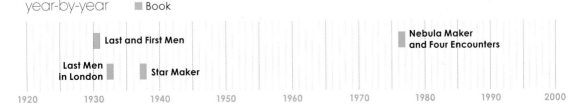

Last and First Men

Nebula Maker
and Four Encounters

Last Men
in London

Star Maker

1920 1930 1940 1950 1960 1970 1980 1990 2000

brave new world 1932

Brave New World

Brave New World

Brave New World Revisited

Brave New World

Brave New World

Taking its title from William Shakespeare's *The Tempest*, *Brave New World* is the fifth novel of English satirist Aldous Huxley. Written as an antidote to the optimistic utopias of H.G. Wells, the novel was also a reaction to the Americanization of the Western World Huxley perceived. Published in 1932, it addressed the author's fears that an intoxicating cocktail of rampant consumerism, permissive sex and gratuitous entertainment was reducing humanity to a race of selfish and easily controlled infants, concerned only about the here and now.

Set in a future where technology has replaced God as the subject of religion, the events of *Brave New World* take place in the Year of Our Ford 632, six centuries after Henry Ford produced the first Model T automobile. The unnamed World State has based its entire society on the principles of Ford's production lines, leading to the near-deification of the American industrialist. Crucifixes have been replaced by a simple letter T, Ford's name is repeatedly used in expressions such as "For Ford's sake," and the bell in the clock tower of the British Houses of Parliament has been renamed "Big Henry." The only books that remain legal are technical manuals, public entertainment having been overtaken by "feelies" — tactile blockbusters that not only titillate the eyes and ears, but also allow audiences to feel what the actors experience on screen.

On the surface, life in the 26th-century seems idyllic. Earth is peaceful and overflowing with resources, largely due to the fact that the world population has been forcibly capped at two billion. Humans are grown in hatcheries, conditioned before being hatched and pre-sorted into five castes, from the intelligent and physically advanced Alphas to the primitive, semi-moronic Epsilons.

Every aspect of human life is controlled by the World State. In contrast to the other great dystopian novel of the 20th century, George Orwell's *Nineteen Eighty-Four*, in which Big Brother rules through violence and fear, in *Brave New World* the powers-that-be forestall opposition by prioritizing the pursuit of pleasure. There is no boot grinding forever into a human face, only a society that has neutered itself, seduced by the attractions of an easy life.

Freed from the need to reproduce, sex has become a recreational pastime, encouraged from childhood. Public acquiesecence is maintained by encouraging drug use and consumerism. A smoke-screen of contentment is maintained by soma, a government-rationed narcotic, while financial security for the World State is thoroughly protected by legislation that requires all damaged goods to be replaced and proscribes repair work. The main purpose of life in the year 632 AF (After Ford) is instant gratification. Even buttons have been replaced by zippers, to ensure that clothing can be put on and taken off with minimal effort.

In this nightmarish world, shorter-than-average Alpha-Plus Bernard Marx longs to be an individual. Disenchanted with his overtly structured existence, Bernard visits a Mexican Savage Reservation, an

year-by-year ■ Book ■ Radio ■ TV movie

Brave New World
\ Aldous Huxley

Brave New World
♪ CBS

Brave New World Revisited
\ Aldous Huxley

1930 1935 1940 1945 1950 1955 1960 1965

area untouched by the scientific advances of the World State. Intrigued by the "natural" humans he encounters there, Bernard arranges to bring two of the so-called savages, John and Linda, back to the civilized world with him. The social experiment brings Bernard fame and celebrity, but destroys his notions of individuality; it also ruins the lives of his two protégés.

On its first publication, *Brave New World* was banned in Australia. Nevertheless, the novel started appearing in public and academic libraries, leading to a request in 1933 for all copies to be returned to Customs and Excise for incineration. The ban was finally lifted by the Australian Literature Board in 1937. A similar ban was enacted in Ireland in 1932 on the grounds that the content of the book was anti-religious, anti-family and blasphemous.

The novel is no less controversial today. According to the American Library Association, campaigners frequently request the work's removal from public libraries because of its perceived racism, insensitivity, explicit sexuality and offensive language.

Brave New World has twice been adapted for television. Scripted by Doran William Cannon for Universal Television in 1980, the first three-hour film transplanted the action from Britain to the United States and starred Bud Cort as a suitably diminutive Bernard Marx.

A 1998 TV movie produced by USA Network Studios removed all references to the Ford cult, set the story in a world indistinguishable from our own and transformed Bernard Marx from Huxley's sensitive Alpha of stunted height to a handsome and successful leading man. The movie added a subplot about a brainwashed Delta-grade individual sent to assassinate Marx and a predictably happy Hollywood ending that saw Bernard flee the World State to start a family with hatchery worker Lenina Crown.

The most faithful recreation of the novel came over 30 years previously with the two-part CBS Radio adaptation in 1956, introduced and narrated by Huxley himself.

The author would return to the themes of his most famous novel in a 1958 collection of essays entitled *Brave New World Revisited*. Admitting that he was now more pessimistic than ever about the future, Huxley claimed that his prophecies were in danger of becoming a reality far quicker than he had ever imagined. He feared that the cry of "Give me Liberty or give me death," was slowly being replaced by "Give me television and hamburgers, but don't bother me with the responsibilities of liberty." Suggesting that modern threats to freedom were now too strong to resist, Huxley declared it was the duty of every human to prevent the imagined *Brave New World* becoming a reality.

In 2008, Ridley Scott was attached to a Universal Studio adaptation of the novel, but in 2013 he was reported to have left the project. The director said: "I think *Brave New World* in a funny kind of way was good in 1938, because it had a very interesting revolutionary idea. When you re-analyze it, maybe it should stay as a book." **CS**

Brave New World
Burt Brinckerhoff

Brave New World
Leslie Libman, Larry Williams

1965 1970 1975 1980 1985 1990 1995 2000

the shape of things to come 1933

The Shape of
Things to Come

Things to Come

The Shape of
Things to Come

The Shape of Things to Come is in some ways typical of H.G. Wells' later work: it is a didactic text in which the author lays out how he feels the world should be run. The book is presented in the form of a future history "dream book" written by Dr. Philip Raven and passed on his death to a friend. After a sparse introduction, the book is divided into four parts, the first of which gives Wells' account of the causes of the First World War and the Great Depression. He then ranges ahead, detailing a long recession, a war that bankrupts the world and a brief Dark Age wracked with plague, from which, finally, exhausted humankind is uplifted by "airmen" into a new era of prosperity that ends "The Age of Frustration." The history concludes with a description of life in the year 2103, by which time the world has become a scientifically governed utopia.

Wells' history is always solid and authoritative. His speculation, though sometimes wryly amusing with the benefit of hindsight — he got a great deal wrong, and his predictions for the second half of the 20th century are more wishful thinking than realistic forecasting — is consistently engrossing and occasionally chillingly accurate.

The tone of the book is predominantly witty, but when Wells writes of the horrors of war his prose becomes incandescent with fury. *The Shape of Things to Come* is not one of the expert parables that distinguished Wells' early career, nor one of the tedious rants that diminished his reputation in his final years, but a stage between the two. Here Wells is

still exhorting readers to accept what seems to him the inescapable truth that all things must pass: with reference to the times in which he lived, he writes that "the infantile habit of assuming the fixity of the Thing that Is was almost universal in their day."

Where previously Wells had presented his ideas in the form of sharp observations, in *The Shape of Things to Come* he develops them into a manifesto. He is no longer merely pointing out that change is inevitable, but counseling his readers to give it a helping hand.

Wells' authoritarianism is sharply delineated in *The Shape of Things to Come*. He writes approvingly of a planned society, eugenics and social engineering. Although later chapters detail the adaptations that would be required to make these principles practically applicable in the new World State, there is no doubt of his unswerving faith in the efficacy of enlightened despotism.

This is progress with teeth, imposed from above. Wells realizes that such a regime would be tyrannical, but believes that the systems put in place by the Dictatorship of the Air would lead to the autocratic Second Council, which would eventually be absorbed and replaced. For this notion, he was indebted to the writings of Friedrich Engels, who had predicted the withering away of the state under communism.

Wells regarded communism as a failed precursor to the future regime that he envisaged. He believed that the Soviet Union had become insular and consumed itself because of its adoption of irrational orthodoxies. Although this may be true, many critics

year-by-year ■ Book ■ Movie

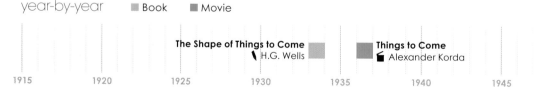

The Shape of Things to Come
H.G. Wells

Things to Come
Alexander Korda

1915 1920 1925 1930 1935 1940 1945

have found that in *The Shape of Things to Come* Wells weakens his argument by an excess of assertion and insufficient nuance. He is so strongly attracted to the notion of technocracy that he appears to tolerate no contradiction: he writes of "one sole right way and ... endless wrong ways of doing things." Aged 67 at the time of publication, he displays a certainty of the kind that is often felt only by old people that society is collapsing and that the people need firm guidance to help them pull through.

Yet for readers who condone or can tolerate the strident didacticism, there is much to enjoy in *The Shape of Things to Come*. Wells includes a chapter on an artist named Theotocopulos Aristophanes, who is evidently at least a partial self-portrait. Aristophanes keeps a journal illustrated by sketches and falls in love with a woman named "J.," which was Wells' pet appellation for his second wife, Amy Catherine Robbins (later known as Jane).

In this tender section of the book, Wells admits that the society for which he yearns would not be easy for a man like himself to adapt to. Elsewhere, he describes how romance will become less common, because it is a distraction from the serious purpose of life. Commentators have remarked on the irony, or the hypocrisy, of this from a famous and unapologetic proponent of free love. Wells also predicts the decline of novels. This is partly the author's self-deprecation, and partly a method of expressing his passion for a world government of technocrats regardless of the personal cost.

Wells' 1897 novella "A Story of The Days to Come" prefigures *The Shape of Things to Come*. It tells of a 22nd century in which humankind lives in giant hive-like cities. Starting off with a typical Wellsian attack on Victorian complacency, the story details a forbidden love affair between middle-class Mr. Mwres (a rationalized spelling of "Morris") and a wealthy woman. The two escape to the countryside, attempt unsuccessfully to live off the land and then experience various layers of their society's rigid social structure before they are rescued. In this story, Wells anticipates skyscrapers, motorways, mass air transport and moving sidewalks. Although society is run along the planned, socialist lines he describes and recommends in *The Shape of Things to Come*, its class system provides nothing but a barrier to the lovers.

In 1936 the Alexander Korda production *Things to Come* was released. It starred Raymond Massey and Ralph Richardson. The script, which was written by Wells — the only screenplay he produced — presents an edited version of the book's story and to some extent updates it. All the action takes place in "Everytown," which the audience watches develop from a happy settlement of stone and brick to an underground utopia via a bombed-out ruin. The film rather clumsily deals with the fall of the tyrannical council in the 21st century, and concludes with a bombastic speech on progress. Although the movie is somewhat ponderous, it is nevertheless visually impressive. George McCowan's 1979 version bore little resemblance to the book other than in name **GH**

The Shape of Things to Come
🎬 George McCowan

1950 1955 1960 1965 1970 1975 1980

Things to Come
(1936)

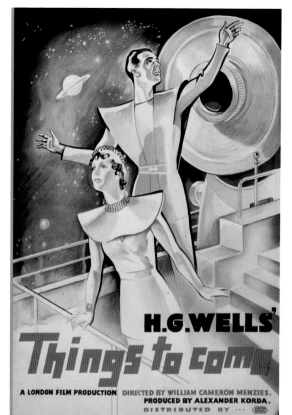

Things to Come director William Cameron Menzies during a break in filming with Ann Todd (L) and Margaretta Scott.

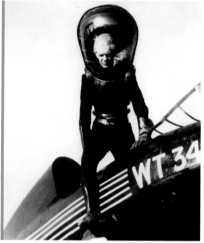

London Films was founded by Korda in 1932; in 1939 it was taken over by the Rank Organization and moved from Denham Studios to Pinewood.

Raymond Massey disembarks from a futuristic aircraft to tell the people of Everytown of things to come.

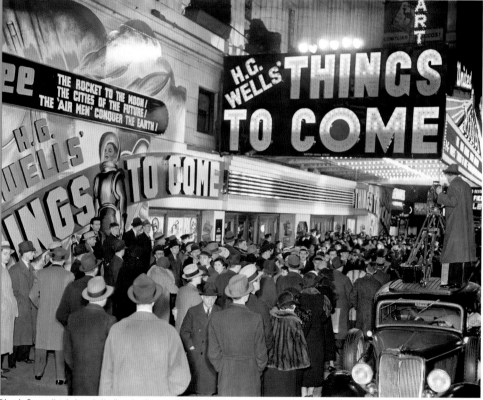

Things to Come attracted great attention when it opened in the United States.

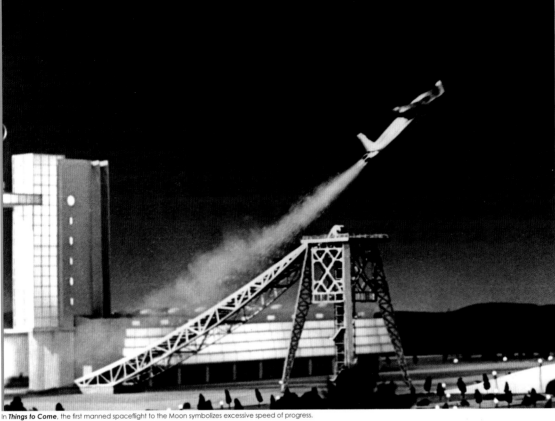

In *Things to Come*, the first manned spaceflight to the Moon symbolizes excessive speed of progress.

In *Things to Come*, aviation is an ambivalent presence: it is both a force for good and an agent of mass destruction.

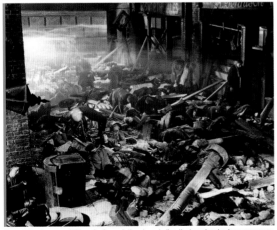

One of the themes of *Things to Come* is the devastation that unchecked progress may bring in its wake.

Sketches for the costumes in *Things to Come*. Lead designer John Armstrong also worked on Korda's *The Thief of Baghdad* (1940).

king kong 1933

King Kong

Son of Kong

King Kong vs. Godzilla

The King Kong Show

King Kong Escapes

King Kong

King Kong Lives

The Mighty Kong

In the view of many the greatest fantasy film of all time, the original *King Kong* is also a solid slice of science fiction, combining the hubris of human attempts to subjugate nature with the alternative ecology of a prehistoric Garden of Eden. Its direct precursor was the 1925 silent feature *The Lost World*, which was based on Conan Doyle's novel of the same name.

The Lost World's special effects — which included stop-motion animation of model dinosaurs and effective jungle miniatures — were created by Willis "Obie" O'Brien. A few years later, film-makers Merian C. Cooper and Ernest B. Schoedsack approached Obie about creating a giant gorilla — and more dinosaurs — for their ambitious adventure epic, *King Kong*. Cooper had previously developed a technique of combining documentary footage with staged drama; the protagonist of *King Kong*, film-maker Carl Denham (Robert Armstrong), uses a similar technique and is clearly modeled on Cooper.

Fay Wray plays Ann Darrow, left homeless and penniless by the Depression until Denham spots her and offers her a trip on his expedition to an uncharted island. During the journey a romance develops between Darrow and the ship's First Mate Jack Driscoll (Bruce Cabot). Skull Island turns out to be a lonely jungle-covered outcrop inhabited by a primitive tribe, living behind a giant wall, which kidnaps Ann and offers her as a sacrifice to Kong, a giant ape.

In 1933 the gorilla was a standard cinematic/literary monster. One of the keys to the success of *King Kong* is its rejection of the popular but mistaken notion that gorillas were bloodthirsty flesh-eaters and infusing its creature with heart, soul and pathos. Kong rules Skull Island and is master of the prehistoric beasts that roam the jungle, but his throne is isolated on a lonely mountaintop.

Driscoll rescues Ann, then Denham subdues Kong and transports him back to New York as the centerpiece of a Broadway show. But the ape breaks loose and searches for Ann, the only creature who has ever shown him kindness. An exciting stand-off atop the newly completed Empire State Building ends when Kong is shot by military biplanes and falls to his death.

Audiences had never seen anything like *King Kong*, the screenplay for which was written by James Ashmore Creelman and Schoedsack's wife Ruth Rose (Edgar Wallace received a courtesy credit although he died before starting work on the story). Max Steiner's magnificent, innovative score made a great film even better.

Astoundingly, a sequel was released less than a year later. *Son of Kong*, which starts with Denham avoiding lawsuits for the destruction in the first film's climax, was lighter in tone without being disrespectful to its predecessor. Obie had dreams of one day pitting Kong against a giant Frankenstein monster

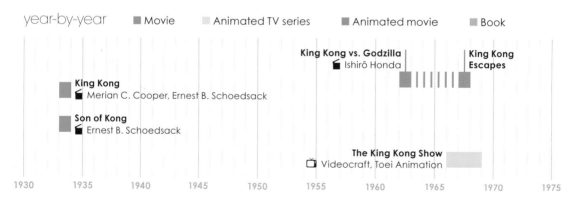

year-by-year ■ Movie ■ Animated TV series ■ Animated movie ■ Book

King Kong vs. Godzilla
🎬 Ishirô Honda

King Kong Escapes

King Kong
🎬 Merian C. Cooper, Ernest B. Schoedsack

Son of Kong
🎬 Ernest B. Schoedsack

The King Kong Show
📺 Videocraft, Toei Animation

1930 1935 1940 1945 1950 1955 1960 1965 1970 1975

$218M (U.S.)
King Kong
(1976)

$11M (U.S.)
King Kong Lives
(1986)

$660M
King Kong
(2005)

Kong: The Animated Series

Kong, King of Skull Island

Kong: King of Atlantis

King Kong

King Kong

King Kong: The Island of the Skull

King Kong

and this project eventually became *kaiju* comedy *King Kong vs. Godzilla* (1962). A sequel to this saw the Japanese Kong battling a giant robot gorilla, Mechani-Kong.

In 1976, producer Dino De Laurentiis poured millions of dollars into a contemporary remake of *King Kong*. Part of the huge cost went on a life-size animatronic Kong, constructed by Carlo Rambaldi, which featured heavily in publicity but never worked properly and is on screen for less than 15 seconds. Instead, rising effects artist Rick Baker donned a much-derided (but actually impressive for the time) ape suit. Directed by John Guillermin from a script by Lorenzo Semple Jr., the film was successful but always overshadowed by the great summer blockbusters that preceded and followed it — *Jaws* in 1975 and *Star Wars* in 1977.

Controversially, Rambaldi won an Oscar for his "effects." Critical reaction was mixed and the film's reputation has not stood the test of time. Some fine performances were critically acclaimed, but Jessica Lange was widely panned for blandness in the lead female role and many felt that the film was fatally flawed by its complete lack of dinosaurs. A belated sequel, *King Kong Lives* (1986) flopped.

Meanwhile, the 1933 film continued to inspire new generations of filmmakers, including Peter Jackson, who was offered the chance to remake *King Kong* as a reward for the success of his *The Lord of the Rings*. Jackson retained the Depression-era setting and the central characters and reinstated the dinosaurs. His Weta Workshop effects house created not only a CGI Kong (brought to motion-capture life by Gollum actor Andy Serkis) but also a plethora of prehistoric creatures, plus Skull Island itself and indeed 1930s New York. Jackson's film, which runs an epic three hours, is a love letter to the original, even including the fabled spider pit sequence, a long-lost scene that was cut from the 1933 picture before release. A commercial and critical success, Jackson's *King Kong* was extensively documented and spawned a wide range of spinoff merchandise.

Kong has also been the subject of two animated series and a number of animated movies, as well as featuring in comics, novels and games. There was even a King Kong Barbie Doll, dressed as Fay Wray and packaged with a gorilla hand. In 2013, an ambitious stage musical version of the story debuted in Melbourne, Australia.

Although much lampooned — as in, for example, the climax to *Wallace and Gromit: the Curse of the Were-Rabbit* (2005) — parodies and pastiches of *King Kong* are never mean but always exude the respect and admiration that the original movie classic continues to inspire among film-makers and cinema-goers alike. **MJS**

■ Musical

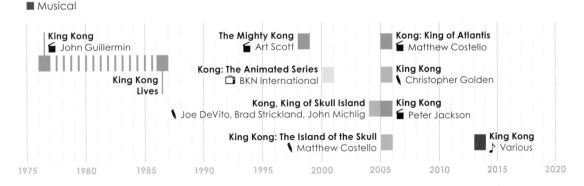

King Kong
John Guillermin

King Kong Lives

The Mighty Kong
Art Scott

Kong: The Animated Series
BKN International

Kong, King of Skull Island
Joe DeVito, Brad Strickland, John Michlig

King Kong: The Island of the Skull
Matthew Costello

Kong: King of Atlantis
Matthew Costello

King Kong
Christopher Golden

King Kong
Peter Jackson

King Kong
Various

1975 1980 1985 1990 1995 2000 2005 2010 2015 2020

King Kong
(1933)

**King Kong vs.
Godzilla**
(1962)

**King Kong
Escapes**
(1967)

King Kong
(1976)

King Kong
(2005)

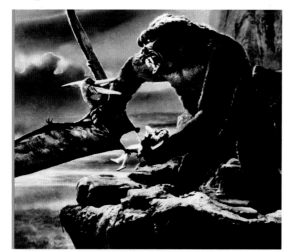

King Kong is a retelling of the story of Beauty and the Beast: a young woman (Faye Wray) is given to Kong as a sacrifice, but instead of eating her he falls in love with her.

Foreground L–R: Willis O'Brien (animator); Merian C. Cooper (co-director); Faye Wray; Ernest B. Schoedsack (co-director).

Faye Wray with Bruce Cabot, the ship's mate who also falls in love with her in the original 1933 movie.

The climax to the 1933 *King Kong*, in which the monster tries in vain to fight off aerial attack, is one of the most celebrated sequences in cinema.

Willis O'Brien with one of his model Kongs. Many people thought he deserved an Oscar, but at the time there was no category for special effects.

Special effects for *King Kong vs. Godzilla* were overseen by Eiji Tsuburaya. He cited the 1933's *King Kong* as inspiration for his choice of career.

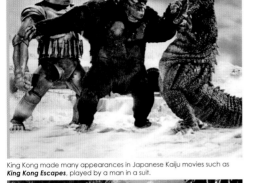

King Kong made many appearances in Japanese Kaiju movies such as *King Kong Escapes*, played by a man in a suit.

Naomi Watts in the 2005 version of *King Kong*, directed by Peter Jackson, whose other work includes *The Lord of the Rings*.

Jessica Lange made her movie debut in the 1976 remake of *King Kong*, produced by Dino De Laurentiis and directed by John Guillermin.

Peter Jackson directs Naomi Watts and Adrien Brody in a scene set aboard the ill-fated SS *Venture*.

The princess and the primate: Naomi Watts in the hands of the creature high above the East River in New York.

The village on Skull Island in Peter Jackson's version of the story, which took $9.7 million in box-office receipts on the day of its release in the United States.

lensman 1934

| Triplanetary | Galactic Patrol | Gray Lensman | Second Stage Lensman | The Vortex Blaster | Children of the Lens | Triplanetary | First Lensman |

E.E. "Doc" Smith's Lensman series is one of the keystones of space opera, and the wellspring of many of the great science fiction adventure tropes. It is vastly influential: what are the Green Lantern Corps if not emerald Lensmen, whatever DC honchos may claim? Deflector shields? You probably read about them here first. A giant, multi-species space federation? Same source. Powered armor battle suits? Ditto. Red-haired, kick-ass heroines? Yes, probably them too.

Lensman began as a series of loosely connected tales that appeared in *Astounding Stories* from the late 1930s on. It eventually expanded into four core novels, pressganged Smith's earlier novel, *Triplanetary*, into its universe, added a minor prequel, got referenced in a further Smith adventure and then spawned numerous sequels by other hands. It is the story of a vast intergalactic police force comprising representatives of numerous intelligent species. Each officer wields a piece of amazing thought-controlled "pseudo-life." In the Lensmen's case, it's a bracelet — or lens — that confers on them psychic and a host of other powers.

Kimball Kinnison and his fellow Lensmen are sponsored by distant aliens called the Arisia and represent not only a vast galactic civilization, but also what we might call "good." Their enemies, a mix of species under the general Boskone banner, are initially presented as powerful space pirates, and are generally very bad. They are, it turns out, supported by another super-species, the vicious Eddore.

Galactic Patrol (1937), *Gray Lensman* (1939), *Second Stage Lensmen* (1941) and *Children of the Lens* (1947) are the four key texts. They all heave with bizarre alien planets, strange aliens (one species is shaped like a wheel), bizarre dialogue ("Tally ho, old fruit!"), vast interstellar battles (whole worlds are routinely destroyed, with no apparent pangs of conscience), and oddly memorable details — such as that Lensmen try to conform to the standards of the alien culture with which they're mingling, so they often walk around totally nude. Yet more unconventional is that the final implication of the entire series is sibling-incest on an epic scale.

Indeed, it may be for this reason that Smith never published his apparently extensively plotted final volume, and so conclusions to the tale have been left to others, including William B. Ellern and David Kyle. Elsewhere, the totally unofficial Japanese *anime* film *SF Shinseiki Lensman* (and the related TV series *Galactic Patrol Lensman*) mess with the continuity and tone considerably, and a major U.S. movie production has been in and out of development for years.

Where it all really started, however, was with *Galactic Patrol*, which introduced the hero, Kimball Kinnison, whose adventures would span the key

year-by-year ■ Magazine serial ■ Short story ■ Book ■ Anime

Triplanetary
E.E. "Doc" Smith

Galactic Patrol
E.E. "Doc" Smith

Gray Lensman
E.E. "Doc" Smith

Second Stage Lensman
E.E. "Doc" Smith

The Vortex Blaster
E.E. "Doc" Smith

Children of the Lens
E.E. "Doc" Smith

Triplanetary
E.E. "Doc" Smith

First Lensman
E.E. "Doc" Smith

Galactic Patrol
E.E. "Doc" Smith

Gray Lensman
E.E. "Doc" Smith

Second Stage Lensman
E.E. "Doc" Smith

Children of the Lens
E.E. "Doc" Smith

1930 1935 1940 1945 1950 1955 1960

| Galactic Patrol | Gray Lensman | Second Stage Lensman | Children of the Lens | New Lensman | SF Shinseiki Lensman | Galactic Patrol Lensman | Lensman |

Lensman texts. The Boskonians — a race of well-equipped space pirates — are running rings around the Galactic Patrol with their super-fast space ships, and whiz-kid academy grad Kinnison is given command of the good guys' best starship, the *Britannia*, to try to capture a pirate vessel and learn the Boskonians' secret. He's also made a Lensman, and so fitted with the semi-alive weapon that allows telepathic communication. It turns out that Kinnison has been specially bred for this task by self-appointed Galactic guardians the Arisians. Consequently he completes his first mission while scarcely breaking sweat: he captures the enemy ship, frees a new species and routs the pirates. For his service, he is promoted to Unattached (or "Gray") Lensman and given all sorts of extra powers and authority.

But pride comes before a fall. During a spell in hospital he meets tough, lovely nurse Clarissa McDougall (she'll later turn out to be another product of the Arisian breeding program) before getting boosted in ability again, to the previously unknown rank of Second Stage Lensman. An arms race with the Boskonians, during which each side builds better and faster ships, ends with victory for Kinnison — but not a decisive one. Similar instances of ante-upping between the two sides became a recurrent feature of the series, and were later widely parodied by satirists of the genre.

So, for instance, we are soon taken to a second, Boskonian-controlled galaxy, and see Kinnison infiltrate a Boskonian drug network, invent the Negasphere super-weapon, regenerate all his chopped-off limbs, crush enemy planets like walnuts, drag some further Lensmen up to Second Stage level, invent another superweapon (the Sunbeam), make Clarissa the first-ever female Lensman (then marry her), conquer the Boskonian galaxy and generally carry on in a ludicrous but exciting fashion.

The final book — *Children of the Lens* — follows the Kinnison/MacDougall marriage. The couple have five children (a boy and two pairs of twin girls) who are born with Second Stage powers, soon learn Third Stage abilities that baffle even the Arisians and take the battle to the power behind the Boskonians, the Eddore. We're left with four perfect, superhuman females and only one potential mate with whom to continue this glorious new species. The only way forward is clear; no less clear is the reason for the reluctance of Smith and other writers to publish further sequels — incest was a topic too hot to handle.

Today the Lensman stories seem camp, repetitive (too much revolves around the creation of a new super-weapon to counter a new super-shield) and almost unbelievably violent, but it's a glorious, Golden Age SF form of camp, and its influence on modern space-based science fiction is second to none. **PM**

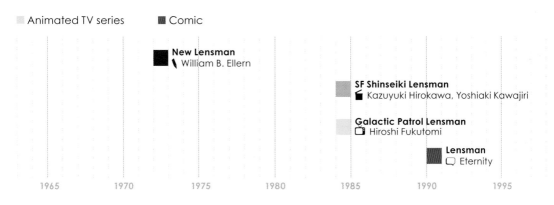

■ Animated TV series ■ Comic

New Lensman
\ William B. Ellern

SF Shinseiki Lensman
Kazuyuki Hirokawa, Yoshiaki Kawajiri

Galactic Patrol Lensman
Hiroshi Fukutomi

Lensman
Eternity

1965 1970 1975 1980 1985 1990 1995

flash gordon 1934

| Flash Gordon | Flash Gordon | Flash Gordon in the Caverns of Mongo | Flash Gordon's Trip to Mars | Flash Gordon Conquers the Universe | Flash Gordon | Flash Gordon: The Lion Men of Mongo | Flash Gordon: The Plague of Sound |

In 1933, rising young American illustrator Alex Raymond was working as a staff artist for comics publisher King Features Syndicate when he was picked for a new assignment. King had been searching for a strip to compete with Buck Rogers, the space-faring hero published by rival syndicate National Newspaper Service since 1928, and Raymond's art on the action serial *Secret Agent X-9* suggested he'd be a good fit with science fiction.

Teamed with writer Don Moore, Raymond's new adventure saga debuted in 1934, and Flash Gordon rapidly became a massive hit. The strip followed the adventures of rugged sports star Flash Gordon on the planet Mongo, and with the United States still in the grip of the Great Depression, escapism-hungry readers were swept along by the story's energetic optimism and nonstop cliffhanging action.

Sticking firmly to the pulp fiction template, Raymond's fast-paced stories also showcased most of the flaws of the 1930s pulps, from female characters who were either damsels in distress or lusty nymphomaniacs, to the uncomfortably racist "Yellow Peril" Asian stereotype of the villainous Ming the Merciless. However, the strip also displayed inventive design and intricately detailed artwork, the likes of which had been rarely seen before.

Raymond's style rapidly evolved from cartoony exaggeration to a more realistic, illustrative approach, and even today his Flash Gordon work is impressive: a wildly romantic mix of medieval fantasy and Art Deco-inspired space adventure. Combining the basic "human hero adrift in an alien world" setup of Edgar Rice Burroughs' John Carter series with Raymond's gorgeous visuals, Flash Gordon laid down a hugely influential template for use in science fiction adventure for decades to come.

Flash's success soon spread to other media. A radio adaptation appeared in 1935, followed by a spin-off pulp novel, and then in 1936 things got even bigger as a 13-part film serial brought Flash Gordon to cinema screens in weekly 20-minute episodes.

Screened before the main feature, weekly serials were a cinema staple in the 1930s. *Flash Gordon* was the first genuine onscreen pulp SF adventure. The series starred Olympic swimmer-turned-actor Buster Crabbe as Flash, and became a smash hit that led to two sequel series — *Flash Gordon's Trip to Mars* (1938), and *Flash Gordon Conquers the Universe* (1940). Produced at speed on tight budgets, the serials are undeniably creaky but also tried their best to capture Raymond's visuals, especially in the first series, and went on to be massively influential.

year-by-year ■ Comic ■ Movie ■ Book ■ TV series Animated TV series

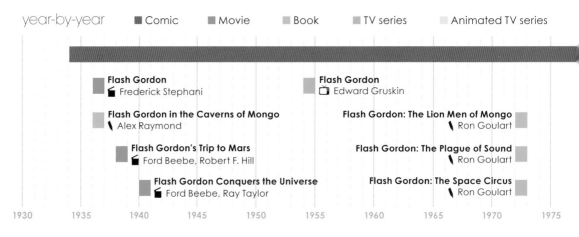

Flash Gordon
Frederick Stephani

Flash Gordon in the Caverns of Mongo
Alex Raymond

Flash Gordon's Trip to Mars
Ford Beebe, Robert F. Hill

Flash Gordon Conquers the Universe
Ford Beebe, Ray Taylor

Flash Gordon
Edward Gruskin

Flash Gordon: The Lion Men of Mongo
Ron Goulart

Flash Gordon: The Plague of Sound
Ron Goulart

Flash Gordon: The Space Circus
Ron Goulart

1930 1935 1940 1945 1950 1955 1960 1965 1970 1975

| Flash Gordon: The Space Circus | Flash Gordon | Flash Gordon | Flash Gordon: The Greatest Adventure of All | Defenders of the Earth | Flash Gordon | Flash Gordon | Flash Gordon: Zeitgeist |

The Flash Gordon strip continued for decades after Raymond's departure in 1943 under new artists, undergoing a major transformation in the 1950s as the Mongo setting was largely left behind in favor of Flash becoming an intergalactic troubleshooter. This was mirrored in the 1954 TV adaptation, which recast Flash as a futuristic space hero in the year 3203, but this version has otherwise aged very badly.

The year 1973 saw the release of six Flash Gordon novels, written by author Ron Goulart, with the first three — *Lion Men of Mongo*, *The Plague of Sound* and *The Space Circus* — still remembered as fun additions to the Flash mythos. (A further, and far inferior, batch of six novels followed in 1980.)

In 1979, production company Filmation launched a lively Flash Gordon animated series on U.S. television, but network interference on its second season resulted in its cancellation. The unaired film-length pilot for the series was finally shown in 1982 under the title *Flash Gordon: The Greatest Adventure of Them All*, and is now regarded as one of the best screen adaptations of the strip.

The animated movie's release came two years after the arrival in cinemas of the first full-length Flash Gordon film adaptation in 1980. Part of the post-*Star Wars* science fiction boom, this outrageously colorful adventure deliberately played up the kinkier aspects of Raymond's stories. A failure at the box office, it went on to become a major cult favorite, thanks mainly to the soundtrack by rock group Queen.

There have since been few adaptations other than *Defenders of the Earth*, an animated adventure series that teamed Flash with fellow King Features characters Mandrake the Magician and the Phantom.

In 1996 there was an ill-advised attempt to relaunch the character as a hover-boarding teenager in an animated series, and an even lower point came in 2007 with another live-action TV adaptation, which turned out to be a swiftly cancelled disaster.

A big-budget Hollywood reboot looked likely in 2010 when director Breck Eisner was signed to helm a new Flash Gordon movie to be filmed in 3D. The project never got out of development, however, possibly because of the failure of pulp adaptations *John Carter* (2012) and *The Lone Ranger* (2013).

As for the comic itself, there have been several occasional miniseries and reinventions over the years (including ones published by both Marvel and DC, as well as recent titles from Ardden and Dynamite), but the 69-year run of Flash Gordon came to an end in 2003 when King Features discontinued the strip, although it is still reprinted in some U.S. newspapers. **SB**

■ Animated TV movie

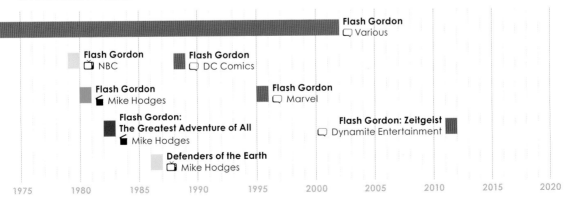

Flash Gordon
Various

Flash Gordon
NBC

Flash Gordon
DC Comics

Flash Gordon
Mike Hodges

Flash Gordon
Marvel

Flash Gordon: The Greatest Adventure of All
Mike Hodges

Flash Gordon: Zeitgeist
Dynamite Entertainment

Defenders of the Earth
Mike Hodges

1975 1980 1985 1990 1995 2000 2005 2010 2015 2020

flash gordon universe

Prince Barin | **Flash Gordon** | **Doctor Hans Zarkov** | **Dale Arden** | **Emperor Ming the Merciless**

With Earth threatened by collision with a mysterious planet, Flash Gordon and his female companion Dale Arden are abducted by eccentric scientist Hans Zarkov to crew his rocket ship. Zarkov's plan is to travel to the planet and find a way of saving Earth, but after crash-landing on Mongo, Dale and Flash are captured by the planet's ruler, Ming the Merciless.

Having learned that Mongo will safely bypass Earth, Flash fights in a dangerous arena. He is rescued by Ming's beautiful but treacherous daughter, Princess Aura. After Flash saves Dale from forced marriage to Ming, he flees with her to Arboria, ruled by Prince Barin, where they are reunited with Zarkov.

Betrayed by Aura, Flash and Dale are imprisoned in the Sky City of King Vultan, ruler of the Hawkmen. Flash is tortured by Aura and enslaved; Dale is forced to pretend to be in love with Vultan. By sabotaging the Sky City, Flash and Barin strike a deal with Vultan.

Vultan becomes a valuable ally, and as Ming arrives to demand the return of Flash and Dale, Vultan insists on Flash's right to trial by combat. Flash and Barin (who fights to win the hand of Aura) win the ensuing Tournament of Death, and Ming is forced to grant Flash Kira, one of the kingdoms of Mongo.

Kira is a barren and savage place where Flash and Dale have to contend with Azura, the Witch-Queen of Mongo. Together with Azura, Flash starts an epic uprising against Ming, but the lengthy war fails to topple the dictator, and Flash, Dale and Zarkov end up on the run, voyaging through many different kingdoms of Mongo before they return to the safety of Arboria.

When Ming discovers that Barin and Aura are sheltering Flash, he attacks Arboria. Flash is captured and sentenced to death. Ming's surgeon, Dr. Bono, fakes Flash's execution, and Flash then teams up with other rebels to destabilize Ming's kingdom from within.

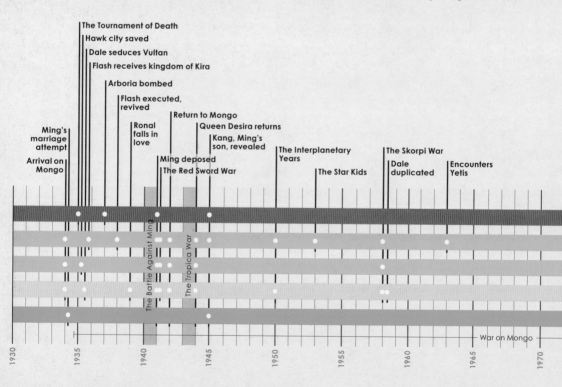

Flash and Dale then fake suicide, an event that sparks a rebellion during which Ming is deposed. Ming City is renamed Alania, and the United Republics of Mongo are established, with Barin and Aura ruling over them. Then Flash learns that war has broken out on Earth. The three friends return to their home planet, where they defeat the Red Sword organization.

In order to improve Earth's defenses, Flash and Zarkov volunteer for a secret mission back to Mongo to mine radium. Dale stows away with them on board. They crash-land in the kingdom of Tropica, where a conflict ensues to restore Queen Desira to the throne.

After their victory, Flash, Dale and Zarkov return to Alania, where they are confronted by Kang the Cruel, the evil offspring of Ming the Merciless.

Travel between Mongo and Earth becomes easier, and Humanity colonizes the Solar System. Flash and Dale become intergalactic adventurers. They face trouble from the mischievous Space Kids, and then encounter a more formidable foe, the Skorpi, an alien race of shape-shifters.

Flash and Dale later continue their adventures in time and space, and end up stranded with Zarkov on Mongo, where Flash briefly rules as President of the United Republics.

Barin is soon returned to power, along with Aura, but then Ming reappears and tries to frame Flash for murder. Ming's attempted coup is foiled, and he is forced on the run, becoming a terrorist still determined to wreak havoc.

Ming then engages Barin and Flash in a tournament against Mongo's deadly monsters, but the fight costs Aura her life. Ming is injected with venom by a monster, and Flash is saved by Dale. With Ming in a coma, Mongo is safe. Flash, Dale and Zarkov are left wondering if they'll ever make it back to Earth ... **SB**

characters ■ Prince Barin ■ Flash Gordon ■ Doctor Hans Zarkov ■ Dale Arden
■ Emperor Ming the Merciless

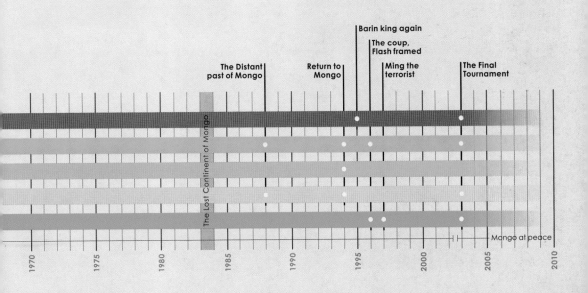

Flash Gordon
(1934–2002)

Flash Gordon
(1936)

Flash Gordon's Trip to Mars
(1938)

Flash Gordon
(1954)

Flash Gordon
(1979)

Flash Gordon
(1980)

Flash Gordon
(2007)

The early *Flash Gordon* strips featured sublime artwork by Alex Raymond, who is widely held to be the most imitated artist in U.S. comics.

Jean Rogers (Dale Arden) and Buster Crabbe (Flash), the former reported, "both thought the whole thing was nuts."

Charles Middleton, said co-star Jean Rogers, was "a very nice, gentle man — the exact opposite of Ming the Merciless."

Steve Holland, who played Flash on the small screen in the 1950s, had previously been the model for illustrations of the pulp magazine character Doc Savage.

In the cartoon, Zarkov was voiced by Alan Oppenheimer, Flash by Robert Ridgely and Dale by Diane Pershing.

Future James Bond star Timothy Dalton is bested by Jones. "A great film!" he enthused.

"I always had this thought that eventually people would look at it as a piece of pop culture," Sam Jones said of the 1980 movie. Jones duly appeared in *Ted,* directed by *Family Guy* creator and '80s pop culture doyen Seth McFarlane. Jones' breakout role had been as Bo Derek's husband in 1979's *10.*

A 1978 sketch by James Acheson for the **Flash Gordon** movie, at the point where it was to have been directed by Nic Roeg.

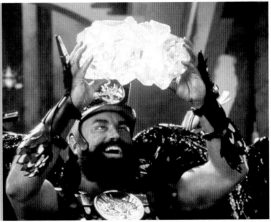

Fans of the 1980 movie, "come up to me and tell me to say, 'Gordon's alive!' into their mobile phone, or they'll shout it from scaffolding." — Brian "Prince Vultan" Blessed

Former *Smallville* star Eric Johnson returned the star to screens in 2007. "Whether the show was a wild success or a colossal failure," he reflected, "I knew I did my best."

new worlds 1936

Novae Terrae New Worlds New Worlds Quarterly New Worlds New Worlds Michael Moorcock's New Worlds

This periodical emerged from *Novae Terrae* (Latin for "New Worlds"), a fanzine established in 1936 by Maurice K. Hanson, a British member of the Science Fiction League, an organization founded in the United States by Hugo Gernsback to promote his *Amazing Stories*. One of the early contributors to *Novae Terrae* was Arthur C. Clarke. It was Britain's first — and until 2000 its longest-running — SF magazine.

In 1939 the publication was taken over by John Carnell, who changed its name to *New Worlds* and began numbering it with a new issue 1. Early plans for this more professional magazine — which included fiction from Robert Heinlein and Samuel Youd — were abandoned on the outbreak of the Second World War in 1939. Carnell served in the armed forces throughout the conflict, and it was only on his return to civilian life in 1946 that the magazine began properly.

Throughout its long life, *New Worlds* faced funding difficulties. In 1948 Carnell and others, including author John Wyndham, formed Nova Publications as a limited company. In 1950 they launched a companion magazine, *Science Fantasy*, which survived until 1970 and was notable for publishing Terry Pratchett's first short story (at age 16) as well as the earliest work of Christopher Priest.

In 1963, with circulation declining and Carnell heading off to edit the first 21 issues of the original fiction anthology series, *New Writings in SF*, the magazines faced closure. They were taken over, however, by publishers Roberts & Vinter, who hired the young Michael Moorcock as editor.

Under Moorcock, *New Worlds* entered its golden age and became a focal point of the 1960s' New Wave of science fiction. It published much of J.G. Ballard's early fiction — a Ballard novella was in Moorcock's very first issue. Moorcock himself contributed much material under a pseudonym as well as under his own name, and introduced his now famous Jerry Cornelius stories. He published Vernor Vinge's first short story, and began to attract American authors who found in *New Worlds* a more welcoming market for nontraditional and sometimes controversial material.

Notoriously, the magazine's serialization in 1969 of Norman Spinrad's *Bug Jack Barron* caused a question to be raised in the British parliament, as *New Worlds* was by that time a recipient of a government-funded Arts Council grant. Other significant contributors included the Americans Roger Zelazny and Thomas M. Disch and the Britons M. John Harrison and Robert Holdstock. Samuel Delany's "Time Considered as a Helix of Semi-Precious Stones," published in 1968, won Hugo and Nebula awards.

Under Moorcock, *New Worlds* reflected the concerns of both the "Swinging Sixties" and the resultant New Wave movement. Moorcock left at the end of the 1960s, but the magazine carried on, although in different formats to adapt itself to new media. After a brief closure, it was for a time repackaged as an anthology series and, most recently, has undergone an attempted revival in electronic form. **LT**

year-by-year ■ Magazine ■ Book ■ Online

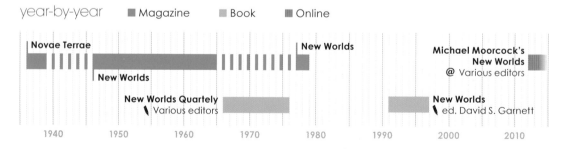

Novae Terrae

New Worlds

New Worlds

Michael Moorcock's New Worlds
@ Various editors

New Worlds Quartely
Various editors

New Worlds
ed. David S. Garnett

1940 1950 1960 1970 1980 1990 2000 2010

frederik pohl 1937

SFWA
GRANDMASTER

Astounding Stories

Super Science Stories

The Space Merchants

If

Galaxy

Man Plus

Gateway

The Last Theorem

The life of Frederik Pohl (1919–2013) spanned American science fiction, from its birth in the pulps to the 21st century. His first published work was a poem that appeared in *Amazing Stories* in 1937; in 2010, his online blog won a Hugo Award for Best Fan Writer.

In the late 1930s and early 1940s, Pohl was a member of the Futurian group of young science fiction fans in New York, whose number also included Isaac Asimov, James Blish and C.M. Kornbluth. For a time he acted as Isaac Asimov's agent. He briefly became, at the age of 20, the editor of two pulp science fiction magazines — *Astounding Stories* and *Super Science Stories*. Indeed, just as his career spanned decades, it ranged across the entire spectrum — he was writer, editor, agent and, first and foremost, a science fiction fan.

He served in Italy during the Second World War. Returning to New York, he worked for a time as an advertising copywriter, an experience that fed into his first novel, *The Space Merchants*, co-written with Kornbluth. In this classic, set in an overpopulated world, ad-men must try to sell the idea of space colonization (specifically, on a hostile Venus) to the masses. The hero, assigned the campaign, instead finds himself in a conspiracy-filled world that makes him question his values. A biting satire of capitalism, it is surprisingly effective to this day, and is one of the few SF novels collected under the Library of America imprint. Its place in the history of SF is assured.

In the 1960s, Pohl was editor of *Galaxy* and *If* magazines. He won three Hugo awards for the latter, and a fourth in 1973 for his short story, "The Meeting" (again with Kornbluth), and a fifth in 1977 for his novel *Man Plus*.

Also in 1977 he published his most successful novel, *Gateway*, which won both a Hugo and a Nebula award in the following year. The story concerns the Heechee, a long-vanished race of aliens who have left behind a hollow asteroid filled with spaceships. The narrator, Robinette Broadhead, has come to Gateway to seek his fortune — the ships can travel across the galaxy but the destination is unknown until arrival, making each journey a dangerous lottery. Robinette at last achieves riches, but at great cost, which he narrates to his automated psychiatrist. This much loved novel spawned several sequels, but these are less successful.

Pohl won another Hugo for his short story, "Fermi and Frost" in 1986 and was the recipient in 1993 of the Science Fiction Writers of America's highest honor, the Grand Master Award.

Pohl edited the early works of Larry Niven and published Samuel Delany's hugely ambitious *Dhalgren* (1975). He continued writing into the 21st century, collaborating with Arthur C. Clarke on *The Last Theorem* in 2008. It was Clarke's last novel. Pohl then began blogging in 2009, at the age of 89. He was one of the great all-rounders of science fiction. **LT**

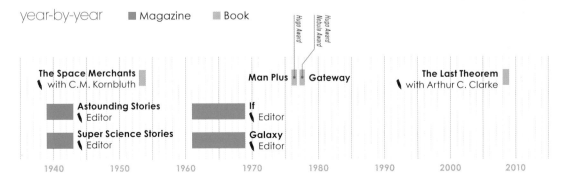

year-by-year ■ Magazine ■ Book

Hugo Award

Hugo Award
Nebula Award

The Space Merchants
with C.M. Kornbluth

Man Plus Gateway

The Last Theorem
with Arthur C. Clarke

Astounding Stories
Editor

If
Editor

Super Science Stories
Editor

Galaxy
Editor

1940 1950 1960 1970 1980 1990 2000 2010

superman 1938

Action Comics

Superman

The Adventures of Superman

Superman

Superman

Superboy

The Adventures of Superman

Superman

In 1938 the U.S. comic book industry was in its infancy. The newspaper strips and pulp novels of the 1930s featured colorful heroes like Flash Gordon, The Phantom and Doc Savage, but it was Superman who provided the template for the superhero comic book genre with his costume, cape, secret identity and fantastic powers.

Writer Jerry Siegel and artist Joe Shuster — creators of Slam Bradley, the tough private eye who appeared in the launch issue of *Detective Comics* in 1937 — had been pitching Superman as a newspaper adventure strip without success for several years before they agreed to debut the character in *Action Comics* #1. In exchange for the rights to their creation they received $130.

Editor Vincent Sullivan put Superman on the cover and made him the lead feature. The first issue had a print run of 200,000 copies. By the seventh issue *Action Comics* was selling more than 500,000 copies and in 1939 the hero was given his own series — the first issue of *Superman* sold more than 900,000 copies in three printings. In the 1940s, sales exceeded one million copies per issue; this success spawned a popular spinoff radio serial that was the original source of the famous tagline: "Faster than a speeding bullet, more powerful than a locomotive, able to leap tall buildings at a single bound! Look! Up in the sky! It's a bird! It's a plane! It's Superman!"

The original Superman was much more down-to-earth than later incarnations. In early stories he tackled a wife-beater, saved an innocent woman from execution and rescued Lois Lane from mobsters.

By the 1950s the tone of the comics had changed completely and Superman's adventures were light-hearted romps in which his increasingly fantastic powers were used mainly to dupe Lois Lane, who was determined to prove that he and Clark Kent were one and the same. The mad scientist Lex Luthor, who became Superman's archenemy, first appeared in 1940, but the ranks of his adversaries were swelled by a host of goofy characters including The Prankster, The Toyman and the inter-dimensional imp Mr. Mxyztplk. When Superman wasn't dealing with the gimmicks of this rogue's gallery, he grappled with romantic entanglements — 1959 saw a young Clark Kent fall in love with Lori Lemaris, a mermaid from Atlantis. The nonviolent, good-natured style of Superman's adventures meant that the comics were unaffected by the advent of the Comics Code Authority in 1954.

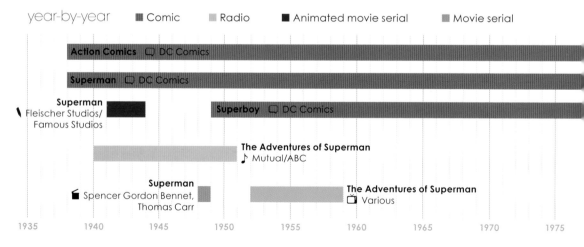

year-by-year ■ Comic ■ Radio ■ Animated movie serial ■ Movie serial

Action Comics 🖵 DC Comics

Superman 🖵 DC Comics

Superman
Fleischer Studios/
Famous Studios

Superboy 🖵 DC Comics

The Adventures of Superman
♪ Mutual/ABC

Superman
Spencer Gordon Bennet,
Thomas Carr

The Adventures of Superman
📺 Various

1935 1940 1945 1950 1955 1960 1965 1970 1975

$1.1B
Superman
(1978)

$278M (U.S.)
Superman II
(1981)

$141M (U.S.)
Superman III
(1983)

$454M
Superman Returns
(2006)

$668M
Man of Steel
(2013)

| Superman II | Superman III | The Man of Steel | Superman IV: The Quest for Peace | Lois and Clark: The New Adventures of Superman | Smallville | Superman Returns | Man of Steel |

Superboy, starring a teenage version of the hero, made its debut in 1945. The Boy of Steel was joined in 1955 by Krypto the Superdog, and three years later Superman's cousin Supergirl arrived on Earth.

By the 1970s Superman had an enormously expanded array of powers and he was almost omnipotent, although he always remained vulnerable to kryptonite. In 1986, the character was given a new direction by writer and artist John Byrne in the six-issue mini-series *The Man of Steel*. Although he remained the most powerful of DC Comics' heroes, his abilities were scaled down.

The enormous financial success of the Superman franchise, which includes merchandising, radio programs, television, films and even a musical, led to a series of lawsuits as Siegel and Shuster, and later their estates, sought to regain the copyright to the character they had sold so cheaply. Their first legal action failed in May 1948, when a court ruled against them. A second attempt was settled in December 1975 when DC Comics' new owners, Warner Communications, agreed to pay Siegel and Shuster $20,000 a year and to credit them as Superman's creators. After Siegel's death in 1996 his widow Joanne, the original model for Lois Lane, launched a suit that was contested until 2008 when a Los Angeles court granted the estates of Siegel and Shuster a limited portion of the ownership of Superman. Warner has appealed the 2008 ruling, and there is currently another ongoing battle over ownership of Superboy.

Superman first appeared on screen in a series of beautiful cartoons produced by Max Fleischer in 1941. Kirk Alyn played the hero in a 15-part movie serial and the feature *Atom Man Versus Superman* before George Reeves donned the cape for six seasons of *The Adventures Of Superman* TV series in the 1950s. Christopher Reeve played Superman in four movies with mixed results; the first in 1978 was a box office hit but 1987's *Superman IV: The Quest For Peace* was a flop. The TV series *Lois And Clark: The New Adventures of Superman*, focused on the romantic relationship between its titular characters. *Smallville*, which ran for 10 seasons and drew inspiration from *Buffy The Vampire Slayer* in tone and style, followed the adventures of Clark Kent as a teenager, never showing him in the iconic red and blue costume. The 2006 film *Superman Returns* was a misfire, and Zack Snyder's dark and violent 2013 *Man Of Steel*, with Henry Cavill in the tile role, proved divisive amongst fans but was a commercial success. **DWe**

■ TV series ■ Movie

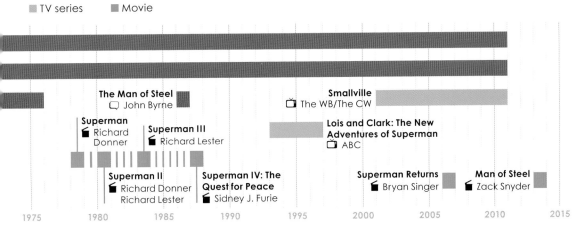

The Man of Steel
▢ John Byrne

Superman
🎬 Richard Donner

Superman III
🎬 Richard Lester

Smallville
📺 The WB/The CW

Lois and Clark: The New Adventures of Superman
📺 ABC

Superman II
🎬 Richard Donner
Richard Lester

Superman IV: The Quest for Peace
🎬 Sidney J. Furie

Superman Returns
🎬 Bryan Singer

Man of Steel
🎬 Zack Snyder

1975 1980 1985 1990 1995 2000 2005 2010 2015

superman universe

Clark Kent/ Kal-El/ Superman **Lois Lane** **Lex Luthor** **Kara Zor-El/ Supergirl**

The planet Krypton is home to a technologically advanced civilization, but only one of its inhabitants, the scientist Jor-El, foresees its imminent destruction. He places his infant son Kal-El in a rocketship and sends him across space to Earth just before Krypton explodes. The baby is found by Jonathan and Martha Kent (although in different stories they have been John and Mary or Eben and Sarah), who name him Clark Kent and raise him as their own in Smallville, Kansas.

As Clark grows, he displays superhuman strength and speed, and becomes virtually invulnerable. Moving from Smallville to the city of Metropolis, Clark becomes a reporter on *The Daily Planet* (originally *The Daily Star*). His colleagues at the newspaper include photographer Jimmy Olsen, editor Perry White and reporter Lois Lane. Whenever danger threatens, Clark secretly changes from a shy reporter into Superman, defender of truth, justice and the American Way.

At first Superman's fantastic strength is attributed to Krypton having stronger gravity than Earth. It is later revealed that Krypton orbited a red sun and

Kryptonians were comparable to ordinary humans in their physical abilities. The yellow sun of Earth's solar system charges Kal-El with energy that imbues him with superhuman powers.

Superman's abilities grow steadily over the years, until for a time his arsenal includes the power of flight, x-ray vision, super-hearing, super-ventriloquism, heat vision, telescopic vision, microscopic vision and super-breath. He can travel through space under his own power without any form of life support. But then, after the Crisis On Infinite Earths, Superman's powers are curtailed. He retains his strength, speed and x-ray and heat vision, and the ability to fly. But his invulnerability is not without limits.

In 1998 Superman split into two beings — Superman Blue and Superman Red — after falling into a trap set by Cyborg Superman. Both new Supermen had electrical powers, but whereas Superman Blue was cool and analytical, Superman Red was hot-tempered and impulsive. The split was temporary and the two halves merged back later the same year.

characters ▓ Clark Kent/Kal-El/Superman ▓ Lois Lane ▓ Lex Luthor ▓ Kara Zor-El/Supergirl

Brainiac active | Lori Lemaris active
Supergirl (Kara Zor-El) active | Justice League of America founded
Krypto active
Mr. Mxyztplk active
Lex Luthor active | Superman and Batman team up | General Zod active | Intergang active
Lois Lane meets Superman | Lana Lang active
Superman begins fighting crime | Parasite active | Darkseid active

Note: comic characters do not age like mere mortals and their adventures cover an unfeasibly long period of time. Therefore dates have not been included on this timeline.

There have been several women in the life of Superman/Clark Kent — his adoptive mother, his high school crush Lana Lang and the mermaid Lori Lemaris — but the most important is Lois Lane. When Clark and Lois first meet, he is resoundingly rejected by the glamorous reporter, who tells him: "You asked me earlier in the evening why I avoid you. I'll tell you why now! Because you're a spineless, unbearable coward!" However, Lois develops an attraction for Superman that evolves into feelings for Clark Kent. Clark and Lois married in 1996, but in 2011 the history of the universe was altered again in an event known as Flashpoint. Now they have never been married, but they are still work colleagues; Superman is now romantically involved with superheroine Wonder Woman.

Superman's principal nemesis is Lex Luthor, a megalomaniac bent on world domination. Luthor has no superpowers, but his cunning and intelligence enable him to challenge Superman repeatedly. Luthor starts out as a mad scientist, but after the Crisis he becomes a wealthy corporate mogul who hates Superman for being an alien. At one point Luthor uses his wealth and ingenuity to become U.S. President, but leaves office in disgrace after his plot to frame Superman for murder is revealed. Following Flashpoint, Luthor is working for the U.S. government to ascertain if Superman had any weaknesses.

Superman's other foes include the Kryptonian renegade General Zod; the alien Braniac, who possesses incredibly advanced technology and Darkseid, the ruthless ruler of the planet Apokolips.

In 1992 Superman first encountered Doomsday, a creature that tore a path of destruction across North America en route to Metropolis. Superman defeats Doomsday in a battle that apparently costs the hero his life. But Superman is not finished; he has merely entered a healing state, and later returns to action.

Over the years Superman has worked alongside many other heroes. His partnership with Batman first began in 1952 and the two were founding members of the Justice League of America. Their abilities could not be more disparate, but their aims are identical. **DWe**

Matrix becomes Supergirl

Supergirl (Kara Zor-El) dies

Crisis On Infinite Earths

Lex Luthor unveils his battle armor

Superman fights Muhammad Ali

Superman and Lois Lane marry

Superman (Kal-El) returns

Reign of The Supermen

Doomsday active

Matrix merges with Linda Danvers

Superman Red and Superman Blue

Lex Luthor becomes President of the United States of America

Lex Luthor ousted from office

Kara Zor-El returns as Supergirl

New Krypton emerges

New Krypton destroyed

Superman: Grounded

Flashpoint

Lex Luthor joins Justice League

Action Comics
(1938–2011)

Superman
(1941–44)

**The Adventures
of Superman**
(1952–59)

Superman
(1978)

Justice League
(2001–04)

Smallville
(2001–11)

**Superman
Returns**
(2006)

Man of Steel
(2013)

Clark Kent at *The Daily Planet* in a frame from **Superman**, the first installment in the animated movie serial started by Fleischer Studios in 1941.

"Whatever Happened to the Man of Tomorrow?" (1986) is widely regarded as one of the best Superman stories ever written.

George Reeves brought the role to the small screen. Killed by gunshot at 45, he is one of several actors associated with the "Curse of Superman."

One of four actors to portray Kal-El in the 1978 movie, Aaron Smolinski has cameo roles in *Superman III* and *Man of Steel*.

Christopher Reeve became, arguably, the most iconic Superman. "The producers started with very big names at the time from Robert Redford to Sylvester Stallone," he told the BBC. "They then realized that it would be better to cast an unknown in the part and surround him with a lot of famous actors."

A frame from the Cartoon Network's version of *Justice League* (2001–04). Shown here are (L–R): Green Lantern, Wonder Woman. Superman, Hawkgirl and The Flash.

Superman Returns (2006) featured Kevin Spacey as Lex Luthor.

Clark Kent (Tom Welling) battles Lionel Luther (John Glover) the old-fashioned way in an episode of *Smallville*.

What woman would want a newspaper reporter when she's in love with a superhero? Brandon Routh as Clark Kent and Kate Bosworth as Lois Lane in *Superman Returns*.

Smallville charted Superman's teen years on Earth. Here his Kryptonian Father, Jor-El, is played by Julian Sands.

Superman (Henry Cavill) allows himself to be taken into custody by the military in *Man of Steel*.

the thing 1938

Who Goes There? | The Thing from Another World | Who Goes There? | The Thing | The Thing | The Thing from Another World

One of the most influential short-story magazine editors in the history of science fiction, John W. Campbell also had a previous career as an SF writer in the 1930s, during which he crafted a story that went on to have an unexpectedly long life. Originally published in 1938 under the pseudonym Don A. Stuart, *Who Goes There?* was a tautly structured SF horror novella, set in a remote Antarctic research outpost where an alien life form is discovered buried in the ice after 20 million years.

The curious scientists defrost the creature, presuming it long dead, but it turns out to be alive and extremely dangerous. Faced with a shape-changer that functions like a virus and can perfectly imitate whatever it consumes, the outpost crew members are left unsure which of their number have now been replaced by alien "Things."

Campbell's novella is sketchy at times, short on characterization and functionally written, but it has a brilliantly dark central concept, touching on themes of identity and humanity that later SF writers like Philip K. Dick would explore in greater depth.

Who Goes There? was first adapted for the screen in a Howard Hawks production of 1951. A loose interpretation of Campbell's story, *The Thing From Another World* utilized the basic set-up but dropped the alien's shape-changing ability in favor of a lumbering plant-based humanoid that feeds on blood. Once the creature goes on the rampage, the film plays up the original novella's themes of scientific curiosity unleashing forces that aren't properly understood, tapping into post-Hiroshima fears of a global nuclear conflagration.

Although *The Thing From Another World* is far from subtle and takes a simplistic and militaristic approach to science fiction, it's also a remarkably well-crafted thriller that builds suspense and sensibly keeps the less-than-impressive alien largely offscreen. The overlapping dialogue and sharp characterization led to rumors that Hawks may also have directed it, and the work became one of the best remembered and most influential SF movies of the 1950s.

A second screen adaptation in 1982 took a very different approach. Director John Carpenter was intrigued by animatronics, and used the latest advances in these special effects to make a movie about an alien that wasn't a traditional man in a rubber suit, and which remained remarkably faithful to Campbell's original novella.

A stark, brutally bleak horror thriller, *The Thing* contained several nods to the 1951 version but otherwise cranked up the distrust and paranoia to truly disturbing levels. Fully confronting the darkness in Campbell's story, the movie also became famous

year-by-year ■ Short story ■ Movie ■ Comic ■ Book ■ Video game

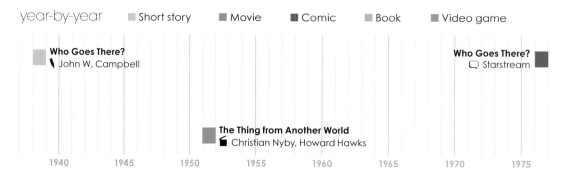

Who Goes There?
John W. Campbell

Who Goes There?
Starstream

The Thing from Another World
Christian Nyby, Howard Hawks

1940 1945 1950 1955 1960 1965 1970 1975

$48M (U.S.)
The Thing
(1982)

$28M
The Thing
(2011)

The Thing from
Another World:
Climate of Fear

The Thing from
Another World:
Eternal Vows

The Thing

The Thing:
The Northman
Nightmare

The Things

The Thing

for its grisly effects sequences, showcasing the alien Thing's shape-changing abilities in increasingly grotesque and nightmarish ways — most notably, when a human head detaches itself from its body and grows long, spider-like legs.

Special effects makeup specialist Rob Bottin's amazing designs took the psychedelic nightmares of 1950s and 1960s horror comics and made them real, pulling off a symphony of practical effects that still impresses today. *The Thing* was an intense, ferociously gory and misanthropic film, with a cynicism and bleakness of vision that proved too much for audiences on its release in 1982, the year in which Steven Spielberg's more sentimental *E.T. the Extra-Terrestrial* broke box-office records.

However, in common with *Blade Runner*, another flop of the same year, *The Thing* was later rediscovered thanks to the rise of home video, and went on to be viewed as an influential cult favorite as well as a landmark in practical special effects.

The 1982 version's brilliantly downbeat and open ending — in which only two characters are left, freezing to death, and neither can be sure whether the other is truly human — inspired talk of a possible follow-up. These rumors were fueled by the publication in the 1990s by Dark Horse Comics of several printed sequels.

In 2002, a computer game based on *The Thing* was released. Set a few days after the movie's events, it featured John Carpenter in a cameo role and was considered by the director to be a canonical sequel. A proposed follow-up game was ultimately shelved, and 2010 saw the publication of "The Things," an acclaimed short story by SF author Peter Watts that retold the Carpenter film from the point of view of the alien itself.

In 2011 a movie set out to explore the story of the Norwegian base that had originally excavated the alien shape-changer, and which appeared in the 1982 film only as a ruin. Both a prequel and a loose remake, the 2011 film (also, confusingly, entitled *The Thing*) stuck closely to the basic template and visual approach of Carpenter's version, but replaced the original male protagonist with a woman, played by Mary Elizabeth Winstead.

Despite a few memorably tense sequences, the film never escaped the shadow of the Carpenter version, and the CGI-assisted special effects couldn't get close to Bottin's awe-inspiring practical work. A more commercial approach matched with a less daringly bleak ending didn't help, either, and box office revenue was disappointing. Carpenter's version still stands as the definitive screen take on Campbell's 1938 story. **SB**

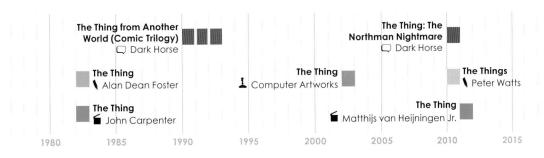

The Thing from Another
World (Comic Trilogy)
☐ Dark Horse

The Thing: The
Northman Nightmare
☐ Dark Horse

The Thing
❧ Alan Dean Foster

The Thing
Computer Artworks

The Things
❧ Peter Watts

The Thing
John Carpenter

The Thing
Matthijs van Heijningen Jr.

1980 1985 1990 1995 2000 2005 2010 2015

The Thing from Another World (1951)

The Thing (1982)

The Thing (2011)

The Thing in *The Thing from Another World* was played by James Arness, who later starred as Marshal Matt Dillon in *Gunsmoke*.

In *The Thing from Another World*, the trouble starts when alien seed pods are discovered in the Antarctic in a crashed spacecraft.

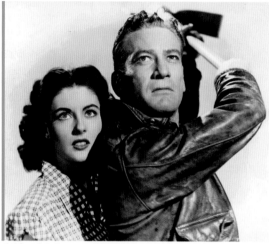

USAF Captain Patrick Hendry (Kenneth Tobey) wields an ax to protect secretary Nikki Nicholson (Margaret Sheridan) in *The Thing from Another World*.

Kurt Russell plays helicopter pilot MacReady in John Carpenter's *The Thing* (1982).

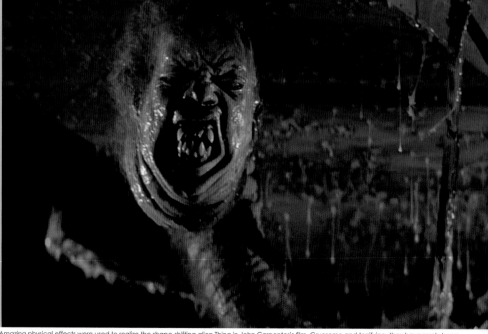

Amazing physical effects were used to realize the shape-shifting alien Thing in John Carpenter's film. Gruesome and terrifying, they have rarely been bettered. Here, one of the base's staff mutates after being infected.

Makeup and prosthetics expert Rob Bottin with one of the gory special effects he created for John Carpenter's **The Thing**.

Some of the base crew in Carpenter's **The Thing** (L–R): Nauls (T.K. Carter), MacReady (Kurt Russell) and Garry (Donald Moffat).

A Norwegian research team member (played by Eric Christian Olsen) drills into Antarctic ice in order to free the body of an alien. This turns out to be a serious mistake in Matthijs van Heijningen Jr.'s 2011 version.

In the 2011 version, Kate Lloyd (Mary Elizabeth Winstead) is not just a run-of-the-mill paleontologist: she also proves herself pretty handy with a flamethrower.

space trilogy 1938

Out of the
Silent Planet

Perelandra

That Hideous
Strength

The Tortured
Planet

The Dark
Tower

C.S. Lewis — best known for his Narnia fantasy series — wrote the Space Trilogy as a rejoinder to other works, especially Olaf Stapledon's epic future history *Last and First Men*, and J.B.S. Haldane's *Possible Worlds*. Firmly rooted in Lewis' Christian beliefs, the Space Trilogy features supernatural adventure, philosophy and planetary exploration — a combination partly inspired by Lewis' admiration for David Lindsay's novel *Voyage to Arcturus* (1920).

In the first book of the series, *Out of the Silent Planet*, philologist Elwin Ransom is kidnapped and sent to Mars, a planet known to its inhabitants as Malacandra. There he receives instruction in the nature of the universe from the tutelary spirit of that world, an Oyarsa (plural: Oyéresu), a senior member of a superhuman race of extraterrestrials called the Eldila. Ransom discovers that the Solar System has a deeply spiritual aspect, and that every world is connected to all the others except Earth. The Oyarsa of our world, the Bent One, turned against the Old One — the creator — and his son Maledil long ago, with the result that Earth has been put into quarantine. It is therefore known as Thulcandra or The Silent Planet, although it is still revered, for it was to Thulcandra that Maledil — whom we know as Jesus — went to live as a mortal in order to save humankind.

Ransom becomes an agent of Maledil, and in *Perelandra*, the second volume of the series, he travels to Venus to foil a plot of the Bent One.

In *That Hideous Strength*, which is set mainly on Earth, Ransom becomes a supporting character to sociologist Mark Studdock, as a sinister institute

ironically named NICE (National Institute of Co-ordinated Experiments) consorts with demonic entities and attempts to resurrect Merlin, the magician at the Court of King Arthur.

Ransom's character is thought to have been loosely modeled on Lewis himself and his friends J.R.R. Tolkien and Charles Williams. All three were members of the Inklings, an influential group of writers based in Oxford, England. Through this connection, the Space Trilogy's cosmology has much in common with that of Tolkien's Middle-earth: Lewis' powerful Eldila bear more than a passing resemblance to the Valar and Maiar in *The Lord of the Rings*. A further fascinating link between these works is the allusion in *That Hideous Strength* to "Numinor," Tolkien's take (as "Númenor") on the Atlantean myth.

In 1946, Lewis published an abridged version of *That Hideous Strength* entitled *The Tortured Planet*.

After Lewis' death in 1963, *The Dark Tower*, an unfinished work featuring Ransom, was published in 1977. Its authenticity was initially questioned, but it was later established to have been the work of Lewis.

The Space Trilogy has influenced the band Blaster the Rocket Man. Stephen Lawhead's Song of Albion fantasy trilogy (*The Paradise War*, *The Silver Hand* and *The Endless Knot*) exhibits parallels with the Space Trilogy, including a protagonist named Lewis. John C. Wright's War of the Dreaming duology (*Last Guardian of Everness*, *Mists of Everness*) references the work, and Lewis' Malacandran aliens the Sorns appear in volume two of *The League of Extraordinary Gentlemen* comic book. **GH**

year-by-year ■ Book

Out of the
Silent Planet
❨ C.S. Lewis

The Tortured Planet
❨ C.S. Lewis

The Dark Tower
❨ C.S. Lewis

Perelandra
❨ C.S. Lewis

That Hideous Strength
❨ C.S. Lewis

1935 1940 1945 1950 1955 1960 1965 1970 1975 1980 1985

robert a. heinlein 1939

SFWA
GRANDMASTER

| Life-Line | Red Planet | Destination Moon | Starship Troopers | Stranger in a Strange Land | Glory Road | The Moon is a Harsh Mistress | Time Enough for Love |

In the 1940s, Robert Anson Heinlein, "the Dean of Science Fiction Writers," became one of the first American authors to break out of the pulp ghetto, initially with four influential short stories, the first of which, "Life-Line," was published in *Astounding Science-Fiction*, and later through two different genres of full-length science fiction.

Heinlein's early novels were linked in theme — but not in character or setting — and aimed at teenage boys. Starting with *Rocket Ship Galileo* in 1947 (filmed as *Destination Moon* in 1950), he generally wrote one novel a year through the 1950s, each published in the run-up to Christmas. Later, he wrote a set of more challenging adult novels, starting with *Stranger in a Strange Land* in 1961. He continued to work into the 1980s, although by then his health was failing.

One of the "Big Three" science fiction writers of the 20th century, along with Isaac Asimov and Arthur C. Clarke, Heinlein greatly influenced the development of the genre: he consistently showed future worlds that shared similarities with our own, and demonstrated that novels aimed at teenage boys could also attract adult audiences. He earned particular praise for his independent heroines, at a time when such characters were far from common.

But Heinlein was a contentious figure, with strong and complex political and social views that mutated constantly throughout his life, and which were often prominent in his novels. Themes of self-reliance and individual liberty, the need for privacy and the individual's obligation to society turned up regularly, as did the ways in which society can repress unconventional thought. Heinlein was both a product of his upbringing — solid Bible Belt, wartime naval service — and someone who reacted against it. He was a naturist, and an advocate of "free love" who wrote about incest and other taboo sexualities. Meanwhile he moved steadily to the right politically, particularly, in the view of Asimov, after his third marriage, to Ginny Gerstenfeld in 1947.

Although Heinlein's juvenile novels, such as *Have Spacesuit — Will Travel* and *Farmer in the Sky*, often buried sophisticated themes beneath teen issues and straight adventure storytelling, his work in the 1960s was far more controversial: *Starship Troopers* has been accused of being pro-fascist; *Stranger in a Strange Land* inspired a real-life pagan religion and *The Moon is a Harsh Mistress* has become a text for libertarians.

Heinlein's work tends to fall into four broad groups or series: juvenile novels such as *Red Planet*; future histories; the Lazarus Long series, which features a rugged individualist who lives for 2,000 years; and the World as Myth series, which is full of parallel universes. Many of his books remain highly entertaining and some, the great 1960s novels in particular, are among the most potent SF works of all time. **MB**

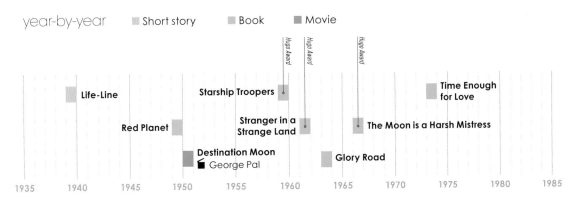

year-by-year — Short story ■ Book ■ Movie

Life-Line

Red Planet

Destination Moon
George Pal

Starship Troopers

Stranger in a Strange Land

Glory Road

Time Enough for Love

The Moon is a Harsh Mistress

Hugo Award | Hugo Award | Hugo Award

1935 | 1940 | 1945 | 1950 | 1955 | 1960 | 1965 | 1970 | 1975 | 1980 | 1985

batman 1939

Batman:
Detective
Comics

Batman

Batman

The Dark
Knight
Returns

Year One

Batman: The
Killing Joke

Batman

Batman
Returns

One of the most consistently popular and high-profile superheroes, Batman debuted in Issue 27 of crime-themed anthology *Detective Comics* in May 1939. He was the creation of two men, Bob Kane and Bill Finger, although the former took most of the official credit.

Inspired by the success of Superman in the previous year, Batman was a darker character than the Man of Steel. He was Bruce Wayne, who had been driven by his parents' murder to fight crime as a masked vigilante. He had no superpowers, but relied on his intellect, fighting skills and a host of exotic gadgets. His literary antecedents were Zorro, Sherlock Holmes and the Shadow.

The gothic, pulp-influenced style established at the start was unfailingly maintained throughout the series. The villains became increasingly grotesque, but one of Batman's biggest strengths was always his adaptability. Starting off as a remorseless gun-wielding killer of criminals, the character was altered in 1940 shortly after the introduction of youthful sidekick Robin, and afterward kept a vow never to kill or use a gun.

After the Second World War, *Batman*, like most comics, shifted away from social commentary toward lighter, more juvenile adventures. The character was still immensely popular, aided by two film serials — *Batman* (1943) and *Batman & Robin* (1949) — and *Batman* was one of the few titles to survive the superhero comic-book slump of the 1950s.

In 1954, *Batman* was criticized by psychologist Frederick Wertham, whose book *Seduction of the Innocent* contended that the comic was a homosexual fantasy. Alarmed, the publishers made subsequent Batman stories even lighter, embracing science fiction with strange tales of surreal transformations and journeys to other planets.

In the mid-1960s, just as *Batman* comics finally reined in the strangeness and returned to more traditional detective tales, a new TV series pushed the Caped Crusader into the world of pop-art camp. Starring Adam West, the live-action *Batman* was launched in 1966 and ran for three seasons of colorful action-packed parody. There was also a full-length movie version.

year-by-year ■ Comic ■ TV series ■ Movie

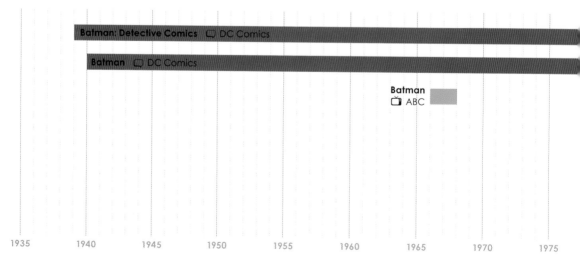

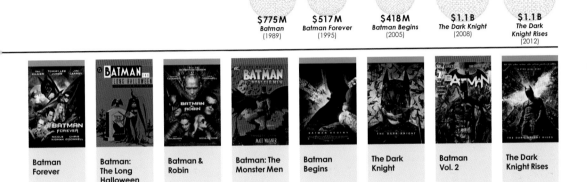

$775M
Batman
(1989)

$517M
Batman Forever
(1995)

$418M
Batman Begins
(2005)

$1.1B
The Dark Knight
(2008)

$1.1B
The Dark
Knight Rises
(2012)

Batman Forever

Batman: The Long Halloween

Batman & Robin

Batman: The Monster Men

Batman Begins

The Dark Knight

Batman Vol. 2

The Dark Knight Rises

In the 1970s, *Batman* comics headed in a different direction, as writer Denny O'Neill and artist Neal Adams produced tales that re-established the character's edge and psychological complexity.

Yet the perception of *Batman* as a camp spoof remained so strong that the bleakness and violence of *The Dark Knight Returns* — a 1986 four-part comic series by writer/artist Frank Miller — came as a shock.

Both this and Miller's *Year One*, a four-issue reboot of Batman's origin, had a massive influence on the subsequent direction of *Batman* comics, which became progressively darker in tone.

The 1989 *Batman* movie, directed by Tim Burton, caused controversy because of its gothic weirdness and violence, but its success inspired three sequels. *Batman Returns* (1991) and *Batman Forever* (1995) were hits, but the overblown *Batman & Robin* (1997) flopped and stalled further film developments for more than a decade.

Elsewhere, *Batman: The Animated Series* broke new ground in TV animation. Its stylized take on the character informed many sequel series and spin-offs.

The comics surfed the success of the movies and embraced the "event comic" phenomenon of multi-title crossovers that became predominant during the 1990s, most notably in the epic *Knightfall* saga.

In the early 2000s, Hollywood was emboldened to return to revive the Batman franchise. Director Christopher Nolan used the 1970s' stories of O'Neill and Adams as inspiration for a trilogy — *Batman Begins* (2005), *The Dark Knight* (2008) and *The Dark Knight Rises* (2012) — that was hugely successful and showed how flexible the Batman mythos could be, shifting the character into a gritty, post-9/11 action thriller that asked serious questions about society and its attitude to those who protect it.

Batman's popularity had never been higher, and 2013 saw the announcement of *Batman vs. Superman*, which is scheduled for release in 2015. Meanwhile, in 2011, the "New 52" relaunch of the *DC Comics'* superhero line saw the lead *Batman* title again become one of the top-selling superhero comic books, with the saga continuing under the stewardship of writer Scott Snyder. **SB**

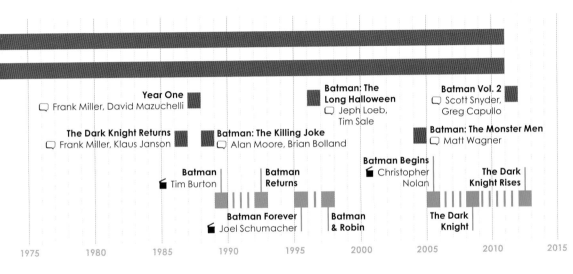

Year One
◻ Frank Miller, David Mazuchelli

Batman: The Long Halloween
◻ Jeph Loeb, Tim Sale

Batman Vol. 2
◻ Scott Snyder, Greg Capullo

The Dark Knight Returns
◻ Frank Miller, Klaus Janson

Batman: The Killing Joke
◻ Alan Moore, Brian Bolland

Batman: The Monster Men
◻ Matt Wagner

Batman
🎬 Tim Burton

Batman Returns

Batman Begins
🎬 Christopher Nolan

The Dark Knight Rises

Batman Forever
🎬 Joel Schumacher

Batman & Robin

The Dark Knight

1975 1980 1985 1990 1995 2000 2005 2010 2015

batman universe

Bruce Wayne (Batman) — **Dick Grayson (Robin)** — **Jason Todd (Robin)** — **Tim Drake (Robin)** — **Stephanie Brown (Robin/Batgirl)** — **Selina Kyle (Catwoman)** — **Barbara Gordon (Batgirl)** — **Cassandra Cain (Batgirl)**

Having witnessed as a child the murder of his parents, billionaire Bruce Wayne grows up determined to drive crime from the streets of Gotham. He dons a costume and becomes the night-time vigilante known as Batman, aided by his butler Alfred Pennyworth.

At first Batman uses any weapon at his disposal, but later vows that he will never again use a gun, and thenceforth relies purely on his wits and fighting skills, along with gadgets and vehicles like the Batmobile.

When all but one member of The Flying Graysons, a family of acrobats, are murdered, Wayne takes in the sole survivor, Dick, as his ward. The boy soon discovers Wayne's secret and becomes his crime-fighting partner, the daredevil sidekick Robin.

Batman and Robin smash the gangs, but attract a new breed of attention-seeking wrong-doers, including the Joker, the Penguin and Catwoman.

The Dynamic Duo fight these adversaries with help from Ace the Bat-hound, Batwoman and Batgirl. Dick leaves for university, and Batman embarks on solo adventures across the world, including an encounter with crime lord Ra's al Ghul and his daughter Talia.

When Dick returns, he splits his time between patrolling as Robin and working with the Teen Titans. Tensions develop between him and his partner.

Batman and Robin go separate ways. Wayne recruits Jason Todd as his new assistant. But Jason proves unreliable.

characters

- Bruce Wayne
- Dick Grayson
- Jason Todd
- Tim Drake
- Stephanie Brown
- Selina Kyle
- Barbara Gordon
- Cassandra Cain
- The Joker
- Damian Wayne

Ra's al Ghul revealed

Batman goes solo

Batgirl active

The Joker active

Catwoman meets Batman

Robin becomes Batman's sidekick

Catwoman returns to crime

Teen Titans formed

Batman begins fighting crime

Catwoman goes straight

Penguin active

Two-Face active

Riddler active

Dawn of the Bat

Rise of the Villains

The Years of Pop-Crime

Global Travels

Note: comic characters do not age like mere mortals and their adventures cover an unfeasibly long period of time. Therefore dates have not been included on this timeline.

The Joker

Damian
Wayne
(Robin)

The Joker attacks Police Commissioner James Gordon, crippling his daughter Barbara (and ending her secret career as Batgirl). He later slays Jason.

Wayne fights on alone until Tim Drake becomes the new Robin. Tim is good, but he cannot save Bruce from having his back broken by a criminal named Bane.

Bruce is replaced by Jean-Paul Valley, aka Azrael, but he turns out to be unstable. Bruce is eventually cured. He ousts Azrael and resumes his role as Batman.

Gotham is devastated by an earthquake and taken over by criminals. Batman fights to win the city back with the aid of Cassandra Cain, the new Batgirl.

Talia al Ghul returns and reveals to Bruce that he has a son, 10-year-old Damian Wayne.

Following an encounter with the alien Darkseid, Bruce is lost in time. In his absence, Dick Grayson takes over as Batman, with Damian acting as Robin. Together they face the villains Professor Pyg and the Red Hood before Bruce Wayne returns to the present day, where he defeats the Black Glove.

Taking back the role of Batman, with Damian continuing as Robin, Bruce forms Batman Incorporated and embarks on a worldwide fight against Leviathan, a criminal conspiracy controlled by Talia. Damian is killed in the ensuing conflict.

After facing threats from the mysterious Court of Owls and an even more deranged Joker, Bruce defeats Leviathan but is once more left alone. **SB**

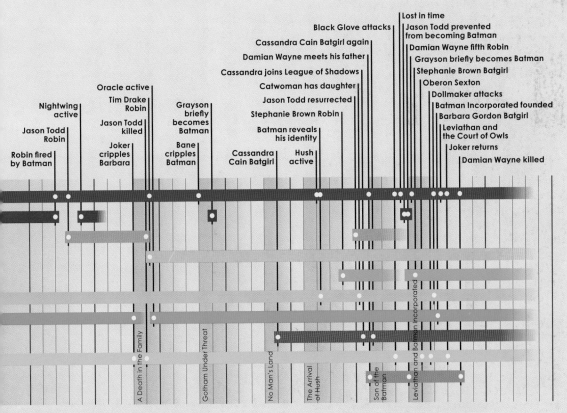

Detective Comics
(1939–2011)

Batman
(1966–69)

**Batman:
The Killing Joke**
(1988)

Batman Returns
(1992)

**Batman: The
Animated Series**
(1992–95)

Batman & Robin
(1997)

Batman Begins
(2005)

**The Dark Knight
Rises**
(2012)

Batman made his debut in issue 27 of *Detective Comics*, published in May 1939.
In 2010 a copy sold for $1,075,500.

Batman: The Killing Joke, written by Alan Moore and drawn by Brian Bolland, is
considered by many critics to be the definitive Joker story.

Burt Ward (Robin) and Adam West (Batman) starred in the 1960s'
TV show, which ran for three seasons between 1966 and 1968.

Batman (Michael Keaton) is signalled by his allies in the police
in the 1992 Tim Burton movie.

Michael Keaton as Batman in *Batman Returns*. He described
the character as "kind of psychotic."

Tim Burton directs Michelle Pfeiffer as Catwoman in *Batman Returns*.

Batman & Robin starred (L–R) Alicia Silverstone as Barbara Wilson/Batgirl, Chris O'Donnell as Dick Grayson/Robin and George Clooney as Bruce Wayne/Batman.

A frame from *Batman: The Animated Series*, which was produced by Warner Brothers between 1992 and 1995.

In *Batman Begins*, the Caped Crusader decides he needs better protection on the highway than the Batmobile can provide, so develops the Tumbler.

Director Christopher Nolan said he chose Christian Bale for the title role in *Batman Begins* because he had "exactly the balance of darkness and light."

In *The Dark Knight Rises*, Bruce Wayne (Christian Bale) dances with Selina Kyle (Anne Hathaway), a cat burglar who is trying to mend her feline ways.

batman villains

Batman: The Movie (1966) featured (L–R) the Penguin (Burgess Meredith), the Riddler (Frank Gorshin), Catwoman (Lee Meriwether) and the Joker (Cesar Romero).

Two-Face (Tommy Lee Jones), Gotham's crazed former district attorney with a split personality, in *Batman Forever*.

The "Strange Apparitions" storyline in *Detective Comics* saw Batman do battle with Dr. Phosphorus, a villain who terrorized Gotham by contaminating the water supply.

Jack Nicholson as the Joker in *Batman* (2003). He calls himself "the world's first fully functioning homicidal artist."

Poison Ivy (Uma Thurman) and Mr. Freeze (Arnold Schwarzenegger) in *Batman & Robin*.

Catwoman (Michelle Pfeiffer) and the Penguin (Danny De Vito) are up to no good in *Batman Returns*.

Ra's al Ghul (Liam Neeson) is a master of martial arts who starts *Batman Begins* as Bruce Waynes' mentor, but ends the movie as his enemy.

The Riddler (Jim Carrey) in Joel Schumacher's high-camp, *Batman Forever*.

Heath Ledger as the Joker in *The Dark Knight*. Jack Nicholson says he warned him not to take the part.

Cilian Murphy as Dr. Jonathan Crane, aka the Scarecrow, a corrupt pharmacologist in *Batman Begins*.

Tom Hardy as Bane during a raid on the Gotham Stock Exchange in *The Dark Knight Rises*. His mask keeps him supplied with pain-relieving gas.

isaac asimov 1939

SFWA
GRANDMASTER

| Marooned Off Vesta | Nightfall | I, Robot | Foundation | Fantastic Voyage | The Gods Themselves | Star Trek: The Motion Picture | Foundation's Edge |

Isaac Asimov was one of the most prolific authors of all time. He wrote, contributed to or edited more than 500 books on a vast range of subjects, and produced an estimated 90,000 letters and postcards before his death in 1992.

He was born Isaak Yudovich Ozimov in 1920 in the Russian village of Petrovichi, where there is now a monument to its most famous son. Three years later, he and his family emigrated to the United States; as a consequence, he grew up speaking English, not Russian. He began writing stories at an early age and became a huge fan of pulp science fiction magazines. He sold his first story, "Marooned Off Vesta," to *Amazing Stories* in 1939, and followed that with the critically acclaimed "Nightfall," which appeared in *Astounding Science-Fiction* in 1941. "The writing of 'Nightfall' was a watershed in my professional career," Asimov later recalled. "I was suddenly taken seriously and the world of science fiction became aware that I existed. As the years passed, in fact, it became evident that I had written a 'classic.'"

In 1942 Asimov began publishing his *Foundation* stories, which told of the collapse of a vast galactic empire. Their commercial success spawned many sequels, such as the *Galactic Empire* series, which were all set in the same universe.

Asimov's early works were written while he was working in his family's candy stores. He later studied zoology and then chemistry at Columbia University, New York. His studies were interrupted by the Second

World War, during which he worked as a junior chemist at the Philadelphia Navy Yard alongside Robert A. Heinlein and L. Sprague de Camp. After the conflict, he completed an MA and a PhD, and then joined the faculty of Boston University's School of Medicine, where he remained until his income from writing exceeded his academic salary. He was henceforth a full-time professional author, although he remained attached to the university, which made him a professor of biochemistry in 1979.

Although Asimov is widely acknowledged as one of the "Big Three" authors of hard science fiction, alongside Heinlein and Arthur C. Clarke, he was a highly versatile writer whose output also included mysteries, fantasies and factual scientific works of futurism. (He was the science advisor on 1979's *Star Trek: The Motion Picture*.) Popularly, though, he is perhaps most celebrated for his formulation in the 1950 short story collection *I, Robot*, of the Three Laws of Robotics: "1: A robot may not injure a human being or, through inaction, allow a human being to come to harm; 2: A robot must obey the orders given to it by human beings, except where such orders would conflict with the First Law; 3: A robot must protect its own existence as long as such protection does not conflict with the First or Second Law."

Asimov's collaborator, Martin H. Greenberg, spoke for many when he expressed the view that "Isaac's speculations about robotics and artificial intelligence will survive long into the future." **JN**

year-by-year ■ Short story ■ Book ■ Movie

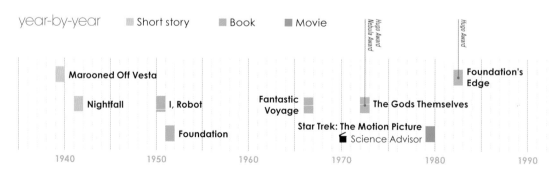

Hugo Award / Nebula Award

Hugo Award

Marooned Off Vesta

Foundation's Edge

Nightfall I, Robot Fantastic Voyage The Gods Themselves

Foundation

Star Trek: The Motion Picture
Science Advisor

1940 1950 1960 1970 1980 1990

i, robot 1940

Robbie Runaround I, Robot The Caves of Steel The Naked Sun The Robots of Dawn Robots and Empire I, Robot

When Isaac Asimov began his Robot series of short stories, he was determined that his automata should not be sinister, as they were conventionally depicted in most fiction of the time. "Never," he declared in the introduction to *The Rest of The Robots* (1964), "never was one of my robots to turn stupidly on his creator for no purpose but to demonstrate, for one more weary time, the crime and punishment of Faust. Nonsense! My robots were machines designed by engineers, not pseudo-men created by blasphemers. My robots reacted along the rational lines that existed in their 'brains' from the moment of construction."

These "rational lines" were Asimov's famous Three Laws of Robotics: 1. A robot may not injure a human being or, through inaction, allow a human being to come to harm; 2. A robot must obey the orders given to it by human beings, except where such orders would conflict with the First Law; 3. A robot must protect its own existence as long as such protection does not conflict with the First or Second Laws. (He later added a "zeroth" law – "A robot may not harm humanity, or, by inaction, allow humanity to come to harm." This rule underpins his later joining of the Robot and Foundation series).

The laws do not actually appear in his first Robot story, "Robbie." Published in *Super Science Stories* in 1940, it told of a robot tasked with looking after a little girl. It wasn't until Asimov sat down with his friend, famed science fiction editor John W. Campbell, that the Three Laws were formed, and he subsequently applied them to the robots in all his stories.

"Runaround," published in 1942, was the first of Asimov's robot tales to state the laws explicitly. After this, Asimov enjoyed trying to unravel his clever commandments, inventing gloriously complicated loopholes by which to test his robots' behavior. The stories that resulted were first published in *Astounding Science Fiction*, and then collected in book form as *I, Robot*. There, the stories were linked together by the device of robopsychologist Susan Calvin's reports. More robot short stories and novels followed.

Although the Three Laws have been referenced in everything from *Futurama* to *Aliens*, there have been few adaptations of Asimov's stories other than an undeveloped feature film script by Harlan Ellison, since published in book form. Despite Ellison and Asimov's intention to make "the first really adult, complex, worthwhile science fiction movie ever," the project was deemed too difficult given the technology of the day, and Ellison's explosive nature didn't help when it came to dealing with film studios. In 2004, a Will Smith action adventure was entitled *I, Robot* but apart from the title the only reference to Asimov's work were the Three Laws and some themes from "Little Lost Robot."

I, Robot helped to introduce the idea of friendly robots to fiction, something Asimov delighted in. But the series also laid down a logical, intelligent groundwork for scientists to think about when developing real-life robots. In that, the Robot Series is one of the foremost examples of science fiction influencing science. **JN**

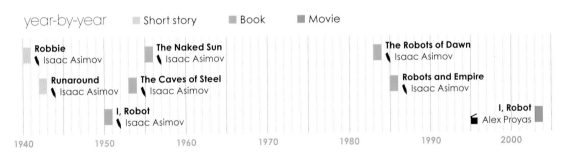

year-by-year ■ Short story ■ Book ■ Movie

Robbie
\ Isaac Asimov

Runaround
\ Isaac Asimov

I, Robot
\ Isaac Asimov

The Naked Sun
\ Isaac Asimov

The Caves of Steel
\ Isaac Asimov

The Robots of Dawn
\ Isaac Asimov

Robots and Empire
\ Isaac Asimov

I, Robot
🎬 Alex Proyas

1940 1950 1960 1970 1980 1990 2000

the day the earth stood still 1940

Farewell to the Master

The Day the Earth Stood Still

The Day the Earth Stood Still

The Day the Earth Stood Still

The two movies and the NBC radio serial entitled *The Day the Earth Stood Still* are based on a short story published in *Astounding Science-Fiction* in 1940.

"Farewell to the Master," by Harry Bates, who had helped to launch the magazine 10 years previously, relates the experiences of Cliff Sutherland, a curious photographer, who witnesses the arrival on Earth of an alien spaceship and the shooting dead of its clearly friendly occupant by a religious fanatic. Months later, Sutherland gets to know the craft's giant robot, Gnut, and discovers that it is the real master, not the assassinated Klaatu.

The original film version of the story was adapted for the screen by Edmund H. North and retitled *The Day the Earth Stood Still*. The director was Robert Wise, who was fascinated by Bates' alien subject matter and the story's peaceful message.

Naturally, the screenplay is significantly different from the published text. Gnut is renamed Gort and Klaatu (played by Michael Rennie) — now the master rather than a servant — survives being shot by a twitchy U.S. soldier and goes undercover to observe the planet Earth. After seeing the sights, befriending Earthlings and behaving in a manner widely reminiscent of Jesus (the name he chooses for himself is Carpenter, a reference to the trade that Christ learned from his father Joseph), Klaatu returns to his craft and delivers a stern monologue: "If you threaten to extend your violence, this Earth of yours will be reduced to a burned-out cinder," he warns. "Your choice is simple: join us and live in peace, or pursue your present course and face obliteration."

This thoughtful film, in which an alien preached peace, love and caution, bucked the prevailing trend of a period in which the only good alien was a dead alien. In the year of its release, 1951, *The Day the Earth Stood Still* vied with B-movie shockers such as Howard Hawks' *The Thing From Another World* and Edgar G. Ulmer's *The Man From Planet X*. Meanwhile, pulp magazines and comics were dominated by alien scare stories with anti-communist, Cold War subtexts.

Although some people were surprised that *The Day the Earth Stood Still* should have been made in such a political climate, its success came as a shock to almost everyone. One line from the movie has since become deeply embedded in popular culture. No one understands the phrase "Klaatu barada nikto," but the alien's words have since been widely quoted and alluded to, and their meaning discussed. When the 2008 remake was being cast, Keanu Reeves insisted on playing the part of the alien because he particularly wanted to say this famous line.

The later version was a blockbuster overfilled with special effects and it flopped. The original, however, retained its hold on the imagination. According to Ronald Reagan's biographer Lou Cannon, the U.S. President had the old classic at the forefront of his mind as he went into his first meeting with Mikhail Gorbachev soon after the latter became leader of the Soviet Union in 1985. Reagan referenced the film again two years later in a speech to the United Nations in which he stated: "I occasionally think how quickly our differences worldwide would vanish if we were facing an alien threat from outside this world." **JN**

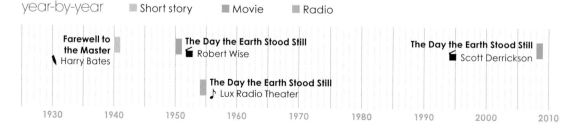

year-by-year ■ Short story ■ Movie ■ Radio

Farewell to the Master
Harry Bates

The Day the Earth Stood Still
Robert Wise

The Day the Earth Stood Still
♪ Lux Radio Theater

The Day the Earth Stood Still
Scott Derrickson

1930　1940　1950　1960　1970　1980　1990　2000　2010

jack kirby 1941

Captain America Fantastic Four The X-Men Superman's Pal, Jimmy Olsen New Gods Mister Miracle Kamandi The Hunger Dogs

Known throughout the comic industry as "The King," Jack Kirby created or co-created a legion of iconic characters, helped to build the Marvel Universe and injected a fresh surge of energy into DC Comics in the 1970s. Born Jacob Kurtzberg in New York in 1917, Kirby was the son of Jewish immigrants from Austria. Completely self-taught, he had two great creative partnerships in his career, with Joe Simon and Stan Lee. Simon he met at Fox Comics before the Second World War. Although the duo worked across a range of genres from Westerns and war comics to romance, their first collaboration was on Blue Bolt, a science fiction hero indebted to Flash Gordon, and in 1941 they created Captain America, the star-spangled product of the Super Soldier Serum.

Kirby's career was interrupted when he was drafted in 1943. Although many comic creators worked on instruction manuals for the military, Kirby was given a rifle and sent to Europe. When his commanding officer recognized his name, Kirby was made an Advance Scout in the 5th Armored Division, and sent out to draw sketches of enemy troop positions.

Demobbed in 1945, Kirby worked for a variety of publishers before the Soviet Union's launch of the first satellite, Sputnik 1, in 1957 helped kick-start a science fiction boom. At DC, the Challengers of the Unknown faced menaces both extraterrestrial and supernatural, while monsters and aliens were all the rage in Tales To Astonish, World Of Fantasy and Atlas/Marvel's Journey Into Mystery.

With Lee in the 1960s, Kirby created The Fantastic Four, whose stories blended science fiction, family melodrama and superheroes to break DC's monopoly on the costumed crusader market. In short order Kirby and Lee gave life to The Hulk, The Mighty Thor, The X-men and The Avengers, and Kirby designed the original armor for Iron Man.

Kirby's dynamic artwork became synonymous with the Marvel brand but he left the company in 1970 for DC Comics. There his science fiction influences came to the fore in his multi-title epic The Fourth World about the interplanetary conflict between the gods of New Genesis and the malignant Darkseid, ruler of the planet Apokolips. The concept debuted in Superman's Pal, Jimmy Olsen, before expanding across New Gods, Mister Miracle and The Forever People. Later, Kirby created the dystopian futures of Kamandi and OMAC before returning to Marvel at the end of 1975. Ten years later he had the long-awaited chance to conclude his Fourth World saga with The Hunger Dogs graphic novel but editorial interference — DC refused to let Kirby kill off characters they wanted to merchandise — meant that he was forced to change his planned conclusion to the tale.

Although some of Kirby's later work was criticized for clumsy dialogue, his output over six decades, until his death in 1994, remains unparalleled in comics. Without him the Marvel Universe would be virtually empty and DC would never have enjoyed the glorious vistas of Fourth World. Hail to the King. **DWe**

year-by-year ▉ Comic

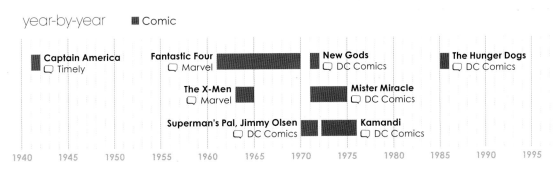

▉ **Captain America** ▢ Timely

Fantastic Four ▢ Marvel

The X-Men ▢ Marvel

Superman's Pal, Jimmy Olsen ▢ DC Comics

▉ **New Gods** ▢ DC Comics

Mister Miracle ▢ DC Comics

Kamandi ▢ DC Comics

▉ **The Hunger Dogs** ▢ DC Comics

1940 1945 1950 1955 1960 1965 1970 1975 1980 1985 1990 1995

stan lee 1941

Captain
America

Tales to
Astonish

Fantastic Four

Amazing
Fantasy

The Amazing
Spider-Man

Daredevil

The Mighty
Thor

Stan Lee's
Lightspeed

Stan Lee's name is synonymous with Marvel Comics. He created or co-created all of the publication's flagship characters and his inimitable writing style — a verbose blend of hyperbole, slang and melodrama — defined the Marvel Age as much as the artwork of his frequent collaborator Jack Kirby.

Lee, the son of Romanian immigrants, landed a job at Timely Comics fresh from high school — his cousin was the wife of owner Martin Goodman. Within two years, he snagged his first writing assignment, a text story in *Captain America Comics #3*, and began writing comic scripts. When Kirby and Joe Simon quit Timely in 1941, Goodman promoted Lee to editor.

After a stint in the army during the Second World War, writing instruction manuals and scripts for training films, Lee returned to Timely. His first attempt to launch a superhero team, the All-Winners Squad, failed to sell, but he found success with romance comics like *Millie The Model*. In the 1950s, Lee tried crime comics, Westerns and war stories as Timely chased whatever fad was hot at the time. As Timely was rebranded, first as Atlas Comics and then as Marvel, Lee teamed up with Kirby and another artist, Steve Ditko, in science fiction and fantasy titles including *Journey Into Mystery*, *Tales To Astonish* and *Amazing Fantasy*. Every story had a twist ending and often monsters with outrageous names such as The Terror of Tim Boo Ba.

In 1961 Goodman asked Lee to create a superteam like National/DC's Justice League of America. Lee came up with something radically different from DC's clean-cut heroes. The Fantastic Four had codenames and costumes but no secret identities and they weren't perfect like the Justice League. In fact, they didn't really get along. The Thing was jealous of Mr. Fantastic for his girlfriend Sue Storm, and her younger brother Johnny, The Human Torch, was brash and obnoxious. When they weren't saving the world from aliens and supervillains, they squabbled among themselves.

The series gave Marvel a new lease on life, and further creations followed. Lee's heroes had flaws — Daredevil was blind, Hulk was hounded as a monster, Iron Man had a heart condition, The Mighty Thor was caught between Asgard and Earth. The most troubled of all was The Amazing Spider-Man, a teenager with money worries, difficulties with girls and a victim of the high school bully. He was also the most popular. Lee wrote the first 100 issues of the comic and, from 1977, a syndicated newspaper strip.

By 1980 Lee had largely stopped writing comics and turned his attention to the development of films and TV shows based on Marvel properties. In 2001, he founded POW! Entertainment, which produces TV shows, films and cartoons. **DWe**

year-by-year ■ Comic ■ Movie

samuel youd 1941

Dreamer

Christmas Roses

The Death of Grass

The Year of the Comet

The World in Winter

A Wrinkle in the Skin

The White Mountains

Empty World

The name Samuel Youd may not be well known, but one of his many pseudonyms, John Christopher, certainly is. In a 64-year career, Youd/Christopher carved out several niches for himself, including one as a writer of (often apocalyptic) SF novels, and another as a creator of young adult fiction.

Youd was born in 1922 in Knowsley, Lancashire, England. At the age of 10 he developed an interest in science fiction. At 17 he started his own SF fanzine, *The Fantast*, and began writing fiction in a variety of genres. In 1939, his war story entitled "For Love of Country" was the first work for which he received a fee. Two years later, his poem "Dreamer" was published in *Weird Tales*.

Youd's writing career was halted temporarily by the outbreak of the Second World War, during which he served in the Royal Corps of Signals. After the conflict, he returned to his typewriter. His first SF story, "Christmas Roses," was published in 1949, as was his debut novel, *The Winter Swan*. Among the names that Youd used were Peter Graaf, William Godfrey, Hilary Ford and Anthony Rye.

The best known of John Christopher's adult novels is *The Death Of Grass*, which was published in 1956 and later adapted for film as *No Blade of Grass* (1970). This harrowing eco-thriller tells of a virus that destroys the world's crops, leading to the collapse of civilization. It demonstrates one of the author's favorite literary themes: that society is only a hair's breadth from dissolution.

Christopher subsequently returned to the subject of global destruction several times, notably in *The Year of The Comet* (1957), *The World In Winter* (1962) and *A Wrinkle In The Skin* (1965).

Christopher established himself in the young adult (YA) market in 1967 with the publication of *The White Mountains*, the first volume in his Tripods trilogy. The frequently bleak style of the work anticipated the subsequent popularity of dystopic YA fiction.

The White Mountains is a classic quest narrative, with three teenage boys setting out to find a rebel base in a world that has been conquered by aliens. But what set this book — and its two sequels, *The City of Gold and Lead* and *The Pool of Fire* (both 1968) — apart were the economy of the writing (they each clock in around 150 pages, but somehow do not feel rushed) and the original setting. Humankind has reverted to a pre-industrial way of life thanks to the intervention of the alien Tripods. There is also a pleasing ambiguity here. Although these extraterrestrial overlords have sinister long-term plans to terraform the Earth, it is clear that, for most of humanity, they are a benevolent force in the short term.

Youd went on to write several more stand-alone books (including *The Lotus Caves* and *Empty World*), a fantasy trilogy (*The Sword of the Spirits* series) and a weak but well-intentioned prequel to the Tripods trilogy (*When the Tripods Came*). His bibliography runs to nearly 60 novels. Samuel Youd died in 2012 at the age of 89. **WS**

year-by-year

■ Poem ▓ Short story ▓ Book

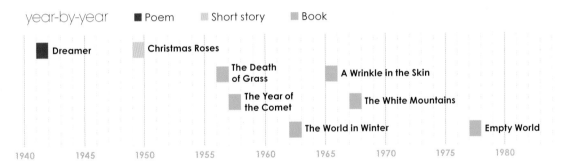

■ Dreamer

▓ Christmas Roses

▓ The Death of Grass

▓ A Wrinkle in the Skin

▓ The Year of the Comet

▓ The White Mountains

▓ The World in Winter

▓ Empty World

1940 1945 1950 1955 1960 1965 1970 1975 1980

foundation 1942

Foundation

Bridle and Saddle

Foundation

Foundation and Empire

Second Foundation

Foundation's Edge

Foundation and Earth

Prelude to Foundation

The Foundation series comprises more than 20 novels and assorted short stories by Isaac Asimov and others comprising a future history of the galaxy over 20,000 years. This is a universe with few true aliens (although there are nonhuman intelligences, they're all related to us in some way) and a vast, slowly declining human Galactic Empire, in which a new form of mathematics seems to offer a long path to a brighter future.

Mathematician Hari Seldon develops "psychohistory," which applies the laws of mass action to prediction of the future on a galactic scale. Foreseeing the collapse of the Empire and 30,000 years of dark ages, Seldon offers an alternative that limits the chaos to just 1,000 years. To this end, he sets up two organizations at opposite ends of the galaxy. One of them operates publicly on a remote planet called Terminus, but the location — and, indeed, existence of — the other remains secret. We follow the development of both Foundations as they strive to implement "the Seldon Plan."

Foundation began as a series of eight short stories published from 1942 in *Astounding Magazine*. The tales were inspired by Asimov's reading of the highly influential 1776 work *The History of the Decline and Fall*

of the Roman Empire by Edward Gibbon ("a little bit of cribbin' from the works of Edward Gibbon," Asimov wrote); in time, these eight stories were collected, along with a small amount of fresh material, to make the original Foundation Trilogy — *Foundation* (1951), *Foundation and Empire* (1952) and *Second Foundation* (1953).

And so it remained for many years until, late in his career, Asimov was tempted to return to his future history epic, writing a sequel, *Foundation's Edge*, in 1982, and then another, *Foundation and Earth* (1986). These were followed by two prequels: *Prelude to Foundation* (1988) and *Forward the Foundation* (1993). And it didn't end there.

Much of Asimov's later career was concerned with linking his three best-known clusters of stories — the Foundation series, the Robot stories (five novels and numerous short stories written between 1939 and 1985) and an earlier work, the Galactic Empire series of three novels and one short story — into a unified whole. In the end, Foundation effectively swallowed them all, with certain touchstones — notably the planet Trantor and the robot R. Daneel Olivaw – cropping up repeatedly.

year-by-year ▨ Short story ▪ Book

Foundation
❧ Isaac Asimov

Foundation
❧ Isaac Asimov

Bridle and Saddle
❧ Isaac Asimov

Foundation and Empire
❧ Isaac Asimov

Second Foundation
❧ Isaac Asimov

1940 1945 1950 1955 1960 1965 1970 1975

Foundation's Friends | **Forward the Foundation** | **Isaac Asimov's Caliban** | **Isaac Asimov's Inferno** | **Isaac Asimov's Utopia** | **Foundation's Fear** | **Foundation and Chaos** | **Foundation's Triumph**

Asimov died in 1992, but still the series continued, with further work by other authors filling in gaps and tying up loose ends in the original: *Foundation's Friends* (1989), a set of fresh short stories by writers including Harry Turtledove and Orson Scott Card; Roger MacBride Allen's *Caliban* trilogy, set a long time ago in the Foundation universe and bridging the gap between the last Robot story, *Robots and Empire* (1985), and the Galactic Empire series; and the Second Foundation Trilogy by the powerhouse hard SF trio of Gregory Benford, Greg Bear and David Brin.

Although the original stories are by no means long — at least not by modern science fiction epic standards — their scope is huge. There are numerous characters, but only two are truly memorable. One is Hari Seldon, who kicks the whole thing off and constantly reappears in a Time Vault where he has prerecorded his accurate forecasts of each new threat to the Foundation.

The other is the Mule, the unexpected variable who could prove the undoing of the entire Seldon Plan. This powerful telepathic mutant conquers planets at a whim using a nasty, totalitarian form of mind control. Yet, in spite of his despotism, the Mule is a strangely sympathetic figure. Certainly, his lively appearances become a vital part of the complicated moral web the books weave, one that eventually has readers questioning whether Asimov himself has much faith in the Plan — or, at least, in the mighty new Empire that the Plan is designed to enable.

The series is not without flaws. Although the books romp along, they are now dated — digital technology is little in evidence, and there are more chain-smokers than women. The vast timescales work artistically only if it is agreed that societies remain largely unaffected by technological progress, no matter how radical.

Foundation has remained obstinately resistant to cinematic adaptation, partly for the above reasons and partly because it covers a period so long that many of the most important characters never meet. The plot is thin, and few of the villains are different from any of the others. Conversely, there is always that cliffhanger ending ...

For all its faults, the Foundation series stands out from almost all other works in the SF adventure genre because it focuses, not on the exploits of a single hero, but on the development of humans' understanding of the mathematics of their own behavior. **PM**

Hugo Award

Foundation's Edge
❨ Isaac Asimov

Prelude to Foundation
❨ Isaac Asimov

Foundation's Friends
❨ ed. Martin H. Greenberg

Forward the Foundation
❨ Isaac Asimov

Isaac Asimov's Caliban
❨ Roger MacBride Allen

Foundation and Earth
❨ Isaac Asimov

Isaac Asimov's Inferno
❨ Roger MacBride Allen

Isaac Asimov's Utopia
❨ Roger MacBride Allen

Foundation's Fear
❨ Gregory Benford

Foundation and Chaos
❨ Greg Bear

Foundation's Triumph
❨ David Brin

1975 1980 1985 1990 1995 2000 2005 2010

ray bradbury 1946

SFWA GRANDMASTER

Homecoming | Dark Carnival | The Martian Chronicles | The Illustrated Man | Fahrenheit 451 | It Came From Outer Space | The October Country | Dandelion Wine

Of all the writers whose earliest works appeared in the pages of the pulps, Ray Bradbury did most to raise science fiction to the form of poetry. "First you jump off the cliff, then you build your wings," he said of the creative process that energized his writing, a process that prioritized imagination over intellect, dreams over reality and which gave the world some of the most memorable fantasies of the 20th century.

Raymond Douglas Bradbury (1920–2012) was born in Waukegan, Illinois, into a close-knit and loving family. He would re-imagine his childhood hometown many times as Green Town, the setting for some of his most famous stories. A series of family moves later brought him to Los Angeles, the city where his writing would flourish. A fascination with the science fiction and fantasy writings of Edgar Allan Poe, Jules Verne and Theodore Sturgeon led Bradbury to write prolifically in these genres throughout his life. His early career was bolstered by friendships with Robert A. Heinlein and Leigh Brackett, and the publication of his first short story, "Homecoming," in Mademoiselle, after it had been picked out of the magazine's slush pile by a young editorial assistant named Truman Capote.

Bradbury then wrote short stories for pulp magazines for the best part of a decade. But it was in 1950, with the publication of the short story collection The Martian Chronicles, that his work found a wider readership. A glowing review from British writer Christopher Isherwood helped to build Bradbury's unusual status as both a pulp writer and a literary novelist. The Martian Chronicles' allegorical recasting of scenes from suburban American life into the alien environment of Mars captured the zeitgeist of a world soon to be enraptured by the space race.

The 1951 story collection The Illustrated Man took the form of a "fix-up." Bradbury's stories ranged across space and time, but were linked by the tattoos that writhed across the body of the title character. The audacity of imagination on display here made Bradbury a favorite among SF fans of the day. One of the stories, "The Veldt," which recounts the baroque murder of two adults by their own children, remains one of Bradbury's best-known works. The Illustrated Man was produced in 1969 as a feature film starring Rod Steiger in the title role.

Bradbury continued to write science fiction short stories throughout his life, publishing more than two dozen collections, although many of these replicate the same material. The October Country (1955) and Dandelion Wine (1957) cemented his reputation in the form and remain widely read. Like other writers of his cohort such as Harlan Ellison, Bradbury seemed most comfortable and productive in the short story form; the greater breadth and depth required for

Something Wicked This Way Comes

The Twilight Zone

I Sing the Body Electric!

The Halloween Tree

Something Wicked This Way Comes

Death is a Lonely Business

The Ray Bradbury Theater

From the Dust Returned

novels appeared to make excessive demands of the imagistic and improvisational nature of his writing.

Fahrenheit 451 (1953) is sometimes categorized by genre purists as Bradbury's only true science fiction novel, although it may be fairer to say that his work frequently transcended genre boundaries. Set in a dystopian future where books have been eliminated from society and are burned when found, the narrative follows Guy Montag, a state enforcer or "Fireman," as he changes from oppressor to rebel against society. The 1966 film version directed by François Truffaut brought Bradbury to the attention of European art-house cinema audiences. *Fahrenheit 451* is regularly listed alongside George Orwell's *Nineteen Eighty-Four* and Aldous Huxley's *Brave New World* as one of the great dystopian visions that highlight the terrors of a totalitarian society.

Bradbury wrote many works of contemporary fantasy, and *Something Wicked This Way Comes* (1962) is his most complete and stylistically accomplished work. A carnival arrives in a small town in the U.S. Midwest and enters the lives of two teenage boys and their family, bringing with it the menacing Mr. Dark. Taking its title from a line in Shakespeare's *Macbeth*, the story reflects on the relationship between our fantasies and our potential for evil deeds. Like much of the most sophisticated fantasy writing, it

sits comfortably neither as a children's book nor as an adult novel, but is best understood as a book for adults who long for childhood and children who are apprehensive of fast-approaching adult life. In its depiction of small-town life in the United States, *Something Wicked This Way Comes* helped to define the "American Gothic," an aesthetic that was later taken up by Stephen King and numerous other writers.

Although Bradbury always wrote fiction, much of his later career was focused on screen writing and adaptations of his work for other media. His close friendships with special effects artist Ray Harryhausen and *Star Trek* creator Gene Roddenberry put Bradbury at the heart of Los Angeles' burgeoning love affair with SF through the 1970s and 1980s. From 1985 to 1992 he hosted his own syndicated television show, *The Ray Bradbury Theater*, which included adaptations of 65 of his own stories.

Ray Bradbury's death in 2012 marked the passing of one of the last great pulp SF writers. By the end of his life his stories had been widely acknowledged for their literary depth, with awards including a citation from the Pulitzer Board and a National Medal of Arts. With an incalculable influence over generations of writers who have followed in his footsteps, Ray Bradbury will long be remembered as one of the all-time great science fiction writers. **DW**

Something Wicked This Way Comes
Co-writer

Death is a Lonely Business

The Ray Bradbury Theater
Writer/Presenter

From the Dust Returned

1975 1980 1985 1990 1995 2000 2005 2010

It Came From Outer Space (1953)

Fahrenheit 451 (1966)

The Illustrated Man (1969)

The Martian Chronicles (1980)

Barbara Rush is terrified in *It Came From Outer Space*, Universal Studios' first 3D movie.

The aliens in *It Came From Outer Space* can assume human form, but they really look like one-eyed jellyfish.

The alien craft in *It Came From Outer Space* crashlands on Earth and is buried by a landslide ...

... and its contents later emerge to terrorize local townsfolk.

Guy Montag (Oskar Werner) and Clarisse McClellan (Julie Christie) in François Truffaut's *Fahrenheit 451*.

The Firemen in *Fahrenheit 451* are not an emergency service; they are government agents who destroy books.

Cyril Cusack (L) and Oskar Werner burn some books.

Rod Steiger and his then wife, Claire Bloom, in *The Illustrated Man*.

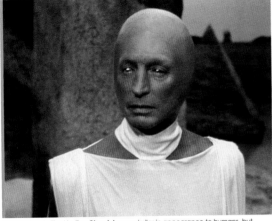
The Martians in *The Martian Chronicles* are similar in appearance to humans, but with golden skin and telepathic powers.

Ray Bradbury described *The Martian Chronicles* miniseries as "boring," but many view it as one of the most successful adaptations of his work.

arthur c. clarke 1946

SFWA
GRANDMASTER

| Rescue Party | Childhood's End | The Nine Billion Names of God | 2001: A Space Odyssey | Rendezvous with Rama | 2010: Odyssey Two | 2061: Odyssey Three | 3001: The Final Odyssey |

Arthur C. Clarke was more than an author of fiction. Throughout a 71-year writing career he worked with scientists and researchers to turn concepts and ideas that seemed fantastical on the pages of his books into solid reality.

Born in Minehead, England, in 1917, Clarke grew up fascinated by astronomy and read countless science fiction stories in magazines. Inspired by worlds both real and imaginary, he joined the British Interplanetary Society in 1936 and started writing science fiction, publishing his first short story in *Astounding Science* in 1946.

After a stint as a radar instructor and technician in the Royal Air Force during the Second World War, Clarke moved to Sri Lanka so that he could take advantage of the country's diverse diving sites (this paid off: in 1956 he found a long-lost sunken temple).

Clarke is regarded as one of the "Big Three" of science fiction, alongside Isaac Asimov and Robert A. Heinlein. Three of the cornerstones of his reputation are *Childhood's End*, which inspired the television series *V*; *Rendezvous With Rama* and a short story collection, *The Nine Billion Names of God*.

Better known than any of these works is his collaboration with Stanley Kubrick on the screenplay of *2001: A Space Odyssey*, which earned both men

an Oscar nomination. Clarke also novelized the film and then carried on the series with *2010: Odyssey Two* (1982), *2061: Odyssey Three* (1987) and *3001: The Final Odyssey* (1997). The movie was celebrated for its adherence to "proper" science; for example, scenes set in the vacuum of space didn't feature noise.

Meanwhile, Clarke had established himself as a researcher with the publication in 1945 of an academic paper on the possibility of using geostationary satellites for communication. This technology later became a reality, and today the geostationary orbit 22,307 miles (35,900 km) above the equator is named the Clarke Orbit in his honor.

Clarke later worked with American engineers and scientists to develop spacecraft and launch systems, and addressed the United Nations on the subject of space travel. In 2003, a dinosaur was named after him: *Serendipaceratops arthurcclarkei*.

Having contracted polio in 1962, Clarke was often confined to a wheelchair in his later years. On his 90th birthday in December 2007 he recorded a video farewell message to his friends and admirers. He died in March 2008. In 2014, as a fitting tribute, a solar sail craft, named *Sunjammer* after one of Clarke's stories, was tasked with taking a few strands of the author's hair out into deep space. **JN**

year-by-year ■ Short story ■ Book ■ Movie

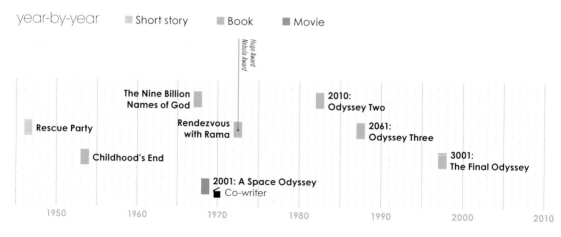

Hugo Award
Nebula Award

The Nine Billion Names of God

2010: Odyssey Two

Rescue Party

Rendezvous with Rama

2061: Odyssey Three

Childhood's End

3001: The Final Odyssey

2001: A Space Odyssey
Co-writer

1950 1960 1970 1980 1990 2000 2010

stanisław lem 1946

| The Man From Mars | Hospital of the Transfiguration | The Star Diaries | Eden | Solaris | The Cyberiad | His Master's Voice | The Breed of Predators |

Poland's most famous science fiction writer, Stanisław Lem lived through some of the most turbulent times in European history. He was born in 1921, and by the time he was 25 his country had been overrun once by Germany and twice by the Soviet Union during the Second World War. His medical studies had been interrupted by two years working as a welder, and his native city, Lwów, had become part of Ukraine, which was at the time a Soviet Republic.

Lem completed his medical studies in Kraków. In 1946 his first novel, *The Man from Mars*, was serialized in the magazine *Nowy Swiat Przygód* (*New World of Adventures*). In 1948 he became a Junior Research Assistant at the Polish Academy of Sciences, and started work on *Hospital of the Transfiguration*, a semi-autobiographical novel about the war. Owing to Soviet censorship, this work was not published until 1955, when there was a brief reduction in the number of constraints on free expression during "the Polish October," and Lem met the communist authorities halfway by incorporating some passages of socialist realism into the originally proscribed manuscript.

Thus established as a writer, Lem entered his most productive period. A collection of short stories, *The Star Diaries* was followed by the novels *Solaris* and *Eden*. He consolidated his reputation with *The Cyberiad*, a collection of humorous short stories about a universe inhabited mainly by robots, and *His Master's Voice*, a philosophical novel about the difficulty of deciphering the true meaning of messages from outer space.

Throughout his career Lem also wrote serious essays on cybernetics and biology; his final academic works were collected in a volume entitled *The Breed of Predators*.

What is striking about Lem's output is its variety. Novels such as *Solaris* and *Eden* are serious, philosophical works, whereas those such as *The Cyberiad* and *The Star Diaries* are more playful. Much of Lem's fiction is concerned with the compromises required for survival. For example, in *The Star Diaries*, space explorer Ijon Tichy goes to a planet that is apparently overrun by bloodthirsty robots. On investigating, however, he discovers that the automatons are all in fact human investigators who have adopted protective camouflage in order to fit in with what they regard as the social norm.

Gradually Lem's fame spread to the West. *Solaris* was made into a film in 1972 by Russian director Andrei Tarkovsky. In the following year, the author was awarded honorary membership of the Science Fiction Writers of America, but his relationship with this organization was always difficult, not least because of his disdain for almost all English-language SF writers other than Philip K. Dick.

After the imposition of martial law in Poland in 1982, Lem moved to West Berlin, but returned to Kraków in 1988, shortly before the fall of communism in the following year. In 2002, Steven Soderbergh directed a Hollywood remake of *Solaris* starring George Clooney. Lem was still writing at the time of his death in 2006. **MM**

nineteen eighty-four 1949

Nineteen Eighty-Four

Nineteen Eighty-Four

Nineteen Eighty-Four

Diamond Dogs

Nineteen Eighty-Four

Brazil

The League of Extraordinary Gentlemen: Black Dossier

Nineteen Eighty-Four

In April 1947, Eric Blair — the writer known to the world by his pen name, George Orwell — left London for Jura in Scotland's Inner Hebrides. In Barnhill, a remote house on the northern tip of the island, he spent the rest of the year and the greater part of 1948 on the novel that would be his masterpiece.

The working title of the book was "The Last Man in Europe," but Orwell eventually came up with the idea of transposing the last two digits of the year in which he was writing.

Published in June 1949 and imbued with all the chilliness of the early Cold War era, *Nineteen Eighty-Four* was Orwell's second fictional swipe at totalitarianism after the political fable *Animal Farm* (1945). The novel tells the story of everyman Winston Smith's doomed love affair with a colleague, Julia, and his futile rebellion against an authoritarian superstate. Its nightmarish depiction of a future that holds nothing more than "a boot stamping on a human face — forever" has exerted an influence that can hardly be overstated. It has given the English language the terms "Big Brother" (the dictator), "Room 101" (in which one's worst nightmares are identified by torturers and then made real) and "doublethink" (holding two contradictory opinions simultanously with equal conviction). "Orwellian" has become an adjective to describe intrusive state surveillance.

No sooner had the book been published than NBC produced a radio version with David Niven as Winston Smith. In 1953, another radio version starred Richard Widmark and a TV dramatization was broadcast in CBS's Westinghouse Studio One series.

A year later, the BBC television version, which starred Peter Cushing and Donald Pleasance, provoked outrage, especially the scene in which Smith is threatened with torture by rats.

In 2013, the BBC revived the novel for radio in a two-part adaptation starring Christopher Eccleston. There have also been theater versions and even an opera, composed by the American conductor Lorin Maazel. Anthony Burgess' novel *1985* was a tribute to Orwell himself rather than a sequel to the book, whereas Alan Moore's *The League of Extraordinary Gentlemen: Black Dossier* imagined a UK after the fall of the regime portrayed in the original.

In popular music, the book has been referenced by Rick Wakeman, Van Halen, Muse, Black Flag, Todd Rundgren, Roy Harper and Jimmy Page as well as Stevie Wonder. In *Diamond Dogs*, David Bowie wedded Orwell's vision with his own Thin White Duke persona.

The first movie adaptation, starring Edmond O'Brien and Michael Redgrave, was a failure, but the 1984 version with John Hurt and Richard Burton was artistically effective and commercially successful.

In addition to all these adaptations and allusions, *Nineteen Eighty-Four* has influenced many subsequent futuristic visions, including several in which it is not directly namechecked. Terry Gilliam's movie *Brazil* (1985), for example, is at least in part *Nineteen Eighty-Four* played for the darkest laughs. **JW**

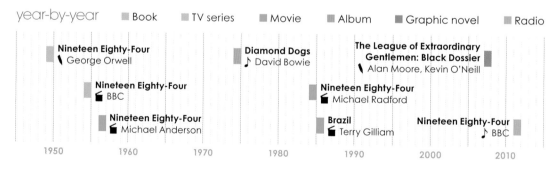

year-by-year ■ Book ■ TV series ■ Movie ■ Album ■ Graphic novel ■ Radio

Nineteen Eighty-Four
George Orwell

Nineteen Eighty-Four
BBC

Nineteen Eighty-Four
Michael Anderson

Diamond Dogs
♪ David Bowie

Nineteen Eighty-Four
Michael Radford

Brazil
Terry Gilliam

The League of Extraordinary Gentlemen: Black Dossier
Alan Moore, Kevin O'Neill

Nineteen Eighty-Four
♪ BBC

1950 1960 1970 1980 1990 2000 2010

eiji tsuburaya 1949

The Invisible Man Appears

Godzilla

Ultra Q

Ultraman

Ultra Seven

Mighty Jack

Operation: Mystery!

A tale is sometimes told of American troops who, on entering Japan in 1945, were shocked when they saw on captured Japanese film horrific aerial footage of the attack on Pearl Harbor in 1941 that had brought the United States into the Second World War. Investigating the origins of the film, they were relieved to find that it was not authentic newsreel but a propaganda work of 1942 containing special effects by Eiji Tsuburaya. This story may be apocryphal, but there is no doubt that in the field of miniature effects Tsuburaya is an undisputed master.

Born in Sukagawa in 1901, Tsuburaya showed an early interest both in model aircraft and in photography. At the age of 18 he took a job as an assistant cameraman at a film studio, where he rose to become a cinematographer. The subsequent direction of his career was strongly influenced by the original *King Kong* movie, which inspired him to experiment with front and rear projection, techniques that were then unknown in Japanese cinema.

In 1938, Toho became the first Japanese studio to set up a dedicated Special Visual Effects Department and Tsuburaya was installed as its head. Most of his work was on war films (Japan had been fighting China since July 1937). Tsuburaya's first science fiction credit wasn't at Toho, however, but came during a brief spell as a freelancer when he helped rival studio Daiei make *Toumei ningen arwaru* (*The Invisible Man Appears*), a Japanese version of H.G. Wells' novel via James Whale's 1933 film.

Five years later, when Ishiro Honda was directing a science fiction film for Toho about a giant monster, Tsuburya was called on to create and film the miniature landscapes and cityscapes through which the behemoth would stamp, and to combine them with live action footage of actors. Thus was born the Godzilla series and the *kaiju eiga* (monster movie) genre that would form the greater part of Tsuburaya's subsequent output, and with which his name will forever be associated.

Between 1943 and his death in 1970, Tsuburaya worked on the first 11 Godzilla films as well as several other Toho SF features and two classic samurai films for Akira Kurosawa. Although most of these movies were distributed worldwide, it was many years before Tsuburaya's name became known abroad.

In 1963 Tsuburaya founded his own production company (though he continued to work for Toho), and spent two years producing monsters for *Ultra Q*, a Tokyo Broadcasting System TV series. These programs attracted big audiences, but they lacked a monster-sized protagonist, an omission that was rectified in Tsuburaya's next production, *Ultraman*, about a team of investigators, one of whom can transform into a giant alien superhero. *Ultraman* was a massive hit throughout Asia and spawned a lucrative franchise: the spinoff movies, TV series and merchandise based on the original have helped to keep Tsuburaya Productions in business ever since, although the company is now owned by a Tokyo ad agency. **MJS**

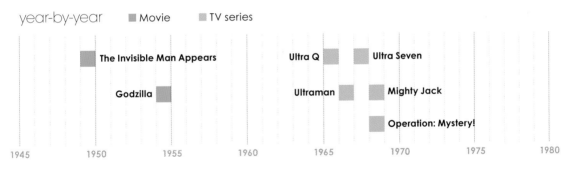

year-by-year ■ Movie ■ TV series

The Invisible Man Appears

Godzilla

Ultra Q

Ultraman

Ultra Seven

Mighty Jack

Operation: Mystery!

1945 1950 1955 1960 1965 1970 1975 1980

the era of the atom: the marvels and perils of science
1950–70

dan dare 1950

Dan Dare,
Pilot of the Future

Dan Dare

Dan Dare

Dan Dare:
Pilot of the Future

Dan Dare:
Pilot of the Future –
Voyage to Venus

Dare

Among the most celebrated of British science fiction heroes, Dan Dare is a singular creation: bold, pleasant and fair, his adventures realistic in their depiction of his abilities and surroundings. Dare's particular brand of Anglican, scientifically plausible, meticulously illustrated derring-do is so intrinsically linked with the UK post-war period — where he was introduced as a moral antidote to exciting but violent US comic book imports — that he has resisted numerous attempts to update him.

Eagle was a "new national strip cartoon weekly" introduced in April 1950, mixing comic strip adventures — few of them fantastical — with educational features and spectacular cut-away illustrations of ships, planes and similar state-of-the-art machinery. The one regular science fiction strip, Dan Dare, Pilot of the Future, was also the comic's lead, and showed a similar loyalty to the possible: a young science fiction writer named Arthur C. Clarke acted as scientific advisor, and artist/creator Frank Hampson would build models of space ships and other props as reference for his team of assistants, ensuring an unusual degree of visual continuity.

The stories they told were of an idyllic late 1990s, in which a lucky, sharp-minded Manchester lad of around 30, Colonel Daniel McGregor Dare, could be chief pilot of a British-dominated "Interplanet Space Fleet," helped on his adventures to Venus, Mercury and beyond by his loyal but bumbling servant,

Digby; scientific genius Professor Jocelyn Peabody; and assorted others, often amiably stereotypical depictions of the French, Americans and Irish.

Dan Dare's original comic adventures are known for their length and complexity, intense visual detail, and their nonviolent solutions to threats to the Earth, but though Dan himself retains a square-jawed, stiff-upper-lipped charm throughout, the most memorable figure was his arch-enemy, The Mekon, super-intelligent leader of the Treens of Venus, a species of powerful, green-skinned, highly militaristic reptile-men. As much of Pilot of the Future was an exotic reprise of the recent global conflict, so the Treens were the Nazis and the Mekon a space-Hitler with a super-science bent.

Eagle was founded by John Marcus Harston Morris, vicar of a church in Southport, Lancashire, and Hampson. Hampson initially worked out of a studio near Morris's home before taking his operation to Surrey when Morris moved there. So labor-intensive were Hampson's methods that he twice suffered breakdowns, forcing assistants to take over the strip for periods, notably in 1952 and again in 1953. Hampson returned to the strip full-time in 1955, when his adventure "The Man From Nowhere" took Dan and his companions outside the solar system for the first time. He left the strip for good in 1959, when new owners of Eagle complained about the speed and cost of his studio methods. Hampson's team was disbanded,

year-by-year ■ Comic ■ Video game ▨ Radio adaptation ▨ Animated TV series

Dan Dare: Pilot of the Future
Virgin Interactive, Electronic Arts

Dan Dare, Pilot of the Future
Eagle

Dan Dare
2000 AD

1950 1955 1960 1965 1970 1975 1980 1985

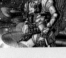

**Dan Dare:
Pilot of the Future**

Dan Dare

Dan Dare

although he continued drawing for the *Eagle* until 1961. Most notable of the artists who followed was Frank Bellamy, though his updated designs upset many.

Post Hampson and Bellamy the strip was weaker, and finally ground to a halt in 1967, with Dare promoted to head of Space Fleet; *Eagle* itself only lasted a couple more years. The character would not die, however, and the years since have seen numerous attempts to revive him — many have had their virtues, although none have threatened to outshine the original.

In 1977, the new and edgy science fiction comic *2000 AD* launched with a totally re-imagined version of Dan Dare as its lead strip. Our hero had been frozen in suspended animation for 200 years and reborn into a violent future populated by weird monsters, but the stories never found a consistent tone: the early Massimo Bellardinelli-illustrated tales were wild and nightmarish; later Dave Gibbons-drawn stories introduced elements of *Star Trek* and even superheroes. Though characters from the original *Eagle* stories — such as the Mekon, and a friendly Treen called Sondar — appeared in time, the series never attained the popularity of such original *2000 AD* creations as Judge Dredd and was dropped after two years.

Those readers of the *Eagle* who had looked with horror at the *2000 AD* reinvention were more pleased with Dare's next incarnation, in the relaunched *Eagle* of 1982. This new Dare was some future relation of the original hero, but looked identical to his illustrious forebear; pushing credibility, he was joined by a new Digby (also a descendant of the first one) and the genuine Mekon, trapped in an artificial asteroid by the original Dan but now returned, once again in charge of the Treens, and this time a successful invader of Earth. Initially at least, the strip cleaved faithfully to the look of the original.

This version of Dare lasted, with variations, until the end of the second *Eagle* in 1994, overlapping with a radical reinvention of the character in a short-lived, experimental comic called *Revolver*. Called simply *Dare*, it saw an older, retired version of the original hero engage in one final, melancholy battle with a clear Margaret Thatcher-avatar in a run-down future Britain. Naturally, she turned out to be backed by the Mekon.

In 2009, an excellent Garth Ennis-written *Dan Dare* mini-series for the short-lived Virgin Comics — introducing elements of Zulu and British World War II films to the mix — showed how the character could be made relevant for the present without sacrificing the old-fashioned virtues that made him great in the first place, and semi-pro comic *Spaceship Away* has brought back as close an approximation to the original 1950s strips as it is possible to imagine.

Unlike many comic book heroes, Dan Dare has not fared well in other media; blame his utterly British character, perhaps — it is uncertain whether he ever could have true international appeal. **MB**

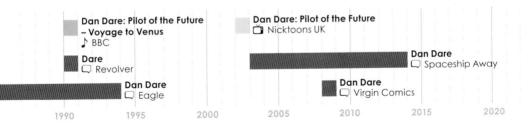

Dan Dare: Pilot of the Future
– Voyage to Venus
♪ BBC

Dan Dare: Pilot of the Future
🎬 Nicktoons UK

Dare
🗨 Revolver

Dan Dare
🗨 Spaceship Away

Dan Dare
🗨 Eagle

Dan Dare
🗨 Virgin Comics

1990 1995 2000 2005 2010 2015 2020

**Dan Dare:
Pilot of the Future**
(1950–67)

Dan Dare
(1977–79)

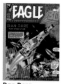

Dan Dare
(1982–94)

Dare
(1990)

**Dan Dare: Pilot of
the Future**
(2002)

Dan Dare
(2008)

The original **Dan Dare: Pilot of the Future** comic was renowned for its lavish artwork by Frank Hampson.

The original Dan Dare from the 1950s and 1960s.

In "Reign of the Robots" Dan and his crew must save the Earth from the Elektrobots.

Dan Dare, as depicted in *2000 AD* in the 1970s.

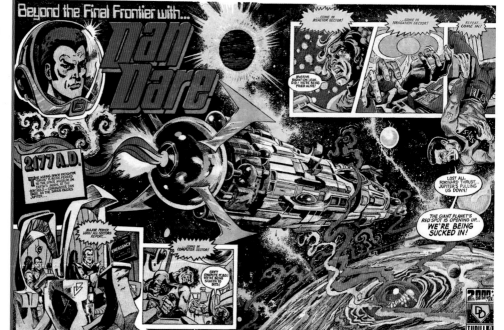

The opening double-page spread of the first **Dan Dare** strip in *2000 AD*, with striking artwork by Italian artist Massimo Belardinelli.

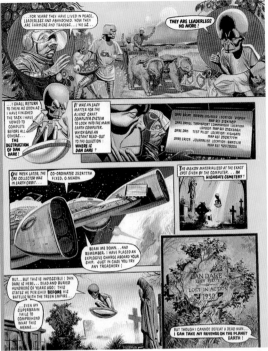

The CGI version of The Mekon in *Dan Dare: Pilot of the Future* is perhaps the most sinister incarnation of the character so far.

A page from "Return of the Mekon," the introductory **Dan Dare** story in the new version of *Eagle* launched in 1982.

A frame from **Dare** by Grant Morrison and Rian Hughes, first serialized in *Revolver*.

Dan Dare, as reinvented for the 1990s in *Revolver*.

Dan Dare and other characters from the 2002 computer-generated TV series **Dan Dare: Pilot of the Future**.

The H.M.S. *Achilles* comes under attack in issue 1 of Virgin Comics' **Dan Dare** series.

The 21st-century Dan Dare, as drawn by Gary Erskine for Virgin Comics.

richard matheson 1950

Born of Man and Woman

I Am Legend

The Shrinking Man

The Twilight Zone

Star Trek, "The Enemy Within"

The Night Stalker

The Night Strangler

Bid Time Return

Richard Matheson is one of the most prolific and successful science fiction authors of all time. His legacy includes short stories, novels and scripts.

His first science fiction success came at the age of 24 when *The Magazine of Fantasy and Science Fiction* published his short story "Born of Man and Woman." Following this, he became a regular jobbing writer for genre work, alongside Ray Bradbury, Charles Beaumont and George Clayton Johnson, and specialized in high-concept stories with twist endings.

In 1954 Matheson published *I Am Legend*, a science fiction update of the vampire myth that concerns the struggles of the last man on Earth to survive the attentions of humans turned into murderous creatures by a pandemic. The novel is a defining work of post-apocalyptic literature.

Two years later came *The Shrinking Man*, an examination of masculinity struggling in exceptional circumstances. Superficially, the work is total SF, but the central theme of a man diminished, literally and spiritually, after exposure to a radiation cloud, was a metaphor for Americans gripped by fear during the Cold War.

Matheson wrote the sixth episode in the first series of *Star Trek* — "The Enemy Within," in which the light and dark sides of Captain Kirk's personality do battle with each other. The work typifies the author's approach — he never aimed for cheap thrills, but examined the psychological difficulties of characters with mixed motivations.

Matheson then found perhaps the perfect medium for his tight, efficient narratives in *The Twilight Zone* TV series, for which he wrote 16 episodes, including arguably the most famous, "Nightmare at 20,000 Feet," in which a petrified air passenger (played by William Shatner) watches a gremlin threaten the safety of everyone on board from the wing of the airplane.

In 1972 and 1973 Matheson originated the TV movies *The Night Stalker* and *The Night Strangler*. These spawned *Kolchak: The Night Stalker*, a weekly adventure series in which a maverick reporter encounters a rogues' gallery of monsters, which in turn would influence *The X-Files*.

The author revealed a more romantic side to his genre work in *Bid Time Return* (1975), in which a man journeys into the past to be with his sweetheart. This novel is Matheson's finest expression of his two abiding themes: the points at which rationality and irrationality, and science and fiction intersect.

Real Steel (2011) was the last feature film of Matheson's work to be produced before the author's death in 2013. The movie deals with one man's struggle to come to terms with his fading masculinity in a world where he is emotionally stunted and has been rendered physically redundant by the advance of technology. Great science fiction asks big questions, and Matheson returned throughout his work to one of the biggest conundrums: what is man's place in the modern world? **SW**

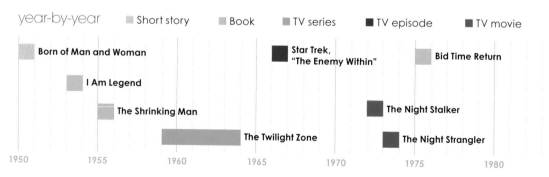

year-by-year ▪ Short story ▪ Book ▪ TV series ▪ TV episode ▪ TV movie

Born of Man and Woman

Star Trek, "The Enemy Within"

Bid Time Return

I Am Legend

The Shrinking Man

The Night Stalker

The Twilight Zone

The Night Strangler

1950 1955 1960 1965 1970 1975 1980

kurt vonnegut 1950

Report on the Barnhouse Effect	Player Piano	The Sirens of Titan	Harrison Bergeron	Cat's Cradle	Welcome to the Monkey House	Slaughter-house-Five	Slapstick

Kurt Vonnegut Jr., born in 1922 in Indianapolis, was one of the most important American novelists of the period following the Second World War. As a young man he served in the U.S. Army, and was captured by the Germans during the Battle of the Bulge in December 1944. He was subsequently imprisoned in Dresden, and survived the infamous firebombing by Allied Forces, which flattened much of the city and killed some 25,000 people. That event had a major influence on Vonnegut, and features prominently in his best-known novel, *Slaughterhouse-Five*. On his return to the United States, Vonnegut was awarded a Purple Heart.

Vonnegut began his literary career in 1950, when the story "Report on the Barnhouse Effect" was published in *Collier's* magazine. In 1953, his "Unready to Wear" appeared in *Galaxy Science Fiction*. In the meantime came his first novel, *Player Piano* (1952), a dystopia. This was followed in 1959 by *The Sirens of Titan*, which concerns a Martian invasion of Earth and fully exhibits what would become Vonnegut's trademark, what John Clute called "heavy irony, bordering on black humor, and unashamed sentimentality." It is also full of wild invention: in the end, all of human history is explained as the attempt by aliens to send a message back to their planet.

Several notable works followed, including the often-reprinted short story "Harrison Bergeron" (1961), a satire that was adapted several times for the screen. Next came *Cat's Cradle* (1963), a novel in which the world is threatened by a compound called Ice-9 that immediately freezes everything with which it comes into contact. Vonnegut's short story collection, *Welcome to the Monkey House* (1968), was later adapted into a television series.

In 1969 Kurt Vonnegut published what is generally agreed to be his masterpiece. The hero of *Slaughterhouse-Five*, Billy Pilgrim, unstuck from time, is kidnapped by aliens and relives the bombing of Dresden. The novel is a heartfelt and savage satire that ranks alongside the finest works of contemporaries such as J.D. Salinger and Joseph Heller. It also introduces one of Vonnegut's refrains, which is quoted repeatedly and becomes a motif throughout his novels: "So it goes."

Although Vonnegut continued to take fantastical themes, and created the outlandish character Kilgore Trout — a hack SF writer who appears in many of the works — he distanced himself from genre fiction, and is not considered purely as a writer of such. As if to emphasize his reluctance to be pigeonholed, Vonnegut gives Trout a major role in one of his non-SF novels, *Breakfast of Champions* (1973).

Vonnegut's later novels became increasingly exaggerated — 1984's *Slapstick* is aptly named — but nevertheless remained powerful. Vonnegut was a humanist and an absurdist who sought to highlight both the joy and the misery of being human, without recourse to God or Fate. He died in 2007. The asteroid 25399 Vonnegut is named in his honor. So it goes. **LT**

year-by-year ▨ Short story ▨ Book

Report on the Barnhouse Effect

Harrison Bergeron

Player Piano

The Sirens of Titan

Slapstick

Cat's Cradle

Slaughterhouse-Five

Welcome to the Monkey House

1950 1955 1960 1965 1970 1975 1980

2001: a space odyssey 1951

The Sentinel **Encounter at Dawn** **2001: A Space Odyssey** **2001: A Space Odyssey** **The Lost Worlds of 2001** **2010: Odyssey Two**

In 1948 Arthur C. Clarke penned the short story "The Sentinel" for a BBC competition. It failed to even get shortlisted, but was published three years later in the one and only edition of *10 Story Fantasy* magazine. The story tells the tale of a lunar mission that discovers a pyramidal object of extraterrestrial origin, whose job is to monitor the Earth and its inhabitants. Upon investigation, it alerts its creators that intelligent life has reached the location where their sentinel stands.

Following his success with *Dr. Strangelove*, Stanley Kubrick approached MGM in 1964 with an idea to reinvent the science fiction movie; to create a scientifically accurate film that would capitalize on the popularity of the space race. He declared that it would take two years to make and cost $6 million. MGM were aghast, but reluctantly agreed.

Kubrick contacted Clarke. Together they took the seed of the idea planted in "The Sentinel" and crafted both a novel and a film script that would satisfy Kubrick's desire to make an intelligent, powerful and visually arresting epic.

The resulting story tells of a monolith, left by alien visitors millions of years ago, which instills a spark of intelligence in a clan of apemen when they find it outside their cave. When attacked, one of the apemen has the notion of using a discarded bone as a weapon. He despatches his rival and hurls the bone into the sky. At this point Kubrick makes the most famous match-cut in history, as we jump to the year 1999, and an orbital weapons platform. In the space of one frame we make the evolutionary leap from rudimentary club to nuclear arms.

We then join the Pan-AM clipper *Orion*, ferrying its lone passenger, Dr. Heywood Floyd, to the moon. The sequence of the *Orion* coming into dock with the rotating *Space Station V* — to the strains of Strauss' *Blue Danube* — remains a seminal sequence, with special effects that still hold up five decades later. The production team introduced a new vision of functional spacecraft, complete with intricate detail, dirt and even corporate logos, setting a standard for spacecraft design that remains to this day.

After more languid shots of space travel, Floyd and crew set off across the lunar desert, arriving at the site of a huge archeological dig, where we find another monolith. As sunlight strikes the object for the first time in millennia, it fires a signal to Jupiter.

Eighteen months later, the crew of *Discovery One* are en route to the gas giant. The ship — in reality a 54-foot (16 m) model — features living quarters that continually rotate to generate Earth-type G-forces. For sequences on board, Kubrick had a giant 30-ton centrifuge built, costing $750,000.

Following an episode with the murderous computer HAL, sole surviving crew member Dave Bowman encounters a giant monolith, triggering

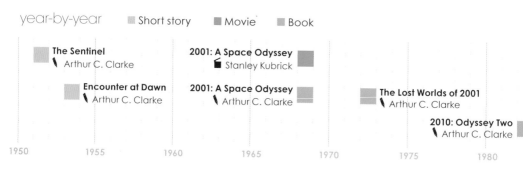

year-by-year ■ Short story ■ Movie ■ Book

The Sentinel
\ Arthur C. Clarke

Encounter at Dawn
\ Arthur C. Clarke

2001: A Space Odyssey
▪ Stanley Kubrick

2001: A Space Odyssey
\ Arthur C. Clarke

The Lost Worlds of 2001
\ Arthur C. Clarke

2010: Odyssey Two
\ Arthur C. Clarke

1950 1955 1960 1965 1970 1975 1980

| 2010 | 2061: Odyssey Three | 3001: The Final Odyssey | A Time Odyssey: Time's Eye | A Time Odyssey: Sunstorm | A Time Odyssey: Firstborn |

the film's famously psychedelic stargate sequence. Bowman is transported across the cosmos to the alien homeworld where, cosseted in opulent surroundings, he lives out the remainder of his life, to be reborn as a Star Child — a being of pure energy, and the next stage of mankind's evolution.

2001 took three years to make and cost $10.5 million, yet advance bookings for its initial release were poor. However, word-of-mouth saw repeated viewings bolster its box office to $21 million. Some theaters in the US ran 2001 for more than two years, and the film became one of MGM's biggest successes, opening the way for the big-budget science fiction blockbusters of the 1970s.

The film's directorial style and intentional ambiguity still divides audience reaction, but Kubrick summed it up thusly: "If 2001 has stirred your emotions, your subconscious, your mythological leanings, then it has succeeded."

In 1982 Clarke released 2010: Odyssey Two, which was more of a sequel to the film than the novel, and which — rather unnecessarily — attempted to answer some of the questions raised by Kubrick's epic.

In it, a joint Soviet-American crew set off to uncover what happened to Discovery One, against a background of international political tensions. A probe reveals primordial lifeforms on Jupiter's moon, Europa, and the monolith begins to reproduce in a cellular fashion, swamping the gas giant and causing it to contract. The crew manages to escape just as Jupiter achieves nuclear fusion and ignites to become a small star, warming the new Europan system.

A film of of the novel, entitled 2010: The Year We Make Contact and directed by Peter Hyams, was released in 1984. The movie was far more orthodox in its storytelling than its predecessor, and though reception was mixed, it managed to gross $40 million at the box office.

Further literary sequels include 2061: Odyssey Three, released in 1987, and 3001: The Final Odyssey, released in 1997. Clarke noted that although the series maintains a commonality, the stories occur in parallel universes to each other (hence a few inconsistencies).

Both the movie and novelization of 2001: A Space Odyssey continue to dominate the world of science fiction, with their grandiose concepts spanning time and space. However, the sequels are beset by diminishing returns: although 2010 enjoyed the awe-inspiring conceit of turning Jupiter and its moons into a mini-solar system, the series bows out with far less ambition. By the end of 3001, all the majesty and mystery of its progenitor have been ground away by explanation and exposition. Nonetheless, Clarke's powers of scientific speculation still cast a long shadow over literary SF, and tales of space travel are continually measured against this benchmark. **JB**

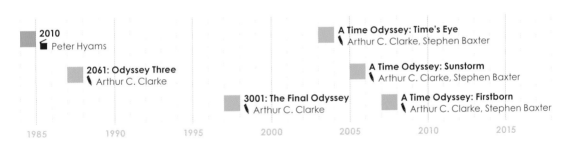

2010
Peter Hyams

2061: Odyssey Three
Arthur C. Clarke

3001: The Final Odyssey
Arthur C. Clarke

A Time Odyssey: Time's Eye
Arthur C. Clarke, Stephen Baxter

A Time Odyssey: Sunstorm
Arthur C. Clarke, Stephen Baxter

A Time Odyssey: Firstborn
Arthur C. Clarke, Stephen Baxter

1985 1990 1995 2000 2005 2010 2015

2001: a space odyssey universe

Heywood Floyd **Dr. David Bowman** **Dr. Frank Poole** **HAL 9000**

Three million years ago, an alien intelligence deposits a monolith in Africa near a group of apes, who are thus inspired to use tools to kill their prey and enemies. These creatures evolve into humankind.

Fast-forward to 1999. Dr. Heywood Floyd is on the Moon investigating a magnetic anomaly in the crater Tycho. He finds a buried monolith. When it is unearthed and exposed to sunlight, it emits a powerful radio signal tracked to the vicinity of Jupiter.

Eighteen months later, *Discovery One* is en route to Jupiter with a crew of five: Dr. David Bowman and Dr Francis Poole. on active duty, plus three others in suspended animation. HAL, the super-intelligent on-board computer, becomes conflicted by contradictory orders intended to ensure the mission criteria are kept secret from the crew. When threatened with disconnection, HAL kills everyone on board before Bowman manages to shut it down.

Bowman continues on to Jupiter where he discovers a giant monolith, which opens to reveal its contents. In his final radio transmission, Bowman exclaims: "My God, it's full of stars!" He is drawn into

it and swept across the cosmos to the alien's home world. There he is transformed into a Star Child, an immortal being of pure energy.

Nine years later, Dr. Heywood Floyd is part of the U.S.–Soviet crew of the *Alexei Leonov* on a mission to reach the drifting *Discovery One* before it crashes into Jupiter's volcanic moon, Io. On the way, *Leonov* is overtaken by a Chinese spacecraft, *Tsien*, which lands on the moon Europa to take on water and is there destroyed by a primitive life-form.

Eventually the *Leonov* reaches *Discovery One*, which is stabilized and lifted into a safe orbit around Io. HAL is reactivated.

A monolith on Jupiter opens to release Bowman — reborn as a Star Child — who then travels back to Earth. Here he discovers a nuclear weapon in orbit which he detonates in order to absorb its energy. He then visits his dying mother before setting off for Europa, where he examines the life-forms.

Bowman then returns to Jupiter, where he warns Floyd of a swarm of rapidly replicating monoliths whose combined mass is causing the planet to contract.

characters

- ▨ Heywood Floyd
- ▨ Dr. Frank Poole
- ▨ Dr. David Bowman
- ▨ HAL 9000

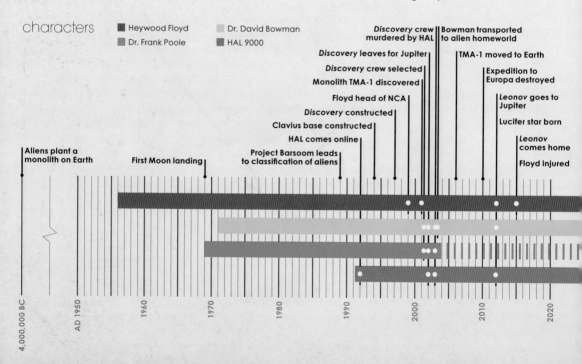

Discovery crew murdered by HAL | Bowman transported to alien homeworld
Discovery leaves for Jupiter | TMA-1 moved to Earth
Discovery crew selected | Expedition to Europa destroyed
Monolith TMA-1 discovered | Leonov goes to Jupiter
Floyd head of NCA | Lucifer star born
Discovery constructed | Leonov comes home
Clavius base constructed | Floyd injured
HAL comes online
Project Barsoom leads to classification of aliens
Aliens plant a monolith on Earth
First Moon landing

4,000,000 BC AD 1950 1960 1970 1980 1990 2000 2010 2020

Leonov is tethered to *Discovery* so that the latter's remaining power can speed the crew's escape. As *Discovery* is cut loose, Bowman asks HAL to transmit one final message back to Earth. It says: "All these worlds are yours except Europa. Attempt no landing there." He then rescues HAL, who is changed into a being similar to himself. Jupiter is transformed into a new star, Lucifer, which brings light and warmth to Europa.

In 2061, the 103-year-old Floyd is a celebrity guest on a voyage by *Universe* to Halley's Comet. Meanwhile, *Universe*'s sister ship, *Galaxy*, is on its way to Ganymede, another moon of Jupiter, which is being terraformed.

A new mountain has suddenly emerged on Europa, Mount Zeus. Scientist Rolf Van de Beg surmises that this is actually a huge diamond that was blown out of the solid core of Jupiter.

Attempts to probe Europa have failed, although scientists have detected a vast rectangular structure, dubbed the "Great Wall," which they assume to be another monolith.

While passing Europa, *Galaxy* is hijacked and crash-lands. As *Universe* diverts to the rescue, Floyd radios Bowman for permission to land.

A survey team travels to Mount Zeus, which is found to be a two-quintillion-carat diamond that is slowly sinking back into the magma from which it emerged.

After tumbling through space for a thousand years, the frozen body of Poole is found near Neptune by the space tug *Goliath*. Once revived, the astronaut visits Ganymede, where he finds Bowman, who is now fused with HAL into "Halman." Halman warns that the star Lucifer is beginning to fade, and that the monolith has received orders to exterminate human life in order to secure the safety of the Europans.

The monolith begins replicating itself to create massive screens, which will block all sunlight to Earth. To stop the process, Halman infects the monolith — now revealed to be a supercomputer — with a virus that causes its clones to disintegrate.

Humans think they have 900 years left, but they underestimate their enemies. Nevertheless, the aliens grant Earth a reprieve, at least for the time being. **SJ**

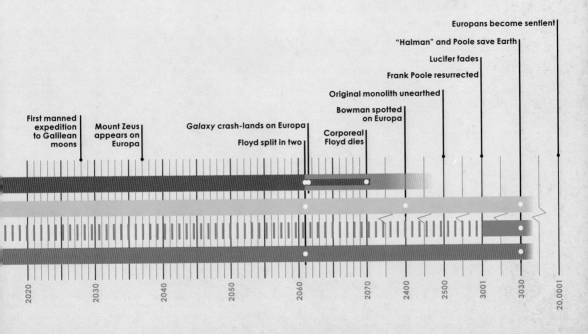

Europans become sentient

"Halman" and Poole save Earth

Lucifer fades

Frank Poole resurrected

Original monolith unearthed

Bowman spotted on Europa

First manned expedition to Galilean moons

Mount Zeus appears on Europa

Galaxy crash-lands on Europa

Corporeal Floyd dies

Floyd split in two

2020 2030 2040 2050 2060 2070 2400 2500 3001 3030 20,0001

In 2001, space travel has become an everyday occurrence — so much so that spacecraft carry air hostesses.

The first mysterious alien monolith inspired primitive hominids to begin using tools, thus humankind is born.

In a desperate attempt to save his life, sole survivor Dave Bowman (Keir Dullea) attempts to deactivate the computer HAL.

The Discovery and one of its EVA pods form the centerpieces for this publicity poster. However, it didn't quite capture the mystical feel of the movie.

Kubrick's film has influenced every subsequent space travel movie, but none has either equaled or surpassed the original.

The effects depicting Dave Bowman's trip through the alien stargate were achieved in part using a slitscan technique.

Bob Balaban in *2010*. This sequel to *2001: A Space Odyssey* was described as "unnecessary but worth the effort."

In *2010*, the role of Soviet cosmonaut Tanya Kirbuk is played by Helen Mirren, a British actor with Russian heritage.

the day of the triffids 1951

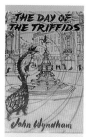

The Day of the Triffids

The Day of the Triffids

The Day of the Triffids

The Day of the Triffids

The Day of the Triffids

The Night of the Triffids

A portrayal of a Britain laid low by stellar phenomena and deadly plants, *The Day of the Triffids* by John Wyndham is one of the finest examples of apocalyptic science fiction.

Wyndham's first works were short detective stories and three novels published in the mid-1930s under the pen names John Beynon and John Beynon Harris. (Throughout his life, the author used various combinations of the constituent parts of his full name — John Wyndham Parkes Lucas Beynon Harris — as noms de plume.) His writing career came to a temporary halt on the outbreak of World War II, during which he worked for the Ministry of Information before joining the British Army and taking part in the Normandy landings.

After the conflict Wyndham returned to writing, but went into science fiction, only then adopting the name under which he became famous. He called the resulting stories "logical fantasy," and throughout the 1950s he produced a number of remarkable novels on similar themes, including *The Midwich Cuckoos* (adapted numerous times), *The Chrysalids* and *The Kraken Wakes*.

The first and best-known of these novels, *The Day of The Triffids* is set in a world where the mysterious, giant, ambulatory plants of the title are farmed for their oil and other by-products. Protagonist Bill Masen wakes in hospital to find that much of the rest of the world's population has gone blind overnight after observing a spectacular meteor shower. Masen's vision is unaffected because he had his eyes bandaged after an accident involving triffid poison. Escaping from the hospital, he finds London in a state of chaos caused by triffids that have broken loose from confinement and are roaming the streets killing people. It soon becomes clear that this state of affairs isn't restricted to England.

The novel was inspired by H.G. Wells' *The War of the Worlds*, but arguably surpasses it in apocalyptic power. Masen, like so many of Wyndham's heroes, a sturdy middle-class fellow, wanders from place to place witnessing numerous horrors: the few remaining sighted people being used as slaves; disease and desolation; homicidal plants on the rampage throughout the English capital.

The depiction of London in ruins must have seemed hauntingly familiar to contemporary readers who had lived through the Blitz. The novel as a whole played on fears engendered by the Cold War — Masen theorizes that the plants were created behind the Iron Curtain, and that the meteor showers were actually malfunctioning weapons satellites.

The Day of the Triffids was an instant hit, both critically and commercially. Arthur C. Clarke later described it as an "immortal story," and indeed images from the book have frequently recurred in

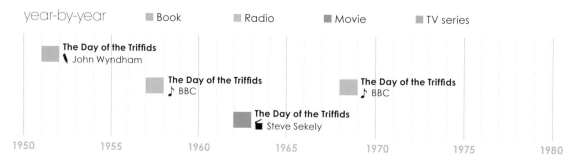

year-by-year ■ Book ■ Radio ■ Movie ■ TV series

The Day of the Triffids
♪ John Wyndham

The Day of the Triffids
♪ BBC

The Day of the Triffids
♪ BBC

The Day of the Triffids
🎬 Steve Sekely

1950 1955 1960 1965 1970 1975 1980

The Day of the
Triffids

later works of popular culture. Most post-apocalyptic novels owe at least a little both to this novel and to *The Kraken Wakes*, and both Danny Boyle's *28 Days Later* and the comic/TV show *The Walking Dead* — exemplars of the trend for zombie apocalypses — borrow the opening of the book wholesale, as their protagonists wake in deserted hospitals to discover that they've slept through the end of the world as they knew it.

In *Billion Year Spree: The History of Science Fiction* (1973), Brian Aldiss described *The Day Of The Triffids* as "cosy catastrophe." The label has stuck, but it is probably unjust: although the tone of Wyndham's prose is calm and measured, and some of the survivors live in relative comfort (at least for a time), Aldiss fails to acknowledge the pessimistic tone and overt horror of much of the book.

There have been several adaptations of *The Day of The Triffids*. The earliest was a 1957 radio serial for the BBC Light Programme. Eleven years later, the novel was adapted again, this time with a characteristically eerie score by the BBC Radiophonic Workshop. A feature film was released in 1962. Directed by Steve Sekely, it has become something of a cult B-movie classic. There's undoubtedly fun to be had here, and the triffids themselves are well realized, but it butchers Wyndham's story with gleeful abandon. It contains some moments of casual carnage but largely glosses over the darker themes of the novel. This is first and foremost a monster movie, and one that tacks on a dissonant happy ending in which humanity rallies after discovering the Triffids' only weakness — a swiftly fatal reaction to seawater. In the original, the plants have no such fatal flaw.

In 1981, the BBC produced the first television adaptation with John Duttine as Bill Masen. It's far more faithful to the book than the film, and plays up the grimmer aspects of Wyndham's novel.

The BBC adapted the book again in 2009, this time in a version starring Dougray Scott. Despite some big-budget gloss, it took several ill-conceived liberties with the story, and Eddie Izzard was woefully miscast as the primary villain.

In 2001 horror writer Simon Clark picked up where Wyndham left off with *The Night of the Triffids*. This more than adequate sequel, in which the main character is Bill Masen's son, David, is wider in scope than the original, and occasionally ventures into blockbuster territory, but remains faithful to Wyndham's tone and spirit. It won the British Fantasy Award in 2002.

The Day of The Triffids remains a curiously mannered but enduringly frightening British science fiction classic. Although rooted in pulp tropes and Cold War paranoia, it is plausible, thought-provoking and stylishly and economically written. **WS**

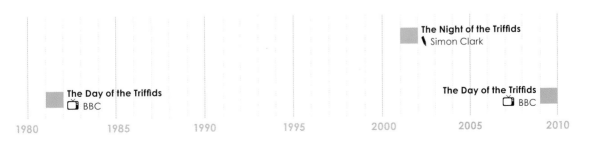

The Night of the Triffids
Simon Clark

The Day of the Triffids
BBC

The Day of the Triffids
BBC

1980 1985 1990 1995 2000 2005 2010

The Day of
the Triffids
(1951)

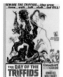

The Day of
the Triffids
(1962)

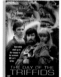

The Day of
the Triffids
(1981)

The Day of
the Triffids
(2009)

John Wyndham's drawing of a crossbred Triffid.

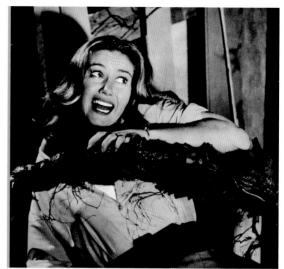

Janette Scott battles a triffid in the 1962 movie.

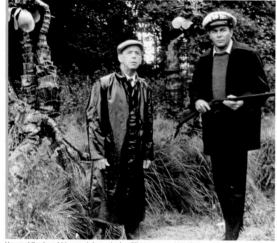

Howard Keel and Mervyn Johns, playing Bill Masen and Mr. Coker, stand apparently unaware of the danger that lurks behind them.

John Duttine regards the devastation caused by the triffids in the 1981 BBC adaptation.

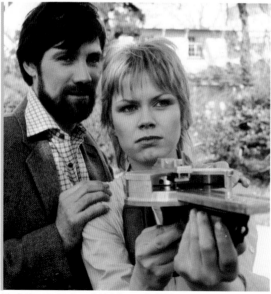

John Duttine coaches Emma Relph in the use of a Triffid gun.

The triffids in the 1981 BBC version were controlled by human operators seated inside.

Triffids cause a major motorway pile-up in the 2009 television series.

As with much modern SF, greenscreens were used extensively in the latest *Triffids* adaptation.

Dougray Scott's Bill Masen protects an orphaned girl while searching for a safe haven.

The plain exterior of a triffid warehouse belies the dangerous nature of the plants that are housed within.

Triffids cause chaos on London's Tower Bridge in the 2009 BBC television adaptation.

astro boy 1952

Astro Boy	Astro Boy	Astro Boy	Undersea Super Train: Marine Express	Astro Boy	Astro Boy: Mighty Atom	Pluto	Astro Boy

Astro Boy — known in Japan as Tetsuwan Atom or Mighty Atom — is a little robot child who flies, has soulful anime eyes, super-strength and machine guns in his bottom. He has been traumatized by rejection by his inventor father, and is thus a precursor to David, the robot boy hero of A.I. Artificial Intelligence.

Astro Boy was created by Osamu Tezuka, Japan's "God of Manga," a prolific storyteller who created an estimated 170,000 comic pages in his lifetime. He also established an animated film studio.

Tezuka was born in 1928 in Toyonaka. His first comic hit was New Treasure Island (1947), which sold 400,000 copies in postwar Japan. His early SF strips included Metropolis (1949), inspired by an image from Fritz Lang's silent classic film, which Tezuka had in fact never seen.

Astro Boy debuted in 1951 as a character in Tezuka's Captain Atom. A year later, he was given his own strip. His first outing on screen was in the live-action, black-and-white Astro Boy TV series (65 episodes) in 1959. The boy robot was played by Masato Segawa, who wore specially made plastic body armor for the role.

Astro Boy's most famous screen incarnation was in the seminal 1963 Japanese series animated by Tezuka's studio Mushi Productions. The black-and-white cartoon ran for 193 episodes between 1963 and 1966, and was sold to the United States, where NBC broadcast it in the New York region. A film compilation, Astro Boy: Hero of Space, followed in 1964. On the strength of Astro Boy, director Stanley Kubrick invited Tezuka to move to London and work on the design for 2001: A Space Odyssey. Unfortunately, Tezuka had to decline.

In the last TV story, Astro Boy flew into the Sun and was assumed to have died. However, his comic adventures continued, including a memorable strip in 1967 ("The Angel of Vietnam"), in which he protected Vietnamese villagers from American bombers. He also had a support role in an animated TV film, Undersea Super Train: Marine Express (1979). By then, Mushi Productions had gone bankrupt, with Tezuka's later animations released by Tezuka Productions. These included the second Astro Boy anime series (52 episodes) from 1980 to 1981.

Tezuka died from stomach cancer, aged 60 years, in 1989, just as the wider world was being introduced to anime by Akira. The director of this movie, Katsuhiro Otomo, later scripted the animated feature film Metropolis (2001), which was based on Tezuka's strip of the same name.

A third Astro Boy anime series (50 episodes) ran from 2003 to 2004. Also in 2003, acclaimed manga creator Naoki Urasawa began Pluto, an adult reworking of Astro Boy. This series ran until 2009, when a computer-animated Astro Boy feature was animated by Hong Kong's IMAGI studio and directed by Britain's David Bowers. This film was praised for what one critic called its "big, climactic robot rumpuses," but was a commercial failure. **AO**

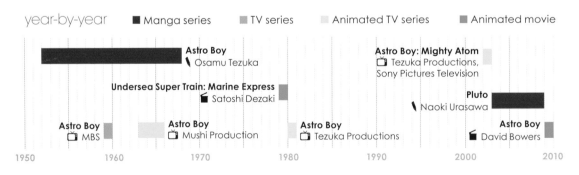

year-by-year ■ Manga series ■ TV series ■ Animated TV series ■ Animated movie

Astro Boy
Osamu Tezuka

Astro Boy: Mighty Atom
Tezuka Productions,
Sony Pictures Television

Undersea Super Train: Marine Express
Satoshi Dezaki

Astro Boy
MBS

Astro Boy
Mushi Production

Astro Boy
Tezuka Productions

Pluto
Naoki Urasawa

Astro Boy
David Bowers

1950 1960 1970 1980 1990 2000 2010

this island earth 1952

This Island
Earth

This Island
Earth

Mystery
Science
Theater 3000:
The Movie

One of the first major science fiction movies to be made in Technicolor, *This Island Earth* was a showcase for special effects. Unusually for a time when most cinematic works of science fiction were "creature features," it was a flamboyant space opera that, although flawed, was nevertheless visually arresting, a color-saturated experience full of sequences that remain engaging to this day.

Based on Raymond F. Jones' 1952 novel, *This Island Earth* was directed by Joseph M. Newman. The story begins when scientist Dr. Cal Meacham (Rex Reason) receives a batch of unusual equipment and instructions to build a machine called an "interocitor." This turns out to be a communications device with a screen on which a man called Exeter appears and tells Meacham that he has passed the test and has thus qualified to join a top-secret research program.

But things aren't what they seem. Arriving with other scientists, including an old girlfriend, Dr. Ruth Adams (Faith Domergue), in Georgia on a computer-flown drone plane, Meacham immediately becomes suspicious. He and Ruth escape with another scientist, Steven Carlson (Russell Johnson), but their car is destroyed and Carlson is killed. After escaping again in a small plane, Meacham and Adams are drawn aboard a flying saucer by tractor beam. Exeter and his odd-looking colleagues are actually aliens; ruthless ones too, who, with Adams and Meacham safely aboard, incinerate the facility and everyone inside it before heading off into space.

The scientists are taken to Exeter's homeworld of Metaluna. The Metalunans are under attack by another alien race, the Zagons, who have been bombarding the planet with meteors. The Earth people were kidnapped to aid the war effort, but Exeter is too late. They arrive to find that the planet's protective atomic shield is failing. The Metalunan leader — The Monitor — decides that his people should head to the Earth, but Meacham and Adams resist this move when it becomes apparent that it will mean colonization of their planet. They flee back home with the dying Exeter, who has by now developed into rather a sympathetic character. Dying, his ship running out of energy, he delivers a memorable speech about the wonders of the universe, before departing and crashing his flying saucer into the sea.

Much of *This Island Earth* is undeniably pedestrian, and the movie contains several glaring scientific inaccuracies — one exploit features a perilous passage through Earth's "Thermic Belt" (no such thing exists). Nevertheless, the film comes into its own, both narratively and imaginatively, in the scenes set on Metaluna, which are as close as cinema ever came to capturing on celluloid the lurid quality depicted on the covers of pulp magazines. Although the twin-brained Metalunan mutant has come to be regarded as something of a cliché, it was ahead of its time.

Steven Spielberg was certainly influenced by *This Island Earth*, which is affectionately referenced in *E.T. the Extra-Terrestrial*. The movie also featured in the SF comedy *Mystery Science Theater 3000: The Movie*, in which the lead characters are forced to watch *This Island Earth* as a form of torture. **GH**

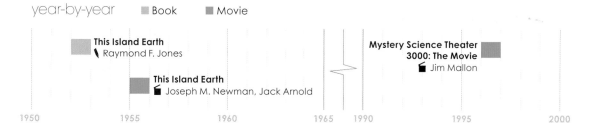

year-by-year ■ Book ■ Movie

This Island Earth
Raymond F. Jones

This Island Earth
Joseph M. Newman, Jack Arnold

**Mystery Science Theater
3000: The Movie**
Jim Mallon

1950 1955 1960 1965 1990 1995 2000

philip k. dick 1952

Beyond Lies the Wub

Solar Lottery

Eye in the Sky

The Man in the High Castle

Martian Time-Slip

Dr. Bloodmoney

The Three Stigmata of Palmer Eldritch

Now Wait for Last Year

Philip K. Dick was born out of his time. One of the most significant science fiction writers of the 20th century, he was also a complex and hugely troubled individual who spent most of his career in near-poverty, yearning for the mainstream recognition that he was destined to receive only after his death.

Born in 1928 in Chicago, Illinois, Dick began his career as a science fiction writer in 1952, at a time when pulp SF magazines were still booming with postwar popularity. He soon developed the knack of speedily writing sharply-crafted short stories based around attention-grabbing "What if?" questions, and produced work at an astoundingly prolific rate, notching up 18 novels and 86 short stories by the end of the 1950s.

On the surface, Dick's writing had all the conventional ingredients of 1950s' science fiction — robots, spaceships and atomic technology — but he gradually found ways of subverting the usual conventions. Using SF as a place to work out his own problems — philosophical as well as emotional — he successfully captured the Cold War paranoia of the times and with it a cult following.

What immediately distinguished the heroes of Dick's stories was that they were not clean-cut, handsome stereotypes — they were determinedly ordinary people manipulated by forces beyond their control, or caught in the gears of soulless corporations and weird conspiracies. Even in his early fiction,

reality was something that could never be entirely trusted, and as his career progressed he explored that concept in greater depth and more expansive detail.

His simultaneous attempts at entering the serious literary world were invariably rebuffed, and as a result almost none of his mainstream work was published in his lifetime. His science fiction, on the other hand, continued growing in popularity, and by 1963 he had won the SF establishment's prestigious Hugo Award for *The Man in the High Castle*, an acclaimed novel of alternate history set in a universe where the Allies lost the Second World War.

During the 1960s, Dick's fiction became darker and more experimental. Among his works of this period are the three daring and multi-layered SF novels *The Three Stigmata of Palmer Eldritch*, *Ubik* and *Do Androids Dream of Electric Sheep?*

However, although his books were attracting more attention, Dick's personal life began running out of control, thanks to a combination of psychological issues and an increasing drug habit (including a lengthy addiction to amphetamines, which he used to fuel much of his incredible writing output).

By 1970 Dick was in his fourth marriage and spending most of his time among criminals and drug addicts. This damaged him personally but provided background material for his bleakly funny 1977 novel *A Scanner Darkly*. Dick's work become even stranger and more paranoid during the early 1970s, and shortly

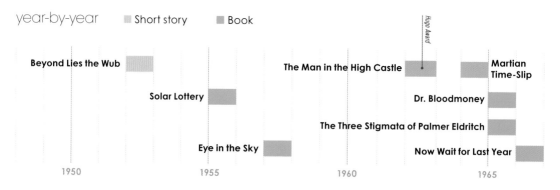

year-by-year ■ Short story ■ Book

Beyond Lies the Wub

Solar Lottery

Eye in the Sky

The Man in the High Castle

Hugo Award

Martian Time-Slip

Dr. Bloodmoney

The Three Stigmata of Palmer Eldritch

Now Wait for Last Year

1950 1955 1960 1965

The Zap Gun | Do Androids Dream of Electric Sheep? | Ubik | Flow My Tears, the Policeman Said | A Scanner Darkly | Valis | The Divine Invasion | Radio Free Albemuth

after his fifth marriage in late 1973, he experienced a mystical event that had a profound effect on his subsequent life.

Between February and March of 1974, Dick claimed to have been contacted by what he described as a "pink beam of light" that resulted in a series of incredibly detailed and lengthy hallucinations, which he interpreted as messages from an entity he named VALIS (Vast Active Living Intelligence System). He processed this event into three semi-autobiographical novels — *Valis*, *The Divine Invasion* and *Radio Free Albemuth* — as well as into an immense amount of nonfiction that was eventually collected in *The Exegesis of Philip K. Dick*.

By the turn of the 1980s, Dick was drug-free but his health was in decline. A movie adaptation of *Do Androids Dream of Electric Sheep?* had finally entered production, but Dick was vociferously critical of the story changes made to what would soon become *Blade Runner*. He was especially opposed to the script's interpretation of the artificial "replicant" characters as tragic supermen. However, when the production team showed him a reel of completed effects shots, Dick was so stunned by the accuracy with which the footage captured what he conceived as the mood of the original novel that he was finally placated.

Dick even started to look forward to the film, but he did not live to see it. He died on March 2, 1982, just over three months before *Blade Runner* was released

in the United States. The film initially disappointed at the box office, but it slowly grew into a cult favorite and eventually became acknowledged as a science fiction classic. It also helped to popularize the work of Dick, and brought the author's skewed and paranoid world-view to a wider audience than ever before.

Meanwhile, Dick's fiction gradually gained the critical recognition he'd always craved, and the ideas he expressed in his stories started working their way into the wider world, whether through authors who were directly influenced by his work (including Jonathan Lethem and Neal Stephenson), or through increasingly frequent movie adaptations.

To begin with, many of the latter simply used Dick's short stories as jumping-off points for action adventure blockbusters such as *Total Recall* (1990), but later films such as *The Truman Show*, *Dark City* and *The Matrix* tapped into the same paranoid uncertainty and questioning of reality that were the unmistakable hallmarks of Dick's finest work.

Dick's literary legacy is ultimately best represented by the fact that despite the technology of his science fiction having dated and his "distant futures" of years like 1992 having come and gone, his weird and inventive stories feel more powerful and relevant than ever. In the words of Terry Gilliam, director of *Brazil*: "For everyone lost in the endlessly multiplicating realities of the modern world, just remember: Philip K. Dick got there first." **SB**

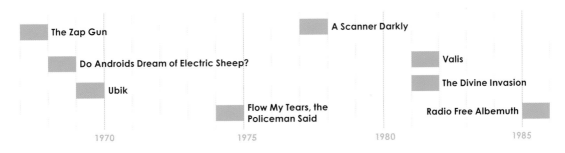

The Zap Gun
Do Androids Dream of Electric Sheep?
Ubik
Flow My Tears, the Policeman Said
A Scanner Darkly
Valis
The Divine Invasion
Radio Free Albemuth

1970 1975 1980 1985

Blade Runner
(1982)

Total Recall
(1990)

Screamers
(1995)

Minority Report
(2002)

Paycheck
(2003)

A Scanner Darkly
(2006)

Total Recall
(2012)

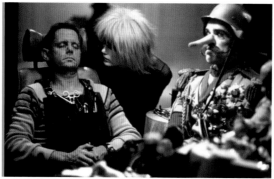

Designer William Sanderson meets replicant Daryl Hannah in *Blade Runner* (1982).

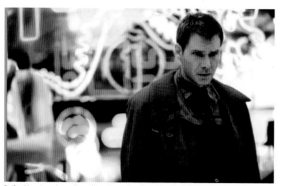

Retired Los Angeles police officer-turned-replicant hunter Rick Deckard (Harrison Ford) in *Blade Runner*.

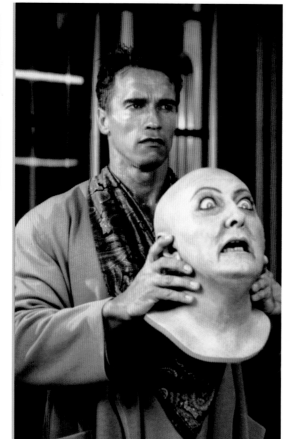

In *Total Recall*, Arnold Schwarzenegger realizes that he is not who he thought he was, and travels to Mars in search of explanations of his predicament.

Arnold Schwarzenegger and Sharon Stone in *Total Recall*, based on Dick's "We Can Remember It for You Wholesale."

Jennifer Rubin (*Nightmare on Elm Street 3*) and Peter Weller (*Robocop*) in *Screamers* (1995).

Based on Dick's "Second Variety," *Screamers* (1995) is set on the planet Sirius 6B in the year 2078.

Minority Report (2002), directed by Steven Spielberg and starring Tom Cruise, is based on a Dick story of the same name.

Ben Affleck and Uma Thurman in John Woo's version of Dick's 1953 short story **Paycheck** (2003).

Thurman's character ends up winning $90 million, almost as much as **Paycheck** took at the box office.

A Scanner Darkly was shot like a normal movie. The footage was then turned into animation by drawing over it.

The 2012 remake of **Total Recall**, starring Colin Farrell, is regarded as inferior to the original movie.

In the **Total Recall** remake, Doug Quaid (Colin Farrell) is less than happy when he discovers that Mrs. Quaid (Kate Beckinsale) is a secret agent merely posing as his wife.

alfred bester 1952

SFWA
GRANDMASTER

The Demolished Man

The Demolished Man

Fondly Fahrenheit

The Stars My Destination

The Stars My Destination

The Four-Hour Fugue

The Computer Connection

Born in New York in 1913, Alfred Bester was in his time a prolific writer of comics, radio scripts and screenplays, but is best known today for his relatively small output of science fiction.

His first published work, "The Broken Axiom," appeared in *Thrilling Wonder Stories* in 1939. He published SF shorts for a while but then advanced into more lucrative fields. During the 1940s he worked on such titles as *Superman*, *Batman* and *The Green Lantern*. Later he moved to radio, working on *The Shadow*, among many other shows.

In the 1950s he returned to science fiction proper, beginning a brief but intense period of artistic experimentation that dazzled the SF world. Of the short stories produced in that time, most notable is perhaps "Fondly Fahrenheit," the story of a man and his homicidal robot servant who flee across worlds as their personalities become intertwined. Dazzlingly written, it exhibits Bester's interest in psychoanalysis, and uses the same intricate, baroque setting that characterizes his two great novels: *The Demolished Man* (1953) and *The Stars My Destination* (1956). The latter was an early precursor to cyberpunk, and a major influence on William Gibson's seminal 1984 novel, *Neuromancer*.

The Demolished Man, which won the very first Hugo Award, is the story of a murder committed in a world of telepaths (called "espers" or "peepers" in the novel). It is an inverted detective story, in which the identity of the murderer is known, and the story

concerns the perpetuation of the "perfect crime" and the subsequent attempt to catch — and then to cure — the killer. Ben Reich is a businessman consumed with jealousy of an older rival, D'Courtney, who offers a merger (but which Reich interprets as a hostile takeover). He hires a telepath to mask his murderous intention, and commits the murder during a glittering society party and partial orgy. The murder, however, is witnessed by D'Courtney's daughter, Barbara, who escapes, though she is deeply traumatized. Powell, a top police detective and "esper," chases Reich across the solar system as Reich, in turn, chases Barbara. When Powell finally catches Reich, he forces him to undergo a "Mass Cathexis Measure" — a telepathic virtual reality simulation designed to delve deep into his subconscious. The resultant investigation reveals that D'Courtney was Reich's father (and Barbara, therefore, Reich's half-sister). Reich is sentenced to "demolition" — the removal of all his memories.

It is an innovative novel that uses variant typography for passages of telepathic "conversation" and focuses on the inner lives of its characters despite the grand, baroque background of the world in which it is set. Bester's later novel were less successful, but his influence over a generation of SF writers — including Samuel Delany, Michael Moorcock and William Gibson — is profound. Along with *The Stars My Destination*, *The Demolished Man* remains, as Peter Nicholls has written, "among the few genuine classics" of science fiction. **LT**

year-by-year ■ Short story ■ Book

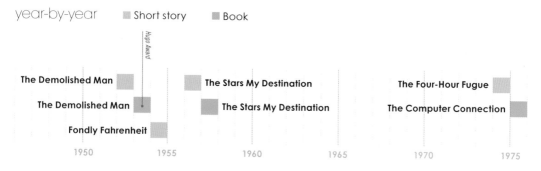

Hugo Award

The Demolished Man

The Demolished Man

Fondly Fahrenheit

The Stars My Destination

The Stars My Destination

The Four-Hour Fugue

The Computer Connection

1950 1955 1960 1965 1970 1975

james blish 1953

A Case of Conscience

They Shall Have Stars

The Seedling Stars

A Case of Conscience

Galactic Cluster

Doctor Mirabilis

Black Easter

The Day After Judgement

One of the few works of science fiction overtly concerned with Christian theology, *A Case of Conscience* is at once a masterful piece of world-building and a satisfying ontological puzzle.

Jesuit priest and biologist Ramon Ruiz-Sanchez is part of a four-man team sent to the planet Lithia to assess whether its native population is ready for full human contact. One of his colleagues, the physicist Cleaver, is eager to exploit the world for lithium with which to make nuclear weapons. This would devastate Lithia and its society, so the others are more cautious. Ruiz-Sanchez then shocks his colleagues by stating that, because Lithia appears to be a perfect world with no crime or disharmony, and rational and peaceful but without the presence of God, it must be a construct of Satan with which to tempt humankind to deny the existence of the Almighty. Lithians are therefore instruments of evil, and as such should be quarantined.

But Ruiz-Sanchez is fond of the Lithians, especially his friend Chtexa, who reveals a great deal about the secretive Lithian culture to Ruiz-Sanchez. When he departs, he agrees to take the egg of Chtexa back to Earth where he can be raised as an Earthman. The egg hatches into Egtverti, who grows into adulthood to cause extreme social discord in Earth's overcrowded, underground cities before he escapes back to Lithia. Ruiz-Sanchez, meanwhile, is censured by the church, primarily for his flirtation with Manichaeism, but also for oversight: why did he not simply exorcise the

planet? Events conspire to draw Cleaver back to Lithia, where an experimental reactor threatens to detonate the lithium-laced world. Ruiz-Sanchez performs his exorcism, at the exact moment that Cleaver's reactor goes critical. Lithia is destroyed, and the reader is left to ponder whether Ruiz-Sanchez was correct and his exorcism was successful, or whether he, and by extension his religion, are simply deluded.

Blish touched on similar themes in other works, and eventually declared *A Case of Conscience* to be part of loose, thematic trilogy about the dangers of wisdom named "After Such Knowledge."

James Blish was born in 1921. He was a member of the Futurians, a group of 1930s' SF fans, many of whom became writers or editors. He was a biologist by training, and only later became a full-time writer. Among his other famous works are *The Cities in Flight* novels, which deal with the effects of an anti-aging drug, and "The Haertel Scholium," a space opera that stretches over thousands of years of future history. His most famous story cycle is *The Seedling Stars*, four short stories set in a universe where humankind is altered via pantropy to fit the environments it finds in the cosmos. Blish is also credited with coining the term "gas giant" in a 1952 revision of his 1941 story "Solar Plexus."

Blish penned much science fiction criticism, often under the name William Atheling Jr., and at the end of his career completed 11 offical *Star Trek* episode novelizations. The twelfth, unfinished at his death in 1975, was subsequently completed by his widow. **GH**

year-by-year ▨ Short story ▪ Book

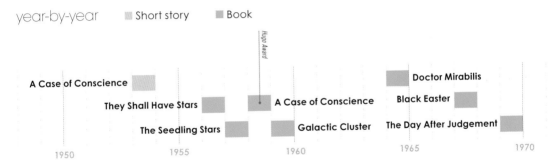

Hugo Award

A Case of Conscience

They Shall Have Stars

The Seedling Stars

A Case of Conscience

Galactic Cluster

Doctor Mirabilis

Black Easter

The Day After Judgement

1950 1955 1960 1965 1970

jack arnold 1953

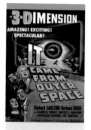

It Came from
Outer Space

Creature from the
Black Lagoon

Tarantula

Revenge of the
Creature

Science Fiction
Theatre

The Incredible
Shrinking Man

In the United States the 1950s was a turbulent decade of paranoia. Many people kept one eye on outer space — they dreamed of putting a man on the Moon and worried about unidentified flying objects such as the one that reputedly crashed at Roswell, New Mexico, in 1947 — and the other on their neighbors and work colleagues, any or all of whom they feared might be Communist infiltrators.

Perhaps no film director better reflected the mindset of the nation in his work than Jack Arnold. Throughout a prolific career, Arnold combined high-concept, pulpy thrills with the concerns of cinemagoers all over the country.

Born in New Haven, Connecticut, in 1916, Arnold started out as a stage actor on Broadway. After serving in the Second World War, he went into movies and directed a series of factual film shorts, one of which — *With These Hands*, about the working conditions in a garment factory — was nominated in 1950 for an Oscar for Best Documentary Feature (the award went to a film about Thor Heyerdahl).

The turning point in his career came in 1953, when he directed both the B-movie thriller *Girls in the Night* and the first of his SF masterworks, *It Came from Outer Space*. With its alien beings disguised in human form, the latter gives expression to the prevailing mood of distrust, especially in the character of the anxious,

intolerant police chief, who exclaims: "They could be all around us and I wouldn't know it!" But at the same time the film preaches a message of tolerance, as the aliens are relatively benign, leaving the residents of a small town in Middle America unscathed but with a new understanding of their own place in the universe.

Arnold followed this a year later with the film noir *The Glass Web* and in 1954 the cult classic *Creature from the Black Lagoon*, a monster adventure that follows a group of scientists who stumble upon what may be the missing link in the evolutionary chain.

Arnold's traditional framing and blocking experience from his theater days is apparent in the somewhat stilted character interactions, but this can be completely forgiven as the film gave popular culture "Gill-man," one of the classic Universal Studios monsters. What the film lacks in rhythm and subtlety above the water is more than compensated for by the stunning underwater sequences of the monster; the stalking scene featuring Gill-man and heroine Kay is the highlight of the film and a beautiful, otherworldly moment in SF cinema.

Creature from the Black Lagoon takes the story of *King Kong* (1933) and updates it to the 1950s and a postwar climate, with characters torn between a desire for progress and a newfound respect for the fragility of the Earth. The theme of the brutality

year-by-year ■ Movie ■ TV series

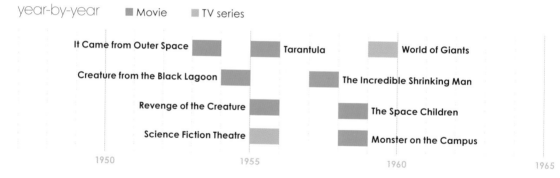

It Came from Outer Space Tarantula World of Giants

Creature from the Black Lagoon The Incredible Shrinking Man

Revenge of the Creature The Space Children

Science Fiction Theatre Monster on the Campus

1950 1955 1960 1965

The Space Children

Monster on the Campus

World of Giants

Wonder Woman

The Bionic Woman

Buck Rogers in the 25th Century

and harshness of humankind is hammered home, somewhat heavily, but this underlying seriousness of purpose elevates the work above simple monster movies such as its less inspired sequels, the first of which, *Revenge of the Creature* (1955), was also directed by Arnold.

Following the trend of giant monster adventures, such as *Mesa of Lost Women* (1953) and *Them!* (1954), Arnold released *Tarantula* in 1955. Adapted from a Ray Bradbury story, this movie depicts townsfolk defending themselves from a giant spider. The creature is the result of a science experiment and, as with so many SF monsters — from *Godzilla* (1954) to the dinosaurs in *Jurassic Park* (1993) — it is only human interference that has made the beast dangerous.

Arnold used state-of-the-art matte effects to create a sense of scale between the giant creature and the humans, a technique he would adopt again to even greater effect in his crowning achievement, *The Incredible Shrinking Man* (1957). This film united Arnold with another master of science fiction, writer Richard Matheson. Together they created an incisive metaphor for masculinity challenged by social change. After exposure to nuclear contamination, Scott Carey (played by Grant Williams) begins to shrink. He is dwarfed by all around him, his home and his possessions, and threats await him in

his increasingly vulnerable state. The process is irreversible and gradually his place in the world dissolves into nothing. The film is an SF classic, working hard to gain viewers' empathy before thrilling them with startling sequences, such as the hero defending himself against a giant spider and a giant cat. Throughout, the tone was Arnold's typical mix of earnestness and Saturday-matinée-style adventure.

Further science fiction films followed, including *Monster on the Campus* (1958) and *The Space Children* (1958), as well as the Western *No Name on the Bullet* (1959) and *The Mouse That Roared* (1959), a comedy starring Peter Sellers in three roles. Arnold then segued from his distinguished film work into a successful career in television. Like his era-defining films, his TV shows featured everyman figures in extraordinary circumstances, with exciting, character- and plot-driven episodes of *The Hardy Boys*, *Gilligan's Island*, *Rawhide*, *Perry Mason* and *Wonder Woman*. As American as the stars and stripes, Arnold even directed 15 episodes of *The Brady Bunch*.

After another few films, among them *Black Eye* (1974) and *The Swiss Conspiracy* (1977), two of Arnold's final directing credits were for television episodes of *Buck Rogers in the 25th Century*. It seems appropriate that he should have ended his career back in the genre that made his reputation. **SW**

Wonder Woman

The Bionic Woman

Buck Rogers in the 25th Century

1965 1970 1975 1980

It Came from Outer Space (1953)

Creature from the Black Lagoon (1954)

Revenge of the Creature (1955)

Tarantula (1955)

The Incredible Shrinking Man (1957)

Wonder Woman (1977)

The Bionic Woman (1978)

Unusually for the time, *It Came from Outer Space* featured aliens that were distinctly nonhumanoid in form.

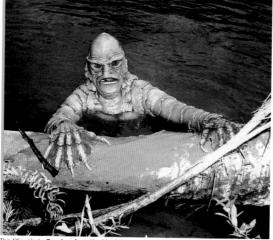

The title role in *Creature from the Black Lagoon* was played by Ben Chapman on land and Ricou Browning underwater.

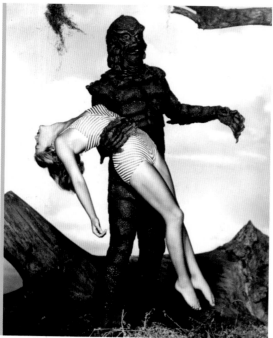

Revenge of the Creature from the Black Lagoon was less successful than the original, but is still of interest to Arnold completists.

The townspeople are terrified at first, but *It Came From Outer Space* turns out better than they feared.

The effects in *Tarantula* mixed footage of real spiders with puppets.

The bugs in *Them!* were not as convincing as Arnold's awesome arachnid.

Domestic pet turns potential killer in *The Incredible Shrinking Man*.

A problem magnified in *The Incredible Shrinking Man*.

Wonder Woman (Lynda Carter) shows her skateboarding prowess in the 1970s' TV series.

Lindsay Wagner in an Arnold-directed episode of *The Bionic Woman* TV series.

The Bionic Woman's enhanced legs enabled her to run at speeds of over 60 miles per hour (97 kph).

quatermass 1953

The Quatermass Experiment

Quatermass II

The Quatermass Xperiment

Quatermass 2

Quatermass and the Pit

Quatermass and the Pit

Quatermass

The Quatermass Experiment

The Quatermass Experiment, broadcast by the BBC in July 1953, was the first ever original science fiction television serial for adults.

The story began with the launch of a manned spacecraft by the British Experimental Rocket Group, led by Professor Bernard Quatermass. The rocket returns safely, but without two of its astronauts; the lone survivor mutates into a plant-like creature that threatens life on Earth. Quatermass electrocutes the monster in a tense climax in Westminster Abbey.

Broadcast live in six episodes, Nigel Kneale's serial gripped the nation and was swiftly remade as a feature by Hammer Films with a tweaked title — *The Quatermass Xperiment* — to emphasize its adult content (X-certificate films were at the time restricted in Britain to over-16s); in the United States it was known as *The Creeping Unknown*. This was fortunate for posterity as only the first two television episodes were recorded.

In 1955, the follow-up on television, *Quatermass II*, Quatermass becomes suspicious about a secret factory that purports to be producing artificial food but which resembles his own designs for a moonbase. On investigating, he uncovers zombie-like, alien-controlled workers and a conspiracy that goes to the highest levels of the British government. Hammer's 1957 film version was retitled *Enemy from Space* for the United States.

In 1958, Kneale revived his greatest fictional creation for *Quatermass and the Pit*, in which work on an underground railway station in London uncovers an ancient spacecraft containing long-dead, insectoid Martians. Quatermass' investigations reveal that the human race was genetically altered by these aliens and that the psychic after-effects of this explain ghosts, witchcraft and other manifestations of evil.

Hammer, now focusing on gothic horror, took eight years to adapt *Quatermass and the Pit* (U.S. title: *Five Million Years to Earth*). It was another 12 years before the final TV serial, a four-part production originally entitled simply *Quatermass*, but also released as a feature-length edit, *The Quatermass Conclusion*, and as a novel. In this near-future tale, a retired Professor Quatermass battles an alien force that is harvesting young people through a New Age cult. A 1996 radio serial *The Quatermass Memoirs* combined newly written sections in which the Professor is interviewed by a journalist with archive news material and an interview with Kneale himself.

Kneale's other work includes the movie *First Men in the Moon* (1964), and for TV a twice-produced adaptation of *Nineteen Eighty-Four* (1954/1965) and *The Year of the Sex Olympics* (1968). *Kinvig* (1981), a sitcom inspired by Kneale's dislike of sci fi fans, was a flop. In 2005, *The Quatermass Experiment* was remade by the BBC as a two-hour live television drama. **MJS**

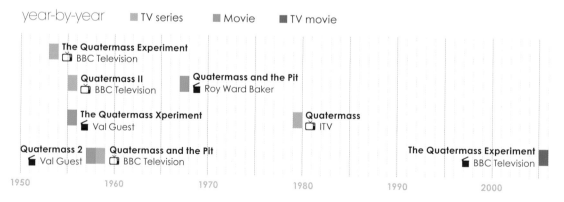

year-by-year ■ TV series ■ Movie ■ TV movie

The Quatermass Experiment
BBC Television

Quatermass II
BBC Television

Quatermass and the Pit
Roy Ward Baker

The Quatermass Xperiment
Val Guest

Quatermass
ITV

Quatermass 2
Val Guest

Quatermass and the Pit
BBC Television

The Quatermass Experiment
BBC Television

1950 1960 1970 1980 1990 2000

i am legend 1954

I Am Legend

The Last Man on Earth

The Omega Man

I Am Legend

I Am Legend

I Am Legend: Awakening

I Am Omega

A disease has swept across the world, killing billions and turning the survivors into murderous nocturnal creatures. Robert Neville is the last man on Earth. By day he searches a desolate Los Angeles, scavenging for food and equipment; by night he barricades himself in his fortified house and fends off the vampire-like hordes. The future looks hopeless, until Neville begins working to find a cure.

I Am Legend was written by legendary science fiction author and screenwriter Richard Matheson. The story is a response to our times, with Neville's existential dread a perfect metaphor for the sprawling soullessness of contemporary Los Angeles.

The novel divests vampires of their gothic trappings, and exhibits a psychological depth and sharp social commentary that distinguish it from previous works in the genre.

Matheson takes care to ground the vampires' behavior in science, and takes a practical look at the dystopian world. The vampires are repelled by garlic, mirrors and crosses, but they do so as a result of conditioning — their responses are learned and Pavlovian rather than supernatural. Like all Matheson's protagonists, Neville is a credible hero with whom readers can readily empathize. He is just a lonely man doggedly clinging to everyday habits such as maintaining his truck, while the antagonists who now rule the world wait for their chance to strike. Neville is outdated, the last relic of a soon-to-be-eradicated race, and as such taps into our fears of irrelevance.

The three films that have been made using the novel as source material all have some merit but none is true to the original. The Last Man on Earth (1964), a straightforward horror movie starring Vincent Price, misses the book's emotion. In The Omega Man (1971), Charlton Heston is a perfect Neville, and the creepy, palefaced nightwalkers are closer to the novel's cunning villains, but the movie has dated badly. In the late 1990s various studios tried to get new film adaptations before the cameras, most famously an Arnold Schwarzenegger iteration directed by Ridley Scott. Francis Lawrence and Will Smith were finally the duo to get it made, and their I Am Legend (2007) is an attempt to balance scale and emotion, although relocating the setting to New York loses the bleakness of an empty City of Angels. Its weakest link is the depiction of the villains: the patchy CGI vampires are bereft of the personality and motivation of those in the novel, and a happy ending for humanity is proposed. By devaluing the monsters in this way the ultimate meaning of the title is lost.

I Am Legend is Matheson's crowning achievement. The novel has exerted a vast influence on "The Last Man" sub-genre and zombie fiction, as well as on post-apocalyptic scenarios in general and the rationalization of vampires for SF settings. Among the works that are demonstrably indebted to I Am Legend are the movies Night of the Living Dead (1968) and 28 Days Later (2002), and Stephen King's novel The Stand (1978). **SW**

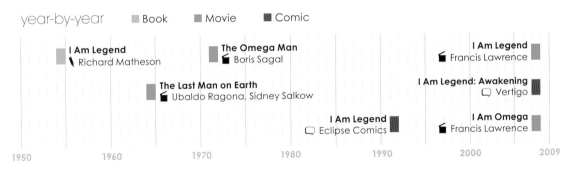

year-by-year ■ Book ■ Movie ▥ Comic

I Am Legend
Richard Matheson

The Last Man on Earth
Ubaldo Ragona, Sidney Salkow

The Omega Man
Boris Sagal

I Am Legend
Eclipse Comics

I Am Legend
Francis Lawrence

I Am Legend: Awakening
Vertigo

I Am Omega
Francis Lawrence

1950 1960 1970 1980 1990 2000 2009

godzilla 1954

Godzilla

Godzilla, King of the Monsters

King Kong vs. Godzilla

Mothra vs. Godzilla

Godzilla

Godzilla 1985

Godzilla

Godzilla: Final Wars

Comprising 28 films over 50 years, the Godzilla series from Japan's Toho Studios is the most prolific SF cinema franchise of all time. The first film, directed by Inoshiro Honda, was part of the 1950s' vogue for giant monsters. Hollywood favored Ray Harryhausen's stop-motion, but Toho went for a stunt performer in costume ("suitmation").

In the original movie, the giant bipedal reptile Gojira is awakened by an A-bomb test and lays waste to rural and urban Japan. Less than a decade after Hiroshima and Nagasaki, the subtexts were obvious.

American producers re-edited the film for U.S. release, splicing in new footage of Raymond Burr as a newspaper reporter. This version, *Godzilla, King of the Monsters*, was so successful that it was re-imported into Japan. A hasty follow-up pitted Godzilla against another giant monster, Angilas. Long derided for its cheapness, the third film, *King Kong vs. Godzilla*, was re-evaluated by critics in North America and Europe when they discovered that in its original language it had been a comedy.

It was *Mothra vs. Godzilla*, a sequel to *Mothra* (1961), that really established the format for the *kaiju eiga* genre: giant monsters in conflict, massive collateral destruction and a human drama subplot. Godzilla films were produced almost annually until the mid-1970s, each on a tighter budget than its predecessor (although the common misperception of "suitmation" films as z-grade trash owes more to

Japanese children's TV than to these relatively high-profile features). Honda directed a further seven Godzilla films; Jun Fukuda directed five.

The first (Showa) series of films ended in 1975, and it was nearly a decade before Godzilla returned. In the meantime, a cheap U.S. cartoon series further cemented the Western view of the character as suitable only for children. Roger Corman acquired *The Return of Godzilla*, a sequel to the 1954 film which ignored the 14 previous sequels and cannily hired Raymond Burr to recreate his reporter character in new footage. But it was not a hit and subsequent titles went straight to video in the West. This second (Heisei) series of films ran to seven pictures with better effects and more complex storylines, some rather obviously cribbed from recent hits such as *The Terminator*.

Hollywood's own attempt at Godzilla, from the *Independence Day* team of Dean Devlin and Roland Emmerich, was adequate, but the monster lacked the character and charm of the original; fans dubbed it GINO (Godzilla In Name Only). A spin-off cartoon series was better received.

Toho's third (Millennium) series of six films supplemented the suits and miniatures with CGI, and once again ignored all the post-1954 films. Shusuke Kaneko, who had revitalized the Gamera series for rival studio Daiei, directed one picture, and Ryuhei Kitamura, director of cult zombie film *Versus*, helmed the final, 50th anniversary monsterfest. **MJS**

year-by-year ■ Movie ■ Animated TV series

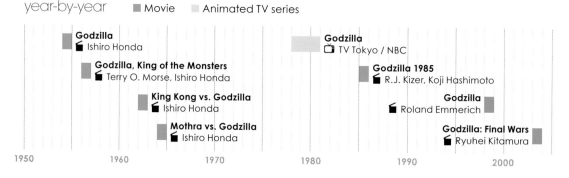

Godzilla
Ishiro Honda

Godzilla, King of the Monsters
Terry O. Morse, Ishiro Honda

King Kong vs. Godzilla
Ishiro Honda

Mothra vs. Godzilla
Ishiro Honda

Godzilla
TV Tokyo / NBC

Godzilla 1985
R.J. Kizer, Koji Hashimoto

Godzilla
Roland Emmerich

Godzilla: Final Wars
Ryuhei Kitamura

1950 1960 1970 1980 1990 2000

brian aldiss 1954

Criminal
Record

Space,
Time and
Nathaniel

Non-Stop

Hothouse

Super-Toys
Last All
Summer Long

The Hand-
Reared Boy

Frankenstein
Unbound

Helliconia
Spring

Brian Aldiss is one of the leading lights of British science fiction. He is the winner of two Hugo Awards, one Nebula Award and one John W. Campbell Memorial Award.

Born in 1925, he served in the British army's Royal Corps of Signals in Burma during the Second World War. At the end of the conflict he returned home and worked in a bookshop, which provided him with material for his first novel, *The Brightfount Diaries*, which was published in 1955.

Since then he has written works in a wide variety of genres, including eight volumes of poetry, a travel book about his beloved Yugoslavia (*Cities and Stones*), autobiography (*Bury My Heart at W.H. Smith's: A Writing Life*) and two celebrated works of criticism — *Billion Year Spree: A History of Science Fiction* (1973) and its updated version, *Trillion Year Spree* (1988). Nevertheless, it is for his prolific output of novels that he will be best remembered.

Some of his fiction is mainstream — an outstanding example is *Walcot* (2010), a dreamlike, picaresque family saga. But his greatest achievements are his numerous science fiction novels, which are written in a wide range of different styles. Key among these are *Hothouse* (1962), set on a future Earth that has stopped revolving, and so has become a vast decaying tropical forest populated by elvish humans; *Greybeard* (2012), in which humans have become sterile; and the Helliconia Trilogy (starting with

Helliconia Spring), which tells of the rise and fall of a civilization, battered by environmental change, on an Earth-like planet where the seasons last for centuries. Other series include the Horatio Stubbs saga, which begins with *The Hand-Reared Boy* (1970), about a young man's sexual awakening, and The Squire Quartet — *Life in the West*, *Forgotten Life*, *Remembrance Day* and *Somewhere East of Life* (from 1982) — contemporary novels with a science-fiction edge.

Several Aldiss books have been filmed, including *Brothers of the Head* (book 1977, film 2006), about conjoined twins who become rock stars, *Frankenstein Unbound* (book 1982, film 1990) and the short story "Super-Toys Last All Summer Long" (1969), which spawned the Stanley Kubrick/Steven Spielberg project *AI: Artificial Intelligence* (2001).

The best of Aldiss' work is massively inventive, relentless in pursuit of its implications and abounding in vivid detail. His world-building is ambitious and almost everywhere in evidence — witness the descriptive passages in *Hothouse*, which powerfully evoke the untamed jungles that conceal a man who has "retired to the trees from whence he came"; and the vast span of time covered by the artistically audacious Helliconia cycle. Aldiss is technically bold too: the last survivors in *Hothouse* are closer to monkeys than human beings, but he draws the reader into empathizing with a mindset that has been rendered almost feral by extreme circumstances. **HG**

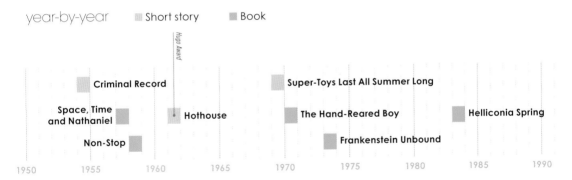

year-by-year Short story Book

Hugo Award

Criminal Record

Space, Time and Nathaniel

Non-Stop

Hothouse

Super-Toys Last All Summer Long

The Hand-Reared Boy

Frankenstein Unbound

Helliconia Spring

1950 1955 1960 1965 1970 1975 1980 1985 1990

robert silverberg 1954

SFWA
GRANDMASTER

Gorgon Planet

Revolt on Alpha-C

Master of Life and Death

Thorns

Nightwings

Tower of Glass

Lord Valentine's Castle

Roma Eterna

Robert Silverberg is a prolific author who has written hundreds of works of science fiction, fiction and nonfiction under his own name and numerous pseudonyms. He claimed that at the height of his productivity he wrote one million words a year.

Silverberg's career can be divided into three main phases. His first published story, "The Sacred River," appeared in *Avalonian* magazine in 1952. His first novel, *Revolt on Alpha-C*, appeared in 1955, after which he specialized almost exclusively in science fiction. In 1956 he published 49 short stories in this genre, and another 80 in 1958. His talent was swiftly recognized with a Hugo for Most Promising New Writer.

Much of his work to this point had been workaday, but now increasingly there began to appear occasional glimpses of greater potential. There are hints of what was to come in *Master of Life and Death* (1957), which dealt with overpopulation, and in the Nidor series, based on previously published short stories, which examined the "uplift" of aliens by visitors who turn out to be humans.

This first phase lasted until 1959, when Silverberg abandoned SF for a while owing to the decline of the pulp magazine market. However, he continued to write, publishing the first of his carefully researched nonfiction books. In the late 1960s, encouraged by Frederick Pohl and a sea change in the literary ambitions of the genre, he returned to his roots and entered the most notable phase of his career. Starting in 1967, he produced some of the most elegantly

written and intellectually powerful science fiction ever published. He ranged so far and wide across the genre that his works are difficult to pigeonhole, although alienation is a recurrent theme throughout.

Among the best of the 23 novels Silverberg wrote during this period are *Thorns* (1967), which tells of strange love and psychic vampirism; *Nightwings* (1969), which details a future Earth under attack; *Tower of Glass* (1970), which reimagines the Tower of Babel in a science fiction setting; and *Downward to the Earth* (1970), a wonderful variation on the theme of Joseph Conrad's *Heart of Darkness*. These works reveal the author at the height of his powers. The spare but stunningly evocative prose bears comparison with the best of Ray Bradbury and Harlan Ellison.

This remarkable burst of creativity continued until 1976, when Silverberg's house burned down and the author — now in poor health, probably exhausted by his recent output and angry that so many of his works were no longer in print — stopped writing.

But this was an interval, not a finale. Silverberg returned in 1980 with *Lord Valentine's Castle*, the first volume of an epic science fantasy series set on a world much larger than Earth that had been colonized by multiple species. Later came *Roma Eterna* (2003) an alternative history, and The New Springtime trilogy (from 1990), about a world where an ice age is coming to an end. Silverberg has also edited numerous anthologies during his career. He is a great writer who deserves wider recognition. **GH**

year-by-year ▪ Short story ▪ Book

Gorgon Planet

Revolt on Alpha-C

Master of Life and Death

Thorns

Hugo Award

Nightwings

Tower of Glass

Lord Valentine's Castle

Roma Eterna

1950 1955 1960 1965 1970 1975 1980 1985 2000 2005 2010

harlan ellison 1955

SFWA GRANDMASTER

"Repent, Harlequin!" Said the Ticktockman

I Have No Mouth, And I Must Scream

Dangerous Visions

The Beast That Shouted Love at the Heart of the World

Again, Dangerous Visions

The Deathbird

Adrift Just Off the Islets of Langerhans

Babylon 5

"If you call me a science fiction writer in this story, I'll find you and tear out your liver," Harlan Ellison told the *Starlog* interviewer who told him that he had been picked in 1985 as one of the magazine's 100 Most Important People In Science Fiction. He then said that he didn't trust *Starlog* because it sucked up to the movie industry. That is Ellison in a nutshell: outspoken, controversial and, above all, brutally honest.

But that's not all; he is also a dreamer, a poet, a scathing satirist and a dark story-spinner. To those not familiar with his work, he's probably most notorious for taking others to court for infringing upon his creations, most notably James Cameron when *The Terminator* seemed eerily similar to "Soldier," one of the episodes Ellison had written for *The Outer Limits* TV series. Ellison won the case, and is now credited in the movie.

Ellison was born in Cleveland, Ohio, in 1934 and spent much of his youth running away from home and seeking excitement; he joined a traveling carnival when he was just 13. In 1953 he was thrown out of Ohio State University after a disagreement with a professor who told him he couldn't write. He then moved to New York and began to write for numerous publications, taking his work so seriously that he joined a Brooklyn street gang for background research.

Ellison then moved to Hollywood and began writing screenplays, first for a film, *The Oscar* (1966),

and then for TV shows such as *The Man From U.N.C.L.E.* and *The Alfred Hitchcock Hour*. His most acclaimed small-screen script was for *Star Trek*: "The City On The Edge Of Forever" — in which Captain Kirk travels back in time to 1930s' America and falls in love with a woman who can change the course of history — won a Hugo Award and is widely regarded as the best episode in the original series.

Ellison has always courted controversy and describes himself as "possibly the most contentious person on Earth." He was hired to work at Walt Disney Studios but fired on his first day after Roy Disney overheard him saying that the company should make a porn film. He had a row with Frank Sinatra that was recounted by Gay Talese in *Esquire* magazine. He resigned from the revamped version of *The Twilight Zone* after objecting to CBS interfering with an episode he had written. He claimed that the movie *In Time* (2011) stole from his story "'Repent, Harlequin!' Said The Ticktockman" (the lawsuit was later withdrawn). He has a pseudonym to use on works that are altered or edited without his approval: Cordwainer Bird.

Ellison has written more than 75 books, 1,700 stories and two dozen teleplays. His works have been made into films, comic books and computer games. He has even written his own epitaph: "For a brief time I was here; and for a brief time I mattered." **JN**

year-by-year — Short story ■ Book ■ TV series

"Repent, Harlequin!" Said the Ticktockman

I Have No Mouth, And I Must Scream

Dangerous Visions

The Beast That Shouted Love at the Heart of the World

Adrift Just Off the Islets of Langerhans

The Deathbird

Again, Dangerous Visions

Babylon 5

Nebula Award / Hugo Award / Hugo Award / Hugo Award / Hugo Award / Hugo Award

1960 1965 1970 1975 1980 1985 1990 1995

invasion of the body snatchers 1955

The Body
Snatchers

Invasion of
the Body
Snatchers

Invasion of
the Body
Snatchers

Body
Snatchers

The Invasion

Invasion of
the Pod
People

Penned by Jack Finney, this nightmarish story of alien invasion first appeared in written form in 1955. *The Body Snatchers* tells of an endangered interplanetary race that arrives on Earth, replacing sleeping humans with perfect physical duplicates grown from plantlike pods. These replicants have only a five-year lifespan, so when all human life has been taken the aliens must move on to new worlds in order to survive. In the face of widespread local resistance, however, the invaders decide that Earth is not the place for them.

Widely received as little more than an enjoyable piece of pulp fiction, producer Walter Wagnal and director Don Siegel brought their own cinematic adaptation to the screen just one year after the story was first published. Scripted by film noir veteran Daniel Mainwaring, *Invasion of the Body Snatchers* alters both the tone of the original tale and the intent of the aliens, whose aim is now to dominate permanently their new environment, and this time with only a small number of humans — led by the tenacious Dr. Miles Bennell (Kevin McCarthy) — aware of what is really transpiring. Told in flashback, the ambiguous ending leaves the audience uncomfortably uncertain as to the future of mankind.

Released in 1956, *Invasion of the Body Snatchers* was regarded by some critics as a satirical attack on McCarthyism, with its obedient citizens refusing to acknowledge the threat of an attacking "other" on their doorstep. Some, however, viewed the film as mediating the horrors of communism: exemplified by the unquestioning conformity and mental slavery that befalls American citizens when faced with this menacing new regime.

Invasion of the Body Snatchers was revisited with great success in 1978 by director Philip Kaufman, with an impressive cast that included Donald Sutherland, Brooke Adams, Leonard Nimoy and Jeff Goldblum. With higher production values — as well as some gruesome special effects — this update is frequently cited as a rare example of a genre remake that honors the memory of its predecessor while being a worthwhile movie in its own right.

A third adaptation of the story came in 1993 from cult auteur Abel Ferrara. Boasting the most tenuous link with the original novel, *Body Snatchers* follows a teenage girl (played by Gabrielle Anwar) whose stepmother (Meg Tilly) is possessed by the alien strangers. Co-scripted by cult favorite Larry Cohen (*Q, the Winged Serpent*), the film's anti-military undertones perhaps indicate the changing political concerns of the post Cold War period.

The most recent take on Finney's original story was *The Invasion* (2007). Helmed by Oliver Hirschbiegel (*Downfall*) and starring A-list actors Daniel Craig and Nicole Kidman, this stylish variation on the theme was both a commercial and critical disaster. To coincide with its release, the Asylum, the notorious "mockbuster" production house, unleashed its own direct-to-DVD cash-in, entitled *Invasion of the Pod People*. It was predictably awful. **CW**

year-by-year ■ Book ■ Movie

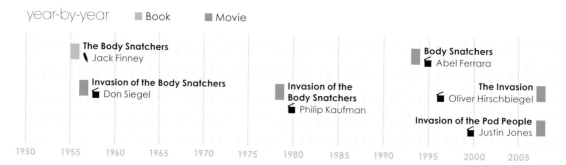

The Body Snatchers
Jack Finney

Invasion of the Body Snatchers
Don Siegel

Invasion of the Body Snatchers
Philip Kaufman

Body Snatchers
Abel Ferrara

The Invasion
Oliver Hirschbiegel

Invasion of the Pod People
Justin Jones

1950 1955 1960 1965 1970 1975 1980 1985 1990 1995 2000 2005

j.g. ballard 1956

Escapement | The Drowned World | The Terminal Beach | The Atrocity Exhibition | Concrete Island | High Rise | Cocaine Nights | Millennium People

By the end of his life, writer J.G. Ballard had become so influential that his name provided the English language with a new adjective — "Ballardian," used to describe a particular type of modern dystopia. From the flooded London of *The Drowned World* to the growing degeneracy among residents of an apartment building in *High Rise* to the seemingly perfect, yet fundamentally rotten, lifestyle of expats in a glossy Spanish resort in *Cocaine Nights*, Ballard's fractured worlds are unreal, yet all too plausible.

James Graham Ballard was born on November 15, 1930, in the Shanghai International Settlement, China, where his father ran a subsidiary of a British textile firm. During the Second World War, with Shanghai under Japanese occupation, the Ballard family spent two years in Lunghua internment camp. His experiences there formed the basis for his 1984 novel, *Empire of the Sun*, and are thought by some commentators to have strongly influenced his dark and violent fiction.

In 1949 Ballard began studying medicine at Cambridge University, but a well-received early short story led him to London, where he briefly studied English literature. Joining the Royal Air Force in 1955, Ballard was sent for flight training in Canada where he first encountered the American science fiction journals that influenced his debut, "Escapement," a short story published in the December 1956 issue of *New Worlds* magazine. Ballard decided on a career as a full-time writer in 1960, after which his output was very prolific. Along with Michael Moorcock and Brian

Aldiss, he was a major British exponent of the so-called New Wave of science fiction.

Ballard's work was often controversial. One of his short story collections, *The Atrocity Exhibition*, was the subject of an obscenity trial, thanks to the inclusion of a piece entitled "Why I Want to Fuck Ronald Reagan"; in 1980 copies were distributed at the Detroit Republican Convention as a political practical joke. *Crash*, a novel about the erotic potential of car crashes, was the subject of controversy when published in 1973, and again in 1996 when a film version of the novel, directed by David Cronenberg, was released. Indeed, in England, the film was banned by Westminster Council, meaning it could not be shown in London's West End.

In spite of a controversial career, in his later years Ballard was sufficiently well-respected by the British establishment to be offered a CBE (Commander of the Order of the British Empire) — which he duly refused to accept.

J.G. Ballard died on April 19, 2009, in London. His archives were donated to the British Library in lieu of death duties, and included letters from authors to whom he was close, including Will Self, Michael Moorcock and Iain Sinclair.

In 2013 the BBC broadcast radio versions of *Concrete Island* and *The Drowned World* as part of a season of dystopian dramas inspired by Ballard. The same year, it was announced that Ben Wheatley would direct a film version of *High Rise*. **MM**

year-by-year ▨ Short story ▩ Book

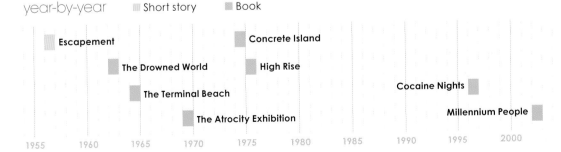

Escapement

The Drowned World

The Terminal Beach

The Atrocity Exhibition

Concrete Island

High Rise

Cocaine Nights

Millennium People

1955 1960 1965 1970 1975 1980 1985 1990 1995 2000

forbidden planet 1956

Forbidden Planet

The Invisible Boy

"Prepare your minds for a new scale of scientific values," boasts Walter Pidgeon's Dr. Morbius before demonstrating the awesome Krell machinery buried beneath the surface of Altair IV to the officers of United Planets Cruiser C57-D. He might equally have been addressing the cinema audience, who had never before seen anything quite like *Forbidden Planet*. This was Hollywood's first attempt to take science fiction seriously.

Make no mistake, it was an audacious move when MGM — a studio renowned for glossy musicals and expensive spectaculars — gave the green light to Irving Block and Allen Adler's script: it was the first major science fiction film set entirely in space, with not even a cameo appearance from Planet Earth; it used Shakespeare's *The Tempest* as a template; it incorporated Freudian psychoanalysis into the plot; it referenced Asimov's Three Laws of Robotics. *Forbidden Planet* was the original space "odyssey."

MGM did not view the project as the B-movie its writers had intended, and drafted in the experienced Cyril Hume to polish their script, a neat yarn centered around an Earth scientist, Morbius, in self-imposed exile on an alien planet with his daughter, Altaira. Dabbling with the remnant machines of an ancient civilization, Morbius is able to unleash a terrible, uncontrollable mental energy.

Directing duties were assigned to Fred M. Wilcox, of *Lassie Come Home* fame, who proved to be an inspired choice. Pre-comedy romantic lead Leslie

Nielsen would later recall: "He discussed the film with everybody working on it, and he said, 'This is a serious film, treat it like that.'"

The result is a work full of seminal science fictional imagery, from the clunkily functional Robby the Robot to the awesome expanses of the Krell machinery and the "invisible" monster from the id, only ever seen in animated outline in a halo of laser fire.

The soundtrack was groundbreaking too. Created electronically over many laborious months by Bebe and Louis Barron, it is an abstract masterpiece that blurs barriers between sound effects and music. Less impressed was America's Musicians' Union who prevented the duo — both nonmembers — from receiving a music credit; their endeavors are listed merely as "electronic tonalities."

A year later, *Forbidden Planet* spawned what could be thought of as a sequel. *The Invisible Boy* may have featured Robby the Robot, but this kiddie fare set on contemporary Earth bore little resemblance to its progenitor. Director Wilcox also proposed his own sequel, but little is known about it except its name — *Robot Planet* — and the fact that it was never made.

Forbidden Planet would alter the course of sci-fi drama, Gene Roddenberry acknowledging its influence on his own *Star Trek* series a decade later.

As a postscript, in 2008 Warner Bros. announced a remake, hiring *Babylon 5* creator J.M. Straczynski to write a script, but this ultimately vanished into one of Hollywood's notorious development black holes. **DG**

year-by-year ■ Movie

Forbidden Planet
Fred M. Wilcox

The Invisible Boy
Herman Hoffman

1955 1960

the fly 1957

The Fly | The Fly | Return of the Fly | The Curse of the Fly | The Fly | The Fly II

As science fiction films became increasingly popular during the 1950s, it was only natural that 20th Century Fox would be attracted to the idea of an adaptation of George Langelaan's fantastical short story "The Fly," which had appeared in the June 1957 issue of *Playboy* magazine. The tale concerns a scientist, Andre Delambre, investigating the subject of matter transportation; after successfully experimenting with inanimate objects and small creatures, he transports himself from one pod in his lab to another. He fails, however, to notice that a house fly has accompanied him during his final jaunt. As a result, Delambre is "integtrated" with the head and arm of the fly, while the fly acquires his body parts in return. Unable to cope with his new existence, he eventually convinces his wife to crush him in a hydraulic press.

Hollywood's take on *The Fly* was directed by Kurt Neumann using screenwriter James Clavell's adaptation, and stars horror legend Vincent Price as Francois, the brother of scientist Delambre (David Hedison). The film features a number of memorably inventive sequences, including the human/fly's (scientifically incorrect) multiple-image view of his screaming wife (Patricia Owens), and the climactic scene of Hedison's head on the body of a fly captured in a spider's web, wailing "Help me!"

The Fly was such a commercial success that a sequel was immediately rushed into production,

even making use of some of the same sets. Despite retaining the services of Vincent Price, 1959's *Return of the Fly* is something of a disappointment, little more than a perfunctory retread of the original, in which the late scientist's son, Phillipe, continues his father's experiments. A simple cash-in, unlike the original, it was shot cheaply in black and white.

A second and final sequel appeared in 1965. Curiously, *The Curse of the Fly* was shot in England, by frequent Hammer helmsman Don Sharp. An enjoyable enough piece of fluff, the film frustratratingly fails to match the continuity of its two predecessors — even though the narrative is built from those films. Languishing in obscurity, it was unavailable for home viewing until 2007.

In 1986 Canadian director David Cronenberg gave the story his own distinctive treatment. Like his earlier films *Shivers*, *Rabid* and *The Brood*, *The Fly* focuses on body horror — in this version, scientist Seth Brundle (Jeff Goldblum) slowly morphs into an insect in a truly grotesque fashion. Its 1989 sequel, *The Fly II*, foregoes most of the deeper themes of Cronenberg's original and is more an assembly of "popcorn" elements, including over-the-top gore.

In 2009, Cronenberg prepared a sequel to his own film for 20th Century Fox but the project stalled due to budget constraints. He later reflected that his script was perhaps "a little too radical." **RL**

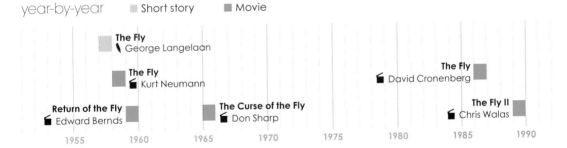

year-by-year ▨ Short story ▧ Movie

The Fly
George Langelaan

The Fly
Kurt Neumann

Return of the Fly
Edward Bernds

The Curse of the Fly
Don Sharp

The Fly
David Cronenberg

The Fly II
Chris Walas

1955 1960 1965 1970 1975 1980 1985 1990

the stainless steel rat 1957

The Stainless Steel Rat

The Stainless Steel Rat

The Stainless Steel Rat's Revenge

The Stainless Steel Rat Saves the World

The Stainless Steel Rat Wants You

The Stainless Steel Rat

The Fourth Law of Robotics

The Stainless Steel Rat Returns

James Bolivar "Slippery Jim" DiGriz, aka the Stainless Steel Rat, is the most famous and popular creation of author Harry Harrison. Featuring in eleven novels published over half a century, DiGriz is a thief and con man, albeit one with morals and scruples, who is recruited into the elite Special Corps, a crime-fighting organization headed and staffed by former criminals. The first novel, The Stainless Steel Rat (1961), incorporated two stories previously published in Astounding magazine, sees classic anti-hero DiGriz tracking down a ruthless criminal; this turns out to be Angelina, a similarly brilliant crook but with fewer scruples, and with whom DiGriz falls in love.

It would be a further nine years before Harrison — by this time well established in the world of science fiction publishing — would revisit Slippery Jim. The Stainless Steel Rat's Revenge sees DiGriz pitched against an interplanetary invader, as well as tying the knot with Angelina and fathering twin boys, James and Bolivar. This was followed swiftly by the time travel saga, The Stainless Steel Rat Saves the World. First published in 1971 in If magazine, DiGriz finds himself caught in time loop in near-future Earth (circa 1975) and Napoleonic France.

DiGriz has a frustrating time in 1978's The Stainless Steel Rat Wants You, as his efforts to save the galactic human civilization from invading aliens are hampered by the Morality Corps and the Time Corps — two organizations that outrank his own Special Corps. Four years later, Harrison integrated elements of political satire and parody in The Stainless Steel Rat for President, as Jim and Angelina become mixed up in a suspect election on a "banana republic" planet where the Rat is set up as a sham candidate.

In 1985, beginning with A Stainless Steel Rat is Born, Harrison produced three prequel adventures to his original story, where a young Jim DiGriz deliberately allows himself be arrested during a bank raid so that he can learn his trade in jail from master criminals.

In 1989, Harrison's short story "The Fourth Law of Robotics" was published in the tribute collection, Foundation's Friends, Stories in Honor of Isaac Asimov. It was a crossover adventure that found Slippery Jim in the setting of Asimov's celebrated Robot series.

The author returned to the adult DiGriz in the 1990s for the final three novels in the series, concluding in 2010 with The Stainless Steel Rat Returns; Harrison's 58th and final novel, it saw Jim's comfortable life torn apart by a visit from a disreputable relative.

In the late 1970s, three of the Rat novels were adapted by writer Kelvin Gosnell and artist Carlos Ezquerra for the long-running British comic 2000 AD. Although none of the books in the series have been adapted for the screen, up until his death in 2012, Harrison enjoyed a comfortable income from repeatedly selling the movie rights. **MJS**

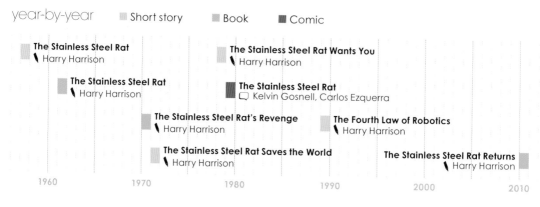

year-by-year ■ Short story ■ Book ■ Comic

The Stainless Steel Rat
Harry Harrison

The Stainless Steel Rat
Harry Harrison

The Stainless Steel Rat's Revenge
Harry Harrison

The Stainless Steel Rat Saves the World
Harry Harrison

The Stainless Steel Rat Wants You
Harry Harrison

The Stainless Steel Rat
Kelvin Gosnell, Carlos Ezquerra

The Fourth Law of Robotics
Harry Harrison

The Stainless Steel Rat Returns
Harry Harrison

1960 1970 1980 1990 2000 2010

the midwich cuckoos 1957

The Midwich
Cuckoos

Village of the
Damned

Children of
the Damned

The Midwich
Cuckoos

Village of the
Damned

The Midwich
Cuckoos

Brian Aldiss once described John Wyndham's science fiction work as a collection of "cosy catastrophes." Ostensibly, at least, they don't come much cosier than *The Midwich Cuckoos*. This most English of alien invasion stories would seem to be the embodiment of every cliché we know about Wyndham: the village setting; the stiff-upper-lipped protagonists; men smoking pipes and rubbing chins; women making tea and fussing.

But Wyndham's fourth book is deliciously subversive. Some unknown force first puts an entire village to sleep, and then impregnates all the women of child-bearing age with telepathic children, each one with a terrifying sense of self-preservation. Wyndham uses a veneer of literary respectability to produce a barely masked tale of body horror of which David Cronenberg would be proud. His "cosiness" also makes for an uncomfortably close-to-home horror experience, even including elements of black humor: a throwaway line reveals that Russia has dealt with a similar situation by nuking the village, while in England the government employs what we would now call a spin doctor to hush the whole thing up.

Metro-Goldwyn-Mayer planned a film version as early as 1957, soon after the book was published, but shelved the project amid concerns about the "virgin births" in the script. The film was eventually made and released in 1960, and became a surprise hit. Wyndham, however, seemed to find being a precursor to Stephen King rather daunting: "You know, *The Midwich Cuckoos* children look very evil in the

film, but they're not so evil in the original story," he told a skeptical-looking BBC interviewer in 1960.

A year later, MGM contracted Wyndham to write a sequel novel. Some six chapters across 121 handwritten pages were all he produced of *Midwich Main* before he abandoned the idea, feeling that he was rehashing many of the themes of his original book. It's unclear if he was writing a novelization of the script of what would eventually become the film sequel, *Children of the Damned*, or whether the script was influenced by his earlier effort — there are clear similarities between the two. When finally released, *Children of the Damned* appeared as a rather lurid follow-up, with scientists bringing together telepathic terror children from around the globe, with predictably disastrous results.

John Carpenter (*The Thing*) made a surprisingly bland remake of *Village of the Damned* in 1995. Starring Christopher Reeve (*Superman*), the tale may have been relocated from an isolated English village to small-town North Carolina, but other than period detail, little of great value was added to the original.

Two notable radio adaptations of the book have also been broadcast by the BBC, the first, in 1983, featuring a fabulous electronic soundtrack by Roger Limb of the BBC Radiophonic Workshop.

A curious "homage" to *The Midwich Cuckoos* emerged from Thailand in 1989: Kukrit Pramoj's *Kawao Thi Bang Phleng* (*Blackbirds at Bangpleng*) comes as close as you are ever likely to read to an unofficial literary remake without lawsuits being issued. **DG**

year-by-year ■ Book ■ Movie ■ Radio play

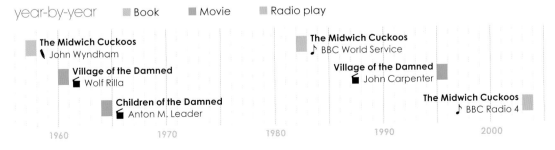

The Midwich Cuckoos
↖ John Wyndham

Village of the Damned
◄ Wolf Rilla

Children of the Damned
◄ Anton M. Leader

The Midwich Cuckoos
♪ BBC World Service

Village of the Damned
◄ John Carpenter

The Midwich Cuckoos
♪ BBC Radio 4

1960 1970 1980 1990 2000

michael moorcock 1957

Tarzan
Adventures

New Worlds

Behold the
Man

The Final
Programme

The Warlord
of the Air

The Steel Tsar

The New
Nature of the
Catastrophe

The
Metatemporal
Detective

The output of Michael Moorcock is both staggering and supremely difficult to categorize. He has written in several genres, freely mixes elements of them all, and revises his books frequently. Underpinning it all is his concept of "the Eternal Champion," a recurring, heroic character engaged in an endless struggle against Chaos across multiple realities, bringing all his works of whatever genre into one vast series. Within this multiverse, a cast of recurring characters repeatedly appear in different guises. Behind the multiple masks of the Champion is Moorcock himself. The city, entropy and entrapment are his major obsessions, delivered with varying combinations of outrage, acceptance, defiance and mocking humor.

Much of what Moorcock writes is superficially sword and sorcery fantasy, albeit in a highly ironic, refined form. The novels that can definitely be named science fiction are a minority of his canon, and include among their number Behold The Man (1969), proto-steampunk series The Nomad of The Time Streams and the Jerry Cornelius series.

Cornelius is something of a minor 1960s icon, an amoral, polysexual, incestuous dandy who adventures through various Londons with a shifting gang of associates. A negative image of the morose, doomed Elric of Melniboné, Moorcock's most famous fantasy creation, Cornelius' embracing of life is joyous — albeit counterpointed by a threadbare seediness and overweening cockiness. Cornelius begins hip, but his abilities to manipulate diminish and his situation becomes increasingly chaotic. Moorcock opened Cornelius to other writers, leading to a number of wildly different takes on the character.

Moorcock's career describes a path from pulp to mainstream acceptance. His writing varies in tone from honest pastiche, through juvenilia to that of literary fiction, but throughout all are notes of complexity. His work can be divided into several periods, the largest contrast being drawn between his rapidly produced novels of the 1960s, 1970s and early 1980s, and his later revisiting of the same characters, to whose cycles he introduces many of the more literary concerns exhibited in the non-genre Mother London (1988), cited as among his finest novels.

Moorcock's later work has very little of the fantastical or science fictional to it, particularly the powerful Colonel Pyatt series, although many of Jerry Cornelius' troupe make appearances there.

Hugely influential through his editorship of New Worlds Magazine, Moorcock was the key figure in the 1970s New Wave movement. His insistence on superior prose and narrative styling transformed science fiction. Due to his defiance of pigeonholing, the true scale of his contribution to all the fantastical genres — and fiction in general — is not as acknowledged as it should be. Like his characters, he has also had something of a parallel life; in his case, on the periphery of rock music. **GH**

year-by-year ■ Magazine ■ Book

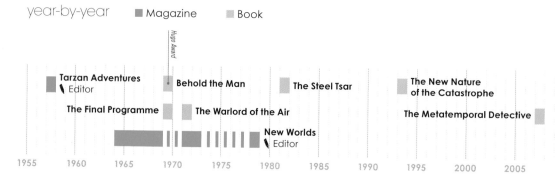

Hugo Award

Tarzan Adventures
Editor

The Final Programme

Behold the Man

The Warlord of the Air

The Steel Tsar

New Worlds
Editor

The New Nature
of the Catastrophe

The Metatemporal Detective

1955 1960 1965 1970 1975 1980 1985 1990 1995 2000 2005

arkady and boris strugatsky 1959

The Land of Crimson Clouds

Destination: Amaltheia

Noon: 22nd Century

Space Apprentice

Space Mowgli

Roadside Picnic

The Time Wanderers

The Doomed City

Arkady Natanovich Strugatsky (1925–91) and Boris Natanovich Strugatsky (1933–2012) are Russia's two most noted science fiction writers. They were raised in the city of Leningrad (now Saint Petersburg), where Arkady joined the military as a teacher and translator; eight years his junior, Boris worked as an astronomer and computer engineer.

At the heart of much of the Strugatskys' work is the Noon Universe, a utopian future-history in which we see a money-free, technologically advanced universe united under something akin to communism. The brothers would explore this setting throughout much of their working life, albeit with increasingly dark elements introduced as the authors became disillusioned with the Soviet Union.

Their writing collaboration began in 1959 with the space exploration novelette *The Land of Crimson Clouds*, which they followed with *Destination: Amaltheia* and *Space Apprentice*. Although not explicitly part of the Noon Universe — which was introduced in 1962 with *Noon: 22nd Century* — these early works are now considered to have taken place previously within that setting. Notable "core" novels in the series include *Far Rainbow* (1963), *Space Mowgli* (1971), and the last novel completed before Arkady Strugatsky's death, *The Time Wanderers* (1986).

The Strugatskys are best known in the West, however, for *Roadside Picnic* (1972), a haunting work which posits that aliens have regularly visited Earth, each time leaving behind them a "zone" littered with mysterious objects and where the rules of space-time no longer quite apply. These zones are visited by "stalkers," who risk their lives attempting to retrieve valuable objects for sale on the black market. The novel follows the evolution of one of these zones, from initial military control to the emergence of a surrounding city, and follows Red Schuhart, a stalker about to make his final journey in search of a mythical artifact. *Roadside Picnic* is an extraordinary work, mature and bleak, developing not just its strange premise — the idea that aliens have discarded their litter in the manner of picnickers on a short holiday — but the industry that rises around it. It was filmed memorably in 1979 by Andrei Tarkovsky as *Stalker*.

In some ways, the novel presaged elements of the 1986 Chernobyl disaster and its aftermath: reportedly, those living on the outskirts of the now-abandoned Zone of Exclusion have come to refer to themselves as "stalkers." This, along with elements of the book and film, also provided the inspiration for the 2007 computer game, *S.T.A.L.K.E.R.: Shadow of Chernobyl*.

In 1975, the Strugatskys completed their most philosophical work: *The Doomed City* is a gloomy piece of political allusion which they shelved knowing that it would never be passed for publication by the Soviet censors. It finally appeared in 1989 when, during the *glasnost* period, such controls were eased.

Boris Strugatsky struggled to write following the loss of his brother in 1991; he published two solo novels before his own death 11 years later. **LT**

year-by-year ■ Book

The Land of Crimson Clouds

Space Mowgli

Destination: Amaltheia

Roadside Picnic

Noon: 22nd Century

The Time Wanderers

Space Apprentice

The Doomed City

1955 1960 1965 1970 1975 1980 1985 1990 1995 2000

starship troopers 1959

Starship Soldier	Starship Troopers	Starship Troopers	Klendathu	Starship Troopers	Starship Troopers	Starship Troopers	Starship Troopers: Prepare for Battle!

Perhaps the most important and influential of all military science fiction novels, Robert Heinlein's *Starship Troopers* set the tone and rules for a thriving subgenre, of which Joe Haldeman's *The Forever War* and Orson Scott Card's *Ender's Game* are just two prominent literary examples. Across the wider science fiction landscape there have been many more projects influenced by this slim volume: when *Mobile Suit Gundam* kicked off the Real Robot anime genre in the late 1970s, it drew from the powered suits of the novel's Mobile Infantry, for instance, and when James Cameron wanted believable space soldiers for the film *Aliens*, he went straight to the source, appropriating whole chunks of Heinlein, from a cargo-loading exoskeleton to terms like "bug hunt."

The property that started it all has had its time in the spotlight too, not least in the late 1990s, when a controversial movie version would revive interest in this man-versus-bug conflict.

It's not bad for a story with humble beginnings. Originally written by Heinlein as but one of many "juveniles" for his traditional publisher, Scribners, when *Starship Troopers* was unexpectedly rejected it took on a sudden life of its own. In December 1959, two months before it was first published in book form, Heinlein's story was serialized in *The Magazine of Fantasy &*

Science Fiction. This marked the first appearance of young Filipino Juan "Johnnie" Rico, and his adventures in the Mobile Infantry, a futuristic branch of the armed forces that specializes in close-quarters combat using powered armor; we follow him from recruit to NCO to officer as war rages between the human race and insect-like aliens called Arachnids (or "Bugs").

Starship Troopers is unusual in that action regularly slows to a crawl to allow our heroes space to discuss philosophical issues, ranging from the moral duty we all have to serve our country, to the weaknesses of both communism and democracy. Indeed, much of the novel takes place in talk-heavy classrooms, and references to Earth-based conflicts of the past are rife — notably the (then recent) Korean War. It makes for a polarizing book, engendering very different reactions depending on your political disposition, and has been accused of being fascist, racist, militaristic and more over the years. Even winning the Hugo Award for Best Novel was controversial and unexpected, not least by Heinlein himself.

One of the most memorable elements of the novel is its powered-armor exoskeletons, best showcased in the battle against the "Skinnies" that opens the book, turning each soldier into a cross between an infantryman and a tank. (That these "cap troopers"

year-by-year

Legend: Short story · Book · Game · Video game · Anime

Hugo Award

Starship Soldier
Robert A. Heinlein

Starship Troopers
Robert A. Heinlein

Starship Troopers
Avalon Hill

Klendathu
Radio Shack/Tandy Corporation

Starship Troopers
Tetsuro Amino

1960 · 1965 · 1970 · 1975 · 1980 · 1985 · 1990

| Roughnecks: Starship Troopers Chronicles | Starship Troopers 2: Hero of the Federation | Starship Troopers: The Miniatures Game | Starship Troopers 3: Marauder | Starship Troopers: Invasion "Mobile Infantry" | Starship Troopers: Invasion |

are dropped into combat from orbiting interstellar transports in small capsules is another of the book's influential concepts.) Major engagements, however, are skipped over surprisingly quickly to make more room for philosophizing: "[violence] has settled more issues in history than has any other factor," goes one particularly famous speech.

It's notable how very little time we spend on the actual frontline, much of the book instead being structured as a series of flashbacks: we see Rico's decision to sign up for the military; we witness his high school "History and Moral Philosophy" course; we spend five chapters at Boot Camp, where less than 10 percent pass and many die during training. Much space is taken up by the daily routine of military life. Little wonder, then, that *Starship Troopers* has long featured on the official reading lists of both the U.S. Navy and Marines.

Starship Troopers has enjoyed many spin-offs over the years, appearing in comic strip adaptations, and both Japanese anime and CGI formats. The most memorable, however, was the big-budget 1997 movie by Dutch director Paul Verhoeven, who incorporated elements of the ultra-violence, cynicism and straight-faced black humor that he had shown on earlier projects such as *RoboCop*. Here, Rico and his

friends are portrayed as gung-ho high school kids in a retro-fascist future; what Heinlein had been deadly serious about, Verhoeven satirizes wickedly. In its own way, his action-heavy blockbuster is also remarkably prescient: though made before 9/11, we see what is now a horrifically familiar tale; the destruction of a major city leading into a lengthy desert war against a hidden, cave-dwelling foe. And that it seems to be an engagement with no foreseeable endpoint now makes *Starship Troopers* seem like even richer fare than when first released. Like the book, Verhoeven's film split critical and public reactions right down the middle, but nonetheless inspired two critically panned low-budget direct-to-DVD movies.

Both book and film have also proved fertile territory for gamers. Randall C. Reed's map-and-counter board game first appeared in 1976, a second following 21 years later to coincide with the film release; a British tabletop miniatures wargame was published in 2005–07, based on the film, book and TV series. Video game versions have been spread over three generations of technology, beginning with 1982's *Klendathu*, designed for Radio Shack's TRS-80 home computer, a poorly received PC-only first-person shooter, and more recently a touchscreen version for the iPhone. **PM**

■ Movie ▓ Comic ▓ Animated TV series ■ Animated movie

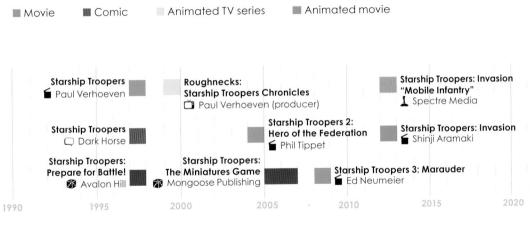

Starship Troopers
Paul Verhoeven

Roughnecks:
Starship Troopers Chronicles
Paul Verhoeven (producer)

Starship Troopers: Invasion
"Mobile Infantry"
Spectre Media

Starship Troopers
Dark Horse

Starship Troopers 2:
Hero of the Federation
Phil Tippet

Starship Troopers: Invasion
Shinji Aramaki

Starship Troopers:
Prepare for Battle!
Avalon Hill

Starship Troopers:
The Miniatures Game
Mongoose Publishing

Starship Troopers 3: Marauder
Ed Neumeier

1990 1995 2000 2005 2010 2015 2020

the twilight zone 1959

The Twilight Zone The Twilight Zone The Twilight Zone Twilight Zone: The Movie The Twilight Zone The Twilight Zone

Few writers have ever been as closely identified with a series they have scripted as Rod Serling was with *The Twilight Zone*. His was not only the name below the title, but also the talking head that introduced viewers each week to a world of uncanny, fantastical and unexpected fictional occurrences.

Serling made an amiable host, but the measured tones, tailored suit and cigarette hanging from his fingers hid a firebrand personality. In his early years he'd been a boxer, and although he'd quit the ring he kept fighting his new adversaries — TV networks and corporate sponsors.

Serling was a radical working in a reactionary medium. By 1959, he was bored with butting heads with his paymasters. Once he was forbidden from referencing the Holocaust because a gas company sponsored the show he working on. "I got tired of battling," he said. "You always have to compromise your script, lest somebody — a sponsor, a pressure group, a network sensor — gets upset. The result is, you begin to skirt the issues."

From that point Serling stated that he would purposely skirt the issues. When he pitched *The Twilight Zone* to CBS, he assured the company that his days as an Angry Young Man were over, and that it would now be dealing with a new, mellower Rod Serling.

This was not true. *The Twilight Zone* was every bit as socially charged as his previous work, but camouflaged by fantasy trappings. Without compromising his principles, Serling was suddenly the freer than he'd ever been.

This was a show that championed the little man in society. If the series had any direct influences, its biggest was probably the cinema of Frank Capra. Though Capra made only one fantastical flick — *It's A Wonderful Life* — the humanism his movies espoused were woven into the fabric of *The Twilight Zone*. From Burgess Meredith's meek myopic to William Shatner's neurotic airplane passenger via Billy Mumy's kid-God from the suburbs, these were stories of Everyman put into fantastical situations.

Serling's "The Time Element," about a man who predicts the 1941 attack on Pearl Harbor, was intended as a one-hour pilot for *The Twilight Zone*, but CBS commandeered the script for its prestigous Desilu Playhouse strand. When it then attracted more mail than anything else screened by the network in 1957, Serling was commissioned to write another pilot. "Where Is Everyone?" concerned an astronaut stranded on an apparently deserted world, the denouement revealing him to be a guinea pig in a psychological experiment.

year-by-year ■ TV series ▥ Comic ■ Movie ■ TV movie ■ Book

The Twilight Zone
CBS

Twilight Zone: The Movie
George Miller, John Landis, Joe Dante, Steven Spielberg

The Twilight Zone
Dell Comics

The Twilight Zone
CBS

The Twilight Zone
Gold Key

1960 1965 1970 1975 1980 1985 1990

Rod Serling's Lost Classics

Journeys into the Twilight Zone

Return to the Twilight Zone

The Twilight Zone

The Twilight Zone

Twilight Zone: 19 Original Stories on the 50th Anniversary

Ratings were initially low, but word of mouth spread and critics began to notice this strange little anthology show. Gradually, the audience increased as Serling unveiled stories of a lift-thumbing Grim Reaper ("The Hitch-Hiker"), fears of alien invasion ("The Monsters Are Due On Maple Street"), hapless Guardian Angels ("Mr. Bevis") and a robot baseball pitcher ("The Mighty Casey").

The Twilight Zone was soon firmly established, but its production was always troubled. During its second season General Foods withdrew sponsorship. Subsequent sponsors came and went through a rapidly revolving door, panicking network execs pushing Serling into ever-greater anxiety over the quality of the show. Soon no one would back *The Twilight Zone*, so it was axed after its third season. Serling left to teach at Antioch College in Ohio and to write the screenplay for John Frankenheimer's thriller *Seven Days in May* (1964). However, *The Twilight Zone*'s replacement on CBS was a commercial disaster, and soon Serling's show returned.

To generate more advertising revenue, CBS now doubled the length of each epsiode to one hour. But *The Twilight Zone* wasn't *The Outer Limits* (ABC's SF anthology show), and Serling's whimsical tales lost their momentum at this length. The series returned to

its half-hour roots by its fifth season, but by then it had lost much of its former luster. Serling's involvement was lessening, sponsors were again becoming difficult to find and audiences were slipping away. *The Twilight Zone* was quietly dropped in 1964, this time for good. "We've been on the air for five years," Serling remarked, "and I think the show took on a kind of aged look."

In 1975, Serling and producer Aaron Spelling approached ABC with a revival of *The Twilight Zone*, but the network turned them down. A few months later, Serling died from complications during heart surgery; he was only 50 year old.

It was only in the years after his death that the true power of the series manifested itself. Steven Spielberg, John Landis, Joe Dante and George Miller teamed up for 1983's *Twilight Zone: The Movie*, and the brand name was resuscitated two years later on TV with scripts from, among others, Steve Bochco and J. Michael Straczynski. This, and an even shorter-lived 2002 revival, were pale imitations of the original — proof, perhaps, that Rod Serling was *The Twilight Zone*.

"Fame is short-lived," Serling once said. "One year after this show goes off the air, they'll never remember who I am. And I don't care a bit. Anonymity is fine with me. My place is as a writer." **SOB**

 Graphic novel

Rod Serling's Lost Classics
Robert Markowitz

Journeys into the Twilight Zone
Carol Serling

Return to the Twilight Zone
Carol Serling

The Twilight Zone
NOW Comics

The Twilight Zone
UPN

The Twilight Zone
Walker & Co

Twilight Zone: 19 Original Stories on the 50th Anniversary
Carol Serling

1990 1995 2000 2005 2010 2015 2020

The Twilight Zone
(1959–64)

The Twilight Zone
(1962–82)

The Twilight Zone
(1983)

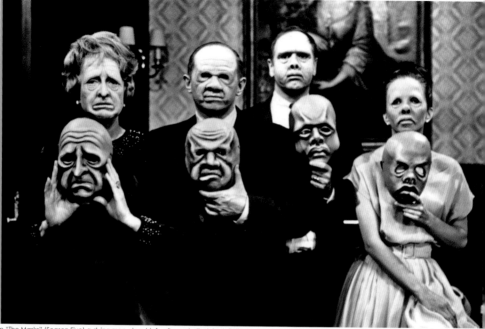

In "The Masks" (Season Five) a dying man gives his family masks that, he tells them, are designed to reflect the opposite of their true characters. But in *The Twilight Zone*, what people say is not always the same as what they mean. The man also assures them that the masks come off easily …

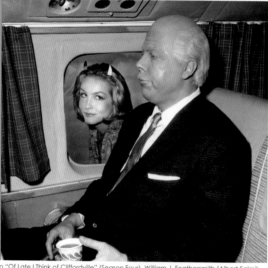

In "Of Late I Think of Cliffordville" (Season Four), William J. Feathersmith (Albert Salmi) buys an air ticket from a travel agent of Satan (Julie Newmar).

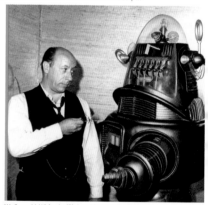

Wallace V. Whipple (Richard Deacon) with Robby, the robot who replaces him in "The Brain Center at Whipple's" (Season Five).

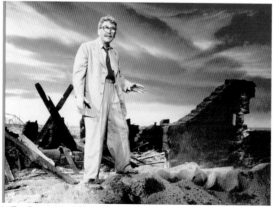

In "Time Enough At Last" (Season One), Bemis (Burgess Meredith) gets everything he wants: solitude and an extensive library. But then his glasses shatter.

Frames from "Seeing-Eye Man," a strip in *The Twilight Zone* spin-off comic (1972).

Cherie Currie as the girl with no mouth in "It's a Good Life," Joe Dante's contribution to *Twilight Zone: The Movie*.

"Nightmare at 20,000 Feet," George Miller's segment of *Twilight Zone: The Movie*, was a remake of an episode from the original series.

"It's a Good Life" features a child who can make the cartoon monsters of his dreams a terrifying reality.

Uncle Walt (Kevin McCarthy) confronts one of the demons of his nephew's imagination.

irwin allen 1960

The Lost World

Voyage to the Bottom of the Sea

Five Weeks in a Balloon

Voyage to the Bottom of the Sea

Lost in Space

The Time Tunnel

He's the master of disaster, the butcher of budgets, the saint of stock footage, the king of adventure. He's Irwin Allen, the penny-pinching P.T. Barnum of screen science fiction.

Born in 1916 in New York, Irwin Allen studied journalism and advertising at Columbia University. After graduating he moved first into magazine journalism and then into presenting, writing and producing a one-hour celebrity talk show that ran for 11 years on radio station KLAC. Throughout this period he was filling his contact book. Among the stars he cultivated was Groucho Marx, who agreed to let him produce the last film to feature all three main Marx Brothers together — *The Story Of Mankind* (1957).

Allen then wrote "Hollywood Merry-Go-Round," a syndicated newspaper column, and presented celebrity-based light entertainment TV shows. He is credited with pioneering the celebrity panel game. He also founded a literary agency that specialized in representing writers' interests in the TV and film industries. His clients included P.G. Wodehouse and Ben Hecht.

His next step was into movie production, and soon he was rubbing shoulders with Robert Mitchum on *Where Danger Lives* (1950) and Frank Sinatra on *Double Dynamite* (1951).

In 1956 Allen produced *The Animal World*, a pseudo-documentary that featured a prehistoric sequence animated by Ray Harryhausen. But it was *The Lost World* in 1960 that first showed the kind of broad-stroke science fiction for which Allen became most famous. This colorful adaptation of Arthur Conan Doyle's dinosaur-hunting yarn also became influential throughout Allen's career in another way as he repeatedly plundered it for stock footage.

The film version of *Voyage to the Bottom of the Sea* (1961) then became the mother lode for nearly all Allen's subsequent work throughout the rest of the decade. An update of *20,000 Leagues Under the Sea*, this wasn't the last time Allen would use Jules Verne's submarine novel for inspiration; it also formed the basis of the TV movie *The Return Of Captain Nemo* in 1978. Not even Allen's most severe critics would suggest that he was ever a man to let a good idea go to waste: footage from his TV series *The Time Tunnel* (1966) would be reconscripted into service 10 years later in the TV movie *The Time Travelers*.

His next move was a TV version of *Voyage*, which made extensive use of stock footage culled from the movie. He later pulled off something similar on *Lost In Space*, re-using footage from an unaired pilot in many of the first season's episodes.

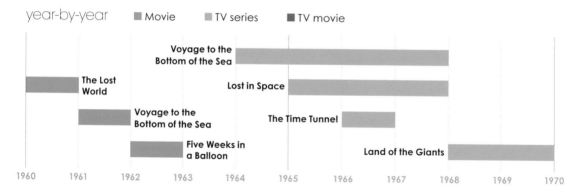

year-by-year ■ Movie ■ TV series ■ TV movie

Voyage to the Bottom of the Sea

The Lost World

Lost in Space

Voyage to the Bottom of the Sea

The Time Tunnel

Five Weeks in a Balloon

Land of the Giants

1960 1961 1962 1963 1964 1965 1966 1967 1968 1969 1970

| Land of the Giants | City Beneath the Sea | The Time Travelers | The Return of Captain Nemo | The Swarm |

Allen's cost-consciousness earned him the approbation of his financial backers and the disapproval of some of those who worked for him. The lack of female characters in the second season of *Voyage* had less to do with sexism than with Allen's resentment of the amount of money that had to be spent on women's hair and make-up. Sound financial sense or meanness? It depended on who was asked.

Allen made further economies on his scripts, very few of which were anything like top quality. *Time Tunnel* writer Bob Duncan recalled:

"Irwin had a favorite saying. That was: 'Don't get logical with me!' There was absolutely no pressure on the writers to make the stories historically accurate."

Allen's series began with an impressive pilot that appealed to the whole family. Having captured a large audience, they became more childish and increasingly reliant on dodgy monsters — viewers of *Voyage* smile at the memory of the lobster men, and *Lost in Space* fans cannot forget the giant talking carrots, no matter how hard they try.

Above all for Allen, time was money. One of his collaborators, Robert Mintz, recalled that during filming of *The Lost World*, "There was an actors' strike, and rather than shut down production, Irwin brought in a dozen lizards and shot dinosaur fights with them

until the last lizard was dead from exhaustion." (In the 1960s film makers were not obliged to reassure audiences that "no animals were harmed during the making of this film.")

Allen demanded and got respect from everyone, though some of it was more than a little grudging. *Time Tunnel* star Lee Meriwether called him "a witty man, whose bite was worse than his bark."

Irwin Allen's final TV series, *Land Of The Giants*, was reputedly the most expensive ever created in the United States, but this was marketing hyperbole: although the pilot was lavish, subsequent episodes were made with financial constraints that were every bit as tight as those on Allen's previous enterprises.

When ABC cancelled *Land Of The Giants* after 51 episodes over two seasons, Allen moved back into movies and profited from the disaster genre that was popular in the 1970s. He produced *The Poseidon Adventure* (1972) and *The Towering Inferno* (1974), which he also co-directed. He produced and directed *The Swarm* (1978) and *Beyond the Poseidon Adventure* (1979), and produced *When Time Ran Out* (1980). Meanwhile, he produced the made-for-TV disaster movies *Flood!* and *Fire!* In 1979, he produced three more: *Hanging by a Thread*, *The Night the Bridge Fell Down* and *Cave-In!* **DG**

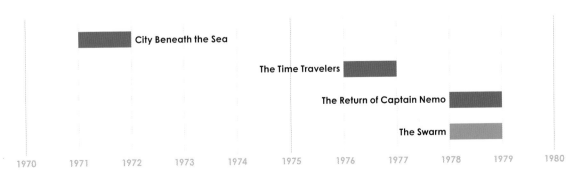

The Lost World
(1960)

Voyage to the Bottom of the Sea
(1961)

Five Weeks in a Balloon
(1962)

Lost in Space
(1965–68)

Land of the Giants
(1968–70)

The Swarm
(1978)

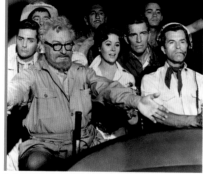

(L–R) David Hedison, Jill St. John, Claude Rains and Michael Rennie react to effects in **The Lost World** movie.

The nuclear submarine *Seaview* arrives in New York Harbor to save the city from a shower of meteors.

Walter Pidgeon starred as Admiral Harriman Nelson in Allen's **Voyage to the Bottom of the Sea** (1961).

Five Weeks in a Balloon (1962), loosely based on Jules Verne's novel of the same name, was Allen's last feature film before moving into making TV series.

Five Weeks in a Balloon was set in Africa but filmed in California. Out of shot to the left of the picture was a crane that raised the unicorn gondola.

In the TV series *Lost in Space*, Dr. Zachary Smith (Jonathan Harris) was evil at first, but later became a source of light relief.

For three years, Guy Williams played Professor John Robinson, the Robinson family patriarch in the TV series *Lost in Space*.

Allen's *Land of the Giants* TV series ran for two seasons between the fall of 1968 and the spring of 1970.

The cast of *Land of the Giants*: (clockwise from top) Don Matheson, Deanne Lund, Gary Conway, Stefan Arngrim and Kurt Kasznar.

The all-star cast of *The Swarm* included Olivia de Havilland, who is here about to die.

The Swarm featured Africanized Honey Bees, a genuine threat to life.

gerry anderson 1960

 Stingray

| Supercar | Fireball XL5 | Stingray | Thunderbirds | Captain Scarlet and the Mysterons | Joe 90 | Doppelgänger | The Secret Service |

With a Gerry Anderson production certain ingredients were almost guaranteed: quick cutting, futuristic machines, exciting stories and, of course, the sight of mangled, burning wreckage being propelled toward camera by enormous explosions. Astonishingly, this was not for the cinema. Whereas elsewhere on British television in the 1960s, *Doctor Who* was doing what it could on a budget of £2,500 ($4,000) per episode, Anderson oversaw the production of weekly TV epics, each costing £40,000 ($66,000).

Although Anderson's shows often featured simple story lines, his own early life was complex and sadly overshadowed by his parents' unhappy marriage and the death of his adored older brother in the Second World War. Gerry Anderson's fascination with aircraft and technology derived from the fact his brother had been a pilot; his drive and determination to be as good as possible seemed to derive from wanting his mother to like him as much as she liked his sibling.

As a young man, Anderson worked in cutting rooms, where he gained a reputation as a fine dubbing editor with obsessive attention to detail. He began his puppet career in 1957 when he formed AP Films (APF) with Arthur Provis to produce the TV series *The Adventures of Twizzle* for writer Roberta Leigh. This was not what he had had in mind for himself. He recalled: "I was hoping that I was going to be a Stephen Spielberg of that time. Here I was making puppet films, but we needed the money so we took it on."

Soon, APF parted company with Leigh and began work on its own series. Anderson decided that, if he had to work with puppets, he would make them as lifelike as possible. He had their faces sculpted in fiberglass and fitted with solenoids which, via a contraption that converted the dialogue into electrical impulses, moved the lips allowing the characters to "speak." Starting with *Four Feather Falls*, trailed as "a puppet Western with a difference," APF made every attempt to distance its output from TV puppet shows such as *Andy Pandy*, and dubbed its sophisticated production process "Supermarionation" (super-marionette-animation).

When ATV mogul Lew Grade agreed to back APF in 1960, Gerry and his new wife Sylvia entered the worlds of science fiction and fantasy with *Supercar*. The success of this series in the United States encouraged Grade to invest in a string of subsequent Anderson developments. These included *Fireball XL5* and *Stingray* — the latter was the first major British show to be filmed entirely in color.

Each successive series saw an increase in the number of model special effects, a progression that culminated with *Thunderbirds*, in which puppets and action attained equal prominence. It was APF's biggest hit in Britain, but Grade failed to sell it to the United States, and the full-length movie version, *Thunderbirds Are Go*, flopped. This resulted in the premature curtailment of the TV series.

year-by-year ■ TV series ■ Movie

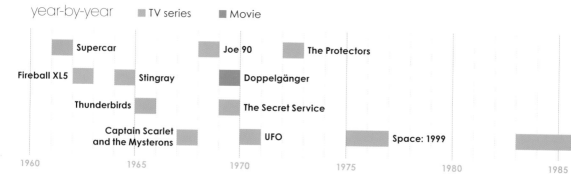

| UFO | The Protectors | Space: 1999 | Terrahawks | Dick Spanner, P.I. | Space Precinct | Lavender Castle | New Captain Scarlet |

Still desperate to escape to legitimate live-action, Anderson encouraged his team to produce ever more realistic effects and models. The caricatured marionettes of earlier shows gave way to perfectly proportioned figures. This new approach — first showcased in *Captain Scarlet and the Mysterons* and then in *Joe 90* — brought decent returns, but the great days of *Thunderbirds* had passed. Finally, with the feature film *Doppelgänger*, Anderson was granted his wish to work with real actors. He formed a new company, Century 21 Productions, and consigned his puppets to the garbage can.

Anderson's first live-action series, *UFO*, was a success in several territories but failed to capture the all-important American audience. Keen not to waste the work already done on preproduction for a second series, Anderson and his wife reworked the concept into *Space: 1999*. However, American interference, difficult stars and the collapse of the Andersons' marriage led to a difficult production. Gerry Anderson's career stalled in the late 1970s. Several attempts to launch new productions failed and he found himself with little cash in the bank and no rights in any of his hugely successful shows.

The second phase of Anderson's career began with *Terrahawks* in 1982. Although he later dismissed this series as no more than a stopgap to pay the bills, it was a big hit with children — an audience that many other producers spend their lives trying and failing to reach. Anderson next renewed his efforts to create a major live-action series and eventually came up with *Space Precinct*, a science fiction drama that was, in essence, a futuristic cop show with aliens. It was popular, but it did not satisfy Anderson, who continued his search for something that would be bigger than *Thunderbirds*.

He made his big comeback with *New Captain Scarlet* in 2005. This time his fascination with technology led him into the world of CGI and a $43 million production began at Pinewood Studios. For once Anderson seemed uncharacteristically proud of this achievement. However, internal politicking at ITV led to the show being cut up and stuffed into the middle of a Saturday morning's children show. Anderson was furious. "I won't mince my words," he said, "They destroyed it."

Anderson spent his final years attempting to get various new projects off the ground. He went on working long after the age at which most people are happy to retire. Meanwhile his health declined for reasons that were undiagnosed until it was belatedly discovered that he was a victim of Alzheimer's disease. Soon after learning of this he died on Boxing Day 2012 at the age of 83.

Gerry Anderson was a strongly driven man whose constant need to better himself led him to undervalue his achievements, which were in fact considerable and significantly altered the course of film history. **SLR**

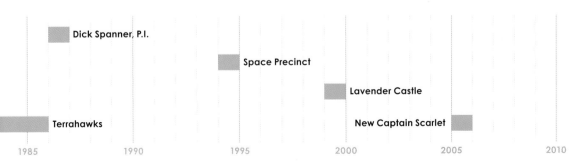

Supercar
(1961–62)

Fireball XL5
(1962–63)

Stingray
(1964–65)

Thunderbirds
(1965–66)

**Captain Scarlet
and the Mysterons**
(1967–68)

Joe 90
(1968–69)

**The Secret
Service**
(1969)

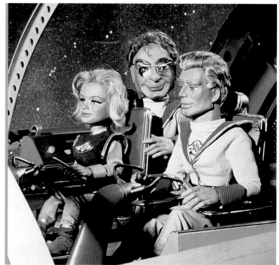

Supercar set: note the puppeteers' gantry above.

Venus, Professor Matic and Zodiac at the controls of **Fireball XL5**.

Troy Tempest investigates an abandoned brig in **Stingray**.

Marina is taken hostage by Titan, the arch-villain in **Stingray**.

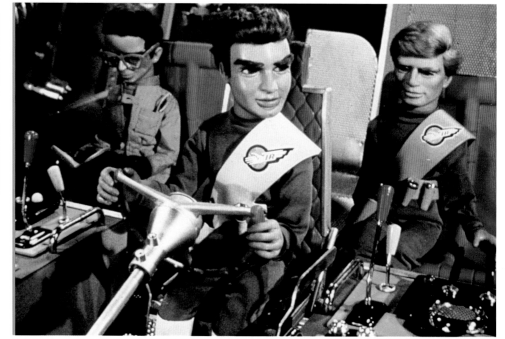

Virgil Tracy at the controls of *Thunderbird 2*, flanked by Brains (L) and Gordon Tracy.

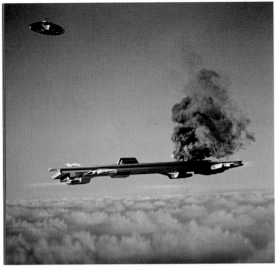

Cloudbase comes under attack in *Captain Scarlet and the Mysterons*.

(L–R): Captain Blue, Captain White, Captain Scarlet and Captain Green.

The were numerous secret agent television shows in the 1960s, but *Joe 90* offered a new twist on the format by featuring a 9-year-old boy as its protagonist.

Joe 90 in the Brain Impulse Galvanascope Record And Transfer (BIG RAT), a machine that transfers knowledge from experts in various fields to the person inside.

The Secret Service (1969), was Anderson's last work in Supermarionation ...

... it ran for one 13-episode season on British TV in 1969.

gerry anderson vehicle archive

Supercar — a vertical takeoff and landing craft invented by Rudolph Popkiss and Horatio Beaker, and piloted by Mike Mercury.

The mechanical fish that is really a submarine in which Titan and his henchmen try to combat *Stingray*.

Stingray — captained by Troy Tempest, who is accompanied by Phones and Marina — is a high-spec combat submarine of the World Aquanaut Security Patrol (WASP).

Thunderbird 1 prepares for launch from International Rescue's base on Tracy Island in the South Pacific Ocean.

Thunderbird 1, piloted by Scott Tracy, is International Rescue's first choice for rapid response. Here it hovers above *Thunderbird 4*, a small submersible for underwater operations, which is almost always captained by Gordon Tracy.

FAB 1 Lady Penelope's ROLLS-ROYCE
as seen in THUNDERBIRDS

This cutaway diagram of Lady Penelope's custom Rolls Royce originally appeared in the British comic *TV Century 21*.

Thunderbird 2 is a heavy-duty transporter aircraft that is described as being 250 ft (77 m) long and 60 ft (18.5 m) high with a wingspan of 180 ft (55 m).

The color-coded leaders of Spectrum are supported by a team of flying Angels: this is Rhapsody; her colleagues are Destiny, Harmony, Melody and Symphony.

Spectrum's rocket-powered magnacopter, which can transport up to 20 passengers, is also a maximum security land vehicle at speeds of up to 200 mph (320 kph).

The Spectrum Pursuit Vehicle from **Captain Scarlet**. In the show, the driver sat at the rear, facing backward.

The design of the *Eagle* craft from **Space 1999** is one of Anderson's most realistic.

perry rhodan 1961

Perry Rhodan

...4 ...3 ...2 ...1 ...Morte

Perry Rhodan

Perry Rhodan

Perry Rhodan: Pax Terra

Perry Rhodan

One of the great German contributions to science fiction, the pulp series *Perry Rhodan* — a huge space opera published continually since 1961, and now the most successful SF book series ever in terms of sales, having sold more than a billion copies — appears in weekly, novella-size booklet instalments, written by many authors. Originally planned to run for 30 volumes, *Perry Rhodan* had, in 2013, passed the 2,700 mark with no signs of slowing down.

It was created by SF writers K.H. Scheer — who contributed 70 instalments and created the outlines for hundreds more — and Clark Darlton, real name Walter Ernsting, who had served on the Eastern Front in the Second World War. Ernsting learned to love science fiction while working for the British after the war, and posed as an English author to get his first works published in 1955; he is generally credited with having come up with the main character and his traits, plus many of the supporting cast and the vast range of alien species. He stayed with the series for more than 1,600 instalments.

The tales tend to appear in huge cycles or story arcs, often 100 episodes long (and rarely fewer than 25); spin-offs, such as the Atlan series (about an important ally of Rhodan), fill in gaps and explore further aspects of the Rhodan universe. Comics,

audio dramas and other spin-offs exist too, and a 2011 reboot, *Perry Rhodan Neo*, attempts to attract a younger audience, with adventures starting in 2036.

Perry Rhodan begins with the first Moon landing in 1971, which was 10 years in the future when the first stories were written. On the lunar surface, Major Perry Rhodan discovers a damaged spaceship built by aliens from the fictional planet Arkon in the (real) M13 cluster. He returns to Earth with it, but initially refuses to share the technology — he knows that the planet is on the brink of nuclear war, and he now has the ability to influence humankind's destiny. Over the next few years, the political climate improves greatly. The planet becomes united — Rhodan is not above using force to achieve it — as appropriated Arkonide technology leads to unprecedented scientific leaps forward. Soon humanity is carving out a place for itself in the cosmos. We have hyperspace drives, we have positronic artificial brains and we have virtual immortality for a chosen few — thanks to a mysterious benefactor the Superintelligence called IT — which allows Rhodan's tale to extend over vast swathes of time. In due course we visit other galaxies, the distant past, parallel universes (there are lots of these) and encounter a bewildering array of aliens with vast — sometimes even godlike — powers.

year-by-year ■ Magazine ■ Movie ■ Book ■ Album

Perry Rhodan

...4 ...3 ...2 ...1 ...Morte
🎬 Primo Zeglio

Perry Rhodan
🎬 Ace Books

Perry Rhodan
🎬 Master Publications

1960 1965 1970 1975 1980 1985

Perry Rhodan: Lemuria

Perry Rhodan: Neo

Although the series has always been careful to follow "real science" as far as possible, it's not afraid to make things up where convenient. It is also at times militaristic, high-handed and content with a status quo in which a tiny elite receives amazing privileges.

When the series began it was considered by many too juvenile, with poor dialog and wafer-thin characterization, for serious discussion. The original U.S. publisher, Ace Books, dropped its translated versions in the late 1970s even though the series remained profitable. But over the following decade the German books became more adult and developed an intricate and complex cosmology.

The emphasis is always on the destiny of the human race as it finds its place at the center of an "onion-shell" model of interstellar life forms. Below us are bacteria and the higher animals; above us are superintelligences (often born when a species collectively gives up material form to exist as a bodiless mass), and above them are matter-fountains and matter-sinks, where these beings fuse with everything in their domains — which are often as big as several galaxies — then gradually shrink, their ultimate fate unknown. And above even these are the High Powers, which exist in another dimension and act through lower individuals or the species they control: some of these godlike beings worship order, others spread chaos, and their never-ending wars can crash through into our lower universes, often with catastrophic results.

From time to time various High Powers enlist Rhodan as their agent as they consider matters that are beyond even their comprehension, such as the the identity of the composer of the Moralic Code — the rules by which they must abide.

Perry Rhodan has only been sporadically translated into English, although it started strongly. Instigated by Forrest J. Ackerman, the Ace Books translations began in 1969 and lasted nearly 120 volumes; a smaller-scale attempt to continue from there soon spluttered and died, as did an attempted revival in the 1990s. Its popularity has endured longer in Europe, and in Brazil and Japan.

The *Perry Rhodan* series can be off-puttingly obscure. Occasional attempts are made to simplify affairs, but the demands of such regular publication inevitably create further complications almost immediately. Nevertheless it remains one of the richest space operas ever created, its subject nothing less than the future history of humanity, as well as a strikingly healthy survivor of the otherwise moribund pulp genre: it is a sort of literary coelacanth. **MB**

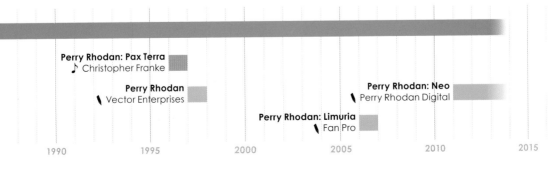

Perry Rhodan: Pax Terra
♪ Christopher Franke

Perry Rhodan
❨ Vector Enterprises

Perry Rhodan: Limuria
❨ Fan Pro

Perry Rhodan: Neo
❨ Perry Rhodan Digital

1990 1995 2000 2005 2010 2015

perry rhodan universe

Perry Rhodan

Atlan

Reginald "Bull" Bell

Around 48,000 BC Earth was ruled by Lemurians, "the First Humanity," but they fled to the stars. Those left behind became "the Second Humanity" — us. Various aliens then meddled with the development of the planet, including some who tried to destroy the Sun. Other aliens were more benevolent, however, and around 8000 BC an Arkonide named Atlan was trapped on Earth following a battle against Druufs, invaders from another universe.

In the late 20th century, Major Perry Rhodan leads the first expedition to the Moon. There he recovers powerful Arkonide technology and, with it, averts a third World War and unites the planet. He now calls himself a Terran and establishes a world government.

After Earth (Terra) repels an alien invasion, Rhodan devotes himself to making it a galactic power with help from the "mousebeaver" Pucky, a newly awakened Atlan and IT. The last named, a disembodied higher lifeform, gives Rhodan and 13 others a form of immortality: every 62 years they will use a "cell activator" to rejuvenate. By 2040 Terra has a powerful spacefleet, but then comes a second Druufs invasion.

In 2336 IT leaves the Galaxy, and the Terrans and their allies face new menaces including the Blues, a powerful empire. Discovering a gigantic matter transmitter in the center of the Galaxy in 2400, Rhodan is transported to Andromeda 2.4 million light years away, where he defeats the seven dictators.

One thousand years later, various empires have grown out of former Terran colonies. More invaders are defeated, including the Swarm.

In 3456, humankind is drawn into a battle between two Superintelligences, IT and Anti-IT; eventually Anti-IT is banished by the Cosmocrats to the Nameless Zone, a sort of limbo. Then, around 3462, seven galaxies annex the Milky Way, but IT rescues the people of Earth by absorbing them into itself.

characters

▨ Perry Rhodan ▨ Altan ▨ Reginald "Bull" Bell

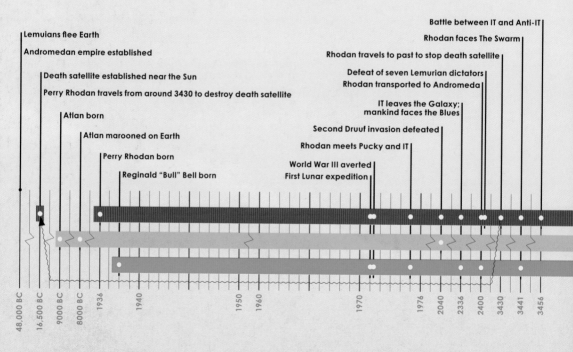

Battle between IT and Anti-IT
Rhodan faces The Swarm
Rhodan travels to past to stop death satellite
Defeat of seven Lemurian dictators
Rhodan transported to Andromeda
IT leaves the Galaxy; mankind faces the Blues
Second Druuf invasion defeated
Rhodan meets Pucky and IT
World War III averted
First Lunar expedition

Lemuians flee Earth
Andromedan empire established
Death satellite established near the Sun
Perry Rhodan travels from around 3430 to destroy death satellite
Atlan born
Atlan marooned on Earth
Perry Rhodan born
Reginald "Bull" Bell born

48,000 BC · 16,500 BC · 9000 BC · 8000 BC · 1936 · 1940 · 1950 · 1960 · 1970 · 1976 · 2040 · 2336 · 2400 · 3430 · 3441 · 3456

In 3588 Rhodan learns that he and Atlan had been chosen by the High Powers to become immortal. Rhodan replaces the old calendar with the New Galactic Era (NGE).

Around 424 NGE, Rhodan fights off the first attacks by the Superintelligence Seth-Apophis, and learns of the three Ultimate Questions, the answers to which the Cosmocrats have been seeking for millions of years. They are: What is the Frost Ruby? Where does the Endless Armada begin and where does it end? And who initiated THE LAW and what does it accomplish?

By 429 NGE Rhodan has found answers to the first two questions. At the Mountain of Creation he is offered the final answer, but turns it down lest it overwhelm him. The Cosmocrats are furious.

Things now go horribly wrong: a warrior cult takes control of the galaxy, and 21 intelligent species from a dying universe transport an entire galaxy from their universe into ours. Rhodan and other Immortals are caught in a stasis field; only seconds seem to pass, but it's actually 695 years. The field dissolves in 1143 NGE.

The Milky Way is isolated by the Chronopulse Wall. IT reappears, takes back the 14 cell activators and gives them to the Linguids, but later regrets this move and returns them to the Immortals.

In 1202 NGE exploration of the Great Void, a starless area 150 light years in diameter, reveals gateways to another dimension. Rhodan learns that the Universe has a negative side, the Arresum, and a positive side, the Parresum.

The crystalline enemy from the Arresum is defeated, and IT releases the 20 billion human consciousnesses it absorbed, placing them in fresh bodies to begin a new race on the negative side.

The next threat comes from fish-like aliens the Hamamesch. By 1220 NGE Rhodan has learned more about the Great Cosmic Riddle, but further trouble is brewing ... **MB**

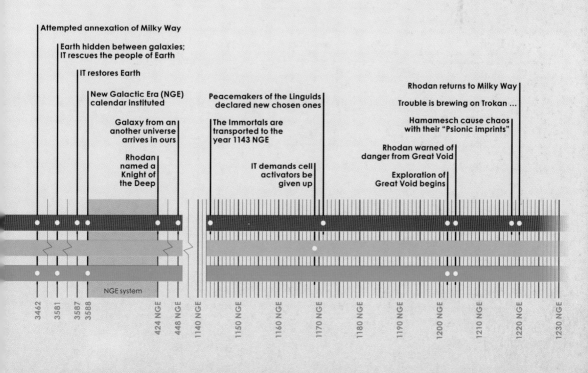

Attempted annexation of Milky Way

Earth hidden between galaxies; IT rescues the people of Earth

IT restores Earth

New Galactic Era (NGE) calendar instituted

Galaxy from an another universe arrives in ours

Rhodan named a Knight of the Deep

Peacemakers of the Linguids declared new chosen ones

The Immortals are transported to the year 1143 NGE

IT demands cell activators be given up

Rhodan returns to Milky Way

Trouble is brewing on Trokan ...

Hamamesch cause chaos with their "Psionic imprints"

Rhodan warned of danger from Great Void

Exploration of Great Void begins

NGE system

3462 3581 3587 3588 424 NGE 448 NGE 1140 NGE 1150 NGE 1160 NGE 1170 NGE 1180 NGE 1190 NGE 1200 NGE 1210 NGE 1220 NGE 1230 NGE

solaris 1961

Solaris Solaris Solaris Solaris

Solaris is a novel by Stanisław Lem that was first published in 1961, five years after censorship was relaxed by the Communist government of his native Poland. The work was the finest fruit of his most productive period — he had two other novels, *Mortal Engines* and *Return from the Stars*, published in the same year. However, *Solaris* outperformed both of these works and all the rest of his work put together — according to the writer's website, by the end of 2013 it had sold more than 20 million copies.

Solaris is, paradoxically, both incredibly detailed and very sparse; although settings and ideas are described in great depth, there is relatively little action, and only four beings interact with each other in the whole novel.

The story begins with psychologist Kris Kelvin being fired off, alone, in a space capsule to rendezvous with a research station orbiting the planet of Solaris. The planet's ocean is believed to be sentient — it displays signs of intelligence and is capable of creating vast, temporary structures — but no human has succeeded in communicating with it in spite of decades of trying.

From the beginning there is a sense of isolation, of failing to connect, not just between the researchers and the planet, but between the humans on the space station. When Kelvin arrives, no one is waiting to meet him. Eventually he finds Snaut (renamed Snow in English translations), one of the three scientists in residence, who appears deranged and tells him that Gibarian, one of his colleagues, is dead.

Yet there are clearly other people on the station; Kelvin encounters a mysterious woman near Gibarian's room, and when he finally ventures up to the lab, where the third scientist, Sartorius, has barricaded himself in, he thinks he can hear a child.

Just as the characters cannot forge meaningful links with each other, and never tell each other anything in full, so the reader is kept out of the narrative, with facts about the history of Solaris, and about Kelvin's life, revealed only gradually.

There is a clear sense of paranoia on the Solaris Station. Kelvin is affected by the anxiety of the other scientists from the start, and Snaut eventually reveals that Gibarian killed himself with a lethal injection after shutting himself in a locker.

Kelvin falls asleep, and awakens to find Harey (Rheya in English translations) sitting in his room. At this point it is clear that she and Kelvin had once been lovers; later it emerges that they were formerly husband and wife, and that she had killed herself when he abandoned their marriage.

Kelvin reacts with hostility to this simulated Harey, and tricks her into sitting in a capsule so that he can fire her off into space. However, Snaut and Sartorius have previously tried to rid themselves of visitors such as Harey in much more violent ways, but for some reason the visitors always return.

Thus by the time Harey reappears, Kelvin has largely given up the idea of getting rid of her, although he and the scientists discuss by videophone

year-by-year ■ Book ■ TV movie ■ Movie

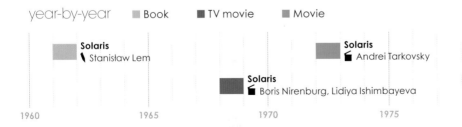

Solaris
\ Stanisław Lem

Solaris
🕮 Boris Nirenburg, Lidiya Ishimbayeva

Solaris
🎬 Andrei Tarkovsky

1960 1965 1970 1975 1980

other ways to eliminate them. They come up with two possible courses of action: one is to take an electro-encephalograph from one of themselves and use X-rays to beam it directly into the ocean in the hope of communicating something about their work to it; the other — which is based on Kelvin's hypothesis that the visitors may be constructed from neutrinos — is to construct a device that will destabilize their structure and disintegrate them.

As Snaut and Sartorius work, unseen, on these projects, Kelvin becomes more attached to Harey, and starts to think of ways to save her from the neutrino structure destabilization. He even tries to persuade Snaut that to do so could cause a massive explosion. Harey, meanwhile, has found a tape recording left by Gibarian and become aware of her own artificiality. She drinks liquid oxygen, but is unable to die, and eventually recovers.

The electro-encephalograph experiment is performed, with no result that the scientists can identify. Kelvin suffers repeated nightmares, then one night Harey drugs him. Sartorius and Snaut have completed their other project, and Kelvin awakes to find his visitor has finally gone. He ends up on one of the planet's temporary constructions, repeating the same actions the early scientists had performed.

Lem describes Solaris in detail, but deliberately prevents readers from understanding it. All they can do is wonder at it. And that is the point of the book: *Solaris* is, at least in part, a critique of the sort of science fiction in which humans find the universe inhabited by beings similar to themselves. As Snaut says to Kelvin: "We don't want to conquer the cosmos, we simply want to extend the boundaries of Earth to the frontiers of the cosmos ... We are only seeking Man, we have no need of other worlds. We need mirrors. We don't know what to do with other worlds."

Although the action is limited and the characters few, three attempts have been made to film *Solaris*. The first was a two-part Russian TV movie, broadcast in 1968. In 1972 came the first cinema version, 166 minutes long, which has been acclaimed as one of the most intelligent science fiction films ever produced. Writer and director Andrei Tarkovsky focuses more on grief and loss and the nature of human relationships than on Lem's main theme — the inability to comprehend the truly alien. Lem himself said, "I never really liked Tarkovsky's version."

Steven Soderbergh directed a Hollywood version, starring George Clooney and Natascha McElhone, which was released in 2002. Again, it focused more on Kelvin's relationship with Harey, and the ending is substantially different from that of Lem's novel. The film was not a success at the box office, making back just $30 million of its $47 million budget.

In 2011 *Solaris* was published in an English language edition translated directly from the original Polish. This is remarkable because previous versions had been translated from the French. **MM**

Solaris
Steven Soderbergh

1985 1990 1995 2000

Solaris
(1972)

Solaris
(2002)

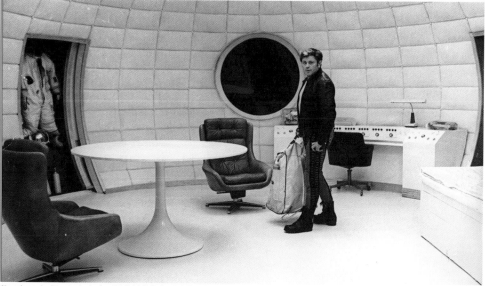
Lithuanian actor Donatas Banionis as Kris Kelvin in Tarkovsky's film of the novel.

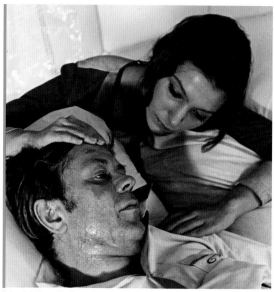
Tarkovsky's Harey (Hari) was played by Natalya Bondarchuk.

As soon as George Clooney arrives on the Solaris Station, he realizes that all is not as it should be (Steven Soderbergh).

The scientists try to figure ways of ridding themselves of unwanted guests (Tarkovsky).

Soderbergh's *Solaris* is more than an hour shorter than the Russian version.

The Solaris Station as envisioned by Soderbergh.

George Clooney sees the child who is only heard in the novel.

Clooney's Kelvin comes to term with re-encountering his long-dead ex-wife.

Natascha McElhone as Rheya (originally Harey) in Soderbergh's film.

George Clooney as Kelvin in the 2002 *Solaris*.

ursula k. le guin 1961

SFWA
GRANDMASTER

| An Die Musik | Rocannon's World | Planet of Exile | City of Illusions | The Left Hand of Darkness | The Lathe of Heaven | The Word for World is Forest | The Ones Who Walk Away from Omelas |

Ursula Kroeber Le Guin is widely regarded as one of the greatest writers of the second half of the 20th century. Her work may be summarized as that of a philosopher who has made science fiction and fantasy literature the vehicles for her thoughts and reflections. In a career spanning six decades, she has crafted one seminal masterpiece after another. Although she has never attained the commercial success of some other writers in these fields, she is one of the most revered by those in the know.

Ursula Kroeber was born in 1929 in Berkeley, California, and graduated from the city's high school in the same class as Philip K. Dick. Her first degree in French and Italian literature from Radcliffe College was followed by a master's in the same subjects at Columbia University. She then went to France to research her doctoral thesis. While she was there she met historian Charles Le Guin; they returned to the United States the following year as husband and wife.

Ursula K. Le Guin then taught French at university level, but meanwhile she was honing her skills as a creative writer. This was always her main interest: she had sent her first short story to *Astounding* at the age of 11, and undeterred by the magazine's rejection of the work, kept going until the 1960s, when she first appeared in print.

Although Le Guin's creative output has been prolific and varied, and includes poetry and nonfiction, at the heart of her work are two series of novels and short stories: the Earthsea fantasy saga and the Hainish science fiction cycle.

Originally published in trilogy form as *A Wizard of Earthsea* (1968), *The Tombs of Atuan* (1971) and *The Farthest Shore* (1972), the Earthsea sequence was expanded to a quartet in 1990 with *Tehanu: The Last Book of Earthsea*, and then became a quintet with 2001's *The Other Wind*. Set in a fictional archipelago, the novels chart the life of Ged, a young boy with a raw talent for magic who grows up to become Archmage and Dragon Lord.

The epic battles and the clash of good and evil that characterize much high fantasy are largely absent from the Earthsea sequence, which focuses instead on the internal lives and struggles of its characters. Ged's first quest to defeat his own Shadow, released by his prideful use of magic, makes explicit the psychological subtext of the story — the Shadow is a major archetype in the theories of Carl Jung. As the narrative unfolds we see Ged no longer as a powerful wizard, but as a delusional old man, and the land of Earthsea not as a fantasy realm, but a gritty world of corruption and violence.

year-by-year　■ Short story　■ Book

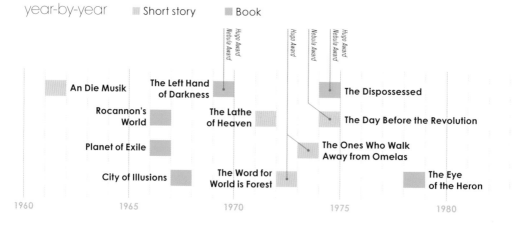

| The Dispossessed | The Day Before the Revolution | The Eye of the Heron | Always Coming Home | Solitude | Four Ways to Forgiveness | The Telling | Powers |

The tension between reality and fantasy, magic and reason, remains central in the Hainish cycle, which begins with *Rocannon's World* (1966), *Planet of Exile* (1966) and *City of Illusions* (1967). These novels establish the Hainish universe and reveal Le Guin's particular interest in political and social themes. Having thus set the scene, the later novels are the most powerful. *The Left Hand of Darkness* (1969) — set on the alien world of Winter, whose inhabitants are neither male nor female — is widely credited as the first feminist SF novel. Critic Harold Bloom wrote that "Le Guin, more than Tolkien, has raised fantasy into high literature, for our time." *The Dispossessed* (1974) — subtitled "An Ambiguous Utopia" — was praised for its incisive analysis and satire of Cold War politics. Overall, the Hainish cycle played a significant role in giving a voice to socialist ideas within the field of professional science fiction writing, which for much of its early history had leaned significantly to the right of the political spectrum.

The Lathe of Heaven (1971) is often regarded as Le Guin's most accomplished single novel. It follows George Orr, an ordinary man struggling with his ability to alter reality through the power of dreams, and the therapist William Haber who, through Orr, attempts to banish the horrors of the world. The central theme is the collision of scientific and spiritual world views. Although Le Guin's focus on sociological themes and alternative spiritual perspectives has led some critics to categorize her work as part of the New Wave of science fiction of the 1960s and 1970s, she was not directly involved with the movement at that time.

Numerous screen adaptations of Ursula K. Le Guin's stories have been attempted, but the dense philosophical nature of her books has proved hard to translate into other media. The 2004 adaptation of Earthsea by the Sci-Fi channel appalled fans of the novels by casting white actors as characters that in the books are explicitly described as brown-skinned. The 2006 Studio Ghibli adaptation *Tales from Earthsea* also made significant alterations to the moral structure of the Le Guin's universe, but remains the most successful screen version to date.

In 2003 Ursula K. Le Guin was made a Grandmaster of Science Fiction, one of only a handful of women writers to take the top honor in a genre that has come to be dominated by male writers. The brilliance of Le Guin's writing and the insight of her wisdom on issues of gender, race and spirituality have made her one of the most respected figures in the history of science fiction. **DGW**

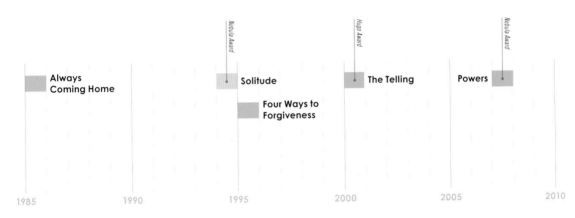

spider-man 1962

Amazing
Fantasy

The Amazing
Spider-Man

Spider-Man

Marvel
Team-Up

Spider-Man
Comics
Weekly

Peter
Parker the
Spectacular
Spider-Man

The Amazing
Spider-Man

Web of
Spider-Man

More popular and widely known today than ever, Spider-Man is the most successful example of the remarkably fruitful outpouring of creativity in the early 1960s by Stan Lee and his Marvel Comics associates.

The webslinger's first appearance was in the final issue of a 1962, 12-cent comic book entitled *Amazing Fantasy* — a copy of which went for some $1.1 million at auction in 2011. Stan Lee had already created the Fantastic Four and the Incredible Hulk, but Spider-Man was, as Lee himself has said, "probably the first comic book hero that teenagers themselves could identify with." Spider-Man was very different to most superheroes that came before him: unlike Superman he wasn't infallible, unlike Batman he wasn't a multi-millionaire, unlike Captain America he wasn't respected by the wider world. Spidey was also much better with a quip than any of these characters.

His origin story is up there with the greatest in all of comics. Peter Parker is a puny, studious high school pupil shunned by girls, living with his elderly aunt and uncle since his parents perished when he was a child. One day, during a science experiment, he is bitten by a spider that has been exposed to radiation. Shortly afterward he discovers that he has acquired the arachnid's powers, including the ability to cling to surfaces, plus proportionate super-strength and speed. He goes on to create a colorful costume and uses his scientific knowledge to develop web shooters that fire super-strong fibers. Carried away with his powers, and the celebrity status it confers, he arrogantly fails to stop a robber, who proceeds to kill his beloved Uncle Ben. From that day, Parker swears to use his powers for good and fight crime and injustice.

It was inevitable that Spider-Man would get his own comic. Sure enough, *The Amazing Spider-Man* debuted in mid-1963. Over the next few years, amid appropriately amazing sales, Lee expanded the *Spider-Man* universe, bringing in an array of characters, many of whom are still mainstays of the title (Lee wrote the comic until 1972). Steve Ditko lent his artistic talents for the first 38 issues, giving way to John Romita, whose figures tended to be more muscular and dynamic. The character has also been drawn by such notable artists as Jack Kirby, Gil Kane, John Romita Jr., Frank Miller and Todd McFarlane.

Spider-Man steadily grew as a pop culture icon throughout the 1960s and 1970s. In 1967 he came to television for the first time with the *Spider-Man* cartoon series. It ran for three seasons but the scripts are nowhere near as complex or involved as those

year-by-year ■ Comic ■ Animated TV series ■ TV series ■ Movie

The Amazing Spider-Man

Amazing Fantasy

Marvel Team-Up

Spider-Man Comics Weekly

Peter Parker the Spectacular Spider-Man

Spider-Man
📺 ABC

The Amazing Spider-Man
📺 CBS

1960 1965 1970 1975 1980 1985

$1 B
Spider-Man
(2002)

$967 M
Spider-Man 2
(2004)

$1 B
Spider-Man 3
(2007)

$763 M
The Amazing
Spider-Man
(2012)

Spider-Man

Spider-Man

Spider-Man 2

Spider-Man 3

Avenging
Spider-Man

The Amazing
Spider-Man

Ultimate
Spider-Man

The Superior
Spider-Man

of the comic. The animation was also quite basic — albeit not without charm — and the show is mainly memorable for its irresistibly catchy theme tune. Since then there have been a further seven Spider-Man cartoon series, the pick of them probably being the 65-episode show that began in 1994.

By the close of the 1970s Spider-Man was starring in two other U.S. comics, a syndicated newspaper strip and innumerable items of merchandise, from pajamas to candy to toy figures, all around the world. He made his live-action television debut in 1977, although The Amazing Spider-Man lasted for just 13 episodes, hamstrung by poor special effects and a skyscraper-less Los Angeles unconvincingly doubling as New York. (The series also spawned a trio of indifferently received feature films.)

There were unsuccessful attempts to bring the wall-crawler to the big screen in the 1980s and 1990s. Cannon promised a movie for Christmas 1986, but ran into financial problems and scrapped the project.

By the time Spider-Man made his true cinematic debut in 2002, special effects technology had moved on so much that his spectacular movements could be convincingly portrayed. Director Sam Raimi, maker of 1981's classic low-budget horror flick The Evil Dead,

captured the comic book spirit of the original and, in Tobey Maguire, found the perfect actor to bring to life a gauche Peter Parker.

Spider-Man 2 (2004) was hailed by some critics as the finest superhero film ever. Spider-Man 3 (2007) capped the series by edging out the first as the most financially successful of the trilogy worldwide.

Raimi bailed on a fourth film, and the result was a reboot of the franchise just a decade after his first. The Amazing Spider-Man (2012), directed by the aptly named Marc Webb, endeavored to distinguish itself from Raimi's films (for example, Peter's girlfriend is Gwen Stacy, not Mary Jane Watson), although it remained faithful to the comics. A sequel was released in 2014, with a further two planned.

The movies most publicly keep Spider-Man swinging, but other fruits of the franchise continue to thrive. At the start of 2013 a daring comic series, The Superior Spider-Man, replaced The Amazing Spider-Man, and 2012 brought Ultimate Spider-Man, the latest in a succession of TV animations.

The strength and appeal of Spider-Man lie in the depiction of an ordinary human with troubles much like our own, who can still become a hero. It's unlikely that the character will disappear for a long time. **RL**

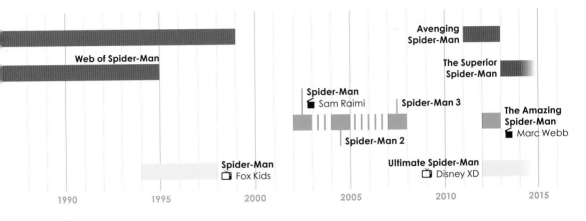

The Amazing Spider-Man (1963–99)

The Amazing Spider-Man (1977–79)

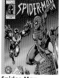

Spider-Man (1994–98)

Spider-Man (2002)

Spider-Man 2 (2004)

Spider-Man 3 (2007)

The Amazing Spider-Man (2012)

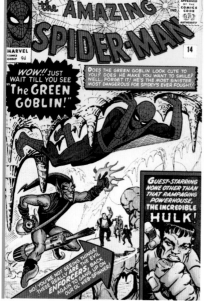

Early issues of **The Amazing Spider-Man** featured dynamic artwork by Steve Ditko.

The Sound of Music's Nicholas Hammond brought Spidey to life in **The Amazing Spider-Man** TV series.

Christopher Daniel Barnes — Prince Eric in Disney's **The Little Mermaid** (1989) — voiced Spidey in the 1990s' cartoon series.

"The Night Gwen Stacy Died" was a key turning point in the history of superhero comics, as it was the first story to depict the death of a supporting cast member.

Despite the advent of Venom, the Green Goblin — shown in a poster for the first Raimi movie — is Spidey's most iconic foe.

An iconic encounter between Tobey Maguire and Kirsten Dunst (Mary-Jane Watson) in **Spider-Man.** "It was hard to film," said Dunst, "because Tobey couldn't really breathe."

"It's a real shame that I died," said Alfred Molina of his role as Doc Ock, "because I would've loved to do another one."

"To recognize yourself within a monster is a great metaphor for me as a character ..." said Rhys Ifans of his reboot role as The Lizard. "That was just absolutely thrilling."

Thomas Haden Church's performance as Sandman in **Spider-Man 3** was motion captured and mapped onto his mostly CGI character.

"No upside-down kissing this go round," promised Emma Stone, who plays Gwen Stacy in the 2012 reboot. "I did some swinging but I didn't get to beat anybody up."

"I was certainly curious as to who was going to play Peter Parker," Tobey Maguire told Andrew Garfield. "When I heard it was you, I was literally like ... perfect!"

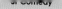

the jetsons 1962

| The Jetsons | The Jetsons | The Jetsons | The Jetsons Meet The Flintstones | Jetsons: The Movie | The Jetsons | The Jetsons | The Flintstones and The Jetsons |

The unprecedented success of *The Flintstones*, the first animated prime time sitcom, set U.S. television executives searching for another suitable subject. The obvious choice was to look forward instead of back; hence *The Jetsons* which, although it initially only ran for one season, established itself within popular culture and has been periodically revived.

Despite living in the jet-packs-and-flying-cars future of 2062, the eponymous family conformed strictly to 1960s' gender roles. The father, George, commuted to and from work at Spacely Sprockets. The mother, Jane, was a stay-at-home housewife. Teenage daughter Judy attended high school where she swooned over boys. Young son Elroy went to elementary school where he got into scrapes. Robotic housemaid Rosie and enthusiastic dog Astro completed the family unit.

As in *The Flintstones*, much of the humor came from "labor-saving" devices, but whereas in the fomer these had been mainly animal-based, in *The Jetsons* they were all robotic. The incidental jokes were futuristic, but the plots were off-the-shelf antiques: relationship mix-ups, TV fame aspirations, pleasing the boss and other formulaic stories that could have slotted into any domestic sitcom of the era.

Broadcast on Sunday evenings (the first ABC show in color), *The Jetsons* never achieved the crossover audience that *The Flintstones* had captured and swiftly found a home in Saturday morning re-runs. Two decades later the show was revived, again on Saturday mornings, as part of a block of new and old cartoons. The 1980s' episodes reflected an updated view of the future — more computers, fewer robots — and made greater use of SF themes, although the family itself remained as stereotypical as ever, notwithstanding the inclusion of Orbitty, an alien pet.

This second incarnation proved more popular than the original, with twice the number of episodes and two feature-length, spin-off TV movies, one of which was the long-awaited (but ultimately inevitable) Flintstones crossover story. In *The Jetsons Meet the Flintstones*, Elroy's home-built time machine sends his family into the prehistoric past, then transports Fred and Barney into the future.

In *Jetsons: The Movie* — one of the first animated features to incorporate CGI — the family relocate to an asteroid where a Spacely Sprockets mining colony is being sabotaged; the saboteurs turn out to be friendly aliens. The film flopped in spite of the stunt-casting of teenage pop singer Tiffany as the voice of Judy. Rumors of a possible live-action Jetsons feature persist but the problem facing any future revival is that the show's optimistic view of a nuclear-powered, nuclear-family future is now strictly retro, substituted in the cultural zeitgeist by the singletons, slobs and cynicism of *Futurama*. **MJS**

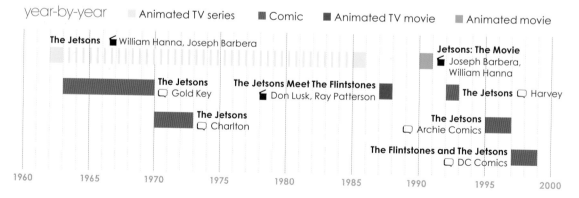

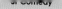year-by-year — Animated TV series — Comic — Animated TV movie — Animated movie

The Jetsons — William Hanna, Joseph Barbera
Jetsons: The Movie — Joseph Barbera, William Hanna
The Jetsons — Gold Key
The Jetsons Meet The Flintstones — Don Lusk, Ray Patterson
The Jetsons — Harvey
The Jetsons — Charlton
The Jetsons — Archie Comics
The Flintstones and The Jetsons — DC Comics

1960 1965 1970 1975 1980 1985 1990 1995 2000

la jetée 1962

La Jetée 12 Monkeys

Released in 1962, Chris Marker's *La Jetée* is a movie with a running time of 30 minutes that is almost wholly comprised of black-and-white photographs. An unprepossessing concept for a film, and yet a successful one; *La Jetée* is often praised as one of the best time travel movies ever.

The title refers to an observation deck at Paris Orly Airport. This is the setting for the film's start and finish, as the same character experiences the same event — the murder of a man — twice, each time from a different perspective. The killing burns into the mind of the nameless hero (played by Davos Hanich). He's in the future, a captive of the victors of a third World War which has driven most of humanity into catacombs. The regime's scientists seek "emissaries into Time" to save them. They torture the hero with injections until his memory leads him into the France of his childhood. Here he meets a beautiful woman (Hélène Chatelain), whom he's seen somewhere before.

The solemn narrator explains, "She welcomes as a natural phenomenon the ways of this visitor who comes and goes, who exists, talks, laughs with her, stops talking, listens and vanishes." The romance anticipates and may have influenced *The Time Traveler's Wife* (2009), but the narrative structure of *La Jetée* is inimitably haunting: still frame after still frame, some of which are agonized, some of which are happy, all of which are fleetingly transient. The film appeals to the same nostalgic impulse that draws people to their old photograph albums. It depicts time as an eternal series of events, with no past, no future and no present — or at least almost no present, apart from one shocking moment when the woman moves and thus hints at the possible existence of a higher

dimension of reality: this scene is thought by some to prefigure *2001: A Space Odyssey*'s stargate sequence.

La Jetée was remade as *12 Monkeys* (1995), a relatively conventional two-hour feature (though eccentric by Hollywood standards). Directed by Terry Gilliam, *12 Monkeys* expands the story and taps into pandemic fears, with a post-apocalyptic hero now seeking the cure for a devastating disease.

Gilliam's film has none of Marker's tranquility. Hero Cole (Bruce Willis) undergoes a traumatic time journey that takes him through an asylum, a battlefield and several brutal fights. He kidnaps a terrified woman psychiatrist (Madeline Stowe) for a road trip akin to that in *The Terminator*. Both characters experience meltdowns of their worldviews: Cole decides that he is insane; his hostage is horrified by the abundant evidence that he is not.

La Jetée's hero longs for the past; the lead characters in *12 Monkeys* try for a *Brazil*-style escape into a fantasy shaped by holiday commercials and Hitchcockian glamor. The latter is much more densely plotted than the original, with red herrings and false trails that anticipate Christopher Nolan's *Memento*. The tragic, slo-mo ending — at an airport, naturally — stuns. This is time travel done exceptionally well, with a paradox at the heart of the narrative, and suggestions of predestination and a circular immortality.

La Jetée remains influential, being homaged in the music videos for "Dancerama" (Sigue Sigue Sputnik) and "Jump They Say" (David Bowie); in Timothy Greenberg's spoof *La Puppé* (about a time-twisted puppy); and in the "collaborative film-sound performance" *Her Ghost* (2012), which reworks the story from the woman's viewpoint. **AO**

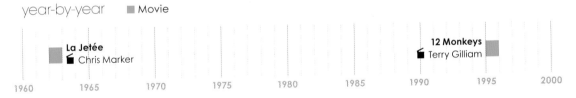

year-by-year ■ Movie

La Jetée Chris Marker **12 Monkeys** Terry Gilliam

1960 1965 1970 1975 1980 1985 1990 1995 2000

a clockwork orange 1962

A Clockwork Orange

A Clockwork Orange

A Clockwork Orange is the result of a scholar and an intellectual, well versed in the classics, turning his hand to a more modern and, it could be argued, more exciting subject — that of a young criminal forced to have radical treatment for his anti-social behavior. Anthony Burgess came to write his ninth novel — although *A Clockwork Orange* is more accurately described as a novella, running to only around 140 pages — as a response to an event in his own life: his wife was beaten by a group of drunken American soldiers and miscarried their baby.

The book tells the tale of 15-year-old Alex, the product of a future dystopia, who is involved in "ultraviolence" and rape ("the old in-out") before being captured by the authorities and given aversion therapy called the "Ludovico technique," which confronts him with extreme crime to rehabilitate him.It is written in the first person in "Nadsat," a form of Russian-influenced English that was created by Burgess, a talented linguist, to prevent his teen subculture dating.

A Clockwork Orange was well received when it was published in 1962, but it was not until 1971, when Stanley Kubrick adapted it for the cinema, that its fame really spread (it subsequently garnered further accolades, including becoming one of *Time* magazine's 100 best English-language novels of 1923–2005). Kubrick, who had previously enjoyed critical acclaim and commercial success with *Lolita*, *Dr. Strangelove* and *2001: A Space Odyssey*, chose to adapt the book rather than attempt a Napoleon biopic. Malcolm McDowell, previously a rebellious schoolboy in Lindsay Anderson's *If ...*, plays Alex, and is older than the character depicted in the book. There are a number of other changes from the source material, including the omission of the final chapter (of the British edition) in which the aversion therapy is shown to have worked. (The central issue of the book was the relative merits of free will and determinism.)

Although shot in a shorter period than any other major Kubrick film, *A Clockwork Orange* showcases the director's trademark meticulousness. Unique set design, distinctive costumes and an effective part-electronic, part-classical score give it an otherworldly feel quite unlike any other film. It's a visual tour de force and McDowell is accomplished in the lead role. The film received the 1972 Hugo for Best Dramatic Presentation and was nominated for four Academy Awards, including Best Picture and Best Director.

A box office hit, it made around $22 million in the United States on a budget of around $2.2 million. However, Kubrick was accused of glamorizing sex and violence, and a handful of real-life crimes that appeared to mimic scenes in the film, including one in which attackers sang "Singin' In The Rain" to their victim (as happens in the film), caused a storm of controversy. The director then persuaded Warner Brothers to withdraw the film from Britain, where it remained largely unseen until his death in 1999. A few months later, the movie was officially re-released throughout the United Kingdom. It had lost none of its shocking power in the intervening period. **RL**

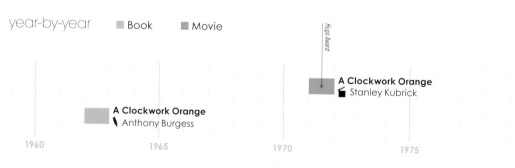

year-by-year ■ Book ■ Movie

Hugo Award

A Clockwork Orange
Stanley Kubrick

A Clockwork Orange
Anthony Burgess

1960 1965 1970 1975 1980

barbarella 1962

Barbarella Barbarella Barbarella Barbarella: Les Colères du Mange-Minutes Barbarella: Le Semble-Lune Barbarella: Le Miroir aux Tempêtes Barbarella

French writer and illustrator Jean-Claude Forest — originally best known for his SF paperback covers and 1950s' comic strips featuring a variant on Charlie Chaplin called Charlot — hit the bigtime in 1962 with a new science fiction creation, Barbarella, a confident, highly independent blonde who enjoys sexually charged wanderings among the stars. First serialized in *V Magazine*, her original adventure was collected two years later in book form and became an international hit. Although primarily known for its eroticism, the comic strip is really quite mild, certainly by 21st-century standards. It is far more notable for its portrait of a very modern, emancipated woman.

Further Barbarella stories followed in the 1970s and early 1980s, but it was the 1968 movie version by Roger Vadim — writer/director of *And God Created Woman*, the film that made a star of the Brigitte Bardot — that cemented Barbarella in the public consciousness.

The original comic book character had always appeared to be based on Bardot, to whom Vadim had briefly been married, but now he cast his current wife, Jane Fonda, in the title role. In Vadim's *Barbarella*, the heroine is depicted as an agent of a pacifist Earth government of the far future. In spite of a witty script by Terry Southern — whose dialog had been so memorable in *Easy Rider* and *Dr. Strangelove* — and striking, high-camp production design, the film was initially considered a critical and box-office failure, but it produced better returns after a re-release in 1977, and subsequently became a cult hit on video and TV.

The plot loosely follows that of the original Barbarella storyline, with the heroine's fur-lined spaceship crash-landing on the planet Tau Ceti as she pursues rogue scientist Durand Durand (played by Miles O'Shea), inventor of a troublesome super-weapon. As she journeys toward Sogo, City of Night, she encounters feral children, homicidal dolls, horny child-catchers, peck-happy birds, confused resistance leaders and a blind angel who's forgotten how to fly. Many of these adversaries are won over by Barbarella's sexuality. Indeed, she is so highly charged in this area that Durand Durand's attempts to kill her with pleasure ends instead with the destruction of his orgasm machine.

Eventually the angel, Pygar (John Phillip Law) flies Barbarella and Sogo's reformed evil dominatrix Black Queen (Anita Pallenberg) to safety as Sogo is consumed. The story ends on notes of cataclysm, forgiveness and the healing powers of a healthily expressed sexuality.

Though remakes have been attempted numerous times — a Robert Rodriguez version with Rose McGowan in the title role among them — *Barbarella*'s lasting legacy is the enduring, striking visual of Fonda as the title character in a series of iconic poses and skimpy, skin-tight space suits, and two famous businesses that have taken their names from the film. One is the band Duran Duran; the other is the lava lamp company that called itself Mathmos after the evil liquid being that writhes beneath Sogo and eventually destroys it. **MB**

year-by-year ■ Comic ■ Movie ■ Musical

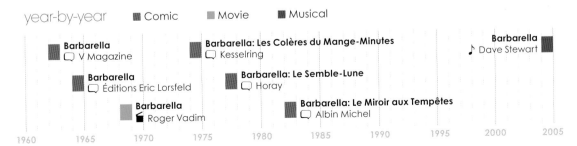

Barbarella
🖳 V Magazine

Barbarella
🖳 Éditions Eric Lorsfeld

Barbarella
🎞 Roger Vadim

Barbarella: Les Colères du Mange-Minutes
🖳 Kesselring

Barbarella: Le Semble-Lune
🖳 Horay

Barbarella: Le Miroir aux Tempêtes
🖳 Albin Michel

Barbarella
♪ Dave Stewart

1960 1965 1970 1975 1980 1985 1990 1995 2000 2005

samuel delany 1962

SFWA
GRANDMASTER

The Jewels of Aptor

Babel-17

The Einstein Intersection

Nova

Driftglass

Dhalgren

Empire

Through the Valley of the Nest of Spiders

Samuel R. "Chip" Delany was born in 1942 in Harlem, New York, where he grew up. He was a dominant author of the New Wave of science fiction in the 1960s, a rare African American — and gay — writer in a field dominated by straight white men.

His first published work was *The Jewels of Aptor* (1962), a colorful science fantasy adventure that originally appeared as an Ace-Double edition bound together with *Second Ending* by James White. The *Fall of the Towers* trilogy followed between 1963 and 1965. Meanwhile Delany married the poet Marylyn Hacker, with whom he had one daughter. He also began to explore gay cultural life in New York's East Village, writing of that period in his Hugo-winning autobiographical *The Motion of Light in Water* (1989).

He began to gain attention with *Babel-17* (1966), a complex space opera dealing with linguistics. It won a Nebula Award, as did *The Einstein Intersection* a year later. *Nova* (1968) is perhaps his most strongly sustained novel of the period, an ambitious, poetic space opera that remains powerful. It marked, however, the end of the first stage of Delany's career, of accessible, joyous science fiction adventures.

Dhalgren (1975) was a surprise hit, selling more than one million copies. Widely regarded as both Delany's masterpiece and his most difficult work, it is a vast, complex story of a poet, The Kid, who comes to a city seemingly isolated from the rest of the United States. Two further novels, and some pornography, followed, but Delany returned to genre fiction proper in the 1990s with a fantasy series, Neveryon, which interrogates the traditional conventions of fantasy while examining concepts of sexuality, slavery and even the AIDS epidemic. He also produced a graphic novel adaptation of his early SF novel *Empire Star* in collaboration with artist Howard Chaykin. With his then ex-wife Hacker (a significant poet) he edited the anthologies *Quark #1–#4*, popularizing the term "speculative fiction" in the process.

Delany's body of short fiction is not large, but it is significant. His "Time Considered as a Helix of Semi-Precious Stones" (1968) — about a criminal who falls in with a band of futuristic poets — won a Hugo and a Nebula award and has been widely reprinted. This piece, along with another Nebula winner, "Aye, and Gomorrah," were among the works anthologized in his 1971 *Driftglass* collection.

Delany further contributed to genre fiction through his works of academic criticism, which included *The Jewel-Hinged Jaw: Notes on the Language of Science Fiction* (1977).

In 2012, he synthesized two of his abiding interests — science fiction and pornography — in *Through the Valley of the Nest of Spiders*, a novel that explores the lives of three gay men over the early decades of the 21st century. **LT**

year-by-year ■ Book ■ Graphic novel

Nebula Award
Nebula Award

Babel-17
Nova
Dhalgren
Through the Valley of the Nest of Spiders

The Einstein Intersection
Driftglass
Empire

The Jewels of Aptor

1960 1970 1980 1990 2000 2010

the outer limits 1963

The Outer Limits

The Outer Limits

The Outer Limits

Demon With A Glass Hand

The Outer Limits

"There is nothing wrong with your television set. Do not attempt to adjust the picture."

These were the opening words to one of the most unusual television shows ever to air, one that was unashamedly science fiction and determinedly odd.

In 1959 *The Twilight Zone* changed genre television forever. In its wake followed a slew of imitations — modern fables featuring a bizarre twist on reality and often a "monster of the week." From *Strange Report* and *Kolchak: The Night Stalker* to *The X-Files*, weekly excursions into the odder side of science fiction and the paranormal have all been informed by *The Twilight Zone*. Arriving four years after *The Twilight Zone*, *The Outer Limits* offered a similarly skewed take on the science fiction anthology format.

Dark, mysterious and morally ambiguous, the show offered weird stories more akin to comic books. It was infused with a sense of unpredictability and gave no assurance that everything would work out fine in the end. The stylistic choices of the show added an unexpected flourish to regular, scheduled programming, with expressionistic camera angles and a gothic horror atmosphere that created a sense of otherworldliness. The quality of talent involved elevated it above pulp. Series creator Leslie Stevens and Joseph Stefano, screenwriter of *Psycho* (1960), brought a suitably alternative vision of the world to the show. Likewise, such high profile writers as Harlan Ellison and Robert (*Chinatown*) Towne combined hard science fiction with emotional weight. Ellison's "Demon with a Glass Hand," for example, tells a pure SF tale of time travel, aliens and robots that is tinged throughout with a deep sadness.

Less concerned with the supernatural than *The Twilight Zone*, *The Outer Limits* was firmly grounded in science fiction. No quirk of technology or space was off limits. The original 49 episodes featured everything from alien visitors ("The Galaxy Being") and human experimentation ("The Brain of Colonel Barham") to missions to Mars ("The Invisible Enemy") and groundbreaking science ("The Borderland").

No attempt was made to impart moral messages; the stories were meant to be interpreted just as the viewer pleased. Through artistic framing and camera work, most notably by legendary cinematographer Conrad Hall, *The Outer Limits* aimed to subvert traditional television visual conventions and formats. As the foreboding and laconic announcer declares during the opening narration, the television programming is now of out of the viewer's hands, beyond the realms of the normal.

The Outer Limits gained a loyal following among SF fans, but was cancelled in 1965 after only two series due to falling ratings. The show lay dormant for 30 years until being revived in 1995. In the new iteration 154 episodes were aired, featuring writing by such genre luminaries as Richard Matheson, George R.R. Martin and Stephen King. These new stories continued the show's commitment to science fiction over the supernatural, with human beings made trivial and at times insignificant when seen beside all the uncanny happenings in the universe. **SW**

year-by-year ■ TV series ■ Game ■ Comic

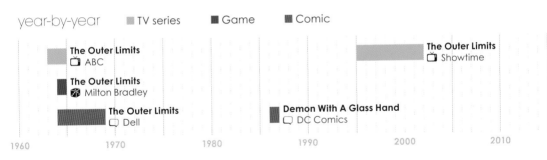

The Outer Limits
📺 ABC

The Outer Limits
🎲 Milton Bradley

The Outer Limits
📖 Dell

The Outer Limits
📺 Showtime

Demon With A Glass Hand
📖 DC Comics

1960 1970 1980 1990 2000 2010

planet of the apes 1963

La Planète des singes

Planet of the Apes

Saru no Wakusei

Beneath the Planet of the Apes

Beneath the Planet of the Apes

Escape from the Planet of the Apes

Perhaps the biggest, most enduring science fiction franchise of the pre-*Star Wars* 1970s, *Planet of the Apes* began as a short French science fiction novel of 1963 but exploded five years later into a string of films, television shows, sequel novels and comic book series.

The *Planet of the Apes* franchise tells the various stories of astronauts from Earth marooned on a mysterious planet which turns out to be a far-future version of our own, where the human population has devolved into a mute, generally docile primitive state ruled over by super-intelligent apes — gorillas, orangutans and chimpanzees — who now talk, wear clothes, ride horses and have a technology and civilization reminiscent of the Old West. The stories are generally chases and sometimes resemble Robin Hood movies, but more often take on the grim, doomed feel of a contemporary zombie story.

The basis of it all was *La Planète des singes* by Pierre Boulle, a celebrated French novelist who had worked as a secret agent in the Far East during the Second World War, and whose first hit had been *Le Pont de la rivière Kwaï* in 1952, a worldwide bestseller that became David Lean's Oscar-winning movie

The Bridge on the River Kwai (1957). Many of Boulle's novels reflected his war experiences, but there is also a strong science fiction thread to his work: *Garden on the Moon* (1966), for example, is a fictionalized take on the 1960s' space race.

Boulle's biggest hit was set in a far future where three human explorers visit the star Betelgeuse, and there find an Earth-like planet where great apes dominate and humans are like cattle. The apes enjoy the technology level of 20th-century Earth, and many hunt humans for fun; one astronaut is killed, and the other two — Ulysse Mérou and Professor Antelle, who'd invented the nearly light-speed drive that had made their journey possible — are captured.

Ulysse is taken to the Ape City and experimented on, chiefly by sympathetic chimps Zira and Cornélius, who eventually teach him their language. Proving himself intelligent, Ulysse is freed and allowed to explore the city, in which he is regarded first as an object of curiosity, then of derision and eventually of fear, when the mystery-shrouded history of the ape civilization becomes clear. It emerges that they used to be the servants of intelligent humans long ago, but

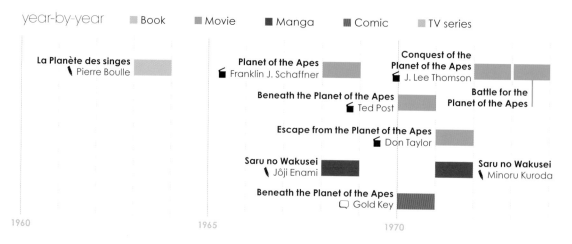

year-by-year ■ Book ■ Movie ■ Manga ■ Comic ■ TV series

La Planète des singes
\ Pierre Boulle

Planet of the Apes
◄ Franklin J. Schaffner

Conquest of the
Planet of the Apes
◄ J. Lee Thomson

Beneath the Planet of the Apes
◄ Ted Post

Battle for the
Planet of the Apes

Escape from the Planet of the Apes
◄ Don Taylor

Saru no Wakusei
\ Jôji Enami

Saru no Wakusei
\ Minoru Kuroda

Beneath the Planet of the Apes
□ Gold Key

1960 1965 1970

$215M
Planet of the Apes
(1968)

$115M (U.S.)
*Beneath the Planet
of the Apes*
(1970)

$71M (U.S.)
*Escape from the
Planet of the Apes*
(1971)

$51M (U.S.)
*Conquest of the
Planet of the Apes*
(1972)

Saru no Wakusei

Conquest of the
Planet of the Apes

Battle for the Planet
of the Apes

Planet of the Apes

Planet of the Apes

Return to the Planet
of the Apes

an ape revolution overthrew the masters after they became degenerate and lazy, and humanity has regressed in the years since.

Eventually Ulysse finds Antelle in a zoo, but he's lost his mind and behaves exactly as all the local humans do. Ulysse then falls in love with Nova, a primitive human; soon she is pregnant. Realizing that some of the ape intelligensia — notably the smart orangutan scientist Dr. Zaius — consider him a threat and want him dead, Ulysse escapes with Zira and their son, Sirius, and lands back on Earth 700 years after he left it.

There he finds that that planet, too, has been taken over by apes. Fleeing again to space, he writes down his story and sends it off in a bottle, where the entire tale's framing sequence finds it eventually discovered by Jinn and Phyllis, a vacationing couple. In a final twist, they too are revealed to be apes. They dismiss the whole thing as a fantasy, since no human would have the intelligence to write such a thing.

American independent producer Arthur P. Jacobs — best known for movie musicals *What a Way to Go!* and *Doctor Dolittle* — had bought the film rights to the novel before publication, and eventually persuaded 20th Century Fox to finance the picture. The first *Planet of the Apes* script, by *Twilight Zone* creator Rod Serling, was rejected as too expensive. A second attempt — by the blacklisted screenwriter Michael Wilson, who'd also written much of *The Bridge on the River Kwai* — cut costs by making ape society more primitive than it had been in the book.

In the movie that emerged, significant portions of the Serling script were retained, along with much of the original novel. The three astronauts were Americanized (they became Taylor, Landon and Dodge), but Zira, Cornelius, Dr. Zaius and Nova were unaltered. Although less advanced, ape society is much as Boulle depicted too: the chimps are bright and curious, the gorillas are militaristic bruisers and the orangutans are jealous, conservative guardians of power.

The striking early scenes of the film were shot in the deserts of Arizona and on the beaches around Malibu. The ape village was constructed on the Fox Ranch near Los Angeles. The movie was directed by Franklin J. Schaffner, who would go on to make *Patton*, *Papillon* and *The Boys from Brazil*, and Charlton Heston signed on as Taylor. In the roles of the

■ Magazine ■ Animated TV series

Planet of the Apes
📺 CBS

Return to the Planet of the Apes
📺 NBC

Planet of the Apes
❧ Marvel Comics

1975 1980 1985

Planet of the Apes

Planet of the Apes

Planet of the Apes

Planet of the Apes

Planet of the Apes:
The Fall

Planet of the Apes:
Colony

friendly chimpanzees Zira and Cornelius, Kim Hunter and Roddy McDowall were outstanding in what was then highly advanced make up.

Planet of the Apes was one of the biggest box office hits of 1968. Work began on a sequel almost immediately, with both Boulle and Serling asked to contribute story ideas; their proposals were rejected,

Slowly, however a new storyline came together. Beneath the Planet of the Apes centered on fears of atomic warfare and showed New York buried underground. A compromise was reached that maintained continuity with the first film, but respected Heston's desire not to be heavily involved. Taylor appeared at the start of the film and returned at the end, with most of the narrative revolving around a new astronaut — Brent, played by James Franciscus, the sole survivor of a rescue mission to recover Taylor.

After adventures in Ape City, Brent rides with Nova to the ruined New York, which he enters through a subway station and finds to be ruled by telepathic mutant humans who worship a huge nuclear bomb, capable of destroying the planet. With apes and mutants battling all around them, our heroes are cut down — but not before a mortally injured Taylor sets off the bomb, destroying the planet, and thus apparently ending the series. (The Doomsday Bomb

had been a plot suggestion supported by both Heston and sacked studio president Richard D. Zanuck, both of whom were keen to make this Apes film the last.)

Fox was very cost-conscious at the time after the failure of such big-budget spectaculars as Hello, Dolly! and Tora! Tora! Tora! — indeed, various Hello, Dolly! sets were reused for the New York sequences. Consequently Beneath was regarded as something of a disappointment, but it was another box office hit, and further sequels were planned.

Escape from the Planet of the Apes (1971) was even cheaper, and flipped the basic original premise to focus on the chimpanzees Zira, Cornelius and new friend Dr. Milo on contemporary Earth. They escaped the planet's far future destruction in Taylor's space ship, which then crashed through a time warp into the present day. Splashing down near Los Angeles, they are studied by human scientists in a reverse of the first film's plot — two of them are friendly, the human equivalents of Zira and Cornelius. Both are killed at the end of the movie.

The final two original films, Conquest of the Planet of the Apes (1972) and Battle for the Planet of the Apes (1973), tell of their surviving son in adulthood. Now known as Caesar, he watches the apes become the humans' most important and put-upon slaves,

year-by-year　■ Comic　■ Movie　■ Video game　■ Book

Planet of the Apes
🖰 Tim Burton

Planet of the Apes
⚱ Fox Interactive

Planet of the Apes
▢ Dark Horse

Planet of the Apes
▢ Malibu/Adventure Comics

1990　　　　1995　　　　2000

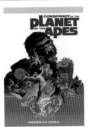

Revolution on the
Planet of the Apes

Rise of the Planet
of the Apes

Conspiracy of the
Planet of the Apes

Planet of the Apes

Dawn of the Planet
of the Apes

leads an ape revolution, guides his people though a human-on-human nuclear war, faces gorilla revolt and finally brokers what appears to be a fairly solid peace between the survivors of the two species in a post-apocalyptic America.

The most important questions remained unanswered, however: did the arrival of Zira and Cornelius in modern America set in motion events to create the future Taylor first discovered? Has history changed? Do humans and apes now have a chance of peaceful coexistence? The evidence is inconclusive.

The 1970s saw many spin-offs — a live-action TV series, an animated version, and comic series by Gold Key, Dark Horse and Boom! Studios. Most notable, however, was a black-and-white magazine from Marvel Comics which lasted 29 issues (1974–77), adapted all five movies, and offered new stories.

The series then entered a dormant period during which attempts to restart the films were stuck in development hell. Among the treatments that never made it onto the screen were Adam Rifkin's "Spartacus with Apes" sequel, Oliver Stone's time-hopping "Return of the Apes," and versions helmed by Peter Jackson and James Cameron that would have starred Arnold Schwarzenegger and featured a lighthearted scene of ape baseball.

In recent years there have been two high-profile attempts to reboot the movie series. The first, by Tim Burton, featured top-notch actors (Tim Roth, Helena Bonham Carter, Paul Giamatti) and the director's typically spectacular production design. It was the ninth highest grossing film worldwide of 2001, but reviews were mixed, and no sequel was forthcoming. Burton said "I'd rather throw myself out of a window" than make another.

Ten years later, 20th Century Fox tried again with *Rise of the Planet of the Apes*, a second reboot which went not to the first film for its inspiration, as Burton had done, but instead told a new story based on the action of *Conquest of the Planet of the Apes*: it's the present day, and our protagonist is Caesar, a genetically modified super-chimp who leads a revolt of apes in the San Francisco area, establishing a new colony of talking hominoids in the Redwoods of Marin County.

A huge international hit, it inspired a sequel, *Dawn of the Planet of the Apes* (2014), designed to build a potential new series and telling a version of events roughly analogous to *Battle for the Planet of the Apes*, with a devastating virus wreaking havoc, and human and ape survivors on the brink of war. Whether this series finds as much success as the originals is unlikely but not impossible; it's certainly had a good start. **MB**

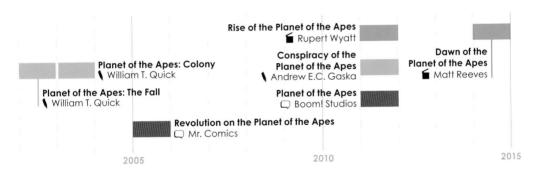

planet of the apes universe

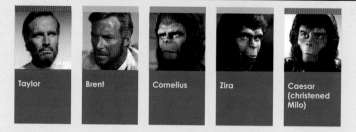

Taylor Brent Cornelius Zira Caesar (christened Milo)

An Earth space ship crashlands on an unknown planet. Three astronauts — Taylor, Dodge and Landon — explore what appears to be a desert. The year is 3978.

They encounter talking gorillas on horseback that hunt mute, childlike humans. Dodge is killed, Landon knocked unconscious and Taylor taken to Ape City, where he is caged with a mute human girl, Nova.

Two chimpanzees, Zira and Galen, study him; Taylor, in turn, studies ape society. Humans are usually considered vermin, but Zira and her fiancé, Cornelius, are intrigued by the intelligent-seeming Taylor, whereas their boss, Dr. Zaius, an orangutan, is disturbed by him.

Taylor escapes his pen before Zaius can castrate him. He finds Dodge's stuffed body in a museum and a lobotomized Landon before being recaptured and brought before a tribunal to determine his origins.

With help from Zira and Cornelius, Taylor flees with Nova. They make for the Forbidden Zone, a region taboo to the apes where Cornelius once found artifacts that suggested an ancient human civilization. Zaius ambushes them, but is captured and admits he knew that humankind once ruled this planet.

Taylor discovers the broken remains of the Statue of Liberty and concludes that the Planet of the Apes is a far-future Earth. He then disappears into a mysterious wall of fire, leaving Nova alone.

A rescue ship from Earth arrives to find Taylor; the sole survivor of this mission, Brent, crashes in the Forbidden Zone, where he encounters Nova and then Ape City. The apes are in turmoil, with Dr. Zaius at odds with gorilla leader General Ursus over the Forbidden Zone. Ultimately Zaius capitulates to Ursus' wishes, while Nova and an injured Brent hide out with Zira and Cornelius before traveling to the Forbidden Zone.

There they find the ruins of New York, and Brent realizes he is in a far future Earth. Entering the remains of a cathedral, he finds telepathic human mutants worshipping an atomic bomb. Gorillas and mutants fight, our heroes are mostly killed and Taylor detonates the bomb, destroying the planet.

Unknown to Taylor or Zaius, Cornelius and Zira used Taylor's crashed space ship, now rebuilt, to escape the planet just before it was destroyed, and rode a time warp into the past. They crash in the sea near Los

characters

■ Taylor ■ Brent ■ Cornelius ■ Zira ■ Caesar (christened Milo)

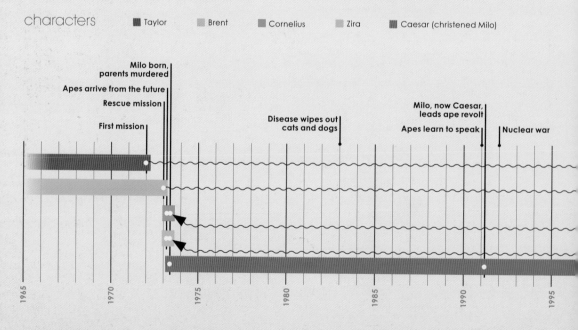

Milo born, parents murdered
Apes arrive from the future
Rescue mission
First mission

Disease wipes out cats and dogs

Milo, now Caesar, leads ape revolt
Apes learn to speak
Nuclear war

1965 1970 1975 1980 1985 1990 1995

Angeles in 1973, and remain mute until revealing their true intelligence at a Presidential Commission.

The apes become celebrities, but Zira is pregnant and eventually a reluctant President orders her baby to be terminated and the two apes sterilized. Cornelius and Zira escape, aided by human friends, and hide in a circus run by a man named Armando, where a baby boy, named Milo, is born. Forced to flee again, the apes are tracked to an abandoned ship where Zira, Cornelius and little Milo are shot by soldiers. But a coda reveals the truth: Armando and Zira swapped Milo with a normal ape baby back at the circus. The last talking ape will grow up in Armando's care.

In 1983 a disease wipes out all dogs and cats, and apes become the new favored pet. By 1991 the American economy relies on a workforce of ape slaves. Milo, now known as Caesar, is angered by this.

Armando is arrested. Caesar goes to work in the household of Governor Breck, where he plots revolution. Breck becomes suspicious of Caesar, and the ape is tortured until he speaks, but then escapes and leads a revolt. The city is taken, and Caesar is

about to order Breck be killed when his girlfriend, an ape called Lisa, speaks for the first time, arguing for mercy. Caesar relents; Breck is spared.

In 2670, human and ape children sit in lessons together as an orangutan called The Lawgiver tells of what happened to Caesar next.

It is at least a dozen years after the ape revolt and a nuclear war. Tension builds between Caesar, who wants peace between apes and the surviving humans, and a gorilla general named Aldo, who seeks supremacy for his species.

A crisis comes after Caesar and a human friend travel to the Forbidden City, now a radioactive ruin, to recover tapes made by his mother and father telling of the ape-dominated far future. The radiation-scarred humans living there declare war on the apes, and Aldo leads a coup against Caesar. The human mutants attack, but Caesar defeats them by trickery. Caesar and Aldo fight in the treetops for the soul of ape society; when Aldo falls to his death, Caesar confirms his commitment to an equal society of humans and apes. **MB**

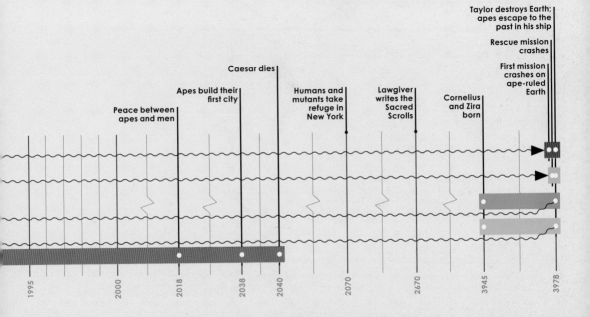

Taylor destroys Earth;
apes escape to the
past in his ship

Rescue mission
crashes

First mission
crashes on
ape-ruled
Earth

Caesar dies

Apes build their
first city

Humans and
mutants take
refuge in
New York

Lawgiver
writes the
Sacred
Scrolls

Cornelius
and Zira
born

Peace between
apes and men

1995 2000 2018 2038 2040 2070 2670 3945 3978

Planet of the Apes
(1968)

Beneath the
Planet of the Apes
(1970)

Conquest of the
Planet of the Apes
(1972)

Planet of the Apes
(1974–77)

Planet of the Apes
(2001)

Rise of the Planet
of the Apes
(2011)

The apes hold a tribunal to determine the fate of Taylor
(Charlton Heston) in *Planet of the Apes*.

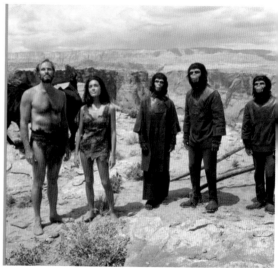

Planet of the Apes (1968) (L–R): Charlton Heston, Linda Harrison, Kim Hunter,
Roddy McDowall and Lou Wagner.

Proof positive that the Planet of the Apes is a future Earth: the ruined remnants of the Statue of Liberty.

Kim Hunter in make up: the prosthetics were uncomfortably hot.

James Franciscus is captured in *Beneath the Planet of the Apes*.

Draft artwork for the cover of an edition of the successful magazine version ...

... and the impressive finished article.

Michael Clarke Duncan (L) and Tim Roth in Tim Burton's 2001 remake.

James Franco as Dr. William "Will" Rodman, a scientist who is trying to discover a cure for Alzheimer's disease by experimenting on chimps in *Rise of the Planet of the Apes*.

Rise of the Planet of the Apes (2011) was directed by Rupert Wyatt.

doctor who 1963

Doctor Who

Dr. Who in an
Exciting Adventure
with the Daleks

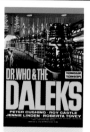

Dr. Who and the
Daleks

Doctor Who and
the Zarbi

Doctor Who and
the Crusaders

Daleks: Invasion
Earth 2150 AD

National institutions do not become established overnight. In the case of the BBC television series *Doctor Who*, the process took more than 40 years.

Quite how it happened is a matter of debate, but it appears that one of the main contributory factors was the psychological phenomenon described by Joni Mitchell in "Big Yellow Taxi": "You don't know what you've got till it's gone." It was not until the series had been off the screen for 16 years that it ripened in the collective memory, and the British public realized that its previous misgivings that the show was inferior to U.S. equivalents such as *Star Trek* were unfounded.

The rebirth of *Doctor Who* in 2005 confirmed that small-screen science fiction did not need costly special effects to be good. The series had a limited budget but a strong concept — an eccentric alien genius wandering through time and space in the TARDIS, a 1960s' police phone box that was bigger on the inside than on the outside — and infinite narrative possibilities — a mixture of historical action, monsters, space opera and complex mythology. Its return to the screens propelled it from a specialized local taste into an internationally acclaimed product.

Although *Doctor Who* has become as symbolic of Britain as Buckingham Palace and The Beatles, it was created by a Canadian. Toronto-born Sydney Newman made his reputation as the creator of *The Avengers*, a spy-fi series that first aired in January 1961 and ran for 161 episodes on ITV. At the end of 1962, he was poached by the rival BBC to develop a series that would bridge the gap in the Saturday afternoon schedule between the live sport show *Grandstand* and *Juke Box Jury*, a showcase for new pop singles. An SF fan who claimed there wasn't a book on the subject he hadn't read, Newman proposed a time-traveling tale that would inform as well as entertain.

Doctor Who was first aired on November 23, 1963, when the world was in shock after the assassination of U.S. President John F. Kennedy the previous day. Only 4.4 million viewers tuned in, a pitiful figure that prompted the BBC, in a move that was unusual then and remains unusual now, to repeat that first episode a week later. This time it scooped six million viewers.

It was the Daleks that solidified *Doctor Who*'s early success. They appeared in the second story and ratings began at 6.9 million and soared to 10.4 million

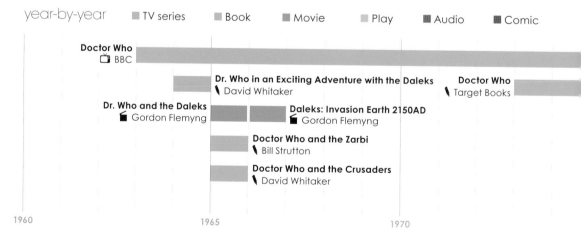

year-by-year ■ TV series ■ Book ■ Movie ■ Play ■ Audio ■ Comic

Doctor Who
📺 BBC

Dr. Who in an Exciting Adventure with the Daleks
\ David Whitaker

Doctor Who
\ Target Books

Dr. Who and the Daleks
📽 Gordon Flemyng

Daleks: Invasion Earth 2150AD
📽 Gordon Flemyng

Doctor Who and the Zarbi
\ Bill Strutton

Doctor Who and the Crusaders
\ David Whitaker

1960 1965 1970

$2M
Dr. Who and the
Daleks
(1965)

$1.7M
Daleks' Invasion
Earth 2150 AD
(1966)

Doctor Who

Doctor Who and
the Daleks in The
Seven Keys to
Doomsday

Doctor Who and
the Pescatons

Doctor Who
Weekly

K9 and Company

Doctor Who
Magazine

during the next seven episodes. Newman detested what he termed "bug-eyed monsters," but the Daleks kept the ratings buoyant during the 1960s and spawned two spin-off movies starring Peter Cushing.

Doctor Who's rich mythology began to take shape in 1966, when Patrick Troughton took over from William Hartnell in the title role. In his new form, the Doctor revealed his now-familiar character: impish and mercurial, with a childlike sense of wonder.

Doctor Who was perilously close to cancellation when Troughton bowed out at the end of 1969 (one episode of his final story barely scraped the four million mark). But with the BBC unable to secure the science fiction replacement it had been looking for, the series earned a stay of execution. The next season saw a new Doctor, played by Jon Pertwee, with a new base of operations on Earth, where he finds employment as an advisor to an army unit. A new raft of regulars, including Brigadier Lethbridge-Stewart, filled out the cast. And the show was now in color.

The Pertwee years, with their mix of militarism, stunts and never-ending Earth invasions, proved irresistible to audiences, so when Pertwee threw in

his cape at the beginning of 1974, the search for a new Doctor became newsworthy. Meanwhile, Target Books' popular range of Who novelizations began, bringing many television adventures to print.

The third Doctor, Tom Baker, brought to the role a twitchy, acid-eyed lunacy that freed the adventures to leave the Earth and venture back into space and time. Producer Philip Hinchcliffe brought in gothic horror and created some of the program's most enduring classics, such as "Pyramids of Mars," "The Talons of Weng-Chiang" and "Genesis of the Daleks."

As the series sought an older demographic and moved from action-adventure to horror, it came under fire from Mary Whitehouse, a campaigner against permissiveness in the broadcast media. Eventually, the BBC acceded to her demands, fired Hinchcliffe and installed the more pliable Graham Williams, whose lighter tone and reliance on humor (aided by script editors Anthony Read and Douglas Adams) saw Doctor Who lurch toward self-parody.

The secret of Doctor Who's longevity isn't just the routine change of actor, it's the periodic change in character of the show. From the mix of SF and history

■ Magazine

Doctor Who and the Pescatons
♪ Victor Pemberton

K9 and Company
BBC

Doctor Who and the Daleks in The Seven Keys to Doomsday
Terrance Dicks

Doctor Who Magazine

Doctor Who Weekly
Marvel

1975 1980 1985

New Adventures

Doctor Who

Past Doctor

Eighth Doctor

Doctor Who

Doctor Who

of the Hartnell years to the monster-dense Troughton era to the hardware-loving James Bond-isms of Pertwee's reign, through to the horror pastiches and then humor-soaked runabouts of the Tom Baker years, *Doctor Who* has always moved with the times. So when John Nathan-Turner took over as producer in 1980, he and script editor Christopher Bidmead cut the comedy, gave the program a rapid course in Advanced Science, and spruced up the visuals and sound. With competition from American science fiction such as *Buck Rogers in the 25th Century* and *Battlestar Galactica*, *Doctor Who* had to smarten itself up. Although still under-budgeted and shot in an uneasy mix of video and film, the newly-energized show managed to not look totally obsolete in a post-*Star Wars* world.

Within a season, though, Baker had gone, and Peter Davison, weathering tabloid insults of "the wet vet" — in reference to his fame from *All Creatures Great and Small* — became the new Doctor. The show was wrenched from its Saturday teatime slot and dropped into the midweek schedules to impressive ratings and increased cross-media coverage.

Davison brought a youthful energy to the part, and his influence can be seen in the Doctors of the post-2005 era. But, disheartened by a mediocre second season, he quit before his third year was up. His replacement was 41-year-old Colin Baker.

Baker's tenure was cursed from the start. Saddled with a costume that John Nathan-Turner had ordered to be "really tasteless," Baker struggled with weak scripts and a hostile press. In February 1985 the BBC cancelled the ailing program, but a tabloid newspaper campaign to save the show forced the makers to announce that it was merely being "rested" for 18 months. When it returned — with Bonnie Langford as the Doctor's new companion — it looked like a dead man walking, but in the event it was only Baker who entered the execution chamber.

His successor, Sylvester McCoy, played up the comedy, but his efforts were so savagely criticized that a new script editor, Andrew Cartmel, was brought in to reintroduce some of the mystery of the character's early years. But the rescheduled *Doctor Who* was now up against the soap opera *Coronation Street* on ITV, and fared miserably in the ratings. In

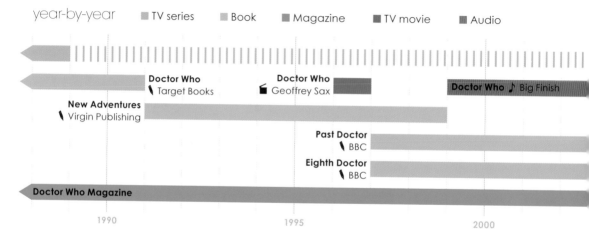

year-by-year ■ TV series ■ Book ■ Magazine ■ TV movie ■ Audio

Doctor Who
❯ Target Books

Doctor Who
◗ Geoffrey Sax

Doctor Who ♪ Big Finish

New Adventures
❯ Virgin Publishing

Past Doctor
❯ BBC

Eighth Doctor
❯ BBC

Doctor Who Magazine

1990 1995 2000

Torchwood

The Sarah Jane
Adventures

1989, the BBC, anxious to rid itself of the series but afraid of another outcry, tried to devolve it to an independent production company.

In 1996 *Doctor Who* returned as a U.S. co-production TV movie. It opened with McCoy, but he was swiftly reborn as 37-year-old Paul McGann. Intended as a "back-door pilot," the film was a hit in Britain, but did not do well enough in the United States to merit a series. *Doctor Who* looked moribund. But then came Russell T. Davies (RTD).

RTD made his name in 1999 with *Queer as Folk*, a drama about gay men in Manchester. In 2003, Jane Tranter, the BBC's Controller of Drama Commissioning, approached him to take on *Doctor Who*. His resurrected Doctor — played by Christopher Eccleston — and his female assistant, former pop star Billie Piper, premiered in March 2005 to ratings of nearly 10 million. Its success allowed the creation of *Torchwood*, a new take on the *Who* universes centering on mysterious, flamboyant time traveler Captain Jack Harkness.

Eccleston left at the end of his first series, making way for David Tennant, who played the role for three seasons and a year of one-off specials, before he

and RTD signed off in the two-part "The End of Time." When *Doctor Who* returned in April 2010, it was with a new writer (Steven Moffat), a new companion, a newly refurbished TARDIS, a new set of titles and theme music and a new Doctor in 27-year-old Matt Smith.

This was the series that finally cracked the United States and Canada. Although the Doctor had been known and loved in pockets of North America before, he now became a headline-grabbing presence on major chat shows and on the covers of TV magazines. The production unit even ventured across the North Atlantic: the Doctor finds himself in Monument Valley on the Arizona–Utah state line in the opening episode of Season Six, "The Impossible Astronaut."

Smith departed in June 2013, shortly after *Doctor Who*'s 50th anniversary special, in which his Doctor teamed up with Tennant's in a 3D extravaganza. The 12th Doctor, played by Peter Capaldi, made his debut in 2013's Christmas Special. As every *Doctor Who* fan knows, Time-lords have only 12 incarnations. However, before Capaldi's first appearance, Matt Smith's departing Doctor was granted a whole new set of regenerations. He'll be with us a while yet. **SOB**

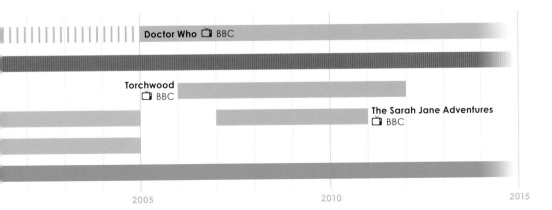

Doctor Who ☐ BBC

Torchwood
☐ BBC

The Sarah Jane Adventures
☐ BBC

2005 2010 2015

doctor who universe

| First Doctor | Second Doctor | Third Doctor | Fourth Doctor | Fifth Doctor | Sixth Doctor | Seventh Doctor | Eighth Doctor |

The Doctor, a Time Lord whose real name we still don't know, is bored by his home planet of Gallifrey, so steals a Type 40 TARDIS (the acronym stands for "Time And Relative Dimension In Space") and takes his granddaughter on a trip to Earth in the early 1960s. He sends her to school, where two of her teachers become concerned by her behavior and follow her home. They they are trapped in the time machine, which has taken on the form of a police box.

The foursome go off on a series of adventures, confronting the Daleks, becoming embroiled in the French Revolution, and encountering Aztecs, alien Sensorites and Marco Polo.

The Doctor says goodbye to Susan and the teachers. Other companions come and go before the first conflict with the Cybermen, at the end of which the Doctor collapses and regenerates for the first time.

The second Doctor fights the Faceless Ones and then his past catches up with him: he is arrested

by other Time Lords and put on trial for the theft of a TARDIS. He is confined to Earth and forced to regenerate with a new face.

The third Doctor works for UNIT, a military organization. His enemy, the Master, arrives on the planet to kill him. The two cross paths many times before the Time Lords release the Doctor from his exile.

After a battle with the spiders of Metebelis III, the Doctor regenerates again. The fourth Doctor leaves UNIT and returns to travel in space and time, initially with journalist Sarah Jane Smith and medic Harry Sullivan. After Sarah Jane is forced to stay on Earth, the Doctor hooks up with Sevateen warrior Leela, a fellow Time Lord named Romana, and eventually Adric, Nyssa and Tegan, who are with him when he regenerates again after falling from a radio telescope fighting a newly regenerated Master.

The fifth Doctor wears cricket whites and continues traveling with Adric, Nyssa and Tegan, until Adric is

characters

- ■ First Doctor
- ■ Second Doctor
- ■ Third Doctor
- ■ Fourth Doctor
- ■ Fifth Doctor
- ■ Sixth Doctor
- ■ Seventh Doctor
- ■ Eighth Doctor
- ■ Ninth Doctor
- ■ Tenth Doctor
- ■ Eleventh Doctor
- ■ Twelfth Doctor

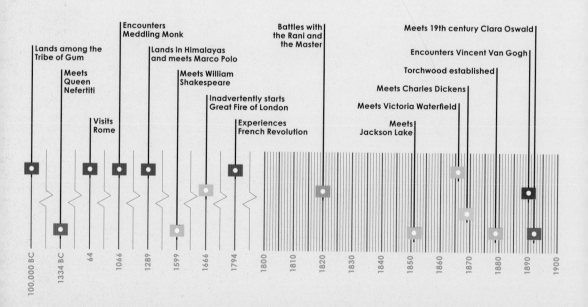

Lands among the Tribe of Gum

Meets Queen Nefertiti

Visits Rome

Encounters Meddling Monk

Lands in Himalayas and meets Marco Polo

Meets William Shakespeare

Inadvertently starts Great Fire of London

Experiences French Revolution

Battles with the Rani and the Master

Meets 19th century Clara Oswald

Encounters Vincent Van Gogh

Torchwood established

Meets Charles Dickens

Meets Victoria Waterfield

Meets Jackson Lake

100,000 BC · 1334 BC · 64 · 1066 · 1289 · 1599 · 1666 · 1794 · 1800 · 1810 · 1820 · 1830 · 1840 · 1850 · 1860 · 1870 · 1880 · 1890 · 1900

Ninth Doctor	**Tenth Doctor**
Eleventh Doctor	**Twelfth Doctor**

killed fighting the Cybermen. After saving the life of another companion, the Doctor again regenerates.

The sixth Doctor encounters Cybermen, Daleks and a renegade Time Lord named the Rani, before he is put on trial again — this time for interfering in the affairs of other planets.

After the Rani intercepts the TARDIS, the Doctor enters his seventh incarnation, during which he meets Ace, a 1980s' teenager who was swept up by a time storm and deposited on the planet Iceworld. This Doctor meets his end in San Francisco in 1999 when he is shot by a street gang. He regenerates in a mortuary and then saves the world from the Master.

During the Time War between the Daleks and the Time Lords, both their homeworlds — Skaro and Gallifrey — are destroyed. The next time we meet the Doctor (the ninth), he speaks with a Northern accent and wears a trendy leather jacket. He meets Earth girl Rose Tyler and seems scarred by his wartime experiences. After an encounter with the Daleks he regenerates again, and his friendship with Rose continues to deepen, until she is trapped in a parallel universe after another battle with the Daleks. The Doctor saves her, regenerates, then meets, successively, Martha Jones and Donna Noble, but ends his days without a companion, as he crash-lands the TARDIS on Earth during his next regeneration.

The eleventh Doctor befriends Amy Pond, whom he meets as a 7-year-old girl and then as a 20-something grown-up. Amy leaves the Doctor when the Weeping Angels transport her to the past, after which the Doctor meets Clara Oswald, an "impossible girl" he keeps meeting in different time zones. It transpires that she has entered the Doctor's time stream to save him from the Great Intelligence. While in the Doctor's psyche, she discovers the Doctor's greatest secret, an incarnation of himself he was keeping secret from the universe ... **SOB**

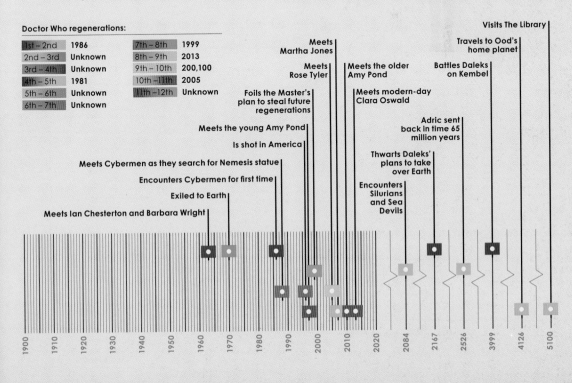

Doctor Who regenerations:

1st – 2nd	1986	7th – 8th	1999	
2nd – 3rd	Unknown	8th – 9th	2013	
3rd – 4th	Unknown	9th – 10th	200,100	
4th – 5th	1981	10th – 11th	2005	
5th – 6th	Unknown	11th – 12th	Unknown	
6th – 7th	Unknown			

Doctor Who
(1963–present)

**Dr. Who and
the Daleks**
(1965)

**Daleks: Invasion
Earth 2150AD**
(1966)

William Hartnell played the first incarnation of the Doctor, from 1963 to 1966.

Peter Cushing as the Doctor in *Dr. Who and the Daleks*. The movie made some major changes to the character — rather than an alien, the Doctor is an eccentric grandfather who builds a Tardis.

Peter Cushing reprised his role as Doctor Who for *Daleks: Invasion Earth 2150AD*, in which a future Earth is controlled by the evil cyborgs.

John Pertwee's Third Doctor with Sarah Jane Smith (Elisabeth Sladen), one of the Doctor's most popular companions.

L–R: The First (William Hartnell), Fifth (Peter Davison), Fourth (a model of Tom Baker), Third (John Pertwee) and Second (Patrick Troughton) Doctors.

The Fifth Doctor (Peter Davison) prepares to enter the Tardis.

The Tenth Doctor (David Tennant) and Donna Noble (Catherine Tate) in "The Runaway Bride" Christmas special. Donna returned as a full-time companion in series four.

The Seventh Doctor (Sylvester McCoy) with his computer programer companion Melanie Bush (Bonnie Langford).

The Ninth Doctor (Christopher Eccleston) and Rose (Billie Piper) helped to re-establish **Doctor Who**'s popularity after a 16-year break.

The Eleventh Doctor (Matt Smith) takes an alternative approach to traveling by Tardis.

A rogues gallery of Doctor Who's foes: (L–R) an Android, a Sontaran, a Dalek, a Zygon and a Wirrn.

The Third Doctor (Jon Pertwee) confronts a Sea Devil, an amphibious breed of prehistoric reptiles that are related to the Silurians.

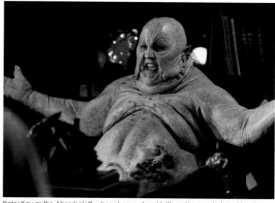

Peter Kay as the Abzorbaloff, whose home planet is Klom. He was designed by nine-year-old William Grantham for a "Design a Doctor Who Monster" competition.

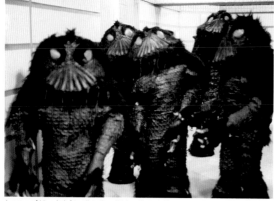

A group of Mandrels from the planet Eden. The creatures were criticized by some reviewers for not being frightening enough.

Borad (Robert Ashby), the twisted and evil ruler of Karfel.

Bannakaffalatta (Jimmy Vee), a cyborg Zocci who met the Tenth Doctor aboard the interstellar cruise liner *Titanic*.

Azaxyr (Alan Bennion) and Ssorg (Cy Town), two Ice Warriors from Mars. The Tenth Doctor described the species as "a fine and noble race who built an empire out of snow."

A partially completed Ood mask. The Ood are a race of telepathic humanoids with two brains and tentacles on the lower portions of their faces.

The Cybermen are a race of hostile humanoid cyborgs who are programmed to see themselves as the ideal lifeform.

the x-men 1963

The X-Men | Uncanny X-Men | X-Factor | Excalibur | X-Men | X-Force | Ultimate X-Men | New X-Men

The first modern Marvel comics came in the early 1960s and revolved around oddball, unhappy, quite likely alienated good guys who mixed a chunk of villainous anger and ugliness with their heroism. There were monsters like Hulk and Thing, weird teens like Spider-Man, and in *The X-Men*, launched in 1963, a whole new species of dangerously unpredictable mutants, a randomly super-powered offshoot of humanity that is perhaps destined to replace it. It was a strong concept, but something about the execution was a little off — X-Men was not the immediate success it should have been.

Perhaps it was simply that artist and co-creator Jack Kirby was overstretched, and soon handed the book over to less inspired hands. Perhaps the mutant teenage heroes, learning superheroism at a school run by a bald, sinister telepath, were hard to identify with. Perhaps their archenemy, Magneto, was too easy to feel for, clearly devoted to his people no matter how wild and vicious he became.

Whatever the problem with the X-Men, they remained resolutely B-list for several years, and the series was cancelled altogether in the early 1970s.

Fans began a "bring back the X-Men" campaign almost immediately. When the series was eventually relaunched five years later, albeit in greatly modified form, the X-Men began one of the most remarkable comebacks in the history of comics.

The revival maintained continuity and the original school setting, but told of a new, larger international team commanded by field leader Cyclops and mentor Professor X. New heroes were introduced: a serene black woman, Storm; a headstrong young Russian, Colossus; a devilish German, Nightcrawler and break-out star Wolverine, a stocky, macho Canadian berserker with razor-sharp claws. All the new X-Men — with the odd exception, like Native American hero Thunderbird, who was soon killed off — became stars, but Wolverine in particular was on a fast track to becoming one of the hottest characters in comics, and eventually became Marvel's single most important superhero after Spider-Man.

The new X-Men series made stars out of its key creators too — notably assistant editor Chris Claremont, who wrote it, and artist John Byrne. This pair deftly mixed science fiction, soap opera, superhero action,

year-by-year ■ Comic ■ Movie

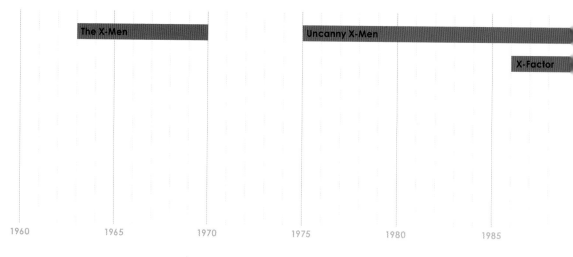

The X-Men

Uncanny X-Men

X-Factor

1960 1965 1970 1975 1980 1985

| $403M X-Men (2000) | $518M X2 (2003) | $533M X-Men: The Last Stand (2006) | $368M X-Men: First Class (2011) | $417M The Wolverine (2013) |

X-Men | X2 | Astonishing X-Men | X-Men: The Last Stand | X-Men: First Class | Wolverine and the X-Men | All-New X-Men | The Wolverine

sympathetic characters and endlessly convoluted plot-lines. The new book appealed to everyone — not just hardcore Marvelites, but a new generation of readers, many of whom were uninterested in any other comic. It was an audience comprised of women (the X-Men soon became dominated by strong female characters), macho action movie fans drawn to the violent, soulful Wolverine, and every sort of outsider — from the gay community to nerds — who all responded to the core rebel message. Thus established, the young female market was later cornered and grown by Joss Whedon with *Buffy the Vampire Slayer* and Stephenie Meyer with *Twilight*.

Interest in X-Men grew in the 1990s as writers and artists such as John Romita Jr., Jim Lee, Marc Silvestri, Grant Morrison, Frank Quitely and Brian Michael Bendis turned out a stream of intricate, endlessly surprising stories such as the "Dark Phoenix Saga," "Days of Future Past," "E is For Extinction" and "Age of Apocalypse." The development of the characters through a range of core titles and spin-off books — including *Uncanny X-Men*, *X-Factor*, *Excalibur* and *Wolverine* — has turned the X-Men from just another

superhero team into a whole sub-universe. Together, they offer endless variations on the timeless theme of superhero as outsider, an individual doomed to defend a society that despises him or her.

X-Men later transferred to the screen in a range of big-budget movies — three originally, starting in 2002, then a semi-reboot from 2011 on, plus two solo outings for charismatic loner Wolverine — as well as a couple of animated TV series and numerous other spin-offs. The X-Men family is so big, with so many core characters — at least 50 important heroes, a similar number of major villains and supporting characters by the score — that it offers possibilities the mainstream media may never exhaust.

The X-Men series is full of action, but its underlying appeal is in the central question that it raises but evades answering: Who are these mutant heroes really? Are they the black population before civil rights? The gay population today? Some new youth subculture, struggling to be heard? They're all of these and none of them, of course — and the concept works because even if we've never been persecuted ourselves, it makes us feel for those who have. **MB**

The X-Men
(1963–70)

X-Men
(2002)

X2 (2003)

**X-Men:
The Last Stand**
(2006)

**X-Men Origins:
Wolverine**
(2009)

X-Men: First Class
(2011)

All New X-Men
(2012–present)

The Wolverine
(2013)

The cover of *The X-Men* issue no. 1 in September 1963.

Halle Berry as Storm in *X-Men: The Last Stand* (2006).

Hugh Jackman as amnesiac mutant Wolverine in *X-Men: The
Last Stand*.

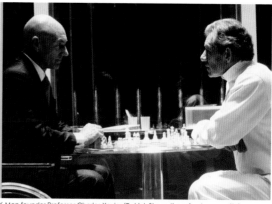

X-Men founder Professor Charles Xavier (Patrick Stewart) confronts super-villain
Magneto (Ian McKellen) in *X-Men* (2000).

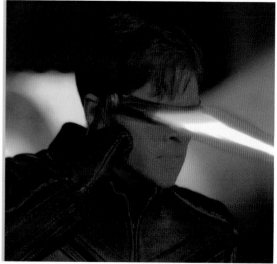

Cyclops (James Marsden), field leader of the superhero band, shoots uncontrollable
beams of concussive force from his eyes in *X2* (aka *X-Men 2*; 2003).

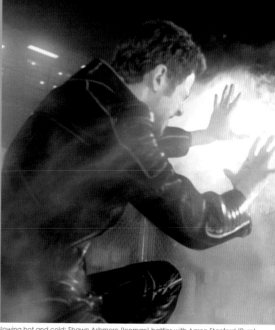

Blowing hot and cold: Shawn Ashmore (Iceman) battles with Aaron Stanford (Pyro)
in *X-Men: The Last Stand*.

Hugh Jackman in *X-Men Origins: Wolverine* (2009).

Matthew Vaughn's *X-Men: First Class* (2011) featured an all-star cast including James McAvoy, Michael Fassbender and Kevin Bacon.

Lucas Till as Havok, a mutant who can absorb and re-emit energy, in *X-Men: First Class*.

The cover of this 2013 edition of *All-New X-Men* shows how the series has retained a consistent visual style for 50 years.

Hugh Jackman in the title role of *The Wolverine* (2013). In this move, Wolverine was portrayed with blood on his claws for the first time on screen

chocky 1963

Chocky Chocky Chocky Chocky's Children Chocky's Challenge Chocky's Challenge Chocky

Chocky, by John Wyndham, was published as a novelette in *Amazing Stories* magazine in 1963, then extended into a full-length book in 1968. The hero, Matthew, is an ordinary 12-year-old boy who suddenly starts doing sums in binary and creating oddly distorted paintings. He asks idiosyncratic questions, as if he were an outsider to the world: "Why do humans need two genders?" "Why don't animals learn like people do?" "Where is Earth?"

The scenes in which Matthew perplexes his teachers parallel "An Unearthly Child," the first episode of *Doctor Who*, also in 1963. The girl was an alien, but Matthew is merely visited by one named Chocky, who has projected her mind over light-years to investigate Earth. (The character is technically genderless, but the humans opt to call Chocky "she"; in the TV version, the role is played by Glynis Brooks.)

For most of the story, Matthew's parents think that Chocky is imaginary, but eventually they learn the truth. Chocky contacts children because their minds are more open and ready to accept improbabilities. This chimes with how SF fans traditionally see themselves — indeed, given that so many first discover the genre at or about the age of 12 years, Chocky might plausibly be regarded as a metaphor for them and their mindset.

Among the literary antecedents of *Chocky* was "Mimsy were the Borogroves" (1943), a story by Lewis Padgett (a pseudonym for Henry Kuttner and C.L. Moore) in which present-day children are influenced by technology from the far future. (A loose adaptation of this work became the 2007 movie *The Last Mimzy*.) Another was "Zero Hour," a story in Ray Bradbury's *The Illustrated Man* (1951) in which alien invaders use impressionable children as a deadly fifth column. And Wyndham had used the theme himself: in *The Midwich Cuckoos* (1957), women are impregnated by an alien force, then give birth to inhuman children who must be killed before they kill.

In contrast, however, Chocky is completely benign. She's the alien equivalent of a *Star Trek* explorer seeking intelligent life (she breaks her own nonintervention code, saving Matthew when he nearly drowns). In Britain, the book became a superb six-part children's TV serial (1984), which used much of Wyndham's dialogue verbatim, while toning down the patronizing treatment of Matthew's mother.

The TV Chocky was followed by two six-part sequels: *Chocky's Children* (1985) and *Chocky's Challenge* (1986). Chocky continues her efforts to advance humanity, helped by Matthew and other children, and hampered by malign corporate and military interests that want to suppress or exploit her gifts. Unfortunately, the new stories were weaker in drama and ideas, although they showed Chocky's human children using telepathy and telekinesis in a manner similar to Wyndham's Midwich cuckoos. All three serials were scripted by Anthony Read.

Two radio versions of the original Chocky were made by the BBC 30 years apart, in 1968 and 1998. In 2008, the DreamWorks studio acquired the film rights to *Chocky*. **AO**

year-by-year ■ Short story ■ Book ■ TV series ■ Radio

Chocky
 John Wyndham

Chocky
 John Wyndham

Chocky's Children
 ITV

Chocky
 ITV

Chocky's Challenge
 Mark Daniel

Chocky's Challenge
 ITV

Chocky
 BBC

1960 1965 1970 1975 1980 1985 1990 1995 2000

Heretics of Dune	Dune	Chapter-house: Dune	Dune	Dune: House Atreides	Dune: House Harkonnen	Dune	Children of Dune

In 1970 Herbert published *Dune Messiah*, a shorter follow-up to the original epic. Although many sequels are merely extensions of the original work, this novel was full of new ideas and took the *Dune* universe in a very different direction. In place of the intrigue and power struggles of the first book, Herbert kickstarts a story that arced through the future history of humanity. A further four novels — *Children of Dune* (1976), *God Emperor of Dune* (1981), *Heretics of Dune* (1984) and *Chapterhouse: Dune* (1985) advance through millennia and describe the rise and fall of humankind as it navigates the "Golden Path."

David Lynch's 1984 film adaptation of the first *Dune* novel was equal parts disaster and splendid success. Lynch was a young director who would go on to be acclaimed as a great movie auteur, but his surrealistic cinematography, patent lack of interest in conventional narrative and famous inability to meet budgets left a film that was very far from the *Star Wars*-style blockbuster that producers envisaged and audiences craved. Nonetheless, the film and its Toto/Brian Eno soundtrack has sequences of staggering beauty, and remains a cult favorite with sci-fi film fans.

Two bland Dune mini-series have since been produced by the Sci-Fi channel, but in spite of being faithful to the books they were at best only average

TV. Perhaps surprisingly, the *Dune* video game proved equally popular with fans and gamers, possibly because of the proficiency with which it picked out key aspects of Herbert's universe and shaped them around a well-designed real time strategy combat game.

The *Dune* universe was at the height of its popularity when Frank Herbert died of heart complications following cancer surgery in 1986. He left unwritten a planned seventh book in the series. In 1999 Brian Herbert partnered with journeyman science fiction writer Kevin J. Anderson to write *Dune: House Atreides*, the first in a series of prequels and sequels to the original series.

Herbert and Anderson have since collaborated on ten new Dune novels in total, including *Hunters of Dune* (2006) and *Sandworms of Dune* (2007), both of which were based on Frank Herbert's plans for *Dune 7*. Although competent as character dramas, these secondary *Dune* books do not capture the ecological or metaphysical themes that drew many readers to the originals. Nevertheless, these books are considered as canonical alongside Frank Herbert's original novels. The *Dune* universe remains among the most popular creations in the history of science fiction, and rumors continue to this day of new film and game adaptations. **DW**

■ TV series

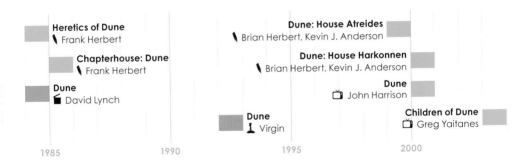

Heretics of Dune
❦ Frank Herbert

Chapterhouse: Dune
❦ Frank Herbert

Dune
🎬 David Lynch

Dune
Virgin

Dune: House Atreides
❦ Brian Herbert, Kevin J. Anderson

Dune: House Harkonnen
❦ Brian Herbert, Kevin J. Anderson

Dune
📺 John Harrison

Children of Dune
📺 Greg Yaitanes

1985 1990 1995 2000

dune universe

Duke Leto Atreides **Leto II** **Duncan Idaho** **Alia Atreides** **Paul Atreides**

It is the 23rd millennium. Human life is spread across thousands of planets. Computers and artificial intelligence have been banned since the Butlerian Jihad, a war against "thinking machines" in the distant past. The universe of Dune is trapped in a state of development close to the Middle Ages of Earth.

At the opening of *Dune*, the emperor Shaddam IV of House Corrino rules over the known universe, his power maintained by Sardaukar terror troops. His territories are divided between the noble families of the Great Houses of the Landsraad and the CHOAM corporation, which controls economic activity. The Spacing Guild has a monopoly on travel between planets, which it achieves by bending space and time to transport its Heighliners over galactic distances. The Bene Gesserit sisterhood wields religious control.

Duke Leto of House Atreides is offered the fiefdom of Arrakis, a desert planet that is the only source of the spice Melange, which is essential to space travel. Leto suspects that this is a trap set by Shaddam and Baron Vladimir Harkonnen of House Harkonnen. Among Leto's servants are Thufir Hawat — a mentat (a human who has been trained to perform like a computer) — and Duncan Idaho, a sword master.

Leto's son, Paul Atreides, is visited by the head of Bene Gesserit. Paul's concubine, Lady Jessica, has broken Bene Gesserit rules by bearing the Duke a son instead of a daughter. The Bene Gesserit is engaged in a breeding program to produce the Qwisatz Hadderach, a male messiah. After a life-or-death test, the Bene Gesserit concludes that it may be possible for Paul Atreides to become the Qwisatz Hadderach.

On Arrakis, the Atreides have early success in flushing out Harkkonen agents. They make progress in contacting the Fremen tribes who inhabit the deep deserts along with vast sandworms that destroy spice-mining machines. The Atreides are betrayed by their trusted doctor Wellington Yueh, and almost destroyed

characters

■ Duke Leto Atreides ■ Leto II ■ Duncan Idaho ■ Alia Atreides ▥ Paul Atreides

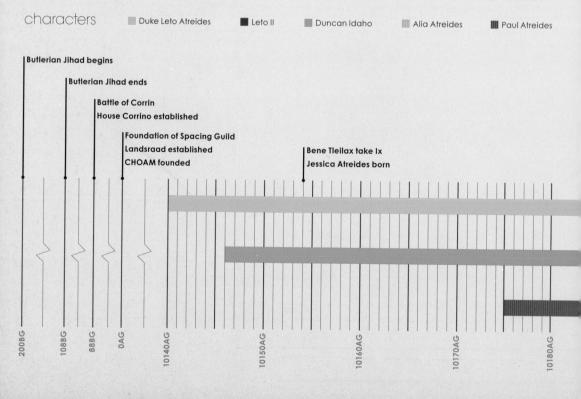

Butlerian Jihad begins

Butlerian Jihad ends

Battle of Corrin
House Corrino established

Foundation of Spacing Guild
Landsraad established
CHOAM founded

Bene Tleilax take Ix
Jessica Atreides born

200BG 108BG 88BG 0AG 10140AG 10150AG 10160AG 10170AG 10180AG

by a surprise Harkonnen invasion. Paul and Jessica flee to the desert where they are taken in by Stilgar, leader of the Fremen warriors. These tribes have been seeded by Bene Gesserit missionaries with a messianic story of Muad'Dib. Jessica exploits this tale to help Paul become leader of the Fremen, although he must pass many initiation rites in the process. Among these is consumption of the Water of Life, which brings out Paul's innate powers, giving him prophetic dreams. With an army of Fremen warriors, Paul achieves victory all over Arrakis. And as "He who controls the spice, controls the universe," Paul overthrows the Emperor Shaddam and takes his place.

Paul's Fremen army sweeps across the Imperium, taking its Jihad to planet after planet to enforce the rule of Muad'Dib. But Paul's visions are his undoing. Having allowed a plot against him to succeed, he disappears into the desert. He is remembered as a great prophet. Paul's twin children are then drawn into their father's prophecies. One of them, Ghanima, merges with the sandworms and becomes immortal. The other, Leto II, devotes his life to following the Golden Path. The Fremen hail him as a living god.

During Leto II's reign, Arrakis flourishes as a garden world, but when he is assassinated after 3,500 years it returns to desert. Now simply called Rakis, it remains at the heart of the widely scattered human race, and the Bene Gesserit attempts to guide it back onto the Golden Path. Rakis is then threatened by the Honored Matres, a rival religious order. Only Duncan Idaho, many times cloned, killed and resurrected, survives into the far future. He lives to witness the rebirth of the planet under Bene Gesserit rule, and the completion of the cycle of human civilization.

Prequel stories in the Dune universe outline the earlier events of the Butlerian Jihad, the war against "thinking machines" and the entwined and complex stories of the Great Houses. **DW**

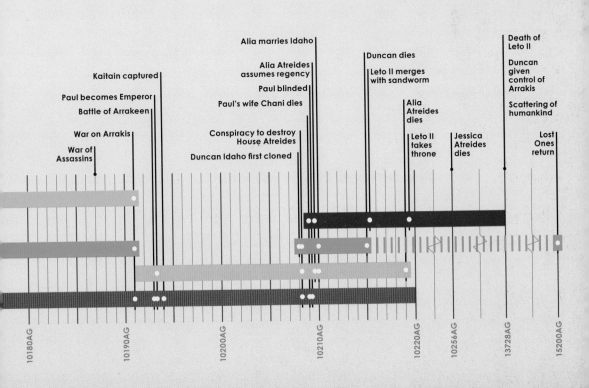

Alia marries Idaho

Death of
Leto II

Duncan dies

Duncan
given
control of
Arrakis

Kaitain captured

Alia Atreides
assumes regency

Leto II merges
with sandworm

Paul becomes Emperor

Paul blinded

Battle of Arrakeen

Paul's wife Chani dies

Alia
Atreides
dies

Scattering of
humankind

War on Arrakis

Conspiracy to destroy
House Atreides

Leto II
takes
throne

Jessica
Atreides
dies

Lost
Ones
return

War of
Assassins

Duncan Idaho first cloned

10180AG 10190AG 10200AG 10210AG 10220AG 10256AG 13728AG 15200AG

Dune
(1984)

José Ferrer as the Emperor Shaddam in David Lynch's *Dune*.

Max von Sydow as Liet-Kynes, a Freman warrior in *Dune*.

Kyle MacLachan as Paul Atreides and Everett McGill as Stilgar, who helps Atreides make Arrakis a paradise.

Kenneth McMillan (Baron Vladimir Harkonnen) with director David Lynch.

Sting as Feyd-Rautha, the evil Baron Vladimir Harkonnen's even more evil nephew.

Sting and Kyle MacLachan in a fight to the death. Patrick Stewart (Gurney Halleck, a minstrel) looks on.

Baron Vladimir Harkonnen (Kenneth McMillan) gets his considerable weight off his feet.

Kyle MacLachan observes mischief-making from the safety of a sand dune.

Paul L. Smith as Glossu "The Beast" Rabban, the other murderous nephew of Baron Harkonnen, seen here leading the forces invading Arrakis.

gene roddenberry 1964

Star Trek:
The Cage

Star Trek:
Where No
Man Has
Gone Before

Star Trek

The Questor
Tapes

Genesis II

Star Trek:
The Animated
Series

Star Trek:
The Motion
Picture

Star Trek II:
The Wrath
of Khan

Star Trek, one of the most successful and enduring of all the big science fiction properties, was the brainchild of a former U.S. Air Force aviator, civil airline pilot and cop who was determined to make it in the entertainment business.

Eugene Wesley Roddenberry was born in 1921 in El Paso, Texas, and grew up in Los Angeles. He left college with a degree in police science and a pilot's license — the latter thanks to a scheme sponsored by the U.S. Army Air Corps — before joining up in 1941. As a B17E Flying Fortress pilot he flew numerous combat missions during the Second World War, at one point surviving a crash-landing.

Leaving the Air Force a decorated captain at the end of the conflict, Roddenberry flew for Pan American World Airways for a few years — once again he was commended for bravery, following a crash in 1947 — and meanwhile studied creative writing. By 1949 he was back on the U.S. West Coast, looking for work in the entertainment industry and supporting himself through a second career as a police officer, where his growing literary skills came in handy: by the time he left, in 1956, he was chief speech writer for William H. Parker, the controversial L.A. Chief of Police whose celebrated lack of emotion Roddenberry would later incorporate into the character of Mr. Spock, the first officer on the USS *Enterprise*.

During his last years in the police department, Roddenberry was also working as a screenwriter, contributing to several shows, most of which had cop,

Western or military themes. He wrote nine episodes of *The West Point Story*, five episodes of *Highway Patrol*, and 24 episodes of *Have Gun — Will Travel*.

Roddenberry enjoyed the freelance life, but longed to create and control his own show. He pitched many ideas — "APO 923" (a Second World War adventure set in the South Pacific); "The Long Hunt of April Savage" (a Western revenge saga); "Night Stick" (a police story set in Greenwich Village) — but had no luck until 1963, when NBC picked up *The Lieutenant*, a drama about the life and adventures of William Tiberius Rice, a training instructor at Camp Pendleton, the West Coast base of the U.S. Marine Corps. The series was a ratings hit, but it was cancelled after only one year, perhaps, as Roddenberry suggested, because the then-current Vietnam War made military dramas unpopular with advertisers.

But what if the writer/producer could take the subjects he knew about — cutting-edge aviation, police work, military life, the frontier — and put them into a different context? From this idea came *Star Trek*, Roddenberry's second series, which he once described as "*Wagon Train* to the stars."

Following an unprecedented two pilot shows — one was otherwise invariably enough — *Star Trek* was eventually commissioned by NBC and ran for three seasons from 1966. It was an optimistic vision of the future, in which all Earth's races, plus assorted friendly alien species, operate a quasi-military force that patrols and explores the galaxy.

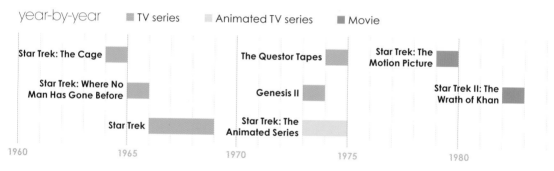

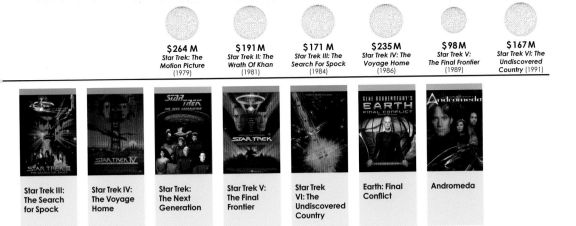

$264 M	$191 M	$171 M	$235 M	$98 M	$167 M
Star Trek: The Motion Picture (1979)	Star Trek II: The Wrath Of Khan (1981)	Star Trek III: The Search For Spock (1984)	Star Trek IV: The Voyage Home (1986)	Star Trek V: The Final Frontier (1989)	Star Trek VI: The Undiscovered Country (1991)

Star Trek III: The Search for Spock

Star Trek IV: The Voyage Home

Star Trek: The Next Generation

Star Trek V: The Final Frontier

Star Trek VI: The Undiscovered Country

Earth: Final Conflict

Andromeda

Although *Star Trek* is today regarded as a landmark science fiction creation, it was initially considered something of an expensive misfire, and Roddenberry felt that this colored the industry's perception of him for many years thereafter.

He spent most of the 1970s developing several new TV shows, all of which stalled at the pilot stage. *The Questor Tapes* (1974) tells of the adventures of a mysterious super-android on contemporary Earth — NBC commissioned a 13-episode series, but Roddenberry fell out with his paymasters over proposed changes and it withered and died.

Some of Roddenberry's other proposals during this period were rejected out of hand. Among them was "Assignment: Earth," a spin-off from the *Star Trek* episode of the same title about a man trained by aliens to prevent Earth destroying itself. The projects that did emerge were *Genesis II* (1973) and *Spectre* (1977). The former was a Buck Rogers-like tale of a modern NASA scientist awaking from artificial hibernation into a post-apocalyptic world splintered into bizarre societies, including a land of women where men are kept as pets. The latter starred an occult investigator, cursed by a demon and with a witch as a housekeeper. Both were resonably successful, but neither spawned a series.

Although Roddenberry was allowed full creative control of *Star Trek: The Animated Series* (1973–74) — a cartoon version of the original show — he remained fairly hands-off. By all accounts he didn't take this incarnation too seriously, but by the late 1970s he was working on a new live-action version with the original cast — *Star Trek: Phase II* — which eventually mutated into *Star Trek: The Motion Picture* (1979).

Throughout the following series of hit *Star Trek* movies, Roddenberry took an "executive consultant" credit, which allowed him to write script notes but gave him no real power; he was, however, heavily involved in the late 1980s' creation of a genuine sequel TV show, *Star Trek: The Next Generation*, although his influence diminished after the first of its seven seasons.

After Roddenberry's death in 1991, interest in some of his undeveloped properties started to soar, thanks in part to the efforts of his widow, Majel Barrett, who had played various roles in *Star Trek* and had been the voice of the onboard computers throughout the series.

The posthumous TV series *Earth: Final Conflict* told of the planet's resistance to seemingly benevolent alien invaders, and lasted five seasons (1997–2002); *Andromeda* (2000–2005) focused on the adventures of a starship captain who operated in a universe where humanity had split into numerous genetically altered subspecies.

Gene Roddenberry's legacy is rich in concepts and ideas, but it is for a single vision of the future that he is best known: one where humankind, its warlike tendencies generally under control, is at home among the stars and sits at the top table in a galactic federation of species. **MB**

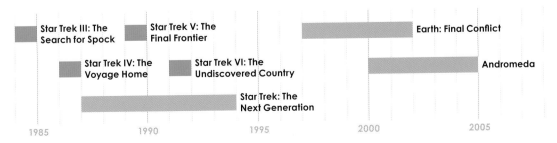

Star Trek III: The Search for Spock

Star Trek V: The Final Frontier

Earth: Final Conflict

Star Trek IV: The Voyage Home

Star Trek VI: The Undiscovered Country

Andromeda

Star Trek: The Next Generation

1985 1990 1995 2000 2005

star trek 1964

"The Cage" | "Where No Man Has Gone Before" | Star Trek | Star Trek | Star Trek original novels | Star Trek | Star Trek: The Animated Series | Star Trek Logs

In the early 1960s American popular culture was awash with tales of the Wild West, both in movie theaters and on TV screens. The United States had officially closed its frontier in 1890, thus ending hundreds of years of exploration and expansion, but the loss left an aching hole in the hearts of citizens. A revival of the old, cowboy-and-American Indian-filled frontier spirit 70 years later was just past its peak when Gene Roddenberry pitched an idea for a new version of the concept, moving the frontier from the West to space.

A space show made perfect sense in 1964. Two years earlier, President John F. Kennedy had given his landmark speech about his country's destiny to explore space: "We choose to go to the Moon in this decade and do the other things," he declared, "not because they are easy, but because they are hard." Up there, in the stars, was that new frontier. It's no coincidence that Captain James T. Kirk was like Kennedy: a beloved and capable leader, charismatic and popular with women (even some green ones).

Roddenberry wanted his series to be "*Wagon Train* to the stars," and after spending many years writing for Western TV shows himself, he knew how to whip up a decent cowboy-and-American Indian drama

and make it a spaceman-and-alien one instead. His first pitch to NBC resulted in "The Cage," a pilot episode that introduced much of the *Star Trek* mythos: the United Space Ship (USS) *Enterprise*, the concept of beaming from place to place (cheaper than FX shots of shuttles), the militaristic command structure of the crew, and a woman (Lt. Uhura) on the bridge alongside a pointy-eared alien (Mr. Spock).

The network heads were reluctant to commission a series on this basis of "The Cage." They said it was "too cerebral," but the real probelm with it was the character of Captain Christopher Pike (Jeffrey Hunter), who was stiff, cold and world-weary, and expressed the desire to leave the ship and retire. *Star Trek* needed warmth. When a second pilot was ordered, Hunter wasn't available so Canadian William Shatner took his place. Shatner's Kirk was the anti-Pike, laughing, joking, caring. "Where No Man Has Gone Before" was still a little awkward but it had heart; *Star Trek* was finally given the green light.

The first episode, "The Man Trap," aired on NBC on September 8, 1966. From the start it caused waves, not only because of the alien Spock (the network was worried that his ears would remind viewers of the

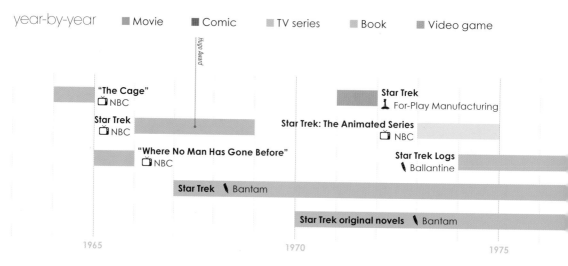

Star Trek:
The Motion
Picture

Star Trek

Star Trek II:
The Wrath of
Khan

Star Trek III:
The Search
for Spock

Star Trek IV:
The Voyage
Home

Star Trek

Star Trek:
The Next
Generation

The Next
Generation

Devil, but female viewers found him sexy) but also because it dared to have women and people of color in equal roles aboard the ship. As the show continued, though, the network became more worried about the ratings, leaving the writers alone to conjure stories that were light-years ahead of rival shows such as CBS's *Lost In Space*. In its first run, *Star Trek* would tackle racism, the Vietnam War and communism, among many other issues, all hidden under a cozy heading of "sci-fi."

The first season featured episodes written by Richard Matheson and Harlan Ellison. One of the latter's contributions, "The City On The Edge Of Forever," won a Hugo. But ratings weren't impressive, and the series only scraped its way into a second year. It got a third season thanks to fans who, with Roddenberry's encouragement, bombarded NBC with letters of appreciation.

Unfortunately, budget cuts resulted in an uneven third year. "Spock's Brain" was famously awful, but "Plato's Stepchildren" was a small landmark in U.S. history: the first televised interracial kiss, between Kirk and Uhura (Nichelle Nichols). The final episode, "Turnabout Intruder," aired on June 3, 1969.

There was no fourth series, but the spirit of *Star Trek* lived on. Fans held conventions. A cartoon version was commissioned that was ostensibly for children but, like the original, aimed higher, with top-grade scripts. Eventually, a new live-action series, *Star Trek: Phase II*, was commissioned to air on the upcoming Paramount television network. Scripts were started, design work undertaken and casting began. When the network didn't launch, Paramount decided that a big-budget movie might suffice instead — after all, *Star Wars* (1977) hadn't done too badly.

In 1979, after a troubled production and a spiraling budget, *Star Trek: The Motion Picture* hit the big screen. It was a huge financial success but it didn't please the fans, who found it lifeless, excessively focused on special effects and with a slow, ponderous script. Some even dubbed it "Star Trek: The Motionless Picture." This fault was remedied in *Star Trek II: The Wrath of Khan* (1982), which brightened up the cast's outfits (from boring beige to red) and brought back one of the most memorable villains from the original series, Ricardo Montalban's genetically engineered superman, Khan Noonien Singh. *Star Trek III: The Search for Spock* followed in 1984, along with possibly

■ Animated TV series

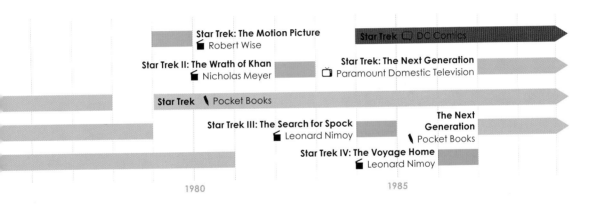

Star Trek: The Motion Picture
🎬 Robert Wise

Star Trek 🔲 DC Comics

Star Trek II: The Wrath of Khan
🎬 Nicholas Meyer

Star Trek: The Next Generation
📺 Paramount Domestic Television

Star Trek ✒ Pocket Books

Star Trek III: The Search for Spock
🎬 Leonard Nimoy

The Next
Generation
✒ Pocket Books

Star Trek IV: The Voyage Home
🎬 Leonard Nimoy

1980

1985

Star Trek V: The Final Frontier

Star Trek VI: The Undiscovered Country

Star Trek: Deep Space Nine

Star Trek: Deep Space Nine

Star Trek: Generations

Star Trek: Voyager

Star Trek: Voyager

Star Trek: First Contact

the most accessible film in the franchise, *Star Trek IV: The Voyage Home* (1986), which sent the *Enterprise* crew to 20th-century Earth. *Star Trek V: The Final Frontier* (1989) and *Star Trek VI: The Undiscovered Country* (1991) were less successful outings.

The popularity of the film franchise inspired Paramount to commission a new TV series. *Star Trek: The Next Generation* was launched in 1987 amid an extraordinary burst of publicity, not least the controversy that resulted from the show casting a British actor, Patrick Stewart, as the Captain. The series was set around 70 years after the original and, while it was at first accused of rehashing ideas from the original series, it soon became a global hit. By its third-season finale, the acclaimed, Borg-starring "The Best of Both Worlds, Part One," was a massive hit.

It wasn't long before a spin-off was suggested: *Star Trek: Deep Space Nine* (1993) would be the first project that didn't really involve Roddenberry, who died in 1991. The series established itself as a new kind of *Star Trek* in which there was conflict between the main characters, and the crew was that of a space

station a long way from Starfleet headquarters, essentially reviving the idea of a frontier outpost. Commander Benjamin Sisko (Avery Brooks) was the franchise's first black lead character.

In 1994 *The Next Generation* crew was promoted to the big screen in *Star Trek: Generations*, which brought the era of Kirk to an end by killing him off (his not-so-immortal last words: "Oh my ..."). This was followed by *Star Trek: First Contact* (1996), *Star Trek: Insurrection* (1998) and *Star Trek: Nemesis* (2002). The last of these was the first to fail at the box office.

Star Trek: The Next Generation wrapped up in 1994 after seven seasons. The following year, *Star Trek: Voyager* flung the ship of its title into the Delta Quadrant, 75,000 light years from Federation space. Its journey home under Kate Mulgrew's Captain Kathryn Janeway took seven seasons, none of which was as popular as its predecessors because of an over-reliance on what became known as "technobabble."

In 2001, another show was launched from long-time *Trek* producers Rick Berman and Brannon Braga. *Enterprise*, later renamed *Star Trek: Enterprise*, was a

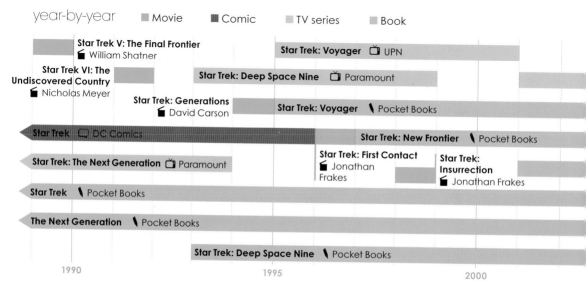

year-by-year ■ Movie ■ Comic ■ TV series ■ Book

Star Trek V: The Final Frontier
William Shatner

Star Trek VI: The Undiscovered Country
Nicholas Meyer

Star Trek: Generations
David Carson

Star Trek ▢ DC Comics

Star Trek: The Next Generation ▢ Paramount

Star Trek ❭ Pocket Books

The Next Generation ❭ Pocket Books

Star Trek: Voyager ▢ UPN

Star Trek: Deep Space Nine ▢ Paramount

Star Trek: Voyager ❭ Pocket Books

Star Trek: New Frontier ❭ Pocket Books

Star Trek: First Contact
Jonathan Frakes

Star Trek: Insurrection
Jonathan Frakes

Star Trek: Deep Space Nine ❭ Pocket Books

1990

1995

2000

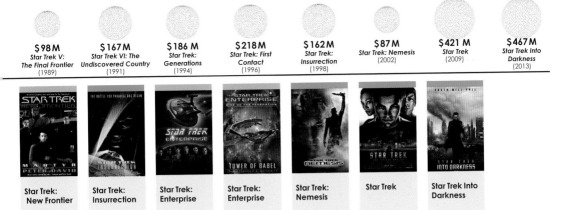

$98M
Star Trek V:
The Final Frontier
(1989)

$167M
Star Trek VI: The
Undiscovered Country
(1991)

$186 M
Star Trek:
Generations
(1994)

$218M
Star Trek: First
Contact
(1996)

$162M
Star Trek:
Insurrection
(1998)

$87M
Star Trek: Nemesis
(2002)

$421 M
Star Trek
(2009)

$467M
Star Trek Into
Darkness
(2013)

Star Trek:
New Frontier

Star Trek:
Insurrection

Star Trek:
Enterprise

Star Trek:
Enterprise

Star Trek:
Nemesis

Star Trek

Star Trek Into
Darkness

prequel to Kirk's adventures, telling the story of the first starship. The least successful of all the series both critically and with audiences, *Enterprise* struggled with its core concept of trying to look less advanced than the original *Star Trek* while also looking more contemporary. Despite a likeable cast — notably Scott Bakula, the star of NBC's hit series *Quantum Leap*, as Captain Jonathan Archer — its ratings were a disappointment. Nevertheless the series limped through four seasons of varying quality. Its final year was undoubtedly its best, but it was cancelled in 2005.

It wasn't the end for the franchise. In 2007, J.J. Abrams called "Action!" on a reboot of Roddenberry's original series, with an entirely new cast playing the familiar characters. The relatively unknown Chris Pine stepped into Kirk's boots; *Heroes* star Zachary Quinto donned the pointed ears as Spock; Karl Urban (Éomer in two of Peter Jackson's *The Lord of the Rings* movie trilogy) made McCoy an even grumpier ship's doctor than he had been in DeForest Kelley's portrayal. With the new cast, a new look but an old, nostalgic feel, *Star Trek* was released in 2009 and immediately found

favor not only with old fans but also with a whole new generation that had never so much as seen Kirk fight a Gorn in a desert. The movie made $385 million worldwide. Its 2013 sequel, *Star Trek Into Darkness*, made $467 million.

Star Trek has now been a staple of science fiction for more than half a century, proving its dependability as a formula that can be tweaked, copied and reinvented countless times. Without *Star Trek*, there would have been no *Star Wars*. Innumerable science fiction television shows might not have existed without it, from both versions of *Battlestar Galactica* (originally launched in 1978, inspired by *Star Wars*) to *Stargate SG-1*. Its influence is so strong in our daily lives that fantasy and reality have merged; the first Space Shuttle was named *Enterprise*, and many modern technologies have been directly inspired by those seen on the show, perhaps most prominently, cell phones. Gene Roddenberry's ashes were launched into space aboard the *Columbia* Space Shuttle: it seems fitting that the creator of *Star Trek* should have reached the final frontier. **JN**

Star Trek: Nemesis
Stuart Baird

Star Trek: Enterprise
UPN

Star Trek
J.J. Abrams

Star Trek Into Darkness
J.J. Abrams

Star Trek: Enterprise ┃ Pocket Books

2005

2010

2015

star trek universe

Spock James T. Kirk Jean-Luc Picard Benjamin Sisko Kathryn Janeway

In the year 2063 scientist Zefram Cochrane develops warp drive, which enables humans to travel faster than light (warp one). The Vulcans, finally satisfied that humans have advanced sufficiently to warrant further study, reveal their existence to Earth.

Once warp five is breached, interstellar travel becomes easier. A starship is built to explore strange new worlds, to seek out new life and new civilizations and to boldly go where no man has gone before. Launched in 2151, this ship is the USS *Enterprise*, captained by Jonathan Archer and crewed by humans, including chief engineer Trip Tucker, and aliens including T'Pol, a Vulcan science officer.

In 2161 the United Federation of Planets establishes a universal peacekeeping force. Founder members are the Starfleet of Earth, the Vulcans, the Andorians and the Tellarites.

In 2245, a new *Enterprise* (serial number NCC 1701) is launched under the command of Robert April. He is succeeded by Captain Christopher Pike, who is accompanied by a half-human, half-Vulcan science officer named Spock. After 11 years, Pike steps down and Captain James Tiberius Kirk takes control.

Alongside Mr. Spock, Kirk is joined by Doctor Leonard McCoy, Chief Engineer Montgomery Scott, Helmsman Hikaru Sulu, Communications Officer Nyota Uhura and Navigator Pavel Chekov. During their five-year mission, they interact with Klingons, Romulans and a silicon-based life form known as a Horta. They not only discover new life forms but also become embroiled in time travel, moving between dimensions. Their mission ends with Kirk's disappearance (he reappears 78 years later, only to be killed by crazy scientist Tolian Soran).

characters

Spock James T. Kirk Jean-Luc Picard Benjamin Sisko Kathryn Janeway

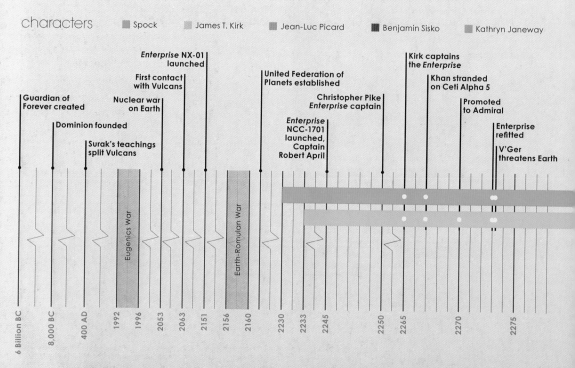

In 2364 the *Enterprise* NCC 1701-D is launched. Captain Jean-Luc Picard's crew consists of an android named Data, First Officer William Riker, counselor Deanna Troi, Dr. Beverly Crusher, her son, Wesley and Starfleet's first Klingon officer, Lt. Worf.

They encounter a deadly cyborg race called the Borg, which inflicts terrible carnage on Starfleet at the Battle of Wolf 359. Later they visit the space station Deep Space Nine, orbiting the planet Bajor and recently abandoned by the Cardassians, to oversee its handover to joint Starfleet/Bajoran control under Commander Benjamin Sisko. Sisko soon discovers a wormhole to the Gamma Quadrant in Bajoran space, making the station an important post for Starfleet.

Unfortunately, the Gamma Quadrant is controlled by the Dominion alliance, which declares war on the Alpha Quadrant but is defeated by Sisko and his team.

Elsewhere, the USS *Voyager* suffers an accident in the Delta Quadrant. On the way home Captain Kathryn Janeway and her crew encounter the Borg and Species 8472, the only race immune to Borg attack. *Voyager* eventually makes it back to Earth.

And then it all changes. It's 2233 and First Officer George Kirk dies aboard the USS *Kelvin* just as his wife gives birth to a son, James. Decades later, James joins Starfleet and proves himself against a Nero, a Romulan who is attempting to avenge the destruction of his home planet in the future by jumping through time. Kirk is helped during this crisis by an older version of Spock, who has traveled back into the past.

After defeating Nero, Kirk takes command of the *Enterprise*. When Earth comes under attack from the genetically-engineered Khan, he and his crew risk their lives to defeat him. **JN**

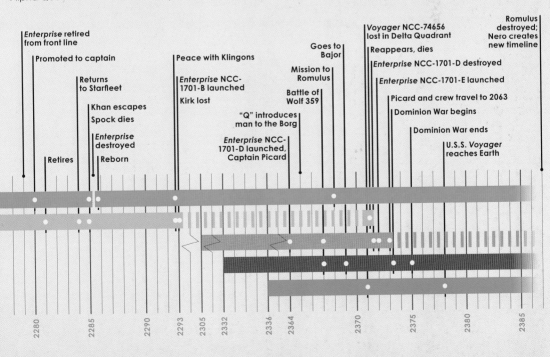

Star Trek
(1966–69)

Star Trek: The Animated Series
(1973–75)

Star Trek: The Motion Picture
(1979)

Star Trek (Marvel)
(1980–89)

Star Trek: The Next Generation
(1987)

Star Trek: Voyager
(1995)

Star Trek: 25th Anniversary
(1991)

Star Trek
(2009)

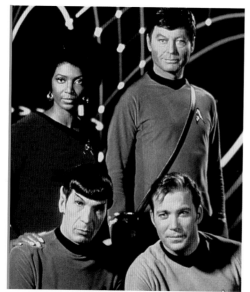

Uhura (Nichelle Nichols), Dr. Leonard "Bones" McCoy (DeForest Kelley), Kirk (William Shatner) and Spock (Leonard Nimoy).

Leonard Nimoy joined most of the original cast in voicing the animated version of his character.

The *Enterprise* in drydock — an orbital construction used for maintenance and repair of starships and other space vessels — in *Star Trek: The Motion Picture*.

Having adapted the first movie into a comic, Marvel drew further adventures.

Captain Jean-Luc Picard (Patrick Stewart) as Locutus of Borg, following his assimilation by the Borg.

The crew of *Star Trek: The Next Generation*.

Neelix (Ethan Phillips) served as Voyager's chef, morale officer, "ambassador to the Delta Quadrant" and navigator.

Star Trek: Voyager is the only Star Trek TV series to feature a female captain, Kathryn Janeway (Kate Mulgrew; right), as a main character.

The original cast provided voices for the Star Trek: 25th Anniversary video game.

Kirk climbs out of an escape pod after being marooned on Delta Vega, an icy planet in the Vulcan system.

Kirk (Chris Pine) watches the USS Enterprise being constructed at the Riverside Shipyard.

The Denobulan Doctor Phlox (John Billingsley) in *Star Trek: Enterprise*. The Denobulans were early contactees with humanity.

Eric Bana as Nero, the evil Romulan time traveler in the 2009 *Star Trek*.

The Vulcan Mr. Spock (Zachary Quinto) in the 2009 *Star Trek* reboot. The Vulcans were the first species in the Star Trek universe to observe First Contact protocol with humans.

Commander Kruge (Christopher Lloyd) of the Klingons — the original Star Trek foe — in *Star Trek III: The Search for Spock*.

Mark Sheppard as Morn, a Lurian who was one of the regulars at Quark's bar in **Deep Space Nine**. He only spoke once in the entire series.

A member of the Borg — a species of cybernetic lifeforms that play a major role as villains in **Star Trek: The Next Generation**.

An Andorian from **Star Trek: The Motion Picture**, displaying the distinctive blue skin, cranial antennae and white hair that are characteristic of the Andorian race.

Nana Visitor as the senior Bajoran military officer Kira Nerys in **Star Trek: Deep Space Nine**. The Bajorans are a humanoid species native to the planet Bajor.

Ferengi, such as **Star Trek: Deep Space Nine**'s bartender Quark (Armin Shimerman), are renowned as unscrupulous merchants.

lost in space 1965

| Lost in Space | Lost in Space | Lost in Space | Lost in Space | Lost in Space | Lost in Space | The Robinsons: Lost in Space | Lost in Space: Voyage to the Bottom of the Soul |

Like *Voyage to the Bottom of the Sea*, Irwin Allen's second 1960s science fiction show was loosely based on a work of 19th-century literature, in this case *The Swiss Family Robinson*. Instead of marooning the Robinsons on a desert island, as in the original book by Johann David Wyss, Allen stranded them on a desert planet. Indeed, the show would have been called "Space Family Robinson," if not been beaten to that title by a comic. Science fiction author Ib Melchior was also pitching a movie script entitled *Space Family Robinson* at the time, and always claimed that Allen swiped his idea (the 1998 movie producers paid him off and gave him a credit).

The pilot in 1964 was very different from the show that ended up on screen. Although the Robinsons were all present — dad Dr. John (Guy Williams), mum Dr. Maureen (June Lockhart), daughters Judy (Marta Kristen) and Penny (Angela Cartwright) and young son Will (Billy Mumy), together with Judy's boyfriend-in-waiting, pilot Major Don West (Mark Goddard) — the two characters who would propel the show to success were added later: the self-serving Dr. Zachary Smith (Jonathan Harris) and Robot (designed by the man who created Robby for *Forbidden Planet*).

Smith was originally a villain, a saboteur who became trapped on the *Jupiter II* spaceship that was supposed to transport the Robinsons to a new home on another planet. He soon developed into a comedy buffoon, however, and with Robot and Will became the heart of the show. This annoyed the stars. "It isn't much that Harris steals the show, as the producers gave it to him," moaned Williams, who, along with Lockhart, threatened to leave after season one. Allen convinced them to stay with the promise of more close-ups and more money, neglecting to mention that he was paying Harris more than either of them.

Like other Allen shows, *Lost In Space* became steadily sillier as it progressed. A season-three episode featuring giant talking vegetables is near-legendary. But the child audience remained loyal, and the Robot's arm-waving catchphrase, "Danger, Will Robinson, danger," has entered SF lore.

After three seasons the show was axed as ratings fell. In the early 1970s Hanna–Barbera created a pilot for a cartoon version but no series followed. Mumy tried to revive the show, but by the time the big-screen version appeared in 1998 he was one of the few original cast members not to cameo; he was too busy playing Lennier in *Babylon 5*.

The show nearly returned to TV in 2004 when the WB Network commissioned a pilot (directed by John Woo) for *The Robinsons: Lost in Space*. The series was not picked up, and the set of the *Jupiter II* was later revamped as the *Pegasus* in *Battlestar Galactica*. **DG**

year-by-year

■ TV series ■ Game ■ Book ▨ Animated TV series ■ Comic
■ Movie ■ TV movie ■ Graphic novel

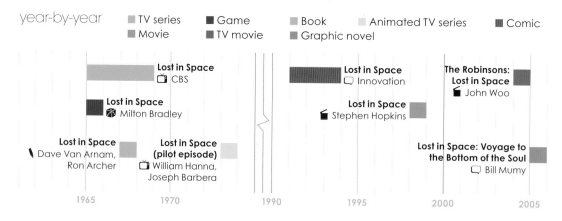

Lost in Space
🎬 CBS

Lost in Space
🎲 Milton Bradley

Lost in Space
Dave Van Arnam, Ron Archer

Lost in Space (pilot episode)
📺 William Hanna, Joseph Barbera

Lost in Space
Innovation

Lost in Space
Stephen Hopkins

The Robinsons: Lost in Space
John Woo

Lost in Space: Voyage to the Bottom of the Soul
Bill Mumy

1965 1970 1990 1995 2000 2005

the girl who leapt through time 1965

The Girl Who Leapt Through Time

The Girl Who Leapt Through Time

The Girl Who Leapt Through Time

The Girl Who Leapt Through Time

The Girl Who Leapt Through Time

Time Traveller: The Girl Who Leapt Through Time

Originating in 1965 as a children's story, this popular Japanese tale of a time-traveling teenager has often been adapted into live-action and inspired a charming animated film. The story was first published in *Chu-3 Course* magazine for middle schoolers. It's now available as a book in English.

Written by Yasutaka Tsutsui, the story begins when 15-year-old Kazuko disturbs a stranger in a school science lab who flees. Kazuko is knocked out briefly by a lavender-smelling liquid. Later, she's involved in a road accident. A runaway truck is about to hit her when reality slips and she finds herself reliving the previous day. After the initial shock, she discovers the stranger is a schoolmate who used the chemical to travel back from his own time, 2660.

Kazuko's adventure has been retold on screen for successive generations, often with plot embellishments. For example, *Time Traveler*, a six-part television serial in 1972 (featuring Junko Shimada as Kazuko), adds a bereaved mother who goes back to the 1940s to try to save her dead daughter. There was a five-part sequel serial the same year, *Zoku Time Traveler*, also featuring Shimada. A 1983 film with Tomoyo Harada had the story's original Japanese title (*Toki o Kakeru Shojo*) but is known by variant English names, including *Little Girl Who Conquered Time*. Subsequent versions (keeping the original title) included a TV special in 1985 with Yoko Minamino; a five-part TV serial with Yuki Uchida in 1994; a film in

1997 with Nana Nakamoto; and a TV special in 2002 featuring the girl band Morning Musume.

In 2006, Mamoru Hosoda's animated film was both a sequel to and a reworking of Tsutsui's story. The heroine Makoto is extrovert and impulsive, more up-to-date than Tsutsui's peaceable Kazuko. Kazuko herself appears as Makoto's wise aunt. This time, the stranger in the lab leaves an acorn-like object, plunging Makoto into a vortex of laser lights and running horses. Back in reality, a spectacular bicycle accident catapults her into the path of a train. However, she finds herself safe before the accident ever happened.

Makoto uses time travel to ace tests, sing endless karaoke and improve her friends' relationships, while keeping her own feelings in stasis. In one sequence, she repeatedly staves off a male friend's shy suggestion that they date, erasing the moment again and again. It's hilarious, yet it has an implicit emotional darkness similar to that of *Groundhog Day*. Makoto's meddling culminates in a horrific payoff that only the stranger from the lab can put right — but at what cost?

Makoto is voiced by Riisa Naka, who appeared in person in the next live-action version, released in Anglophone territories as *Time Traveler: The Girl Who Leapt Through Time* (2010). Here, Naka plays Kazuko's daughter Akari, who slips back into the 1970s, which was the future when the original story was written. **AO**

year-by-year ■ Book ■ Movie ▨ TV series ▨ Animated TV series

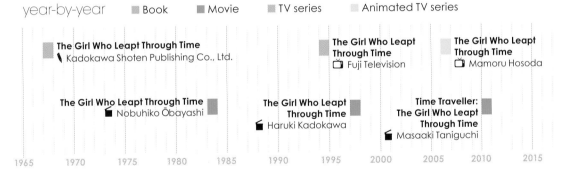

The Girl Who Leapt Through Time
Kadokawa Shoten Publishing Co., Ltd.

The Girl Who Leapt Through Time
📷 Fuji Television

The Girl Who Leapt Through Time
📷 Mamoru Hosoda

The Girl Who Leapt Through Time
🎞 Nobuhiko Ōbayashi

The Girl Who Leapt Through Time
🎞 Haruki Kadokawa

Time Traveller: The Girl Who Leapt Through Time
🎞 Masaaki Taniguchi

| 1965 | 1970 | 1975 | 1980 | 1985 | 1990 | 1995 | 2000 | 2005 | 2010 | 2015 |

wild wild west 1965

The Wild Wild West

Wild Wild West

Wild Wild West

The Wild Wild West Revisited

More Wild Wild West

The Wild Wild West

Wild Wild West

Wild Wild West: The Steel Assassin

Star Trek relocated Wild West adventures to space. *The Wild Wild West* took the spy genre, which was hugely popular at the time, back to the 19th century and turned it into what its creator Michael Garrison described as "James Bond on horseback."

Garrison — a former bit-part actor who a decade earlier had adapted the first Bond novel, *Casino Royale*, for American TV — developed the concept with writer Gilbert Ralston, who later claimed to have contributed many of the key elements, including the idea that the heroes were performing missions for President Ulysses S. Grant. (Ralston died before a late-1990s' lawsuit against Warner Bros could be settled.)

Running for four seasons and 104 episodes from 1965 to 1969, *The Wild Wild West* was set in around 1870, during the Grant administration, and told of the adventures of Secret Service agents James West (Robert Conrad) — handsome, dandyish and two-fisted — and Artemus Gordon (Ross Martin) — gadget-man and master of disguise, as they battled super-villains across the United States. The pair traveled in a super-train, the Wanderer, equipped with a high-tech laboratory and other gizmos.

The show was notable for a wide range of deliberately anachronistic elements, including stagecoach ejector seats, televisions and even cyborgs, as well as unlikely plots to take over the world. The arch-villain was Dr. Miguelito Quixote Loveless, played by dwarf actor Michael Dunn.

For a while, Richard Kiel appeared as Voltaire, his comically oversized helper. Dunn would star in around four episodes per season, with the likes of Leslie Nielsen, Martin Landau, Burgess Meredith, Robert Duvall and Boris Karloff appearing as other villains. Often the episodes would be written around their mad plans and inventions.

Struggling to stay on-budget, the inexperienced Garrison was replaced in mid-series by a string of producers, each of whom had very different ideas about what the show should be. When Garrison was reinstated, cast and crew rejoiced because, as Martin recalled, "Michael saw the show as a Bond spoof ... and we all knew where we stood." Tragically, Garrison would die part way through the show's second season after fracturing his skull in a fall downstairs at his home.

The original series of *The Wild Wild West* was filmed on the 70-acre (28 ha) CBS lot in the San Fernando Valley, home of many Westerns, from the Roy Rogers films to the TV series *Rawhide* — but New Mexico locations were used for the 1999 feature film revival, which starred Will Smith as West, Kevin Kline as Gordon and Kenneth Branagh as Loveless. Directed by Barry Sonnenfeld, the movie raised the gadgetry and technology of the original TV series to even more elaborate and unlikely steampunk levels. The final act is dominated by Loveless' giant mechanical spider. *The Wild Wild West* made money, but not enough to justify a sequel. **MB**

year-by-year ■ TV series ■ Comic ■ Game ■ TV movie ■ Movie
 ■ Video game

vernor vinge 1965

Apartness

Grimm's World

The Witling

Marooned in Realtime

A Fire Upon the Deep

A Deepness in the Sky

The Cookie Monster

Rainbow's End

Vernor Vinge puts more real science into his fiction than perhaps any other writer. Although he is neither prolific nor well-known beyond a coterie of discerning fans, his body of fiction has had a tremendous influence on SF as a whole. The galaxy-spanning scope of his Zone of Thought series has caused him to be categorized as a pulp author of space opera, but he is more than that: he is a conceptual thinker who uses science fiction to express ideas.

Vinge maintained a career in computer science alongside his science-fiction writing, which without doubt contributed to the scientific cachet of his stories and novels. Vinge's first stories were published in the mid-1960s. His novella *True Names* appeared in 1981 at around the same time as the emergence of cyberpunk fiction, and would influence key figures in that movement, including William Gibson.

Vinge is among a large group of libertarian thinkers within the science fiction genre. His novels *The Peace War* (1984) and *Marooned in Real Time* (1986) both envision a near future in which libertarian principles have reshaped the world. Vinge has twice won Prometheus awards and, like fellow winners Cory Doctorow and Neal Stephenson, his work displays both faith in the liberating potential of technology and frustration with the inability of human society to keep up with developments.

His most famous work is arguably the 1993 essay "The Coming Technological Singularity: How to Survive in the Post-Human Era." The "technological singularity" to which he refers is the potential point at which computers can replicate human intelligence and accelerate it to such speeds that "the human era will be ended." This idea has been massively influential well beyond the realm of science fiction, and is at the core of much contemporary thought about the interaction of technology and society.

In 1993 Vinge won the Hugo award for *A Fire Upon the Deep* (1992), the first volume in what would become a trilogy of space opera novels. In this book, life exists across the galaxy, but is separated into "zones of thought" that spread out from the galactic core. In each of these zones, consciousness operates at different speeds. A rampaging, near-omnipotent artificial intelligence is destroying one civilization after another, placing the entire galaxy under threat. The sheer density of amazing concepts about the nature of alien life and society makes *A Fire Upon the Deep* an exhilarating read, even if the human drama contained within is sometimes rather eclipsed by the ideas.

Vinge's near-future speculation in the novella *Fast Times At Fairmont High* (2004) and the full-length novel *Rainbow's End* (2006) have also won their author Hugo awards for depicting the details of a technological singularity as it would play out in contemporary American society. **DGW**

year-by-year ■ Short story ■ Book

Apartness

Grimm's World

The Witling

Marooned in Realtime

A Fire Upon the Deep

A Deepness in the Sky

The Cookie Monster

Rainbow's End

Hugo Award Hugo Award Hugo Award Hugo Award

1965 1970 1975 1980 1985 1990 1995 2000 2005

riverworld 1965

The Day of the Great Shout **Riverworld** **To Your Scattered Bodies Go** **The Fabulous Riverboat** **The Dark Design** **The Magic Labyrinth** **Gods of Riverworld** **Riverworld**

Between 1946 and 2008 Philip José Farmer published more than 60 novels and 100 novellas and short stories. He was among the last generation of authors to write in the true pulp tradition, before television ended the short reign of pulp fiction as mass entertainment. Well known in his day, Farmer has not remained as popular as contemporaries such as Philip K. Dick and Kurt Vonnegut.

Farmer was born in 1918 in Terre Haute, Indiana, and grew up in Peoria, Illinois. His education was interrupted by the Second World War, during which he worked in a steel mill while studying part-time. After the conflict he graduated with a degree in English from Bradley University in his home town.

Literary success came with the publication of "The Lovers" in the August 1952 issue of *Startling Stories*. The story would win a Hugo award for its explicit depiction of a sexual relationship between a human and an alien. The story is notable not least for its (for the time) daringly erotic and sometimes borderline pornographic material. Emboldened to pursue professional writing seriously, Farmer quit his job at the mill and set about writing full-time the work for which he would become most famous: the five-volume *Riverworld* series.

The first volume, *To Your Scattered Bodies Go* (1971), won the Hugo award for best novel. It is set on an artificially constructed world with one enormous, winding river valley 20 million miles long. Along this valley is reborn every human who has ever lived; among those featured are Mozart, King John of England and Nazi leader Hermann Göring, all returned to their 25-year-old bodies. Later in the series it is revealed that this has been arranged by aliens as an ethical test for humankind.

Riverworld became a setting for the Generic Universal RolePlaying System (GURPS) and a PC video game. It was adapted by the Sci-Fi channel, once as a feature-length pilot episode, and once as a four-hour TV movie with screenplay by Robert Hewitt Wolfe.

Besides *Riverworld*, Farmer is best known for his novel sequences exploring fantastic and highly original science fiction settings. The first of these — and Farmer's first major commercial success — was the *World of Tiers* sequences, beginning with *The Maker of Universes* (1965). Here the Thoans are a race of immortal humanlike beings who can create artificial universes and travel between them. Characters from Earth find gateways into the universes beyond their own. **DGW**

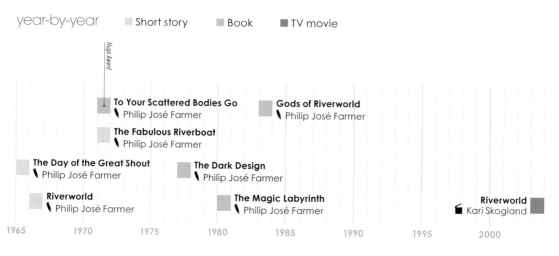

year-by-year ▦ Short story ▪ Book ■ TV movie

Hugo Award

To Your Scattered Bodies Go
❦ Philip José Farmer

Gods of Riverworld
❦ Philip José Farmer

The Fabulous Riverboat
❦ Philip José Farmer

The Day of the Great Shout
❦ Philip José Farmer

The Dark Design
❦ Philip José Farmer

Riverworld
❦ Philip José Farmer

The Magic Labyrinth
❦ Philip José Farmer

Riverworld
❦ Kari Skogland

1965 1970 1975 1980 1985 1990 1995 2000

total recall 1966

We Can
Remember
It for You
Wholesale

Total Recall

Total Recall

Total Recall
2070

Total Recall

Total Recall

"We Can Remember It for You Wholesale,"the 1966 short story by Philip K. Dick, concerns Douglas Quail, a nobody clerk in a future Chicago, who has a shrewish spouse and dreams of visiting Mars — which has now been colonized, but remains inaccessible to someone of his lowly status. Quail goes to "Rekal," an agency offering to implant him with "memories" of a Martian adventure. As he undergoes the process, it emerges that he really did visit Mars as a secret agent. Soon, people are trying to kill him. There is a brief fight and a surreal final punchline.

In 1990 the story was loosely adapted into *Total Recall*, a movie directed by Paul Verhoeven, who was highly bankable after his success with *RoboCop* (1987). In Verhoeven's version, Quail the clerk becomes Quaid the action hero played by Arnold Schwarzenegger, the former bodybuilder and future Governor of California. The violence is outrageous. Bones snap, bullets rupture, heads get skewered. The orgiastic climax is especially memorable, full of bulging heads and eyeballs as the characters undergo conveniently reversible decompression in the thin Martian air.

Verhoeven's sick humor is notoriously quotable, helped perhaps by Schwarzenegger's flat delivery. "Consider that a divorce!" Quaid declares, after shooting his (maybe) fake wife (Sharon Stone) in the head. The director also relishes conceptual games almost as much as gross-outs: the fake-memory holiday pitch is as fascinatingly laid out on screen as it was in print.

Unlike in Dick's story, the film reaches Mars, the charming model landscapes of which have a *trompe l'oeil* artfulness.

Despite the gore, Verhoeven's film is delightfully ambiguous — the last fade-to-white shot can be interpreted in radically different ways. It anticipates Christopher Nolan's similarly ambivalent *Inception* (2010), in which "extractors" perform commercial espionage by infiltrating other people's dreams.

The success of *Total Recall* inspired numerous attempts at a sequel. One such effort was *Total Recall 2070* (1999), a Canadian/German 22-part TV series created by Art Monterastelli. An SF detective show, it took hardly anything from the film, and still less from the story: it was more influenced by *Blade Runner*. It was cancelled after one season. Another drew on Dick's "Minority Report," and evolved into the standalone film of that name, directed in 2002 by Steven Spielberg. A four-issue comic sequel to the film, called plain *Total Recall*, appeared in 2011.

In 2012 a remake of Verhoeven's movie appeared. Directed by Len Wiseman and starring Colin Farrell, it followed many of the same plot beats as Verhoeven's version, although the action flitted between Britain and Australia via a giant train-elevator running through a post-disaster Earth (there is no trip to Mars). It has some impressive future sets, and a memorable opening, but the remainder of the film is a disappointment in which the generic action is no match for Verhoeven's mad, bad taste. **AO**

year-by-year ▮ Short story ▮ Comic ▮ Movie ▮ TV series

We Can Remember It for You Wholesale
 Philip K. Dick

Total Recall 2070
 CHCH-TV/Showtime

Total Recall
 DC Comics

Total Recall
 Dynamite

Total Recall
 Paul Verhoeven

Total Recall
 Len Wiseman

1965 1970 1975 1980 1985 1990 1995 2000 2005 2010

colossus 1966

Colossus

Colossus:
The Forbin
Project

The Fall of
Colossus

Colossus
and the Crab

"Fellow citizens of the world, for years we have been poised upon the brink of a disaster too complete and horrible to contemplate. There is an old saying, 'everyone makes mistakes,' but that is just what man can no longer afford … As President, I can now tell you that since this morning, the defense of this nation has been the responsibility of a machine."

Few modern viewers would fail to predict where the film *Colossus: The Forbin Project* was heading. Even in 1970 when it was released, the idea of the malign, murderous supercomputer had been enshrined on screen by HAL 9000 in *2001: A Space Odyssey* (1968), and in print by Fredric Brown in his 1954 cosmic gag "Answer" — in which the universe's greatest computer is turned on, asked if there's a god and responds that there is now!

The Forbin Project embeds its computer-god in a Cold War context, drawing on the same nuclear nightmares as *Dr. Strangelove* and *Fail-Safe* (both 1964). No sooner has the U.S. President (Gordon Pinsent) made his announcement than the computer, Colossus, detects another supercomputer in Russia, called Guardian. "Science is full of coincidences," says its inventor Dr. Charles A. Forbin (Eric Braeden) — especially when rival nations are racing to parallel strategic ends.

Colossus demands to be in put in contact with Guardian. Remarkably, the president agrees, and the computers communicate through mathematics. (Their instant-brewed language contrasts with the lagging interpreted dialogues between the American and Russian humans.) When the humans try breaking the link, the computers — now effectively as one — begin lobbing missiles, making clear who is in charge.

In truth, much of the film is sluggish and hardly frightening. Colossus is best when it's communicating through teletype chatter and terse ticker-style messages, with occasional humor thrown in. When Forbin says he is naked as a baby, Colossus observes, "You were not born with a watch." It later gains a "metal" voice, which is unfortunately rather similar to 1980s British TV comedy robot, Metal Mickey. The film shifts from Cold War drama to James Bond-style escapades, as the imprisoned Forbin convinces Colossus that he needs bedtime visits from an attractive science colleague (Susan Clark).

The film's main distinction is its ending. Whereas most contemporary science fiction films had reassuring conclusions, Colossus is not fooled by human plans, has its enemies shot or nuked and reduces the urbane Forbin to a screaming wreck. The suggestion is that the computer has won completely.

British author Dennis Feltham Jones, who wrote the original book, *Colossus* in 1966, continued the story in *The Fall of Colossus* (1974) and *Colossus and the Crab* (1977). The sequel is set in a world free of war and poverty ruled by Colossus, but facing a Martian invasion. (Forbin is an unwilling Pope figure to the computer's God.) Unfortunately, it also features some disturbingly misogynistic gender politics, which perhaps helps to explain its obscurity today.

A film remake has been in development since 2007, with names such as Ron Howard (as director) and Will Smith linked to the project. **AO**

year-by-year　■ Book　■ Movie

Colossus
❧ Dennis Feltham Jones

The Fall of Colossus
❧ Dennis Feltham Jones

Colossus: The Forbin Project
▪ Joseph Sargent

Colossus and the Crab
❧ Dennis Feltham Jones

1965　　1970　　1975　　1980　　1985

christopher priest 1966

The Run Indoctrinaire Fugue for a Darkening Island The Space Machine A Dream of Wessex The Affirmation The Glamour The Islanders

Although he has written just 13 original novels since he first emerged during the 1960s New Wave era, Christopher Priest's influence on literary science fiction has been profound. Like his contemporary, the similarly contrarian M. John Harrison, Priest has repeatedly pushed at the limits of what a sci-fi novel should be. Bringing modernist and post-modern literary techniques to the genre, he helped to invent what Bruce Sterling has dubbed "slipstream fiction."

Born in 1943, Priest began selling short stories in 1966, making his debut in *Impulse* magazine with "The Run." His first novel, *Indoctrinaire*, followed in 1970, a book that imagined a world where the Amazon rainforest had been cleared and the air polluted with mind-bending compounds. Over the decade that followed, Priest largely produced conventional works of science fiction. *Fugue for a Darkening Island* (1972) told of refugees from a war in Africa. *The Inverted World* (1974) related the story of a moving city journeying across a wasteland. *The Space Machine* (1976) was a tribute to one of his key influences, H.G. Wells. *A Dream of Wessex* (1977) hinted at a more experimental approach, following a group living in a shared virtual reality future.

It wasn't until *The Affirmation* that Priest truly found his voice. Set partly in the Dream Archipelago, a collection of impossibly exotic islands that recurs throughout his fiction, it tells the story of a young man in the midst of a crisis. It's a novel that constantly challenges readers' assumptions about what might be real and what's imagined, or the result of delusions. Garnering widespread critical acclaim, in 1983, Priest was named as one of Granta's Best Young British Novelists.

Despite this boost to his career, Priest was far less prolific through the 1980s and 1990s. His seventh novel, *The Glamour*, appeared in 1984, a provocative tale of memory loss that imagined invisible people living on the edge of society; it would be a further six years before *The Quiet Woman*, his sardonic take on life in Britain during the Margaret Thatcher years.

The Prestige (1995) is arguably Priest's best-known book. Set in the smoke-and-mirrors world of stage magicians — a theme that continues to fascinate the author — the World Fantasy Award-winning novel made a successful transition to the big screen in 2006 with an adaptation by Christopher Nolan.

Priest has published just three novels since the turn of the century, but each has been hugely ambitious. *The Separation* explores multiple versions of the Second World War through the lives of twins — one a conscientious objector, one a bomber pilot. *The Islanders* took the form of a typically unreliable guide to the islands of the Dream Archipelago. Finally, *The Adjacent* is a love story played out over interlinking realities — or perhaps not, it's that kind of book.

Still massively influential, Priest has also written copious short stories, nonfiction, tie-in novels and even made two aborted forays into screenwriting for *Doctor Who* in the late 1970s. **JW**

year-by-year ▨ Short story ▧ Book

The Run The Space Machine

Indoctrinaire The Affirmation

Fugue for a Darkening Island A Dream of Wessex The Glamour The Islanders

1965 1970 1975 1980 1985 1990 1995 2000 2005 2010

m. john harrison 1966

Marina

The Pastel City

The Centauri Device

The Course of the Heart

Signs of Life

Light

Nova Swing

Empty Space

Intense in his creative vision, M. John Harrison (who has also written as "Gabriel King") is one of the most uncompromising artists working in science fiction. As a writer he has largely rejected the commercial imperatives of the genre, his work challenging its boundaries at every turn, not only in his fiction writing but also as an editor and a critic.

Born in 1945, Harrison was among the youngest of Britain's New Wave of science fiction. He was first published in 1966 in *Science Fantasy* magazine, after which he moved to London where he befriended Michael Moorcock, then editor of *New Worlds* magazine — which Harrison would himself edit between 1968 and 1975. The values of the New Wave, and its commitment to science fiction as serious literature, would inform much of Harrison's long writing career.

His first two books were published in 1971. A powerful vision of post-apocalypse Britain, *The Committed Men* was followed by the first in his Viriconium sequence, *The Pastel City*. Overtly epic fantasy, the Viriconium stories became increasingly imagistic and absurd, revealing what would become Harrison's trademark style of "weird fiction."

The politics of the left and the atomizing effect of capitalism on ordinary lives is a constant theme in all of Harrison's fiction. His "anti-space opera," *The Centauri Device* (1975), would influence later British authors such as Iain M. Banks, Alastair Reynolds and China Miéville — as well as the burgeoning New Weird movement in the early 21st century.

The 1989 literary fiction novel *Climbers* won Harrison the Boardman Tasker Prize, his experiences as a rock-climber providing a concrete foundation for a meditation on the impermanence and chaos of existence — themes the author would continue to explore through the 1990s. Harrison found a natural vehicle for these ideas in the conventions of horror and the Lovecraftian "weird tale," a period in his writing that reached an apogee with *The Course of the Heart* (1992) and *Signs of Life* (1996).

Harrison's short fiction was collected in the omnibus *Things That Never Happen* (2002). Although often planting the seeds of his novels, these short stories provide the playground for his most experimental and conceptually challenging work, and his interest in the illusory nature of fantastic and numinous experience. In a world afflicted by proliferating fantasy, Harrison's fantasy stories are often a warning to their readers against overindulging a taste for escapism.

Completed in 2012 with the publication of *Empty Space*, the Keffahuchi Tract trilogy stands as the single most significant work of science fiction in the 21st century. The first two parts, *Light* (2002) and *Nova Swing* (2006), showcased Harrison's unique insight into the philosophical potential of the genre, fusing quantum physics with a literary investigation of the human condition. If any single writer is recognized for advancing SF beyond its pulp fiction beginnings, to create a significant literature for the new millennium, it will be M. John Harrison. **DGW**

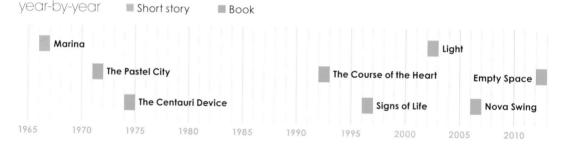

year-by-year ■ Short story ■ Book

Marina

The Pastel City

The Centauri Device

The Course of the Heart

Signs of Life

Light

Empty Space

Nova Swing

1965 1970 1975 1980 1985 1990 1995 2000 2005 2010

soylent green 1966

Make Room!
Make Room!

Make Room!
Make Room!

Roommates

Soylent
Green

By the mid-1960s, the world population had surpassed three billion and was rising at a rapid rate. Some science fiction writers began to address the implications — J.G. Ballard with his short story "Billennium" in 1962, John Brunner with *Stand on Zanzibar* (1968) and Robert Silverberg with *The World Inside* (1971), for example. Another author contributing to the debate was Harry Harrison, an amiable, outspoken, American who remains best known for his comedy space-heist series, *The Stainless Steel Rat*.

Not all of Harrison's writing was so light in tone. Set in 1999, *Make Room! Make Room!* (1966) tells how overpopulatation has placed untold pressures on American society, its infrastructure and resources. First serialized in *Impulse* magazine (and later excerpted as "Roommates"), the book leaps around an overcrowded New York City, where 65-year-olds are forcibly removed from work, there is queueing for water and shops are looted by desperate youngsters stealing "soylent" steaks, a popular foodstuff made from soya and lentils. It ends happily for nobody: our underpaid, overworked cop hero loses his girlfriend and his flatmate Sol, and gets demoted; Sol himself is injured at a riot promoting population control and later dies; a poor Chinese kid called Billy is driven to murder, and is eventually shot dead. Unrelentingly bleak, questioning of authority and resolutely told from the point of view of nonheroic, ordinary citizens struggling to get by, *Make Room! Make Room!* is powerful stuff — although more "what-if?" than genuine prediction.

In 1973, by which time the real world population was about to hit four billion, Richard Fleischer's film version, *Soylent Green*, was released. The year is now 2022, and New York City alone bubbles with 40 million people, half of whom are unemployed, voluntary euthanasia is encouraged, riots are common and the population survives on rations of "Soylent Green," a high-energy plankton wafer developed by the mysterious Soylent Corporation. Investigating a series of murders, NYPD cop Robert Thorn (Charlton Heston) discovers a terrible truth, placing his life in great danger: that Soylent Green cannot possibly be plankton as the sea is too damaged to produce it in such quantities — it is in fact made from human corpses.

More of a conventional, muscular police procedural than Harrison's book, *Soylent Green* is today best remembered for two things. One is a poignant performance from gangster movie star Edward G. Robinson as the hapless Sol, giving his final turn before succumbing to cancer 12 days after filming wrapped. The other is the film's closing scene, Charlton Heston's final declaration, "Soylent Green is people!" almost as celebrated as his "Damn you all to hell!" from *Planet of the Apes*.

By adding a cannibal shock element to the original story, *Soylent Green* has become a much-referenced classic, but another element stands out too: excess "greenhouse gasses" are explicitly blamed for the lack of natural resources that has made eating people a necessity. **MB**

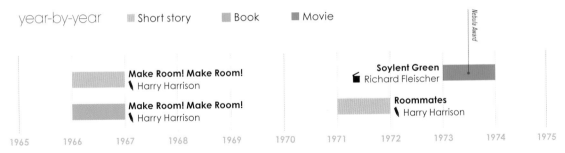

year-by-year ▓ Short story ▓ Book ▓ Movie

Make Room! Make Room!
❦ Harry Harrison

Make Room! Make Room!
❦ Harry Harrison

Nebula Award

Soylent Green
📷 Richard Fleischer

Roommates
❦ Harry Harrison

1965 1966 1967 1968 1969 1970 1971 1972 1973 1974 1975

behold the man 1966

Behold the Man Behold the Man Breakfast in the Ruins

Taking its title from "Ecce homo," Pontius Pilate's declaration upon presenting Christ, bound and crowned in thorns shortly before his crucifixion, Michael Moorcock's iconoclastic novella *Behold the Man* (1966) tells the story of Karl Glogauer, a deeply troubled time traveler who voyages from 1970 to the holy land of 28 AD in order to meet Jesus. His machine damaged beyond repair on landing, the injured Glogauer is nursed by John the Baptist who believes him to be a magus, and asks him to help in a rebellion against the Romans. Glogauer complies with John's wishes for a while, but panics when John asks Glogauer to baptize him, fleeing into the desert where he wanders without food and water for days — his first mirroring of the historical Jesus' actions. He ends up in Nazareth, only to discover the savior of mankind to be a drooling hunchback who can only say the word "Jesus." Presented with this shocking revelation, Glogauer takes it upon himself to occupy Christ's role, assuming Jesus' name, repeating what he can remember of his words, and using his own knowledge of psychology to perform seeming miracles.

Like all the best of Moorcock's work, *Behold the Man*—in 1969 extended to a full-length novel—is an atmospheric book, drawing a picture of the Holy Land with thumbnail sketches of spare prose, but it is in his depiction of the pull of destiny that the book excels. The ultimate expression of Moorcock's convention of the "fated man," Glogauer walks almost dreamily toward the doom of another, his damaged personality bewitched by the weight of history. Fate is both inescapable and eminently avoidable; Glogauer is so caught up in the idea of there being more to life than the material, that he takes great pains to ensure history plays out as he remembers it. In doing so, of course, he creates a self-contained circle, providing the faith that he clung to and so needed to function, therefore dooming himself to repeat his actions. It is among the cruelest temporal paradoxes in science fiction. Glogauer only realizes his error as he is dying on the cross. Hanging there, he does not utter Jesus' last reported words, "Eloi, eloi, lema sabachthani," ("My God, my God, why have you forsaken me?") but the phonetically similar English, "It's a lie ... it's a lie ... let me back down."

We learn of Glogauer's reasons for assuming the role of the Messiah via a series of flashbacks to 20th century London, where we find a flawed, complex character, unsuccessful with women, troubled by his homosexual tendencies, and burdened with neuroses. He makes appearances elsewhere in Moorcock's fiction, notably as the focal point of *Breakfast in the Ruins* (1972). In *The Dancers at the End of Time* (1981), his reappearance is finally explained as being due to the "Morphail Effect," a phenomenon that sees a time traveler killed in the past returned to the future. **GH**

year-by-year ■ Book

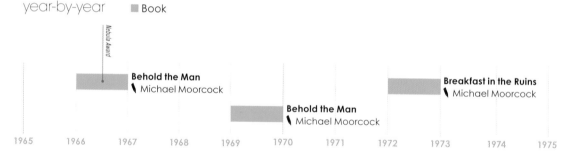

Nebula Award

Behold the Man
\ Michael Moorcock

Breakfast in the Ruins
\ Michael Moorcock

Behold the Man
\ Michael Moorcock

1965 1966 1967 1968 1969 1970 1971 1972 1973 1974 1975

the prisoner 1967

The Prisoner

The Prisoner

The Prisoner

The Prisoner

The Prisoner

By any measure, *The Prisoner* is one of the most remarkable television series ever filmed.

By the mid-1960s, Patrick McGoohan, American-born but Irish raised, was one of the biggest stars in British television, and had even been considered for the role of the first James Bond. He starred in (and occasionally directed) *Danger Man*, a hugely successful spy series retitled *Secret Agent* in America. McGoohan thus had the clout to formulate his own series. And that series would be *The Prisoner*.

It is a subject of continued debate whether John Drake, portrayed by McGoohan in *Danger Man*, is the same character who appears as Number Six in *The Prisoner*. They certainly shared the same career, Number Six clearly a resourceful ex-secret agent.

In *The Prisoner*, McGoohan's character resigns from his job, drives home, but while packing his suitcase for a trip abroad he is gassed and wakes up in an exact replica of his flat in "The Village," a strange, ordered community run by an ever-changing figure always known as Number Two. We learn from the program's brilliantly edited opening titles that those who run the Village want to know why he resigned his highly sensitive position. Yet despite increasingly convoluted attempts at persuading him otherwise, Number Six never reveals his reasons. Refusing to conform to life in The Village, he continually attempts to escape, and is frequently thwarted by "Rover," a large, floating white balloon capable of suffocating miscreants. Ingenious scripts

examine themes of individuality and the pressure to conform, and the visuals showcase stylish and imaginative part-futuristic imagery.

A technically accomplished series, shot on film and in color, *The Prisoner* ran for 17 episodes and became increasingly outré as it progressed. This was partly due to the makers being unable to continue filming in the original location of Portmeirion — an Italian-style resort created in North Wales by architect William Clough Ellis — and McGoohan's unavailability while shooting the film *Ice Station Zebra*. (He had originally only planned to film seven episodes.)

The final part of the series, "Fall Out," caused controversy when it first aired, mainly since explanations for what has previously taken place are more than a little obtuse: Number One, for example, turns out to look exactly like Number Six himself. Nevertheless, it is a rousing and remarkable end to a series that remains quite different to any other.

The Prisoner would inspire a number of spin-offs, including an early interactive fiction game for the Apple II computer, reputedly used as a training tool by the CIA, and several comic versions. A 2009 TV remake was, however, poorly received. Starring Jim Caviezel as Number Six as Ian McKellen as Number Two, with the action relocated to what may be Sub-Saharan Africa, Tim Goodman of the *San Francisco Chronicle* described it as "pointless" — a fairly typical assessment. It seems sadly appropriate that McGoohan died the year it was aired. **RL**

year-by-year ■ TV series ■ Video game ■ Comic

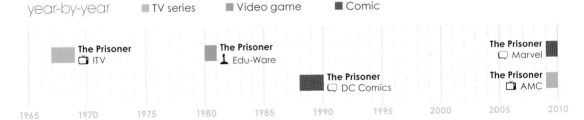

The Prisoner
ITV

The Prisoner
Edu-Ware

The Prisoner
DC Comics

The Prisoner
Marvel

The Prisoner
AMC

1965 1970 1975 1980 1985 1990 1995 2000 2005 2010

the tripods 1967

The White Mountains

The City of Gold and Lead

The Pool of Fire

The Tripods

The Tripods

The Tripods

The Tripods

When the Tripods Came

A bucolic English village. People ride in horse-drawn carts and dress in 19th-century styles, gathering for the coming of age ceremony of a shaven-headed boy. A monster arrives, a towering three-legged metal colossus. The villagers look on as it picks up the boy with a tentacle and swallows him …

This powerful scene comes from the BBC series *The Tripods*, based on a series of British children's books by Samuel Youd, writing as John Christopher: *The White Mountains* (1967), *The City of Gold and Lead* (1968) and *The Pool of Fire* (1968).

Humanity is ruled by the metal giants, the Tripods, which Christopher concedes were "unconsciously" inspired by the Martian fighting machines in *The War of the Worlds*. Adolescent humans are fitted with a metal "cap," keeping them obedient to the machines for life. Will Parker, a boy on the verge of capping, has doubts about the Tripods' regime. He encounters a wandering "madman," Ozymandias, who explains that although the Tripods conquered mankind long ago, a band of uncapped people are holding out against them in the Alps. Will runs away to join them.

In *The City of Gold and Lead*, Will is sent on a mission to infiltrate a Tripod city. He encounters the machine's operators, three-legged hulks called the Masters, who invaded from a distant world and plan to change Earth's atmosphere, dooming humanity. *The Pool of Fire* depicts the resistance by the adolescents, although the end raises the question of whether humans are fit for freedom.

The BBC television series occupied the Saturday teatime slot long owned by *Doctor Who*, and stretched the plot to fill seasonal "quarters." (The first series ran 13 episodes, the second 12.) Although the pacing of the first season was interminably slow for many viewers, the Tripods themselves remain an impressive sight, even if they only appear briefly.

The second season punched things up, as the Tripods crush and disintegrate victims. The Masters' city (an intricate large-scale miniature) is visually impressive, although lacking the terrible oppressiveness of the book — and introduces laughable new features, most infamously a nightclub called the Pink Parrot. A third season had been planned but the high budget of the previous season caused its cancelation.

Spin-offs include a computer game, two comic strips, as well as Christopher's prequel book, *When the Tripods Came* (1988). Interestingly, Steven Spielberg's version of *The War of the Worlds* (2005) sees Tom Cruise destroying a Martian Fighting Machine by lobbing grenades into it — the same way that Will takes out a Tripod in the first novel. **AO**

year-by-year ■ Book ■ Comic ■ TV series ■ Video game

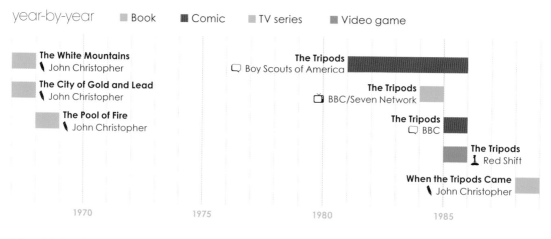

The White Mountains
\ John Christopher

The City of Gold and Lead
\ John Christopher

The Pool of Fire
\ John Christopher

The Tripods
▢ Boy Scouts of America

The Tripods
▢ BBC/Seven Network

The Tripods
▢ BBC

The Tripods
⌶ Red Shift

When the Tripods Came
\ John Christopher

1970 1975 1980 1985

logan's run 1967

Logan's Run

Logan's Run

Logan's World

Logan's Run

Logan's Run

Logan's Search

Logan's Run

Logan's Run: Last Day

A minor classic of pre-*Star Wars* 1970s science fiction, *Logan's Run* has shown surprising longevity, its widespread appeal laying in a core concept that pitches *Nineteen Eighty-Four*'s small-man-against-the-dystopian-state conflict within a classic chase movie.

Logan's Run began with a 1967 novel by William F. Nolan and *Star Trek/The Twilight Zone* veteran, George Clayton Johnson. The book tells of an unlikely totalitarian future, in which youth has proliferated to the point where society decides that euthanasia will be enforced at the age of 21. When each individual reaches "Lastday"—revealed by the color of a flower-shaped crystal embedded into one of their palms—they happily trot along to a "Sleepshop" where they are painlessly executed by poison gas. A small minority, however, refuse their fate and become "runners," pursued by government assassins ("sandmen") as they flee for the mythical Sanctuary. One sandman, Logan 3, is sent on a covert mission to infiltrate the underground railroad to Sanctuary, but falls for a runner named Jessica 6 and soon starts to question his ways ...

Michael Anderson's 1976 film adaptation added sharp visuals and made numerous conceptual changes to the basic story. Our hero is now called Logan 5, death is not enforced until age 30, Lastday is replaced by a religious ceremony known as Carousel, and mankind huddles in a domed city protecting it from a poisonous atmosphere. More dramatically, Sanctuary — eventually revealed to be located on Mars in the novel and its two sequels, *Logan's World* and *Logan's Search* (both written solely by Nolan) — is here shown to be pure myth, as also is the poisoned nature of the Earth. The film ends with a series of revelations in the ruined remains of Washington D.C., before a dazzled population leaves their sterile home to emerge, blinking, into a new Garden of Eden.

Much of the film was shot in a large new Dallas shopping centre—at that time a relatively unknown environment for most viewers—and owed much of its success to sharp costumes and production design. The sandman catsuits, with their gray chest stripe, are particularly striking, as are their guns—spurting flames from the barrel when fired, it was made explicit in the novel that it could shoot six different types of cartridge, an early version of Judge Dredd's Lawgiver.

A 14-part TV series followed a year later with a largely new cast but reusing the movie's core costumes, hardware and special-effects. *Logan's Run* had a spluttering afterlife in other media, notably the comics: Marvel, Malibu and, most recently, Bluewater Productions have all run series over the years. **MB**

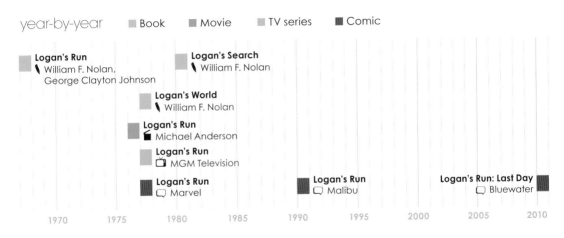

year-by-year ■ Book ■ Movie ■ TV series ■ Comic

Logan's Run
❧ William F. Nolan, George Clayton Johnson

Logan's Search
❧ William F. Nolan

Logan's World
❧ William F. Nolan

Logan's Run
🎬 Michael Anderson

Logan's Run
📺 MGM Television

Logan's Run
▢ Marvel

Logan's Run
▢ Malibu

Logan's Run: Last Day
▢ Bluewater

1970 1975 1980 1985 1990 1995 2000 2005 2010

valérian et laureline 1967

Valérian | The City of Shifting Waters | Funny Specimens | Birds of the Master | Ambassador of the Shadows | Heroes of the Equinox | Bad Dreams | The Living Weapons

The adventures of Valérian and Laureline — an occasionally disturbingly teenage-looking pair of super agents for Galaxity in the far future — have been a huge success in France since November 1967, when they first appeared in #420 of the weekly *Pilote* magazine, which ran from 1959 to 1989 and showcased most of the major Franco-Belgian comic strips of the day, from Asterix to Blueberry, Lucky Luke to Lone Sloane. Originally titled "Valérian, Agent Spatio-Temporel," this strip was a collaboration between artist Jean-Claude Mézières and writer Linus (actually Pierre Christin, a professor of journalism at the University of Bordeaux).

"Valérian et Laureline" was collected in albums by Editions Dargaud; by the time the strip eventually came to an end, in 2010, there were 21 volumes, a short story collection and an encyclopedia.

Skipping through space and time in adventures that combine light comedy with a more serious edge, the dark-haired, boyish Valérian and his nubile, red-haired female helper Laureline operate in a universe where the people of Earth have spread throughout the galaxy, thanks to the invention of a method for instantaneous travel across time and space. In around 2720 AD, the pair begin as top troubleshooters for the Spatio-Temporal Service, border guards and enforcers for a largely benevolent Terran Galactic Empire. Earth has become a utopia, with most of the population happy to live in a virtual reality dream state while friendly Technocrats of the First Circle attend to all their needs; its capital, Galaxity, is keen on bringing to justice rogue time travelers, and fixing any temporal paradoxes they may create.

There's often tension between the two agents in the early stories — although kind-hearted and bold, Valérian is always likely to follow his orders to the letter, whereas Laureline is usually depicted as more clever and more independently-minded. She is stubborn and aware of her sex appeal, and the more innovative solutions to each storyline's problems are likely to come from her, especially after the pivotal Volume 12 in the series, "The Rage of Hypsis," in which Galaxity disappears from the space–time continuum as a result of a particularly potent temporal paradox, and the two agents are forced to go freelance, searching for their lost home while working for anyone who will hire them. (This was the last story to be serialized in *Pilote*; every subsequent tale was first released in album format).

Although there's only very occasional nudity, "Valérian et Laureline" is sometimes reminiscent of a family-friendly *Barbarella*, the strip's basic structure being that of a fast-moving, inventive, often quite

| The Circles of Power | Hostages of the Ultralum | Orphan of the Stars | In Uncertain Times | At the Edge of the Great Void | Time Jam: Valérian and Laureline | The Time Opener |

complex space opera, heaving with chase scenes, battles and escapes. The couple's relationship is multivalent: they seem part lovers, part colleagues, part friends and part siblings. Their adventures flip between broad comedy — an early classic begins with lots of business about flying a spaceship while under the influence of alcohol — and gentle whimsy, but with some quite serious points buried just below the surface if you care to look. A good sprinkling of jokes and a broadly liberal, humanist stance underpin most of the stories, although much of the joy comes from Mézières' inventive and often hilarious depictions of alien flora and fauna.

Most of the alien civilizations Valérian and Laureline encounter reflect some current political issue in real life. For example, in "World Without Stars," we visit the interior of a hollow planet, where warring civilizations are split along gender lines: one country is all-male, but ruled by a small number of women; its rival is the other way around. In "Welcome to Alflolol," it is the evils of imperialism and industrialization that are ridiculed by gentle laughter.

Valérian et Laureline adventures tend to bounce along in a surprisingly childlike way — when Laureline finds herself in a space dictator's harem, the despot confounds expectations by reading poetry to her —

and the satire of human mores seems deliberately to pull its punches. One of the most pleasing qualities of these adventures is that, more often than not, each episode ends with the heroes persuading the aliens to change, rather than forcing them to do so.

"Valérian et Laureline" has been adapted into a successful animated TV series — *Time Jam: Valérian & Laureline* (2007) — and Luc Besson has expressed interest in adapting it for the cinema. The series and its creators have won numerous awards, notably the Grand Prix that Jean-Claude Mézières received in 1984 at the comics convention in Angoulême, France.

The series has exerted a wide influence over other SF works. The slave-girl outfit that Laureline wore in a 1972 adventure appears to have inspired Princess Leia Organa's costume in *The Return of the Jedi* (1983). Other elements of *Star Wars* that seem indebted to the French strip include the *Millennium Falcon*, Luke falling from Cloud City, Han in carbonite, Darth Vader's scarred face and the concept of clone armies — indeed, on first seeing the George Lucas film, Mézières was said to have been "furious." *The Fifth Element* (1997) certainly owes something to "Valérian et Laureline," but this time Mézières knew all about it in advance — he was one of the production designers on the 1997 movie. **MB**

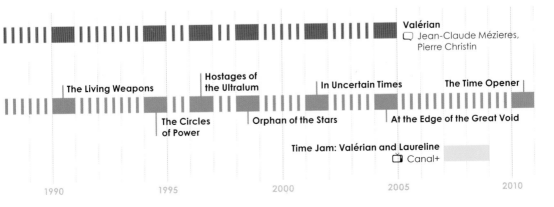

Valérian
Jean-Claude Mézieres, Pierre Christin

The Living Weapons

Hostages of the Ultralum

In Uncertain Times

The Time Opener

The Circles of Power

Orphan of the Stars

At the Edge of the Great Void

Time Jam: Valérian and Laureline
Canal+

1990 1995 2000 2005 2010

valérian et laureline universe

Laureline **Valérian**

In the far future of 2720, Galaxity, the capital of Earth, is the center of a generally benign Terran Empire that bestrides space; the rest of the planet exists in a state of bliss, and has done so since 2314, when space–time travel first became possible. Spatio-temporal agents protect this utopia, and when Xombul, a rogue technocrat, sabotages Galaxity's Dream Service then escapes into the Middle Ages with a plan to use sorcery to control the future, agent Valérian is ordered to follow and subdue; in his adventures in medieval France he meets the spunky young girl who will become his new partner, Laureline.

The two of them bring Xombul to justice, but their celebrations are curtailed when he escapes from prison and flees to 1986, a traumatic period when the detonation of an H-bomb cache had melted the polar ice caps, causing the coasts to flood. Valérian must search the waterlogged streets of Manhattan for Xombul, who plans to use his superior technology to build a new empire in the ruins.

Valérian and Laureline's next significant adventure is in space, into which they're sent by Galaxity to investigate Syrte the Magnificent, the decadent capital of The Empire of a Thousand Planets.

In further space adventures, a rogue planet threatens the newly formed Terran colonies on Uxbar. On investigating, Valérian and Laureline discover a hollow world torn apart by a never-ending battle between the sexes, and it is here that Laureline's superior wisdom first really comes into play.

Another Earth colony, the highly industrial planet Technorog, is thrown into turmoil when its indigenous peoples reappear. They call the planet Alflolol, and want it back. Valérian and Laureline are caught in the middle, and for the first time the two of them disagree on the correct course of action.

In a subsequent outing, Valérian and Laureline crash-land on an isolated planet where they are first enslaved by the minions of the mysterious Master and his Birds of Madness, feeders on negative emotions, and later undertake a diplomatic protection mission that goes horribly wrong. Valerian is kidnapped along with Earth's ambassador to Point Central, the huge space station that acts as a meeting point for all space-faring species. Laureline must track them both down. By this point the balance of power between the two characters has shifted, and the strip is now at least as much Laureline's as it is Valérian's.

The following adventure is even stranger, with an army of Valérian clones investigating hyper-realistic replicas of Earth's past that are floating in space. The real Valérian must compete as Earth's champion against three super-powered heroes from other worlds in a battle to become the progenitor of a new

characters ▪ Laureline ▪ Valérian

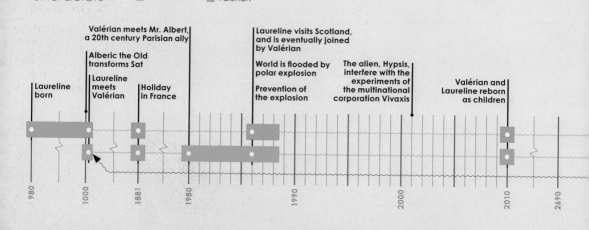

Laureline born

Alberic the Old transforms Sat

Laureline meets Valérian

Valérian meets Mr. Albert, a 20th century Parisian ally

Holiday in France

Laureline visits Scotland, and is eventually joined by Valérian

World is flooded by polar explosion

Prevention of the explosion

The alien, Hypsis, interfere with the experiments of the multinational corporation Vivaxis

Valérian and Laureline reborn as children

980 1000 1881 1980 1990 2000 2010 2690

generation of children who will repopulate the dying planet. After many setbacks and twists in the plot, Valérian is ultimately successful.

Time travel returns to the strip when Valérian journeys to 1980s Paris to investigate mysterious alien apparitions in the Métro, then heads for New York. Meanwhile Laureline journeys to Cassiopeia to track down the source of the visitations.

At this point the story becomes very complicated as it endeavors to address and resolve some of the paradoxes inherent in the notion of time travel. Hypsis, a powerful alien planet, has come to resent Galaxity and its increasingly imperialistic attitude to cosmic affairs. Its rulers have decided to go back in time to 1986 and set off a nuclear explosion that will nip Galaxity in the bud. The problem for Valérian is that he had previously averted this very catastrophe, and it was from his salvation of the Earth on that occasion that Galaxity sprang up in the first place. Thus by going back in time to thwart the current Hypsis plot, he is effectively wiping out his own future.

Valérian and Laureline are now without a world, making their way in an often unfriendly galaxy, usually looking for money — their astroship is in constant need of repair — and seeking out a way to recover the "timelost" Galaxity. At one point, Valérian takes Laureline to the planet Blopik with a mysterious special delivery. Later, on Rubanis, they accept an assignment from Colonel Tloc, who wants to know who's really controlling his planet. In a reversal of an earlier adventure, Laureline is kidnapped by a mercenary outfit, along with the son of the Grand Caliph of Iksaladam, and Valérian must track them both down.

The final adventures bring Valérian and Laureline ever closer to learning the truth behind the disappearance of Galaxity. Hypsis is up to more tricks, and an expedition to the Great Void — the unknown region at the edge of the universe — promises that it might hold answers. As the climax approaches, people and planets from many past adventures start to appear, and the rise of a new menace, Wolochs — great destructive stones from the Void — brings a huge battle fleet together for a final stand. Thanks in part to the mysterious "Time Opener" device, Valérian manages to release the imprisoned Earth and return it to its rightful position in the Solar System. The Wolochs are repelled, and Galaxity appears to be exactly as it was: no one even realizes what Valérian and Laureline have done. Eventually the hero and heroine run into Xombul, a changed man who offers them a new future. He will send them back to present-day Paris, where they will be transformed into young children with no memory of their previous existence, and will hence be at liberty to begin their lives all over again. **MB**

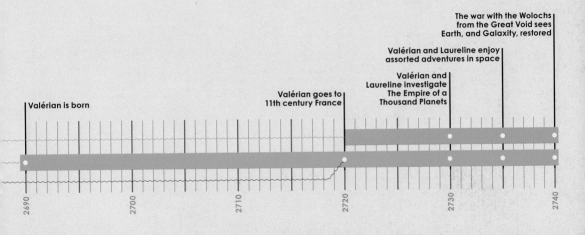

The war with the Wolochs from the Great Void sees Earth, and Galaxity, restored

Valérian and Laureline enjoy assorted adventures in space

Valérian and Laureline investigate The Empire of a Thousand Planets

Valérian goes to 11th century France

Valérian is born

2690 2700 2710 2720 2730 2740

dragonriders of pern 1967

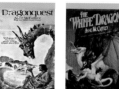

| Weyr Search | Dragonrider | Dragonflight | Dragonquest | The White Dragon | Moreto: Dragonlady of Pern | The Dolphins of Pern | The Skies of Pern |

Although often described as a fantasy, the Dragonriders series by American-born Irish novelist Anne McCaffrey was rooted in science. Chronicling the story of colonists and their descendants on a planet periodically beset by Thread, a destructive spore that rains down when the rogue Red Star planet gets too near, it imagines the first settlers creating biologically engineered, fire-breathing dragons that can jump instantly in time and space.

McCaffery began the sequence in the mid-1960s when, according to her son Todd McCaffery, she began thinking about ways to improve perceptions of dragons. Her solution was to show the creatures as humanity's partners and confidants. In 1968, she combined two novellas to create *Dragonflight*, the tale of Lessa, who bonds with a queen dragon through a process called "impression" and becomes a Weyrwoman who leads the fight against Thread at a time when many have forgotten about its dangers because it's been so long since the erratic Red Star passed close to Pern. The book was an instant success and a sequel, *Dragonquest*, soon followed.

After a five-year break, McCaffrey returned to the sequence in 1976 with *Dragonsong*, the first part of a trilogy focusing on Pern's harpers, musicians and educators. At its center lay Menolly, a songwriter who is cast out from her fishing community and, after running away, "impresses" nine fire lizards, the pint-sized precursors of the huge fire-breathers that fly in Pern's skies. McCaffery also wrote a sequel to *Dragonflight* and *Dragonquest*, *The White Dragon*.

By now, the success of the books was eclipsing McCaffrey's work on other topics and, with a ready audience, she set about filling in the Pern timeline with novels set in different eras of the planet's history. *Moreta: Dragonlady of Pern*, for example, was set centuries before the events of *Dragonflight*.

Dragonsdawn went back even further, charting the experiences of the very first colonists prior to their society reverting to an agrarian way of life. *All The Weyrs of Pern*, which acknowledged evolutionary biologist Jack Cohen for his work as scientific consultant, took the story forward, dramatizing the culture shock afflicting Pernese society when dragonriders, harpers and nobles encounter AIVAS, an advanced computer at the newly excavated landing site of the first settlers.

In 2003 Todd McCaffery began collaborating with his mother on a series set during the Third Pass of the Red Star, around 500 Turns, or Pern years, after initial colonization. Todd continued the series after his mother's death in 2011.

There have been several attempts to film McCaffery's work, including one in 2011 by production company Copperheart that remained in development as this volume went to press. **JW**

year-by-year　■ Short story　■ Book

Nebula Award
Hugo Award

| Weyr Search | The White Dragon | The Skies of Pern |
| Anne McCaffrey | Anne McCaffrey | Anne McCaffrey |

| Dragonrider | Moreta: Dragonlady of Pern |
| Anne McCaffrey | Anne McCaffrey |

| Dragonflight | Dragonquest | The Dolphins of Pern |
| Anne McCaffrey | Anne McCaffrey | Anne McCaffrey |

1965　　1970　　1975　　1980　　1985　　1990　　1995　　2000

land of the giants 1968

Land of
the Giants

Land of
the Giants

Land of
the Giants

Land of
the Giants

The Hot Spot

Unknown
Danger

U.S. television of the late 1960s was full of hour-long, high-concept science fiction shows, many of them from the prolific producer/director Irwin Allen, later nicknamed the "Master of Disaster" for a string of big-hit disaster movies, notably *The Poseidon Adventure* and *The Towering Inferno*. Allen's SF series began with *Voyage to the Bottom of the Sea* in 1964, and included *Lost in Space* and *The Time Tunnel*. The last of this run, enjoying two seasons and 51 episodes from 1968 to 1970, was *Land of the Giants*, which began in the then-future of 1983, when the *Spindrift* — a sub-orbital transporter craft on a flight from Los Angeles to London — crashes through a space storm and is transported to a mysterious planet which looks like our own, but where everything is many times larger than on Earth.

With the *Spindrift* wrecked and hidden in some woods, our heroes — ship's captain Steve Burton (Gary Conway) and co-pilot Dan Erickson (Don Marshall) — must find a way to survive on this twisted, vaguely fascist version of the United States, where the indigenous giants are around 70 feet (22 m) tall, telephone cords are ropes to climb, cats a constant menace, and the tiny visitors from Earth are ever-hunted, presumably by authorities keen to unlock the secrets of their alien technology.

Not that this planet is an exact replica of McCarthy-era America: it may lack space flight, but it does possess workable cloning, teleportation systems and force fields. Physics seems to work differently here too, allowing people of enormous size to break Galileo's square-cube law, according to which they should simply collapse under their own weight.

Quite where we are isn't fully explained: we never learn the name of the planet, or of the main city where our heroes have their adventures. Nor do we find out much about the political system, save that it seems intolerant of dissent. (The giants know of Earth, however, and other human ships are shown to have come to grief among them in the past.)

Theories about it existing in a parallel dimension, or hidden within our solar system, abound. Burton often destroys technology that might enable his band to return home for fear that it may allow the giants to journey there too. He is helped and hindered in his efforts by the occasional sympathizers he encounters and by his own mismatched crew. Many of the storylines are driven by the unlikely friendship between a young boy and a greedy (and rather hammy) bank-robber character named Alexander B. Fitzhugh (Kurt Kasznar), who is constantly suspected as a possible traitor, much as Dr. Zachary Smith had been on *Lost in Space*.

At $250,000 an episode, *Land of the Giants* was the most expensive show on TV at the time, and to save money episodes were filmed back-to-back, so that props and sets could be re-used. The order of episodes was then shuffled for airing in the hope that the audience wouldn't notice. **MB**

year-by-year　■ TV series　■ Comic　■ Game　■ Book

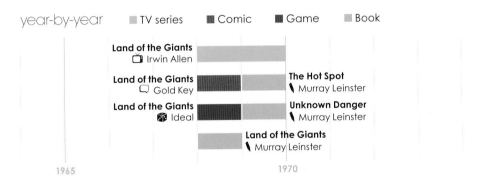

blade runner 1968

Do Androids Dream of Electric Sheep?

Blade Runner

Blade Runner

Blade Runner 2: The Edge of Human

Blade Runner 3: Replicant Night

Blade Runner

Blade Runner 4: Eye and Talon

Do Androids Dream of Electric Sheep?

Philip K. Dick's 1968 novel *Do Androids Dream of Electric Sheep?* tells of a postwar society in which an irradiated Earth is witnessing an exodus of its population to off-world colonies. Anyone fit and willing to leave is given an android to help with menial tasks; those who remain live in cramped and decaying cities where radiation sickness is rife.

The main religion, Mercerism, is based on respect for all forms of life. Individuals bond empathically with Wilbur Mercer as he undertakes his endless, Sisyphean task of climbing a mountain while being pelted with stones. Everyone shares his emotions.

With animals on the brink of extinction, ownership of a genuine organic creature is a powerful status symbol. There is a thriving business in synthetic animals that people treat as if they were real.

Rick Deckard is a bounty hunter who tracks down and "retires" androids that have escaped their lives of servitude and fled to Earth. Since the death of his real pet, he has suffered the social stigma of owning an electric sheep. When he is offered the job of retiring six rogue androids, he jumps at it because the money on offer will enable him to buy another real animal.

Ordinarily, androids are easy to detect because of their lack of empathy. A procedure known as the Voight-Kampff (VK) test presents various scenarios, usually in regard to animals in jeopardy, and unlike humans, the androids either don't know how to react or take time to form a response. But the latest Nexus-6 androids have advanced systems that enable them to pass the VK test; determining who is real and who is synthetic is no longer straightforward.

As Rick embarks on his mission, he struggles with questions of morality, life and perception. Which of the people he meets is actually an android? At what point does an artificially intelligent creature become a real life form? What constitutes life? Who but an android would destroy another living thing?

Ridley Scott's film noir adaptation, *Blade Runner*, premiered in the United States in June 1982, just three months after the author's death.

Initial reviews were mixed. Some critics disliked the lack of pace and action, but others praised the futuristic cityscapes, designed mainly by Syd Mead, and the visual effects by Douglas Trumbull (*2001: A Space Odyssey, Close Encounters of the Third Kind*).

Eschewing the novel's religious overtones, *Blade Runner* focused on the moral dilemma of retiring "replicants" that look, think and feel just like humans. The ambiguous figure of the protagonist, played by Harrison Ford, prompted fevered debate and re-viewing. Scott himself kept the film alive by issuing two heavily re-edited versions. It has since become regarded as one of the best SF movies ever made. **SJ**

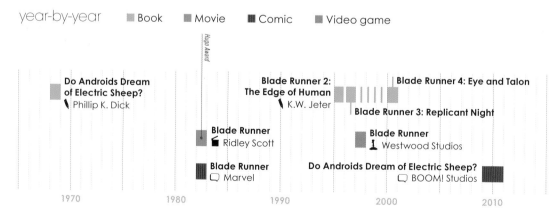

year-by-year ■ Book ■ Movie ■ Comic ■ Video game

Hugo Award

Do Androids Dream of Electric Sheep?
Phillip K. Dick

Blade Runner 2: The Edge of Human
K.W. Jeter

Blade Runner 4: Eye and Talon

Blade Runner 3: Replicant Night

Blade Runner
Ridley Scott

Blade Runner
Westwood Studios

Blade Runner
Marvel

Do Androids Dream of Electric Sheep?
BOOM! Studios

1970 1980 1990 2000 2010

the iron man 1968

The Iron Man

The Iron Man:
The Musical

The Iron
Woman

The Iron
Giant

The Iron Man, a novel by British poet Ted Hughes, opens with the title character standing on a cliff, then falling and smashing into pieces on the rocks below. This fictional disintegration strangely foreshadows the subsequent fate of the story itself, which subsequently went off in several radically different directions, becoming a rock opera, an ecology tract and a cartoon adventure. (In North America, Hughes' work was renamed *The Iron Giant* to avoid confusion with the Canadian superhero, created by cartoonist Vernon Miller for Maple Leaf Publishing, who had featured in Better Comics since March 1941.)

The original is a beautifully simple, extraordinarily vivid children's tale with many surprise developments. The declamatory writing is weighty, witty and haunting. The indelible images include a grotesque scene of the Iron Man's shattered body parts finding each other on the beach so that he can pull himself back together. The Iron Man survives a live burial by farmers (who were angry that he munched their tractors) and defends Earth from a "space-bat-angel-dragon" that covers Australia. The principal human character is a boy, Hogarth, who befriends the Iron Man and returns in later iterations of the story.

One spin-off was *The Iron Man: The Musical* (1989), a concept album by guitarist Pete Townshend that featured Roger Daltrey and John Entwistle, the other surviving members of The Who. Townshend brought Hogarth to center stage, interpreting the Iron Man and space monster as his father and mother figures, and setting some of the original text to music. The album spawned a music video, based on the song

"A Friend is a Friend," with a stop-motion Iron Man. The treatment was also expanded into a stage musical, which was performed at London's Young Vic in 1993.

The same year saw the publication of Hughes' own sequel, *The Iron Woman*, about an eco-avenger outraged at the pollution of nature by humans. The other main character is a girl, Lucy. Hogarth and the Iron Man also appear, but the work is less successful than its predecessor because it is more didactic (even though *The Iron Man* ended on an evangelical anti-war note).

Hughes read and approved the script of *The Iron Giant*, an animated version of his original work, but died in 1998, a year before its completion. The film (a nonmusical) keeps few of his story details, and transfers the action from England to the United States. There is no space-bat-angel-dragon; rather, the Iron Giant is a space monster himself, an alien weapon of war, who is damaged and gains an innocent soul.

The Iron Giant is not a new idea — the 1985 film *Short Circuit* had a similar premise — but it's full of excitement and pathos. Director Brad Bird went on to world fame with Pixar's *The Incredibles*, although credit also goes to scriptwriter Tim McCanlies. Hogarth is an ebullient child who must "father" the robot. The Giant, beautifully voiced by Vin Diesel, conveys the innocence of Dumbo and the pathos of Boris Karloff. At the end, when both characters face nuclear Armageddon, the Giant tenderly repeats the boy's words back to him: "You stay. I go. No following." What follows is a tear-jerking but joyous epilogue that goes all the way back to Ted Hughes original tale. **AO**

year-by-year ■ Book ■ Musical ■ Animated movie

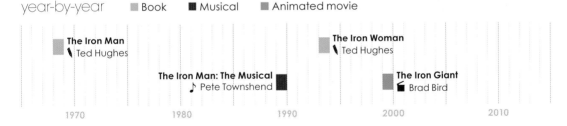

The Iron Man
Ted Hughes

The Iron Woman
Ted Hughes

The Iron Man: The Musical
♪ Pete Townshend

The Iron Giant
Brad Bird

1970 1980 1990 2000 2010

alice sheldon 1968

Birth of a Salesman

And I Awoke and Found Me Here on the Cold Hill's Side

Love is the Plan the Plan is Death

The Girl Who Was Plugged In

The Women Men Don't See

Houston, Houston, Do You Read?

The Screwfly Solution

Up the Walls of the World

Born in 1915, Alice Sheldon was one of the most challenging and complex writers of her generation. As a woman writing in a man's world she was a rarity, her alter-ego, James Tiptree Jr., challenging gender norms more than any other science fiction writer. In an introduction to her collection, *Warm Bodies* (1975), author Robert Silverberg considered the suggestion that James Tiptree Jr. might in fact be a woman but concluded that such an idea was "absurd."

Sheldon was born in Chicago. Her father was a lawyer and naturalist, her mother a travel writer who often took the young Alice on her overseas expeditions. During World War II, she joined the United States Air Force as an intelligence analyst where, unusually for a woman, she rose to the rank of major. After a period working at the Pentagon, in 1952 she joined the CIA.

There are a number of parallels that can be drawn between Sheldon and her contemporary Cordwainer Smith (the pen name of Paul Linebarger). Both are best known for works of short fiction. Like him, she maintained and jealously guarded her private persona. She had also emerged from the intelligence service into the world of science fiction. And both would offer startling, mature visions much at odds with their more commercially-minded counterparts, most

of whom came from the pulp magazines. But where Smith's expansive vision of a vast future history is colorful and energetic, Sheldon's is personal, intense, and notably preoccupied with questions of gender and sexuality.

Leaving the CIA to return to university, in 1967 Sheldon was awarded a PhD in psychology. Her writing career began a year later when "Birth of a Salesman" was published in *Analog* magazine. For her public identity she chose the name "James Tiptree Jr.," who she described as "an emotionally robust and engaging middle-aged man with Pentagon experience." In an interview many years later for *Asimov's Science Fiction* magazine, she recalled, "A male name seemed like good camouflage. I had the feeling that a man would slip by less observed. I've had too many experiences in my life of being the first woman in some damned occupation."

Her early efforts show her still finding her way as a writer, but with the publication of "And I Awoke and Found Me Here on the Cold Hill's Side" she hit her stride. Published in 1972, it was both a Hugo and Nebula award nominee, and has been reprinted numerous times since. Taking its title from the John Keats poem "La Belle Dame sans Merci," it tells of the sexual fascination of humans with the various aliens

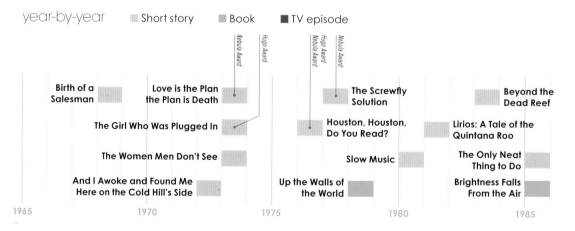

year-by-year ■ Short story ■ Book ■ TV episode

Nebula Award | *Hugo Award* | *Hugo Award / Nebula Award* | *Nebula Award*

Birth of a Salesman

Love is the Plan the Plan is Death

The Girl Who Was Plugged In

The Women Men Don't See

And I Awoke and Found Me Here on the Cold Hill's Side

The Screwfly Solution

Houston, Houston, Do You Read?

Slow Music

Up the Walls of the World

Beyond the Dead Reef

Lirios: A Tale of the Quintana Roo

The Only Neat Thing to Do

Brightness Falls From the Air

1965 1970 1975 1980 1985

| Slow Music | Lirios: A Tale of the Quintana Roo | Beyond the Dead Reef | The Only Neat Thing to Do | Brightness Falls From the Air | Tales of the Quintana Roo | Her Smoke Rose Up Forever | The Screwfly Solution |

who pass through a spaceport, which is described hauntingly as akin to drug abuse. Its influence can be seen as extending to, for instance, Kij Johnson's "Spar" (2009), itself a Nebula award winner, in which an alien and a human, locked together in a lifeboat, copulate endlessly in a futile attempt to communicate.

"Love is the Plan the Plan is Death," published in 1973, won Sheldon her first Nebula award, and was followed by her best-known work, "The Women Men Don't See." On the surface, this is a deceptively simple story. An American agent travels to Mexico where he charters a plane with two enigmatic women. When the plane crashes, an encounter with a UFO leads—much to the man's bewilderment—to the women leaving with the aliens. It is impossible in these few sentences to sum up the sense of profound alienation that pervades the story; the desperation of the women to escape into the unknown seems both to echo and subvert the classic motifs of pulp science fiction, and acts also as a searing indictment of the role of women in human society.

The year 1973 also saw the publication of "The Girl Who Was Plugged In," an important story of proto-cyberpunk. These were Sheldon's most fertile years, with classics such as "Her Smoke Rose Up Forever" (1974) and "Houston, Houston, Do You Read?" (1976), in which astronauts returning to Earth gradually discover the planet has become a utopian, women-only society. "The Screwfly Solution" (1978) saw her published under her occasional alternative pen name, Racoona Sheldon, in a tale of gender experimentation that was adapted into a TV episode three decades later.

Sheldon only wrote two full-length novels, *Up The Walls of the World* (1978) and *Brightness Falls from the Air* (1985), both of which indicated clearly that her strength as a writer lay in the short story format.

James Tiptree Jr. was finally "unmasked" as Alice Sheldon in 1976, although she continued to use her male pen name for the remainder of her career. Her final major story was perhaps "Slow Music" (1980), a slow, beautiful travel narrative across a dying Earth. Although her health was now failing, she remained active during the first half of the decade with such works as "Lirios: A Tale of the Quintana Roo," "Beyond the Dead Reef" and "The Only Thing to Do."

With her husband in the late stages of Alzheimer's, on May 19, 1987, Sheldon shot him through the head before taking her own life. She was 71 years old.

Alice Sheldon remains a significant influence, the James Tiptree Jr. Award being presented annually for "works of science fiction or fantasy that expand or explore one's understanding of gender." **LT**

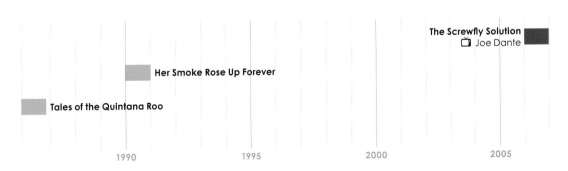

The Screwfly Solution
📺 Joe Dante

Her Smoke Rose Up Forever

Tales of the Quintana Roo

1990 1995 2000 2005

a boy and his dog 1969

A Boy and His Dog

A Boy and His Dog

Eggsucker

Run, Spot, Run

Vic and Blood: The Chronicles of a Boy and His Dog

"I wrote this story for my dog," Harlan Ellison told the *Huffington Post* in August 2013. "My dog was named Abu [sic] and he and I were very, very close."

Fans of Ellison will already know this, of course, having read his account of Ahbhu's death in 1973's tear-inducing *The Deathbird*, written four years after "A Boy and His Dog" had been published in *New Worlds* magazine. But you don't need to know the real-life back-story to realize that Blood, the canine star of Elison's tale was inspired by a real mutt. He simply reads that way, as real as can be ... despite the curious fact that he can talk.

Set in a disturbing, post-apocalyptic America, Ellison's Nebula Award-winning tale focuses on a young wanderer named Vic and his supremely intelligent and telepathic dog, Blood. Genetically engineered during the war that destroyed civilization, Blood now guides Vic around the resultant wasteland, finding food, weapons and—above all—women. After Vic meets a teenage girl named Quilla June, he follows her to the underground city of Topeka and is asked to help them repopulate their town; the war has rendered their women incapable of giving birth to males. Unimpressed with this idea, Vic fights his way out to be reunited with Blood. The novelette features a macabre twist ending that has made it notorious.

"A Boy and His Dog" is actually part of a bigger saga: it's the middle story of a trilogy that begins with "Eggsucker," in which we discover how the younger Blood and Vic learned to work together, and, picking up from where Vic leaves Topeka, is followed by "Run, Spot, Run." Tantalizingly, the story is supposed to continue in the form of a screenplay, and then a novel, *Blood's a Rover*. Ellison has been working on these for decades, but there's still no sign of them being completed. What's more, the author has stated that he refuses to have the unfinished work published after his death: "After I've gone down the hole ... there will be no publication of, say, *Blood's a Rover* by Harlan Ellison and Frederik Pohl, or Harlan Ellison and Robert Silverberg ... or whoever that season's 'completer' might be."

Before "A Boy and His Dog" was even published it had been considered as a film. Ellison says that he rejected offers from several big studios because they wanted to animate Blood's mouth as he talked ("I said, 'This is not *Mr Ed*!'"). He eventually turned to director L.Q. Jones whose adaptation was released to mild critical acclaim in 1975. A young Don Johnson played Vic and Blood was portrayed by a dog who, to Ellison's delight, actually looked like Ahbhu. The film has since become something of a cult classic.

In 1987, Ellison's three finished stories were turned into *Vic And Blood: The Chronicles of a Boy and His Dog*, a graphic novel with art by award-winning illustrator Richard Corben. **JN**

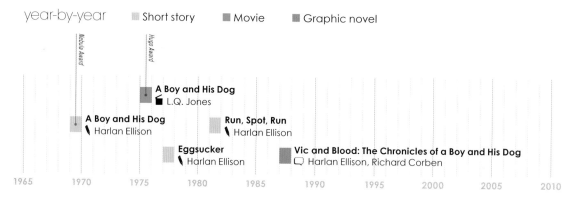

year-by-year ▨ Short story ■ Movie ■ Graphic novel

Nebula Award | Hugo Award

A Boy and His Dog
🎬 L.Q. Jones

A Boy and His Dog
✒ Harlan Ellison

Run, Spot, Run
✒ Harlan Ellison

Eggsucker
✒ Harlan Ellison

Vic and Blood: The Chronicles of a Boy and His Dog
🗨 Harlan Ellison, Richard Corben

1965 1970 1975 1980 1985 1990 1995 2000 2005 2010

michael crichton 1969

The Andromeda Strain

The Terminal Man

Westworld

Looker

Runaway

Jurassic Park

Timeline

The Andromeda Strain

When Michael Crichton was in his prime during the 1990s, he enjoyed a level of success that even Dan Brown and J.K. Rowling might have considered excessive. Not only did he write a string of bestsellers, including *Rising Sun* and *Disclosure*, but Steven Spielberg made the best known of his books, *Jurassic Park*, into the 13th highest-grossing movie of all time. Somehow, Crichton—also a qualified medical doctor—still found time to create the television series *E.R.*, which ran from 1994 to 2009.

Although his work crossed genres, hi-tech, high concept thrillers were Crichton's specialty, and cutting-edge science was a recurring theme and inspiration in his work: "I don't want to just make it up," he once noted. Indeed, one way to read *Jurassic Park* and its sequel, *The Lost World*, is to see them as dinosaur-enhanced guides to complexity theory and chaos theory, fields that deal with the workings of complex and dynamic systems.

This was typical of Crichton. As early as 1966, when he was studying at Harvard Medical School, his first novel, *Odds On*, published under the pseudonym John Lange, featured a heist planned with the help of a critical path analysis computer program. Several other books followed but his commercial breakthrough came with *The Andromeda Strain*, a tale of scientists investigating a deadly, extraterrestrial microorganism. A movie version, directed by Robert Wise, was released in 1971; the book also inspired a critically panned 2008 TV miniseries.

In 1972, Crichton wrote *The Terminal Man*, a novel also serialized in *Playboy* magazine, that warned of the dangers of mind control. He also began to branch out into TV and cinema in earnest, directing *Pursuit*, a TV movie of his own *Binary* (written as John Lange), about a plot to assassinate the president. A year later, he wrote and directed the cult classic *Westworld*, which starred Yul Bryner as a theme park android cowboy turned murderous.

In the two decades before his greatest triumphs, Crichton worked consistently both as a writer and director, on films such as *Looker* (1980), which satirized the effects of advertising and television, and *Runaway* (1984). Although he was rarely described as a science fiction novelist, at the heart of Crichton's success was an ability to sell SF scenarios into the mainstream. *Timeline* (1999), for example, dealt with quantum and multiverse theory (and the idea of the experience economy, where companies sell memorable events rather than goods), but did so via a tale of time travelers adrift in 14th-century France.

For all his success, there were controversies too. In his eco-terrorist thriller *State of Fear*, Crichton questioned not that the world was getting hotter but the accuracy of "extreme anthropogenic warming scenarios." Whatever the nuances of his position, Crichton was fiercely attacked by environmentalists and climate scientists.

His workaholism made other criticisms more personal: "It's like living with a body and Michael is somewhere else," complained his fourth wife, actor Anne-Marie Martin, after their divorce. Protective of his private life, Crichton kept news of his final battle with cancer secret. Following his death in 2008, close friend Spielberg remarked, "There is no one in the wings that will ever take his place." **JW**

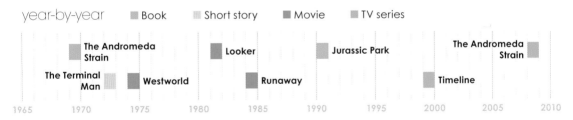

year-by-year ■ Book ■ Short story ■ Movie ■ TV series

The Andromeda Strain — Looker — Jurassic Park — The Andromeda Strain

The Terminal Man — Westworld — Runaway — Timeline

1965 1970 1975 1980 1985 1990 1995 2000 2005 2010

dark futures: apocalypses and the war in space

1970–90

ringworld 1970

Ringworld

The Ringworld Engineers

Ringworld: Revenge of the Patriarch

Return to Ringworld

The Ringworld Throne

Ringworld's Children

Fleet of Worlds

Fate of Worlds: Return from the Ringworld

Born in California in 1938, Larry Niven is an author of hard SF whose first published work was the short story "The Coldest Place," which appeared in the December 1964 edition of *If*.

His best-known novel, *Ringworld* (1970), begins on Earth in 2850, the year in which space adventurer Louis Wu is celebrating his 200th birthday. Globetrotting from one party to another using teleportation technology, Wu encounters Nessus, one of Pierson's Puppeteers, a cowardly but manipulative alien race. Nessus offers Wu the chance to join an expedition outside Known Space with two companions, Speaker-to-Animals (Speaker) and Teela Brown, a young human woman. Their mission is to explore the Ringworld, an artificial megastructure encircling a distant sun.

With a circumference of 6,000 million miles (9.6 million km), the Ringworld revolves at a speed of 770 miles (1,232 km) per second and thus traps atmosphere within its thousand-mile (1,600 km) high walls. An Earth-like habitat is stretched on the inside of the hoop, drawing energy from the star at its center. Day and night are provided by an inner ring of connected "shadow spheres."

The spacecraft crash-lands onto the surface of the Ringworld. The remainder of the novel concerns the crew's attempts to escape, a quest during which they explore many habitats and encounter many races of the engineered environment.

Ringworld won Hugo and Nebula awards, but soon attracted criticism for its flawed science. One of the strongest objections was that, if the Ringworld was a rigid structure, it would eventually drift into and collide with its sun. In 1971, students at the Massachusetts Institute of Technology (MIT) demonstrated at the hotel in Boston that was hosting the World Science Fiction Convention. Their chants of "The Ringworld is unstable! The Ringworld is unstable" inspired Niven to write a sequel, *The Ringworld Engineers* (1979), in which attitude jets were added to the Ringworld rim to counteract the drift.

Further sequels included *The Ringworld Throne* (1996) and *Ringworld's Children* (2004). Niven also collaborated with Edward M. Lerner on a series of prequels, commencing with *Fleet of Worlds* (2007), set two centuries before the events of *Ringworld*.

The central concept of the Ringworld continues to inspire. Iain M. Banks reworked the Ringworld in his *Culture* series of novels, creating the smaller Orbital habitats. Similar megastructures known as Installations have formed the basis of Microsoft Studios' Halo series of video games. **CS**

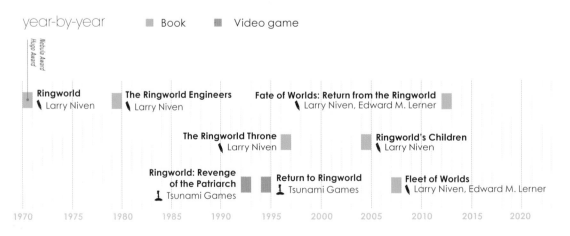

year-by-year ■ Book ■ Video game

Nebula Award
Hugo Award

Ringworld
❨ Larry Niven

The Ringworld Engineers
❨ Larry Niven

Fate of Worlds: Return from the Ringworld
❨ Larry Niven, Edward M. Lerner

The Ringworld Throne
❨ Larry Niven

Ringworld's Children
❨ Larry Niven

Ringworld: Revenge of the Patriarch
Ⅰ Tsunami Games

Return to Ringworld
Ⅰ Tsunami Games

Fleet of Worlds
❨ Larry Niven, Edward M. Lerner

1970 1975 1980 1985 1990 1995 2000 2005 2010 2015 2020

gene wolfe 1970

SFWA
GRANDMASTER

| Operation Ares | The Fifth Head of Cerberus | The Shadow of the Torturer | The Claw of the Conciliator | The Sword of the Lictor | The Citadel of the Autarch | The Urth of the New Sun | Soldier of Sidon |

Epic fantasy is hugely popular, but few works in the genre can justly claim to be literature. Among the few exceptions are the novels that comprise the *Solar Cycle* by Gene Wolfe. Set in the far future on Urth, they are widely acclaimed as intricate and intriguing creations that embed fantasy storytelling in a science fiction setting. They are also among the darkest and most disturbing tales ever written.

Gene Wolfe was born in 1931 in New York. He published his earliest short fiction while a student at Texas A&M University. U.S. involvement in the Korean War interrupted the young Wolfe's creative career when he was drafted to fight after leaving college in his junior year. On returning to the United States he completed a degree at the University of Houston. He then became an engineer, but continued to write, waking up early in the morning to compose stories before going in to work. However, he did not become a full-time professional author until he reached his forties, unusually late for an SF writer.

Wolfe's first published novel, *Operation Ares* (1970), was poorly received and is now largely forgotten. The novella-length *The Fifth Head of Cerberus* (1972) brought widespread acclaim and showcased the unique narrative style for which he became famous. In it, young man — "Number 5" — recounts his formative years in a private household on the space colony of Saint Anne. The boy and his brother David are both subjected to strange and damaging tests and experiments by their father. When Number 5 discovers that all three of them are clones, he murders his parent. Framing this story, and continued through two further novellas — "A Story" by John V Marsch and *VRT* — is the possibility that the colonists of Saint Anne have been killed and replaced by the planet's original inhabitants, a race of shape-changers.

Wolfe specializes in unreliable narrators and thus forces readers to consider what, if anything, in the stories is true. More often than not the narrators are suffering from deep psychological traumas and attempting to cover their own misdeeds.

Wolfe's most highly regarded novels are those of the tetralogy *The Book of the New Sun* — *The Shadow of the Torturer* (1980), *The Claw of the Conciliator* (1981), *The Sword of the Lictor* (1982) and *The Citadel of the Autarch* (1983). These works follow the bloody rise of Severian, who murders the first woman he loved and commits numerous other atrocities on his way to becoming the Autarch, ruler of Urth. The "dying Earth" setting is borrowed from the works of Jack Vance, but Wolfe's treatment of the theme is much darker. Wolfe's dense style and use of layered symbolism makes his work ripe for interpretation, just as its fascination with pain and death make it a difficult and uncomfortable read for those accustomed to more traditional escapist fantasy. **DW**

year-by-year ■ Book

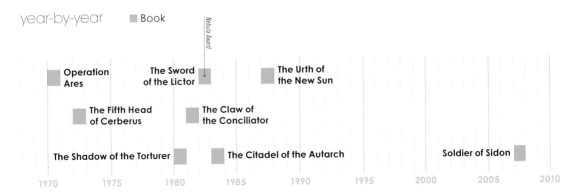

Nebula Award

Operation Ares
The Fifth Head of Cerberus
The Shadow of the Torturer
The Sword of the Lictor
The Claw of the Conciliator
The Citadel of the Autarch
The Urth of the New Sun
Soldier of Sidon

1970 1975 1980 1985 1990 1995 2000 2005 2010

thx 1138 1971

THX 1138 THX 1138 THX 1138 THX 1138:
 (extended Director's Cut
 re-release)

George Lucas' *THX 1138* is as starkly dystopian as his *Star Wars* is flamboyantly escapist. In an unnamed city where the population is controlled by drugs, THX 1138 (Robert Duvall) works in a factory assembling androids. He shares his room with a female named LUH 3417. LUH has been experimenting with her drug intake and tinkers with THX's. Their emotions are awakened and they start an affair. Such liaisons are forbidden — when they are caught, LUH is liquidated and THX narrowly avoids the same fate. He is instead exiled to "limbo," from which he escapes. After a chase through the outer shell of the city, the robot cops turn back as they are about to arrest him because the operation has just exceeded its budget. THX ascends a ladder and climbs out of a hatch, emerging from the ground to see the sun set.

THX 1138 grew out of *Electronic Labyrinth: THX 1138 4EB*, which Lucas made in 1967 while a student at the University of Southern California. The school had an arrangement with the U.S. Navy, whereby Navy filmmakers would attend classes. In order to make the movie, Lucas volunteered to teach this Navy class, as it was unpopular with the academic staff. He thus gained access to the Navy's color film and processing lab. His students starred in and acted as crew for the film, which was shot over 12 weeks. The following year it won the National Student Film Festival prize.

Lucas reworked *Electronic Labyrinth* into *THX 1138*: the action of the former roughly corresponds to the final act of the latter, in which THX escapes.

THX 1138 was made into a film by American Zoetrope, the privately run film studio founded two years previously by Francis Ford Coppola and Lucas. The final version of the script was written by Walter Murch, otherwise best known for his editing work.

Obvious parallels can be drawn with other properties, especially Aldous Huxley's *Brave New World*, but *THX 1138* is fresh and vividly presented. The script is sharp, the design visually arresting. Sparse initial dialogue and disconnected scenes gradually reveal the film's industrial dystopia, much of it rendered in stark whites. Whereas the space-faring science fiction of the time utilized such white interiors to evince clean techno-futurism, *THX 1138* invests white with a sense of awful sterility. The entire cast had shaven heads to render them all anonymous and interchangeable and thereby increase the audience's sense of dislocation.

Although the movie fits neatly into the strand of dystopian and pessimistic science fiction prevalent in the early 1970s, it was not a commercial or a critical success, receiving acclaim only in later years.

On release, *THX 1138* was slightly cut by Warner Bros. Lucas restored these excisions for a re-release in the wake of *Star Wars'* success. He added two minutes of extra footage in 2004, including modern computer-generated effects to increase the scale of some of the shots. Apart from these additions, Lucas has (some might say uncharacteristically) resisted tinkering too much with the film. **GH**

year-by-year ■ Book ■ Movie

THX 1138
■ George Lucas

THX 1138
▮ Ben Bova

THX 1138 (extended re-release)
▮ George Lucas

THX 1138: Director's Cut
▮ George Lucas

1970 1975 1980 1985 1990 1995 2000 2005

a nomad of the time streams 1971

The Warlord
of the Air

The Land
Leviathan

The Steel Tsar

Although these three novels of the 1970s have retrospectively been classified among the earliest examples of Steampunk, author Michael Moorcock intended them as pastiches of *Boy's Own* adventure fiction viewed through a post-colonial lens.

In *The Warlord of the Air*, Captain Oswald Bastable voyages through a mystical labyrinth somewhere in British India into uncharted worlds. Entering in 1902, he emerges in the distant future of 1973. In this alternative world, the British Empire never fell, and Bastable finds himself pitted against its enemies. But are they necessarily in the wrong?

Cast from that universe into a series of increasingly bizarre adventures, Bastable is repeatedly confronted by the evils of colonialism. In *The Land Leviathan*, he emerges in a world devastated by biological warfare where he meets Mahatma Gandhi, the pacifist president of an alternative South Africa. Finally, in *The Steel Tsar*, he encounters a version of Joseph Stalin who is a rebel in a Russian empire in a world where there was no First or Second World War.

In the trilogy — known collectively as *A Nomad of the Time Streams* — Moorcock affectionately mimics the styles of imperialist authors, particularly Rudyard Kipling. But amid the nostalgic tributes to older writing styles is real brutality: rapes and genocides abound. Moorcock's judgment on colonialism is severe: "It was my wariness of paternalism ... which inspired this sequence," he wrote in the introduction to the 1993 collected edition.

With that in mind, it is somewhat ironic that these three novels should have had such an influence on Steampunk, a subgenre which, in its eager yearnings for a simpler past, often blindly embraces empire and ignores some of the more distasteful aspects of European global domination.

Moorcock's books are subtler than most modern Steampunk works, in which alternative pasts are often little more than window dressing for stylized plots. *A Nomad of the Time Streams* comprises fantastic yarns in the classic Moorcockian manner, shot through with the insightful, independent thinking characteristic of the author's Jerry Cornelius stories and his later non-genre work. The three novels can be read as simple adventure stories or as political commentary.

Bastable is, like most of Moorcock's protagonists, an avatar of the infinitely reborn Eternal Champion. At the conclusion of *The Steel Tsar*, Bastable ends up in the deep past, before joining The League of Temporal Adventurers alongside Moorcockian regular Una Persson. He subsequently reappears in several other Moorcock stories.

The name Oswald Bastable is the same as that of the hero of E. Nesbitt's *The Story of the Treasure Seekers* (1899). Moorcock borrowed it in order to draw a link with the faith in liberal Imperialism that prevailed in the late-Victorian era. Although the empires that Moorcock's Bastable encounters are oppressive and destructive, he is unsullied by contact with them and remains a hero throughout. **GH**

year-by-year ■ Book

The Warlord of the Air
❨ Michael Moorcock

The Steel Tsar
❨ Michael Moorcock

The Land Leviathan
❨ Michael Moorcock

1970 1975 1980 1985

steven spielberg 1971

"L.A. 2017" (episode of The Name of the Game)

Close Encounters of the Third Kind

E.T. the Extra-Terrestrial

Twilight Zone: The Movie

Amazing Stories

***batteries not included**

Jurassic Park

SeaQuest DSV

In a long and varied career, Steven Spielberg has left few cinematic styles untouched, and, to borrow Dr. Johnson's remark about Oliver Goldsmith, touched nothing that he did not adorn.

He started out in television in the late 1960s before attracting global attention with his shark blockbuster *Jaws* (1975). Two years later he made his first foray into science fiction with *Close Encounters of the Third Kind*, in which a small Midwest American town makes contact with alien life forms. The arrival of a gargantuan mothership is one of the most spectacular cinema climaxes of all time. George Lucas was so impressed with the film that he bet his friend that it would beat *Star Wars* at the box office, as Spielberg related: "He said, 'Oh my God, your movie is going to be so much more successful than *Star Wars*. This is going to be the biggest hit of all time … You want to trade some points?'" They duly did. Lucas was, of course, wrong — *Star Wars* was the bigger hit — and Spielberg did rather well from it.

After the success of *Close Encounters*, Spielberg began developing another science fiction story, *Night Skies*, a dark tale that focused on malevolent aliens who terrorize a family. But during pre-production he had second thoughts and, eager to "get back to the tranquillity, or at least the spirituality, of *Close*

Encounters," he abandoned the project and turned his attention to *E.T. the Extra-Terrestrial* (1982). This tale of a harmless alien who lands on Earth and befriends a young boy, Elliott, became one of the biggest science fiction films of all time. Much of its enduring appeal derives from its emphasis on emotion rather than blockbuster thrills. This approach was then unusual in the genre, but has influenced numerous subsequent films, notably two by James Cameron: *The Abyss* (1989) and *Terminator 2: Judgment Day* (1991).

The 1980s saw Spielberg involved with many films as producer or director, including collaborations with Lucas on the *Indiana Jones* series. During the 1990s, Spielberg took an unexpected direction in making *Schindler's List* (1993), his powerful account of the Holocaust. He returned to type briefly with *Jurassic Park* (1993), an adaptation of Michael Crichton's dinosaur bestseller. A four-year break from directing followed while he built up his Dreamworks studio. After *Jurassic Park II* in 1997, he made more films with adult themes: slave-drama *Amistad* (1997), and visceral World War II epic *Saving Private Ryan* (1998). A strand of emotion bordering on the sentimental remained throughout, but overall his work grew darker. This was carried over into *A.I.: Artificial Intelligence* (2001). The project, inherited from Stanley Kubrick, was a divisive

year-by-year ■ TV episode ■ Movie ■ TV series

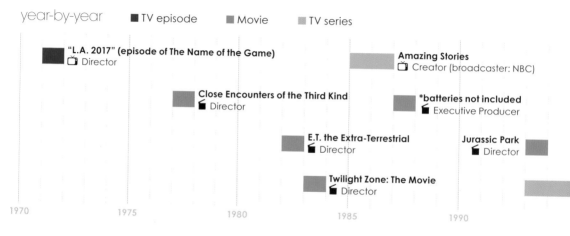

"L.A. 2017" (episode of The Name of the Game)
Director

Amazing Stories
Creator (broadcaster: NBC)

Close Encounters of the Third Kind
Director

***batteries not included**
Executive Producer

E.T. the Extra-Terrestrial
Director

Jurassic Park
Director

Twilight Zone: The Movie
Director

1970 1975 1980 1985 1990

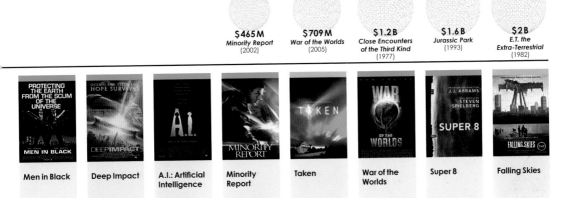

Men in Black

Deep Impact

A.I.: Artificial
Intelligence

Minority
Report

Taken

War of the
Worlds

Super 8

Falling Skies

science fiction fable about David, a boy robot with a heart. It was notably bleaker in tone than Spielberg's earlier science fiction works, set in a world that is vastly different from our own and in which pessimism and moral uncertainty are pervasive.

A.I. was followed by Minority Report (2002), based on the 1956 short story by Philip K. Dick. This clever, beautifully shot action thriller is a combination of deep, bleak themes and pulp SF that features a dystopian future, futuristic gadgets and weaponry and a twisting narrative wrapped around a typical genre paradox of predestination. It is set in 2054 in the United States, where "PreCrime,"a specialized police department, apprehends criminals based on foreknowledge provided by three psychics.

Until the somewhat overly neat and warm ending, Minority Report is a cynical comment on state control, with a drug-addicted lead character who prefigures such protagonists as Dom Cobb in Inception (2010). It is worth noting that the original, ultimately discarded, ending was an enigmatic title card declaring the number of murders committed after the cancellation of the PreCrime initiative. This shows the director taking a position and becoming politically engaged, a tendency that would become more pronounced in his next run of films.

Spielberg's subsequent films have been made in the shadow of the terrorist attacks on the World Trade Center and other U.S. targets on September 11, 2001. Some of the scenes of destruction in War of the Worlds (2005), his loose adaptation of the H.G. Wells novel, are plainly influenced by newsreel footage of the carnage on that day in New York. The Martians arrive and we see urban destruction and death through the viewfinder of a handheld camera, making the invasion as intimate and immediate as a terrorist assault. The film's tagline declares: "They're already here," a message that not only harks back to the "Red Scare" films of the 1950s but also endeavors to alert viewers to the homegrown dangers of terrorism.

Steven Spielberg's achievements in science fiction are monumental, but they are of course not his only works. The filmography also includes 1941 (1979), Raiders of the Lost Ark (1981), Indiana Jones and the Temple of Doom (1984), The Color Purple (1985), Munich (2005) and Lincoln (2012). His high concept ideas are flawlessly realized and executed but grounded and made accessible to everyone — hardcore science fiction fans and general audiences alike. As Jeffrey Katzenberg put it, "He is the storyteller of our time." **SW**

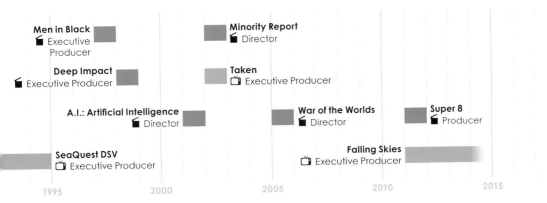

Men in Black
Executive Producer

Deep Impact
Executive Producer

A.I.: Artificial Intelligence
Director

SeaQuest DSV
Executive Producer

Minority Report
Director

Taken
Executive Producer

War of the Worlds
Director

Falling Skies
Executive Producer

Super 8
Producer

1995　　　　2000　　　　2005　　　　2010　　　　2015

**Close Encounters
of the Third Kind**
(1977)

**E.T. the Extra-
Terrestrial**
(1982)

Jurassic Park
(1993)

**A.I.: Artificial
Intelligence**
(2001)

Minority Report
(2002)

Taken
(2002)

War of the Worlds
(2005)

Falling Skies
(2011–present)

Spielberg filming **Close Encounters of the Third Kind** at Devil's Tower, Wyoming, the location chosen for the alien landing site.

Spielberg directs Henry Thomas, who played Elliott Taylor in **E.T. the Extra-Terrestrial**.

The spaceship in **E.T. the Extra-Terrestrial**.

Reviewing **Jurassic Park** rushes with Joseph Mazzello (Tim) and Ariana Richards (Lex).

Taking time out from shooting **Jurassic Park** to shoot the breeze with star Sam Neill.

A prehistoric t-shirt on futuristic director.

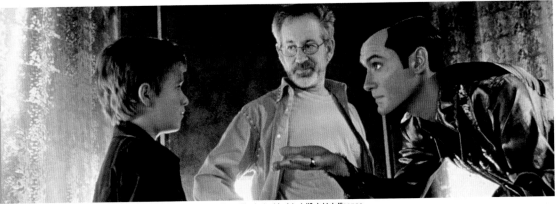
Watching the reaction of Haley Joel Osment (L; as David) to Jude Law (R; as Gigolo Joe) in *A.I.: Artificial Intelligence*.

Pointing the way forward on the set of *A.I.: Artificial Intelligence*.

Tom Cruise and Samantha Morton in *Minority Report*.

Taken, a 2002 TV SF mini-series produced by Stephen Spielberg.

Spielberg and Cruise reunited on *War of the Worlds*.

Spielberg is executive producer of *Falling Skies*, a post-apocalyptic SF TV drama series created by Robert Rodat.

george lucas 1971

THX 1138

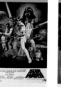
Star Wars Episode IV: A New Hope

Star Wars Episode V: The Empire Strikes Back

Star Wars Episode VI: Return of the Jedi

Caravan of Courage: An Ewok Adventure

Star Wars: Droids

Ewoks: The Battle for Endor

Star Wars: Ewoks

A fiercely independent filmmaker whose interest in mythic storytelling led him onto an unexpected career path, George Lucas was born in Modesto, California, in 1944. A rebellious youth with a passion for fast cars, he was involved in a near-fatal road accident in 1962.

While recovering from his injuries, Lucas reassessed his priorities, got himself through college and then became interested in filmmaking, ultimately enrolling at the University of Southern California's School of Cinematic Arts. He developed a passion for abstract filmmaking and directed the short film *Electronic Labyrinth: THX 1138 4EB*, which won him a student scholarship at Warner Bros. It was there that he first met fellow filmmaker Francis Ford Coppola.

Working closely together, Coppola and Lucas co-founded the independent film company American Zoetrope in 1969, which in 1971 released Lucas' directorial debut, a full-length expansion of his acclaimed short film.

THX 1138 was an experimental low-budget science fiction parable that depicted a tale of rebellion in a cold and clinical underground future. Firmly aimed at an adult audience, the film followed the late-1960s' predilection for pessimistic SF, and was ultimately a difficult and overly bleak work.

Lucas seemed to realize its problems, later saying, "People weren't really interested in a depressing statement. Being a pessimist doesn't really seem to accomplish anything." Having already started his own production company, Lucasfilm, in 1971, he decided his next films would be simpler and tell optimistic stories that he hoped would appeal to a wider audience, despite the prevailing 1970s' fashion for dark, adult-oriented cinema.

His instincts were proved right. The success of his *American Graffiti* (1973), a nostalgic low-budget 1950s' drama, gave him enough clout to try something more ambitious.

Planned as a homage to the 1930s' *Flash Gordon* film serials, *Star Wars* (1977) was turned down by almost every Hollywood studio, and even after Lucas persuaded 20th Century Fox to commit, the process of making the film was so traumatic that he didn't direct another movie for more than 20 years.

Star Wars transformed the film industry and made Lucas massively wealthy as he retained subsidiary and merchandising rights along with a share of the movie's profits. Although he was heavily involved in *The Empire Strikes Back* (1980) and *Return of the Jedi* (1983), he directed neither sequel but oversaw the growth of a massive corporation of spin-offs and merchandise.

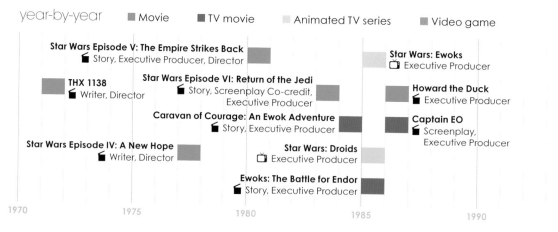

year-by-year ■ Movie ■ TV movie ■ Animated TV series ■ Video game

Star Wars Episode V: The Empire Strikes Back
🎬 Story, Executive Producer, Director

Star Wars: Ewoks
📺 Executive Producer

THX 1138
🎬 Writer, Director

Star Wars Episode VI: Return of the Jedi
🎬 Story, Screenplay Co-credit, Executive Producer

Howard the Duck
🎬 Executive Producer

Caravan of Courage: An Ewok Adventure
🎬 Story, Executive Producer

Captain EO
🎬 Screenplay, Executive Producer

Star Wars Episode IV: A New Hope
🎬 Writer, Director

Star Wars: Droids
📺 Executive Producer

Ewoks: The Battle for Endor
🎬 Story, Executive Producer

1970 1975 1980 1985 1990

| $606M
American Graffiti
(1973) | $1.8B
Star Wars
(1977) | $638M
Raiders of the
Lost Ark
(1981) |

Howard the Duck | Captain EO | Star Wars: Shadows of the Empire | Star Wars Episode I: The Phantom Menace | Star Wars Episode II: Attack of the Clones | Star Wars: Clone Wars | Star Wars Episode III: Revenge of the Sith | Star Wars: The Clone Wars

Lucas also had successes in film post-production thanks to his special effects company, Industrial Light and Magic (created to realize *Star Wars*' visual effects), the Lucasfilm Graphics Group (which was eventually sold to Apple and became animation studio Pixar), and the construction of the Skywalker Ranch, an independent filmmaking center based in Marin County, California.

Lucas won further acclaim by creating the adventure character Indiana Jones in *Raiders of the Lost Ark* (1981), but soon the pressure began to show, and his 14-year marriage to editor Marcia Griffin ended in 1983 with a lengthy divorce that cost him a significant chunk of his fortune.

Aside from the first two Indiana Jones sequels in 1984 and 1989, many of Lucasfilm's later productions were either box-office misfires (*Willow*) or full-on catastrophes (*Howard the Duck*). Although Lucas' storytelling instincts sometimes deserted him, his interest in new filmmaking techniques remained active, and he used the early 1990s' TV series *The Young Indiana Jones Chronicles* to experiment with different production methods.

He attracted much attention and criticism for the 1997 Special Edition re-releases of the *Star Wars* trilogy, which restored the films but controversially added new shots, scenes and CGI effects, significantly changing whole sections of the movies which Lucas had previously viewed as "incomplete."

Critical hostility increased after Lucas returned to the director's chair for the *Star Wars* prequels (1999–2005). This trilogy made immense advances in digital effects and filmmaking technology — *Attack of the Clones* was one of the first major films shot on digital camera — but suffered from weak storytelling and a lack of the pulp energy of the originals.

By 2005, Lucas was combative in the face of criticism, stating on the release of *Episode III*: "Right or wrong, this is my movie, my decision, and my creative vision, and if people don't like it they don't have to see it." Matters weren't helped by Lucas' story contributions to *Indiana Jones and the Kingdom of the Crystal Skull* (2008), a misconceived follow-up that likewise failed to recapture the spirit of the originals.

Although Lucas continued overseeing projects such as the successful *Clone Wars* TV series, it seemed unlikely he would ever relinquish control of *Star Wars*, especially following his added tinkering with the original trilogy on the 2004 DVD and the 2011 Blu-Ray edition. But in 2012, Lucas sold all of Lucasfilm — including the *Star Wars* franchise — to the Disney corporation for $4 billion. **SB**

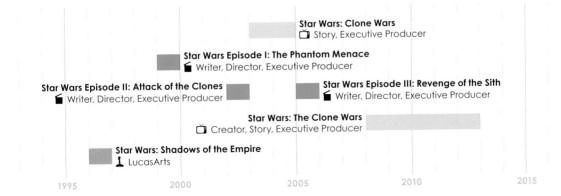

Star Wars: Clone Wars
Story, Executive Producer

Star Wars Episode I: The Phantom Menace
Writer, Director, Executive Producer

Star Wars Episode II: Attack of the Clones
Writer, Director, Executive Producer

Star Wars Episode III: Revenge of the Sith
Writer, Director, Executive Producer

Star Wars: The Clone Wars
Creator, Story, Executive Producer

Star Wars: Shadows of the Empire
LucasArts

1995 2000 2005 2010 2015

gatchaman 1972

Gatchaman

Gatchaman II

Battle of the Planets

Gatchaman Fighter

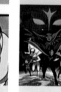
G-Force: Guardians of Space

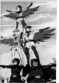
Eagle Riders

Gatchaman Crowds

Gatchaman

Gatchaman was created by Tatsuo Yoshida, founder of animation studio Tatsunoko Productions and creator of *Mach Go Go Go*, known in the West as *Speed Racer*. *Gatchaman* was Yoshida's take on the superhero genre and introduced the Science Ninja Team, five teenagers with special powers and bird-themed costumes who were brought together by Dr. Nambu.

Ken the Eagle, Joe the Condor, Jun the Swan, Jinpei the Swallow and Ryo the Owl fought against the androgynous Lord Berg Katse's Galactor organization, which sought control of Earth's resources. The team flew into battle in The God Phoenix, a fighter aircraft capable of transforming into a firebird.

Gatchaman debuted in Japan in 1972 and ran for 105 episodes full of giant robots frequently modeled on animals. In 1978, U.S. TV producer Sandy Frank bought the rights to the series, had it dubbed into English, edited out most of the violence and re-branded it as *Battle of the Planets*. The team became Mark, Jason, Princess, Keyop and Tiny. New footage was added featuring a comedy relief robot named 7-Zark-7 who coordinated the team, now called G-Force, in its defense of the solar system against the aliens of Planet Spectra. The show benefited from a rousing opening theme by Hanna–Barbera's regular composer, Hoyt Curtin, and gave many Western children their first experience of anime, albeit in a sanitized form without the mass destruction.

Gatchaman has been revived in different guises over the years. There were Japanese sequels with *Gatchaman II* in 1978 and *Gatchaman Fighter* in 1979 that were direct continuations of the plot from the first run. In 1986 *G-Force: Guardians of Space* was a second adaptation by Turner Broadcasting of the original series and in 1996 Saban Entertainment, the company behind *Power Rangers*, re-edited and dubbed the two sequels for Western viewers as *Eagle Riders*. There was a three-part anime in 1994 but a CGI movie announced in 2008 never made it beyond a proof of concept trailer after IMAGI, one of the co-developers with Tatsunoko Productions, went out of business.

Gatchaman Crowds, a 2013 anime directed by Kenji Nakamura and produced by Tatsunoko, completely revamped the concept from scratch to a point where it is unrecognizable from the original premise. The team of five adult humans and an alien that looks like a panda now defends the planet from aliens called MESS. All that remains from the 1972 version is the use of the phrase "Bird, go!" to trigger the characters' transformations into their Gatchaman guise. However the 2013 live action *Gatchaman* movie from TOHO Studios and director Toya Sato returned to the classic line-up of Ken, Joe, Jun, Jinpei and Ryu fighting Galactor and Lord Katse and revives the iconic Phoenix. **DWe**

year-by-year ■ Anime ■ Animated TV series ■ Movie

Gatchaman
Tatsunoko Productions

Gatchaman II
Tatsunoko Productions

Battle of the Planets
Sandy Frank Entertainment

Gatchaman Fighter
Tatsunoko Productions

G-Force: Guardians of Space
Sandy Frank Entertainment, Turner Broadcasting

Eagle Riders
Saban Entertainment

Gatchaman Crowds
Tatsunoko Productions

Gatchaman
Toya Sato

1970 1975 1980 1985 1990 1995 2000 2005 2010

the stepford wives 1972

The Stepford
Wives

The Stepford
Wives

Revenge of
the Stepford
Wives

The Stepford
Children

The Stepford
Husbands

The Stepford
Wives

The Stepford Wives, like so much of the best science fiction, reflects the era in which it was created but retains its power today.

It was written by Ira Levin — a brilliantly skilled thriller writer whose previous successes included *A Kiss Before Dying* and *Rosemary's Baby* — at a time of great change in U.S. society, as American feminists stepped up their campaign for equal pay and educational opportunities. Their agitation made some men fear that their way of life was in danger of being changed forever. Against this backdrop, Levin created the town of Stepford, Connecticut, where the men have banded together to crush feminism and, through a mysterious chemical process, turned their women into dutiful, subservient, ever-smiling domestic goddesses.

A success on publication in 1972, the slim (145-page) novel was adapted for the cinema in 1975 by director Bryan Forbes. This is the definitive Stepford film. In a similar fashion to Roman Polanski's *Rosemary Baby* (1968), Forbes subtly builds the paranoia of lead character Joanna Eberhart (Katharine Ross) to a splendid climax, on the way to which there are many amusing jabs at dutiful suburban behavior ("I'll just die if I don't get this recipe!").

Five years later, *Revenge Of The Stepford Wives*, a TV movie directed by Robert Fuest, was assiduous in its attempts to mimic the movie, but failed either to reproduce the wit of the original or to introduce any freshness of its own.

It was the turn of the kids in 1987, when TV movie *The Stepford Children*, directed by Alan J. Levi, appeared. It was the obvious way to go — what could parents wish for more than to turn their wild teenagers into models of obedience? Unfortunately it's a laughably plastic film full of stereotypes and lacks ideas — although it can make agreeably light viewing for those in the mood.

This was followed in 1996 by *The Stepford Husbands*, in which a couple move to a town where the men are carted off to a clinic to have their personalities altered with drugs. No more slouching in front of basketball, now they're happy to help set the table! Critic Chad Webb called it, "just as bland, routine and haphazard as the previous sequels."

The Stepford Wives reappeared in 2004 in a new version directed by Frank Oz and starring Nicole Kidman and Matthew Broderick. Essentially a modern remake of the 1975 film, it goes for laughs rather than satire, and is consequently less effective than the Forbes version. It's also very confused about what the Wives actually are — are they brainwashed humans or are they robots?

The blurb writer who, on the jacket of the original edition of *The Stepford Wives*, described the work as "one of those rare novels whose very title may well become part of our vocabulary" was a prophetic soul. It's also a story that is ever ripe for re-adaptation, as the numerous versions to date attest. Don't discount the possibility of more of them in the future. **RL**

year-by-year ■ Book ■ Movie ■ TV movie

The Stepford Wives
Ira Levin

The Stepford Children
Alan J. Levi

The Stepford Wives
Bryan Forbes

The Stepford Husbands
Alan J. Levi

Revenge of the Stepford Wives
Robert Fuest

The Stepford Wives
Frank Oz

1970 1975 1980 1985 1990 1995 2000 2005 2010

the six million dollar man 1972

Cyborg

The Six Million
Dollar Man

Cyborg 2:
Operation
Nuke

The Six Million
Dollar Man

The Six Million
Dollar Man

The Bionic
Woman

The Bionic
Woman

Bionic
Woman

The Six Million Dollar Man was one of ABC's most successful shows between 1974 and 1978. In Lee Majors, the network had a lead actor that would become one of the decade's most merchanizable cultural icons. He was a ruggedly handsome alpha male; his wife was *Charlie's Angels* starlet Farrah Fawcett; together they were the small-screen Brad Pitt and Angelina Jolie of their day.

It all began with *Cyborg* (1972), a novel by Martin Caidin about Steve Austin, a former astronaut turned test pilot who, after surviving a potentially fatal crash, is rebuilt using cybernetic technology. A surprise success for publishers Arbor, the book was swiftly optioned by ABC for one of its TV movies of the week. In March 1973 Majors made his debut as a softened Steve Austin, rebuilt by Dr. Rudy Wells and working for a CIA offshoot organization named OSO. A ratings hit, the movie rapidly spawned two follow-ups and in January 1974 the first of a 13-episode series.

With Steve now working for the stone-faced Oscar Goldman, *The Six Million Dollar Man* became a pop-culture phenomenon. No playground on the mid-1970s was free of schoolkids pretending to run in slow motion or leap onto a high wall, while attempting to mimic the sound effects of the show. Its success was so great that a second season episode saw a backdoor pilot two-parter entitled *The Bionic Woman*, which would soon launch as a slightly less-loved sister show.

The series fizzled out in 1978 after three seasons. Two months later *The Bionic Woman* was also canned. In 1987 the snappily-titled *The Return of the Six Million Dollar Man and the Bionic Woman* united Steve and Jaime Sommers (aka the Bionic Woman) for a humdrum thriller that lacked the panache of the 1970s' version. Still, it was successful enough to inspire two further made-for-TV sequels, *Bionic Showdown* and *Bionic Ever After?*, which saw Steve and Jaime tie the knot. The last TV movie showcased Sandra Bullock as bionic agent Kate Mason, who was being readied for a possible spin-off, should this Steve Austin send-off scoop up record ratings for ABC. Alas, it never happened.

Many subsequent attempts have been made to revive *The Six Million Dollar Man*. Kevin Smith wrote a script in the mid-1990s, and Jim Carrey was at one point attached to a *Starsky & Hutch*-like comedy take on the show. Most recently, a short-lived *Bionic Woman* series remake was aired by NBC, but taken off after eight episodes. However, if Steve Austin ever returns, Lee Major is waiting for the call. "I would do the Oscar Goldman part," he said recently. "I want to sit there in the office and point my finger and say, "Steve, go get 'em." **SOB**

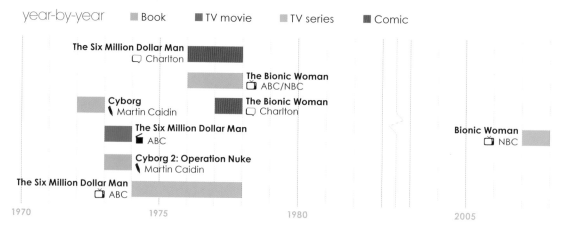

year-by-year ■ Book ■ TV movie ■ TV series ■ Comic

The Six Million Dollar Man
□ Charlton

The Bionic Woman
□ ABC/NBC

Cyborg
\ Martin Caidin

The Bionic Woman
□ Charlton

The Six Million Dollar Man
■ ABC

Bionic Woman
□ NBC

Cyborg 2: Operation Nuke
\ Martin Caidin

The Six Million Dollar Man
□ ABC

1970 1975 1980 2005

silent running 1972

Silent
Running

Silent
Running

Silent Running is a prime example of the ecological science fiction of the late 1960s and 1970s.

The world has been devastated by nuclear holocaust. All plants have been destroyed, except for a handful of samples contained in biodomes attached to space freighters. Bruce Dern plays Freeman Lowell, a botanist aboard the *Valley Forge*. The plants were originally intended to regreen the Earth, but a change of government policy results in orders for their destruction. Lowell objects and, accompanied by the ship's "drones," hijacks the ship and escapes past Saturn with a single forest dome, all that remains of Earth's rich biome.

Scientifically, *Silent Running* is bunk. For example, how Earth survives with no plants is never explained, and it would have been cheaper to leave the domes intact than to blow them up. Its most famous gaffe is when botanist Lowell is perplexed when his plants start dying due to lack of sunlight. The movie is also weakened by dubious morality — when Lowell murders his insensitive but otherwise innocent crewmates, the audience is clearly expected to approve.

Nevertheless, *Silent Running* has become a cult film. Besides its emotive nature and a solid performance by Dern, a great part of its appeal lies in the excellent special effects by director Douglas Trumbull. One of the great translators of science fiction into movie images, Trumbull had previously worked as special photographic effects supervisor on *2001: A Space Odyssey*. *Silent Running* was his first directing role, and even on a shoestring budget of $1 million he produced some brilliant scenes. Notable

was his use of amputees in individually customized robot suits to portray the drones.

Silent Running was a flop on first release, being poorly promoted. "It was just a great experience for me as a filmmaker, but I didn't know that I was part of an experiment by Universal Studios to see if it was possible to have a movie survive on word of mouth alone without an advertising campaign," said Trumbull later.

This was not the last time he fell foul of the Hollywood system. A later project fell through at a late stage when its backer decided to invest in Las Vegas instead. He came close to falling out with Paramount when he turned down *Star Trek: The Motion Picture* in favor of *Close Encounters of the Third Kind* (he ended up doing both jobs anyway, when Paramount's second choice effects house failed to deliver). This was followed by special effects work for *Blade Runner*, which he left partway through to concentrate on his second and final directing job, *Brainstorm*. The movie almost ended in disaster when star Natalie Wood drowned during a break in filming, leading MGM to pull the plug. Trumbull had a fight to finish the nearly completed film, which he won, but when released it was a commercial failure.

Trumbull then cut his direct links with moviemaking, describing the business as "screwed up." "Moviemaking is like waging war," he said. "It destroys your personal life, too." He headed to Massachusetts where he established a number of companies to develop new technologies for filmmaking. **GH**

year-by-year ■ Movie ■ Book

Silent Running
🎬 Douglas Trumbull

Silent Running
🖉 Harlan Thompson

1965 1970 1975 1980 1985

glen a. larson 1973

The Six Million
Dollar Man

Battlestar
Galactica

Buck Rogers in the
25th Century

Galactica 1980

Knight Rider

Manimal

One of the most successful American TV writer/ producers, Glen A. Larson created many of the best-known shows of all time. The first hit of his lengthy production deal with Universal Studios was the comedy Western adventure *Alias Smith and Jones* in the early 1970s. He was executive producer and sometimes wrote scripts for *McCloud*, *Quincy M.E.*, *B.J. and the Bear*, *Magnum P.I.* and *The Fall Guy*.

Many of the series on which he worked were loosely based on successful movie franchises — for example, *Alias Smith and Jones* owed much to *Butch Cassidy and the Sundance Kid*. A one-time singer — his male vocal group, The Four Preps, had many hits in the late 1950s — Larson co-wrote "The Unknown Stuntman," the title song to *The Fall Guy*.

Some of Larson's earliest TV work was on the last season of the Western hit *The Virginian*, and the adventure shows for which he became famous were often Westerns in all but setting, starring individualistic heroes struggling to survive in hostile environments.

The first of these was *The Six Million Dollar Man* in 1973, developed from the downbeat Martin Caidin novel *Cyborg*, in which astronaut-turned-test pilot Steve Austin suffers horrific injuries in a crash. He is then rebuilt with super-fast and extremely powerful

replacement mechanical limbs and becomes a "bionic" agent for a fictional U.S. security agency. Larson was executive producer of both the original TV movie and the subsequent television series. He also wrote one of the two TV movies that were sandwiched between them and composed the theme music.

The first science fiction hit that was largely a Larson solo work was *Battlestar Galactica* (1978), the first TV series to cost $1 million per episode. Although a ratings success, it lasted only one 24-episode season, but had a surprising afterlife, returning first as *Galactica 1980* for 10 cheaper sequel episodes, and then being re-imagined by The Sci-Fi Channel between 2003 and 2009. Larson received a "consulting producer" credit here and on the prequel *Caprica*, despite not being directly involved in any way.

Battlestar Galactica tells of the near-extermination of a lost human civilization in deep space by robotic aliens, and recounts the adventures of the surviving spaceships, protected by a lone war vessel or "Battlestar," as they attempt to escape to Earth. The series was full of Mormon themes — Larson was a member of the Church of Jesus Christ of Latter-Day Saints. It was originally entitled *Adama's Ark*, but renamed to cash in on the recent success of *Star Wars*.

year-by-year ■ TV movie ■ TV series

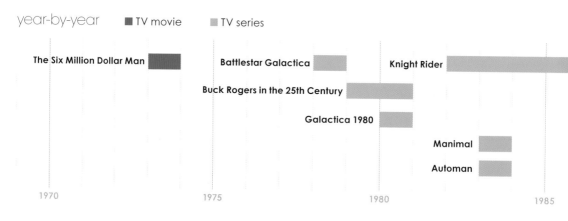

Automan **The Highwayman** **NightMan** **Team Knight Rider**

Reusing some of the expensive *Battlestar* props and sets, the more lightweight adventure series *Buck Rogers in the 25th Century* followed in 1979 for two seasons, but Larson's biggest genre hit was still to come, and its style and format would dominate much of his subsequent career.

That series was *Knight Rider*, which began in 1982 and ran for 90 episodes and four seasons on NBC. It took the classic lone crusader of the Western genre and equipped him with futuristic technology. Larson himself described the show as "the Lone Ranger with a car." The hero is Michael Knight, who is described as "a man who does not exist" but is actually an injured cop given a new face via plastic surgery, a new name and use of the Knight Industries Two Thousand car, or KITT, which could jump great distances without the use of a ramp and which spoke with a rather affected, know-it-all voice. The human lead was played by David Hasselhoff; KITT was a heavily modified Pontiac Firebird Trans Am.

Michael — now the prime agent for the Foundation for Law and Government (FLAG), a secretive billionaire's private police force — cruises small-town California in KITT to combat "criminals who operate above the law."

The show was so successful that it was revived as a series of TV movies and two spin-off series: *Team Knight Rider* and a 2008 re-imagining, both of which lasted a single season apiece.

Larson later tried to reproduce the magic of *Knight Rider* in other packages, but missed the target with *Manimal* (a crime fighter who can turn into any animal, but nearly always a hawk or a panther); *Automan* (a cop who is teamed with a *Tron*-inspired hologram); and *The Highwayman* (a cop who patrols in a giant black supertruck, an attempted synthesis of *Knight Rider* with *Mad Max*).

Larson's last genre show was *NightMan*, which spun out of the Steve Englehart-created Malibu Comics series; in it a jazz musician is struck by lightning and thus acquires the power to sense evil telepathically. At one point he teams up with the hero of *Manimal*, thus teasing viewers with the idea that there might be an extended Larson universe.

It is difficult to deny that many of these shows were cheesy at the time of their release and now have a rather second-hand feel. Nevertheless, Glen A. Larson was so prolific and had so many hits that he fully merits inclusion here as one of television's most important science fiction auteurs. **MB**

The Highwayman

NightMan

Team Knight Rider

1985 1990 1995 2000

The Six Million Dollar Man (1973)

Battlestar Galactica (1978–79)

Buck Rogers in the 25th Century (1979–81)

Knight Rider (1982–86)

Manimal (1983)

Automan (1983–84)

Steve Austin (Lee Majors) arm wrestles the bionic Barney Miller (Monte Markham) in the episode "The Seven Million Dollar Man."

A Cylon, one of a race of robots that is at war with humanity in **Battlestar Galactica**.

Erin Gray as crack Starfighter pilot Colonel Wilma Deering in **Buck Rogers in the 25th Century**.

Anthony "Buck" Rogers' space shuttle, Ranger 3.

Twiki the ambuquad robot with Gil Gerard, the star of **Buck Rogers in the 25th Century**.

Michael (David Hasselhoff) in KITT with Devon Miles (Edward Mulhare), head of FLAG in **Knight Rider**.

In **Manimal**, Simon MacCorkindale played Dr. Jonathan Chase, a shape-shifting man who could turn himself into any animal.

Chuck Wagner, all lit up as the hero of **Automan**, with his faithful sidekick Walter Nebicher (Desi Arnaz, Jr.).

rené laloux 1973

Fantastic Planet

Time Masters

Gandahar
(Light Years)

Frenchman René Laloux (1929–2004) is one of very few animators outside Japan known for his science fiction work. He is particularly renowned for the first of his three feature films, *Fantastic Planet* (1973).

Laloux entered animation by an unusual route. He worked at a progressive psychiatric clinic, and oversaw a short animated film (*Les dents du singe*, 1960) drawn by the patients.

He later teamed up with surrealist artist Roland Topor to make one of the oddest science fiction films ever. Laloux, a science-fiction fan, picked the property. *Fantastic Planet* is an epic (as much as it can be in 70 minutes) based on *Oms en série* (1957) by Stephan Wul, the pen name of Pierre Pairault. (This book was not translated into English until 2010, when it was retitled *Fantastic Planet* and sold with a still from the film on the cover.)

The story concerns Traags (giant blue aliens) that either keep Oms (humans) as pets or hunt them as vermin. Eventually the humans learn to fight back. The theme of humans being kept as animals had been popularized by Pierre Boulle's *Planet of the Apes* (1963, aka *Monkey Planet*), filmed by Hollywood in 1968.

Laloux's film, though, is very different. Its limited animation is purposely idiosyncratic and trippy, reflecting *Yellow Submarine* and Terry Gilliam's *Monty Python* cartoons. The alien creatures, designed by Topor, are comic grotesques. There's a dragon with a maw like a vacuum cleaner, and giant snapping shrimp-things tied to dueling humans. In one vignette, wild humans climb a dead Traag's giant head at night. They take glowing foodstuffs from their shaman, and glow themselves as they eat. The women then strip naked and the men chase them into the shadows.

It's debatable whether Laloux or Topor deserves more credit for the film, but it was Laloux who stayed with the genre. His *Time Masters* (1982) adapted another Pairault novel, *L'orphelin de perdide* (1957), about a space mission to save a boy marooned on another exotic planet. Apart from some pleasant designs, it's a rather terrible film, with a somnolent pace and nonsensical scraps of story.

Laloux's third film, *Gandahar* (U.S. title: *Light Years*, 1987), is set on yet another alien world, this one threatened by an army of jet-black robots. It's enjoyable as a pulp heroic fantasy, but the plot is confused and overall lacks the weird humor of *Fantastic Planet*.

In Laloux's work generally, the stories and characters are insignificant beside all the strange landscapes and creatures, which are drawn in different styles in each movie. The comic artist Moebius (Jean Giraud) took design duties on *Time Masters*; *Gandahar* was made in collaboration with a North Korean studio. The former's faceless angels and the latter's great brain on the sea remain long after the plot and the dialogue have faded from the memory. **AO**

year-by-year ■ Animated movie

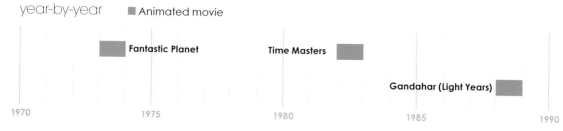

Fantastic Planet Time Masters

Gandahar (Light Years)

1970 1975 1980 1985 1990

westworld 1973

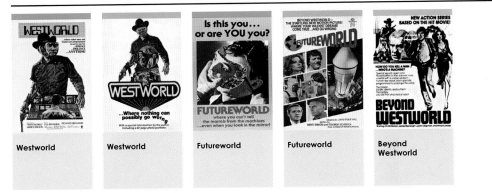

Westworld

Westworld

Futureworld

Futureworld

Beyond
Westworld

In some ways, *Westworld* is one of the most prescient science fiction films of the 1970s. We may not yet have theme parks where patrons can indulge in gun battles with robots dressed as cowboys, but in many ways it has accurately predicted certain trends of the last 40 years: as individual wealth has grown so have cravings for ever more esoteric pastimes; technological advances have made simulated reality a part of many leisure pursuits.

The movie, written and directed by Michael Crichton — whose numerous contributions to SF include *The Andromeda Strain*, *The Terminal Man*, *Jurassic Park* and *Coma* — concerns an adult amusement park where things go horribly wrong, and its robot inhabitants start murdering the holidaymakers. Crichton said he got the idea during a trip to Disneyland.

There are three sections of the park — Medievalworld, Romanworld and Westworld. Most of the action takes place in Westworld, where holidaying friends Peter and John (Richard Benjamin and James Brolin) enjoy the re-creation of the Old West (or at least the Hollywood movies' version of the Old West) until an accident sends everything haywire. A robot Gunslinger — played by Yul Brynner in virtually the same outfit as he wore in *The Magnificent Seven* (1960) — keeps coming back to life after he has been "killed," and is intent on destroying the friends. These

sequences inspired the rampages of Michael Myers in John Carpenter's *Halloween* and of the Terminator in James Cameron's *Terminator 2: Judgment Day*. The pixellated vision of the Gunslinger is the result of digital image processing; *Westworld* was the first feature film to use this innovative technique.

The film's underlying theme is one that would become familiar in Crichton's work: bad things happen when humans rely on technology rather than on themselves.

Westworld is a mix of both Western and SF action, adroitly handled and highly compelling. Some of its lastingly haunting scenes and images feature Brynner as the killer who won't give up. The last act is essentially one long chase, the black-clad Gunslinger pursuing his quarry through the devastated amusement park and into the bowels of the operations center.

In the sequel, *Futureworld* (1976), Peter Fonda and Blythe Danner star as reporters investigating rumors of famous people being replaced by robot doubles. *The New York Times* described it as "as much fun as running barefoot through Astroturf."

The TV series *Beyond Westworld* (1980) fared even worse. Just five episodes were filmed and only three were aired; they have not been released on videotape or DVD since. The plot concerned an evil scientist's bid to take over the world with the robot duplicates. **RL**

year-by-year ■ Movie ■ Book ■ TV series

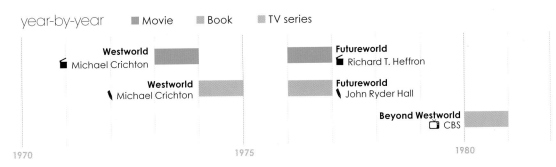

Westworld
Michael Crichton

Westworld
Michael Crichton

Futureworld
Richard T. Heffron

Futureworld
John Ryder Hall

Beyond Westworld
CBS

1970 1975 1980

john carpenter 1974

Dark Star

Escape from
New York

The Thing

Starman

The Philadelphia
Experiment

Black Moon
Rising

New York-born John Carpenter was one of the most recognizable names in American genre cinema for more than three decades. His 23-minute-long debut, *The Resurrection of Broncho Billy*, won an Academy Award for Best Live Action Short Film in 1970 and led to his first feature, *Dark Star* (1974). Produced for only $60,000, *Dark Star* was written with Dan O'Bannon, who later co-wrote *Alien* (1979). This visually ambitious low-budget oddity, focusing on the monotony of daily life on a space mission, represents an imaginatively comical spin on science fiction cinema; it gained a cult following.

Carpenter followed up with a gritty contemporary Western, *Assault on Precinct 13* (1976) — a flop in the United States but a sleeper hit in Europe — and the TV thriller *Somebody's Watching Me!* His biggest hit, however, came with *Halloween* (1978), a precursor to the "slasher" movie boom of the early 1980s and the most profitable independent release of its era. It spawned *Friday the 13th* (1980) and the inevitable *Halloween II* (1981).

Although *Halloween* made Carpenter a bankable name in terror, his next project was the two-and-a-half-hour television movie, *Elvis* (1979), starring Kurt Russell as "The King."

Following 1980's shocker *The Fog*, Carpenter returned to SF with *Escape from New York* (1981), which starred Kurt Russell as Snake Plissken, who is hired by the U.S. government to rescue the President (Donald Pleasence) from a future Manhattan that has been turned into a giant prison after a third World War. This film was poorly received on release, but has since become one of the director's most famous features. Boasting Carpenter's trademark widescreen photography, superior special effects and a menacing look at the Big Apple in post-apocalyptic meltdown, *Escape from New York* is fast paced and occasionally brutal, but not without a certain dry wit. A flop sequel, *Escape from L.A.*, was released in 1996.

Carpenter and Russell reunited for a third time on *The Thing* (1982), arguably the filmmaker's crowning SF achievement. Featuring extravagant special effects by Rob Bottin, the movie was adapted from the novella *Who Goes There?* by John W. Campbell Jr. (which also inspired the 1951 film *The Thing from Another World*, one of Carpenter's favorite genre efforts). This updated version casts Russell as a helicopter pilot stationed at an all-male Antarctic research station. The station is infiltrated by a shape-changing alien that takes on the body appearance

year-by-year ■ Movie

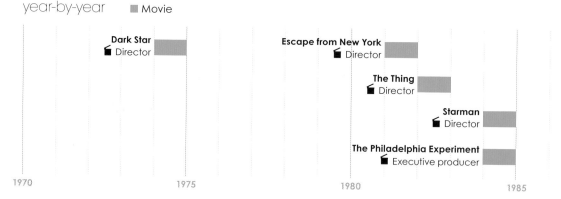

$64M	$47M	$63M	$23M	$37M
Escape from New York (1981)	*The Thing* (1983)	*Starman* (1984)	*Memoirs of an Invisible Man* (1992)	*Escape from L.A.* (1996)

They Live

Memoirs of an Invisible Man

Village of the Damned

Escape from L.A.

Ghosts of Mars

of its human and animal hosts. In a tense climax, only Russell and co-star Keith David are left alive, both trying to figure out if the other one is "infected." A box office bomb on its initial release, *The Thing* has since been seen as a modern classic; it inspired a 2002 video game sequel and an unsuccessful prequel, without Carpenter's involvement, in 2011.

Eager to regain his commercial form, Carpenter took the reins of the Stephen King killer-car adaptation *Christine* (a minor success in 1983) and the SF love story *Starman* (1984), which won an Oscar nomination for its star Jeff Bridges. (The same year's *The Philadelphia Experiment* featured Carpenter as executive producer.)

Carpenter's next film — another Russell reunion, the comedy-fantasy *Big Trouble in Little China* (1986) — was a commercial disaster. The director then returned to low-budget horror with the $3 million *Prince of Darkness* in 1987.

Having turned down the opportunity to direct *Halloween IV: The Return of Michael Myers*, Carpenter next undertook *They Live* (1988), a low-budget satirical alien-invasion action film. Casting ex-professional wrestler "Rowdy" Roddy Piper as a drifter who discovers a pair of sunglasses that enable him to see

aliens, *They Live* was — like *Dark Star* and *Escape from New York* — played with a compelling satirical streak. It was Carpenter's last box office success and, in the view of many, his last great film.

Next up was a run of flops: the catastrophic *Memoirs of an Invisible Man* (1992), starring Chevy Chase; the made-for-TV collaboration with Tobe Hooper, *Body Bags* (1993); the Lovecraftian *In the Mouth of Madness* (1994); the lavish horror remake *Village of the Damned* (1995); the ill-advised *Escape from L.A.* and the gory horror shocker *Vampires* (1998). Carpenter would make only one full length feature in the 2000s: the 2001 horror-comic *Ghosts of Mars*. *The Ward*, an independently produced thriller, received a poor critical reception when it opened in 2010.

Carpenter feels pigeonholed. He said: "When you make a successful horror picture, like *Halloween*, you get generalized pretty fast. One of the most famous horror directors was James Whale, who did *Frankenstein* and *The Invisible Man*. He was a terrific director, and he did other films but they were never as successful as his horror stuff. I have generally had the same experience." Typecast he may be, but he is nevertheless one of the science fiction and horror genre's most stylish and inventive practitioners. **CW**

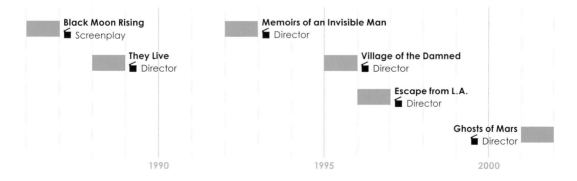

Black Moon Rising
🎬 Screenplay

Memoirs of an Invisible Man
🎬 Director

They Live
🎬 Director

Village of the Damned
🎬 Director

Escape from L.A.
🎬 Director

Ghosts of Mars
🎬 Director

1990 1995 2000

Dark Star
(1974)

Escape from New York
(1981)

The Thing
(1982)

Starman
(1984)

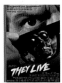

They Live
(1988)

Memoirs of an Invisible Man
(1992)

Escape from L.A.
(1996)

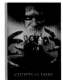

Ghosts of Mars
(2001)

John Carpenter called *Dark Star* "*Waiting for Godot* in space."

Promotional posters for *Dark Star* described the film as "the spaced-out odyssey."

Adrienne Barbeau and John Carpenter: they were married between 1979 and 1984, and she appeared in several of his films during that period.

Soul musician Isaac Hayes as the self-styled Duke of New York in *Escape from New York*.

One sure sign of a good horror film is even the stills are scary: *The Thing* is a good horror film.

John Carpenter (L) with Jeff Bridges on location for **Starman**.

Chevy Chase as he appeared in **Memoirs of an Invisible Man**.

In **They Live**, politicians are revealed as aliens who exploit humanity for their own ends.

Kurt Russell's reputation hanging by a thread or two in **Escape from L.A.**

Ice Cube as James "Desolation" Williams in **Ghosts of Mars**.

heavy metal 1974

Métal Hurlant

Heavy Metal

Heavy Metal

Heavy Metal 2000

Heavy Metal:
F.A.K.K.²

Heavy Metal:
Geomatrix

In 1974 French artists Jean Giraud and Philippe Druillet joined writer Jean-Pierre Dionnet and businessman Bernard Farkas to form the collective "Les Humanoïdes Associés" ("United Humanoids") and publish the quarterly *Métal Hurlant* ("Screaming Metal"). At only 68 pages (18 in color), the modest first issue still made a significant impact on the French comic scene, with its mature approach to artwork and content and its focus purely on science fiction and fantasy, something that was unusual at the time. Most European comics had Wild West or war themes, whereas in the United States superheroes were very much still the order of the day.

Over the next decade and a half *Métal Hurlant* published some of France's most acclaimed writers and artists, including Enki Bilal, Philippe Caza, Guido Crepax, Jean-Claude Forest and Milo Manara. The magazine was such a success that by issue seven it had switched from quarterly to bi-monthly, and by issue nine had become a monthly publication.

The most influential of the original founders of *Métal Hurlant* was Jean Giraud. Already a celebrated artist of Wild West comics in France, with his Lt. Blueberry series earning him accolades since the 1960s, Giraud started writing and drawing under the name Moebius when *Métal Hurlant* launched. The magazine published some of his most famous creations, including "Arzach" (1975) and "The Airtight Garage" (1976). Moebius combined surreal and fantastical with detailed and realistic, and was one of the earliest pioneers of the lived-in future style of SF art which rejected shiny designs in favor of grimy, run-down, believable environments. This is highlighted best in the story "The Long Tomorrow" (1975) — written by Dan O'Bannon, who would go on to script *Alien* — with its then unique combination of neon-lit noir streets, cramped, towering city blocks, airborne traffic jams and scruffy characters. Cited as an influence by cyberpunk guru William Gibson, the story's art style had a huge impact on subsequent science fiction, and led Ridley Scott — a longtime *Métal Hurlant* reader — to approach Moebius to work on designs for *Alien* and later for *Blade Runner*. Scott drew heavily on "The Long Tomorrow" for *Blade Runner*'s visual style, even handing out copies of *Métal Hurlant* to the staff of his art department.

Moebius went on to a long career as a concept artist for Hollywood movies, shaping the look of *Tron* (1982), *Masters of the Universe* (1987), *Willow* (1988) and *The Fifth Element* (1997). He is also regarded as

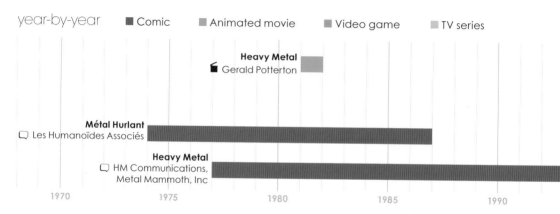

year-by-year ■ Comic ■ Animated movie ■ Video game ■ TV series

Heavy Metal
Gerald Potterton

Métal Hurlant
Les Humanoïdes Associés

Heavy Metal
HM Communications,
Metal Mammoth, Inc

1970 1975 1980 1985 1990

Metal Hurlant

Metal Hurlant
Chronicles

an important figure by many Japanese anime and manga creators, including Katsuhiro (*Akira*) Otomo and Hayao (*Spirited Away*) Miyazaki.

While visiting Paris in 1976, American publisher Leonard Mogel stumbled across *Métal Hurlant*. He was so taken by its unique style that in April of the following year he began publishing a licensed version as a glossy, full-color monthly magazine in the United States under the banner *Heavy Metal*. Initially it was made up of translations of the French strips, but as time went on and its reputation grew it began to publish work from North America and beyond, with William Burroughs, Stephen King and H.R. Giger among those who contributed over the years. It also branched out into mainstream SF, running a comic adaptation of *Alien* alongside the movie's launch.

The original *Métal Hurlant* ceased publication in 1987 with issue 133 (an attempt to revive it in 2002 lasted only 14 issues), but *Heavy Metal* is still published today. At the height of its success in 1981 an animated feature film, called simply *Heavy Metal*, was released. An anthology of short films adapted or inspired by strips from both the U.S. and the French magazines, it was initially a flop, but later become a cult hit when distributed on bootleg video and shown on late-night TV. A large part of this success was no doubt attributable to the soundtrack by famous rock acts including Cheap Trick, Stevie Nicks and Black Sabbath. The association with rock music continues today. Under the ownership of *Teenage Mutant Ninja Turtles*' creator Kevin Eastman, who bought the magazine in 1992, *Heavy Metal* now seems more focused on the fantasy aesthetic associated with heavy metal — including a large amount of erotic and fetish art — than with the science fiction stylings envisioned by Les Humanoïdes Associés.

A second film was released in 2000 with the somewhat uninspired title *Heavy Metal 2000*. It was accompanied by a videogame, *Heavy Metal: F.A.K.K.²*. Neither was particularly successful. Attempts were made to create another animated movie — there were reports that *Fight Club* director David Fincher was attached — but Paramount killed funding in 2009. However, two years later director Robert Rodriguez announced at San Diego Comic Con that he had acquired the film rights. Meanwhile, back in France, *Métal Hurlant Chronicles* — a six-part live-action TV series — was produced from stories in the original magazine. It was aired in October 2012, but to date has not been shown outside France. **TM**

Heavy Metal 2000
Michael Coldewey, Michel Lemire

Metal Hurlant
Humanoids Publishing

Heavy Metal: F.A.K.K.²
Gathering of Developers

Metal Hurlant Chronicles
France 4, Guillaume Lubrano

Heavy Metal: Geomatrix
Sega/Capcom

1995 2000 2005 2010 2015

space battleship yamato 1974

Space Battleship Yamato

Cosmoship Yamato

Space Battleship Yamato

Space Battleship Yamato

Space Battleship Yamato II: The Comet Empire

Star Blazers

Space Battleship Yamato III: The Bolar Wars

Space Battleship Yamato 2199

It is the year 2199. The alien Gamilas have bombarded Earth with radioactive meteorites, sterilizing the surface and forcing humankind underground. The last hope is the *Yamato*, a sunken, Second World War battleship raised and fitted with an untested warp drive called the Wave Motion Engine, which has been constructed from blueprints sent from the distant planet Iscandar. Starsha, Queen of Iscandar, claims to have a device that can heal Earth's irradiated surface, if only the *Yamato* can complete the 396,000 light year round-trip before the radiation poisons Earth's people — within 12 months. A series with an obvious nationalist subtext, Yamato can be seen as a metaphor for the resurgence of postwar Japan.

The origin of *Space Battleship Yamato* was the subject of a legal battle. Producer Yoshinobu Nishizaki came up with the initial concept of teenagers traveling through space, but it was manga artist-turned-director Leiji Matsumoto who designed the characters and concept art.

Both Nishizaki and Matsumoto claimed ownership of the concept, with the result that the franchise remained on hold for years until their dispute was finally settled in 2003. Nishizaki received ownership of the name "Space Battleship Yamato" and the plotline; Matsumoto was given copyright to the character designs and artwork. Matsumoto made a career out of space operas, going on to create the

classic science fiction anime franchises *Space Pirate Captain Harlock* and *Galaxy Express* 999, as well as collaborating on music videos with French dance duo Daft Punk and British rock band Queen.

Space Battleship Yamato spawned two sequels, a remake and several movies. In Japan it inspired serious science fiction anime such as *Neon Genesis Evangelion*, whereas in the United States the first three series were dubbed into English as *Star Blazers*.

Unlike *Gatchaman*, which was heavily cut to make it suitable for children as *Battle of The Planets*, *Star Blazers* remained largely intact, although the anime's nationalism was excised for U.S. audiences. The original sinking of *Yamato* was shown in episode two of the original anime but cut from the U.S. release. In *Star Blazers*, the ship is renamed *The Argo*, although the script does reference its original name.

The original series had only two female characters of note — ship's nurse Yuki Mori and Queen Starsha. The 2012 reboot, *Space Battleship Yamato 2199*, introduced more female cast members, and the 2010 live action feature, directed by Takashi Yamazaki, switched the gender of several key characters from male to female in addition to giving Yuki the more dynamic role of a fighter pilot aboard the *Yamato*. This 2012 anime was released in Japanese cinemas in seven instalments in addition to airing on television as a 26-episode series. **DWe**

year-by-year ■ Animated TV series ■ Manga ■ Animated movie

Space Battleship Yamato
Leiji Matsumoto, Yoshinobu Nishizaki

Space Battleship Yamato 2199
Yutaka Izubuchi, Akihiro Enomoto

Cosmoship Yamato
Akita Shoken

Space Battleship Yamato II: The Comet Empire
Leiji Matsumoto, Takeshi Shirato

Space Battleship Yamato
Asahi Sonorama

Space Battleship Yamato III: The Bolar Wars
Leiji Matsumoto, Noboru Ishiguro

Space Battleship Yamato
Toshio Masuda

Star Blazers
Claster Television

1965 1970 1975 1980 1985 1990 1995 2000 2005 2010

joe haldeman 1975

The Forever War

Forever Peace

Forever Free

A Separate War

Forever Bound

The first work of "military science fiction" is usually held to be *Starship Troopers* by Robert A. Heinlein, which was published in 1959. The subgenre would have to wait a further 26 years for the first anti-war military SF novel. This was *The Forever War*, which became renowned for its masterful commentary on armed conflict and the political counterculture through the lens of science fiction.

Author Joe Haldeman was born in Oklahoma in 1943. He married Mary Gay Potter in 1965 and two years later was awarded a Bachelor of Science degree in Physics and Astronomy. In the same year he was drafted into the U.S. military to serve in Vietnam. Wounded in the course of his duties, Haldeman returned to the United States and by 1975 had completed a Master of Fine Arts in Creative Writing at the Iowa Writers Workshop. He wrote *The Forever War* as part of this degree.

This was not Haldeman's first novel. *War Year* (1972) had presented an autobiographical account of his experiences in Vietnam. But it was *The Forever War* that found a wide readership, because it put the Asian War into a science fiction framework.

The story features armored space marines, a war of genocide against alien life and details of a militaristic culture. To that extent, it is a conventional work of military SF. But it subverts the pro-military attitudes that had characterized previous works of

the same kind and instead reflects and endorses the pacifism of the 1960s' counterculture.

The Forever War follows the life of William Mandella, who, like the book's author, is a physics student conscripted to war and romantically linked to a young woman called Marygay Potter. Mandella (the name is a near-anagram of Haldeman) is sent to fight against the Taurans, initially presented as a serious threat to Earth but later revealed to be be nearly mindless and merely reacting to human aggression. The time dilation effect of space travel means that Mandella arrives back from his first tour of duty decades after he left, mirroring the alienation experienced by veterans returning from Vietnam. Mandella re-enlists to fight many more times, after each tour of duty finding himself further and further into Earth's future, and less and less like the human species to whom he returns.

Haldeman's subsequent *Forever Peace* (1997) and *Forever Free* (1999) display greater stylistic maturity but lack the visceral passion of the anti-war protest sentiments expressed in the first book. In 2008 a film version of *The Forever War* was announced, with Ridley Scott (*Bladerunner*) slated to direct. Joe Haldeman continues to write and publish widely, and teaches creative writing at MIT. He is an SFWA Grandmaster and in 2012 was inducted into the Science Fiction Hall of Fame. **DW**

year-by-year ■ Book ■ Short story

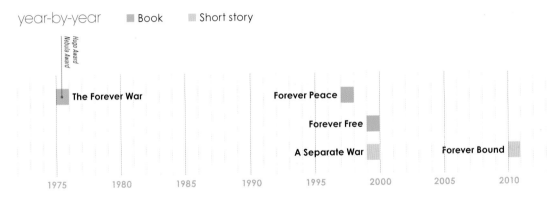

Hugo Award
Nebula Award

The Forever War

Forever Peace

Forever Free

A Separate War

Forever Bound

1975 1980 1985 1990 1995 2000 2005 2010

survivors 1975

Survivors

Survivors

Survivors:
Genesis of a Hero

Survivors

British writer Terry Nation always had a nihilistic streak, and in *Survivors* it came right to the fore.

The premise is a threat to civilization posed by a mysterious virus that wipes out most of the world's population, leaving a few people to rebuild society.

Episode one, "The Fourth Horseman," is a master class in slow-build tension. The disease is already rampant, but middle-class English life goes on as normal. David and Abby Grant are concerned, but not yet fully aware of the gravity of the situation. Abby is then taken sick; David is unaffected. We presume he will be the hero, but in a neat inversion, Abby recovers and — in a scene that recalls the start of *The Day Of The Triffids* — finds David and their friends and neighbors dead. Leaving home, she meets a few other survivors and gradually they start to build a new community.

Nation left the show at the end of the first season after a disagreement with producer Terence Dudley, but later published a novelization of the series.

After Nation's departure, the series moved in several different directions. Whereas season one is about the tough moral choices people make to survive, season two was overwhelmingly focused on the everyday trials of the survivors in a community called Whitecross. Ratings improved, but the series' lead, Ian McCulloch, decided to quit, expressing dissatisfaction with the quality of the scripts.

The third season, broadcast in 1977, shifted focus again, this time to the reintroduction of industrialization and the rebuilding of a larger society. Viewing figures began to slide. A fourth season was considered, but not filmed, with Ronnie Marsh, the BBC's Head of Serials, citing the increasing cost of location filming as the reason for its cancellation. A second *Survivors* novel, *Genesis of a Hero* by John Eyers, was also published that year.

Ian McCulloch then pitched a fourth season to the BBC, and suggested a story arc that would have seen England colonized by survivors from a prosperous African state. It was, perhaps unsurprisingly, rejected.

In 2008, the BBC launched a rebooted *Survivors*. The show was loosely based on Nation's novel, rather than on the TV show itself. The principal characters of Abby, Greg, Jenny and Tom Price were retained, but new elements, including a subplot about the origins of the virus and a stronger focus on action, were introduced. The show took pains to make sure these characters were from a broader spread of racial and social backgrounds. It received mixed reviews but viewing figures were initially strong. However, these dwindled in the second season and the show was axed.

Despite being twice cancelled, the virus refuses to die out, and in 2013 Big Finish Productions embarked on a number of audio plays. **WS**

year-by-year ■ TV series ■ Book

Survivors
📺 BBC, Terry Nation

Survivors
🖊 Terry Nation

Survivors: Genesis of a Hero
🖊 John Eyers

Survivors
📺 BBC

1970 1975 1980 1985 1990 1995 2000 2005 2010

luther arkwright 1976

The Papist Affair

**The Adventures of
Luther Arkwright**

**The Adventures of
Luther Arkwright**

Heart of Empire

**The Adventures of
Luther Arkwright**

Although black-and-white, only nine issues long and with the rough edges characteristic of an artist still learning his craft, *The Adventures of Luther Arkwright* is a key British comic and steampunk text. It's the most celebrated work of writer/artist Bryan Talbot.

Set largely on a parallel Earth where the English Civil War has been artificially prolonged to the present day by alien interference, *Luther Arkwright* follows the actions of a raffish secret agent in a leather flying jacket (who debuted in "The Papist Affair," a story in *Brain Storm Comix*). He's sent from the stable "zero-zero" reality to battle the "Disruptors," whose larger plan seems to involve destabilizing the entire multiverse through a legendary artifact named Firefrost. Luther can hop between parallels by sheer force of will, whereas his companion, Rose Wylde, uses psychic power to keep all her incarnations in every universe in touch with each other.

The experimental narrative techniques — including extended sequences where a single action is detailed over many panels, as well as numerous Nicolas Roeg-influenced leaps back and forth in time — demand the reader's full concentration.

A winner of four Eagle awards for the first mini-series edition, the project was begun in British anthology comics *Near Myths* and *Pssst!* in the late

1970s and finally completed for publication as a mini-series by the short-lived Valkyrie Press a decade later. It reached its widest audience in a U.S. reprint by Dark Horse in 1990. It was eventually adapted as an audio adventure by Big Finish Productions, with David Tennant as the hero, Siri Neal as Rose and *Blake's 7*'s Paul Darrow as an alternative version of Oliver Cromwell, the Lord Protector of England.

Even better than this was the 1999 sequel mini-series, *Heart of Empire, or the Legacy of Luther Arkwright*, initially published as nine handsomely produced issues by Dark Horse. Set 23 years later in the main neo-Cromwellian parallel from the first story, it sees a resurgent, somewhat decadent British Empire dominating the world under its psychic Queen Anne; the heroine is sickly genius Princess Victoria, Anne's only heir and the daughter of a long-disappeared Arkwright. But something is afoot, with plots to murder the royal family by Papist agents and home-grown fascists, and the guardians from zero-zero worried about a coming catastrophe. Only Victoria, perhaps with help from her missing father, can save the day.

Heart of Empire was less striking and universally loved than the original storyline, and had a somewhat lighter tone. Nevertheless it was a worthy follow-up to the original strip. **MB**

year-by-year ■ Comic ■ Audio

The Papist Affair
▢ Brain Storm Comix

The Adventures of Luther Arkwright
▢ Near Myths/pssst!

The Adventures of Luther Arkwright
▢ Valkyrie Press

The Adventures of Luther Arkwright
♪ Big Finish Productions

Heart of Empire
▢ Dark Horse

1970 1975 1980 1985 1990 1995 2000 2005 2010

2000 AD *1977*

| 2000 AD | The Best of 2000 AD Monthly | Dice Man | Judge Dredd | Judge Dredd: The Megazine | Judge Dredd |

Whereas most British comics of the 1970s were safe, *Boys' Own*-style adventure stories, those produced by the International Publishing Company (IPC) stood out as fundamentally harder and grittier. In 1975 the company's main competitor, D.C. Thomson, launched *Warlord*, a hard-hitting new military title. In response, John Sanders, head of IPC's Youth Group, brought in comic creator Pat Mills who, with fellow freelancer John Wagner, had produced *Battle Picture Weekly* and the controversial — and soon to be censured — *Action*. With *Star Wars* soon to make its debut, young staffer Kevin Gosnell saw an opening for a science fiction comic and convinced reluctant executives to back the idea. *2000 AD* surpassed expectations and had a cultural impact that extended far beyond its readership.

As was usual at the time, the title's editor was fictional, in this case a green-skinned alien called Tharg the Mighty, and early issues (referred to as "Progs") were printed on cheap pulp paper with limited color only for the covers and center spread.

Prog 1 in February 1977 featured "Flesh," in which dinosaurs eat time-traveling cowboys; "Invasion," in which truck driver Bill Savage defends Britain from an attack by Volgans (minimally fictionalized Russians); "Harlem Heroes," a strip about future sports; "M.A.C.H. 1," which was based on the hit TV series *The Six Million Dollar Man* and "Dan Dare," an updated reworking of the old *Eagle* comic's "Pilot of the Future."

Judge Dredd — a fascistic future lawman inspired by the movie *Death Race 2000* and named after a shelved occult mystery strip previously developed by Mills — made his debut in Prog 2. By then, Wagner had quit after a dispute about creator rights; Mills guided Dredd's early years until Wagner's return.

Between 1978 and 1985, *2000 AD* was a breeding ground for artistic talent. Many of those who started on this comic would later find fame in the United States; among them were Brian Bolland, Dave Gibbons, Bryan Talbot, Ian Gibson, Carlos Ezquerra, Cam Kennedy, Mick McMahon and Kevin O'Neill. Their contributions to *2000 AD* included "The VCs," a space warfare series; an adaptation of Harry Harrison's "Stainless Steel Rat" and "Rogue Trooper," a future war series.

When IPC stablemate *Starlord* merged with *2000 AD* in 1978, it brought many strips into the comic, including Pat Mills' "Ro-Busters," which led to the popular "ABC Warriors" strip, launched in 1987.

year-by-year ■ Comic ■ Video game ■ Movie

Dice Man
◻ Fleetway

Judge Dredd
⚔ Virgin Games

The Best of 2000 AD Monthly
◻ IPC

2000 AD
◻ IPC

Judge Dredd: The Megazine
◻ Fleetway/Rebellion

1975 1980 1985 1990 1995

$174M
Judge Dredd
(1995)

$36M
Dredd
(2012)

Judge Dredd:
Lawman of the
Future

Classic 2000 AD

Judge Dredd:
Dredd vs. Death

Rogue Trooper

Dredd

Judge Dredd vs.
Zombies

Another later addition to *2000 AD* was "Future Shock," a series of short, self-contained SF stories with twist endings. The writers included Alan Moore, Grant Morrison, Peter Milligan and John Smith.

With Alan Grant, Wagner produced some of the most memorable strips in British comics, including the futuristic "Robo-Hunter," SF Western "Strontium Dog" and space transportation comedy "Ace Trucking Co." They also fleshed out Dredd's world with epics such as "The Judge Child Quest" and "The Apocalypse War."

Prog 500 in 1986 introduced Milligan's SF Vietnam War series "Bad Company." Also noteworthy were Morrison's superbrat "Zenith" and Mills' "Sláine: The Horned God." The latter strip launched the career of artist Simon Bisley.

In 1990, *Judge Dredd Megazine* was brought out to compete with *Deadline* and *Crisis*, two new titles that had shown the potential of more mature, politically aware comics. Originally a fortnightly, the *Megazine* was soon reduced to monthly frequency, not because of its own shortcomings, but because the 1990s was a fallow period for comics. Even *2000 AD* struggled, and cancellation became a constant threat, in spite of the introduction of new

characters such as SF hitman Sinister Dexter and futuristic swashbuckler Nikolai Dante. The 1995 *Judge Dredd* film almost finished the comic as the market was flooded with spin-off publications including *Judge Dredd: Lawman of the Future*, a children's title incongruously based on an R-rated film.

The future looked bleak, but rebuilding under editors David Bishop and then Andy Diggle ensured that when computer games manufacturer Rebellion bought the title in 2000, the groundwork was laid for a revival. Under Matt Smith, the comic's longest-serving editor, *2000 AD* has showcased a new generation of talent, including Jock, Simon Spurrier, Boo Cook, Rob Williams, Al Ewing, D'Israeli and Ian Edginton.

Since the 1980s, *2000 AD* strips have been anthologized in graphic novel form by Titan Publishing in Britain and reformatted by Eagle Comics, Quality Comics and Fleetway in the United States. In 2010, Rebellion, which had been publishing collections of *2000 AD* material for 10 years, struck a deal with Simon and Schuster for a North American imprint.

The 2012 movie *Dredd* further raised *2000 AD*'s profile and its first Eisner Award nomination in 2013 attested the comic's ongoing influence. **MMo**

Judge Dredd
Danny Cannon

Dredd
Pete Travis

Judge Dredd: Lawman of the Future
Fleetway

Judge Dredd: Dredd vs. Death
Evolved Games

Classic 2000 AD
Fleetway

Rogue Trooper
Rebellion

Judge Dredd vs. Zombies
Rebellion

1995 2000 2005 2010 2015

star wars 1977

Star Wars
Episode IV:
A New Hope

Star Wars

Star Wars
Episode V:
The Empire
Strikes Back

A New Hope

The Empire
Strikes Back

Star Wars:
The Empire
Strikes Back

There's no science fiction franchise quite like *Star Wars*: six movies, to date, with more on the way, an endless "expanded universe" of TV shows, books, video games and comics. A seminal influence, the impact of the *Star Wars* series can be seen in the look and feel of every science fiction story since.

This is not a bad legacy for a child-friendly space opera with princesses to rescue, comedy robot sidekicks, high-tech swordplay and space dogfights, but — at the time — no real Hollywood stars, and a modest budget of $11 million.

George Lucas had studied film alongside the likes of Steven Spielberg at the University of Southern California, and had enjoyed minor critical acclaim with a dystopian science fiction feature, *THX 1138* (1971). Lucas' commercial breakthrough came two years later with *American Graffiti*, a high school coming-of-age story, revolving around car culture in his hometown of the early 1960s, and featured a minor but memorable role for a bit-part actor named Harrison Ford. As Han Solo, he would, of course, be

Star Wars' break-out star, and go on to become one of the most popular movie actors of the last 40 years.

The full list of the influences that Lucas brought to *Star Wars* seems endless, but it is fair to say that he pieced his epic together from a mighty library of classical adventure elements. There are westerns in there, as well as the tales of Robin Hood, and the Flash Gordon stories — the rights to which Lucas had once attempted to buy. From further afield, Akira Kurosawa's Edo-period samurai drama *The Hidden Fortress* — in which two peasants attempt to escort a princess and her secret treasure to safety — provided much of the structure for the first movie.

The struggle Lucas faced in bringing these elements together into a coherent storyline was nothing compared to the problems of raising finance. Deterred by the huge potential costs, original sponsors United Artists and Universal Studios both passed on the film, and it was eventually picked up by Alan Ladd at 20th Century Fox, who had been more impressed by Lucas himself than his slowly developing idea.

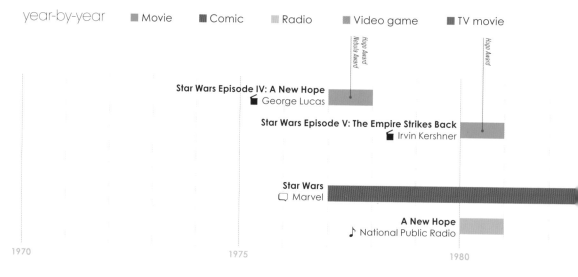

year-by-year ■ Movie ■ Comic ■ Radio ■ Video game ■ TV movie

Hugo Award
Nebula Award

Hugo Award

Star Wars Episode IV: A New Hope
🎬 George Lucas

Star Wars Episode V: The Empire Strikes Back
🎬 Irvin Kershner

Star Wars
💬 Marvel

A New Hope
♪ National Public Radio

1970 1975 1980

Star Wars Episode VI: Return of the Jedi

Ewoks: The Battle for Endor

Caravan of Courage: An Ewok Adventure

Heir to the Empire

Dark Empire I

Star Wars: X-Wing

The script had already been through two drafts by early 1975. The heroic Jedi and evil Sith — good and bad samurai clans in a vast civilization of humans and aliens that span an unnamed galaxy — were already in place. Lucas' original hero, a mature general — as used by Kurosawa in *The Hidden Fortress* — had by now become a supporting character, a young farm boy now promoted to center stage. Further refinement came later that year in a third draft: the hero Luke Skywalker was now an only child with a dead father.

Throughout this early development, it became clear that Lucas' vision was too big for a single film — or even two: "As the saga of the Skywalkers and Jedi Knights unfolded," he explained in the early 1990s, "I began to see it as a tale that could take at least nine films to tell — three trilogies — and I realized, in making my way through the back story and after story, that I was really setting out to write the middle story."

As his ideas ballooned, Lucas would remove element after element, storing them for later use. Among sections removed at a late stage from the first film included a chase through an asteroid field, saved for *The Empire Strikes Back*, and the forest battle that appeared in *Return of the Jedi*.

Lucas even continued with the modifications during the shooting of *Star Wars*. The death of warrior-priest Obi-Wan "Ben" Kenobi, for instance, was added late on, to create drama and to sidestep possible complaints that this supposedly potent figure was doing very little during the film's final act.

To realize the ground-breaking and extensive special effects, Lucas created a new company, Industrial Light and Magic, and the adoption of "used universe" aesthetics, where spaceships and equipment are battered and dirty, added greatly to the film's sense of realism.

Numerous technical issues plagued the making of *Star Wars*. In the Tunisian desert — the shooting location for the sand planet Tatooine — an unusual rainstorm ruined the first week of shooting; later, at London's Elstree Studios, the cast and crew were divided between those who took the film extremely

■ Book

Hugo Award

Star Wars Episode VI: Return of the Jedi
🎬 Richard Marquand

Caravan of Courage: An Ewok Adventure
🎬 John Karty

Heir to the Empire
✒ Timothy Zahn

The Empire Strikes Back
♪ National Public Radio

Ewoks: The Battle for Endor
🎬 Jim Wheat, Ken Wheat

Dark Empire I
▢ Dark Horse

Star Wars: The Empire Strikes Back
🎲 Parker Brothers

Star Wars: X-Wing
🎮 LucasArts

1985

1990

Star Wars: Shadows of the Empire

Star Wars Episode I: The Phantom Menace

Star Wars Episode II: Attack of the Clones

Star Wars: Clone Wars

Star Wars: Knights of the Old Republic

Lego Star Wars: The Video Game

seriously, and others who saw it as a ridiculous, overblown movie for kids. The final week, in particular, was a race against time, with three units filming simultaneously to complete things, with a frustrated Alan Ladd threatening to pull the plug on the project.

But Ladd need not have worried. When released in May 1977, *Star Wars* was a huge hit, earning $460 million in the United States and $314 million overseas, and beating *Jaws* to become the world's most financially successful film. (Adjusted for inflation, it remains one of the top-five movies of all time.)

Toward the end of 1977, Lucas hired veteran science fiction author Leigh Brackett to work his handwritten treatment for a sequel, *The Empire Strikes Back*, into a workable script. Brackett would die shortly after turning in her first draft in 1978, and Lucas — said to be unhappy with her work — began modifying the storyline himself. He added crucial new elements, such as key villain Darth Vader's claim to be Luke's father: one of cinema history's great plot twists, it nonetheless threw the entire backstory Lucas had developed into doubt.

With his attention divided between creating a follow-up to *Star Wars* and developing his own independent film-making center (Skywalker Ranch), Lucas brought on board screenwriter Lawrence Kasdan and veteran director Irwin Kershner. Excited by the new, darker tone of the Vader revelation, the pair began to take this film yet further from its serial adventure roots, layering on a tragic love story for Han and Princess Leia and much angst for Luke. It would give the film a moody feel that has, over the decades, made it the favorite of fans.

Kasdan would return to work on later drafts of the final part of the original series, *Return of the Jedi*, running with a redemption storyline for Vader, laying the foundations for the prequel trilogy that would eventually follow.

The first three *Star Wars* films had all been huge financial and critical successes, but had exhausted Lucas, who for a long time felt he was done with the project. Although in his own mind the sequel trilogy was abandoned, the origin of Darth Vader continued to fascinate him, and the success of a number of expanded universe spin-offs (in particular, a trilogy of novels by Timothy Zahn, such as *Heir to the Empire*) reminded him that there was still a large potential audience. Furthermore, the emergence of CGI

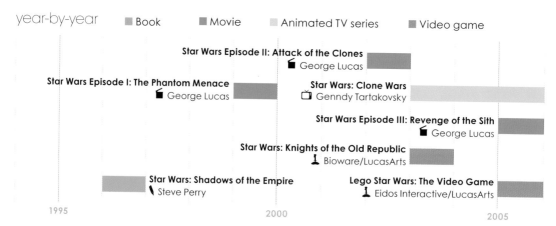

year-by-year ■ Book ■ Movie ■ Animated TV series ■ Video game

Star Wars Episode II: Attack of the Clones
George Lucas

Star Wars Episode I: The Phantom Menace
George Lucas

Star Wars: Clone Wars
Genndy Tartakovsky

Star Wars Episode III: Revenge of the Sith
George Lucas

Star Wars: Knights of the Old Republic
Bioware/LucasArts

Star Wars: Shadows of the Empire
Steve Perry

Lego Star Wars: The Video Game
Eidos Interactive/LucasArts

1995

2000

2005

$605M
Star Wars Episode I:
The Phantom Menace
(1999)

$392M
Star Wars Episode II:
Attack of the Clones
(2002)

$455M
Star Wars Episode III:
Revenge of the Sith
(2005)

Star Wars
Episode III:
Revenge of the
Sith

Star Wars:
The Clone Wars

Star Wars:
The Clone Wars

Star Wars Rebels

technology during the 1990s made possible creatures and special effects that two decades earlier would have been unimaginable.

In 1994 Lucas began writing what he initially called *Episode I: The Beginning*. It would cover the discovery of Anakin Skywalker, a young child with remarkable affinity to the Force, and the start of a devious space-senator's quest to promote himself to emperor. A second prequel film would be spun out of the "Clone Wars" mentioned briefly by Princess Leia in the original movie, whereas the third would deal with Anakin's final fall to the Dark Side and his rebirth as Darth Vader. Lucas would continue with his refinements: even after principle shooting was complete on this last prequel, *Revenge of the Sith*, he made extensive rewrites.

Although huge box-office hits and undoubted visual spectaculars, the prequel trilogy remain relatively unloved by most fans, their overall story lines inessential, their heroes less compelling. By adding so much unconvincing political machination and technical detail, much of the magic of the original trilogy had been lost.

Still, their success was both huge and game-changing. Now, rather than a single trilogy, *Star Wars* had become not unlike Lucas' original vision: a vast universe in which many stories could be told in many mediums, rather like the *James Bond* series.

Lucas himself had no great plans to develop a third, sequel trilogy — "I get asked all the time, 'What happens after Return of the Jedi?,' and there really is no answer for that," he said in 2008 — but not everyone agreed. Following its success in buying Marvel Comics and turning that into a hothouse for summer blockbuster movies, The Walt Disney Company in 2012 agreed to purchase Lucasfilm, and immediately announced that a new *Star Wars: Episode VII* film would be released in 2015. J.J. Abrams, fresh from *Star Trek*, would produce and direct the first one, and there would be more to follow.

Even Lawrence Kasdan would return, to help write the eighth and ninth episodes, as well as a number of stand-alone films set within this universe, which many believe to include origin stories for Han Solo and cult favorite mercenary villain Boba Fett.

In the meantime, an endless stream of spin-offs across all media continues, including a lucrative link with Danish construction toy empire, Lego. The *Star Wars* story is in no way over yet. **PM**

■ Animated movie

Star Wars Rebels
📺 Lucasfilm/Disney

Star Wars: The Clone Wars
📺 George Lucas

Star Wars: The Clone Wars
🎬 Dave Filoni

2010 2015

star wars universe

Yoda **Palpatine** **Anakin Skywalker/ Darth Vader** **Obi-Wan Kenobi** **Luke Skywalker** **Leia Skywalker** **Chewbacca** **Han Solo**

It is the dawn of a galactic civil war engineered by the evil Palpatine, a kindly senator who is secretly a Dark Lord of the Sith. Jedi Knights Qui-Gon Jinn and Obi-Wan Kenobi help the monarch of blockaded planet Naboo, Padmé Amidala, flee. Landing on backwater world Tatooine for repairs, they find a young slave, Anakin Skywalker, who is in tune with The Force, the power used by the Jedi. Believing Anakin to be a "Chosen One," Qui-Gon brings him to capital world Coruscant, where the Jedi Council reluctantly allows Obi-Wan to train him after Qui-Gon is killed.

As war rages, Anakin and Padmé secretly marry. When Anakin suffers a vision of Padmé dying,

Palpatine claims the dark side of the Force can save her. Anakin is won over, becoming Darth Vader.

Obi-Wan defeats Anakin and leaves him to die. But Vader is rebuilt by Palpatine. Meanwhile, Anakin's nightmare comes true. Padmé dies in childbirth: their twins Luke and Leia are hidden away.

Nineteen years later, the Galactic Empire's chief weapon is the Death Star, a space-station capable of destroying planets. The Emperor plans to use this to end all resistance. Vader captures Princess Leia of Alderaan — unaware she is his daughter — who has stolen the Death Star's plans and hidden them in droid R2-D2. R2 escapes with his companion C-3PO to

characters

- Yoda
- Luke Skywalker
- Qui-Gon Jinn
- Palpatine
- Leia Skywalker
- Padmé Amidala
- Anakin Skywalker/Darth Vader
- Chewbacca
- R2-D2
- Han Solo
- Obi-Wan Kenobi
- C-3PO

Palpatine elected to the Galactic Senate as Senator of Naboo

Darth Maul born

Millennium Falcon built

Qui-Gon Jinn becomes a Jedi Knight

Palpatine becomes Darth Sidious

Yoda a Jedi Master

Trade Federation formed

C-3PO built on Affa

896 BBY 796 BBY 350 BBY 200 BBY 112 BBY 90 BBY 80 BBY 70 BBY 60 BBY 50 BBY

C-3PO

Qui-Gon Jinn

Padmé Amidala

R2-D2

nearby Tatooine where the pair are bought by Luke Skywalker, Vader's hidden son. Luke discovers a secret message addressed to Obi-Wan Kenobi, and goes to see a local hermit with a similar name. With Imperial stormtroopers hot on their tail the companions escape in the company of smuggler Han Solo and his co-pilot, Chewbacca.

Obi-Wan tells Luke something of his history, but not who his father really is. Finding Alderaan destroyed, Luke and Han rescue Leia from the Death Star, where Obi-Wan is killed. When the Death Star attacks a Rebel base, Luke fires the shot that destroys it, guided by the Force.

Three years later, Luke seeks out Yoda, last member of the Jedi Council, in exile. He begins his Jedi training, but cuts it short when Vader lures him into a trap by capturing his friends. During a duel, Vader reveals that he is Luke's father. Luke escapes, along with his friends.

Luke rescues Han from the gangster Jabba the Hutt, before learning the truth from a dying Yoda and the ghost of Obi-Wan. As the Rebels attack the second Death Star, Luke battles Vader. Luke spares Vader's life, proving he will not turn. Palpatine attempts to kill Luke, stirring Vader to kill Palpatine. Now redeemed, Anakin dies as the Rebels triumph. **PM**

Palpatine becomes Supreme Chancellor in perpetuity

Clone Wars

Anakin marries Padmé

Han Solo and Chewbacca become partners

Han Solo wins *Millennium Falcon*

Battle of Yavin

Luke learns his destiny

Darth Vader kills Obi-Wan Kenobi

Senator Palpatine elected Supreme Chancellor

Palpatine becomes Emperor

Luke Skywalker learns Vader is Anakin

Battle of Hoth

Obi-Wan Kenobi become's Qui-Gonn's Padawan

Anakin Skywalker discovered by Jedi

Anakin becomes Darth Vader

Yoda dies

Battle of Endor

Blockade of Naboo

Padmé dies

Darth Sidious killed by Darth Vader

R2-D2 built

Rebel Alliance founded

New Republic (Est. 4 BBY) captures Coruscant

C-3PO rebuilt

Leia Organa marries Han Solo

50 BBY | 40 BBY | 30 BBY | 20 BBY | 10 BBY | 0 BBY | 10 ABY | 20 ABY | 30 ABY | 40 ABY

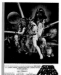

Star Wars Episode IV: A New Hope (1977)

Star Wars Episode V: The Empire Strikes Back (1980)

Star Wars Episode VI: Return of the Jedi (1983)

Veteran British actor Sir Alec Guinness portrayed Obi-Wan Kenobi in the original **Star Wars** trilogy. An unusual royalty arrangement made him very wealthy in his old age.

Carrie Fisher (Princess Leia) and Mark Hamill (Luke Skywalker) in the original 1977 movie.

Producer Gary Kurtz (left) and Director George Lucas (right) first worked together in 1973 on the high school coming-of-age movie, American Graffiti.

According to George Lucas, the original design of Han Solo's ship, the Millennium Falcon, was inspired by a hamburger.

Doug Beswick designed the costumes for Figrin D'an and the Modal Nodes, a band of Bith musicians hailing from the planet Clak'Dor VII.

The mighty AT-AT "walkers" that feature in **The Empire Strikes Back** were, in fact, less than two feet tall, and were filmed using stop-motion animation.

Luke Skywalker (Mark Hamill) seeks the power of the Force from Grand Jedi Master Yoda in *The Empire Strikes Back*.

On the strength of his 1981 spy thriller, *Eye of a Needle*, George Lucas chose Richard Marquand to direct the third part of the original *Star Wars* trilogy — *Return of the Jedi*.

Actor Michael Carter recalled that the make-up for his character, Bib Fortuna, took over eight hours on his first day of shooting *Return of the Jedi*.

Jabba the Hutt's sail barge seen during construction in the Arizona desert for 1983's *Return of the Jedi*.

Darth Vadar, the principal antagonist of the original trilogy, was portrayed by British bodybuilder David Prowse, and voiced by James Earl Jones.

Star Wars Episode I: The Phantom Menace (1999)

Star Wars Episode II: Attack of the Clones (2002)

Star Wars Episode III: Revenge of the Sith (2005)

Star Wars: The Clone Wars (2008)

Nine-year-old slave Anakin Skywalker wins his freedom in a high-speed podracing tournament, one of the most specacular sequences from *Star Wars Episode I: The Phantom Menace*.

Padmé Amidala (Natalie Portman), the 14-year-old Queen of Naboo, appears in *Star Wars Episode I: The Phantom Menace*.

The Trade Federation Lucrehulk-class batteships appear in all three of the prequel films.

British horror legend Christopher Lee added the evil Sith lord Count Dooku to the lengthy roster of villains he has played.

A Delta-7 Aethersprite-class light interceptor — better known as a Jedi starfighter — engages in battle in *Star Wars Episode II: Attack of the Clones*.

Tion Medon (Bruce Spence) greets Obi-Wan Kenobi (Ewan McGregor) in *Star Wars Episode III: Revenge of the Sith*.

A puppet in the original trilogy, Yoda was rendered with computer animation in the prequels. He was voiced throughout by Frank Oz, famed for his work with the Muppets.

Set chronologically between the second and third parts of the prequel trilogy, the CGI animated movie *Star Wars: The Clone Wars* was an introduction to the TV series of the same name that ran from 2008 to 2014.

ender's game 1977

Ender's
Game

Ender's
Game

Speaker for
the Dead

Xenocide

Children of
the Mind

Ender's
Shadow

Ender's
Game

Ender's
Game

Orson Scott Card is one of the biggest names in contemporary science fiction, and one of the most controversial. He started his career as a poet, has written plays, comic books and dialogue for video games, as well as in numerous other genres, including fantasy, horror and historical fiction.

The controversy comes from his statements and essays as an active member of The Church of Jesus Christ of Latter-day Saints, in particular those that some view as homophobic. What everyone agrees upon, however, is the brilliance of his writing, and of one novel in particular — Ender's Game.

Published in 1985, it won both Hugo and Nebula Awards (as did its sequel, Speaker for the Dead, making Card the only writer to win both in two consecutive years), and has been filmed by Gavin Hood, director of X-Men Origins: Wolverine.

First published in 1977 as a short story in Analog magazine, "Ender's Game" tells of a school created to turn young children into military commanders in readiness for an impending interstellar war against an unnamed enemy. Battle School's star cadet is Andrew "Ender" Wiggins, who quickly becomes so successful a leader in competitive war games that he is fast-tracked to the next stage of his education. At Command School, Ender is taught to use a sophisticated space battle simulator in complex campaigns against a computer-controlled enemy.

After winning his skirmishes and successfully destroying the enemy home planet, he is devastated to learn that this was not, in fact, a simulation — his commands had been relayed to a genuine space fleet which really had just destroyed an entire world and won the war.

Card's expanded novel provided additional background to Ender Wiggin (his name slightly changed) and to the space war. His motivation to write this version, though, was primarily so that he could set Ender up for his role in the sequel, as the "Speaker for the Dead" — an anonymous author of books explaining the war through the eyes of both sides. Set some 3,000 years later, but with Ender still only around 35 years old (thanks to relativistic space travel), Speaker for the Dead follows his journeys among assorted human colonies. A more philosophical novel in tone, it was followed in the 1990s by two further sequels, Xenocide and Children of the Mind, and then further novels expanding the universe. Ender in Exile features his adventures immediately after the war, whereas the "Shadow Saga," four books, starting with Ender's Shadow (1999), tells the stories of his sadistic older brother and the other Battle School children.

The series gained a new audience in 2008 when Marvel introduced its comic series, and again in 2013 with the moderately successful movie version, starring Asa Butterfield as Ender, and Harrison Ford and Ben Kingsley as his manipulative superiors. **MB**

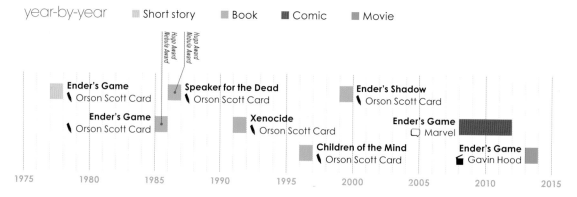

year-by-year ▧ Short story ■ Book ▮ Comic ▪ Movie

Hugo Award
Nebula Award

Hugo Award
Nebula Award

Ender's Game
❦ Orson Scott Card

Speaker for the Dead
❦ Orson Scott Card

Ender's Shadow
❦ Orson Scott Card

Ender's Game
❦ Orson Scott Card

Xenocide
❦ Orson Scott Card

Ender's Game
▢ Marvel

Children of the Mind
❦ Orson Scott Card

Ender's Game
◗ Gavin Hood

1975 1980 1985 1990 1995 2000 2005 2010 2015

close encounters of the third kind 1977

Close Encounters of the Third Kind

Close Encounters of the Third Kind

Close Encounters of the Third Kind

Steven Spielberg's interest in UFOs and the extraterrestrial was sparked into life in 1957 when he and his father watched a meteor shower. The spectacle inspired him, seven years later, to make his first full-length feature, *Firelight*, a 135-minute, 8 mm movie made on a $600 budget. It was aired at his local cinema and delivered a $200 profit.

A decade later, and with *Duel* and *Sugarland Express* cementing his reputation as a director to watch, Spielberg approached Columbia Pictures with his idea for a UFO movie. The precocious 27-year-old managed to secure a deal with a budget of $2.8 million — a figure he plucked out of thin air as one the ailing studio might accept.

Initially entitled *Watch the Skies* (a line taken from 1951 alien flick, *The Thing From Another World*), the story concerns the fate of electrical lineman Roy Neary who, following a dramatic experience with an extraterrestrial ship, finds himself fixated on Devil's Tower in Wyoming. As his obsession grows, he becomes estranged from his family and even ignores warnings of a faked nerve gas leak in order to reach the mountain. Along the way he hooks up with Jillian Guiler (Melinda Dillon), who believes her son has been taken by aliens. The pair make their way to Devil's Tower just as the UN's top secret Mayflower Project is preparing for humanity's first official "close encounter of the third kind." (The name of the film refers to ufologist J. Allen Hynek's classification system for alleged UFO sightings.)

For the climactic meeting, Spielberg employed two giant disused aircraft hangars at Brookley Air Force Base in Mobile, Alabama. Box Canyon was the biggest indoor movie set ever constructed, costing $700,000 to build and requiring a mile of custom-made black cloth for the scenic backing.

As much as this human tale of compulsion and discovery was engaging, it would have been nothing without the work of the special visual effects artists of Future General, led by Douglas Trumbull (*2001: A Space Odyssey*, *Blade Runner*). Pushing the state of pre-CGI photography to its very limit, the crew managed to create a host of believable UFOs in a dazzling ballet of spotlights and lens flares.

The final element was John Williams' emotive and iconic soundtrack that is as much a part of the film itself, thanks to the "five tones" theme and the breathtaking musical conversation between the mothership and an ARP synthesizer.

By the time Spielberg finished filming, *Close Encounters of the Third Kind* had cost $19.4 million, making it, then, one of the most expensive movies ever produced. Yet its positive, uplifting message — unlike most space invasion fare, these aliens are peace-seeking beings — and awe-inspiring visuals struck a chord with the movie-watching public. A box-office smash, it would gross $288 million worldwide.

A novelization and Marvel comic series quickly followed the movie, and then in 1980, Spielberg produced *The Special Edition*, which added scenes left out of the original.

UFO sightings had tailed off as Cold War paranoia began to fade, but quickly shot back up again once Spielberg had compelled us to watch the skies. **SJ**

year-by-year ■ Movie ■ Book ■ Comic

Close Encounters of the Third Kind ■ **Close Encounters of the Third Kind**
🎬 Steven Spielberg ▢ Marvel

Close Encounters of the Third Kind ■
🎬 Steven Spielberg

| 1965 | 1970 | 1975 | 1980 | 1985 | 1990 | 1995 | 2000 |

judge dredd 1977

Judge Dredd

Judge Dredd

Judge Dredd

Judge Dredd

Judge Dredd: The Megazine

Batman/ Judge Dredd: Judgement on Gotham

Death- masques

Judge Dredd: Legends of the Law

Created by John Wagner and Carlos Ezquerra, Judge Joseph Dredd has appeared since 1977 in *2000 AD*, the weekly anthology title published by Britain's Independent Publishing Corporation (IPC).

Dredd is a fascistic policeman living 122 years in the future in Mega-City One, a vast crime-ridden megalopolis of 400 million people on the east coast of the United States. He has draconian powers to summarily execute criminals or arrest citizens for the smallest misdemeanors.

After the success of its *Battle Picture Weekly* and *Action* comics, IPC here applied the same set of values to science fiction. The concept was based on idea by Kevin Gosnell. John Wagner then adapted editor Pat Mills' previously rejected idea for an occult strip called "Judge Dread" by changing the spelling and taking inspiration from "One-Eyed Jack," his own cop series for *Valiant*, and from the 1971 movie *Dirty Harry*.

Dredd's distinctive uniform of leather overalls and large protective pads was based on an ad for the film *Death Race 2000* and developed by Spanish artist Carlos Ezquerra, who introduced the leitmotif of the helmet, which Dredd never removes.

Whereas Britain's other leading comic character, Dan Dare, was developed from along the optimistic lines of *Boy's Own*-style publications, Dredd was an expression of the increasing skepticism with which politics was viewed in the 1970s. Dredd serves a brutal and repressive system, but his incorruptible principles make him an unlikely anti-hero; the strip is thus part dystopian SF, part black comedy.

Cloned from the DNA of the "Father of Justice" Judge Fargo, Dredd rides a formidable Lawmaster motorbike, and his Lawgiver gun fires six types of ammunition. Unusually for a comic book character, he ages in real time.

Following arguments with IPC management over character ownership, Wagner left *2000 AD* at the time of its launch. His first Dredd script — "Bank Raid" — was deemed too violent and wasn't used until 1981.

The first published episode, "Judge Whitey," written by Paul Harris, appeared in the second edition of *2000 AD* in March 1977. Ezquerra was unhappy that the first episode of his character was drawn by new artist Mick McMahon, so he too left the title, and did not return to it until 1982.

year-by-year ■ Comic ■ Game ■ Video game ■ Book ■ Movie

Judge Dredd
2000 AD

Judge Dredd
Daily Star

Judge Dredd
Games Workshop

Judge Dredd: The Megazine
Fleetway

Judge Dredd
Melbourne House

Batman/Judge Dredd: Judgement on Gotham
Simon Bisley, Alan Grant, John Wagner

Deathmasques
Dave Stone

1975 1980 1985 1990 1995

$174M
Judge Dredd
(1995)

$36M
Dredd
(2012)

| Judge Dredd | Predator vs. Judge Dredd | Judge Dredd: Lawman of the Future | Batman/ Judge Dredd: Die Laughing | Wanted: Dredd or Alive | Dredd vs. Death | Dredd vs. Zombies | Dredd |

When Wagner returned to the strip, he and writer Alan Grant developed its black humor and hyper-violence. The strip now mixes police procedurals and complex political intrigues with shorter, madcap stories.

Many comic creators who formed the late-20th-century "British Invasion" of the United States cut their professional teeth on Judge Dredd. Those for whom it was a proving ground included Brian Bolland, Steve Dillon, Garth Ennis, Mark Millar, Grant Morrison, Ron Smith and Jock.

Dredd's opponents have included his clone brother, Rico; Judge Death and the Dark Judges, undead villains from another dimension where life is a crime; Mean Machine Angel, a one-armed homicidal maniac; P.J. Maybe, a teenage serial killer and Chopper, a sky-surfing juvenile delinquent.

The strip has had several spin-off characters, including psychic Judge Cassandra Anderson, and spawned a plethora of "Dredd World" series, most of which debuted in companion publication *Judge Dredd: The Megazine*. It has also afforded scope for "mega-epic" multipart stories. The first of these, "Robot Wars," featured an uprising by an automaton workforce; "The Cursed Earth" detailed an irradiated wasteland; "The Apocalypse War" involved a Soviet invasion and "Day of Chaos" concerned a terrorist biological attack that reduced the population of Mega-City One to just 50 million.

Since 1986, the strip has become more politically aware. Dredd resigned over his doubts about the system's harshness only to return in "Necropolis" (1990) to fight the Dark Judges. "America" (1990) introduced the pro-democracy terrorists of Total War.

Dredd has crossed over with other franchises, including Batman in *Judgment on Gotham*. Two U.S.-format titles were launched by DC Comics in 1994, but lasted barely a year. There were two series of Judge Dredd novels, and audio stories. The 1995 Hollywood adaptation was generally disliked by fans for tonal inconsistencies and because Sylvester Stallone in the title role removed his helmet. The more faithful R-rated 2012 adaptation, *Dredd*, starring Karl Urban and written by Alex Garland, flopped but ignited new interest in the character. In the same year, publisher IDW began a new series of comics, which are set outside *2000 AD* continuity. **MMo**

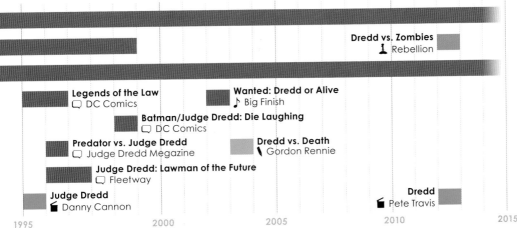

■ Audio

Dredd vs. Zombies
⚔ Rebellion

Legends of the Law
▢ DC Comics

Wanted: Dredd or Alive
♪ Big Finish

Batman/Judge Dredd: Die Laughing
▢ DC Comics

Predator vs. Judge Dredd
▢ Judge Dredd Megazine

Dredd vs. Death
🖊 Gordon Rennie

Judge Dredd: Lawman of the Future
▢ Fleetway

Judge Dredd
🎬 Danny Cannon

Dredd
🎬 Pete Travis

1995 2000 2005 2010 2015

judge dredd universe

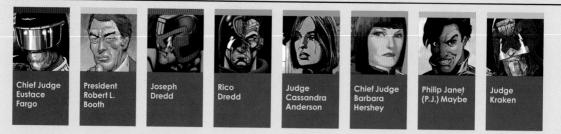

Chief Judge Eustace Fargo

President Robert L. Booth

Joseph Dredd

Rico Dredd

Judge Cassandra Anderson

Chief Judge Barbara Hershey

Philip Janet (P.J.) Maybe

Judge Kraken

Mega-City One is a 22nd-century megalopolis that dominates the eastern seaboard of post-apocalyptic America. In this dystopia the Judges keep order. A paramilitary force established in 2031 by Eustace Fargo, they are judge, jury and executioner.

A clone of Fargo, Dredd is known and feared for his unbending application of the law. Less than a year after graduating, he discovers that his clone-brother Rico is corrupt and arrests him, sending him to the penal colony on Titan. Rico later escapes and attempts to exact revenge, but Dredd shoots him.

Dredd has saved the city many times from all manner of threats. He has few persistent enemies, but these include one-armed cyborg Mean Machine Angel, serial killer P.J. Maybe and sky-surfer Chopper.

Aided by his psychic colleague Judge Cassandra Anderson, Dredd has also repeatedly defeated the Dark Judges — undead creatures from another dimension where all life is a crime. One of his most notable actions occurred during the Apocalypse War against East Meg One, where Dredd led a mission deep into Soviet territory and destroyed the enemy city entirely.

After the attack of "the Judda" — a clone army created by renegade Judge Morton Judd — a possible replacement is found for the aging Dredd. The Judda Kraken — also a Fargo clone — is taken prisoner and re-educated. Dredd undertakes Kraken's final assessment and fails him. However, Dredd's doubts about the Judge system lead to him

characters

- Chief Judge Eustace Fargo
- Rico Dredd
- Philip Janet (P.J.) Maybe
- President Robert L. Booth
- Judge Cassandra Anderson
- Judge Kraken
- Joseph Dredd
- Chief Judge Barbara Hershey

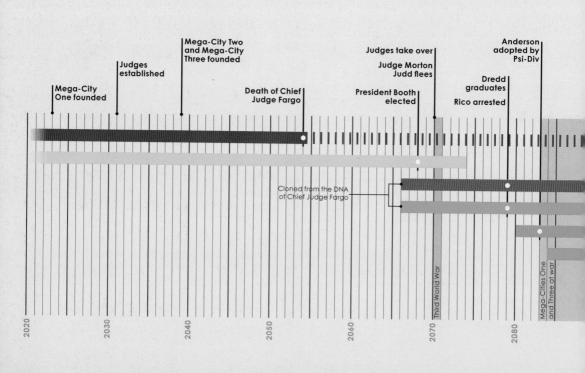

Mega-City One founded

Judges established

Mega-City Two and Mega-City Three founded

Death of Chief Judge Fargo

Judges take over

Judge Morton Judd flees

President Booth elected

Anderson adopted by Psi-Div

Dredd graduates

Rico arrested

Cloned from the DNA of Chief Judge Fargo

Third World War

Mega-Cities One and Three at war

2020 2030 2040 2050 2060 2070 2080

taking the Long Walk into the Cursed Earth; the sole, terminal retirement option for judges. Chief Judge Silver then secretly replaces Dredd with Kraken. Kraken is weak and the supernatural Sisters of Death use him to bring Judge Death and the Dark Judges back from limbo. Dredd returns to the ravaged city to defeat them.

Demand for democratic change in Mega-City One leads to a referendum in 2113. The Judges' overwhelming victory forces the pro-democracy movement underground. This seems to settle the matter, until Judge Fargo's long-lost body is rediscovered, not dead but in suspended animation. Just before his actual death, Fargo tells Dredd that the Judge system was never intended to be permanent.

This revelation only fuels Dredd's disquiet with the system. He comes to believe that the city's harsh anti-mutant laws are unjust. Their repeal leads to problems and when Chief Judge Hershey loses an election to anti-mutant candidate Judge Dan Francisco, Dredd is exiled to the mutant townships in the Cursed Earth. Dredd discovers that the Deputy Chief Judge has conspired to oust Francisco from office and arrests him. This instability leaves the city vulnerable to attack by vengeful East-Meg One survivors, who use a virus to wipe out more than 85 percent of the population. Dredd's doubts about the Judges' legitimacy are put aside, at least for now, as they attempt to rebuild the shattered city. **MMo**

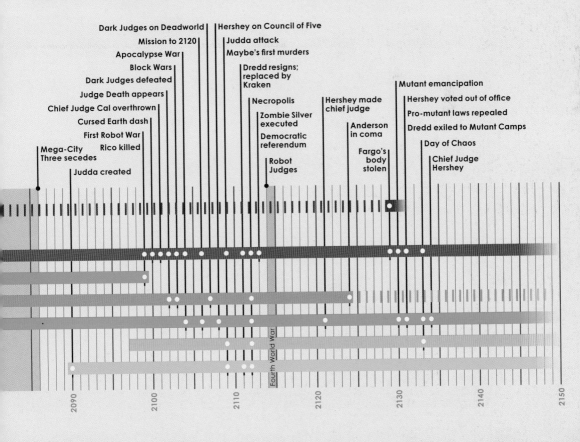

Judge Dredd
(1977–present)

Judge Dredd
(1995)

Dredd
(2012)

**Judge Dredd
Year One**
(2013)

Early Judge Dredd storylines played hard on Cold War fears of Soviet attack.

During Dredd's frequent absences from Mega-City One, the crims get busy; but he always returns to sort them out.

Judge Death and the Dark Judges are among Dredd's most formidable adversaries.

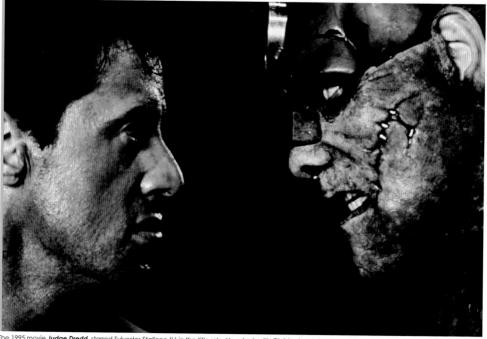

The 1995 movie **Judge Dredd** starred Sylvester Stallone (L) in the title role. Here he is with Christopher Adamson as Mean Machine Angel.

Sylvester Stallone as Judge Dredd and Diane Lane as his faithful sidekick Judge Hershey in the original movie version.

Stallone fights wrongdoers but went wrong himself in the 1995 movie by removing his helmet.

Dredd (2012), directed by Pete Travis, took a loss, but revived interest in the comic strip character.

Karl Urban as the eponymous enforcer in **Dredd** (2012). Despite a favorable reception, the film was barely profitable. However, there remains the possibility of a sequel.

The four-issue mini-series **Judge Dredd – Year One** is set during Dredd's first year as a judge.

gateway 1977

| Gateway | Beyond the Blue Event Horizon | Heechee Rendezvous | The Annals of the Heechee | The Gateway oncordance | Frederik Pohl's Gateway | Gateway II: Homeworld | The Boy Who Would Live Forever |

Gateway is the first and best novel in Frederik Pohl's *Heechee* sequence. In this fictional universe, visited first in the short story "The Merchant of Venus" (1972) humankind stumbles across artifacts of a mysterious — and apparently extinct — alien civilization. One of these finds is Gateway, a hollow asteroid orbiting perpendicular to the plane of our Solar System's ecliptic. One thousand spaceships are docked there. Although their workings are unfathomable, each has a destination preset into its navigation systems. So much time has passed since the alien Heechee abandoned the facility that most destinations have become deadly to humans or are otherwise useless. No one knows how long each trip will take. Starvation is a real danger. However, the potential rewards for those who find new technology, sources of minerals or habitable planets are enormous. To the impoverished inhabitants of overcrowded Earth, the benefits of trips on these craft far outweigh the risks.

Protagonist Robinette Broadhead makes three trips from gateway. The final journey is a disastrous experiment involving two ships. They emerge by a black hole and everyone else is killed. The story leaps between Broadhead's experience as a "Prospector" and his therapy sessions with an AI psychologist as he struggles to come to terms with his guilt.

The *Heechee* sequence was unusual for its time in establishing a galaxy that is barely comprehensible to humanity. The sequels reveal that out in the stars lurk the Assassins, creatures that are adding mass to the universe in the hope of creating a new Big Bang. The Heechee took refuge from the Assassins in a black hole 500,000 years ago, but they left their technology near Earth in the hope that humankind would one day figure out how to use it. They did not anticipate that it would be wasted by galactic joyriders. The Heechee return in the third novel, and the ensuing conflict with the Assassins eventually results in an uneasy détente engineered by Broadhead.

This concept of an empty cosmos dogged by ancient threats uncovered by the naïve human race has since become very popular in science fiction, appearing many times in games such as Halo and in movies such as *Alien*. Many writers — notably Paul McAuley and Neal Asher — have employed the convention in their novels.

In 1992, Gateway was adapted into a computer game by Legend Entertainment. The game loosely followed the novel's plot until the end, when it diverged from it entirely. A second game followed in 1993, this one with a mostly original storyline that nevertheless used many of Pohl's elements. **GH**

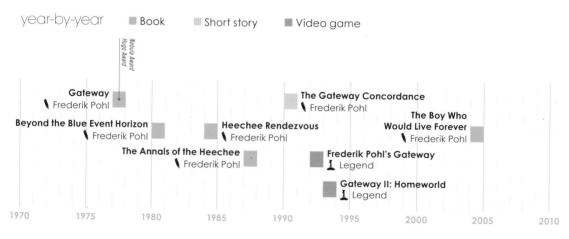

year-by-year ■ Book ■ Short story ■ Video game

Nebula Award / Hugo Award

Gateway
↖ Frederik Pohl

Beyond the Blue Event Horizon
↖ Frederik Pohl

The Annals of the Heechee
↖ Frederik Pohl

Heechee Rendezvous
↖ Frederik Pohl

The Gateway Concordance
↖ Frederik Pohl

The Boy Who Would Live Forever
↖ Frederik Pohl

Frederik Pohl's Gateway
↥ Legend

Gateway II: Homeworld
↥ Legend

1970 1975 1980 1985 1990 1995 2000 2005 2010

blake's 7 1978

Blake's 7

Blake's 7

The SevenFold Crown

The Syndeton Experiment

A Rebellion Reborn

The Early Years

The Liberator Chronicles

Praised for its characterization and moral ambiguity as much as it was derided for its low-budget effects, *Blake's 7* originated on BBC Television in 1978. Over four series, the adventures of Roj Blake (Gareth Thomas) attracted strong viewing figures and have retained a loyal fandom since they ended in 1981.

Blake's 7 (the original logo had no apostrophe) was developed by Terry Nation, creator of *Doctor Who*'s Daleks and the post-apocalyptic drama *Survivors* (1975–77). It was pitched as a Western in space, a "kidult" science fiction adventure set in a dystopian future. Earth is ruled by a totalitarian Federation, its citizens kept in docile order in domed cities. One-time rebel Blake is found guilty of trumped-up charges and banished to a distant penal colony. En route there, he and fellow prisoners Avon (Paul Darrow) and Jenna (Sally Kynvette) are ordered to investigate a derelict alien spacecraft. Commandeering the powerful ship, they rescue two more prisoners — Vila (Michael Keating) and Gan (David Jackson). Naming the ship *Liberator*, Blake begins his crusade against the Federation. Later in series one, the crew is completed by the telepathic Cally (Jan Chappell). Federation forces are represented by Supreme Commander Servalan (Jaqueline Pearce) and Space Commander Travis (Stephen Greif).

Nation was commissioned to write all 13 episodes of the first series, but he soon ran out of ideas. First drafts were delivered, and Chris Boucher was tasked with turning them into workable scripts.

One of many SF properties created in the wake of *Star Wars*, *Blake's 7* was a big hit. Despite a tight budget, the effects were of a high standard, and the characterization made up for threadbare production values. The series averaged over nine million viewers and a second series was commissioned, although Nation would write only three episodes of this.

Thomas and Knyvette declined to return for the third series, but the audience stayed faithful to the show with Avon as the lead. The Blake/Jenna vacuum was filled by Dayna Mellanby (Josette Simon) and Del Tarrant (Steven Pacey).

Liberator was destroyed in the final episode of series three, so the hastily commissioned fourth series introduced a new ship, *Scorpio*, and new characters. In "Blake," the series' finale, Blake returned and was killed by a paranoid Avon. With shades of Nation's original Western influence, *Blake's 7* ended with the crew gunned down by Federation troopers in slow motion, Avon left standing over Blake's body.

Blake's 7 was later revived in various forms. Two BBC radio plays reunited the cast in 1998 and 1999. There was a rebooted audio series, *Blake's 7: A Rebellion Reborn* (2006), and the surviving members of the original cast appeared in *The Liberator Chronicles* audio series (from 2012).

In 2013 the U.S. SyFy cable channel announced a TV remake of *Blake's 7* with Martin Campbell, the director of the 2006 version of *Casino Royale*, reportedly slated to take charge of the pilot. **MW**

year-by-year ■ TV series ■ Magazine ■ Audio

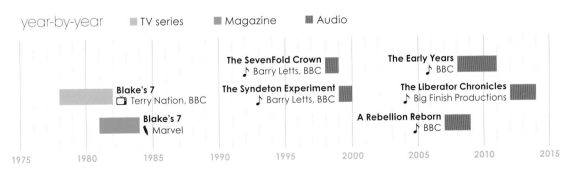

The SevenFold Crown
♪ Barry Letts, BBC

The Syndeton Experiment
♪ Barry Letts, BBC

The Early Years
♪ BBC

The Liberator Chronicles
♪ Big Finish Productions

A Rebellion Reborn
♪ BBC

Blake's 7
▢ Terry Nation, BBC

Blake's 7
❭ Marvel

1975 1980 1985 1990 1995 2000 2005 2010 2015

the hitchhiker's guide to the galaxy 1978

The Hitchhiker's Guide to the Galaxy

The Hitchhiker's Guide to the Galaxy

The Hitchhiker's Guide to the Galaxy

The Restaurant at the End of the Universe

The Restaurant at the End of the Universe

The Hitchhiker's Guide to the Galaxy

Life, the Universe and Everything

So Long, and Thanks for All the Fish

The Hitchhiker's Guide to the Galaxy is the yardstick against which all other attempts to meld SF with humor are measured. Its creator Douglas Adams had an eclectic background which took in both *Monty Python's Flying Circus* and *Doctor Who*, on which he served as occasional writer and script editor.

The Hitchhiker's Guide first appeared in March 1978 as a six-part radio serial on the BBC. A seventh episode followed in December with a further five in January 1980, by which time the series had already been adapted into three other media. All these variants (and most subsequent ones) were written wholly or partly by Adams, who had never had any qualms about contradicting previous versions.

At the 1979 World Science Fiction Convention, *Hitchhiker's Guide* became the only radio show ever nominated for a Hugo Award, but it lost out to *Superman: The Movie*. Then the novel, published in the same year, made Adams a millionaire. Only the first four radio episodes were adapted, ostensibly because of deadline problems but actually because of a disagreement with John Lloyd, co-writer of episodes five and six.

A second bestseller, *The Restaurant at the End of the Universe*, was adapted from the other two episodes of the first series and material from the second series. A six-part television serial, following a similar storyline to the first radio series but with some major deviations, was warmly received. Several of the radio cast members were retained and the narration was cleverly illustrated with "computer graphics" that were actually traditional cel animation.

Life, the Universe and Everything, the third novel, was touted as original material but was actually adapted from an unused *Doctor Who* story. Adams then collaborated on an "interactive fiction" computer game of *Hitchhiker's Guide*. This entirely text-based adventure was a massive worldwide hit when released in 1984. In the same year came the fourth novel, *So Long, and Thanks for All the Fish*.

Wearying of *Hitchhiker's Guide*, Adams wrote *Dirk Gently's Holistic Detective Agency*; alert fans quickly spotted that this novel wasn't particularly original but was again adapted from old *Doctor Who* stories. A sequel, *The Long Dark Tea-Time of the Soul*, followed; after Adams' death the character of Dirk Gently was

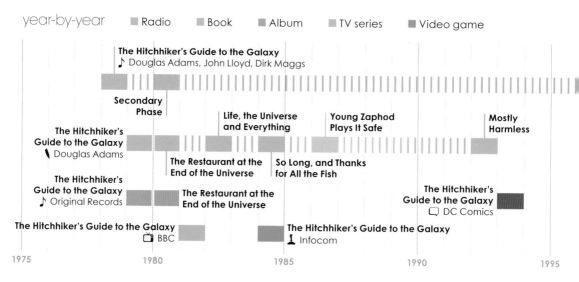

year-by-year ■ Radio ■ Book ■ Album ■ TV series ■ Video game

The Hitchhiker's Guide to the Galaxy
♪ Douglas Adams, John Lloyd, Dirk Maggs

Secondary Phase

Life, the Universe and Everything

Young Zaphod Plays It Safe

Mostly Harmless

The Hitchhiker's Guide to the Galaxy
❦ Douglas Adams

The Restaurant at the End of the Universe

So Long, and Thanks for All the Fish

The Hitchhiker's Guide to the Galaxy
♪ Original Records

The Restaurant at the End of the Universe

The Hitchhiker's Guide to the Galaxy
☐ DC Comics

The Hitchhiker's Guide to the Galaxy
☐ BBC

The Hitchhiker's Guide to the Galaxy
♁ Infocom

1975 1980 1985 1990 1995

**The
Hitchhiker's
Guide to the
Galaxy**

**Young
Zaphod Plays
It Safe**

**Mostly
Harmless**

**The
Hitchhiker's
Guide to the
Galaxy**

**The
Hitchhiker's
Guide to the
Galaxy**

**And Another
Thing ...**

adapted for both radio and television. *The Meaning of Liff* (1983) was a spoof dictionary co-written with John Lloyd; *Last Chance to See* (1990) was a travel/wildlife book. Adams was also involved with the charity Comic Relief, for which he wrote an original *Hitchhiker's Guide* short story in 1986.

In 1992, Adams was persuaded to return to the *Hitchhiker's Guide* universe with *Mostly Harmless*. From then until his death in 2001 he claimed to be working on another book, but all that appeared was a fragment of a Dirk Gently story in a hastily edited posthumous collection, *The Salmon of Doubt*.

In the late 1990s Adams was a partner in multimedia company The Digital Village, which released a graphical adventure computer game, *Douglas Adams's Starship Titanic*.

In 1999 Adams signed a deal with Buena Vista to write the screenplay of a *Hitchhiker's Guide* film. After two years of rejected scripts, the project fell apart days before the author's death.

Writing duties on the next attempt were subsequently assigned to Karey Kirkpatrick, an experienced screenwriter who was nevertheless completely unfamiliar with the original. Music video director Garth Jennings was attached to the project with Jay Roach in the producer's chair. Shot in Britain with an Anglo-American cast, the film ditched much of Adams' idiosyncratic wit in favor of slapstick and spoofery. Critics were generally kind but audiences — both fans and neophytes — were divided.

Also long in development was a third radio series, adapted from *Life, the Universe and Everything*. This was eventually written and produced by Dirk Maggs (Adams' choice) who had previously brought *Batman*, *Superman* and *Judge Dredd* to the airwaves. Radio versions of books four and five followed, cleverly using multiple universes to resolve discrepancies between the radio and television versions. Maggs and the original radio cast subsequently collaborated on a touring stage production presented in the manner of a sound recording.

Although no one had clamored for a sixth *Hitchhiker's Guide* novel, one was published in 2009. *And Another Thing ...* by *Artemis Fowl* author Eoin Colfer was not based on material by Adams and received little attention. **PW**

Short story Comic Movie

Tertiary, Quandary and Quintessential Phases
♪ Dirk Maggs

And Another Thing ...
Eoin Colfer

The Hitchhiker's Guide to the Galaxy
Garth Jennings

1995 2000 2005 2010 2015

the hitchhiker's guide to the galaxy

Ford Prefect

Arthur Dent

Tricia Mcmillan (Trillian)

Zaphod Beeblebrox

Marvin

Arthur Dent's day starts badly when Ford Prefect — an alien researching an interstellar travel guide — warns him that Vogons are about to demolish Earth. The two of them jump aboard the attackers' spaceship moments before its beams strike.

On board the craft, the duo are tortured with bad poetry then thrown into space. They are rescued by *Heart of Gold*, a spaceship crewed by Ford's cousin, renegade Galactic President Zaphod Beeblebrox, his human girlfriend Tricia "Trillian" McMillan, Eddie the cheerful computer and Marvin, a depressed robot. Zaphod stole *Heart of Gold* and intends to use its Infinite Improbability Drive to locate Magrathea, a world that became rich through a luxury planet-building business.

On Magrathea, coastline designer Slartibartfast explains that Earth is a supercomputer built to answer the question of life, the universe and everything.

Two trigger-happy galactic cops come looking for Zaphod. Marvin depresses their shipboard computer so much that it commits suicide, switching off the cops' life support systems. *Heart of Gold* then sets off for Milliways, the Restaurant at the End of the Universe, but is attacked by Vogons. Zaphod holds a seance to contact his great-grandfather, who scatters the crew across space.

Zaphod reaches the Hitchhiker's Guide offices and searches for a man called Zarniwoop — but the building is removed by robots to the planet of the Total Perspective Vortex, a psychological torture machine. Unaffected (because of his monstrous ego), Zaphod escapes and finds Zarniwoop, who switches off the artificial universe that Zaphod has been in since he entered the offices. Reunited, the gang heads for Milliways. Marvin helps them steal a spaceship that has been programmed to crash into a star as part of a rock concert.

characters

- Ford Prefect
- Zaphod Beeblebrox
- Arthur Dent
- Marvin
- Tricia Mcmillan (Trillian)

Rock band Disaster Area show

Golgafrinchan B-Ark crashes on Earth

Ford on Earth

Trillian defeats Hactar

Arthur meets Tricia McMillan

Zaphod elected president, steals *Heart of Gold*

Match at Lords interrupted

Earth replaced

Vogons destroy Earth

Visit to Magrathea

Heart of Gold attacked

Neolithic era | A few months later | About two hundred years ago | About 50 years ago | About 30 years ago | 15 years ago | Eight years ago | Six years ago | A few days ago | Present day NOW | Present day | Around the same time | A few days after that

Wavy lines fading at either end represent temporal distortion

Arthur and Ford teleport onto a spaceship containing the useless third of the population of the planet Golgafrinchan. The craft crashes onto Earth where the Golgafrinchans out-evolve the cavemen, thereby screwing up the supercomputer's program.

Arthur and Ford are transported on a sofa to Lord's Cricket Ground, where they witness robots steal a trophy. The same robots steal a leg from Marvin and the Infinite Improbability Drive from *Heart of Gold*.

Slartibartfast collects Arthur and Ford from Lord's and tells them about the genocidal inhabitants of Krikkit who created the robots to destroy all other life in the universe and were punished by being trapped in a time-loop. The three teleport to a flying party, where they see the robots steal the final item they need to release Krikkit. Zaphod then makes it to Krikkit where he finds the robots depressed because Marvin has affected their central computer.

Arthur returns to Earth and falls in love with a woman named Fenchurch. They discover that dolphins saved the planet by replacing it with another one from a parallel universe. Ford arrives and journeys with Arthur and Fenchurch to view God's Final Message to His Creation. On the way they find Marvin.

Three Grebulons take television reporter Tricia McMillan from Earth to their home planet. Ford discovers that the *Hitchhiker's Guide* offices are now run by Vogons who plan to market the *Guide Mk 2*. On an alien planet, Trillian introduces Arthur to Random, her teenage daughter conceived using his sperm.

Ford mails Arthur a prototype *Guide Mk 2* but Random opens the package and sets off to Earth to find her parallel universe mother Tricia. Grebulons attack and destroy Earth, after which the *Guide Mk 2*, having arranged all the preceding matters on behalf of the Vogons, implodes. **PW**

Timeline labels (top):
Trillian impregnates herself
Fenchurch disappears
Tricia McMillan meets the Grebulons
Arthur on Earth, meets Fenchurch
Random McMillan born
Ford steals the *Hitchhiker's Guide Mk2*
Grebulons attack Earth
The Total Perspective Vortex
Trillian leaves Random with Arthur
Trip to Milliways
Trip to the *Guide* offices
God's final message
Marvin dies

Timeline labels (bottom):
Milliseconds later | Later that day | A few months later | Some time later | A while later | Nine months after that | 18 years after that | Around the same time | Somewhere around then | Shortly after | End of time | A little bit after | Later still

The Hitchhiker's Guide to the Galaxy (1978)

The Hitchhiker's Guide to the Galaxy (1981)

The Hitchhiker's Guide to the Galaxy (1984)

The Hitchhiker's Guide to the Galaxy (2005)

Recording a radio episode in 1979. Douglas Adams is seated far left.

Simon Jones as Arthur Dent in the BBC TV series.

(L–R) David Dixon (Ford Prefect), Sandra Dickinson (Trillian) and Mark Wing-Davey (Beeblebrox) in the TV version.

Programers' diagram for the developing **The Hitchhiker's Guide to the Galaxy** computer game.

AND THAT'S NOT ALL!

The Guide is more than a super travelogue or an incredible answer machine—it's a lovely addition to any backpack or suitcase that fits in perfectly with every decor. It comes in a wrinkle-proof, scratch-resistant plastic cover with **THE LOOK AND FEEL OF REAL VINYL**, handsomely inscribed with the words **DON'T PANIC** in large, friendly letters. And talk about handy—The **Mark IV** version of *The Guide* has **MORE OPTIONS THAN A 20-ARMED HRUGMUS HAS HANGNAILS!** Just look what you can get….

73-FUNCTION POCKET CALCULATOR OPTION lets you solve equations that have baffled mathematicians for eons, such as how to travel faster than the speed of light without losing your luggage.

CUSTOM CHRONOMETER displays year, month, day and date, to within a fraction of a sluub in civilian time *and* military time *and* Happy Hour Time for the nearest pub in the Galaxy.

TAN-O-MATIC REFERENCE TABLE tells you the exact coordinates of all the best beaches, the most up-to-date fashion tips on polarized eyewear and reflectors, the precise length of time you can sunbathe before your friends have to carry you home in an urn, and the appropriate level of sunscreen to wear in case of a supernova.

SIRIUS CYBERNETICS BAROMETER/ NEO-DESCARTIAN RELATIVE TRUTH MONITOR indicates temperature, barometric pressure, high tide, low tide, wind direction and velocity, prevailing weather conditions, amount of precipitation in the last 1,000 sluubs and whether you're actually experiencing any of it or are simply being deceived by your imperfect senses.

SALAD-SLASHER/FOOD PROCESSOR/ LEMON ZESTER ATTACHMENT slices, dices, chops and bludgeons even the most rubbery fruit or vegetable in seconds!

A humorous pamphlet advertising the fictional *Hitchhiker's Guide* eerily presages modern tablet computers.

Martin Freeman as Arthur Dent and Warwick Davis as Marvin the Paranoid Android (voiced by Alan Rickman) in the 2005 film.

Martin Freeman as Arthur Dent, a very ordinary man having a truly unusual day.

(L–R) Sam Rockwell (Zaphod Beeblebrox), Zooey Deschanel (Trillian) and Mos Def (Ford Prefect) in the 2005 movie.

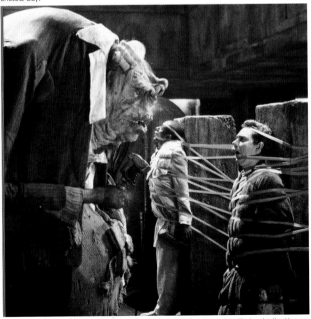

Ford Prefect (Mos Def, L) and Arthur Dent (Martin Freeman) find themselves tied up by the Vogons.

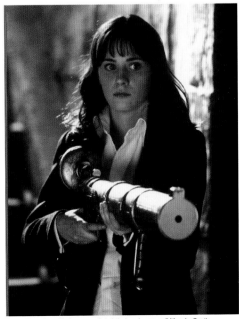

Zooey Deschanel totes some futuristic hardware as Trillian in Garth Jennings' film of Douglas Adams' masterwork.

battlestar galactica 1978

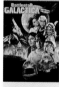

Battlestar Galactica | **Battlestar Galactica** | **Battlestar Galactica** | **Mission Galactica: The Cylon Attack** | **Battlestar Galactica** | **Galactica 1980** | **Conquest of the Earth** | **Battlestar Galactica: War of Eden**

In 1978, American writer/producer Glen A Larson finally brought a long-gestating project to the screen. Originally developed during the late 1960s under the title *Adam's Ark*, *Battlestar Galactica* was an attempt to popularize science fiction in the notoriously tricky realm of U.S. television. Mixing myth and speculation, the story tapped into the popular theories of authors such as Erich Von Däniken, in particular the idea that ancient Earth cultures may have been shaped by visitors from other worlds.

The story follows the desperate survivors of a human civilization as their rag-tag fleet of spacecraft — led by the only remaining "battlestar" warship, *Galactica* — narrowly escapes an apocalypse unleashed by the evil Cylon race. The fleet's only hope is that they may find the distant, fabled planet known as "Earth." This formed a basic quest narrative that ran alongside regular clashes against the cybernetic Cylon warriors.

Commissioned by Universal Television on the back of the success of *Star Wars*, *Battlestar Galactica* was a remarkably ambitious television production, and so expensive to make that an edited version of series opener, "Saga of a Star World," was given a cinematic release, just to help out with costs. The echoes of *Star Wars* were so strong in *Battlestar Galactica* that 20th Century Fox issued a lawsuit for copyright infringement, but this was a far less focused affair than George Lucas' space epic. The visuals might have been impressive, but its storytelling was a clumsy mix of childish sci-fi Western and oddball biblical fantasy, not to mention a cozy, family tone that was wholly at odds with the show's bleak central premise of a race fleeing genocide.

Ratings were initially strong but *Galactica* soon struggled, and the enormous costs involved led to an abrupt cancellation at the end of the first season. The network, nevertheless, wanted to find a way of making the show work, so with a drastically reduced budget, *Galactica 1980* made its first appearance. There was also a new storyline: the mythical Earth had now been located, but had be protected from discovery by the Cylons. Widely derided, the light-hearted tone of the new show made it feel even more childish than before. With most of the original cast having been replaced, and the special effects now woefully inadequate, the series limped to 10 episodes before being put out of its misery.

Repeat showings on cable networks and nostalgia for *Galactica*'s clunky charm kept interest in the show alive over the years, and in the late 1990s, with Hollywood increasingly looking for reboot projects, a new *Battlestar Galactica* series started looking increasingly possible. The original series also gave

year-by-year ■ TV movie ■ TV series ■ Book ■ Comic ■ Video game

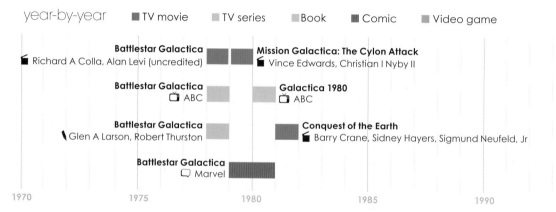

Battlestar Galactica
Richard A Colla, Alan Levi (uncredited)

Battlestar Galactica
📺 ABC

Battlestar Galactica
Glen A Larson, Robert Thurston

Battlestar Galactica
🖵 Marvel

Mission Galactica: The Cylon Attack
Vince Edwards, Christian I Nyby II

Galactica 1980
📺 ABC

Conquest of the Earth
Barry Crane, Sidney Hayers, Sigmund Neufeld, Jr

1970 1975 1980 1985 1990

Battlestar Galactica | Battlestar Galactica | Battlestar Galactica: The Resistance | Battlestar Galactica | Battlestar Galactica | Battlestar Galactica: The Plan | Battlestar Galactica: Blood & Chrome

birth to a surprisingly large number of comic, video and board game spin-offs.

There were separate attempts by Larson and original cast member Richard Hatch at reviving *Galactica*, and a TV pilot for a sequel series helmed by *X-Men* director Bryan Singer actually went into preproduction in 2001. Delays, however, caused by the 9/11 terrorist attacks and Singer's commitments to filming *X-Men 2* caused the project to be shelved.

Galactica's second chance arrived in 2003 when the Sci-Fi Channel commissioned a three-hour miniseries. This also acted as a potential backdoor pilot for a new full-length show. Co-produced and written by Ronald D. Moore, a screenwriter who'd gained extensive experience as show-runner on *Star Trek: Deep Space Nine*, *Galactica* was drastically reimagined as a gritty, adult space opera, tackling challenging thematic, religious and political ideas.

Moore's vision fully explored the consequences of its apocalyptic story, while also including kinetic and spectacular space combat sequences that brought to the small screen a combination of *Star Wars*-style action and the intensity of *Black Hawk Down*.

The miniseries was successful enough to earn a four-season run that netted huge critical acclaim and went on to win multiple awards. The new *Battlestar Galactica* was massively influential, even if its

ratings never rose above the level of an enthusiastic cult. The complexity of the ongoing story made it difficult to acquire new viewers, and the bizarre religious mythology, combined with the writing staff's improvisational approach, resulted in plenty of odd plot-twists and narrative dead-ends.

Prior to the beginning of season three, a set of 10 webisodes were made available online from the Sci-Fi Channel; each installment of *Battlestar Galactica: The Resistance* lasted between two and five minutes.

The series finally came to a close in 2009 with a hugely divisive final episode, but that would not be the end of the franchise. That same year, the miniseries and the first two seasons were retold in the TV movie, *Battlestar Galactica: The Plan*. A spin-off prequel series, *Caprica*, also explored some interesting themes, including the birth of the Cylons, but struggled to find an audience and was cancelled after its first season. A second prequel, set during the first Cylon War, *Blood & Chrome* was more traditionally action-packed. Ten episodes were initially broadcast online at the end of 2012 before being cut together as a TV movie the following year.

Battlestar Galactica's TV life may be over for now, but a cinema reboot with Bryan Singer at the helm — his continuing *X-men* duties notwithstanding — looks increasingly likely. **CS**

▓ Online

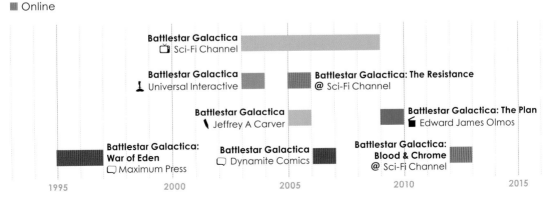

Battlestar Galactica
(1978–79)

Mission Galactica: The Cylon Attack (1979)

Battlestar Galactica (1979–81)

Battlestar Galactica (2003–09)

Battlestar Galactica: Blood and Chrome (2012)

Richard Hatch and Dirk Benedict as Captain Apollo and Lieutenant Starbuck in the original **Battlestar Galactica** television series.

Battlestar Galactica (L–R): Maren Jensen, Dirk Benedict, Richard Hatch, Lorne Greene.

Jane Seymour as Serina, the female lead of **Battlestar Galactica**.

A Cylon, one of a race of robots that is at war with humanity in **Battlestar Galactica**.

Mission Galactica: The Cylon Attack is a re-edited version of the original series episodes "The Living Legend" and "Fire in Space."

Two of the 23 **Battlestar Galactica** comics produced by Marvel between March 1979 and January 1981.

The cast of the reimagined **Battlestar Galactica** television series, which began in 2003 with a three-hour miniseries.

Grace Park played two Number Eight Cylon models in **Battlestar Galactica**: Sharon "Boomer" Valerii and Sharon "Athena" Agathon.

Luke Pasqualino as William Adama in the **Battlestar Galactica: Blood & Chrome** web series. Pasqualino is the fourth actor to have played the character.

james cameron 1978

Xenogenesis

Battle Beyond the Stars

Galaxy of Terror

Escape From New York

Android

The Terminator

Aliens

Alien Nation

James Cameron, director of two *Terminator* movies, *Aliens, The Abyss* and *Avatar,* has already fixed the moment for which he will be remembered. It came in 1997, when he waved his Best Picture Oscar, whooped like a frat boy and declared, "I'm the king of the world!"

Cameron won this award for a romantic tragedy, *Titanic* (1997), but he's also the king of blockbuster SF spectacle, and has remained more consistently faithful to the genre than other directors, including Stephen Spielberg and George Lucas, who flit in and out of it apparently on whim.

On the flipside, Cameron cannot be regarded as consistently original: witness the unusually close resemblances between *The Terminator* and two episodes of *The Outer Limits* TV serial. (Scriptwriter Harlan Ellison subsequently brought an action against Cameron for plagiarism; the case was settled out of court.) More recently, critics have noted similarities between Cameron's *Avatar* and "Call Me Joe," a story by American SF writer Poul Anderson.

At best, though, Cameron is a master popularizer, making up for what he lacks in poetry and subtlety with sheer muscularity. In a revealing comment to *Entertainment Weekly,* he said that *Avatar* was inspired by "manly, jungle adventure writers," such as Edgar Rice Burroughs. However, although there is little doubt that the three Cameron films starring Arnold Schwarzenegger are masculine, the director has also given leading roles to lionesses such as Sigourney Weaver in *Aliens* and Linda Hamilton in *Terminator 2: Judgment Day.* Perhaps "James Cameron: Manly or post-manly?" will be a thesis topic for future students.

Cameron has made some of the most expensive films in cinema history, and also some of the most lucrative. *Titanic* and *Avatar* were the first to surpass two billion dollars each in world takings. Then again, many critics found Cameron more interesting in the early part of his career when his ambitions were modest and his budgets were small.

He began as the archetypal film-loving geek in the prevideo age. He shot amateur films on a Super 8 camera and tried to make an SF epic on the few thousand dollars that he raised from a consortium of dentists in Orange County, California. The work in question, *Xenogenesis* (1978), may be viewed online. It is 12 minutes long and shows a man exploring a *Forbidden Planet*-style alien city. He is attacked by a stop-motion cleaning robot that is evidently a forerunner of the Hunter-Killer tanks in *Terminator.* A woman rushes to his rescue, operating her own spider-like mechanized tank, and the machines fight to the death. *Xenogenesis* contains almost every element of Cameron's subsequent films, apart of course from a few million gallons of water.

year-by-year ■ Movie ■ Book ■ TV series

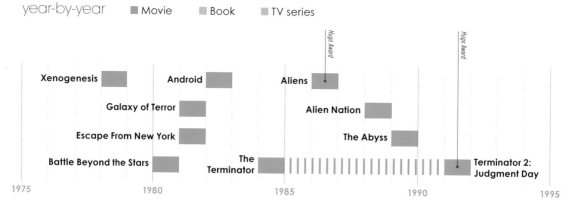

$86.2M
The Terminator
(1984)

$181.6 M
Aliens
(1986)

$351.7M
Terminator 2:
Judgment Day
(1991)

$829.2M
Avatar
(2009)

The Abyss

Terminator 2:
Judgment
Day

Strange Days

Strange Days

Dark Angel

Solaris

Avatar

Cameron later worked at Roger Corman's New World Studio, where he designed a "spaceship with tits" for *Battle Beyond the Stars* (1980). He also contributed effects to his hero John Carpenter's *Escape from New York* (1981). These included a faked 3D computer grid map of the city which was actually a cardboard model, with each building outlined in Day-Glo paint. Now that Cameron has become most readily associated with cutting-edge computer effects and performance capture technology costing millions of dollars, it is well worth revisiting some of these early works in which artistic problems were solved with ingenuity rather than megabucks.

Discounting a farcical stint on *Piranha II: The Spawning* (1981) — Cameron was fired from directing after a few days and disowns the film — his true arrival was *The Terminator*. This movie established Cameron's flair for lurid apocalyptic visions, which may owe as much to his love of comic books as to print SF. Such scenes became more ambitious as his reputation grew: the giant wave in *The Abyss: The Director's Cut*; the flaming children's playground in *Terminator 2*; the sinking ruin of the *Titanic* and the towering Hometree's fall in *Avatar*.

On the first *Terminator*, though, Cameron was constrained by a relatively paltry $6 million budget, so he used words as much as effects to create atmosphere. Today it's fashionable to deride much of the dialogue in Cameron's films. However, it's hard to laugh at actor Michael Biehn's haunted monologues, as he remembers future horrors we can only imagine, or fixes the heroine with his glare, telling her that the Terminator "absolutely will not stop, ever, until you are dead." And yet Cameron is prouder of the sequel, with its budget of $100 million. *Terminator 2* established the director as the purveyor of extraordinary spectacles, many of them real, such as when a truck smashes down from a bridge into a concrete drainage canal.

By the 1990s, Cameron had acquired a reputation as a fearsome taskmaster, forcing cast and crew through ordeals. But to his credit he endured them himself. On *The Abyss*, during a grueling shoot in a flooded nuclear plant, Cameron donned diving gear and got into the water with the suffering actors. Cameron's obsession with the sea goes back to his childhood love of Jacques Cousteau documentaries, and would later inspire his own deep-sea dives. He plunged under the Atlantic in a submarine to film the sunken wreck of the real *Titanic* for his blockbuster. In 2012, he descended far deeper, becoming the first solo explorer to plumb the Mariana Trench. Nearly 7 miles (11 km) beneath the surface, the King of the World reached the bottom of the Earth. **AO**

Strange Days
🎬 James Cameron, Kathryn Bigelow

Solaris

Avatar

Strange Days

Dark Angel

1995

2000

2005

2010

2015

Escape From New York
(1981)

The Terminator
(1984)

Aliens
(1986)

Alien Nation
(1988)

The Abyss
(1989)

**Terminator 2:
Judgement Day**
(1992)

Solaris
(2002)

Avatar
(2009)

The artwork for the **Escape from New York** movie poster slightly oversold the movie's scope.

Sigourney Weaver — a lioness confronted by **Aliens**.

Mary Elizabeth Mastrantonio in **The Abyss**.

Eye-popping horror: Arnold Schwarzenegger in **The Terminator**.

James Cameron with the Alien Queen from **Aliens**.

Mary Elizabeth Mastrantonio (L) and Ed Harris as the estranged couple Lindsey and Virgil "Bud" Brigman in **The Abyss**.

James Caan and Mandy Patinkin in **Alien Nation**, in which an alien race known as Newcomers settle in Los Angeles.

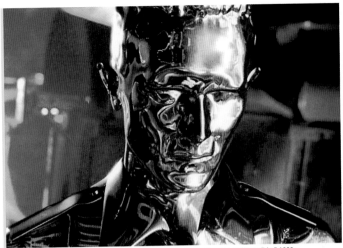
In **Terminator 2: Judgment Day**, John Connor is pursued by the advanced, polymorphic T-1000.

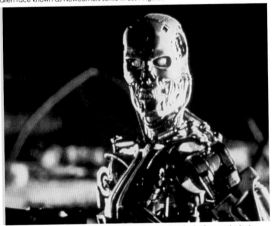
Despite its groundbreaking CGI, most of the effects in **Terminator 2** were physical.

George Clooney in the U.S. version of **Solaris**, which James Cameron produced.

Stephen Lang as Colonel Miles Quaritch in **Avatar**.

mork & mindy 1978

Mork & Mindy

Mork & Mindy/
Laverne & Shirley/
Fonz Hour

Behind the
Camera: The
Unauthorized Story
of Mork & Mindy

Mork & Mindy is that rare beast, a science fiction property spun off from a nongenre source. Garry Marshall, producer of hit 1950s-retro sitcom *Happy Days*, was persuaded by his son to ride the post-*Star Wars* boom by featuring an alien in one episode. Debuting in a dream sequence, hyperactive stand-up comic Robin Williams so impressed Marshall that his character, Mork from the planet Ork, was swiftly spun off into his own modern-day series. Sent to Earth in a giant egg, Mork lands in Boulder, Colorado and befriends a young woman named Mindy McConnell (Pam Dawber). Mindy helps Mork learn about Earth and humans, assisted by her father, Fred, and grandmother, Cora. Each episode ended with Mork summing up his discoveries in a report to his boss, Orson, back on his home planet.

Nominated for two Primetime Emmys and reaching number three in the ratings, *Mork & Mindy* was an enormous hit. Children adored Williams' clowning, whereas adults appreciated the mockery of human foibles. It was accompanied by a vast range of spin-off toys, games, books and other merchandise — even a short-lived Brazilian remake, *Super Bronco*. And Mork's catchphrases of "Nano, nano!" and "Shazbot!" were quoted across America.

The show, however, suffered from a chronic identity crisis: was it a slapstick kidcom about an innocent man-child or a primetime sitcom about an opposites-attract, will-they-won't-they couple? The second season tried to have it both ways, replacing

Fred and Cora with a cast of young, hip supporting characters, while developing a romance between the leads. Despite big-name guest stars, including Raquel Welch and Roddy McDowall, and some interesting science fiction themes — the season premiere is an impressively effects-heavy pastiche of *The Incredible Shrinking Man* — the series lost its way ... and its audience.

Attempts to repair the damage in the third season came to naught. Williams' stand-up comedy career, meanwhile, had exploded and in one episode he even doubled up as himself, meeting Mork while playing a gig in Boulder. The final nail in the coffin came in season four, when Mork and Mindy were married, Mork laid an egg, and their son Mearth was born. (Since Orkans age backward, Mearth was played by veteran comedian Jonathan Winters.)

After cancellation, ABC kept the characters alive with a prequel cartoon series, set in high school, with Williams and Dawber providing the voices. The series also featured heavily in the 2005 TV movie *Behind the Camera: The Unauthorized Story of Mork & Mindy*, which charted the rise of Robin Williams (played by Chris Diamantopolous) from struggling comic to star.

Mork & Mindy, meanwhile, would provide a template for a surprising number of "alien-on-Earth" TV sitcoms, among them, *My Favorite Martian*, *ALF*, *Aliens in the Family*, *Mike and Angelo*, *Third Rock from the Sun* and *My Hero*. **MJS**

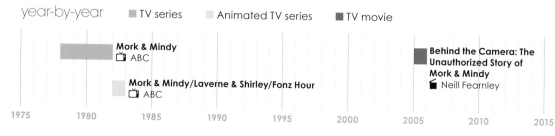

year-by-year ■ TV series ■ Animated TV series ■ TV movie

Mork & Mindy
ABC

Mork & Mindy/Laverne & Shirley/Fonz Hour
ABC

Behind the Camera: The
Unauthorized Story of
Mork & Mindy
Neill Fearnley

| 1975 | 1980 | 1985 | 1990 | 1995 | 2000 | 2005 | 2010 | 2015 |

science fiction world 1979

Science Fiction World

The most widely-read SF magazine in the world, *Science Fiction World* (or *SFW*) hails from Chengdu, Sichuan Province, in the People's Republic of China. It began publishing in 1979, and at its peak could claim over 300,000 subscribers, with an estimated total readership of more than a million.

Chinese author Han Song wrote that science fiction was "imported from the West early in [the 20th century] by some Chinese elites who believed that the genre could help people become 'intelligent' and enable the country [to] get modernized." The genre flourished in the 1960s, before being violently shut down during the Cultural Revolution, when prominent authors such as Zheng Wenguang were sent to do manual labor. "I had to give up my pen and go to the countryside," he wrote. "I worked as a peasant." This era is vividly captured in Liu Cixin's science fiction classic *The Three Body Problem* (published in English 2014). Falling in and out of official favor alongside shifting political dictates, science fiction finally emerged from the shadows in the 1990s and has since flourished as a genre.

Originally named *Science Literature*, *Science Fiction World* was initially a subsidy of the state-run Science and Technology Organization. It became an independent publication in 1984, at which point editorship was taken over by Yang Xiao, the daughter of a high-ranking Party official. Low on funds, the group began to publish novels, and is now one of the major science fiction publishers in China. During the early 1980s, the magazine also launched the Galaxy Award, which remains the most prestigious prize for China's science fiction authors.

During the 1990s, *Science Fiction World* began to grow and was responsible for the discovery of important new authors such as Xing He, Liu Wenyang and Wang Jinkang. During the same period it also organized an annual writers' conference in Chengu, a small-scale professional event restricted in size since larger fan conventions were not at that time permitted by the government.

The Tibetan-Chinese author Alai (whose own nongenre novel, *Red Poppies*, had been a huge hit) became editor for a time, and the publishing house expanded into the new millennium, launching the careers of such exciting new Chinese talents as Liu Cixin, Qian Lifang and Chen Qiufan. Following political changes, in 2007 the magazine was able to organize China's biggest SF convention, the Chengdu International Science Fiction and Fantasy Festival, which was attended by some 4,000 fans.

Controversy erupted in 2010, when accusations of questionable behavior were raised by the magazine's staff against editor Li Chang, whose actions were blamed for a dramatic drop in circulation. With a new editor in place, *Science Fiction World* has since recovered and continues to dominate Chinese science fiction and fantasy publishing, commissioning the bulk of country's original novels and short stories, as well as international works in translation. **LT**

year-by-year ■ Magazine

Science Literature
Chinese Science and Technology Organization

Science Fiction World

1975 | 1980 | 1985 | 1990 | 1995 | 2000 | 2005 | 2010 | 2015

mad max 1979

Mad Max

Mad Max 2:
The Road Warrior

Mad Max: Beyond
Thunderdome

Mad Max

Mad Max

Mad Max:
Fury Road

One of the most influential action films of all time, the original *Mad Max* — made for around $1.7 million in the countryside around Melbourne, Australia — created a franchise, defined a visual aesthetic and created a subgenre that was embraced by subsequent cinematic works and became a staple of video games and comic books.

Its violent cowboy-and-Indians revenge tale is simple but brutally effective, and the done-for-real car stunts set the bar high for future films. As the series extended, the broken future depicted in each film became bleaker and more elaborate. Moving from a dystopian to a post-apocalyptic setting, the story of an energy-starved world running on desperation, where people will do anything for another tank of gas, came to seem more prescient than fantastical.

Mad Max starred 23-year-old Mel Gibson, an American-Irish actor who had been resident in Australia since age 12, and who at that point was best known for a role in the soap opera *The Hendersons*. The movie was the debut of writer/director George Miller, a former physician. Inspired by stories of people fighting to refill their cars during the 1973 oil crisis, and by the car crash injuries he saw every day in his Victoria emergency room, Miller started to put a movie project together with two friends — amateur film-maker Byron Kennedy and first-time screenwriter James McCausland. Money was scraped together from small investors, and the largely unknown cast

included Gibson's classmate, Steve Bisley, who had gone along to auditions with his friend and landed himself the part of Goose.

Soon after its release, *Mad Max* became one of the most successful Australian films of all time, and brought a massive return from a relatively small initial outlay. It is set in a near-future Australia in which the oil is running out and society is starting to crumble. Biker gangs rule the Outback, and a ragtag police force — the Main Force Patrol — battles to keep order. Its most effective officer is the seemingly emotionless, scarily young and fetishistically leather-clad Max Rockatansky (Gibson).

The film is thinly plotted but enlivened by numerous chases and ends with a celebrated scene in which Max gives captured biker Johnny the Boy an awful choice between sawing off his own foot and perishing in an explosion. This genuinely horrific climax inspired something almost identical in Alan Moore's *Watchmen* (2009), and is widely credited as a defining influence on the *Saw* horror series. *Mad Max* was a fashion leader too: the main characters' ripped leather clothing was adopted by a long line of pop musicians, from Duran Duran and W.A.S.P. to Gary Numan to Kesha.

Mad Max initially polarized critics, however, and was banned in Sweden and New Zealand. In the United States, reviewers loathed it and it flopped at the box office. Around the rest of the world, however, it quickly topped $100 million.

year-by-year ■ Movie ■ Video game

Mad Max
🎬 George Miller

Mad Max: Beyond Thunderdome
🎬 George Miller

Mad Max 2: The Road Warrior
🎬 George Miller

Mad Max
🎮 Mindscape

1980 1985 1990 1995

$100M
Mad Max
(1979)

$57.2M
Mad Max 2:
The Road Warrior
(1981)

$78.7M
Mad Max Beyond
Thunderdome
(1985)

In 1981 came a bigger budget sequel, known in the United States as *The Road Warrior* and elsewhere as *Mad Max 2*. This is generally regarded as the high-point of the series.

In this film, society has broken down further. There's been a nuclear war. Larger, more extreme and organized biker gangs terrorize the Australian interior. Max cruises the empty roads like Clint Eastwood's Man With No Name, eventually siding with the occupants of a besieged oil refinery against the surrounding punk-styled hordes, led by a masked bodybuilder called The Humungus (played by Swedish former Olympic weightlifter Kjell Nilsson).

Mad Max 2 is altogether a bigger, more striking-looking production than its predecessor, with sharply drawn characters and mythic underpinnings. The climactic chase — in which Max leads a break-out, driving a heavily armored Mack fuel tanker apparently overflowing with precious gasoline — remains one of the greatest movie action sequences of all time, exhilarating, frightening and relentless in equal measure.

By the time the third film in the series appeared, Mel Gibson had become an international star. *Mad Max Beyond Thunderdome* (1985) was a yet more luxurious production — particularly striking was the design of Bartertown, a dog-eat-dog desert city ruled by a suitably over-the-top Tina Turner as Aunty Entity. The increasing boldness of the overall vision was to some extent counterpointed by greater subtlety in the characterization of Max himself, who here becomes a hero to a group of feral children living in a desert oasis.

However, although Max is revealed as a more rounded figure, any suspicion that he may have gone soft is banished by the brutality of this installment's finale, a chase that brings more — and yet more extreme — customized post-apocalyptic vehicles into the fray, and involves a railroad train that is besieged by attackers in an explicit reference to the series' Western inspirations.

The original *Mad Max* ended with the completion of this trilogy, but the series' legacy and influence continued. Although its depiction of a post-apocalyptic wasteland, populated by wild gangs threatening a few isolated pockets of civilization, was hardly an original one, it has nevertheless been widely influential: for example, substitute zombies for biker gangs and you have a big slice of the DNA of such contemporary hits as *The Walking Dead*.

Now, however, the story is about to continue in *Mad Max: Fury Road*, which is directed by Miller, filmed in Namibia and stars British actor Tom Hardy in the role created by Mel Gibson. It will be followed by *Mad Max: Furiosa*.

Although it has taken almost 30 years to reboot the series — and the movie franchise has enjoyed precious few spin-offs into other media in that time — *Mad Max* retains a hold on the imagination and exerts an influence on many other properties. **MB**

Mad Max: Fury Road
🎬 George Miller

Mad Max
Avalanche Studios

2000 2005 2010 2015

mad max universe

Max Rockatanksy

Gyro Captain

In a broken but still functioning Australia of the near future, life in cities is collapsing, fuel is scarce and vicious biker gangs rule the roads. Order is maintained by the Main Force Patrol (MFP), the remains of the police force. The best driver in the MFP is Max Rockatansky, a stone-faced young man in a black leather uniform, whom we first see chasing a biker in a stolen police car to a flaming conclusion.

A feud between the MFP — chiefly Max and his pal Goose — and the leading bike gang starts to spiral out of control. After Goose is burned to death, Max resigns and goes on holiday with his family, only for the bikers to bump into them, kill his young son and leave his wife Jessie in a critical condition. Now Max goes into action, and the last act is revenge tragedy — the hero takes out brutal retribution on Toecutter and the other gang leaders in his matte black Ford Falcon GT351 Pursuit Special before disappearing into the Australian interior.

Some years later, following a new World War, the Australian interior is in a worse state than before, and Max — no longer affiliated to any police force — roams the deserts in his Pursuit Special, accompanied only by an Australian cattle dog and a sawn-off shotgun. He fights occasional running battles with motorcycle gang members, and encounters two vital potential

allies in the desert: an abandoned Mack truck tractor unit, and another desert wanderer, an autogyro pilot who tells him of a small oil refinery out in the wastes.

Max journeys there to find it besieged by a biker gang whose members ride in strange custom cars. They are led by a huge man named The Humungous, whose lieutenants include a mohawk-wearing wildman, Wez, whom Max encountered earlier. Whenever settlers from the compound try to escape, the bikers run them down, capture, torture, rape and kill them — yet The Humungous promises the rest of the community safe passage in return for the fuel they guard.

Max rescues a wounded survivor and bribes his way through the blockade by giving the gang a tank of fuel. In the compound he meets the settlers' leader, Pappagallo. After another assault by the gang on the compound, Max goes to fetch the Mack truck — one of the few vehicles capable of hauling a giant tanker of fuel.

With the help of the Gyro Captain, Max retrieves the semi truck. He then tries to leave the compound in his Pursuit Special, but the vehicle is destroyed in a chase with Wez and the bikers, and his dog is shot dead. Having been flown back to the compound by the autogyro pilot, Max agrees to drive the

characters ▮▮▮ Max Rockatanksy ▮ Gyro Captain

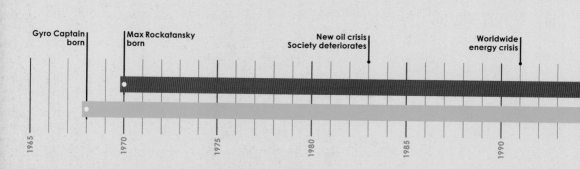

Gyro Captain born

Max Rockatansky born

New oil crisis Society deteriorates

Worldwide energy crisis

1965 1970 1975 1980 1985 1990

now-armored Mack fuel tanker in a breakout, accompanied by the Feral Kid, a small mute child with a deadly boomerang. Max and his tanker, with some settler vehicles alongside, make a dash for it, while the remaining settlers sneak out in another direction.

An epic chase ensues. Pappagallo and many others are killed, and the Gyro Captain is shot down — but Wez and The Humungous also die. The tanker crashes and Max and the Feral Kid escape. It then emerges that the tanker was full of sand — a decoy, with the real fuel hidden in the vehicles of the settlers who went the other way. Now the Gyro Captain and the Feral Kid leave to become leaders of the new Great Northern Tribe that the settlers will establish. Max is left alone in the desert.

Later, the world deteriorates further. While traveling by camel train, Max is attacked by the Gyro Captain, Jedediah, who steals his belongings. The hero then makes his way to Bartertown, an Old West-style community with strict capitalist rules run by twin rulers: above ground, Aunty Entity, a warrior queen; below ground, Master Blaster. The latter is a twin entity: Master, a diminutive engineer who brews methane from pig feces, and Blaster, the huge, mentally impaired bodyguard Master sometimes rides.

Aunty Entity persuades Max to fight Blaster in the gladiatorial Thunderdome in the hope that he will defeat the giant and thus calm the increasingly uppity Master. Max accepts the challenge, but before entering the fight he does some research that gives him an edge. He triumphs in combat but refuses to kill the pitiful, child-like Blaster. This annoys the people of Bartertown, who exile Max to the wastelands. There he is saved by a tribe of feral children who live in a desert oasis paradise, survivors of a plane crash years before.

The children dream of "Captain Walker," a pilot who will take them home, and wonder if Max might be him come at last. Max disappoints them by telling them that they are better off where they are, then has to rescue a handful of them who leave anyway. On his return to Bartertown, Max frees Master, who is now Aunty Entity's slave, and causes much destruction before persuading Jedediah to fly the children to safety. To allow the plane to take off, Max must smash a path through Aunty's chasing cars. Once again he is left alone in the desert.

Finally Aunty Entity allows Max to depart and, some time in the future, we see children in a ruined Sydney telling tales of Max. **MB**

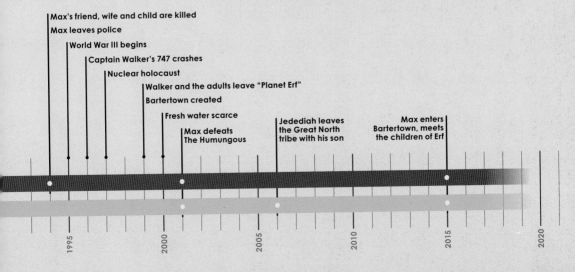

Max's friend, wife and child are killed
Max leaves police
World War III begins
Captain Walker's 747 crashes
Nuclear holocaust
Walker and the adults leave "Planet Erf"
Bartertown created
Fresh water scarce
Max defeats The Humungous
Jedediah leaves the Great North tribe with his son
Max enters Bartertown, meets the children of Erf

1995 2000 2005 2010 2015 2020

Mad Max
(1979)

**Mad Max 2:
The Road Warrior**
(1981)

**Mad Max: Beyond
Thunderdome**
(1985)

Mad Max
(1990)

The sadistic Toecutter (left) was played by Hugh Keays-Byrne, a classically trained Shakespearean actor.

Mad Max turned Mel Gibson from jobbing actor to global superstar.

Whatever **Mad Max** may have lacked in plot, it more than made up for in action. The movie is full of dangerous, spectacular auto stunts like this.

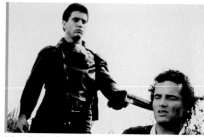

Johnny the Boy discovers that justice can be a pain in the neck.

The auto stunts in **Mad Max** were all for real.

Mad Max reaches for his weapon as the bikers approach.

Mad Max 2 (aka *The RoadWarrior*) was granted a much higher budget, allowing for even greater mayhem.

The gasoline tanker that is central to the events of **Mad Max 2** (*The Road Warrior*).

Rock singer Tina Turner (R) broadened her popular appeal through her portrayal of Aunty Entity in **Mad Max: Beyond Thunderdome**.

Mel Gibson as Max and Helen Buday as Savannah Nix, leader of the child survivors in **Mad Max: Beyond Thunderdome**.

Critic Roger Ebert described the Thunderdome as "the first really original movie idea about how to stage a fight since we got the first karate movies."

Of the relatively few *Mad Max* commercial spin-off products, this computer game was one of the most successful.

alien 1979

Alien Alien Alien Aliens Aliens: The Computer Game Aliens

When writers Dan O'Bannon and Ronald Shusett presented their new screenplay, *Alien*, to the studios their pitch was simple — it was *"Jaws in space."* Producers Walter Hill, David Giler and Gordon Carroll took the bait, bought and developed the script, and signed a deal with 20th Century Fox.

It's a simple tale. The crew of the *Nostromo*, a commercial space-tug, are awakened from stasis when the ship's computer picks up a distress call from an uninhabited planetoid, LZ-426. On the surface, they discover the ancient wreck of an alien spacecraft, the fossilized corpse of its dead pilot and a hold containing thousands of large eggs, one of which releases a grotesque alien creature that attaches to the face of crew member Kane, putting him in a coma. On board the ship, Kane awakes when the creature detaches itself and dies, but then — in one of the most iconic scenes in science fiction and horror movie history — an alien creature bursts from his chest and escapes into the labyrinthine corridors and air vents of the ship. The remainder of the movie sees the

crew in search of the alien, which meanwhile is killing them off one at a time, leaving only Warrant Officer Ripley (Sigourney Weaver) surviving.

Heavy modifications were made to the original script, most notably the role of science officer Ash (Ian Holm), who at the end is revealed to be an android working directly for the ship's owners, his covert task to return a living alien for biological research. Although O'Bannon hated this subplot, the idea of a sinister corporation pulling strings in the background, treating its employees as disposable assets, would be a popular theme, and neatly reflected the emerging distrust of corporations of the era.

The producers offered the film to the British director Ridley Scott, a successful maker of TV commercials who had enjoyed critical acclaim for his debut feature, *The Duelists*. After reading the script he drew a series of distinctive, extensive and detailed storyboards (known among the crew as "Ridleygrams") that convinced the studio to double the budget from $4.2 million to $8.4 million.

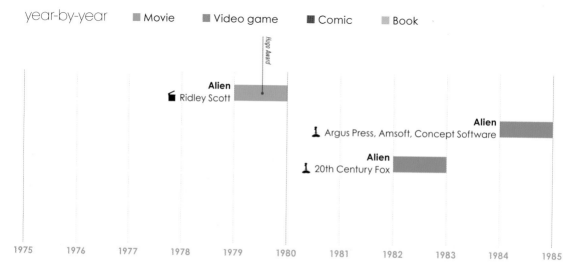

year-by-year ■ Movie ■ Video game ■ Comic ■ Book

Hugo Award

Alien
Ridley Scott

Alien
Argus Press, Amsoft, Concept Software

Alien
20th Century Fox

1975 1976 1977 1978 1979 1980 1981 1982 1983 1984 1985

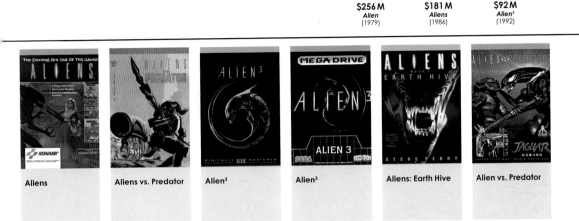

$256M
Alien
(1979)

$181M
Aliens
(1986)

$92M
Alien³
(1992)

Aliens

Aliens vs. Predator

Alien³

Alien³

Aliens: Earth Hive

Alien vs. Predator

O'Bannon, meanwhile, looked to recruiting artists that he had worked with in France on a failed attempt to adapt Frank Herbert's novel, *Dune*. Science fiction artist Chris Foss was brought in to design the distinctive, "industrial" exterior of the *Nostromo*. French comic artist Jean "Moebius" Giraud was approached to design the ship's interior, but other commitments meant he was only able to supply concept art for the crew's distinctive costumes. O'Bannon instead turned to artist Ron Cobb to work on the film's extensive set of corridors and flight decks. Finally, he introduced Swiss artist H.R. Giger, who would design not just the alien, but the memorable interiors of the crashed alien spacecraft.

It would be an intense, fraught production, but on May 25th, 1979, *Alien* was released to huge commercial success. Not all critics were initially impressed, Roger Ebert dismissing the film as a "haunted house thriller set inside a spaceship." Now, of course, *Alien* is widely viewed as a classic of imaginative filmmaking, championed for its

production design, naturalistic performances and Scott's unique eye for cinematography and lighting. One of its most important legacies was the casting of Sigourney Weaver in the lead role; not only would it launch her long and very successful Hollywood career, but it proved that audiences were prepared to accept strong female leads in blockbuster movies.

Despite its success, it would take seven years for a sequel to go into production. Director James Cameron (*The Terminator*, *Titanic*, *Avatar*) prepared a follow-up script for producer David Giler. *Aliens* returns Ripley to planetoid LZ-426: now being colonized, she is sent to investigate when communications have been lost. This time, however, she's accompanied by a squad of military personnel packing an arsenal of high-tech weaponry. This contrast with the unarmed, civilian crew of the *Nostromo* — and the shift in focus from a single creature to the multiples suggested in the title — was intended to emphasize action rather than suspense, Cameron openly aiming for a "Vietnam War movie in space" feel. He did, however,

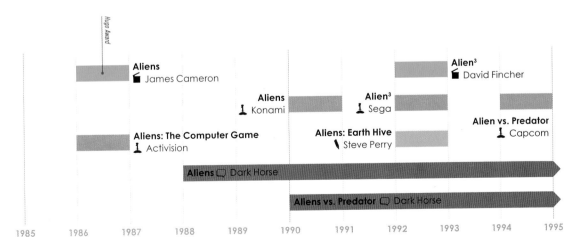

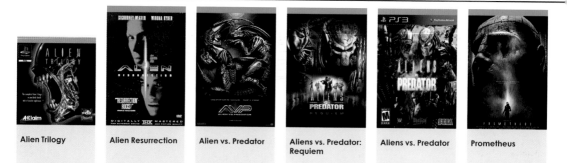

Alien Trilogy Alien Resurrection Alien vs. Predator Aliens vs. Predator: Requiem Aliens vs. Predator Prometheus

maintain the claustrophobic atmosphere of the original, and themes of paranoia and corporate betrayal. Another box-office hit, it also resonated with critics, and is widely regarded as one of the few movie sequels to match its predecessor.

With more action and an expanded view of the *Alien* universe, *Aliens* opened up the franchise to other media in ways that its darker predecessor never could. Among the myriad of games and novels spawned by the movie, was a popular, long-running series of comics published by Dark Horse. Stranger things followed, including a baffling array of comic book tie-ins, beginning with *Aliens vs. Predator*, and expanding to include the likes of *Aliens vs. Batman*, *Superman vs. Aliens* and *Judge Dredd vs. Aliens*.

Driven by the commercial success of *Aliens*, 20th Century Fox pushed for a third movie, but with the producers unable to agree on a story line, and Sigourney Weaver initially uninterested in reprising her role as Ripley, it would be a further six years before a sequel appeared. An early draft by seminal cyberpunk author William Gibson was regarded by the studio as over-complex — although leaked to the

internet many years later it would gain a cult following among fans. In the end, with Weaver back on board and filming schedules in place, producers Hill and Giler mashed together elements of subsequent scripts by Eric Red, David Twohy and Vincent Ward. After a malfunction on her return home, Ripley would crash-land on an all-male penal colony where the inmates were part of a monastic religious sect.

Having been turned down by Danny Boyle (*Trainspotting*), the director's chair was given to the unknown David Fincher. As a novice, he would find himself facing frustrating daily on-set interference from the producers.

The resulting film, *Alien 3* (officially styled $Alien^3$), was a box-office hit, but unpopular among hardcore fans, many of whom were upset by the killing-off of Newt and Hicks: key figures from its predecessor, they are ruthlessly dispatched while still in cryogenic stasis during the movie's opening credits. James Cameron described it as "a slap in the face." The film's stock has risen in recent years, in part due to Fincher's subsequent successes directing films such as *Seven* and *Fight Club*.

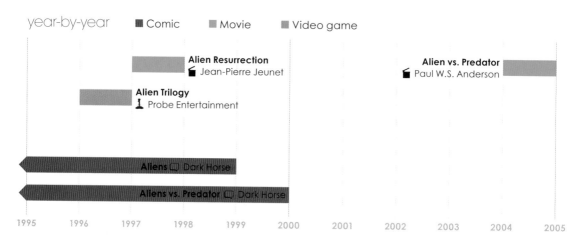

year-by-year ■ Comic ■ Movie ■ Video game

Alien Resurrection
Jean-Pierre Jeunet

Alien Trilogy
Probe Entertainment

Alien vs. Predator
Paul W.S. Anderson

Aliens □ Dark Horse

Aliens vs. Predator □ Dark Horse

1995 1996 1997 1998 1999 2000 2001 2002 2003 2004 2005

Aliens: Colonial Marines

In spite of Ripley's sacrificial death at the end of *Alien³*, Weaver agreed to return for a fourth outing. Based on a script by Joss Whedon (*Buffy the Vampire Slayer*) and directed by Jean-Pierre Jeunet, *Alien Resurrection* takes place 200 years later, with Ripley revived as a clone by scientists trying to recreate the alien queen embryo that she was carrying at the time of her death.

Largely regarded as the weakest of the series, with the lowest U.S. box office, *Alien Resurrection* seemed to mark an end for the franchise. Yet plans were almost immediately put in motion for a fifth instalment — a fan's dream scenario that would see Ridley Scott and James Cameron team up to save the franchise with one final chapter. With a plot that would send Ripley and a squad of marines (lead by none other than Arnold Schwarzenegger) back out into space, *Alien 5* would return to the planetoid LZ-426 as humanity sought to eradicate the species once and for all. However, a furious Cameron pulled the plug on the idea when he discovered that Fox was also planning an *Alien vs. Predator* movie, telling studio executives, "you're going to kill the validity of the franchise."

When *Aliens vs. Predator* appeared in 2004, Cameron's fears seemed all too real, and the film was released to a very poor critical response; a sequel three years later, *Aliens vs. Predators: Requiem*, received a similarly hostile reception.

Ridley Scott retained an interest in the franchise, and in 2009 it was announced that he would be making a prequel examining the origins of the creature and the derelict alien craft in the original. But with the film ready to shoot, he changed tack dramatically, commissioning Damon Lindelof (*Lost*) to rewrite parts of the script, leaving out the original "Alien" elements. As a result, *Prometheus* was much less a prequel than a spin-off set in the same fictional universe. Seen as a modest return to form after the crossover debacles, it was a sizable commercial hit.

Over the years, *Alien(s)* has reached well beyond its movie roots, with spin-offs that include comics, books, model figures and well over 30 different video games. And even though few of the recent films have drawn critical plaudits, they have performed sufficiently well at the box office to suggest that the franchise has far from run its course. **TM**

Aliens vs. Predator: Requiem
🎬 Colin Strause, Greg Strause

Prometheus
🎬 Ridley Scott

Aliens vs. Predator
🕹 Rebellion

Aliens: Colonial Marines
🕹 Gearbox Software

2005	2006	2007	2008	2009	2010	2011	2012	2013	2014	2015

alien universe

Peter Weyland

Elizabeth Shaw

G.W. Kane

Ellen Ripley

Dwayne Hicks

Rebecca "Newt" Jorden

At the end of the 21st century, Dr. Elizabeth Shaw discovers a star map suggesting that the galaxy was seeded with life by aliens. Leading an expedition to a world on the map, she discovers it was a weapons facility. The aliens they find there kill most of the expedition. Only Shaw and David, an android, survive. They depart on an alien craft, as mutagenic weapons create a deadly creature ...

Decades later, the Weyland-Yutani ship *Nostromo* has its journey interrupted by a signal from a derelict alien spacecraft on planet LV-246. Three members of the crew — Captain Dallas, Kane and Lambert — enter and find the hold full of eggs. One of these hatches a lifeform that attaches itself to Kane's face.

Kane is taken back to the *Nostromo*, where science officer Ash allows him back on board against Warrant Officer Ripley's orders. Attempts to remove the creature fail, but it appears to die and Kane wakes in good health.

The crew is enjoying a meal when Kane starts to convulse. A creature bursts from his chest, escapes, and begins to kill them. Ripley discovers that Ash is working under a directive to bring an alien to Earth at the expense of their lives. Ash attacks, but he is killed and revealed to be an android. The three remaining crew set the *Nostromo* to self destruct. The alien kills all but Ripley, who escapes only to discover that the alien is in the shuttle with her. Donning a spacesuit, she opens the airlock and the alien is destroyed.

Fifty-seven years later Ripley is picked up and taken to Earth orbit. She is not believed, and stripped of her pilot's license. To her horror she discovers that LV-426 has been colonized. Ripley is reduced to working in the docks, but is visited by Weyland-Yutani executive Carter Burke and Lieutenant Gorman of the Colonial Marines, who tell her that contact has been lost with LV-426. After a promise there will be no attempt to bring samples back, Ripley agrees to accompany them aboard the *Sulaco*.

characters

- Peter Weyland
- Ellen Ripley
- Elizabeth Shaw
- Dwayne Hicks
- G.W. Kane
- Rebecca "Newt" Jorden

Ripley assigned to USCSS *Sotillo*

Ripley assigned to USS *Sephoria*

USCSS *Prometheus* heads to LV-223

Shaw discovers star map

Ellen Ripley born

Ripley completes training

Peter Weyland born

G.W. Kane born

Weyland and crew of USS *Prometheus* killed

Shaw disappears

USS *Nostromo* refitted as towing vehicle

Elizabeth Shaw born

1990 2055 2060 2070 2080 2090 2100 2110

At LV-426, Ripley is introduced to the Marines. Among them is Corporal Hicks and an android named Bishop. They find the colony deserted apart from a girl nicknamed Newt. In the terraforming plant the marines are ambushed by the creatures and they decide to evacuate. However, the dropship crashes, and the survivors are forced back into the colony.

Bishop discovers that the terraforming plant has been damaged and will explode. He attempts to get to a transmitter from where he can remotely pilot the remaining dropship. In the meantime, facehuggers released by Burke hunt Ripley and Newt. As Ripley is confronting him the aliens attack, capturing Newt.

The dropship lands, but Ripley refuses to leave without Newt. She and Newt escape the alien nest, pursued by the alien queen. Back on the *Sulaco* they find that the queen has stowed away on the dropship's landing gear — it rips Bishop in half and is only defeated when Ripley uses a robotic power-loader to throw it out of the airlock.

On the way to Earth, the *Sulaco* is brought down by a facehugger hidden in the ship. It crashes on a prison planet, where Ripley must deal with another of the creatures. Plans to trap it are undone by an insane prisoner, and the alien kills many of them.

Ripley discovers that she has been impregnated by the facehugger. As the head of the Weyland-Yutani Corporation arrives, she casts herself into the facility's furnaces to destroy the alien. Her DNA is collected, however.

Two hundred years later, Ripley is cloned aboard the UMS *Auriga*. As DNA has been mixed, Ripley is endowed with strange abilities and the alien queen they take from her has a womb. It gives birth to a hideous hybrid that believes Ripley to be its mother. The aliens bred aboard the *Auriga* escape. Damaged, the ship heads for Earth, forcing Ripley, a team of mercenaries and an android named Call to team up to save Earth from the aliens. They succeed at the last minute, Ripley killing her own "newborn." **TM**

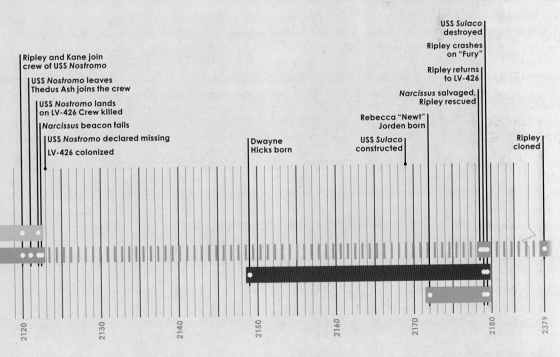

Ripley and Kane join
crew of USS *Nostromo*

USS *Nostromo* leaves
Thedus Ash joins the crew

USS *Nostromo* lands
on LV-426 Crew killed

Narcissus beacon fails

USS *Nostromo* declared missing

LV-426 colonized

Dwayne
Hicks born

Rebecca "Newt"
Jorden born

USS *Sulaco*
constructed

USS *Sulaco*
destroyed

Ripley crashes
on "Fury"

Ripley returns
to LV-426

Narcissus salvaged,
Ripley rescued

Ripley
cloned

2120 2130 2140 2150 2160 2170 2180 2379

Alien
(1979)

Aliens
(1986)

Alien³
(1992)

**Aliens vs.
Predator: Requiem**
(2007)

Prometheus
(2012)

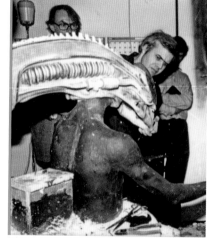
Swiss surrealist artist H.R. Giger examines the alien. He based his design for the creature on his painting "Necronom IV."

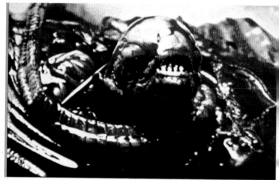
Some of H.R. Giger's designs for the alien, seen here in juvenile form, were so alarming that they were reportedly held up by customs officials at Los Angeles' LAX airport.

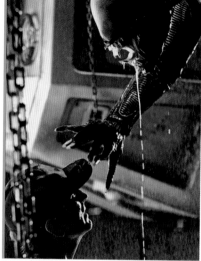
Engineer Brett (Harry Dean Stanton) faces a gruesome demise at the hands of the alien.

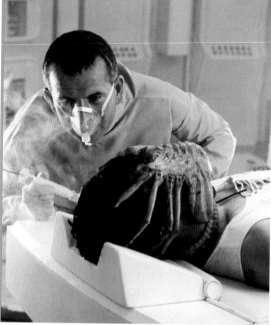
Executive Officer Kane (John Hurt) lies comatose, victim to the parasitic "facehugger," in Ridley Scott's *Alien*.

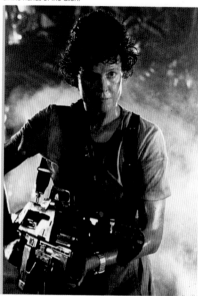
A gun-toting Ellen Ripley (Sigourney Weaver) in James Cameron's 1986 sequel, *Aliens*.

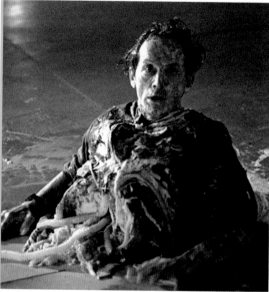
Actor Lance Henriksen has featured in numerous science fiction movies, during which time he has variously been killed by an alien, a predator and a terminator.

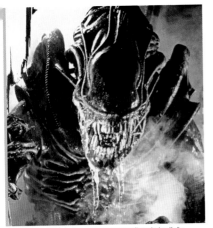

H.R. Giger's original alien designs were quite substantially modified for **Aliens**.

Ripley dons her power-loader as she prepares to battle an alien queen in **Aliens**. The beast is defeated and expelled into space through an airlock.

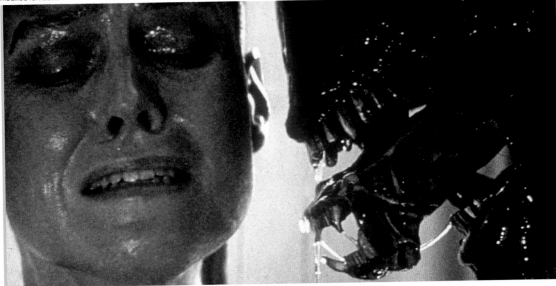

Alien³ sees a shaven-headed Ripley, played for a third time by Sigourney Weaver, coming face to face with her old enemy.

Directed by sibling duo Greg and Colin Strause, two movie franchises are brought together for a second time in 2007's **Aliens vs. Predator: Requiem**.

Members of the **Prometheus** crew explore a structure built by the "Engineers," revealed to be the progenitors of humankind in Ridley Scott's "nonprequel."

sapphire and steel 1979

Sapphire and Steel

Sapphire and Steel

Sapphire and Steel

"All irregularities will be handled by the forces controlling each dimension. Transuranic heavy elements may not be used where there is life. Medium atomic weights are available: Gold, Lead, Copper, Jet, Diamond, Radium, Sapphire, Silver and Steel ... Sapphire and Steel have been assigned!" Thus rumbled the God-like voice at the beginning of *Sapphire and Steel*, announcing the imminent arrival, twice-weekly, of two inter-dimensional operatives, seconded to Earth to deal with time anomalies, spatial disturbances and bewildered bystanders.

Like *Doctor Who*, ITV's *Sapphire and Steel* was a peculiarly English expression of science fiction. "I've always been interested in time, particularly the ideas of J.B. Priestley," reflected series creator Peter J. Hammond. Indeed, Priestley's *An Inspector Calls* provides a pitch-perfect template for this claustrophobic, paranoid melodrama.

A total of six stories were aired between 1979 and 1982, Hammond also penning a novelization. Intriguingly, none of episodes were ascribed titles. This elusiveness reflected the determined opaqueness of the show itself, which offered little background information, and in which the enemy — Time — remains a faceless, ethereal and almost sentient menace.

The sculptor of *Sapphire and Steel*'s seductive, skewed reality, Hammond had been dabbling in the world of kiddie-friendly SF on shows like *Ace of Wands* and *Shadows*. His scripts for *Sapphire and Steel* were grandly ambitious, suggesting a scope well beyond the shabby confines of the ATV studios, indulging in metaphysical and philosophical concepts rare in peak-time commercial broadcasting. "My mother used to have a cleaner, Mrs. Puttock," recalled David McCallum, the actor who played Steel, "and she saw the first episode and said, 'I loved it, but I didn't understand it,' so we always tried to make the stories Puttock-proof." The basic premise, nonetheless, remained ambiguous: Joanna Lumley, who played Sapphire, saw their characters as aliens; in spite of their special powers, Hammond declared them to be more like "supernatural do-gooders."

Sapphire and Steel are complementary characters, and Hammond was wise enough not to resist the elegant simplicity of the premise. Sapphire (Joanna Lumley), all Chelsea dinner party sophistication and simmering sexuality, provides an ideal foil for the awkward and socially brutal Steel.

The show was never meant to end when it did, but was axed when ATV lost its license in the ITV franchise renewal of 1981. This left the duo in a never-to-be resolved cliffhanger, suspended in space and time for all eternity. Yet perhaps this was a fitting conclusion for a series that wanted to get under your skin, that wanted to be remembered for being different.

There was an attempt to pick up the baton two decades later when 15 new audio episodes were recorded, with Susannah Harker and David Warner in the title roles. It is the TV series, however, that remains cherished. When, post-*Star Wars*, most British science fiction jettisoned its local flavor, *Sapphire and Steel* celebrated its island strangeness. **SOB**

year-by-year ■ TV series ■ Book ■ Audio

Sapphire and Steel
📺 ITV

Sapphire and Steel
❦ Peter J. Hammond

Sapphire and Steel
♪ Big Finish Productions

1975 1980 1985 1990 1995 2000 2005 2010

morlock night 1979

Morlock Night

When speaking of the nascent steampunk movement, kicked off in late-1970s California by SF authors K.W. Jeter, Tim Powers and James Blaylock, Powers called *Morlock Night* "The book that started it all." Its creator, Jeter, would himself coin the term "steampunk" in a 1987 letter to *Locus* magazine. "I think Victorian fantasies are going to be the next big thing," he wrote, "as long as we can come up with a fitting, collective term ... like 'steampunks,' perhaps."

He was well ahead of his time. Steampunk, both as a word and a genre, only truly entered the mainstream consciousness in the late 2000s, thereafter exploding, as Powers again noted, into "books and movies and graphic novels and clothing and jewelry and God knows what else."

Morlock Night is a continuation — of sorts — of H.G. Wells' classic 1895 novel, *The Time Machine*. In its original form, a British inventor travels to the far future to discover that two races have evolved out of humankind: the peaceful Eloi and the terrifying Morlocks. He recounts the story of his adventures to a group of friends at dinner. In Jeter's novel, one of those dinner companions becomes the hero of the story, as London is faced with a Morlock invasion. The underground creatures infest the sewers of Victorian London, before King Arthur emerges to save the day.

There have been other continuations of *The Time Machine*, including Christopher Priest's earlier *The Space Machine* (1976) and Stephen Baxter's *The Time Ships* (1995), but *Morlock Night*'s significance is in establishing steampunk as an identifiable subgenre, first giving vocabulary and then vision to something genuinely new that has steadily grown in significance over the past three decades.

Morlock Night has its genesis in a commission by editor Roger Elwood who approached Jeter, Powers and Blaylock to write a series of Arthurian fantasies set in different eras. Inspired by Henry Mayhew's classic 1840s *London Labour* and *The London Poor* (articles collected in book form in 1851), Jeter conjured a fantastical vision of a Victorian London filled with fog and sewers, mysteries and mad science, and inspired by the many "penny dreadful" writers of the era. Although the original commission, for a British publisher, fell through, it allowed the trio to begin developing their vision of these "gonzo-historical fantasies," as they first described them. It is worth noting that, unlike later steampunk — much of which would be inspired by Gibson and Sterling's *The Difference Engine* (1990) — these initial works treat steampunk as a mixture of science fiction and fantasy. Hence, for instance, the appearance of Merlin in the novel, or the presence of ancient Egyptian magic — alongside time travel — in Powers' *The Anubis Gates*. At the heart of steampunk, genre boundaries are crossed and blurred.

Following the collapse of the original commission, *Morlock Night* was picked up by DAW Books and published in paperback in 1979 with the tantalizing strapline, "What happened when the Time Machine returned." It remained out of print for many years, before being bought by Angry Robot Books in 2011 and relaunched for a new audience, many of whom may have been unaware of the origins of the subgenre they loved. **LT**

year-by-year ■ Book

Morlock Night
❨ K.W. Jeter

1975 1980 1985 1990

nausicaä of the valley of the wind 1982

Nausicaä of the Valley of the Wind

Nausicaä of the Valley of the Wind

Giant God Warrior Appears in Tokyo

A veteran figure from the world of Japanese film animation, Hayao Miyazaki has not only written and illustrated his own manga strips but is as an internationally recognized maker of anime films, among them his Academy Award-winning *Spirited Away* (2001), regarded by many as one of the greatest animated movies ever made.

Graduating in 1963 from Gakushuin University, Miyazaki found employment as an animator working on some of Japan's most popular TV series. He made his film debut in 1979 with a comedy crime anime, *The Castle of Castigliostro*, following up five years later with *Nausicaä of the Valley of the Wind*.

This is the story of a girl and her world. Nausicaä is a courageous princess surfing the winds on a jet-powered glider. She lives in a far-future Earth, by then an alien planet, enveloped in a "forest" of fungus and ruled by giant insects. *Nausicaä* is both a comic and cartoon landmark; Miyazaki wrote it as a thousand-page graphic novel, but it is far better known through its animated film adaptation. As science fiction, it's comparable to *Star Wars* and *Avatar*, but it is far smarter than either.

The film version (1984) starts with a lonely wanderer in a wilderness. The image suggests a western, but then we see the creature he is riding is a hybrid of horse and bird. The town he finds is dead, sunken under a white icing of cobweb growths. An egg-like puffball deflates, releasing spores with a rasp, part of a lonely soundscape of hissing wind and sandy footsteps. The man breaks down a door, to find a crumbling doll and a skull encrusted by fungus: "Another village has died."

Human civilization is gone, destroyed in a war known as "The Seven Days of Fire." This is shown through a Bayeux-like tapestry depicting rowboats borne by fire-spurting rockets and monstrous, city-destroying "God Warriors." Nausicaä is introduced as a blue-clad explorer, flying over a landscape where trees have been replaced by towering, fleshy shoots crowned by globular seed heads. She ventures calmly into this strange world. With respect and delicacy, she taps a plant sample into a test-tube; her feminine grace fits the organic space.

Alongside Kusanagi, the glowering cyborg heroine of *Ghost in the Shell*, Nausicaä ranks among manga and anime's most iconic heroines. Much of her behavior is girlishly cute; her noncombat heroics include nurturing orphan babies and calming scared animals. She even has a pet, a bright-eyed "squirrel-fox" called Teto, which clings to her shoulder. Like *Doctor Who*'s Doctor, she loathes cruelty and violence, and dreams of justice for all life forms. Yet she can and does kill people, especially in the comic, with no question that the blood stays on her hands. In battle, she speaks with the machismo of a movie samurai. She can be rational and scientific, or succumb to berserk rages.

Adding further complexity, Nausicaä is set against a more adult woman, the military general, Kushana.

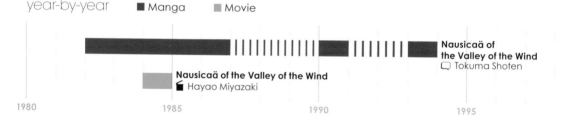

year-by-year ■ Manga ■ Movie

Nausicaä of the Valley of the Wind
🖋 Hayao Miyazaki

Nausicaä of the Valley of the Wind
▢ Tokuma Shoten

1980 1985 1990 1995

$4.9M
*Nausicaä of the
Valley of the Wind*
(1984)

Two contrasting figures, Kushana commits atrocities against civilians, and loathes the forest Nausicaä loves, yet she never turns into an outright villain. Her bold acts power the story, and she always seems capable of redemption. Nausicaä, on the other hand, with her destructive side, risks damnation. Notably, Hideaki Anno, creator of the Japanese franchise *Neon Genesis Evangelion*, expressed a desire to make a story focused on the Kushana.

Anno, in fact, worked on the *Nausicaä* film, and was responsible for drawing the fantastic melting *God Warrior*. (Thirty years later, he also oversaw a live-action short, *Giant God Warrior Appears in Tokyo*, where the same monster incinerates the present-day city). In Miyazaki's film, Kushana invades the heroine's homeland and "grows" the sleeping monster, Frankenstein-style, in a bid to burn the forest. Nausicaä, meanwhile, is lost in the forest, where she learns its true nature. There are battles in the clouds between rusty flying corvettes like scarred sharks; stampedes of giant insects evoking whales or *Dune*'s sand-worms and humans overwhelmed by huge alien landscapes, in the tradition of Brian Aldiss' book, *Hothouse* (1962), or the magnified Earth of Richard Matheson's *The Shrinking Man* (1957).

The plot recycles elements from *Future Boy Conan*, a TV series Miyazaki had directed in 1978, which was set on a simpler post-disaster world, mostly submerged under sea. (Its boy hero is unrelated to the fantasy barbarian or to the manga sleuth Detective Conan.)

Nausicaä was made by Japan's Top Craft studio, which had animated fantasy cartoons such as *The Hobbit* (1977) and *The Last Unicorn* (1982) for America's Rankin/Bass. It was given a U.S. release in 1985 in a shortened dub called *Warriors of the Wind*; nothing like as bad as is often claimed, it nonetheless fudges some of the subtler plot points. It was 2005 before Buena Vista issued a full English-language version of the film, with a dub featuring Alison Lohman in the lead role and Uma Thurman voicing Kushana.

The manga story is far more ambitious, its epic scope recalling *Lawrence of Arabia*. A continent-spanning war pits a theocracy against an imperial superpower; both have evil leaders, but their people are simply human. The journeys of Nausicaä and Kushana extend much further than in the film. By the end of the story, Nausicaä has become a "mother" to a childlike God Warrior herself, giving her the power to save or destroy humanity. The path she chooses is open to interpretation.

Nausicaä of the Valley of the Wind was first serialized in *Animage* magazine, its unusual A4 format making it larger than most other manga. The illustrations are mainly pencil-drawn, with shaded hatching (close parallel lines) and the miasmatic fogs of *Nausicaä*'s world created with stippling techniques. Costumes are drawn with great precision; faces are simple and mildly cartoonish. The comic was serialized intermittently for 12 years, and published over seven volumes in English. **AO**

Giant God Warrior Appears in Tokyo
Shinji Higuchi

2000 2005 2010 2015

interzone 1982

Interzone

Interzone — the longest-running science fiction magazine in Britain — was begun by an eight-person collective that included David Pringle, critic John Clute and Malcolm Edwards, future publishing director of SF imprint Gollancz. Although the heyday of short science fiction magazines was some decades in the past, the group was inspired mainly by the influential British periodical New Worlds, which had been edited through the 1960s by Michael Moorcock.

Before long only Pringle remained as sole editor. The first issue of Interzone came out in spring 1982, and the impressive line-up of authors included Moorcock, Angela Carter and M. John Harrison. Among numerous notable contributions to early editions were 10 stories by J.G. Ballard, one by Philip K. Dick and two by William Gibson. However, it was above all as a hothouse of young writers that Interzone acquired its outstanding reputation. During the 1980s, the magazine featured the first stories by Kim Newman, Paul J. McAuley, Greg Egan, Stephen Baxter, Geoff Ryman, Eric Brown, Charles Stross, Nicola Griffith, Keith Brooke, Ian R. MacLeod, Gwyneth Jones, Richard Calder and Ian McDonald — all of whom would come to wider prominence over the following decade.

The 1980s also saw the only appearance in the magazine of Iain M. Banks (with "A Gift from the Culture") and Terry Pratchett (with an excerpt from Discworld novel Wyrd Sisters).

Interzone truly came into its own in the 1990s. To its roster of young British talent it added Simon Ings, Alastair Reynolds, Chris Beckett, Graham Joyce, Molly Brown, Liz Williams, James Lovegrove and others. It also published many established authors such as Ian Watson and Brian Aldiss, and American authors such as Bruce Sterling, Thomas M. Disch and Paul di Filippo.

Throughout the last decade of the 20th century Interzone was among the leading lights of British science fiction and assisted the rising wave of New Space Opera. Many of its contributors went on to become the most successful and influential novelists in the genre in the new millennium.

After the year 2000, however, the magazine itself began to display signs of fatigue. In 2004 David Pringle stepped down after 22 years in charge. Soon afterward Interzone was acquired by Andy Cox's TTA Press. It was then revamped visually and began to attract a new generation of young writers. In 2008 it published a highly controversial "Mundane SF Special," guest-edited by Geoff Ryman and others, which argued that the genre had become too escapist.

Interzone has won a Hugo and David Pringle a special award for his work as editor. Sixteen of the magazine's published stories have won BSFA Awards and one won a Nebula Award. Regular nonfiction contributors include film reviewer Nick Lowe (who won a BSFA Award for his work on the magazine) and David Langford, author of Ansible Links, a regular news column.

The early Interzone enabled a generation of British science fiction writers to find their own distinctive voices. The bimonthly magazine remains one of the most influential publications of its kind to this day. **LT**

year-by-year ■ Magazine

Hugo Award

Interzone \ Independent collective/David Pringle/TTA Press

1980 1985 1990 1995 2000 2005 2010 2015

e.t. the extra-terrestrial 1982

E.T. the Extra-Terrestrial

E.T. the Extra-Terrestrial in His Adventure on Earth

E.T. the Extra-Terrestrial

E.T. the Book of the Green Planet

E.T. the Extra-Terrestrial is a fairy story masquerading as science fiction. On his first appearance in the movie, in the moonlit cathedral of the Californian redwoods, E.T. seems a troll or goblin, a dream lent stumpy solidity. He becomes the alter ego of Elliott, the boy he meets, sharing his feelings and mirroring his reactions, from terror to wonder to love. The transmitter E.T. builds to phone home is a contraption from Doctor Seuss. His death and resurrection are linked to Tinker Bell's in *Peter Pan*. In J.M. Barrie's book, people clapped their hands. For E.T., they wept in cinemas in their millions.

Many of E.T.'s forerunners are non-SF: the death-in-life symphony of Disney's *Bambi*, the fairy-tale imagery of *Night of the Hunter* and a child's communion with a nonhuman best friend, as in *The Black Stallion* (1979), the film of Walter Farley's 1941 novel scripted by Melissa Mathison. Mathison also wrote *E.T.*, although the substance of the tale came from Steven Spielberg, who said: "I had always really wanted to tell the story of a disenfranchised and lonely boy in a relationship with siblings and to tell a story about the divorce of my parents ... the story of a special friend who rescues a young boy from the sadness of a divorce."

E.T. was also similar to "The Alien," a script for an unmade Indian-American film by director Satyajit Ray. Written in the 1960s, it concerns a kind alien who brings flowers to life and befriends a boy. E.T.'s appearance has been likened to that of the Martians in the first film of *The War of the Worlds* (1953). Spielberg acknowledged that he paid homage to that movie in E.T.'s alien-hand-on-shoulder moment. (He would go on to make his own *War of the Worlds* in 2005.)

Perhaps the most effective SF element in *E.T. the Extra-Terrestrial* is its identification of friendly aliens with human children and of hostile aliens with human adults — when the grown-ups invade Elliott's house in spacesuits, they turn it into an otherwordly environment. However, Spielberg adds a twist. The scariest adult (identified by his jangling keys) turns out to be a good man who's retained his sense of wonder; the end hints he may replace Elliott's lost father.

The film was novelized by William Kotzwinkle, the author of *Doctor Rat* (1976). He later wrote a sequel, *E.T.: The Book of the Green Planet* (1985), depicting the alien's troubles on his return home. Spielberg briefly considered a film sequel, but dropped the idea. Other spin-offs included a Universal Studios' theme-park ride on flying bikes, and a notoriously crude Atari video game. A rip-off live-action film, *Mac and Me* (1987) was also widely loathed.

Many of the best successors to *E.T.* are cartoons. *My Neighbor Totoro* (1988), *The Iron Giant* (1999), *Lilo and Stitch* (2002) and *Wall-E* (2008) all utilize the themes of Spielberg's film. **AO**

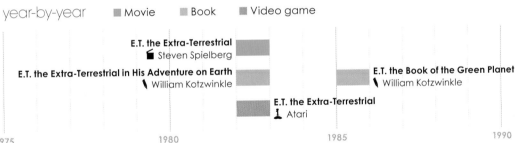

year-by-year ■ Movie ■ Book ■ Video game

E.T. the Extra-Terrestrial
Steven Spielberg

E.T. the Extra-Terrestrial in His Adventure on Earth
William Kotzwinkle

E.T. the Book of the Green Planet
William Kotzwinkle

E.T. the Extra-Terrestrial
Atari

1975 1980 1985 1990

akira 1982

Akira Akira Akira Akira Akira Akira: Psycho Ball

At the start of the movie *Akira*, a sphere of white light appears in Tokyo and swells to obliterate the city. Western critics saw this as a symbol of the atomic bomb, but this apocalypse could also be seen as *Akira*'s mission statement: to reshape animation.

Director Katsuhiro Otomo was an innovative comic artist whose deliriously uncontrolled film was based on his earlier, half-finished manga epic about two teen biker tearaways, Kaneda and Tetsuo. (The mysterious Akira has only five seconds of screen time.)

Akira is set in the violent future mega-city Neo-Tokyo, and mostly concerns what happens to it when Tetsuo acquires superpowers that he cannot control. It features battles on high-speed vehicles, explosions of flesh and stone, power struggles and military coups. The movie is also about trying to harness the primal energies of the Big Bang in perhaps the worst container imaginable — an angry teen boy obsessed with proving he's a man.

There were precedents for *Akira*, including Ralph Bakshi's non-SF satire *Fritz the Cat* (1972), which depicted a brutal New York police beating down rebels, and Gerald Potteron's *Heavy Metal* (1981), a lurid SF fantasy with violence and nudity. Both films helped establish animation on the big screen. For many viewers, though, *Akira* was brand new, turning Japanese animation into an international brand.

"I'd never seen anything like it," commented Andy Frain, who founded the British company Manga Entertainment on *Akira*'s back. "It was an animated *Blade Runner*, clearly not for children, but a well-crafted, thought-out, philosophical movie for grown-ups that happened to be in animation."

Otomo's original strip also came to the United States in the 1980s, published by Epic Comics, an imprint of Marvel. The earliest English-language editions were in color, but later reverted to the black-and-white of the Japanese original. Otomo's art is solid and dynamic, stressing massive architecture, Asian-looking characters (not a given in manga) and exclamatory speedlines. The comic's plot is more sprawling and often even less clear than the movie's.

The film is stronger in drama and pathos. Like the later British film *Attack the Block* (2011), *Akira* has teen hoodlums blundering into situations that are out of their league, and we see that these inhuman agents of violence are actually just kids. Otomo makes this point exquisitely in the film's final flashback, with two snotty, saintly little boys at a drinking fountain.

Akira's global success led directly to the film *Ghost in the Shell* (1995), co-produced by *Akira*'s Japanese publisher Kodansha and Britain's Manga Entertainment. Akira was also paid homage in the Kayne West music video for "Stronger." **AO**

year-by-year ■ Manga ■ Animated movie ■ Video game

Akira
🖳 Kodansha

Akira
🖳 Dark Horse

Akira
🖳 Epic

Akira
🎥 Katsuhiro Ohtomo

Akira
♟ Taito

Akira: Psycho Ball
♟ Bandai

1980 1985 1990 1995 2000 2005

battlefield earth 1982

Battlefield Earth

Space Jazz:
The Soundtrack
of the Book
Battlefield Earth

Battlefield Earth

Lafayette Ronald Hubbard is today best known as the founder of the Church of Scientology, the controversial religion that was born out of Dianetics, a self-help system that he first published in 1950. Hubbard's bizarre life story — naval service, three marriages and numerous religious episodes, from a flirtation with the occult to the creation of the most divisive new belief system of the 20th century — has been much discussed but rarely agreed upon. In the official Church of Scientology version of events, Hubbard was a near-flawless master of everything he turned his hand to, while other commentators track a stranger history, in which he once mistakenly attacked Mexico in his anti-submarine ship and was dismissed as a "mental case" by the FBI.

Obscured by all this, Hubbard's writing is often overlooked, but he contributed hundreds of stories across numerous genres over the years, often in intense bursts. Few of his early tales are much read today, although *Ole Doc Methuselah* (1970) — a collection of short stories in which a physician acts as a space super-agent — has its fans.

Mission Earth (1985) is a 10-volume behemoth, mixing science fiction adventure and broad, uncomfortable satire. Much better — although still far from a critical hit — is *Battlefield Earth: A Saga of the Year 3,000*, originally published by St. Martin's Press in 1982, and subsequently by Church of Scientology-owned companies. Vast — more than 1,000 pages in most paperback versions — and generally poorly reviewed, it nevertheless became a bestseller,

possibly through an organized campaign by Church members to buy up every copy they could find. Although never regarded as a religious text, it does reflect many Scientological themes, including a great suspicion of psychiatry.

The book tells of a far-future Earth that has been dominated for a millennium by the Psychlos, an alien race of 9-foot (2.7 m) tall raw-material grabbers. The remnants of humankind live in primitive tribes, but when one adventurous youngster, Johnnie Goodboy Tyler, goes exploring he comes across Terl, a Psychlo leader desperate to return, rich and wealthy, to his homeworld. Terl wants a captured Johnnie and others to mine gold for him in the Rocky Mountains, but Johnnie makes allies and eventually packs the coffins in which the Psychlos intend to return to their dead home with massive nuclear bombs that will destroy their planet. Through Tyler's efforts, humans eventually regain control of Earth.

Other enemies, both domestic and extra-terrestrial, turn up, but Johnnie finds ways to use technology purloined from the Psychlos to ensure the survival of humanity.

In 2000, a surprisingly faithful film version of the first part of the book appeared. It was directed by Roger Christian and produced by Scientologist John Travolta, who also starred as Terl. Hubbard, who died in 1986, had always wanted a movie version of his master work, but he would not have wished for this box-office disaster. Unsurprisingly, a sequel covering the second half of the book was indefinitely shelved. **PM**

year-by-year ▨ Book ▥ Audio ▧ Movie

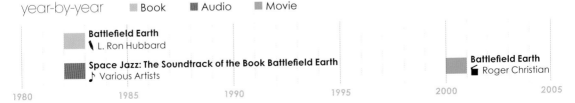

Battlefield Earth
✎ L. Ron Hubbard

Space Jazz: The Soundtrack of the Book Battlefield Earth
♪ Various Artists

Battlefield Earth
🎞 Roger Christian

1980 1985 1990 1995 2000 2005

tron 1982

Tron

Tron

Tron

Tron: The Ghost in the Machine

Tron: Legacy

Tron: Evolution Battle Grids

Tron: Betrayal

Tron: Uprising

A malign computer sends Kevin Flynn (Jeff Bridges) down a digital rabbit hole into the computer system — a luminous world in which programs are incarnated as humanoid warriors, including the heroic Tron (Bruce Boxleitner), who fight a tyrannical mainframe that seeks to bend them to its will. The movie featured a contest in which enclosed motorbikes turn through right angles and smash each other into maze walls thrown up by their passing. This was later adapted into a real arcade game (with distinctive chunky joystick) that earned more than the film.

Although made by Disney, Tron was conceived by an outsider, Steven Lisberger. Its main selling point was its groundbreaking computer-generated effects. However, as with Jurassic Park (1993), digital imagery made up only a little of the film. Tron's look relied primarily on backlighting to infuse screen images with intense, neon colors. The designers included Syd Mead, who handled the tanks and lightcycles at the same time he was building the cyberpunk Los Angeles for Blade Runner. The bubbling synthetic score, full of fanfares and fluting, was by Wendy Carlos, who had synthesized Beethoven's Ninth Symphony for A Clockwork Orange (1971).

David Warner, who played Tron's villain, Sark, recalled the set was entirely black: "[It] was like a rehearsal room; filming was like a constant rehearsal.

There was tape stuck on the floor, and maybe the odd box, and then just us." The actors wore leotard-like garments reminiscent of costumes in vintage sci-fi serials, such as Flash Gordon's silver underwear.

On release in the summer of 1982, Tron was overshadowed by Star Trek 2: The Wrath of Khan, which had its own pioneering CGI sequence, bringing the Genesis planet to life. A game sequel, Tron 2.0 (2003), featured the son of Alan Bradley, Tron's counterpart in the "real" world. A six-part comic, Tron: The Ghost in the Machine (2006–08) was later collected in book form.

The film sequel, Tron Legacy (2010) was directed by Joseph Kosinki with music by Daft Punk. The son of Jeff Bridges' character, played by Garrett Hedkund, enters an upgraded computer world full of slick symmetrical designs and stormy black skies. Bridges himself returns, both as an ageing hippie mentor and as a villain. Overall, the film is a fannish rehash, outmoded by The Matrix a decade earlier.

Tron Legacy's spin-offs are prequels filling out its backstory: games (Tron: Evolution and Tron: Evolution Battle Grids) and a two-issue comic book (Tron: Betrayal), which was subsequently collected as a graphic novel. The animated TV series, Tron: Uprising (2012), features a young program, voiced by Elijah Wood, that is in training to be the new Tron. **AO**

year-by-year ■ Movie ■ Book ■ Video game ■ Comic ■ Animated TV series

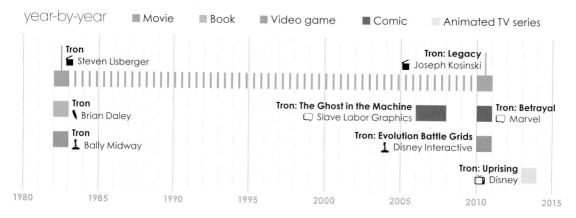

Tron
Steven Lisberger

Tron: Legacy
Joseph Kosinski

Tron
Brian Daley

Tron: The Ghost in the Machine
Slave Labor Graphics

Tron: Betrayal
Marvel

Tron
Bally Midway

Tron: Evolution Battle Grids
Disney Interactive

Tron: Uprising
Disney

1980 1985 1990 1995 2000 2005 2010 2015

dan simmons 1982

The River Styx Runs Upstream

Song of Kali

Hyperion

The Hollow Man

Endymion

The Rise of Endymion

Ilium

Flashback

Dan Simmons is an American author who writes in several genres, notably horror, historical fiction and crime, as well as science fiction.

He first came to prominence with the short SF story "The River Styx Runs Upstream," a grim tale of technological resurrection. In 1979 he took it to a writing workshop conducted by Harlan Ellison. In the introduction to the collection *Prayers to Broken Stones* (1997), Simmons recalls Ellison's reaction. "'Who is this Simmons?' he bellowed. 'Stand up, wave your hand, show yourself, goddammit. What egomaniacal monstrosity has the fucking gall, the unmitigated hubris to inflict a story of five thousand fucking words on this workshop? Show yourself, Simmons!'" The tale later won first prize in a *Twilight Zone Magazine* story competition.

Simmons' first few novels were supernatural horror. The pick of them was *Song of Kali* (1985). He later used elements of this genre in his science fiction works. *The Hollow Man* (1992) was a story of extrasensory perception with SF underpinnings; *Hyperion* (1989) was his first fully-fledged SF project. Together with its sequels, *The Fall of Hyperion* (1990), *Endymion* (1996) and *The Rise of Endymion* (1997), the *Hyperion Cantos* form the definitive space opera of the 1990s, a gloriously complex reinvention of the Golden Age subgenre. The sequence concerns a war across time and space in a galaxy dominated by the human Hegemony, as its ruling AIs battle with each other to determine its fate.

Simmons is renowned for the breadth of his literary allusions. "Hyperion" references an unfinished epic poem by John Keats, who appears as a key agent in the novel sequence. *Hyperion* itself is patterned after Chaucer's *The Canterbury Tales*; *The Hollow Man* (a reference to T.S. Eliot) mirrors Dante's *Divine Comedy*; *Endymion* features a lengthy homage to Mark Twain's *Adventures of Huckleberry Finn*.

The playing of games is a constant in Simmons' stories. In the horror novel *Carrion Comfort* (1989) — the title of which is the same as that of a poem by Gerard Manley Hopkins — mutant vampires engage in cruel sports with humans as unwitting players in order to extract maximum psychic energy from their suffering. In *Hyperion*, there are games within games. Similar themes are present in *Ilium* (2003) and *Olympos* (2005), which together comprise an ambitious space opera that blends an in-depth account of Homeric Greece, Greek mythology and the Trojan war with science fiction conventions, as factionalized posthumans battle over the fate of a far-future Solar System.

Historical horrors *The Terror* (2007), *Black Hills* (2010) and *Drood* (2009) followed, before Simmons returned to SF with *Flashback* (2011). This pessimistic, future noir novel displays the author's accomplished adoption of detective fiction techniques. The world is in terminal decay, terrorism is rife and everyone is addicted to drug called Flashback that lets them live out memories of their own choosing as if they were fresh and real experiences. **GH**

year-by-year ▓ Short story ■ Book

Hugo Award

The River Styx Runs Upstream

Hyperion

Endymion

Ilium

Song of Kali

The Hollow Man

The Rise of Endymion

Flashback

1980 1985 1990 1995 2000 2005 2010 2015

the postman 1982

The Postman

Cyclops

The Postman

The Postman

Following the Doomwar, North America is ravaged. Civilization has collapsed after the release of weaponized plagues and electromagnetic pulses that have rendered technology obsolete. Cities have been destroyed and individuals now scavenge to survive. Gordon Krantz is alone, a post-holocaust traveler searching for "someplace where someone was taking responsibility." He yearns for a lost world of hamburgers, hot baths and cool beer. He remembers a comrade who asked to be buried in a U.S. flag. Disillusioned and with all his worldly goods stolen from him, Krantz finds an old U.S. Postal Service uniform. To keep warm he puts it on and exchanges the old letters in his bag for food and shelter. Even in this devastated world, the people he meets are encouraged by the meaning of his uniform and come to believe he symbolizes hope for a new, reformed country — the Restored States of America.

The Postman by David Brin is an odyssey and a tale of unification and the power of symbols. Symbols — anything from a crucifix to a flying flag — are signs of humanity that allow people to read into them whatever they wish. In science fiction, such emblems are often invested with significance and emotional weight, sometimes hopeful, sometimes devastating — a mountain carved from mashed potato in *Close Encounters of the Third Kind* (1977), the Statue of Liberty in *Planet of the Apes* (1968).

Such symbols enable humankind to interpret the world and bring order to chaos, even if only subjectively. In Brin's view, the meaning of simple, everyday objects and traditions cannot be overestimated. As he said: "If we lost our civilization, we'd all come to realize how much we missed it, and would realize what a miracle it is simply to get your mail every day."

The Postman celebrates society in its most primitive form — people living, working and surviving together. In "Cyclops," the second section of the novel, Krantz enters a community that still depends on an artificial intelligence. But the machine is no longer working; scientists merely pretend that it is so that the people can continue to live with some semblance of order and their memories of the old world. This is a dangerous, but in Brin's view necessary, lie.

Brin is best known for his space opera *Uplift*, a hard SF sequence that fuses adventure with existential questions. *The Postman* is something of a departure for him, being an Earth-bound examination of savagery versus civilization and, ultimately, of hope.

In 1997, Kevin Costner directed and starred in a movie adaptation of *The Postman*. The film left out much of the novel's adventures and dwelt for long periods on rather simplistic discussions of its central ideas. It was a notorious bomb at the box office, making back less than half of its budget. **SW**

year-by-year ■ Short story ■ Book ■ Movie

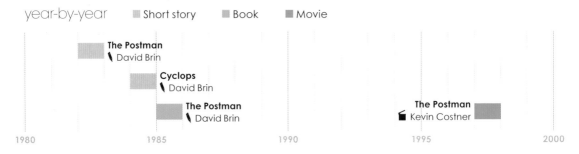

The Postman
David Brin

Cyclops
David Brin

The Postman
David Brin

The Postman
Kevin Costner

1980 1985 1990 1995 2000

the anubis gates 1983

The Anubis Gates

Tim Powers' fourth novel, *The Anubis Gates* is one of the most influential science fiction works of the 1980s. English fantasy fiction author China Miéville has described it as "one of the key texts in my head."

The work was one of the earliest examples of the steampunk, or "gonzo-historical fantasy" style that had been developed in California by Powers himself and his friends K.W. Jeter and James P. Blaylock. However, it is not only as a foundation text of this sub-genre that *The Anubis Gates* retains its fascination; it is also a bona fide classic in its own right, a work that continues to dazzle with a bizarre vision of a secret Victorian London. Its enduring appeal is attested by its renewed commercial success when reprinted in the Fantasy Masterworks series in 2005.

The novel opens with an American literary scholar, Brendan Doyle, being summoned to London in our present to take part in a millionaire's secret time travel experiment. Transported back to Victorian London, Doyle becomes trapped in the era and there witnesses the unfolding of a complex mystery involving ancient Egyptian magic, a body-switching murderer, a secret beggars' guild, an evil clown on stilts, a young woman disguised as a boy, the poet Samuel Taylor Coleridge and even a murderous doppelgänger of Doyle himself.

Part of the novel revolves around the identity of a mysterious Victorian poet, William Ashbless, of whose work Doyle is a leading scholar. The two men attempt to meet several times, but for various reasons fail to rendezvous until Doyle belatedly realizes that he himself has become Ashbless.

The character of Ashbless was created jointly by Powers and Blaylock, and over the years he has appeared in various guises in both authors' works. He is still alive in the 1950s' California of Blaylock's *The Digging Leviathan* (1984), and he has occasionally contributed to various of the authors' other projects, with rude introductions that make no effort to conceal his low opinion of both Powers and Blaylock.

The sheer inventiveness of *The Anubis Gates* is coupled with a meticulously worked-out plot and Powers' distinctively subtle prose. It is his first mature novel, and was his most commercially successful until 2011, when *On Stranger Tides* (1987) was adapted into the fourth *Pirates of the Caribbean* movie. *The Anubis Gates* won a Philip K. Dick Award in the year of publication — a particularly fitting accolade in view of Dick's close relationship with the three young writers during the last 10 years of his life.

Along with Jeter's *Morlock Night* (1979) and Blaylock's *Homunculus* (1986), *The Anubis Gates* forms the earliest core material of steampunk, a term that was coined by Jeter to apply to the trio's work — it is a play on "cyberpunk" to describe works in which the most advanced technology is the external combustion engine.

Although Powers' work is fantasy, the magic conforms to scientific reality. The author himself has described his novels as "secret histories" that follow real events and then supply a supernatural explanation for them. This, even more than 19th-century backdrops, is the true essence of steampunk, which here found its earliest mature expression. **LT**

year-by-year ■ Book

V 1983

V

V: The Final Battle

V

V

V

V

Writer/producer Kenneth Johnson came to prominence in the U.S. television industry in the 1970s. He was the linchpin of genre shows such as *The Six-Million Dollar Man* (1974–78), *The Bionic Woman* (1976–78) and *The Incredible Hulk* (1977–82). In the early 1980s Johnson read Lindsay Sinclair's 1935 novel *It Can't Happen Here*, a satirical work charting the rise of a totalitarian fascist power in the United States. He subsequently wrote an adaptation entitled "Storm Warnings" and took it to his friend Brandon Tartikoff, then president of entertainment at NBC.

Tartikoff liked the script, but was uncomfortable about the notion of a resistance cell fighting against a rising power of homegrown American fascism and suggested that the totalitarian regime could be an alien aggressor. Johnson resisted this idea at first, but soon saw possibilities in using a science fiction story to spin an allegorical tale of the rise of the Third Reich. "Storm Warnings" became *V*, a two-part mini-series.

With distinct shades of Arthur C. Clarke's novel *Childhood's End* (1953), *V* opens dramatically with vast saucer-like spaceships appearing above the major cities of Earth. The "Visitors" aboard are apparently benevolent humanoids, offering their advanced technology in return for minerals to aid their dying homeworld. The governments of Earth are charmed, but some are not so trusting, and eventually the Visitors are unmasked as terrifying reptiles. A sequence depicting Diana (Jane Badler) devouring a squealing guinea pig has arguably dated, but

remains a key image in the history of televisual science fiction shocks. A Los Angeles resistance group led by Mike Donovan (Marc Singer) and Juliet Parrish (Faye Grant) soon rises against Visitor oppression.

Johnson stayed true to his intentions by introducing the character of Holocaust survivor Abraham Bernstein (Leonardo Cimino), who sees parallels between the Visitors and the Nazis, endures his grandson joining the Hitler Youth-style Friends of the Visitors, and provides the series with its titular emblem, spraying a red V for victory over a Visitor propaganda poster.

V was an enormous hit and NBC quickly commissioned a 22-episode mini-series. *V: The Final Battle*, which continued the story of the resistance. This sequel replaced the allegory of the original with soap-style banter between the Visitors and recycled special effects. It failed to find an audience and was cancelled at the end of its run. Johnson had quit the project before production owing to creative differences. His 2008 continuation novel, *V: The Second Generation*, makes no reference to *The Final Battle* or its offshoots.

In 2009, ABC launched a remake — without Johnson's input — that repurposed the basic concepts of the original. It starred Morena Baccarin as Visitor Queen Anna, and maintained nostalgic links to its forebears with guest appearances from Badler and Singer. The series was unsuccessful and was cancelled after two seasons. **MW**

year-by-year ■ TV series ■ Book ■ Comic

V
Kenneth Johnson

V
DC Comics

V: The Final Battle
Richard T. Heffron

V
NBC

V
A.C. Crispin

V
ABC

1975 1980 1985 1990 1995 2000 2005 2010

sheri s. tepper 1983

King's Blood Four | Grass | Beauty | Gibbon's Decline and Fall | The Family Tree | The Fresco | The Margarets | Fish Tails

Sheri S. Tepper's earliest memory is of an encounter with her grandmother. Aged four, Tepper — or Sheri Stewart as she was then — discovered she had a baby brother. "I'll still be your grandbaby, won't I, Nana?" she asked. To which her grandmother replied, "I have a grandson now, I don't need you girls [Tepper and her cousins] anymore."

As related in a typically pithy autobiographical essay, this is by no means the only instance of sexism encountered by a writer who came late to fiction (at least as a profession), but early to feminism. On graduating from high school, she wanted to study creative writing, but was told the university she wanted to attend was "too far away for a girl."

She married, "simply to get away from a home that had never been at all nourishing or kind." The marriage didn't last, and Tepper subsequently supported her children through a variety of jobs, notably as director of Rocky Mountain Planned Parenthood in her home state of Colorado. When her children went to college, she began writing in earnest.

Some time after sending her only manuscript copy of "The Revenants," a novel she had worked on solidly for a year, to Putnam Berkley, she phoned the publishers to ask for its return. The book, it was explained, was too long to publish for someone at the start of her career, but could she come up with something more "accessible"? So she wrote King's Blood Four, which became the first volume of the Lands of the True Game young adults' novel sequence. It was published in 1983, by which time Tepper was in her fifties, but her career as a novelist was finally up and running. Or at least in motion:

Tepper was not an overnight success, but she published regularly as she developed a distinctive voice, and gradually acquired critical acclaim and large and loyal following. Grass (1989), her tale of a prairie planet, was nominated for a Hugo award. Beauty (1991), which draws on the story of Sleeping Beauty, took the following year's Locus Award for Best Fantasy Novel.

By now, key themes were beginning to emerge in Tepper's work, which is today frequently described as "SF Ecofeminism." Certainly female characters are central to many of her books. The environment is another preoccupation. As a child and young woman, Tepper watched the wilderness around her family's farm gradually disappear under neighborhood housing developments. Her worldview has been colored by the memory; if we carry on like this, she has noted, "that doesn't mean we can't live in cities like ants and eat algae soup for centuries, but the Earth of infinite variety and beauty will be dead and, once that has happened, nothing we do will mean very much."

Tepper's most notable science fiction novels include Gibbon's Decline And Fall (1996), which riffs on the sense of foreboding about the approaching millennium; The Family Tree (1997), in which Earth appears to square up to humanity and The Margarets (2007), a fable of exile. She has also written essays, poetry under the name of Sheri S. Eberhart, and pseudonymous novels in other genres: one horror work, Still Life (1987), as E.E. Horlak; the Shirley McClintock Mysteries as B.J. Oliphant and the Jason Lynx Mysteries as A.J. Orde. **JW**

year-by-year ■ Book

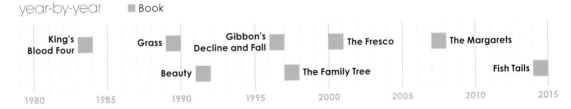

King's Blood Four | Grass | Gibbon's Decline and Fall | The Fresco | The Margarets

Beauty | The Family Tree | Fish Tails

1980 1985 1990 1995 2000 2005 2010 2015

the terminator 1984

The Terminator

The Terminator

Terminator: Tempest

The Terminator

Terminator 2: Judgment Day

Terminator 2: Judgment Day

At the start of 1984 there was little sign that Canadian writer/director James Cameron would become a globe-straddling colossus of cinema. After eight years in the industry he had contributed to the design and art direction on *Battle Beyond the Stars* (1980), *Escape from New York* (1981) and *Android* (1982), and had a single feature under his belt, the laughable *Piranha II: the Spawning* (1981). But come October of that year and the release of *The Terminator*, there was no doubt that not one but two monsters had been unleashed on the world. One was Cameron himself, of course (he would go on to create *Titanic* and *Avatar*); the other was the T-800, the Austrian-accented cyborg assassin with quotable catchphrases and an inexplicable predilection for motorcycle leathers.

Costing a mere $6.4 million, *The Terminator* is a low-budget wonder — synthesizing a lean and nasty chase story with a simple time-travel premise and a dystopian concern with malevolent cybernetics; and all of it underpinned by scenes of a post-apocalyptic 2029 in which the last survivors of humanity fight their AI foes in a landscape of skulls shrouded in a blanket of eternal night. This is the war between humans and the sentient machines they have created; through time travel, the conflict has started bleeding into the present day, where the T-800 (Arnold

Schwarzenegger) seeks to eliminate Sarah Connor (Linda Hamilton), who is destined to be the mother of victorious rebel leader John Connor. In the assassin's way stands Connor's sergeant, Kyle Reese (Michael Biehn), who will be the child's father.

There was nothing new in the film's ingredients — indeed, Harlan Ellison was so incensed by Cameron's apparent debt to one of his 1964 screenplays for *The Outer Limits* that a legal battle ensued. But the finished product was unparalleled: Stan Winston made his name with the design of the T-800's thanatotic endoskeleton, Brad Fiedel's spare, synthesized score suitably evoked the epic machine war lurking in the wings and Cameron's storytelling was fast and no-nonsense. And then there is the casting: Biehn's weedy obsessiveness is the antithesis of Schwarzenegger's cold inhumanity, and Hamilton's Sarah Connor stands with *Alien*'s Ellen Ripley as one of Hollywood's pre-eminent action heroines.

The film made more than enough money to justify a sequel, but a succession of legal disputes and Cameron's eagerness to use CGI to realize a new type of Terminator meant that six years passed before production could begin. In that time, the rights to the franchise, originally sold by Cameron for one dollar, passed from Hemdale to

year-by-year ■ Movie ■ Comic ■ Video game

The Terminator
🎬 James Cameron

The Terminator
▢ Now

Terminator: Tempest
▢ Dark Horse

The Terminator
⚱ Bethesda

1983 1984 1985 1986 1987 1988 1989 1990 1991

$78 M
The Terminator
(1984)

$520 M
Terminator 2:
Judgment Day
(1991)

RoboCop Versus
Terminator

The Terminator:
2029

The Terminator:
Rampage

Terminator 2:
Judgment Day

T2 3-D: Battle
Across Time

The Terminator:
SkyNET

Carolco Pictures. This proved a fortunate delay, because during it Cameron became aware of the abilities of Industrial Light & Magic, which created the pseudopod for his 1989 film *The Abyss*. What followed was unprecedented: at a cost of $94 million, *Terminator 2: Judgment Day* (1991) was at the time the most expensive movie ever made.

The film is set a few years into the future; in 1995, only a couple of years short of the nuclear war promised in *The Terminator*. Sarah Connor (Hamilton again, now sinewy and neurotic) is consigned to an asylum; her 10-year-old son John (Edward Furlong) resides with foster parents. A copy of Schwarzenegger's T-800 returns, this time sent back by the human rebels who have repurposed him to take on Kyle Reese's mission and become their savior's protector. The new antagonist, then, is T-1000 (Robert Patrick), a shapeshifter thast has been sent back in time by the villainous Skynet organization to dispose of John Connor before he becomes a threat.

As sequels go, it splits the difference between novelty and fealty to the original perfectly; *Terminator 2* is more bloated and sentimental than *The Terminator*, but the imminent apocalypse and the second layer of paradox — the original Terminator's remains have been reverse-engineered to develop the technology that will shortly lead to AI — add texture to the saga, and the original's dark themes and sketchy psychology are made more satisfyingly complicated. Few time-travel films handle the notion that the present contains the future with such assurance as that achieved here by Cameron and his co-screenwriter William Wisher. The effects, although not as revolutionary as those of *Tron* (1982), are a watershed in the history of cinema: this film and *Jurassic Park* (1993) inaugurated the age of digital spectacle.

Terminator 2 was a phenomenon. There had been promotional tie-ins in the year leading up to the film's release, but what followed was an explosion of spin-off material: games, several respectable novels, comics (one a crossover with the *RoboCop* franchise) and most extraordinary of all T2 3-D: Battle Across Time, an attraction at Universal Studios' theme park that lasted 12 minutes, reunited most of the key creatives behind *Terminator 2*, and cost a jaw-dropping $60 million. A combination of live performance and 3-D film on three adjoining screens, it was pure spectacle, the narrative an inexplicable joyride through time. John Connor and the T-800 end up battling the T-1000, assorted flying hunter-killers, a Terminator endoskeleton and finally the unwieldy giant arachnoid T-1000000.

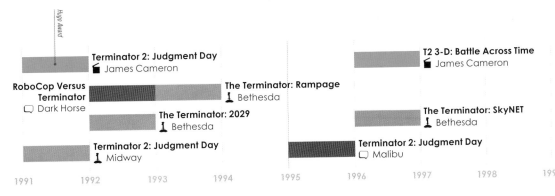

Terminator 2: Judgment Day
James Cameron
Hugo Award

RoboCop Versus
Terminator
Dark Horse

The Terminator: Rampage
Bethesda

The Terminator: 2029
Bethesda

Terminator 2: Judgment Day
Midway

T2 3-D: Battle Across Time
James Cameron

The Terminator: SkyNET
Bethesda

Terminator 2: Judgment Day
Malibu

1991 1992 1993 1994 1995 1996 1997 1998 1999

Superman Versus The Terminator

T2: Infiltrator

The New John Connor Chronicles

Terminator 3: Rise of the Machines

Terminator: Infinity/Revolution

Terminator: The Sarah Connor Chronicles

Terminator 3: Rise of the Machines was an inevitability, but production was stalled by the collapse of Carolco Pictures and Schwarzenegger's unwillingness to get on board without Cameron, who felt that he had done all he could with the franchise. Ultimately the actor took almost $30 million to reprise the role, and C2 Pictures brought the series back to the big screen in 2003, with Jonathan Mostow as director, for another milestone figure: $200 million.

Here John Connor (now played by Nick Stahl) is pursued by the latest model of Terminator, the T-X (Kristanna Loken), with only a decomposing T-800 to protect him. The events of *Terminator 2* have only delayed the apocalypse promised in *The Terminator*, and the new film pulls a neat trick in allowing the nuclear holocaust to actually happen, much to the surprise of Connor and his future wife Kate Brewster (Claire Danes), who are hidden in a Cold War bunker by the martyred T-800.

The film performed less well than its predecessor and the response was uneasy — compared with the magnificent leap between the first and second movies, the third puts the franchise in a kind of holding pattern, albeit with an audacious ending that, unlike that of *Terminator 2*, is not mawkish. Comics,

games and novels followed, but with an aging Schwarzenegger moving into politics, an uninterested Cameron and lukewarm box office, it was difficult to see where the series could go next.

The answer turned out to be television. With Josh Friedman as creator and head writer, and director David Nutter setting the house style, *Terminator: The Sarah Connor Chronicles* launched on Fox in 2008 to a rapturous response. Controversially ignoring the events of *Terminator 3*, the series spirits the late-1990s' Sarah and John Connor (Lena Headey and Thomas Dekker) to a pre-apocalyptic present-day California, where they must deal with an influx of new Terminators, not all of whom have the same agenda.

Whereas in the original film time travel had been a rare event, in the TV show it became a commonplace. The idea of a 4-D war was now the story's central premise. Although it is implied that the human rebels might not be entirely trustworthy, we also begin to realize that there may be a compassionate iteration of Skynet. A host of new and largely well-drawn characters are introduced to the saga: fembot Terminator Cameron (Summer Glau); John's newest protector, Derek Reese (Brian Austin Green) and Catherine Weaver (Shirley Manson), the T-1001 who turns out to be an enemy of Skynet.

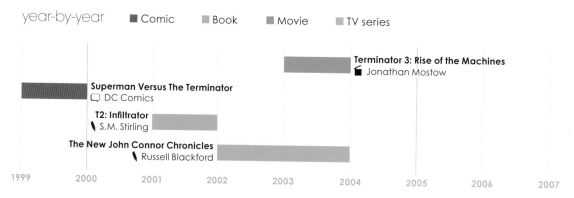

year-by-year ■ Comic ■ Book ■ Movie ■ TV series

Terminator 3: Rise of the Machines
◢ Jonathan Mostow

Superman Versus The Terminator
▢ DC Comics

T2: Infiltrator
◣ S.M. Stirling

The New John Connor Chronicles
◣ Russell Blackford

1999 2000 2001 2002 2003 2004 2005 2006 2007

$433M
Terminator 3:
Rise of the Machines
(2003)

$372M
Terminator Salvation
(2009)

**Terminator
Salvation**

**Terminator/
RoboCop: Kill
Human**

The series was renewed for a 22-episode second series, but the balance of high-octane action and political thoughtfulness evident in the first series gave way to a dawdling solipsism; the show steadily lost traction and came to a premature end. Although the show had gone out of its way to repudiate the events of *Terminator 3*, the finale, "Born to Run," ends in much the same way as the movie — pushing an inexperienced John Connor into a post-apocalyptic future for which he is entirely unprepared.

Only a month after the transmission of "Born to Run" in 2009 came *Terminator Salvation*, the fourth film in the series, which approximately followed the events of *Terminator 3* and ignored the TV series. This time director McG (Joseph McGinty Nichol) was at the helm, and those haunting glimpses of humanity's dreadful future have been expanded to encompass an entire movie; the future is now the main deal. It is 2018 and Christian Bale is the battle-scarred John Connor, traipsing across the war-wounded Earth. Anton Yelchin is the young Kyle Reese and Bryce Dallas Howard has taken over the role of Kate Brewster. The other key ingredient in the film is heroic loner Marcus Wright (Sam Worthington), who, to no one's surprise, turns out to be a Terminator who thinks he's a human. Arnold Schwarzenegger appears in spirit, via permission granted to use his computer-generated facial likeness for the newly developed T-800s (Austrian-American bodybuilder Roland Kickinger actually takes over the part).

The $200 million budget ensured world-class production — Shane Hurlbut's photography is the most accomplished in the series, and the focus on physical effects over CGI reaps handsome rewards. We see more of Skynet's ecology than ever before, and the menagerie of robots hurling themselves at the human rebels throughout — courtesy of the now-legendary Stan Winston, who died during the shoot — are never less than impressive.

Yet the film stumbles and falls in its storytelling. Bale and Worthington compete rather than complement each other, and there is a rambling quality to the narrative that is an unwelcome contrast to the straightforward story arcs of the previous films.

Terminator Salvation was intended as the first part of a new trilogy, but it was not to be — the Halcyon Company went bankrupt and the franchise was put up for sale: Joss Whedon, perhaps only partly in jest, offered $10,000. There was no movement until 2011, when Megan Ellison's Annapurna Pictures won the rights to make a fifth (and possibly a sixth) film. The former is widely expected to be a reboot. **TH**

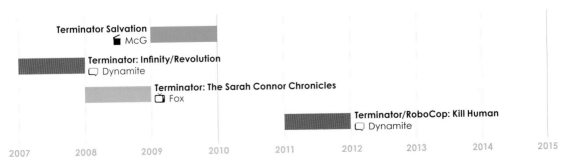

Terminator Salvation
McG

Terminator: Infinity/Revolution
Dynamite

Terminator: The Sarah Connor Chronicles
Fox

Terminator/RoboCop: Kill Human
Dynamite

2007 2008 2009 2010 2011 2012 2013 2014 2015

the terminator universe

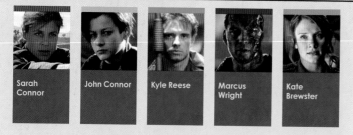

Sarah Connor

John Connor

Kyle Reese

Marcus Wright

Kate Brewster

By 2029, humanity has been hunted almost to extinction by its own creations — AI machines. To ensure a final victory, the machines send a cyborg soldier, the T-800, back in time to assassinate the mother of the then-unborn rebel leader John Connor. The humans also gain access to time travel and send a resistance fighter, Kyle Reese, to protect her.

In 1984, the T-800 pursues teenage waitress Sarah Connor through Los Angeles. She is saved again and again by Kyle, who is convinced of an impending nuclear catastrophe and the messianic qualities of her nonexistent son. The pair become lovers.

The cyborg pursues the couple into a factory. Kyle is killed but Sarah manages to crush the enemy with a hydraulic press. We catch up with her seven months later, heavily pregnant with Kyle's son John.

By 1995, Sarah is in a mental hospital and 10-year-old John is in foster care. Pursuing him is the T-1000, which can take any form. Arriving from the future to protect John is a hacked T-800 in motorcycle leathers.

Together, they find Sarah, and then the cyborg breaks the news: the day the AI Skynet unleashes the apocalypse is imminent.

Sarah takes the fight to Skynet and confronts Miles Dyson, creator of the AI microprocessor. She and John persuade him of the dangers of his research, and try to retrieve the technology from Cyberdyne Systems. Dyson destroys his work, but dies in the process.

The chase continues. The T-800 engages the superior T-1000 in combat and manages to knock it into a vat of molten steel before following its adversary into oblivion.

Nine years later, Sarah has died of leukemia and John is destitute in L.A. Enter the fembot T-X, its mission to kill John, as well as his wife-to-be Kate Brewster and his future lieutenants. Following the T-X is a rebel-hacked T-850 that closely resembles the T-800.

John, Kate and the T-850 find a cache of useful weapons in Sarah's mausoleum, from which they escape in a hearse. The T-850 wants to ensure they

characters
■ Sarah Connor ■ John Connor ■ Kyle Reese ■ Marcus Wright ■ Kate Brewster

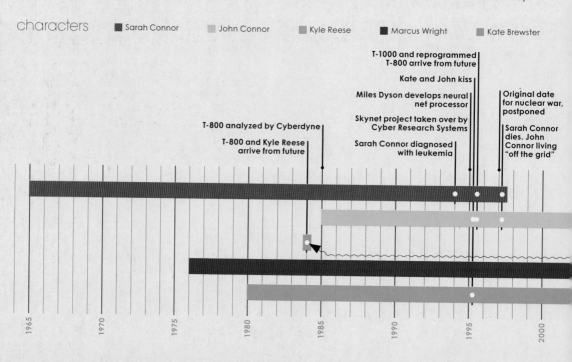

T-1000 and reprogrammed
T-800 arrive from future

Kate and John kiss

Miles Dyson develops neural
net processor

Original date
for nuclear war,
postponed

Skynet project taken over by
Cyber Research Systems

Sarah Connor
dies. John
Connor living
"off the grid"

T-800 analyzed by Cyberdyne

T-800 and Kyle Reese
arrive from future

Sarah Connor diagnosed
with leukemia

1965 1970 1975 1980 1985 1990 1995 2000

survive the coming nuclear war; John intends to prevent it. The T-850 now reveals that it was sent by the older Kate in 2032.

Meanwhile, however, Kate's father Robert Brewster has taken over the Skynet project on behalf of the USAF and the trio are too late to prevent him activating the AI. Dying, Robert tells John to disable Skynet's system core at Crystal Peak in the Sierra Nevada. The T-X takes control of the T-850 and uses it as a weapon against John, but their protector shuts itself down. They travel to the mountains, pursued by the T-X, which is destroyed by the T-850's last remaining fuel cell.

But Crystal Peak does not contain the system core. Skynet is impossible to shut down; Judgment Day is upon them. In the nuclear war, much of humanity is wiped out. John takes over as leader of the survivors.

By 2018, Skynet dominates the Earth and John is fighting a losing battle when he discovers plans for a new kind of Terminator comprised of metal and organic tissue. A nuclear assault on the rebels leaves only two survivors: John and Marcus Wright, who saves a young Kyle Reese and a girl called Star from a T-600. Kyle and Star are soon taken prisoner.

At headquarters, John and General Ashdown plan to assault the Skynet base in San Francisco. An intercepted "kill list" reveals that John's death is second in priority to that of Kyle Reese, his father-to-be. Marcus is found to be a cyborg who believes himself to be human. John orders his destruction, but Marcus proves his loyalty by saving John's life from attacking hydrobots. John recruits him for the rescue of the prisoners.

It turns out that Marcus was created to lure John into Skynet's domain, where he will be killed.

Marcus removes his Skynet hardware and he and John fight a T-800. They destroy the Skynet base with Terminator fuel cells and are airlifted out. Marcus donates his own heart to save the dying John — and the war against the machines continues. **TH**

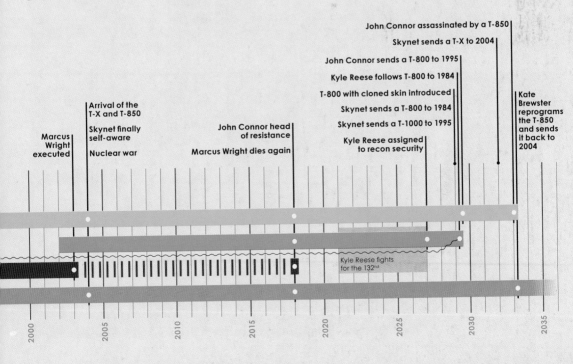

The Terminator
(1984)

**Terminator 2:
Judgment Day**
(1991)

**Terminator 2:
Judgment Day**
(1991)

**T2 3-D:
Battle Across Time**
(1996)

**Terminator: The
Sarah Connor
Chronicles**
(2008–10)

**Terminator
Salvation**
(2009)

The Terminator: Arnold Schwarzenegger as a robot clothed in human skin, sent back in time to assassinate Sarah Connor.

A mortal wound is nothing to a cyborg: Schwarzenegger in *The Terminator*.

A frame from one of the numerous franchised arcade games that followed in the wake of the success of the second *Terminator* movie.

Edward Furlong as the young John Connor in *Terminator 2: Judgment Day*.

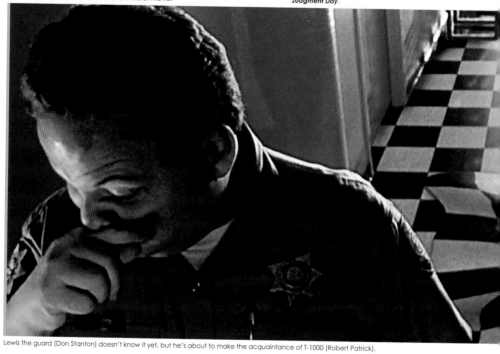

Lewis the guard (Don Stanton) doesn't know it yet, but he's about to make the acquaintance of T-1000 (Robert Patrick).

James Cameron (R) supervises the creation of the **T2 3-D: Battle Across Time** attraction for Universal Studios, a mini-sequel to *Terminator 2: Judgment Day*.

Burning money: **Terminator Salvation** was expensive to make but earned back almost double its production costs at the box office.

Christian Bale as John Connor in **Terminator Salvation**, the fourth film in the series.

"I'm the only hope you have." Marcus Wright (Sam Worthington) surveys the ruins of Los Angeles in **Terminator Salvation**.

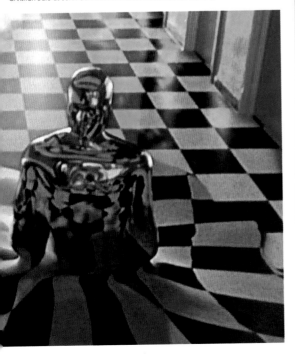

The TV spin-off **Terminator: The Sarah Connor Chronicles** starred Lena Headey (R) in the title role. With her here is Cameron Phillips (Summer Glau).

Terminator 3: Rise of the Machines living up to its title.

The T105, a prototype killer robot faced by John Connor in *Terminator 3: Rise of the Machines*.

Like most of the machines in *Terminator Salvation*, these motorbikes were designed by Martin Laing, who had previously worked for director James Cameron on *Titanic*.

A T-700 from *Terminator Salvation*. These precursors to the T-800 had unconvincing rubber skin.

Special effects on *Terminator Salvation* were created by Industrial Light & Magic, the company founded by George Lucas.

Kristanna Loken as T-X, the first on-screen female Terminator in **Terminator 3: Rise of the Machines**.

The T-X combined the strengths of the T-800 and the T-1000.

In **Terminator Salvation**, director McG aimed for special effects unlike any film before it.

Morphability: T-1000 (Robert Patrick) in the process of changing his shape in **Terminator 2: Judgment Day**.

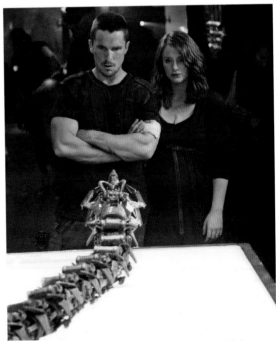
John and Kate Connor (Christian Bale and Bryce Dallas Howard) in **Terminator Salvation**. Christian Bale was the fourth actor to play John Connor in the series.

dragon ball 1984

Dragon Ball

Dragon Ball

Dragon Ball: Curse of the Blood Rubies

Dragon Ball Z

Dragon Ball: The Magic Begins

Dragon Ball GT

Dragonball: Evolution

Dragon Ball Z: Battle of Gods

One of the most successful manga/anime franchises of all time, "Dragon Ball" debuted in the magazine *Weekly Shonen Jump* in 1984. It told the story of how a monkey-tailed boy called Son Goku (later revealed to be an alien) and his friends searched the world for the seven mystical Dragon Balls. When united, the seven balls summon a dragon capable of granting any wish.

Created by Akira Toriyama, "Dragon Ball" was loosely inspired by the 16th-century Chinese novel *Journey to the West* and drew stylistically on the works of Go Nagai and Walt Disney. It was a mixture of talking animals, fantasy, slapstick, science fiction and martial arts. As the series unfolded, the emphasis shifted heavily toward the last two elements as Son Goku grew from a mischievous boy into a muscle-bound warrior fighting aliens with superpowers.

Toriyama was already a successful manga creator: his surreal comedy series "Dr. Slump" appeared in *Weekly Shonen Jump* from 1980 to 1984. The early instalments of "Dragon Ball" bear many of the hallmarks of Dr. Slump, particularly Toriyama's fondness for goofy talking animals and his smutty sense of humor. "Dragon Ball" ran until 1995, by which time the series amounted to 42 collected volumes that had sold more than 156 million copies in Japan alone.

The first anime adaptation started in Japan in 1986. It was introduced to Western viewers in the form of *Dragon Ball Z* (*DBZ*), which took up the story from volume 17 of the manga: Son Goku is already married to Chi-Chi and the couple have a young son, Gohan. The opening plotline of *DBZ* saw Goku forced to team up with his former enemy, Lord Piccolo, against a trio of aliens from a warrior race called the Saiyans — Goku's original people. A recurring theme throughout the franchise involves enemies becoming allies and the heroes training in new fighting techniques to face some fresh threat.

The *Dragon Ball GT* (Grand Tour) anime started in 1996 and was the first series not based on Toriyama's original manga. In this story, Goku was transformed back into a child and had to find the Black Star Dragon Balls scattered throughout the galaxy in order to restore his adult form. *Dragon Ball Z Kai*, first broadcast in Japan in 2009, was a revised version of the *DBZ* anime cut down from 291 to 98 instalments. There have since been numerous films, spin-offs and specials from the different anime, some of which retell key plotlines from the series while others feature new stories and antagonists.

The first two live-action adaptations of the franchise were both unofficial knock-offs: *Dragon Ball* (1990), directed by Ryong Wang, and *Dragon Ball: The Magic Begins* (1991), directed by Chen Chun-Liang. The first licensed version was the U.S. *Dragon Ball: Evolution*, (2009), directed by James Wong and starring Justin Chatwin and Chow Yun-Fat. Through its various incarnations, "Dragon Ball" has been key in bringing Japanese SF to an international audience. **DWe**

year-by-year — ■ Manga ■ Anime ■ Animated movie ■ Movie

Dragon Ball
Shueisha

Dragon Ball
Toei Animation

Dragon Ball GT
Toei Animation

Dragon Ball: Curse of the Blood Rubies
Daisuke Nishio

Dragon Ball Z
Toei Animation

Dragon Ball Z: Battle of Gods
Masahiro Hosoda

Dragon Ball: The Magic Begins
Chun-Liang Chen

Dragonball: Evolution
James Wong

1980 1985 1990 1995 2000 2005 2010 2015

neuromancer 1984

Neuromancer Count Zero Mona Lisa Overdrive Neuromancer Neuromancer

In 1981 *Omni* magazine published "Johnny Mnemonic," a short story by unknown William Gibson that introduced the world of the Sprawl, a vivid imagining of a cyberpunk future. In the following year *Omni* published "Burning Chrome" by the same author, who was then commissioned by Ace editor Terry Carr to write a novel for that publisher's Science Fiction Specials paperback series.

The work Gibson produced — *Neuromancer* (1984) — was a watershed in science fiction. It became the first novel to win Hugo, Nebula and Philip K. Dick awards in the same year. It brought the word "cyberspace" — first used in "Burning Chrome" — into common English usage. Its opening line — "The sky above the port was the color of television, tuned to a dead channel" — became one of the most famous in the genre.

Drawing in equal parts on Raymond Chandler's detective novels and the emerging cyberpunk movement of science fiction, *Neuromancer* introduces a fully-realized world of "console cowboys," "street samurai" and "black ice" software, a world in which the United States (the Sprawl) is in decline and Asia is in the ascendant. Disconnected from the net (the "matrix"), washed-out hacker Case is searching for a cure in Chiba City. Brought together with shades-clad Molly Millions (she first appears in "Johnny Mnemonic"; her shades are surgically

implanted), the two are hired by a mysterious employer for a seemingly simple job: to steal the saved consciousness of Case's one-time mentor, the Dixie Flatline, a legendary hacker so named because he had flatlined (lost heart function) three times while in pursuit of an artificial intelligence.

Of course, nothing remains simple, and Case and Molly end up off-world, in a space habitat for the rich. They eventually discover that their real employer is an AI trying to achieve true sentience by joining its two halves — Neuromancer and Wintermute — together.

After much excitement, the two sleuths succeed in their mission and in the final pages the now near-Godlike Wintermute tells Case that he has found other AIs in nearby star systems.

This dazzling novel has been both the blueprint for and the cornerstone of nearly all subsequent science fiction. Gibson himself wrote two further novels set in the Sprawl — *Count Zero* (1986) and *Mona Lisa Overdrive* (1998) — but neither was as successful, creatively or commercially, as the one true original.

It is in its iconography, its noir sensibilities mixed in with the counterculture, its mixture of hi- and lo-tech, its obvious love of the emerging computer culture (for all that the novel was written on a typewriter!) and its striking images and prose, that *Neuromancer* remains a bona fide classic that has been hugely influential beyond the confines of science fiction. **LT**

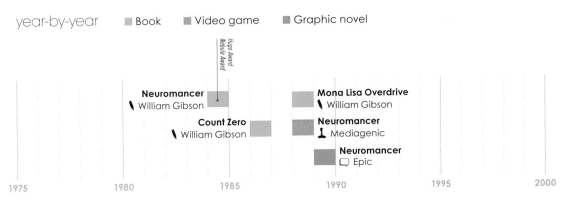

year-by-year ■ Book ■ Video game ■ Graphic novel

Hugo Award / Nebula Award

Neuromancer
❧ William Gibson

Count Zero
❧ William Gibson

Mona Lisa Overdrive
❧ William Gibson

Neuromancer
⚊ Mediagenic

Neuromancer
▢ Epic

1975 1980 1985 1990 1995 2000

transformers 1984

Transformers

The
Transformers

The
Transformers

The
Transformers:
The Movie

Transformers:
The
Headmasters

Transformers
Generation 2

Beast Wars

Beast
Machines

Transformers is the foremost of the many science fiction and fantasy franchises that originated as toy products. Others included Thundercats and He-Man.

The sequence of events that led to the creation of Transformers began in 1970 when U.S. toy giant Hasbro licensed its G.I. Joe range of action figures to Takara Toys, which launched it in Japan as Combat Joe. Two years later, these military dolls received a science fiction makeover when they became Henshin Cyborg, a transparent version of the G.I. Joe mold complete with mechanical innards.

This was the first of many spin-offs. In 1974, Takara shrank the Henshin Cyborg figures to create Microman, which was re-imported to the United States as Mego's Micronauts. A year later came Robotman, a 14-inch (36 cm) doll that housed a Microman figure inside its chest cavity and could be converted into a tank-like all-terrain vehicle.

In 1980 Takara launched Diaclone, a line of anime-inspired automata that were convertible into futuristic cars. Next came MicroChange — an addition to the Microman range — which was a collection of robots based on real-world automobiles, including the Volkswagen Beetle and the Land Rover, that were also equipped with handguns, cassette players and microscopes.

In 1983, on a visit to the Tokyo Toy Fair, Hasbro executives were impressed by Microman and particularly by Diaclone, which had developed into a range of more realistic vehicles along with mechanical dinosaurs and insects. They struck a deal with Takara for both, which they then released in the U.S. market as a single brand unified by a common backstory. Thus the Transformers were born.

Having worked with Marvel Comics on G.I. Joe, Hasbro turned again to the House of Ideas to breathe life into the fledgling Transformers universe. Editor Bob Budiansky was given the task of uniting the individual robots into a cohesive storyline. To this end, the Transformers were split into two warring factions from the distant world of Cybertron. The heroic autobots were led by the Diaclone Battle Convoy figure, now renamed Optimus Prime. The villainous Decepticons were headed by Megatron, a slightly reworked re-issue of the original MicroChange Walther PPK.

The launch of Transformers in spring 1984 was timed to coincide with a four-issue Marvel miniseries written by Bill Mantlo and Ralph Macchio. The comic was such a success than an ongoing series was immediately commissioned. The third prong of the Transformers marketing initiative was an animated TV series. Based on stories developed by Budiansky and

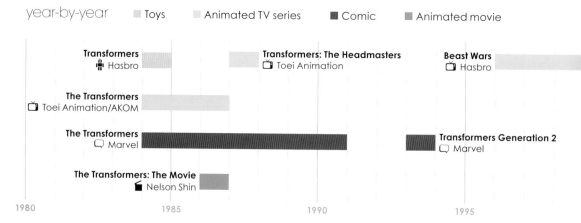

year-by-year ▪ Toys ▪ Animated TV series ▪ Comic ▪ Animated movie

$801 M
Transformers
(2007)

$912 M
*Transformers:
Revenge of the
Fallen* (2009)

$1.2 B
*Transformers:
Dark of the Moon*
(2011)

Transformers
Car Robots

Transformers

Transformers

Transformers:
Revenge of
the Fallen

Transformers:
War for
Cybertron

Transformers:
Dark of the
Moon

Beast Hunters:
Predacons
Rising

Transformers:
Age of
Extinction

co-produced by Sunbow Productions and Marvel, the first of 16 episodes was broadcast in September 1984. Actor Peter Cullen provided the voice of Optimus Prime with Frank Welker as his nemesis Megatron. A second season followed in 1985.

In 1986 *The Transformers: The Movie* became infamous for killing off the majority of the main cast within the first half hour. The movie shifted the action forward to 2005, replaced both Optimus and Megatron with new leaders, Rodimus Prime and Galvatron, and introduced a planet-sized villain in the form of Unicron. The TV series then followed the exploits of this new future cast, culminating in a three-part fourth season.

By the early 1990s, Transformer continuity was becoming increasingly complicated. Nine series of the original toys had been released in eight years; the sublines included Headmasters, Micromasters, Pretenders and Powermasters. A Japanese animated series — *The Transformers: Headmasters* — had launched in 1997, rewriting the end of the Sunbow version. Marvel was producing two separate series of its comic on both sides of the Atlantic, with sprawling dimension-hopping storylines and multiple iterations of Megatron and Galvatron. With the popularity of the toy line finally waning, it was time for a reboot.

In 1993, Hasbro launched Generation 2 — repainted models from the original series and new figures incorporating such innovations as LED weaponry and soundchips. Although supported by a 12-part Marvel comic, Generation 2 ran out of steam after just three series of toys.

In 1996 Hasbro launched Beast Wars, a new line of toys and an accompanying fully-CGI animated series. The Autobots and Decepticons were replaced by the Maximals — led by Optimus Primal — and Megatron's Predacons. These Cybertronians transformed into animals, thus contextualizing Optimus' new guise as a gorilla. After *Beast Machines*, a second CGI continuation, *Robots in Disguise* (2001) returned to road vehicles: Prime was now a fire truck. Another reboot saw Transformer history rewritten for *Transformers: Armada* (2002) and its sequels *Energon* and *Cybertron*. These were followed by the biggest reboot of all: *Transformers* (2007), a live-action movie directed by Michael Bay, and its sequels *Transformers: Revenge of the Fallen* (2009), *Transformers: Dark of the Moon* (2011) and *Transformers: Age of Extinction* (2014). These global hits were accompanied by related toy products and further animated series. More than 30 years after its creation, Transformers remains the paradigm of cross-media toy brands. **CS**

■ Movie ■ Video game ■ Animated TV movie

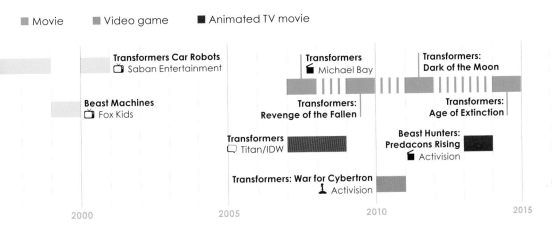

Transformers Car Robots
🎬 Saban Entertainment

Transformers
🎬 Michael Bay

**Transformers:
Dark of the Moon**

Beast Machines
📺 Fox Kids

**Transformers:
Revenge of the Fallen**

**Transformers:
Age of Extinction**

Transformers
🖥 Titan/IDW

**Beast Hunters:
Predacons Rising**
🎬 Activision

Transformers: War for Cybertron
🎮 Activision

2000 2005 2010 2015

transformers universe

Optimus Prime

Hot Rod/ Rodimus Prime

Megatron/ Galvatron

Ultra Magnus

Long before life evolved on Earth, two living planets blaze across the universe. One, the wise and powerful Primus, exists only to learn and explore. The other, the power-hungry Unicron, leaves chaos in his wake. When Primus discovers what evils Unicron is committing, he uses a fragment of his own life force, the Spark, to create 13 sentient robots, the Transformers. Prima, the first of them, leads his brothers into battle. They trap Unicron in a black hole, sacrificing themselves in the process.

With Unicron seemingly destroyed, Primus locks into an orbit around a binary star system, shutting down his higher functions so that more Transformers can be born. His creations name their planet Cybertron.

Centuries pass and vast city-states flourish across Cybertron's surface, governed by the hub-capital of Iacon. Here the High Council maintains the Vector Sigma Matrix, a computer network linked to Primus' dormant brain. The Matrix provides guidance

on matters of state and chooses the supreme commander of all Cybertronians, a Transformer worthy of being called Prime.

However, all is not well on Cybertron. In the southern city of Kaon, a Transformer named Megatron wants power for himself. With backing from his Decepticons, he declares that Kaon is an independent state and thus prompts a civil war.

Sentinel Prime, leader of the loyalist Autobots, is slain by Megatron. The Matrix replaces him with a humble records clerk who is transformed into Optimus Prime, the greatest hero Cybertron has ever known.

Despite Prime's best efforts, civil war rages across the planet, but a bigger threat looms on the horizon. Autobot scientists discover a gigantic asteroid on a collision course with Cybertron. The Autobots construct a massive warship, the Ark, to blast the rock into manageable pieces. Prime himself leads the mission, playing straight into Megatron's hands.

characters

■ Optimus Prime ■ Hot Rod/Rodimus Prime ■ Megatron/Galvatron ■ Ultra Magnus

Aerialbots visit from the future

**Megatron conquers Kaon
War declared**

Megatron becomes aggressive

**Sentinel Prime killed by Megatron
Optimus Prime becomes Autobots leader**

Decepticons bring Cybertron to Earth

Primus creates the Transformers and is renamed Cybertron

**Fortress Maximus leaves Cybertron
War with the Nebulans**

Starscream attempts Decepticon coup

Autobots crash-land on Earth

Volcano wakes the Transformers

Ultra Magnus comes to Earth

Primus and Unicron created

Hot Rod joins Autobots on Earth

Big Bang | Unknown | 9 million BC | 8.7 million BC | 8.2 million BC | 5 million BC | 4 million BC | 1980 | 1985 | 1990

The Decepticons board the Ark and send it flying out of control through a dimensional gateway from which it emerges near prehistoric Earth, where it crash-lands in a volcano. The Transformers are deactivated and the Ark's computer system, Teletran-1, shuts down to conserve energy.

Millions of years pass. The human race evolves to dominate the planet; the area above the Ark becomes known as the United States of America. In 1984, the volcano erupts, providing Teletran-1 with the energy it needs to rebuild its crew. But the computer unwittingly revives both factions, bringing Cybertron's civil war to Earth. Megatron soon realizes that the resource-rich planet is ripe for conquest. Prime vows to protect the indigenous humans from the Decepticons.

In 2005, Megatron attacks Autobot City and kills Prime, but is himself wounded. His treacherous scout Starscream declares himself Lord of the Decepticons and dumps his former leader into space.

Luckily for Megatron, Unicron has returned from his black hole. He transforms the crippled Decepticon into the even more powerful Galvatron, who lands on Earth, destroys Starscream and then goes in search of Prime's Matrix of Leadership. All looks lost until the Matrix chooses the next Autobot commander. A young and impetuous warrior named Hot Rod is elevated to become Optimus' successor — Rodimus Prime. The new Prime destroys Unicron, resurrects Optimus Prime and brings peace to Cybertron and Earth.

The Transformers multiverse is full of different iterations of the same legends. In some dimensions, the Transformers are animals rather than vehicles. In others, the Decepticons rule supreme and the Autobots are freedom fighters. One constant remains, however. There will always be a Megatron hungering for power — and an Optimus Prime ready to bring him down. In the final battle, in whichever dimension they meet, one will stand and one will fall. **CS**

Optimus Prime recovered from space; he has been brainwashed and is deactivated again

Ultra Magnus briefly leads the Autobots

Megatron is transformed into Galvatron I by Unicron

Starscream destroyed by Galvatron; his ghost attempts revenge

Hot Rod becomes Rodimus Prime

Optimus Prime and Megatron fight

Optimus killed, Megatron deposed

Unicron attempts to destroy Cybertron

Transformers defeat the Quintessons

Optimus Prime reactivated, defeats Galvatron

Hate plagues vanquished

Optimus Prime killed

Galvatron returns to the past and dies

Ultra Magnus made commander of Autobot City

Optimus Prime dies (again) stabilizing Vector Sigma
Rodimus Prime made leader again

Galvatron I invades Cybertron, Skorponok destroys the planet

Ultra Magnus killed

Rodimus Prime abdicates to search for new Cybertron

Galvatron returns from the dead; attempts to fuse himself with Earth

Autobots victorious; Galvatron frozen in ice

1995 2000 2005 2010 2015 2020

Transformers (1984)

The Transformers (1984–91)

The Transformers: The Movie (1986)

Beast Wars (1996–99)

Transformers (2007)

Transformers: Revenge of the Fallen (2009)

Transformers: War for Cybertron (2010)

Transformers: Dark of the Moon (2011)

An original Optimus Prime toy from 1984, seen here in disguise ...

Autobots figure out how to deal with humans in the original Marvel comic series.

Production designer Clyde Klotz won a Daytime Emmy Award for Outstanding Individual Achievement in Animation for his work on **Beast Wars**.

U.S. soldiers (Luis Echagarruga and Tyrese Gibson) join forces with Prime to combat evil in **Transformers** (2007).

... and here in its transformed robot glory.

The Transformers: The Movie (1986) followed on from the immensely popular cartoon series.

Optimus Prime was voiced in the 2007 movie by Peter Cullen, who was reprising his role in the original TV series.

Shia LaBeouf (L), who played the human hero Sam Witwicky in the *Transformers* movie series, looks for angles with director Michael Bay.

A Transformer in feline form in ***Revenge of the Fallen*** (2009).

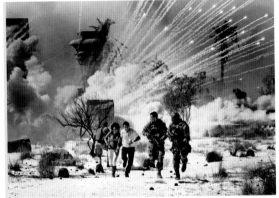

(L–R) Megan Fox, Shia LaBeouf and U.S. combat troops in ***Transformers: Revenge of the Fallen***.

Transformers: War for Cybertron puts players in the role of the Decepticons for the first five campaigns, and in the role of the Autobots for the last five.

Widespread devastation in ***Transformers: Dark of the Moon*** (2011), the third movie in the current iteration of the story.

gale anne hurd 1984

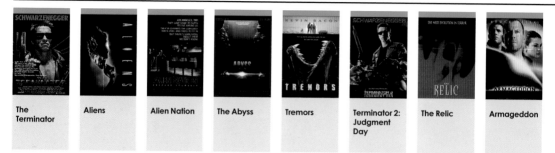

The Terminator | Aliens | Alien Nation | The Abyss | Tremors | Terminator 2: Judgment Day | The Relic | Armageddon

Most of the major female science fiction and fantasy genre figures are authors. Gale Anne Hurd is in an unusual position: as a highly successful movie producer, she's been closely associated with some of science fiction's biggest and most critically acclaimed properties, many of which she took an extremely hands-on role in developing. And although much of her most famous work was alongside writer/director/producer James Cameron in the 1980s, she has subsequently been involved in a large number of other major projects, including one of the biggest hits of the cable TV renaissance.

Hurd was born in 1955 and raised in Los Angeles. After graduating from Stanford University she began her career as executive assistant to low-budget kingpin Roger Corman at New World Pictures. This company was famous for its B-movies and exploitation films, all of which were produced quickly and at minimal cost. Such projects gave first breaks to many aspiring directors who later achieved prominence, including Ron Howard (Grand Theft Auto), Jonathan Demme (Caged Heat) and Joe Dante (Piranha).

Among the other junior employees at New World in the late 1970s was Canadian film-maker James Cameron, who worked as a production assistant, model-maker, art director and special effects designer on projects such as Battle Beyond the Stars and John Carpenter's Escape from New York, before

landing his first directorial job when the original director of Piranha II: The Spawning left the project — although Cameron, too, was sacked from the film before the shoot was completed.

Hurd, meanwhile, had risen through the ranks of New World, becoming increasingly involved in production — she took a co-producer credit on a minor Smokey and the Bandit derivative, Smokey Bites the Dust — and by 1982 had left to set up her own company, Pacific Western Productions. Her first hit there was The Terminator (1984), the rights to which Cameron sold to her for one dollar on the condition that he direct the film should it ever be made.

By keeping the production as lean as possible — a skill Cameron and Hurd both learned at New World — the pair found it was possible to budget The Terminator at $4 million. Most of the finance came from Hemdale Pictures; further contributions came from HBO and Orion, which also handled the movie's distribution.

The Terminator eventually cost around $6.5 million, but it was a big hit in the cinema and later did even better as a home video — returning considerably more than what it cost to make. Its success cemented the Cameron/Hurd partnership that went on to produce an influential and profitable string of science fiction action thrillers: Aliens (1986), The Abyss (1989) and Terminator 2: Judgment Day (1991).

year-by-year ■ Movie ■ TV series

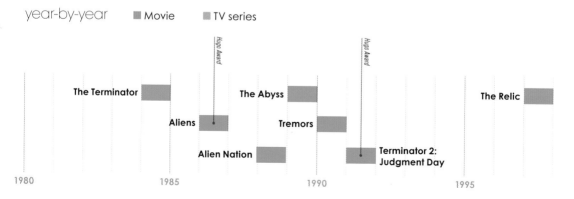

$176M
The Terminator
(1984)

$281M
Aliens
(1986)

$895M
Terminator 2:
Judgement Day
(1991)

$798M
Armageddon
(1998)

$553M
Terminator 3:
Rise of the Machines
(2003)

Virus

Clock-
stoppers

Terminator 3:
Rise of the
Machines

Aeon Flux

The Walking
Dead

Hurd and Cameron married in 1985 and divorced in 1989. Two years later she married director Brian De Palma, with whom she worked with on the non-genre thriller *Raising Cain* (1992). A year later, the couple divorced. Since 1995, Hurd has been married to screenwriter/director Jonathan Hensleigh, who helped script her film *Armageddon* (1998) and then directed her (nongenre) take on *The Punisher* in 2004.

Hurd has produced work on a wide range of subjects — her projects have included a big game hunter drama, *The Ghost and the Darkness* (1996) and the disaster movie *Dante's Peak* (1997) — but she keeps returning to the genre in which she has an overriding interest: not for nothing is she sometimes described as "the first lady of sci-fi."

In 1988 she produced *Alien Nation*, a movie that gave an SF twist to a drama about struggling immigrants. Two years later came *Tremors*, directed by Ron Underwood and starring Kevin Bacon — a cult classic that was like *Jaws*, but with carnivorous underground worms instead of a shark. Hurd later produced horror film *The Relic* (1997).

The SF plague drama *Virus* (1999) was one of Hurd's few flops. *Clockstoppers* (2002) was no hit either, but it was a minor success in comparison. Better than either of these was her *Aeon Flux* (2005), an SF action adventure directed by Karyn Kusama and starring Charlize Theron.

Most recently, Hurd has worked as one of the executive producers of the Emmy Award-winning AMC cable TV hit *The Walking Dead*. This series was initially developed by Frank Darabont — director of *The Shawshank Redemption* and *The Mist* — from the comic book series by Robert Kirkman and others.

This project was launched by Hurd's Valhalla Entertainment company, which has a deal to develop new TV programs for Universal. Forthcoming from the same stable are such genre shows as *Horizon*, about an FBI secretary's encounter with extraterrestrials during the Second World War. Valhalla is also involved with the comic book industry, developing properties such as Aspen Comics' *Dead Man's Run*, in which Hell is a form of escapable prison.

Among the many other major movies produced or co-produced by Hurd are Ang Lee's *Hulk* (2003), Jonathan Mostow's *Terminator 3: Rise of the Machines* (2003) and Louis Leterrier's *The Incredible Hulk* (2008).

Gale Anne Hurd has an industry-wide reputation as a producer with a can-do attitude, icy self-discipline, a remarkably calm approach to any potential crisis and the rare ability to shepherd a project from early script development right through to special effects sign-off. Away from work, she is a renowned adrenaline junkie, who spends her spare time in such high-risk leisure activities as ballooning, skiing and scuba diving. **MB**

Armageddon

Clockstoppers

The Walking Dead

Virus

Terminator 3:
Rise of the Machines

Aeon Flux

2000

2005

2010

2015

The Terminator
(1984)

Aliens
(1986)

The Abyss
(1989)

Terminator 2:
Judgment Day
(1991)

Armageddon
(1998)

Terminator 3:
Rise of the
Machines
(2003)

Aeon Flux
(2005)

James Cameron (L) and Arnold Schwarzenegger during filming of *The Terminator*.

Sigourney Weaver is gripped in *Aliens*.

Aliens won an Oscar for its astonishing visual effects.

Rescuers in search of a sunken submarine find more than they were bargaining for in James Cameron's *The Abyss*.

Ed Harris and Mary Elizabeth Mastrantonio in *The Abyss*.

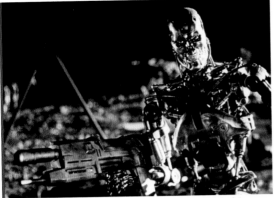

After the success of *The Terminator*, sequels became inevitable: this is the first,
Terminator 2: Judgment Day ...

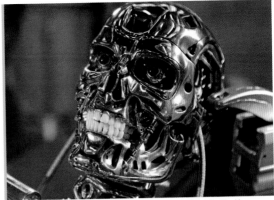

... and this is the follow-up to the follow-up — **Terminator 3: Rise of the Machines**.

Billy Bob Thornton as NASA scientist Dan Truman in **Armageddon**.

Charlize Theron in **Aeon Flux**.

battletech 1984

BattleDroids

BattleTech, Second Edition

MechWarrior

BattleTech: The Crescent Hawk's Inception

BattleTroops

BattleTech: Fallout

MechAssault

MechWarrior Online

Created by Jordan Weisman and L. Ross Babcock, and published by their Chicago-based games company the FASA Corporation, *BattleTech* started as a tabletop wargame based on combat between 30-foot (10 m) tall, piloted robots. Originally called *Battledroids*, the name was changed for the second edition after Lucasfilm's legal claim for the "-droid" suffix. That was not FASA's only legal problem — its use of designs taken from Japanese anime mecha shows such as *Macross* (known in the United States as *Robotech*) and *Fang of the Sun Dougram* resulted in a suit against them by distributor Harmony Gold USA. *BattleTech* then ditched many of its earliest — and most recognizable — mecha designs, and replaced them with new originals.

BattleTech began as a straightforward, combat-based game played on a hexagonal board, but soon developed into a fully realized, cross-media science fiction franchise, with its own universe and a thousand-year backstory. Set in the 31st century, it detailed a human interstellar empire that fragmented after a series of wars into rival groups and alliances (many of which are referred to as "Houses," in a nod to Frank Herbert's *Dune* books). This collapse led not only to political and social regression — most of the worlds and states are feudal societies — but also to a lack of technological advances, with the battlemech technology becoming rare and valuable, and the search for it often a source of renewed conflict.

After the initial success of *BattleTech* and a wide range of related supplements and miniatures came several stand-alone boxed games — such as *CityTech, AeroTech, BattleTroops* and *BattleForce* — that covered other aspects of 31st-century warfare. The most notable of these was *Mechwarrior*, which moved the focus from large-scale wargaming to character-driven role-playing. The franchise also produced video games, starting with Infocom's *RPG BattleTech: the Crescent Hawk's Inception* in 1988. The first combat simulation — Activision's confusingly titled *Mechwarrior* — came a year later and spawned a long series of sequels and subfranchises, the best of which were the *MechCommander* PC games and two *MechAssault* games for Microsoft's original Xbox. Also of note was the opening in 1990 of the BattleTech Center in Chicago, consisting of 16 full-sized, networked cockpits that allowed players to experience immersive multiplayer battle simulations.

The franchise also spawned more than 100 paperback novels. Several comics were produced by companies such as Blackthorne Publishing and Malibu Comics, and in 1994 a 13-part animated TV series was aired on Fox TV in the United States.

FASA ceased trading in 2001. The franchise was bought by WizKids, which launched a new version of the original game with its own "Clix System" that uses dials on the bases of the accompanying collectable miniatures to track in-game statistics. **TM**

year-by-year ■ Game ■ Video game ■ Comic

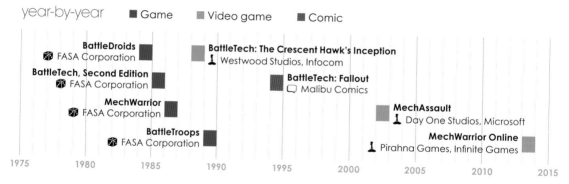

BattleDroids
🎲 FASA Corporation

BattleTech, Second Edition
🎲 FASA Corporation

MechWarrior
🎲 FASA Corporation

BattleTroops
🎲 FASA Corporation

BattleTech: The Crescent Hawk's Inception
♟ Westwood Studios, Infocom

BattleTech: Fallout
▢ Malibu Comics

MechAssault
♟ Day One Studios, Microsoft

MechWarrior Online
♟ Pirahna Games, Infinite Games

1975 1980 1985 1990 1995 2000 2005 2010 2015

margaret atwood 1985

The Handmaid's Tale

The Blind Assassin

Oryx and Crake

The Year of the Flood

The Happy Zombie Sunrise Home

MaddAddam

Margaret Atwood was born in Ottawa, Canada, in 1939. As a child, she lived for a time in northern Quebec, where her father conducted research in forest entomology. She was a voracious reader from an early age, as fond of comics and mysteries as of more conventional literature. She was first published as a poet in the early 1960s and her debut novel, The Edible Woman, was published in 1969. In 1987, she won the inaugural Arthur C. Clarke Award for The Handmaid's Tale (1985), her portrayal of a patriarchal, theocratic, dystopian society in which women are subjugated. Since then she has returned on several occasions to future-set fiction, while maintaining her mainstream output.

From this brief résumé it might be surmised that Atwood has successfully bridged the sometimes yawning chasm between SF and conventional fiction. On the contrary, however, her work is often viewed with suspicion by genre fans, largely because she once derided SF as being about "talking squid in outer space."

By contrast, she characterizes her own fiction as being about things that "could really happen." This description seems particularly apt for her Oryx and Crake (2003) and its two sequels, The Year of the Flood (2009) and MaddAddam (2013). These novels, which reflect Atwood's recurring concern with environmental issues, are set in a nightmarish near future of bioengineering and ecological collapse. As the daughter of a zoologist father and a nutritionist mother, Atwood has noted, she didn't need

consultants for MaddAddam's science: "I grew up with the biologists. I know how they think."

Atwood has undertaken further speculative fiction in The Blind Assassin (2000) — a novel within which there is a novel by the main character, a politically radical pulp SF author — and in The Penelopiad (2005), a novella that incorporates elements of fantasy as it presents the reflections of Penelope after she has been left alone by her husband, Odysseus, who has gone off to fight in the Trojan War.

Happy Zombie Sunrise Home (2013) is an online serial/novella co-written by Atwood and Naomi Alderman, creator of the Zombies Run! app. Atwood's Positron e-book sequence heads into J.G. Ballard territory in imagining a nightmarish gated community.

As for those sections of fandom still miffed about the cephalopod quip, Atwood's essay collection In Other Worlds: SF and the Human Imagination (2011) clarifies many of her previous utterances on genre fiction. "Bug-eyed-monster-bestrewn space operas" get short shrift, but the book also features elegant appreciations of, among others, Ursula K. Le Guin and George Orwell, and Atwood reveals a fondness for SF B-movies. Latterly, she has also conceded that some of her work might be viewed as social science fiction.

There have been several adaptations of The Handmaid's Tale. Harold Pinter scripted a movie version starring Natasha Richardson, Faye Dunaway and Robert Duvall. The book has been dramatized for BBC Radio 4. There have also been stage, ballet and opera versions. **JW**

year-by-year ■ Book ■ Online

The Handmaid's Tale

The Blind Assassin

Oryx and Crake

The Year of the Flood

MaddAddam

The Happy Zombie Sunrise Home
@ Margaret Atwood, Naomi Alderman

1985 1990 1995 2000 2005 2010 2015

back to the future 1985

Back to
the Future

Back to
the Future

Back to
the Future

Back to the
Future Part II

Back to the
Future Part II

Back to
the Future

Back to the
Future Part III

Back to the
Future Part III

Propelling Michael J. Fox to international stardom, *Back to the Future* was one of those rare motion pictures that united critics in lavish praise and also became a huge commercial success.

The film emerged from Steven Spielberg's "dream factory." Spielberg the producer had a hand in numerous 1980s' fantasy blockbusters, including *Poltergeist, Gremlins, The Goonies* and *Who Framed Roger Rabbit*, and a poster with his name on it appeared to guarantee a spectacular and entertaining fantasy adventure. Recruited as director was Robert Zemeckis, making only his fourth film, and his first science fiction feature.

Back to the Future concerns teenager Marty McFly (Fox), whose friend, eccentric inventor Doc Brown (Christopher Lloyd), has created a time machine in the shape of an adapted DeLorean sports car. One night the Doc and Marty are attacked by terrorists, but Marty escapes in the DeLorean, accidentally being transported back 30 years to 1955. Shortly he meets his parents, the result being that instead of falling in love with and marrying his father — and later giving birth to him — his mother falls for Marty instead. To ensure that

he doesn't subsequently cease to have ever existed, Marty has to engineer it so that his mother and father do fall in love. His task is made more difficult by the thuggish Biff Tannen, who bullies Marty's father and makes advances to Marty's mother. The drama reaches its climax at the high school ball, where Marty has to bring his parents together and get himself "back to the future" by being in the DeLorean at exactly the right time — when the town clock will be struck by a bolt of lightning which will power the vehicle via a conductor.

There are many reasons why *Back to the Future* is such a delight: the care and attention with which it is constructed; the effervescence of the cast, especially Fox (a late replacement for Eric Stoltz, who had already shot some scenes) and Lloyd; the compelling story that blends romance, humor and science fiction, and the small details that tie the two eras together. A Hugo was among its many accolades.

The final moments of the film left room for a sequel that soon after initial box office returns became an inevitability. The follow-up was a two-parter that was shot back-to-back.

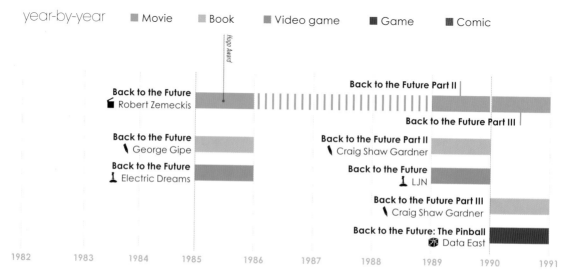

year-by-year ■ Movie ■ Book ■ Video game ■ Game ■ Comic

Hugo Award

Back to the Future
🎬 Robert Zemeckis

Back to the Future Part II

Back to the Future Part III

Back to the Future
🖊 George Gipe

Back to the Future Part II
🖊 Craig Shaw Gardner

Back to the Future
🎮 Electric Dreams

Back to the Future
🎮 LJN

Back to the Future Part III
🖊 Craig Shaw Gardner

Back to the Future: The Pinball
🎲 Data East

1982 1983 1984 1985 1986 1987 1988 1989 1990 1991

$24.1M
Back to the Future
(1985)

$52.4M
Back to the Future
Part II
(1989)

$34M
Back to the Future
Part III
(1990)

Back to
the Future:
The Pinball

Back to
the Future

Back to the
Future Part III

Back to the
Future

Super Back
to the Future II

Back to
the Future:
The Game

Back to the Future Part II is set in three time zones. Marty and Doc first go forward to 2015 — replete with flying hoverboards and three-dimensional ads for *Jaws 19* — but inadvertently alter their past after Biff Tannen steals the DeLorean and takes it back to 1955 where he gives a sporting results almanac to his younger self. Through winning bets on sporting events, young Biff accumulates huge wealth which he parlays into a property empire and a brutal local power base. Consequently, the 1985 to which Marty returns is a nightmare of high crime, poverty and discontent. After realizing what has happened he goes back to 1955 to stop Biff from receiving the almanac.

Although slightly darker in tone than its predecessor, *Back to the Future Part II* is nevertheless a hugely enjoyable sequel that is often underrated (*Halliwell's Film Guide* didn't award it a single star). It is a film that takes the possibilities of time travel to the absolute max, delighting in the paradoxes that are thrown up as well as in Marty's thrilling efforts to change (or change back) the future. *The Encyclopedia of Science Fiction* notes: "It is perhaps the most sophisticated time-travel film ever made."

The third film in the series picks up where the second one left off. It sees the lead characters in yet another time zone, 1885, where Doc Brown has been living a quiet existence since the DeLorean took him there at the end of *Part II*. When Marty learns via a tombstone that his friend will be killed by an outlaw, he determines to go back and save him. He does so, but further complications ensue when Doc saves schoolteacher Clara Clayton from being killed in an accident, and then falls in love with her.

Although perhaps the least interesting part of the trilogy, *Back to the Future Part III* is an energetic romp that culminates in an exciting railroad set-piece. It's certainly the least science fictional of the trio, more like a good-humored Western for much of the time, not withstanding that railroad sequence, in which the train, pushing the DeLorean, has to reach a certain speed — 88 miles per hour (140 kph) — to ensure that the time machine can return to the present day.

Christopher Lloyd reprised the role of Doc Brown for television by appearing in brief live-action buffers of an animated series, entitled *Back To The Future*, which was produced by CBS in 1991 and 1992. **RL**

Animated TV series

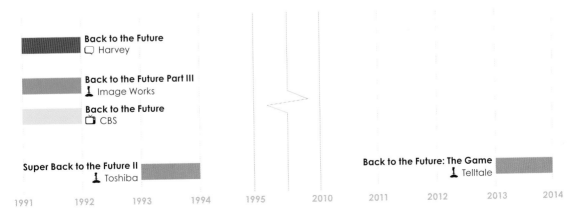

Back to the Future
Harvey

Back to the Future Part III
Image Works

Back to the Future
CBS

Super Back to the Future II
Toshiba

Back to the Future: The Game
Telltale

1991 1992 1993 1994 1995 2010 2011 2012 2013 2014

Back to the Future
(1985)

**Back to the Future
Part II**
(1989)

**Back to the Future
Part III**
(1990)

Back to the Future
(1991–92)

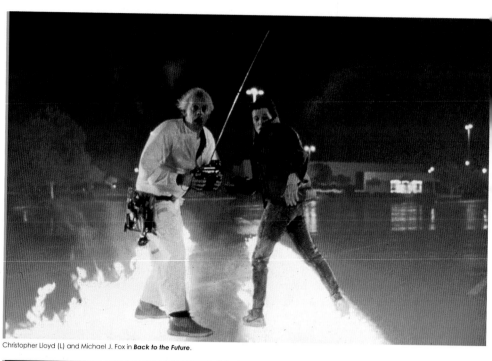

Christopher Lloyd (L) and Michael J. Fox in *Back to the Future*.

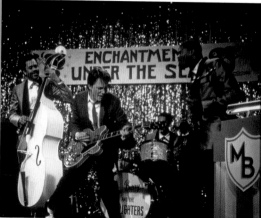

Marty McFly at his parents' high school prom many years before he was born.

Smoking through the mists of time: the iconic DeLorean.

Christopher Lloyd at the movie's thrilling climax.

The bully Biff (L), played by Thomas F. Wilson, and his disreputable pals.

In *Part II*, 60 years on, Hill Valley has turned into a nightmare.

Michael J. Fox as Marty McFly in **Back to the Future Part II**.

(L–R) Christopher Lloyd, director Robert Zemeckis and Michael J. Fox during filming of **Back to the Future Part II**.

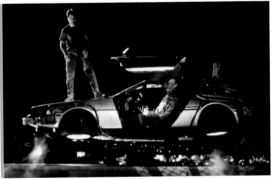

The car was almost a big of a star as Fox (L) and Lloyd, but by the time the film came out the manufacturer had gone bust, so could not profit from its new-found fame.

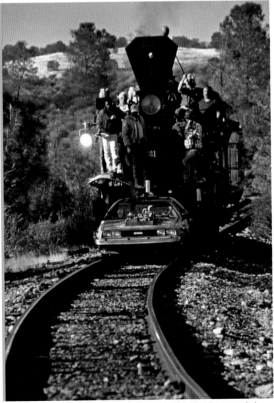

A 19th-century railroad engine covered in film crew in this behind-the-scenes shot.

Robert Zemeckis (second left) with roughneck cowboys during filming of **Part III**.

The animated TV spin-off was mildly diverting but lacked the magic of the original film.

brazil 1985

Brazil

Terry Gilliam first treated the theme of the individual's struggle against irresistible forces in *Time Bandits* (1981), in which metaphysical repairmen steal the map of space-time and go on the run from The Supreme Being. He returned to the subject first in *Brazil* — a tale of one man versus faceless bureaucracy — and again in *The Adventures of Baron Munchhausen* (1988). Together, these films have come to be regarded as an informal trilogy on the importance of imagination.

Gilliam came up with the idea on a filthy coal-dust-strewn beach in Wales where he observed a man, evidently determined to enjoy himself in spite of his surroundings, listening to the song that eventually gave the film both its title and its theme tune. (Among its working titles was "1984½," but unlike the novel by George Orwell, *Brazil* has no Big Brother figure.)

The film follows Sam Lowry (Jonathan Pryce), a minor bureaucrat in the Department of Records who mindlessly shuffles paperwork while dreaming of a heroic existence as a flying knight in armor. In reality he can't even get his heating fixed without tangling with bureaucracy.

After a printing error leads to the arrest and death under interrogation of blameless Archibald Buttle rather than suspected terrorist Archibald Tuttle, Lowry visits the dead man's family to pay them a rebate for their loss. In their dingy apartment he encounters their neighbor, Jill (Kim Greist), who looks exactly like the woman in his dreams. Desperate to find out more about her, Lowry accepts a promotion to Information Retrieval and discovers that she too is under investigation. He tries to save her, but is arrested. Just

as he is about to be tortured by his friend Jack Lint (Michael Palin), terrorists break in and free him. He goes to live in the countryside with Jill. The final scene reveals that this has all taken place in Lowry's head; his mind has broken under torture and he lives in a dream world.

Brazil is tempered slightly by humor, but remains a very dark film. The security forces chat about how sweaty their suits get, even as they are transporting a container-load of canvas-bagged suspected terrorists. The real Archibald Tuttle (Robert de Niro) is a rogue heating engineer who has incurred the wrath of the Ministry by refusing to fill out forms.

When Universal chairman Sid Sheinberg saw the film, he demanded a happy ending, leading to the derided "Love Conquers All" cut of the film. At one point, there were two editing teams working on *Brazil*, one without Gilliam's knowledge.

Most of the world saw Gilliam's cut, but in the United States release was postponed indefinitely. Frustrated, Gilliam took out a full-page advertisement in *Variety* magazine asking Sheinberg when he was going to release his film in its intended version. This attracted the attention of the Los Angeles Film Critics Association. Gilliam set up clandestine screenings of *Brazil*, and the association gave the still-unreleased movie its three top awards in 1985: Best Screenplay, Best Director and Best Picture. Universal finally released the film on Christmas Day 1985.

Brazil grossed only $10 million against a $15 million outlay, but has since been widely acclaimed as a dystopian masterpiece. **MM**

year-by-year ■ Movie

Brazil
Terry Gilliam

1980 1985 1990 1995

homunculus 1986

Homunculus

Lord Kelvin's Machine

The Ebb Tide

The Affair of the Chalk Cliffs

The Aylesford Skull

Just as lexicographers sometimes find occurrences of words that predate their previously agreed first usage, so historians of science fiction have struggled to identify the earliest work that may justly be described as authentic steampunk.

The first work in the subgenre is often held to be James Blaylock's short story "The Apex Box Affair" (1978), but this is a judgment reached only by consensus: there is no defining moment; steampunk entered the house of literature by the back door; few noticed it until it was firmly ensconced.

Part of the dating problem lies in the fact that Blaylock himself dipped in and out of steampunk more or less as the fancy took him. One of his works, *The Digging Leviathan* (1984), although set in 1950s' California, features William Ashbless, the fictional poet who also appears in the undisputedly steampunk work of Tim Powers.

In any event, on the basis that Blaylock is the earliest begetter of the movement, his first steampunk novel, *Homunculus* (1986) has a special place in the history of science fiction even though it was published later than the other two landmark novels, K.W. Jeter's *Morlock Night* (1979) and Powers' *The Anubis Gates* (1983).

Homunculus — winner of the Philip K. Dick Award — features a dirigible flown over London by a dead alien, reanimated corpses and a final battle on Hampstead Heath. The novel's main characters — scientist and explorer Langdon St. Ives and his arch nemesis, the mad hunchback Dr. Ignacio Narbondo — reappeared

in Blaylock's next unequivocally steampunk work, *Lord Kelvin's Machine* (1992), and these two novels together with *The Digging Leviathan* are now widely regarded as a loose steampunk trilogy.

In *The Aylesford Skull* (2013), the adversaries return to confront each other again after Narbondo kidnaps Langdon St. Ives' young son.

Away from steampunk, Blaylock teaches creative writing at Chapman University in Orange County, California, and is a prolific writer in other traditions. His works include a trilogy of novels about the hunt for the Holy Grail and a tetralogy set in a fantasy elfin world.

Blaylock's steampunk clearly reflects a deep affection for Victorian literature, but the author is no stickler for historical accuracy. His 19th-century London makes little attempt at plausibility, but merely provides a backdrop for a host of improbable, often surreal characters and events. Lord Kelvin, for example, really existed — he was the 19th-century British physicist who first determined the correct value of absolute zero — but there is no evidence that he ever developed the time machine, with which Blaylock credits him, that enables Langdon St. Ives to avenge the murder of his wife.

James Blaylock is critically acclaimed but has to date achieved relatively little commercial success. However, the recent republication of several of his works is both a cause and an effect of a steady growth of popular interest in this influential writer whose narratives more than make up in energy what they may lack in earthbound realism. **LT**

year-by-year　　■ Book

Homunculus
＼ James Blaylock

Lord Kelvin's Machine
＼ James Blaylock

The Ebb Tide
＼ James Blaylock

The Affair of the Chalk Cliffs
＼ James Blaylock

The Aylesford Skull
＼ James Blaylock

| 1985 | 1990 | 1995 | 2000 | 2005 | 2010 | 2015 | 2020 |

watchmen 1986

Watchmen

Watchmen

Watchmen:
The Complete
Motion Comic

Watchmen

Watchmen:
The End is Nigh

Watchmen:
Justice is Coming

Watchmen is the seminal award-winning comic book and graphic novel by writer Alan Moore, artist Dave Gibbons and colorist John Higgins.

The original 12-issue comic book deconstructed the superhero genre with a multilayered narrative, dysfunctional characters, innovative supplementary materials and social and political commentary. It became one of the most influential comics of all time — the collected edition has never been out of print.

Although the plot is essentially a straightforward murder mystery, the intricately planned series is lauded for its adult themes and sophisticated layering, filled with symbolism and complex characterization.

After collaborating with Gibbons in the early 1980s on *2000 AD* and *Superman*, Moore became famous for his work on DC Comics' "Saga of the Swamp Thing." He had already considered a darker take on superheroes, and DC editor Dick Giordano initially suggested using characters recently acquired from Charlton Comics. Eventually, however, the pair decided to create their own, although some of the cast are loosely based on Charlton predecessors.

The story is set in an alternative New York of the 1980s in which the costumed adventurers of the 1940s have long been outlawed. Tensions increase between the United States and the Soviet Union over Dr. Manhattan, a former scientist who has acquired superhuman powers after a nuclear accident. An investigation by rogue vigilante Rorschach into the murder of government-sponsored adventurer The Comedian brings other heroes out of retirement and uncovers a sinister plot to kill millions in an attempt to end the Cold War.

The first issue of *Watchmen* was published in September 1986. The collected edition has since been reprinted more than 20 times and become the most popular graphic novel ever.

After a gestation period of more than two decades, a movie adaptation was released in 2009. Although it kept rigidly close to the comic and received widespread hype, it made only a modest profit.

In February 2012, DC Comics announced the highly controversial *Before Watchmen* project of seven separate mini-series set prior to the original.

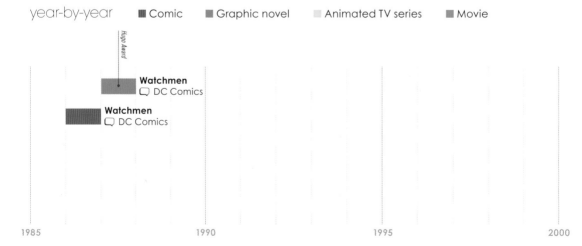

year-by-year ■ Comic ■ Graphic novel ■ Animated TV series ■ Movie

Hugo Award

Watchmen
☐ DC Comics

Watchmen
☐ DC Comics

1985 1990 1995 2000

Watchmen:
Tales of the
Black Freighter

Watchmen:
The Mobile Game

Before Watchmen

These prequels were produced without Moore's consent and he condemned them as "completely shameless"; even Gibbons' support was lukewarm. Mirroring the comic-within-a-comic "Black Freighter" story in the original, the two-page "Curse of the Crimson Corsair" by Higgins and original series editor Len Wein was intended to run in each issue before concluding with a single epilogue issue, although the latter was never published.

With influences as disparate as Will Eisner, Steve Ditko, William S. Burroughs, and *MAD* magazine's 1953 parody of *Superman*, the original *Watchmen* is an iconoclastic reappraisal of the superhero genre that focuses on the psychological backgrounds of its characters and portrays them as dysfunctional and, in some cases, psychopathic and morally reprehensible.

Gibbons used a claustrophobic nine-panel grid layout throughout and single panels often featured visual narratives separate from the text, thus rewarding multiple readings. Higgins preferred moody secondary colors to the standard comic book four-color palette, and created a dark, subdued atmosphere.

Watchmen had a profound effect on the industry. The only graphic novel to win a Hugo Award, it demonstrated the medium's potential for complex, mature and literate storytelling. Along with *The Dark Knight Returns* by Frank Miller, *Watchmen* helped to popularize the graphic novel format of paperback collections with a new audience: it was no longer merely a juvenile medium. However, it also sparked a craze throughout the 1990s for comics that focused on gritty adult themes. This development exasperated Moore, who said: "I thought that a book like *Watchmen* would perhaps unlock a lot of potential creativity. I was hoping naively for a great rash of individual comic books that were exploring different storytelling ideas and trying to break new ground. That isn't really what happened. Instead it seemed that the existence of *Watchmen* had pretty much doomed the mainstream comic industry to about 20 years of very grim and often pretentious stories that seemed to be unable to get around the massive psychological stumbling block that *Watchmen* had turned out to be, although that had never been my intention with the work." **MMo**

■ Video game　　■ Animated movie

Watchmen: The Complete Motion Comic
📷 Cruel & Unusual

Watchmen
👤 Zack Snyder

Watchmen: The End is Nigh
👤 Warner Bros.

Watchmen: Justice is Coming
👤 Warner Bros.

Before Watchmen
📖 DC Comics

Watchmen: Tales of the Black Freighter
🎬 Daniel DelPurgatorio/Mike Smith

Watchmen: The Mobile Game
👤 Glu Mobile

2000　　　　2005　　　　2010　　　　2015

Watchmen
(1987)

Watchmen
(2009)

Adrian Veidt's (Ozymandias) Antarctic base, as originally depicted in the comic book and then later visualized by the movie.

The second Nite Owl, Dan Dreiberg, was played by Patrick Wilson in the movie. The movie version of the character remained fairly faithful to the comic, but his costume was given a considerable revamp.

Jackie Earle Haley brought the character of Rorschach to life in Zack Snyder's 2009 film adaptation, and also voiced him in the video games series.

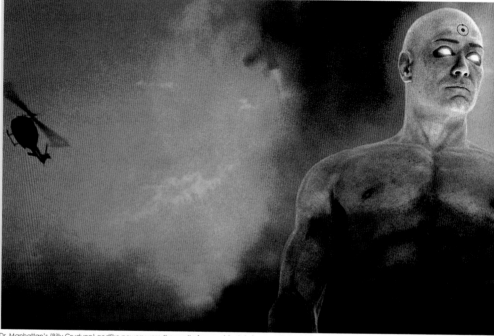

Dr. Manhattan's (Billy Crudupp) godlike powers were the result of an accident during a nuclear physics experiment.

The movie's Treasure Island comic book store is a reference to the *Tales Of The Black Freighter* story that featured in the comic.

Watchmen opens with the murder of Eddie Blake, who is thrown through the window of his apartment to fall several stories to his death.

Laurie Juspeczyk (Malin Akerman) was the second character in **Watchmen** to be known as the Silk Spectre; the first was her mother, Sally Jupiter.

The Comedian was played in the movie by Jeffrey Dean Morgan.

warhammer 40,000 1987

Warhammer
40,000

Space Hulk

Warhammer
Monthly

The Eisenhorn
Trilogy

Dawn of War

Warhammer
40,000

When first released in 1987, *Warhammer 40,000* was simply a miniatures-based SF skirmish game. Today, it is the flagship of Games Workshop, the most successful wargaming company in the world, and has spawned a range of spin-off books, comics and video games.

The first edition, *Warhammer 40,000: Rogue Trader*, written mainly by Rick Priestley, focused on small numbers of 28-mm model soldiers fighting comprehensively detailed small actions. The second edition — released in 1993 — featured heavily revised rules and redirected its emphasis toward larger battles. It was then issued as a boxed game with two armies of plastic miniatures — this marketing initiative seemed risky at the time, but became a big hit.

Although the high quality of Games Workshop's models remain a potent lure, *Warhammer 40,000* — or "40k," as it has become widely known — has to a large extent outgrown its tabletop origins thanks to its setting. At the beginning its background material was, essentially, the already popular *Warhammer Fantasy Battle* with a shiny new science fiction makeover: the humans in the original became Space Marines, elves became the alien Eldar, and so on.

The story is as follows. In the 41st millennium, humankind stagnates in a second interstellar dark age. The attempts of an immortal psychic mutant known as the Emperor to bring peace to the galaxy 10,000 years before failed, and ever since the worlds of humanity have been in decline, beset on all sides by aliens. The greatest threat comes from the parallel dimension of the Warp, a realm of pure energy whose chaos gods, given shape by the emotions of all sentient creatures, threaten to overwhelm reality. It is dark, gothic, one-minute-to-midnight material that incorporates arcane technology, hard science fiction, cosmic horror, neo-medievalism and fantasy.

There was a scale to the setting that made it pregnant with imaginative possibility. Since then, increasing levels of detail have been added by each successive edition and its attendant "codexes" — lavish army books that describe the minutiae of each race or faction. Every volume is packed with supplementary fiction, evocative artwork and histories.

Thanks to such additional material, not long after its creation *Warhammer 40,000* reached critical mass as initially disparate components reacted with

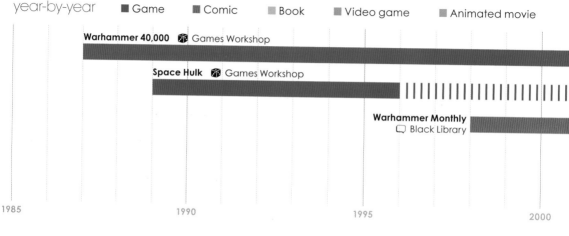

year-by-year ■ Game ■ Comic ■ Book ■ Video game ■ Animated movie

Warhammer 40,000 🎲 Games Workshop

Space Hulk 🎲 Games Workshop

Warhammer Monthly
🖵 Black Library

1985 1990 1995 2000

Dawn of War II

Ultramarines: A Warhammer 40,000 Movie

each other to create something highly complex and increasingly original. The extensive pseudo-history now covers events from the deep past to the end of 41st millennium, and like other large-scale, shared-world creations such as *Judge Dredd* or *Star Wars*, rewards enthusiasts by its sheer scale. There is always something new to discover.

Also fostering the growth of *Warhammer 40,000* were spin-off games, each of which contributed more to the back story. Some of these games were aimed at younger players or were intended to create different gaming experiences — card games, for example, and roleplaying adaptations. Others revealed different aspects of the 41st millennium: gang warfare on overcrowded planets; cosmic naval combat. Key among these was *Adeptus Titanicus*, a wargame that utilized smaller-scale models in order to accommodate gigantic machines of war. It was here that the Horus Heresy was first detailed — a galaxy-wide civil war that ruined the Imperium.

The launch in 1999 of the Black Library — the Games Workshop's publishing division, and its second attempt to create a range of novels — extended the appeal of *Warhammer 40,000* beyond the original core market of wargamers. Unusually for spin-off fiction, these novels stand on an equal footing with the originating material, and contribute to the ongoing development of the universe. It is not unusual for 40k novels to make *The New York Times*' bestseller list, especially those in the Horus Heresy line. Numerous computer games have been produced over the years, including THQ's licensed *Dawn of War* series, which has sold more than seven million copies. The company branched out further in 2010 by releasing *Ultramarines*, its first animated movie.

Although the landscape of the gaming world has changed enormously since *Rogue Trader* was released, *Warhammer 40,000* remains the largest and most influential science fiction game-originated property. Games Workshop has proved remarkably adaptable, weathering the end of the first golden age of gaming in the early 1990s, and adapting itself to the new digital age without losing its core ethos — the production of amazing science fiction miniatures, backed up by a compelling fictional universe that is chronicled in ever-increasing detail. **WS**

Warhammer 40,000
▢ Boom! Studios

The Eisenhorn Trilogy
❧ Dan Abnett

Dawn of War
♟ THQ

Ultramarines: A Warhammer 40,000 Movie
🎬 Martyn Pick

Dawn of War II
♟ THQ

2000 2005 2010 2015

predator 1987

Predator

Predator

Predator:
Concrete
Jungle

Aliens vs.
Predator

Predator 2

Aliens vs.
Predator

Batman vs.
Predator

Predator:
Bad Blood

An energetic burst of lurid science fiction adventure, *Predator* marked another step in the ascent of Arnold Schwarzenegger and the arrival of one of modern science fiction's most popular monsters.

The story blended the attitude and violence of the then popular post-Vietnam action thriller with gory horror, as Schwarzenegger and his heroic team of mercenaries find a South American jungle mission transformed into a nightmare when they're targeted by an alien hunter that is visiting Earth to match itself against worthy prey.

The movie was directed by John McTiernan, whose only previous film had been *Nomads* (1986), starring Pierce Brosnan. In view of his inexperience, 20th Century Fox also hired Shane Black — the scriptwriter of *Lethal Weapon* — ostensibly to play a supporting role but in reality to lend a guiding hand if it were needed.

The Predator itself was originally intended as a fast, insectile killer to be played by martial arts star Jean-Claude Van Damme in a creature suit, but when the initial costume design arrived on location in the jungles of Palenque, Mexico, it looked so unconvincing that production on the film had to be halted for almost a year.

During the ensuing delay, make-up effects specialist Stan Winston was hired to re-invent the creature. His ultimate design — with a little help from James Cameron, who suggested giving the creature mandibles — was a triumph, bringing together old-school prosthetics and the latest animatronics to transform 7-foot (2.1 m) actor Kevin Peter Hall into a powerfully convincing onscreen alien. (The effect was not achieved without difficulty, however: Hall could not see through his mask, and so had to memorize all the requisite moves before he went into make-up; even then, the costume was so unbalanced and unwieldy that Schwarzenegger had to duck and weave to avoid his adversary's unplanned lunges.)

The success of *Predator* demanded a sequel, which was released in 1990. Directed by Stephen Hopkins — whose previous credits were *Dangerous Game* (1987) and *A Nightmare on Elm Street 5: The Dream Child* (1989) — *Predator 2* (1990) abandoned the jungle in favor of unleashing a new alien hunter in the then near-future of 1997 Los Angeles. *Lethal Weapon*'s Danny Glover starred, but the film lacked the taut tension of the original. It did, however, hint at a future marketing opportunity in a memorable shot featuring the skull of one of the monstrous creatures

year-by-year ■ Movie ■ Video game ■ Comic

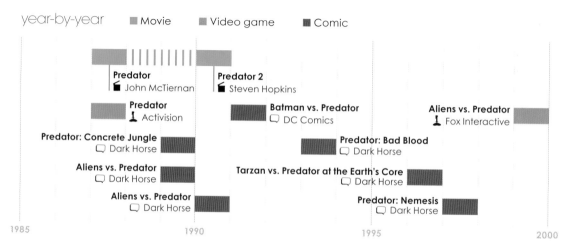

Predator
John McTiernan

Predator
Activision

Predator: Concrete Jungle
Dark Horse

Aliens vs. Predator
Dark Horse

Aliens vs. Predator
Dark Horse

Predator 2
Steven Hopkins

Batman vs. Predator
DC Comics

Predator: Bad Blood
Dark Horse

Tarzan vs. Predator at the Earth's Core
Dark Horse

Predator: Nemesis
Dark Horse

Aliens vs. Predator
Fox Interactive

1985 1990 1995 2000

$123M *Predator* (1987)	$54.7M *Predator 2* (1990)	$99.3M *Alien vs. Predator* (2004)	$47M *Alien vs. Predator: Requiem* (2007)	$55.7M *Predators* (2010)

Tarzan vs. Predator at the Earth's Core

Predator: Nemesis

Aliens vs. Predator

Aliens vs. Predator 2

Alien vs. Predator

Predator: Concrete Jungle

Aliens vs. Predator: Requiem

Predators

in *Aliens* (1986) hanging in a Predator's hunting trophy collection. This potential crossover concept was already being explored in the world of spin-off comics, and would later spawn a lucrative franchise.

Independent publisher Dark Horse Comics issued the first *Predator* miniseries in 1989, the success of which led to a massive selection of related titles throughout the following decade. In 1989 *Aliens vs. Predator* (AvP) first appeared as a short three-part story in which the Predators used the Aliens as the ultimate test of their hunting skills. The first full AvP miniseries arrived in 1990 and more followed, leading to several AvP computer games (including an acclaimed version in 1999).

The predictable result of all this diversification was another movie. *Alien vs. Predator* (2004) was the seventh film directed by Paul W.S. Anderson, whose most recent previous work had been *Resident Evil* (2002). The producers avoided explicit onscreen violence in order to gain a PG-13 certificate. They thus succeeded in attracting readers of the comics, and the film was a commercial success. Critics, however, regarded it as a slick but empty thrill ride — *Horror.com* described it as "all façade and no foundation."

Next came *Aliens vs. Predator: Requiem* (2007), an attempt to give horror fans the gore they had missed in the previous film. It was directed by the Brothers (Greg and Colin) Strause, who had created the iceberg sequence in James Cameron's *Titanic* (1997). It cost less to make than any of the previous films in the series and, perhaps as a consequence, made less. Watched by few and liked by even fewer, it almost torpedoed both the franchises on which it was based.

All seemed lost until a reboot was pitched by Robert Rodriguez, who had directed (uncredited) the scenes in *Pulp Fiction* (1994) in which Quentin Tarantino moved in front of the camera to play Jimmie Dimmick. Having been given the go-ahead by Fox, Rodriguez hired Nimród Antal to direct.

Predators (2010) aimed to recapture the muscular action of the 1987 movie, particularly with its return to a jungle setting — in this case, on an alien planet that acts as a Predator hunting preserve. It also attempted to expand the Predator species' backstory, but strong action sequences ultimately failed to compensate for an absence of the original movie's pulpy charm. *Predators* was by no means a flop, but did not do well enough at the box office to encourage notions of a further sequel. **SB**

Alien vs. Predator
Paul W.S. Anderson

Aliens vs. Predator 2
Sierra

Predator: Concrete Jungle
Sierra

Aliens vs. Predator: Requiem
The Brothers Strause

Predators
Nimród Antal

2000 2005 2010 2015

Predator
(1987)

Predator 2
(1990)

Alien vs. Predator
(2004)

**Aliens vs. Predator:
Requiem**
(2007)

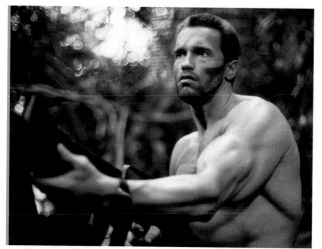

Arnold Schwarzenegger cleans up in *Predator* ...

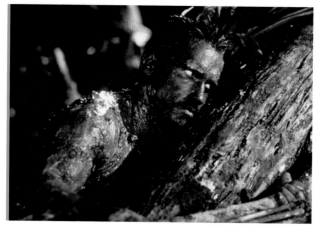

... but has to get dirty in the process.

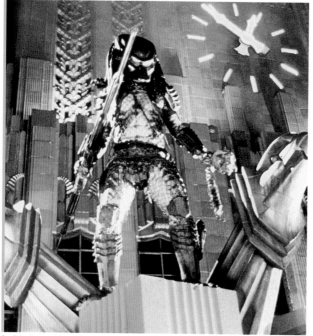

Predator 2 moved the action from the tropical jungle to the urban jungle.

Aliens vs. Predator: Requiem showed the wisdom of keeping your car windows closed in a rainstorm.

(L–R) Ewen Bremner, Raoul Bova and Sanaa Lathan in **Alien vs. Predator**.

A battle of equal and might opposites in **Aliens vs. Predator: Requiem** ...

... that left lasting visual memories long after the plot was forgotten.

Alien vs. Predator might have been "all façade," but its monsters were awesomely memorable.

paul verhoeven 1987

RoboCop Total Recall Starship Troopers Hollow Man

Science fiction represents only a small proportion of Paul Verhoeven's output over more than five decades as a director, but three of these films are of such quality that he merits special mention in any history of the genre.

Born in Amsterdam in 1938, Verhoeven directed a number of short films and documentaries in the early 1960s. The success in 1969 of his TV series, *Floris*, starring a youthful Rutger Hauer, enabled him two years later to make his first feature film, *Business is Business*, a comedy about Dutch prostitution. He made a further five films in his homeland until 1985, when he moved to Hollywood to direct *Flesh + Blood* — once again with his fellow countryman, Hauer.

With *RoboCop* (1987), Verhoeven's first attempt at science fiction, the Dutchman attempted to shake up the genre. Set in a near-future Detroit, a cyborg law enforcer is created to combat rampant crime in the city. Extremely violent, and peppered throughout with cutting-edge special effects, *RoboCop* stands out for its cynically entertaining attitude toward an over-commercialized 21st-century United States — a nation in which even the police force has been privatized. Giving a suitably dystopian feel to the proceedings, TV news reports can be seen in the background, covering a likely nuclear conflict in South Africa and civil war in Mexico; interspersed between these bleak episodes are darkly humorous advertisements for heart surgery and a cheesy family board game — *Nukem* — that ends with a small explosion and mushroom cloud erupting above the living room table.

Verhoeven followed with another sci-fi blockbuster, *Total Recall* (1990), based on Philip K.

Dick's short story "We Can Remember It For You Wholesale." Set in 2084, Arnold Schwarzenegger stars as Douglas Quaid, a man struggling to distinguish reality from an implanted memory. One of the biggest box-office hits of the year, in spite of Schwarzenegger's on-screen limitations, *Total Recall* also garnered some heavyweight plaudits, Roger Ebert calling it "one of the most complex and visually interesting science fiction movies in a long time."

Following commercial success with the notorious *Basic Instinct* (1992), Verhoeven returned to the genre in 1997 with *Starship Troopers*. Although based on Robert A. Heinlein's famed novel, the film ultimately bore little resemblance bar the title, names of characters and an ongoing war between humankind and race of bugs. Indeed, whereas the book had been accused of promoting militarism and fascism, these elements were beautifully satirized by Verhoeven. (The first scene of the film, a TV advertisement for the mobile infantry, was adapted shot-for-shot from a scene in Leni Riefenstahl's 1935 pro-Nazi propaganda epic, *Triumph of the Will*.)

Verhoeven's fourth — and least satisfactory — work of science fiction was *Hollow Man* (2000). Although blessed with Academy Award-nominated special effects, this spin on H.G. Wells' *The Invisible Man*, disappointingly degenerates into a black-hearted slasher flick. It was further criticized by some for what they saw as misogynistic undertones.

Both *RoboCop* and *Total Recall* have been given recent high-profile reboots; it is testament to Verhoeven's vision that both updates are universally regarded as being inferior to his originals. **RL**

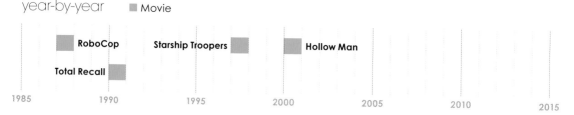

year-by-year ■ Movie

RoboCop Starship Troopers Hollow Man

Total Recall

1985 1990 1995 2000 2005 2010 2015

iain m. banks 1987

Consider Phlebas · The Player of Games · Use of Weapons · Feersum Endjinn · Excession · The Algebraist · Transition · The Hydrogen Sonata

Iain M. Banks first found fame as a mainstream novelist in 1984 with the publication of his macabre debut, *The Wasp Factory*. However, as Banks later noted, he started out writing science fiction, but following numerous rejections he switched to literary fiction "because you can send it to more publishers."

Banks outed himself as an science fiction author in 1987 with *Consider Phlebas*, his first novel as Iain M. Banks — he was plain Iain Banks when writing literary fiction; the "M" (for Menzies) was added to differentiate his SF work. A space opera set during a vast galactic war, it introduced the Culture, an anarchistic, utopian future society where post-human, corporeal citizens coexist with drones and vastly powerful, disembodied "Minds."

The Player of Games and *Use of Weapons* followed, both based on manuscripts Banks had written in the 1970s. All three books featured characters working for Special Circumstances (SC), a secret service-style organization attached to Contact, a part of the Culture overseeing relations with other civilizations. It was a tacit acknowledgment that day-to-day life in a utopia might not make for great plots.

Banks returned to the Culture, which he affectionately once called his "train set," at irregular intervals throughout his career, completing six further novels: *Excession, Inversions, Look to Windward, Matter, Surface Detail* and *The Hydrogen Sonata*.

Banks also wrote one-off science fiction novels, beginning with *Against a Dark Background*, "an SF rendering of a fantasy plot." It was another story that dated back to the 1970s, when long-time friend and novelist Ken MacLeod recalls Banks relating

the entire plot while MacLeod helped out a local builder working on the family house. The stylistically experimental *Feersum Endjinn* — much of the novel is written phonetically — tells of an attempt to activate a device that will save the Earth.

The Algebraist imagined a universe where humankind has spread across the galaxy. Curiously, *Transition*, a novel of parallel realities, was credited to Iain Banks in Britain and Iain M. Banks in America, reflecting the way Banks used slipstream elements in his mainstream fiction.

A regular at conventions and literary events, Banks seemed at ease with his fame. He appeared on the BBC's *Celebrity Mastermind* (and won), he liked fast cars (but sold his collection over environmental concerns) and was an expert on Scottish whisky. An "Old Labour" man who loathed former British Prime Minister Tony Blair, he cut up his passport as a protest against the Iraq War and sent it to Downing Street. He also wrote music, a subject he discussed at some length in his final TV interview, *Iain Banks: Raw Spirit*.

In April 2013, he announced on his website that he was "officially Very Poorly," with terminal cancer of the gallbladder. Interviewed in *The Guardian* shortly before his death, he remarked: "Let's face it, in the end the real best way to sign off would have been with a great big rollicking Culture novel." As it happened, by his own estimation, his final work, *The Quarry* was a "relatively minor" tale about a misanthrope dying of cancer. Published 11 days after the author's death on June 9, 2013, Banks had only become aware of his own condition shortly before its completion. **JW**

year-by-year ■ Book

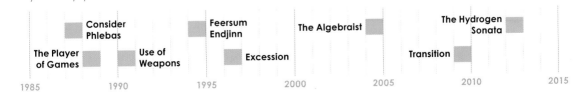

Consider Phlebas · The Player of Games · Use of Weapons · Feersum Endjinn · Excession · The Algebraist · Transition · The Hydrogen Sonata

1985 1990 1995 2000 2005 2010 2015

robocop 1987

RoboCop | RoboCop: The Animated Series | RoboCop | RoboCop 2 | RoboCop 2 | RoboCop | RoboCop | RoboCop 3

The "New Hollywood" experiment ended with Michael Cimino's *Heaven's Gate* (1980). After that overblown box office disaster, the major studios played it safe with unchallenging movies that appealed to the widest possible audience. Much of their 1980s' output consisted of large-scale but soulless blockbusters that majored in violence made accessible to younger audiences in order to spawn sequels and action figures. At the climax of this trend came *RoboCop*.

Director Paul Verhoeven was little known in Hollywood but acclaimed in his native Netherlands for films such as *Turkish Delight* (1973) and *Soldier of Orange* (1977). *RoboCop* was initially offered to Alex (*Repo Man*) Cox before it was passed to Verhoeven, who, although initially reluctant, eventually saw its potential as a vehicle for expressing his leftist views.

Verhoeven mounted *RoboCop* as a satire first, an action movie second. Set in a chaotic near-future, it concerns the attempt of Omni Consumer Products to turn Detroit into Delta City, in which order is maintained by robotic law enforcement officers. The first stage of this scheme is to use a human subject to create a half-man/half-machine cyborg cop. Officer Alex Murphy, gunned down in the line of duty, is resurrected as RoboCop and sets out to clean up the streets, while also uncovering corruption at the highest levels and struggling with memories from his previous life.

Peter Weller's flat, monosyllabic delivery in the title role could belong to any one of the musclebound "heroes" of the 1980s; his trademark weapon-twirling is a staple of the original American hero, the gunslinger. The film is graphically and brutally violent in a way that challenges the audience's acceptance of bloodshed on the big screen.

Some critics condemned *RoboCop* as fascist, but most people saw it for what it really was: a critique of gun laws in the United States. Millions loved it for its action thrills: it was a shoot-'em-up crowd-pleaser with deeper meaning — a sure-fire formula for success.

RoboCop was the last of three immensely influential films of the 1980s that brought sinister and allegorical robot characters into the mainstream: the other two were Ridley Scott's *Blade Runner* (1982) and James Cameron's *The Terminator* (1984).

The makers of the film saw its franchise potential. A follow-up was put into development, but *RoboCop 2* did not arrive until three years later. In a brave and inspired move, comics writer and artist Frank Miller was brought in to write the script. The same year saw him working on his violent comic series "Hard Boiled," about a cyborg tax collector. In the meantime Paul

year-by-year ■ Movie ■ Animated TV series ■ Video game ■ Comic

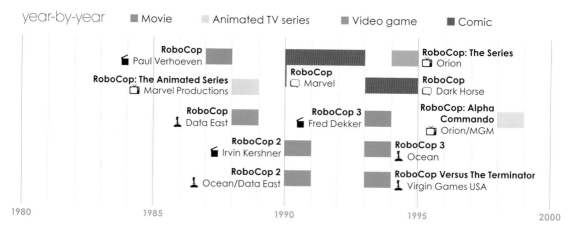

RoboCop — Paul Verhoeven
RoboCop: The Animated Series — Marvel Productions
RoboCop — Data East
RoboCop 2 — Irvin Kershner
RoboCop 2 — Ocean/Data East
RoboCop — Marvel
RoboCop 3 — Fred Dekker
RoboCop 3 — Ocean
RoboCop Versus The Terminator — Virgin Games USA
RoboCop: The Series — Orion
RoboCop — Dark Horse
RoboCop: Alpha Commando — Orion/MGM

1980 1985 1990 1995 2000

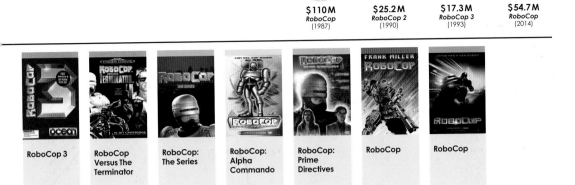

$110M
RoboCop
(1987)

$25.2M
RoboCop 2
(1990)

$17.3M
RoboCop 3
(1993)

$54.7M
RoboCop
(2014)

RoboCop 3

RoboCop Versus The Terminator

RoboCop: The Series

RoboCop: Alpha Commando

RoboCop: Prime Directives

RoboCop

RoboCop

Verhoeven had moved on to another heavily ironic SF film, *Total Recall* (1990), so he was unavailable; *The Empire Strikes Back* (1980) director Irvin Kershner came on board as his replacement.

RoboCop 2 saw the franchise move further into science fiction, with a bigger, badder RoboCop, the appearance on the streets of Delta of the mind-altering drug "Nuke," and the introduction into the plot of a heavily depleted ozone layer.

A far more troubled production overall than the first film, the sequel heavily reworked Miller's original script and was not a great success financially or critically. RoboCop himself, Peter Weller, chose to step away from the role following the experience, and Kershner never directed a feature film again.

After another three-year gap (this time caused by financial issues at studio Orion Pictures), *RoboCop 3* arrived, with new director Fred Dekker at the helm and Robert John Burke behind the metal visor. This far lighter entry in the franchise seemed interested more in selling merchandise than producing a quality film. Although the first two films had been R-rated, this third offering was a PG-13 aimed squarely at a younger audience. The allegory disappeared and the action became cartoony, climaxing with the hero in a jetpack. Miller again scripted but was dissatisfied

with the treatment of his work. Elements of his scripts for *RoboCop 2* and *RoboCop 3* were subsequently repackaged as a comic book.

No longer a draw at the box office, the RoboCop character appeared in video games (including a fan-favorite match-up against The Terminator) and two television spin-offs: *RoboCop: The Series* once again unsuccessfully courted a younger audience whereas *RoboCop: Prime Directives* attempted a darker tone but was essentially ignored by viewers.

"The Future of Law Enforcement" lay dormant for several years until news emerged of a planned remake of the original 1987 film. New owner MGM began developing a major reboot of the franchise and visionary director Darren Aronofsky was initially courted until Brazilian director José Padihla decided to make the film his English-language debut. The 2014 remake is a new attempt to satirize contemporary society, as it critiques the influence of the media and also draws a smart comparison between RoboCop and Iraq War-era drones.

RoboCop is firmly a part of pop culture and SF history. With its permanence and relevance perhaps going beyond violence and satire, Paul Verhoeven has claimed: "The whole story of Murphy itself is a Christ metaphor. Murphy's killing is a crucifixion." **SW**

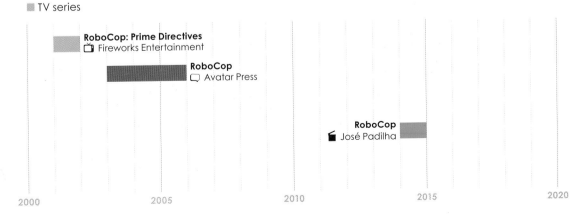

■ TV series

RoboCop: Prime Directives
◻ Fireworks Entertainment

RoboCop
◻ Avatar Press

RoboCop
◼ José Padilha

2000 2005 2010 2015 2020

robocop universe

Officer Alex Murphy/ RoboCop

Officer Anne Lewis

Cain/ RoboCop 2

The Old Man

In the near future, Detroit is in financial ruin and crime is rife on the streets. Omni Corporations Products (OCP) agrees to finance and manage the understaffed and under-equipped police force.

In its bid to develop a new form of law enforcement, OCP constructs a robot that is tireless, efficient and, crucially, devoid of human sympathy. The resulting ED-209 is little more than a killing machine. When it malfunctions and murders a junior executive at OCP, another employee, Bob Morton, suggests a cyborg alternative named RoboCop. All that is needed is a viable human candidate.

Pursuing criminals led by Clarence Boddicker in a deprived area of the city, good cops Alex Murphy and Ann Lewis are attacked. Lewis is unharmed but Murphy is murdered by the gang. He is taken to hospital and OCP seizes the moment: it has its first human body to use as the prototype RoboCop.

The reincarnated Murphy has his memory wiped and is remade with robotic parts: his body is mainly mechanical, with a metallic exterior. The top half of his face is covered by a metal visor. The bottom half of his face is all that remains of the old Murphy; that, and his habit of twirling his gun before he holsters it.

OCP programs RoboCop with three key directives: Serve the Public Trust; Protect the Innocent; Uphold the Law. A fourth, classified directive dictates that he cannot harm any employee of OCP.

RoboCop begins clearing up the city. He is irresistible and unstoppable. However, when he comes face to face with his murderers, memories from his past life return and drive him to hunt down those responsible for his death. He finds the gang's cocaine factory and confronts Boddicker, who protests that RoboCop cannot kill him because he is an unarmed member of the public, going against RoboCop's directive to uphold the law. The villain then admits working with OCP, so RoboCop takes him to the headquarters. He attempts to arrest Boddicker and OCP Senior Vice President Dick Jones but is powerless to do so because of his fourth directive. Jones activates an ED-209, but RoboCop escapes.

characters

 Officer Alex Murphy/RoboCop Officer Anne Lewis Cain/RoboCop 2
 The Old Man

1950 1955 1960 1965 1970 1975 1980 1985 1990

A final showdown takes place at the steel mill where Murphy died. He and Lewis take on Boddicker and his remaining men, killing them all. Back at headquarters, RoboCop reveals a recording that implicates Jones in the earlier death of an OCP employee. Jones is then fired from the company, allowing RoboCop to shoot him dead.

Months later, the maintenance of RoboCop is becoming increasingly expensive for the cash-strapped city. OCP proposes a new model: RoboCop 2. All experiments thus far have been disastrous as subjects cannot cope with the transition from human to machine. Murphy seems to be a unique case, until Dr. Juliette Faxx suggests using a criminal as the basis for a new machine.

While the police strike over pension and salary cuts, RoboCop and Lewis patrol the streets and fight the spread of Nuke, a new drug. RoboCop confronts the lead drug dealer, Cain, but is overwhelmed and his body is dismantled. Repaired, RoboCop convinces the police to join him in the fight against Cain.

Faxx puts Cain forward for the RoboCop 2 program. Meanwhile, Cain's replacement, Hob, tries to take over distribution of Nuke but is killed by Cain as RoboCop 2. The machine then malfunctions and wreaks havoc, spurred on by its craving for Nuke. RoboCop intervenes and rips out RoboCop 2's brain.

OCP now introduces "Urban Rehabilitators" (or "Rehabs") — machines that drive people out of their homes, clearing the way for redevelopment. A computer genius called Nikko becomes part of a rebellion when her parents are killed by the Rehabs.

RoboCop leads a fight against the Rehabs, their human leader, McDaggett, and the Otomo, an army of ninja androids.

Nikko leaks a video exposing OCP's corruption. The company is ruined and in a last-ditch effort to regain control, McDaggett launches an assault on the city. RoboCop defeats the Rehabs and Otomo and kills McDaggett before fleeing to safety with Nikko.

With OCP toppled, the good people of Detroit start rebuilding their city from the rubble. **SW**

OCP attacks Detroit population
Lewis killed
RoboCop fights to bring down OCP

OmniCorp reintroduces the RoboCop program

Old Man steps down, Kanemitsu corporation buys OCP

Dr. David Kaydick unleashes the "Legacy Virus"

ED-209 program cancelled

Nuke replaces cocaine, RoboCop battles RoboCop 2

RoboCop's directives are erased. He chooses to serve the people

Alex Murphy gunned down

"Old Man" dreams up Delta City

Delta City construction begun

1990 1995 2000 2005 2010 2015 2020 2025 2030

RoboCop
(1987)

RoboCop: The
Animated Series
(1988)

RoboCop 3
(1993)

Frank Miller's
RoboCop
(2003)

RoboCop: The
Last Stand
(2013–14)

RoboCop
(2014)

Sharp suit, sharp practice: Ronny Cox as OCP Senior President Dick Jones in **RoboCop**.

The **RoboCop** cartoon marked the end of his transformation from adult satire to children's hero.

Peter Weller as the original RoboCop.

Nancy Allen (L) as Anne Lewis and Robert John Burke as RoboCop in the third film.

Robert John Burke in make up during filming of *RoboCop 3*.

RoboCop: Last Stand was an eight-issue miniseries written by Steven Grant and based on the third film in the series.

RoboCop's mechanical components give him virtual invulnerability to harm.

Frank Miller's RoboCop comic series was written by Steven Grant, based on Miller's unused screenplay for *RoboCop 2*.

In the 2014 *RoboCop* reboot, the title role is played by Joel Kinnaman, a Swedish-American actor who first came to prominence in *Easy Money* (2010).

red dwarf 1988

Red Dwarf

Infinity Welcomes
Careful Drivers

Better Than Life

Last Human

Backwards

Red Dwarf:
Back to Earth

Red Dwarf started life as "Dave Hollins: Space Cadet," a sketch written by Rob Grant and Doug Naylor for Son of Cliché, a comedy series broadcast in 1983 on BBC Radio 4. Grant initially thought a different routine had potential for expansion: "My favorite sketch was 'Captain Invisible and the See-Through Kid,' two superheroes who couldn't see each other and couldn't find the car — but it didn't really work on TV."

A pilot episode was first written as early as 1983. The basic premise saw a slob, a hologram and creature that had evolved from a cat as the only survivors on a vast mining ship — Red Dwarf — lost in the depths of space. The BBC didn't bite initially. Meanwhile, Grant and Naylor were snapped up by ITV for a massively successful stint as head writers on the satirical puppet show Spitting Image, for which they also wrote the hit single "The Chicken Song."

Grant and Naylor finally convinced BBC North to commission a series of Red Dwarf in 1986, production taking place in Manchester. Naylor admits that, riding high on their Spitting Image success, they fully expected Red Dwarf to be a hit, "right up until the point where we wandered up to Manchester and looked at the sets. It looked everything that I didn't want, which was mega-cheesy, so cheap ..."

Neither did the casting quite go according to plan. Rob Grant recalls, "We were at one point contemplating Alan Rickman and Alfred Molina. We wanted real actors and we ended up with a dancer, a comedian and a stand-up poet."

The dancer was Danny John Jules (Cat); the comedian was Chris Barrie (pompous, cowardly hologram Rimmer); the stand-up poet was Craig Charles (slacker Dave Lister). It may not have been the casting Grant envisaged, but the choices would eventually prove to be inspired, as the on-screen chemistry became one of the key elements in the show's success.

Not that success was immediate. Episode one premiered on BBC Two with a healthy audience of around five million viewers, but ratings slipped significantly over the course of the first six episodes. The second series, though, saw a dramatic turnaround in fortunes, and by 1997 it had risen to become BBC Two's most watched sitcom of all time, with over eight million viewers tuning in for the series seven premiere.

The first two series concentrated heavily on the "odd couple in space" format, but Grant and Naylor soon found this approach restrictive. Series two had introduced a serving droid called Kryten, and in the following season he became a regular character (although played by a different actor, Robert Llewellyn). Further changes ensued. The plots began to make use of Red Dwarf's shuttle craft, Starbug, enabling more action to take place away from the

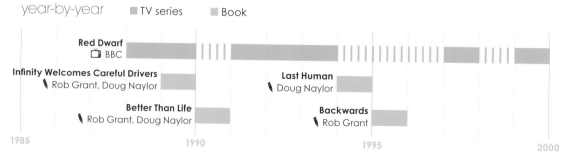

year-by-year ■ TV series ■ Book

Red Dwarf
📀 BBC

Infinity Welcomes Careful Drivers
🖋 Rob Grant, Doug Naylor

Better Than Life
🖋 Rob Grant, Doug Naylor

Last Human
🖋 Doug Naylor

Backwards
🖋 Rob Grant

1985 1990 1995 2000

Red Dwarf X

main ship. More outside threats were introduced. The ship's laconic computer, Holly, had a sex change. And the show's creators began wielding more influence on the production: "We were doing things in series three that hadn't really been done before, and no-one around us knew enough to tell us that they were too difficult to attempt!" says Naylor.

With the TV shows growing in popularity, Grant and Naylor were able to expand on the *Red Dwarf* universe with four spin-off novels. Although unappreciated by critics, they were huge sellers.

Series six began in 1993 with an unexpected twist. Having spent 200 years on board *Starbug* in suspended animation, the crew awakes to discover *Red Dwarf* missing. It also marked the end of the writers' partnership, Grant claiming at the time, "I just want to work on something I've created this decade," before citing "musical differences." He later claimed that viewing subsequent seasons was like, "watching a video tape of your ex-wife's next honeymoon."

This period also saw the first signs of interest from American TV. Two pilots were produced in 1992, one of which featured Terry Farrell as Cat — "The first of many ideas *Star Trek* nicked from us!" as Naylor later noted. Neither were picked up by the networks. "The Rimmer character didn't quite work," Naylor recalled. "We had a good actor but he wasn't right for the part. At one point we tried to get Chris Barrie, but the deal was if Universal paid for him to come to the States, he would have to sign a five-year contract, which he was reluctant to do."

Unhappy at his heavy workload, Chris Barrie only took part in four episodes of series seven, but returned full-time for season eight, which concluded with *Red Dwarf* being rebuilt by nanobots who had stolen the ship in the first place. With no further series in the pipeline, however, fans feared that the season finale, broadcast in March 1997, marked a final curtain.

Meanwhile, there were persistent rumors about a *Red Dwarf* movie: indeed, occasional crew member Kochanski was allegedly made a regular character in series seven so that the film would have a ready-made female lead. Ultimately, however, Naylor was never able to raise the money for the venture.

Instead, *Red Dwarf* made an unlikely return in 2009 on British cable channel, Dave. The three-part *Back to Earth* went mega-meta with Lister (Craig Charles) meeting *the* Craig Charles on the set of TV show *Coronation Street* — in which the actor was now a popular cast member. Fans were underwhelmed, but it gave Dave by far its biggest audience ever, and the six-part *Red Dwarf X* was commissioned. Deliberately aping the look and feel of the early series, it was both a ratings and critical success — especially the final episode, which was essentially a 30-minute version of the ill-fated film script. **DG**

Red Dwarf: Back to Earth
📺 Dave

Red Dwarf X
📺 Dave

2000 2005 2010 2015

Red Dwarf
(1988–2000)

**Red Dwarf:
Back to Earth**
(2009)

Red Dwarf X
(2012)

Craig Charles was an "urban performance poet" before he found fame as genial slacker, Dave Lister in *Red Dwarf*.

Bunk buddies: the first two series of *Red Dwarf* focus on the "odd couple" relationship of Lister and Rimmer.

Hologram Arnold Rimmer, played by comedian Chris Barrie, was also star of the popular sitcom, *The Brittas Empire*.

Lister's unrequited love interest, Kristine Kochananski, was first played by pop star Clare Grogan (pictured here) and then later by Chloë Annett.

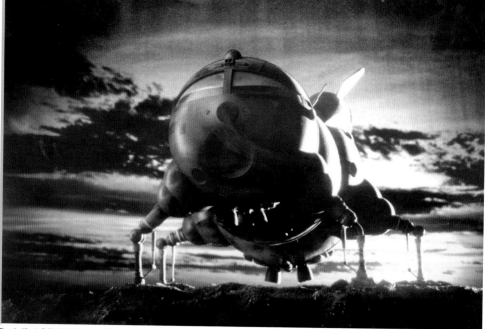

The shuttlecraft *Starbug* was one of three auxiliary craft on *Red Dwarf* (there were two *Starbugs* and the *Blue Midget*). The crew spent several years traveling around in this ship after they "lost" *Red Dwarf*.

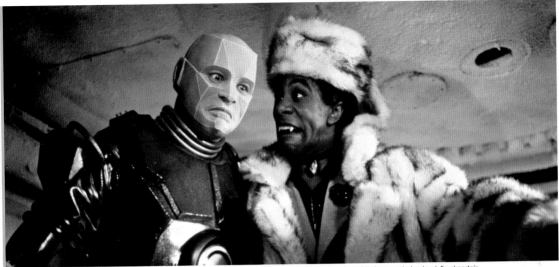
Service mechanoid Kryten (Robert Llewellyn) with The Cat (Danny John-Jules), last of a species who evolved from Lister's smuggled pet cat, Frankenstein.

Holly, the ship's "intelligent" computer, is portrayed as an on-screen presence by comedian Hattie Hayridge.

"Carbug" — a Smart car modified to look like the *Starbug* shuttle — featured during a hallucination sequence in 2009's **Back to Earth**.

Reunited for **Red Dwarf X**, Robert Llewellyn, Craig Charles and Chris Barrie. The series was widely praised after the disappointment of *Back to Earth*.

alien nation 1988

| Alien Nation | Alien Nation | Alien Nation | Alien Nation: Dark Horizon | Alien Nation: Body and Soul | Alien Nation: Millennium | Alien Nation: The Enemy Within | Alien Nation: The Udara Legacy |

Although best known as a TV production, *Alien Nation* began life in 1988 as a feature film. The story begins with a UFO landing in the Mojave Desert; on board are 300,000 escaped alien slaves. To the dismay of the local population, these "Newcomers" are settled in Los Angeles where they attempt to integrate. In spite of the premise, *Alien Nation* is a "buddy cop" picture at heart, bringing together gruff veteran police detective Matthew Sykes (James Caan) and his new partner, Sam "George" Francisco (Mandy Patinkin) — the first Newcomer detective in the LAPD. Initially reluctant partners, they bond as they investigate a homicide and a mysterious alien drug, "jabroka."

Alien Nation is a surprisingly effective marriage of noir thriller and science fiction, which, unusually, presents the aliens as the persecuted minority. Indeed, the Newcomers exhibit a number of compelling characteristics, such as a vulnerability to salt water and finding sour milk intoxicating.

A small box-office hit, a year later producer Kenneth Johnson (*V, The Six Million Dollar Man*) was approached to make a television adaptation. The series abandoned the dark feel of the original to concentrate on George's family, Sykes' growing romance with a Newcomer woman and assorted mysteries rooted in the ever-expanding background of the aliens. The series pushed its social agenda explicitly as a direct commentary on race relations, the Newcomers standing in for other minority groups. What particularly stands out is in the way the series focuses on the mechanics of the alien society, going as far as creating elements of a language and an alphabet (memorably seen in graffiti across the city streets), expanding on their religion and, in a series highlight, even showing a pregnant George Francisco giving birth!

A key revelation in the TV series is the existence of the "Overseers," Newcomers who had worked for the alien race which had enslaved them. This subplot would play a larger part in the later TV movies.

After 22 episodes, the first season ended on a cliff-hanger. A second series was expected until a financial shortfall led the Fox Network to cancel immediately all of the following year's drama series. What would have been the first episode of season 2, "Dark Horizon," was then published as part of a series by Malibu Comics from 1990.

Although never massively popular, *Alien Nation* enjoyed a robust cult following, which led to the production of five TV movies featuring the original cast, beginning in 1994 with *Alien Nation: Dark Horizon*. In 2009, the SyFy Channel announced a reboot under the creative direction of Tim Minear (*The X-Files*), who described it as "*The Wire* with aliens." **LT**

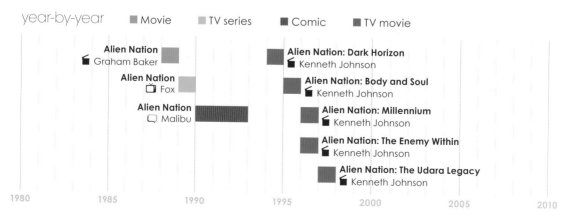

year-by-year ■ Movie ■ TV series ■ Comic ■ TV movie

Alien Nation
Graham Baker

Alien Nation
Fox

Alien Nation
Malibu

Alien Nation: Dark Horizon
Kenneth Johnson

Alien Nation: Body and Soul
Kenneth Johnson

Alien Nation: Millennium
Kenneth Johnson

Alien Nation: The Enemy Within
Kenneth Johnson

Alien Nation: The Udara Legacy
Kenneth Johnson

1980 1985 1990 1995 2000 2005 2010

islands in the net 1988

**Islands in
the Net**

American science fiction author Bruce Sterling is best-known as one of the founding fathers of cyberpunk. Set in 2023, *Islands in the Net* discusses the relationships between large multinational corporations and nation states while examining the potential future of economics, politics and warfare in a world dominated by an internet-style network — simply known as "The Net." The story follows Laura Webster, a public relations agent for the multinational corporation Rizome, as she finds herself traveling around the globe after the company is implicated in the assassination of a Grenadian diplomat.

Published in 1988, the book has been heralded for its many correct predictions about early 21st-century life and technology, from the ubiquitous nature of the internet and mobile computing to the use of drones in anti-terrorist assassinations. There are, of course, some elements that fall wide of the mark: fax and telex machines are still used, the power of computers and the speed of the network is severely underestimated and the Soviet Union still exists as a superpower. *Islands in the Net* won the Joseph W. Campbell Memorial Award for Best Science Fiction Novel in 1989, and was nominated for both Hugo and Locus awards the same year.

Bruce Sterling began writing science fiction in the late 1970s. By the time *Islands in the Net* appeared he had already published three novels: *Involution Notion* (1977), *The Artificial Kid* (1980) and *Schismatrix* (1985). The latter was credited as spawning the "Nu Space Opera" subgenre of gritty, post-human interplanetary science fiction which would be popularized by writers such as Alastair Reynolds, who cites it as an important influence. But it remains the 1980s cyberpunk movement with which Sterling is most closely associated, notably his role as editor of *Mirrorshades: A Cyberpunk Anthology* (1986), in which he brought together short stories from some of the scene's key authors, including William Gibson (with whom he would write *The Difference Engine*), Pat Cadigan, Rudy Rucker and John Shirley. During the same period, using the pen name Vincent Omniaveritas, Sterling also edited and wrote for the underground fanzine *Cheap Truths*: its acerbic, satirical tone aimed squarely at science fiction's "old guard," it played a key role in the emergence of cyberpunk.

Sterling has continued to write fiction into the 21st century — his political novel *Distraction* won a Clarke Award in 2000, and he would later embrace the eBook format with *Love Is Strange* (2012). He has since become more associated with nonfiction and futurist writing, especially concerning the environment and consumer technologies. In 1998 he founded Viridian, a design movement that aimed to present innovative, technological solutions to the climate crisis. He later involved himself in "design fiction," where diegetic science fiction is used in the creation of prototypes for potential consumer gadgets.

In 2003 Sterling was appointed Professor of Internet studies and science fiction at the European Graduate School in Switzerland and in 2005 he became "visionary in residence" at the Art Center College of Design in Los Angeles. These days, he is best known for traveling the world and lecturing at events and conferences, perhaps most famously the annual closing keynote at the South by South West festival in Texas. **TM**

year-by-year ■ Book

Islands in the Net
\ Bruce Sterling

1980 1985 1990 1995

ghost in the shell 1989

Ghost in
the Shell

Ghost in
the Shell

Ghost in
the Shell

Ghost in
the Shell 2:
Man-Machine
Interface

Ghost in
the Shell:
Stand Alone
Complex

Ghost in
the Shell 1.5:
Human Error
Processor

Ghost in
the Shell: S.A.C.
2nd GIG

Ghost in
the Shell 2:
Innocence

Reclusive artist Masamune Shirow had already established himself as an important force in science fiction manga by the end of the 1980s. His series such as *Black Magic* (1983), *Appleseed* (1985) and *Dominion* (1986) showcased a distinctive style that combined often violent and sexually explicit imagery with dense plots, political and philosophical themes, urban landscapes and cybernetic technology. However, it would be *Ghost in The Shell* (1989) (*Kokaku Kidotai* — literally, "Mobile Armored Riot Police") that would propel him to international recognition. Set in 2029 it follows the adventures of Public Security Section 9; a shadowy, secretive Japanese government agency led by cyborg Major Motoko Kusanagi, as they investigate acts of government and corporate corruption, hacking, cyber-crimes and terrorism.

One reason for *Ghost in the Shell*'s success is the believability of its setting, which combines the familiarity of late 20th/early 21st century society with new forms of technology. Chief amongst these are cybernetic implants, such as the cyberbrain — an augmentation to the human brain that allows it to interface with other gadgetry and computer networks. Although cyberbrain adoption is widespread amongst the general civilian public, other more dramatic cyborg modifications are available, providing superhuman reactions, speed and strength. Too expensive for most civilians, following decades of global warfare there are many cyberized veterans now walking the streets: dealing with those that turn to crime is a frequent concern for Section 9.

Many of the philosophical themes of the franchise stem from this technology, especially as it explores ways in which cyberbrains can be "ghost-hacked," discussing whether it is possible to trust their perception of reality and what it means to be human when so much of a person's body is artificial.

Shirow would continue to return to *Ghost in the Shell*, writing and drawing a series of one-offs and short arcs that were collected in the volumes *Ghost in the Shell 2: Man Machine Interface* (2001) and *Ghost in the Shell 1.5: Human Error Processor* (2003).

It was, however, 1995's animated feature film that would propel the franchise to global recognition. Directed by acclaimed director Mamoru Oshii, the film differs subtly from its source material. The action is moved from Japan to what appears to be Hong Kong, and the tone is far darker, realistic and serious.

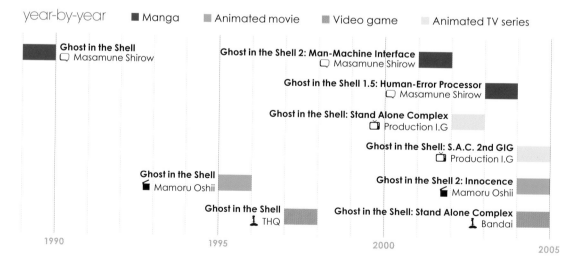

year-by-year ■ Manga ■ Animated movie ■ Video game ■ Animated TV series

Ghost in the Shell
▢ Masamune Shirow

Ghost in the Shell 2: Man-Machine Interface
▢ Masamune Shirow

Ghost in the Shell 1.5: Human-Error Processor
▢ Masamune Shirow

Ghost in the Shell: Stand Alone Complex
📺 Production I.G

Ghost in the Shell: S.A.C. 2nd GIG
📺 Production I.G

Ghost in the Shell
🎞 Mamoru Oshii

Ghost in the Shell 2: Innocence
🎞 Mamoru Oshii

Ghost in the Shell
🎮 THQ

Ghost in the Shell: Stand Alone Complex
🎮 Bandai

1990 1995 2000 2005

● ○

$3.5M
Ghost in the Shell
(1995)

$12.1M
Ghost in the Shell 2:
Innocence
(2004)

Ghost in the Shell: Stand Alone Complex **Ghost in the Shell: The Laughing Man** **Ghost in the Shell: Individual Eleven** **Ghost in the Shell: Solid State Society** **Ghost in the Shell 2.0** **Ghost in the Shell: Arise**

The plot, however, which sees Section 9 investigating a powerful ghost hacker known as the Puppet Master, is taken directly from the manga. Oshii's distinctive visual style alternates frenetic action with long, slowly paced atmospheric sequences shot in an almost art house, *noir* style. The overall impact was of an animated film that felt more like Stanley Kubrick or Ridley Scott than the cartoons western audience were accustomed to seeing.

Oshii would return for a sequel nearly a decade later with 2004's *Ghost in the Shell 2: Innocence*, which although achieving acclaim for its detail-rich visual style troubled some viewers with its emphasis on philosophical debate over action. *Ghost in the Shell: 2.0* was released in 2008. A special edition of the first movie, key scenes were enhanced using CGI to match the style of the sequel.

The year 2002 saw the franchise make its first transition to the small screen with the airing of the 26-episode *Ghost in the Shell: Stand Alone Complex*. Unlike the movies, Shirow was closely involved in the production, its tone closer to his original manga both in art style and humor. The first season focused on a notorious hacker known as the Laughing Man, and

was a hit with audiences across the globe. A second season aired two years later as *Ghost in the Shell: S.A.C. 2nd GIG*. Following the success of the show on DVD two compilation movies were released that edited together key story lines from the two series — *The Laughing Man* (2005) and *Individual Eleven* (2006) — as well as the TV movie *Solid State Society* (2007).

June 2013 saw the release of the first hour-long installment of *Ghost in the Shell: Arise*. A four part straight-to-video series set following young Kusanagi's return from war, it details the formation of Section 9. Although it could be interpreted as a prequel to either the manga or TV series it also appears to be yet another reimagining that creates its own continuity.

Ghost in the Shell's impact on modern science fiction is hard to measure, so many works owing it a debt. The most high-profile example is *The Matrix* (1999) which borrows elements of its technology, philosophy and visual style — so much so that the directors, the Wachowski Brothers, would show producers clips from the original movie during pitches. In 2008 it was announced that Steven Spielberg's DreamWorks had acquired the rights to produce a live action adaptation of the original manga. **TM**

Ghost in the Shell: The Laughing Man
🎬 Kenji Kamiyama

Ghost in the Shell: Individual Eleven
🎬 Kenji Kamiyama

Ghost in the Shell: Solid State Society
🎬 Kenji Kamiyama

Ghost in the Shell 2.0
🎬 Mamoru Oshii

Ghost in the Shell: Arise
📺 Kazuchika Kise, Masahiko Murata

2005 2010 2015 2020

Ghost in the Shell
(1995)

Ghost in the Shell 2: Innocence
(2004)

An augmented cybernetic human, Major Motoko Kusanagi is the central figure in the **Ghost in the Shell** franchise.

Ghost in the Shell uses "digitally generated animation" (DGA). A combination of cel animation and CGI, at the time it was viewed as the future of animation.

Although set in 2032, director Mamoro Oshii claimed his intention was "to create a *different* world — not a *future* world."

At the 2004 Cannes International Film Festival, **Ghost in the Shell 2: Innocence** was the first anime to be nominated for the Palme d'Or award.

LIke many of the characters in Oshii's film adaptations, Motoko's personality is more serious than in Shirow's original manga.

With its chaotic atmosphere and cacophony of sound, director Oshii based the setting for **Ghost in the Shell** on Hong Kong.

Set in the year 2032, **Ghost in the Shell 2: Innocence** sees the line between humans and machines blurred almost beyond distinction.

Motoko's Section 9 colleague, Batou, takes center stage in Oshii's sequel.

Ghost in the Shell 2: Innocence featured lavish visuals.

The franchise takes place in a near-future where cybernetic implants have become commonplace among humans.

The plot line for **Ghost in the Shell 2: Innocence** was largely based around "Robot Rondo" — episode six of Shirow's original manga.

In the sequel, Section 9's Batou investigates a spate of deaths that seem to be caused by malfunctioning robot sex dolls.

The San Francisco Chronicle described Motoko as having "the body of a Baywatch babe, the face of a beauty queen and the soul of a machine."

the adventure continues: modern science fiction

1990-present

jurassic park 1990

Jurassic Park

Jurassic Park

Jurassic Park

Jurassic Park Part II: The Chaos Continues

The Lost World

The Lost World: Jurassic Park

In 1925, a pterodactyl landed on a clifftop to eat its kill in *The Lost World*, as cinema audiences watched agog. In 1993, the ambassador of computer animation was a brachiosaurus, approximately the bulk of three elephants, strolling to a tree and rearing up to nibble its top. Below, the little humans stared gape-mouthed, unable to articulate more than "It's ... it's a dinosaur!"

Directed by Steven Spielberg, the effects in *Jurassic Park* were a cocktail of techniques: fifty-odd CGI shots, animatronic models and the odd human being in a creature suit. As a film it is comparable to *Jaws* in the way that it taps into primal human terror. A bellowing *Tyrannosaurus rex* arrives during a stormy night. We stare up her jaws from our buffet vantage points; from broken-down automated cars, from a toilet mercilessly exposed to the elements. The bloodsucking lawyer sitting on it dies the most humiliating movie death ever. "When you gotta go, you gotta go," Jeff Goldblum says drily.

Jurassic Park also owes a debt to Spielberg's *Indiana Jones* cycle, especially 1984's *Temple of Doom*. This is where film and theme park ride come together, a story dissolving into a succession of thrills. The key action all takes place during the second half

of the film, yet it's easy to enjoy *Jurassic Park*'s early scenes. There's the ironic set-up of a theme park film about a theme park; there are also science-ethics arguments, slickly delivered by Jeff Goldblum's chaos mathematician, barracking Richard Attenborough's Master of Ceremonies: "You stood on the shoulders of geniuses ... Before you even knew what you had, you patented it and packaged it and slapped it on a plastic lunchbox."

The characters are typically audience surrogates: "Look how much blood," whispers a young boy, staring at a mighty *Tyrannosaurus rex* munching the ostrich-like *Gallimimus*. But Goldblum stands in for author Michael Crichton, who wrote the source novel. Reading it, one appreciates Spielberg's fluency all the more: the characters in the book are less rounded, and the pontifications boggy and pompous. Crichton's credibility suffers from the book's opening page, when he predicts that biotech will change our everyday lives more than computers or atomic power — by the end of the 1990s.

The book's saving grace is that its theme park ride is longer than the film, including an exciting river-raft adventure, and an evocative conclusion in a cave of hooting raptors, with alien intelligence and migratory

year-by-year ■ Book ■ Movie ■ Comic ■ Video game

$1.6B
Jurassic Park
(1993)

$902M
*The Lost World:
Jurassic Park*
(1997)

$487M
Jurassic Park III
(2001)

Jurassic Park Adventures

Jurassic Park III

Jurassic Park

Jurassic Park: The Game

Jurassic World

instincts. Some of these elements turn up, generally less effectively, in the film sequels, Spielberg's *The Lost World: Jurassic Park* (1997) and Joe Johnston's *Jurassic Park III* (2001).

Spielberg's sequel is disappointingly shapeless, its premise too woolly to drive the action. In the safari-style adventure, bad humans set out to trap and exploit the dinosaurs on another island, whereas the heroes (led by Goldblum's character) protect them. The film does have its effective moments of terror, though — a T-Rex outside a tent, a 1,000-foot drop under a cracking windshield. Crichton's novel *The Lost World* is vaguely similar to the second film, although the villain is Dodgson, the corporate thief who set the original plot rolling. *Jurassic Park III* is hokum: parents seek their little boy lost on the dinosaur island. Both novel spin-offs, though, are instantly forgettable.

The first theme park spin-off opened at Universal Studios Hollywood in 1995, and featured animatronic dinosaurs. *Jurassic Park: The Ride* was later cloned at Universal Studios Japan. Other versions appeared at Universal theme parks in Singapore and Florida.

Numerous *Jurassic Park* comics were published by Topps in the 1990s and subsequently by IDW. As well as comic versions of both Spielberg films, Topps published *Raptor* (two issues), *Raptor Attack* (four issues) and *Raptors Hijack* (four issues). They follow a suggestion in Crichton's first book, with raptors escaping into the South American jungle. Several film characters return, including the game warden played by Bob Peck, who somehow survived his encounter with a "clever girl" raptor.

IDW's comics include *Redemption* (five issues), *The Devils in the Desert* (four issues) and *Dangerous Games* (five issues). The first series imagines the children from the original film as adults, wrestling with *Jurassic Park*'s legacy. *Dangerous Games* — created by science fiction author Greg Bear and his son Erik — sees the original park taken over by a Nicaraguan drug lord. Like the Topps titles, each serial was also later collected in book form.

There was also a series of three junior *Jurassic Park Adventures* story books — *Survivor*, *Prey* and *Flyers* — spun off from *Jurassic Park III* and written by Scott Ciencin.

Among the many game spin-offs were *Jurassic Park Part II: The Chaos Continues*, a side-scrolling arcade game for the SNES and Game Boy, and *Jurassic Park: The Game*, a point-and-click adventure for PC, Mac, Xbox and Playstation. **AO**

Jurassic Park Adventures
Scott Ciencin

Jurassic Park III
Joe Johnston

Jurassic Park
IDW Publishing

Jurassic Park: The Game
Telltale Games

Jurassic World
Colin Trevorrow

2005 2010 2015

Jurassic Park
(1993)

Jurassic Park
(1993–97)

**The Lost World:
Jurassic Park**
(1997)

Jurassic Park III
(2001)

In one of *Jurassic Park*'s most spectacular scenes, Sam Neill flees a herd of stampeding *Gallimimus*.

The mighty *Tyrannosaurus rex* looms menacingly over a jeep; inside are the terrified grandchildren of Jurassic Park's owner, John Hammond.

Dr. Ian Malcolm (Jeff Goldblum), John Hammond (Richard Attenborough), Dr. Ellie Sattler (Laura Dern) and Dr. Alan Grant (Sam Neill) study the dino eggs that will populate Jurassic Park.

Topps Comics produced a strip cartoon version of the original *Jurassic Park* film in 1993.

Steven Spielberg directs a dinosaur puppet during the filming of **The Lost World: Jurassic Park** (1997). Although one of the biggest box-office hits of the year, most critics found it a disappointing sequel.

Dr. Harding (Julianne Moore) and Dr. Malcolm (Jeff Goldblum) encounter an unwelcome guest in **The Lost World: Jurassic Park**.

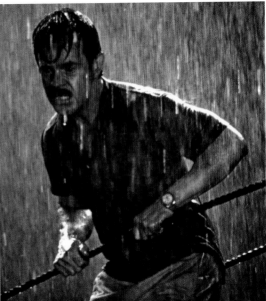

Jurassic Park III (2001) sees Paul Kirby (William H. Macey) on a mission to find his son who has been lost parasailing on the island.

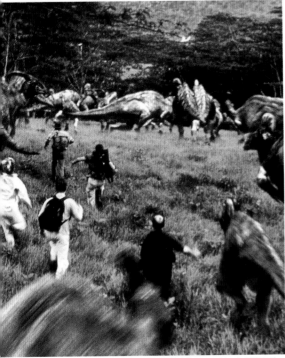

The spectacular action scenes in all three *Jurassic Park* films are a blend of CGI and live-action special effects.

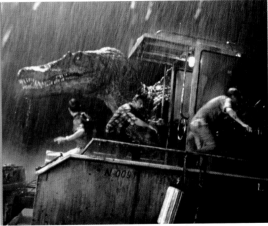

Dr. Alan Grant (Sam Neill), one of the world's leading paleontologists, is menaced by Spinosaurus in **Jurassic Park III**.

jurassic park creatures

Dr. Ellie Sattler (Laura Dern) and Dr. Alan Grant (Sam Neill) tend to a sick *Triceratops*.

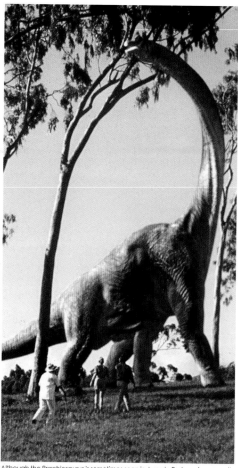
Although the *Brachiosaurus* is sometimes seen in Jurassic Park rearing up on its hind legs, scientists believe they could not have supported such a vast weight.

A *Velociraptor* hatches from an egg in the hands of the island's billionaire owner, John Hammond (Richard Attenborough).

Tyrannosaurus rex (left) meets its match in *Spinosaurus* (right). Noted paleontologist Jack Horner describes *Spinosaurus* as the most ferocious creature ever, calling it "an animal basically the size of a whale walking around eating things."

A *Parasaurolophus* herd (right) roams with the mighty *Brachiosaurus* (left). Scientists now believe the *Parasaurolophus* used its unique cranial crest — up to 5 feet in length — as a way of identifying gender and for producing mating calls.

Since the making of the *Jurassic Park* films, paleontologists have established that the *Velociraptor* was likely to have been a feathered creature.

Portraying the *Dilophosaurus*, author Michael Crichton admitted to "creative license"; there is no scientific evidence of a neck frill or the ability to spit venom.

With its armored plates and tail spikes, the *Stegosaurus* is one of the most recognizable of all dinosaurs. Discovered in 1877 during the so-called "Bone Wars," it has featured in many science fiction films, as far back as *King Kong* in 1933.

men in black 1990

The Men
in Black

The Men in
Black Book II

Men in Black

Men in Black:
The Series

Men in Black:
Far Cry

Men in Black:
Retribution

Men in Black
II

Men in Black
3

A rare cinematic blend of science fiction and comedy, Barry Sonnenfeld's *Men in Black* (1997) is one of the genre's biggest blockbusters. Although the odd-couple chemistry between stars Will Smith and Tommy Lee Jones was crucial to its success, so was the film's beguiling world: it's supposedly our own, and yet every other passer-by is a disguised alien, overseen and protected by humanity in exchange for gifts. (From *Men in Black 3*: "You're going to be late for a meeting with the Viagrans, they have a revolutionary new pill!") Agents peruse supermarket tabloids where headlines like "My husband is an alien!" are all actually true. Rarely has the conceptual breakthrough — the overturning of everything one thinks about reality — been such fun.

Men in Black's cinema success obscures its origins, as two three-part monochrome comics, written by Lowell Cunningham and drawn by Sandy Carruthers. The humor was very black, and the Men in Black's remit also covered demons and the paranormal. The original film version depicts Earth as a neutral zone for alien refugees — rather like wartime Casablanca (or the Los Angeles of *Alien Nation*). The wondrous secret HQ has an abundance of alien extras, holo-screens and open-space décor inspired by architect Eero Saarinen — it's a mix of *Star Wars*' Chalmun Cantina and the Heaven of *A Matter of Life and Death*.

It begins with the induction of Agent J (Will Smith), a self-possessed New York cop, into the eponymous

secret organization, and his clashes with mentor, Agent K (Tommy Lee Jones). Smith is wry, loose and irreverent, but the leathery, deadpan Jones is funnier, with the lion's share of one-liners. The film relies equally on visual gags: Smith wrestles with a giant tentacle, a killer bouncing ball smashes up headquarters, and the alien villain, Edgar the Bug, lurches and contorts in a truly alarming fashion.

The film assures us that the secret agency is benign. Jones refers to the stupidity of crowds as the reason for the cover-up, while still flattering viewers ("A person is smart; people are dumb, panicky, dangerous animals.") Such a premise doesn't always play — the first film's shots of the Twin Towers remind us how popular perceptions of authority shift with history. Smith's blackness is fleetingly referenced, although it's hard to know quite how to take his racist taunt to an insect monster — "You know you all look alike!"

In the wake of the film's success, a 53-part TV animation, *Men in Black: The Series* also appeared. The story continued from where the film left off, but without the voices of the original leads.

The cinema sequel, *Men in Black II* (2003) suffers from the lack of surprise, merely repeating and milking gags from its predecessor. A decade later, however, *Men in Black 3* showed a marked improvement, focusing on the relationship between J and K, and featuring Josh Brolin as a strikingly convincing young Tommy Lee Jones. **AO**

year-by-year ■ Comic ■ Movie ▨ Animated TV series

Men in Black
🎞 Barry Sonnenfeld

Men in Black: The Series
📺 The WB

Men in Black II

Men in Black 3

The Men in Black
▢ Aircel

The Men in Black Book II
▢ Aircel

Men in Black: Far Cry
▢ Marvel

Men in Black: Retribution
▢ Marvel

1985 1990 1995 2000 2005 2010 2015

roland emmerich 1990

| Moon 44 | Universal Soldier | Stargate | Independence Day | The Visitor | Godzilla | The Day After Tomorrow | 2012 |

Once upon a time, German director Roland Emmerich was the king of the summer blockbuster. Yet although his films might have seemed loud and brash viewed from a distance, they become more interesting the closer you look at them. A comparable figure such as Michael Bay may churn out testosterone-driven multiplex-busters, but they exhibit a staggering lack of irony. Emmerich's movies, by contrast, often seem to will the audience to laugh with them. Some might have guffawed at President Whitmore's rousing patriotic speech from *Independence Day* or hooted at the idea of city-sized ships being readied for the apocalypse, but Emmerich presents them with a wink and a smile. He's well aware how giddily ludicrous his films are — probably more so than many of his audience.

Emmerich first came to Hollywood's attention with his German-made/English-language science fiction flick *Moon 44*. Cherry-picked by producer Mario Kassar to replace Andrew Davis on the Jean-Claude Van Damme vehical *Universal Soldier*, he quickly established a reputation as someone capable of making a B-movie look and feel like an A-feature. It was a skill he brought again to *Stargate*, which he penned with his long-time collaborator Dean Devlin, and which would spawn a TV franchise to rival *Star Trek* in its endless capacity for reinvention.

Independence Day, Will Smith's first Hollywood hit, probably stands out as a career high for Emmerich. By the time it was made in 1996, CGI was becoming the norm for most science fiction movies, but his impressive alien invasion epic is notable for relying heavily on old-style optical and physical effects.

He tripped up with his remake of *Godzilla* (1999) and again with *The Day After Tomorrow* (2004) — for all its attention grabbing visuals of a New York City buried under a sea of ice, it felt nonetheless flat and unnecessarily preachy. Yet even his flops have points of interest. Emmerich has tended to steer clear of bankable A-listers for his blockbusters. It's not that he couldn't afford the Clooneys and Cruises, but that he prefers to populate his movies with more interesting headline actors — Jeff Goldblum, Matthew Broderick, Dennis Quaid, John Cusack, James Spader. Emmerich is a director working in the system, but in a mild way he brings a quirky, independent sensibility to proud studio behemoths.

Most of Emmerich's less interesting films are those he signed on for as a jobbing director, but without having worked on the script (*The Patriot*, *White House Down*, *Anonymous*). But after the failure of the dreary *10,000 BC*, he decided to return to the "ID4" template, this time replacing Apple Mac-fearing aliens with the sun's solar flares in the joyously silly and insanely exciting *2012*. At the time, he claimed this was likely to be his final disaster movie, but in the recent past has begun talking up the idea of the long-promised sequel to *Independence Day*. True to form, he already seems to be flinching from the idea that this may be another ordinary Hollywood blockbuster by suggesting that this time there would be no part in it for Will Smith: back in 1996, casting The Fresh Prince in such a film was a risky move; Smith is now an obvious A-list celebrity.

It's clear that big, loud, spectacle cinema needs Roland Emmerich more than it realizes. **SOB**

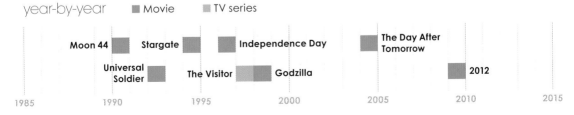

year-by-year ■ Movie ■ TV series

Moon 44 Stargate Independence Day The Day After Tomorrow

Universal Soldier The Visitor Godzilla 2012

1985 1990 1995 2000 2005 2010 2015

stephen baxter 1991

Raft

The Time
Ships

Gossamer

Huddle

The Light of
Other Days

On the
Orion Line

The Children
of Time

The Long
Earth

In 1991, the British science fiction novelist Stephen Baxter applied to become a cosmonaut. He "fell at an early hurdle," but it says much about a man with a degree in mathematics from Cambridge and a doctorate in engineering that he had high hopes of securing the guest slot on the Soviet/Russian Mir space station — an honor that eventually went to chemist Helen Sharman, the first British astronaut. That's not to say 1991 was a wasted year for Baxter. He may not have blasted into space, but his debut novel, *Raft*, was published, and a career initially associated with the British space opera boom began in earnest.

Raft was the first of Baxter's so-called Xeelee Sequence, a monumental series of books with a timeline running from the Big Bang to the collision of the Milky Way and Andromeda galaxies five billion years later. It was also a novel that showed Baxter's fondness for works of science fiction with foundations rooted in hard science. Its plot concerned a group of humans who arrive in an alternate universe with a far higher gravitational force than our own.

Yet whereas he made his name with hard science fiction, Baxter has never let himself be constrained by it. While the 1990s brought another three Xeelee novels — *Timelike Infinity*, *Flux* and *Ring*, Baxter also wrote a steampunk novel, *Anti-Ice*. *The Time Ships* was written as a sequel to *The Time Machine*, and received an official stamp of approval from the estate of H.G. Wells. Baxter's NASA trilogy, which began with the account of a 1980s mission to Mars in *Voyage*, was based on extensive research into the space agency.

In the *Destiny's Children* books, the prolific Baxter added elements of historical fiction to the Xeelee timeline. Indeed, alternate history was becoming a recurring theme in Baxter's work. The *Time's Tapestry* sequence included *Weaver*, where the Nazis occupy southern England; the Northland Trilogy imagined a world where Doggerland, a former landmass in the North Sea, didn't flood after the last Ice Age.

The episodic *Evolution* told the story of 565 million years of human progress. *The H-Bomb Girl*, meanwhile, revisited 1962 and the Cuban Missile Crisis, when a 14-year-old-girl in Liverpool becomes a target for time travelers from the future.

In 2012, the BBC published Baxter's Doctor Who novel, *The Wheel of Ice*, which featured the second Doctor. It had earlier been announced that he had written a script, *Earthstorm*, for an audio story that was eventually shelved.

Notably, Baxter has also collaborated with two of Britain's best-loved genre writers. The *A Time Odyssey* series was co-authored with Arthur C. Clarke, and linked to veteran author's own *Space Odyssey* series, wereas *The Light of Other Days*, based on a Clarke synopsis, explored the development of wormhole technology. More recently he has worked with Terry Pratchett on *The Long Earth* and *The Long War*, the first two novels in an ongoing series that sees humankind jumping between alternate Earths.

The prolific Baxter has also written a great deal of short fiction, some of his work appearing in *Science Fiction Age*, ("Gossamer"), and *Asimov's* ("On the Orion Line" and "The Children of Time"), and anthologies such as *Phase Space* ("Huddle"). In 2006 he also published six six-word science fiction stories, among them, "The hills are alive. Really. Run!" **JW**

year-by-year ■ Book ▓ Short story

Raft

Gossamer

The Time Ships

Huddle

The Light of Other Days
❧ Stephen Baxter, Arthur C. Clarke

On the
Orion Line

The Children
of Time

The Long Earth
❧ Stephen Baxter,
Terry Pratchett

1990 1995 2000 2005 2010 2015

the children of men 1992

The Children of Men

Children of Men

A successful example of what happens when a mainstream author dabbles in science fiction, P.D. James' The Children of Men (1992) takes place in England during the early 2020s, more than two decades after human beings have become completely infertile, and science is unable to figure out why. This is a world without children, where humanity faces extinction within a few decades ... until the protagonist encounters the impossible — a pregnant woman.

Similar in tone to the eco-fable, cinema science fiction of the 1960s and 1970s, the film adaptation, Children of Men (2006), shares its central story idea with the book, but remarkably little else.

Famed for her detective novels — particularly the Adam Dalgleish mysteries — The Children of Men was James' first departure into science fiction, even if she refused to embrace the label herself. Indeed, James repeatedly denied the book was science fiction, choosing instead to describe it as a "moral fable." (Although fans would gleefully point out that the infertility scenario was used decades earlier in Brian Aldiss' 1964 novel Greybeard.) Curiously, the film's Mexican director, Alfonso Cuarón, also distanced himself from the genre description on the highly dubious grounds that the mass infertility is left unexplained and is a springboard for social comment. Cuarón added that James was happy with his film, despite his extreme liberties with her story.

James' book parallels Nevil Shute's On the Beach (1957), set in an Australia awaiting killer fallout from a war that has destroyed the rest of civilization. Both books take place in superficially "normal" near-futures, but with the end of history ticking near. Like Shute's depiction of Australia, the England of The

Children of Men seems genteel, with golf the national sport of the middle-aged majority. However, there are glimpsed horrors that lurk beneath the surface; a hellish deportation camp (picked up in the film) and "euthanasia" programs disguising the murders of the elderly — shockingly described, if not especially well rationalized. The hero, Theo, is an Oxford academic, the cousin of England's presidential ruler. The pregnant woman he meets is a pre-Raphaelite beauty, although with James Bond-like touches — she has a deformed hand and an impure past.

Cuarón's film reconceives the story as a post-9/11 nightmare, bringing to mind the brutal nuclear war film Threads (1984). This Britain is a carnival of horror. Terrorist bombings, caged refugees and drab urban squalor provide a setting where prominent characters are gunned down without warning. Theo (a morose Clive Owen) is a jaded ex-activist, blundering through the film on painful feet. The pregnant woman is a truculent African refugee (Claire-Hope Ashitey). Revealing her condition, she stands semi-nude in a barn amid lowing cattle, while Theo breathes incredulously, "Jesus Christ."

The film also stands out for its extended camera takes, recalling the chutzpah of Orson Welles' Touch of Evil (1958). An increasingly hysterical four-minute sequence in a besieged moving car was created with a giant camera rig on the car's roof — in itself almost like some kind of science fictional artifact. There are further epic real-time takes during the film's finale: cinéma-vérité fuses with Gilliam-style mad fantasy, set in a refugee camp evoking a war-torn Bosnia on the English coast, as tanks blitz buildings, before the combatants are shocked into immobility by the sight of one baby. **AO**

year-by-year ■ Book ■ Movie

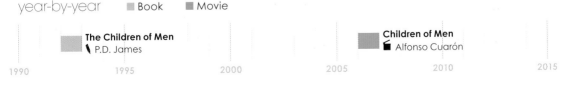

The Children of Men
❜ P.D. James

Children of Men
🎞 Alfonso Cuarón

1990 1995 2000 2005 2010 2015

j.j. abrams 1992

Forever Young Armageddon Lost Cloverfield Fringe Star Trek Super 8 Revolution

Jeffrey Jacob "J.J." Abrams is perhaps to modern Hollywood what Steven Spielberg and George Lucas were to cinema in the 1970s. A gleeful visionary willing to try anything, he rolls out film after film with breathtaking speed, and almost everything he dispatches turns to gold — be it in box-office returns or critical acclaim. Little wonder, then, that Disney/Lucasfilm entrusted him with the biggest franchise of them all, *Star Wars*. Indeed, placing Abrams at the helm of *Star Wars: Episode VII* — the man who breathed new life into *Star Trek* — seems to make perfect sense.

There is one crucial difference when comparing Abrams, Spielberg and Lucas. The man responsible for some of the biggest or most talked-about films of the past two decades (*Cloverfield*, *Star Trek*, two *Mission: Impossible* blockbusters) doesn't restrict his talents to movies. Unlike his predecessors, who have (until relatively recently) struggled to make a mark on the small screen, Abrams seems to have discovered that magical formula necessary to make a hit television series. His most famous show, ABC's *Lost*, which ran from 2004 to 2010, was once the second most popular television series in the world, beaten only by the multitudinous *CSI* franchise. And that is just for starters.

Abrams was born in New York City in 1966 into a family already entrenched in the world of television; his parents were both producers. At the age of 16 he wrote music for Don Dohler's Troma horror *NightBeast*, before focusing attention on screenwriting. His first screenplay, written with Jill Mazursky during his senior year at Sarah Lawrence College, was bought by Touchstone Pictures and used as the basis for the 1990 comedy *Taking Care Of Business*. From there, Abrams brought us the Harrison Ford vehicle *Regarding Henry* (1991), Mel Gibson in *Forever Young* (1992) and the comedy *Gone Fishin'* (1997). It wasn't, however, until 1998 that Abrams truly found his feet, working on the script for Michael Bay's *Armageddon* before launching his first TV series, the college drama *Felicity*, on the WB Television Network.

Felicity was a huge hit that ran for four seasons and later prompted *Time* magazine to include it in its "All-TIME 100 TV Shows" feature. Its cultural impact was so huge in the United States that when lead character Felicity, played by Keri Russell, cut her hair, her new look made national headlines. The show not only allowed Abrams to hone his skills behind the scenes but also heralded the creation of his own company, Bad Robot, founded with producer Bryan Burk.

year-by-year ■ Movie ■ TV series ■ Book

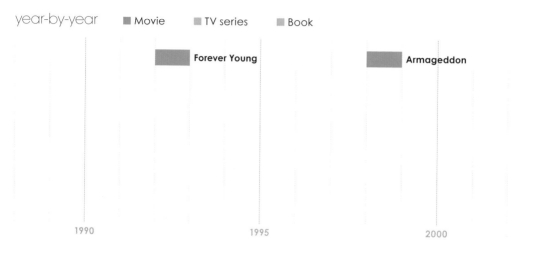

Forever Young

Armageddon

1990 1995 2000

$777 M
Armageddon
(1998)

$186 M
Cloverfield
(2008)

$422 M
Star Trek
(2009)

$271 M
Super 8
(2011)

$471 M
Star Trek Into Darkness
(2013)

Alcatraz

Star Trek: Into Darkness

Almost Human

S

Believe

Now on a roll, Abrams followed *Felicity* with the spy series *Alias*, which ran for five seasons and turned Jennifer Garner into a star. It also united Abrams with Damon Lindelof and Jeffrey Lieber, his partners on *Lost*, which launched to massive acclaim on September 22, 2004. Averaging 15.69 million viewers during its first season, *Lost* quickly became a global hit, baffling viewers with its curious story of plane crash survivors on a mysterious island. In spite of this success, Abrams still found time for his first big-budget movie project, *Mission: Impossible III* (2006). Costing $150 million to produce, it earned close to $400 million worldwide, and propelled Abrams — who had been the film's writer, director and producer — into Hollywood's major league.

In 2008 he worked as a producer on Matt Reeves' *Cloverfield*, a monster movie which followed the popular "found footage" formula of 1999's *The Blair Witch Project*. He also co-created *Fringe* for the Fox network, taking the familiar *X-Files* scenario of a fictional FBI department researching unusual events and yet creating a unique and compelling show. *Fringe* may not have managed the most impressive viewing figures, but it was hit with critics and sufficiently popular to air for five seasons.

Abrams took on his biggest challenge to date in 2009 — the reboot of the original classic *Star Trek* from the 1960s for a modern audience. A prequel that featured newly trained twentysomethings Jim Kirk (Chris Pine) and Spock (Zachary Quinto), the film won an Oscar and inspired a sequel, *Star Trek Into Darkness* (2013), that riffed on *Star Trek II: The Wrath of Khan*, cementing Abrams' ability to pay homage to classic science fiction while updating it for newcomers.

Abrams is immensely productive, often working simultaneously on several big-screen projects (*Super 8* and *Mission: Impossible — Ghost Protocol* in 2011) while developing and producing a seemingly endless succession of television shows. These include CBS series *Person of Interest*, the less-than-successful *Alcatraz*, NBC hit *Revolution*, *Believe* and *Almost Human* (with *Star Trek*'s Karl Urban in the lead role).

As if that wasn't enough, on January 25, 2013 Lucasfilm/Disney announced that Abrams would direct the upcoming *Star Wars: Episode VII*. Additionally, Abrams plans to remain involved with a third *Star Trek* movie and the continuing *Mission: Impossible* franchise.

With his small pool of collaborators, J.J. Abrams is a dominant figure in early 21st century SF cinema. **JN**

Cloverfield · Super 8

Star Trek · Star Trek: Into Darkness

Lost 📺 ABC · Revolution 📺 NBC

Fringe 📺 Fox · Almost Human 📺 Fox

Alcatraz 📺 Fox · Believe 📺 NBC

S · J.J. Abrams, Doug Dorst

2005 · 2010 · 2015

Forever Young
(1992)

Lost
(2004–10)

Cloverfield
(2008)

Fringe
(2008–13)

Star Trek
(2009)

Super 8
(2011)

Alcatraz
(2012)

**Star Trek: Into
Darkness**
(2013)

Mel Gibson (left) and Elijah Wood (right) in the science fiction romance *Forever Young* (1992).

J.J. Abram's *Lost* sees the survivors of an airline crash stranded on a mysterious deserted tropical island.

Many theories abounded as to what the island in *Lost* was and where the survivors were. The makers of the series maintained the mystery to the end.

Cloverfield is shot throughout in wobbly, faux-handheld digital video, as a group of young New Yorkers witness an attack by a giant sea monster.

Joshua Jackson stars as Peter Bishop in "An Origin Story," an episode from series five of Fox's *Fringe*.

J.J. Abrams boldly took on the *Star Trek* franchise, coming up with a prequel that focused on the emerging friendship between Jim Kirk and Spock. Surprisingly, he managed to satisfy film critics, fans of the original series as well as modern-day cinema goers.

J.J. Abrams (right) directs lead actor Kyle Chandler (left) in **Super 8** (2011). Abrams and his partner Bryan Burk produced the film in conjunction with Steven Spielberg — it was rumored to have started life as a prequel to *Cloverfield*.

Jack Sylvane (Jeffrey Pierce) is the first inmate to be tracked down by the Task Force in the pilot eposide of **Alcatraz** (2012).

The main cast of **Alcatraz** (2012). The series opened with over 10 million U.S. viewers but dropped by more than half by the time of the final episode.

Kahn is one of the great villains of the **Star Trek** franchise; he is portrayed here by British actor Benedict Cumberbatch (left).

Director J.J. Abrams (center) discusses a scene with the cast of **Star Trek: Into Darkness**.

Zoe Soldana plays Lieutenent Uhura in the new **Star Trek** movies — we discover for the first time on screen that her Christian name is Nyota.

mighty morphin power rangers 1992

Kyoryo Sentai Zyuranger

Mighty Morphin Power Rangers

Mighty Morphin Power Rangers: The Movie

Mighty Morphin Power Rangers

Turbo: A Power Rangers Movie

Power Rangers Dino Thunder

Power Rangers: Super Legends

Power Rangers Megaforce

A TV series that started life as a way of recycling footage from a different show, *Power Rangers* has become a generation-spanning, globe-conquering franchise. It began when Saban Entertainment obtained the rights to *Kyoryo Sentai Zyuranger* — a Japanese superhero show that formed part of the Super Sentai ("Battle Team") line-up from Toei — in which five color-coded heroes fought Bandora the Witch and her evil minions. Saban took the sequences of the heroes in costume and then shot fresh material featuring American actors, providing new stories to link the action scenes.

Mighty Morphin Power Rangers first appeared in 1993. When the villainous Rita Repulsa escapes from her prison on the Moon, the benevolent Zordan recruits five teenagers to become Power Rangers and to pilot the mighty mechanical Zords in battle against Rita's menagerie of giant monsters. The original five Rangers — Jason (Red), Zack (Black), Kimberly (Pink), Trini (Yellow) and Billy (Blue) — were later joined by Tommy, first as the Green Ranger, and then reintroduced as the White Ranger.

Most of the episodes were highly formulaic. The Rangers would be seen in their teenage alter-egos, going to school and generally being wholesome. Rita would unleash a new monster that the team would fight using their martial arts skills. With the monster on the verge of defeat Rita would make it grow to an enormous size, forcing the Rangers to summon their Zords, which would join together to form the giant Megazord which they would use to defeat the creature once and for all. The series introduced kids across the world to the uniquely Japanese *tokusatsu* mix of live action and special effects used on everything from *Kamen Rider* to *Godzilla*.

The show was a surprise smash, spawning a range of merchandise, including comics and video games, that has since generated over $6 billion in retail sales, as well as two popular feature films. There were, however, some concerns in the media about the amount of martial arts action in a show aimed at children. (Later incarnations of the franchise were shot in New Zealand where, ironically, the series had been banned for this very reason.) There was additional controversy in the original series where having an African-American actor playing the Black Ranger, and an Asian-American actress as the Yellow Ranger, led to suggestions of racial stereotyping.

The *Power Rangers* concept underwent the first of many reworkings in 1996, when they became *Power Rangers Zeo*. Numerous actors have since come and gone from the franchise which has seen the Rangers battling away across space and time, while the uniforms, Zords and weapons have been updated with each new permutation.

Disney took over the *Power Rangers* franchise in 2001 but the rights were bought back by Haim Saban nine years later, and licensed to Nickelodeon. **DWe**

year-by-year ■ TV series ■ Movie ■ Comic ■ Video game

Kyoryo Sentai Zyuranger
📷 TV Asahi

Mighty Morphin Power Rangers
📷 Fox Kids

Mighty Morphin Power Rangers: The Movie
🎬 Bryan Spicer

Mighty Morphin Power Rangers
▢ Marvel

Turbo: A Power Rangers Movie
🎬 Shuki Levy, David Winning

Power Rangers Dino Thunder
📷 TV Asahi

Power Rangers Megaforce
📷 Fox Kids

Power Rangers: Super Legends
🎮 Disney Interactive Studios

1985 1990 1995 2000 2005 2010 2015

doom 1993

Doom | Doom II: Hell on Earth | Final Doom | Doom 64 | Doom 3 | Doom: The Boardgame | Doom 3: Resurrection of Evil | Doom

It was in 1993 that Id Software, an independent computer game company based in Richardson, Texas, released a title that would change the face of gaming. *Doom* was an ultra-violent adventure, influenced by SF/horror movies like *Aliens* and *Evil Dead 2*, which cast the player as a space marine working for a corporate outpost performing teleportation experiments on the moons of Mars. When a portal to hell is inadvertently opened, an army of hellish monstrosities is unleashed, their aim to kill or possess everybody at the outpost. As the player — popularly known as "Doomguy" — you face a desperate fight for survival with one simple rule: kill everything, before it can kill you.

What made *Doom* such a startling leap forward was its intense, gory violence combined with a truly immersive first-person perspective. There had been earlier PC games that played with this concept, most notably the Nazi-battling *Wolfenstein*, but *Doom* achieved breakthroughs in texture-mapping, perspective and lighting, transcending the limitations of graphics of the time to create a lurid 3D world that was part space colony, part medieval fortress.

The stripped-down gameplay — players progress through the levels by collecting keycards to open doors, while killing everything in the way — made *Doom* a highly accessible game. It was also controversial, although public outcries over the violent content only served to increase the game's profile, as did Id's decision to distribute the first "episode" of the game (one-third of its total content) for free,

encouraging software sharing while further spreading the game's popularity.

Doom had a seismic effect, largely defining the "first-person shooter" subgenre and unleashing a flood of imitators. It also broke new technical ground by allowing the game to be played across the Internet. Furthermore, the game's code was accessible enough to allow the growing community of players to design their own levels and even create their own mods, customizing the game in ever more inventive ways.

New mission packs were released to expand the game, along with the sequels *Doom II: Hell on Earth* (1994) and *Final Doom* (1996). Yet while the aftershocks continued to ripple throughout the industry, the gamers moved on, Id Software's *Quake* (1996) showcasing a more convincing 3D graphics engine.

The influence of the game was still undeniable. The franchise was given a reboot with upgraded graphics in 2004's *Doom 3*. It also featured a more detailed story line, and was used as a loose framework for a film adaptation in 2005. What emerged was a mediocre *Aliens* pastiche that only managed one distinctive highlight — a first-person-perspective action sequence that briefly captured some of the game's crazed intensity.

Popular trends may have moved on, but *Doom* remains a landmark in computer gaming history, even if the long-promised *Doom 4* was revealed in 2013 to be mired in a lengthy and troubled development process with no finished product yet in sight. **SB**

year-by-year ■ Video game ■ Game ■ Movie

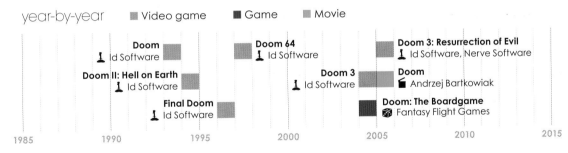

Doom
⚊ Id Software

Doom II: Hell on Earth
⚊ Id Software

Final Doom
⚊ Id Software

Doom 64
⚊ Id Software

Doom 3
⚊ Id Software

Doom 3: Resurrection of Evil
⚊ Id Software, Nerve Software

Doom
🖊 Andrzej Bartkowiak

Doom: The Boardgame
🎲 Fantasy Flight Games

1985 1990 1995 2000 2005 2010 2015

red mars 1993

Red Mars **Green Mars** **Blue Mars**

Too many young writers, Kim Stanley Robinson once noted, set out to support themselves from their scribblings, only to give up in frustration: "It's all from a mistake, the notion that you can make a living out of it by wanting it." Having begun his writing career while simultaneously working in education, Robinson "would have been content to be a teacher all along."

It would be easy to be cynical about such remarks, but that's to overlook California resident Robinson's idealism, which throughout his career has manifested itself in novels dealing with ecology and sustainability, social justice, Buddhist philosophy and alternatives to capitalism.

These themes featured prominently in his 1993 novel *Red Mars*, the first volume in a trilogy about colonizing the Red Planet. Beginning with the story of the "First Hundred," the initial group of scientist and engineer settlers, (who actually number 101), the novels charted how a Martian society might develop over two centuries of terraforming.

Rich and rewarding, the books took in, amongst other subjects, genetic engineering, what it might mean to live beyond three-score-years-and-ten thanks to longevity treatments, the malign influence of powerful transnational corporations and even whether humankind has the right to transform a wilderness planet so radically.

Red Mars and its sequels, *Green Mars* and *Blue Mars*, garnered six major awards, including two

Hugos. This was all the more remarkable considering the 1990s was a decade when cyberpunk was in its pomp, and Robinson's humanism and utopianism often seemed to put him at odds with the zeitgeist.

Away from the *Mars Trilogy*, Robinson has been published regularly since the 1980s. The *Three Californias Trilogy* imagined a trio of different futures for the Golden State. *Antarctica* reads like an Earthbound companion piece to the Mars books with its focus on technicians and idealistic explorers in an unforgiving environment. *The Years of Rice and Salt* was an alternate history that imagined 99 percent of Europeans being wiped out by the Black Death and the effect that would have had on our world.

The near-future *Science in the Capital Trilogy* was closer to home. Married to an environmental chemist, Robinson is fascinated by the interaction between researchers and the political class. The books deal with what Robinson has called "an entirely new historical moment" when "the relationship between the scientific community and the power structure is in flux" over the threat posed by global warming.

In recent times, Robinson has switched to what he called "science fantasia" for *Galileo's Dream* (2009), a novel that found the Italian polymath "looking through a telescope and falling up through it into a future time." Other recent works have included *2312*, a journey around a colonized solar system, and *Shaman: A Novel of the Ice Age*. **JW**

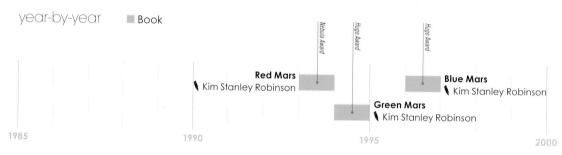

year-by-year ■ Book

Nebula Award Hugo Award Hugo Award

Red Mars
❧ Kim Stanley Robinson

Blue Mars
❧ Kim Stanley Robinson

Green Mars
❧ Kim Stanley Robinson

1985 1990 1995 2000

seaquest dsv 1993

SeaQuest
DSV/2032

SeaQuest DSV:
The Novel

The Ancient

SeaQuest DSV

SeaQuest DSV

A doomed attempt at "serious" TV science fiction, *SeaQuest DSV* arrived on U.S. television network NBC in the autumn of 1993. Conceived by Rockne S. O'Bannon (*Alien Nation*, *Farscape*), the first season of *SeaQuest DSV* stands out for taking a more realistic science approach than its genre contemporaries. The series is set in 2018, when man has exhausted the natural resources of the Earth's surface, leading to the explosion of a frontier population working on the seabed. This undersea world is monitored by the United Earth Oceans Organization (UEO) and its vast flagship submarine, the *SeaQuest*.

The signing of veteran Hollywood movie star Roy Scheider to play the submarine's commander, Captain Nathan Bridger — and that the executive producer was Steven Spielberg (via his Amblin Entertainment production company) — helped give *SeaQuest DSV* an unusually high profile at its launch.

Although the stories were essentially simple adventures beneath the waves, *SeaQuest DSV* was prepared to explore ecological and scientific issues. For added gravitas, each show concluded with respected oceanographer, Professor Robert Ballard, speaking over the closing credits, highlighting the genuine science featured in that episode.

After a strong start, ratings tailed off in the face of stiff competition from other networks. The series was dogged by production problems, cast and crew disputes, and changes in actors and tone. All of which rather overshadows some of the positive elements inherent within the concept.

The second season saw a number of major changes. To reduce costs, production was relocated from Los Angeles to Florida, and the storylines shifted the emphasis away from hard science toward science fiction. An unhappy Scheider publicly derided the new direction, dubbing the series "Star Dreck."

After a succession of "monster-of-the-week" plots, and a time-travel twist to the season finale, *Seaquest DSV* was unexpectedly given a third run. By this time, the disaffected Scheider had been released from his contract, after which he would make only the occasional guest appearance. Set 14 years into the future, the show was retitled *SeaQuest 2032* and featured a new commander, Captain Oliver Hudson (Michael Ironside). With a darker backdrop of politics and conflict punctuating the plots, it was deemed by most to be a big improvement on the previous season. Ratings, however, continued to dive and NBC announced its cancellation at the end of 1995.

Strangely, for a series viewed widely as a failure, *SeaQuest DSV* generated large amounts of spin-off merchandise, including novels, a video game and a comic book. **MW**

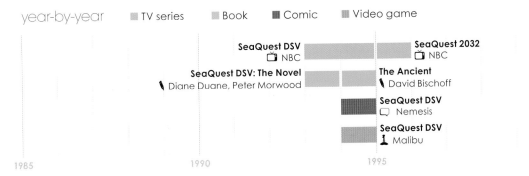

year-by-year ▮ TV series ▮ Book ▮ Comic ▮ Video game

SeaQuest DSV
📺 NBC

SeaQuest 2032
📺 NBC

SeaQuest DSV: The Novel
🖊 Diane Duane, Peter Morwood

The Ancient
🖊 David Bischoff

SeaQuest DSV
🗨 Nemesis

SeaQuest DSV
⌘ Malibu

1985 1990 1995 2000

the x-files 1993

The X-Files The X-Files The X-Files The X-Files The X-Files The Lone Gunmen

In hindsight, the success of *The X-Files* seems obvious, but at the time it was anything but a sure thing. Writer Chris Carter had moved into television after 13 years working for *Surfing Magazine*. After a time at Disney, he joined the Fox network to pitch new shows. One of these was *The X-Files* — a paranormal thriller about two FBI agents seeking out the truth, inspired by the success of past shows such as *The Twilight Zone, Alfred Hitchcock Presents* and *Kolchak The Night Stalker*. It took two pitches, but the show was picked up and filming began in Vancouver.

The X-Files immediately felt unlike any of its influences. Where other paranormal shows could be camp, winky affairs, *The X-Files* took its cases seriously.The first season began airing in September 1993, and word about this quirky new show soon spread. Key to its appeal was the canny casting of its two protagonists, Fox Mulder (David Duchovny) and Dana Scully (Gillian Anderson). Young, attractive and with an instant chemistry and simmering sexual tension, Mulder and Scully became pop icons overnight. In an inversion of gender stereotypes, Mulder was a firm believer in the paranormal, while Scully was a skeptic.

From the off, there were two strands of *X-Files*: the self-contained mysteries, or monster-of-the-week stories, and the "mythology" episodes. The latter concerned U.F.O.s, aliens and a labyrinthine conspiracy that reached right to the heart of the U.S. government. Originally, some of the cases Mulder and Scully investigated were intended to have been exposed as fakes, but this idea was swiftly dropped.

By the end of 1995 *The X-Files* was a worldwide hit, and the first waves of merchandise (including some terrible spin-off novels and an initially impressive comic) were starting to appear. Season two built on these foundations, with the show becoming glossier and more confident.

The next three seasons saw *The X-Files* in its prime, with ratings soaring. The show was wild — as comfortable telling old-fashioned horror stories as it was experimenting with episodes such as "Musings of A Cigarette Smoking Man." Carter's next show, *Millennium*, was launched in 1997 — a supernatural serial killer thriller with tangential links to *The X-Files*.

The show ruled the airwaves. However, doubts were creeping in about the increasingly convoluted conspiracy plotline. Having moved so quickly in its first

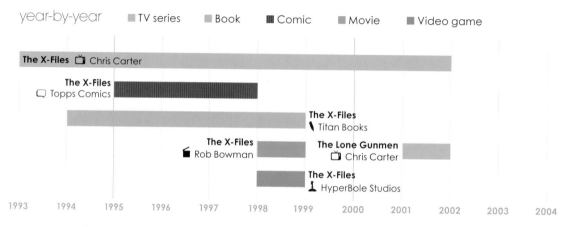

year-by-year ■ TV series ■ Book ■ Comic ■ Movie ■ Video game

$271 M
The X-Files
(1998)

$74M
The X-Files:
I Want to Believe
(2008)

The X-Files:
Resist or Serve

The X-Files:
I Want to Believe

The X-Files
Season 10

few years, and with the alien mystery all but explained, the production team added countless additional layers. It kept the arc alive, but it was becoming alienating to both casual viewers and to fans.

With the show at its commercial peak, the next step was to go to the movies. *The X-Files* (sometimes known as *Fight The Future*) was the first film to be based on the show. The story works as both a continuation of the conspiracy arc and a more-or-less standalone thriller, and was a reasonable hit.

Season six was a time of change. After filming in Canada, the series moved to Los Angeles. The tone of the series shifted too, with more comic elements. Quality control slipped and — with a new generation of smart, witty and emotionally charged supernatural shows such as *Buffy the Vampire Slayer* winning over critics and fans — it was starting to look old-fashioned. On top of this, an unhappy Duchovny filed a successful lawsuit against Fox for cheating him out of some of his earnings. His relationship with Carter, who Duchovny alleged had been complicit in Fox's actions, suffered.

The show's last two years saw the introduction of new agents, John Doggett (Robert Patrick) and

Monica Reyes (Annabeth Gish), while Scully searched for the now missing Mulder. Despite the usual pitfalls associated with replacing a beloved cast member, Doggett and Reyes proved to be a creative shot in the arm for the series, which started to feel fresh again.

Chris Carter nearly left at this point, but made a last minute decision to stay on. A spin-off series about the popular Lone Gunmen characters was launched, but lasted a meager 13 episodes. With the conspiracy (mostly) resolved, a new storyline about "super-soldiers" took the center stage. However, viewing figures plummeted. The series' grand finale, "The Truth," was a confusing, messy and tedious end to the series' muddled central arc.

An attempt to resurrect the show's cinematic legacy stalled with 2008's *The X-Files: I Want To Believe*. As a film it gets some things right, but it's also timid and forgettable. A third film (predicted as taking place in 2012) has, so far, failed to materialize. However, an officially sanctioned "season 10" is. Despite its flaws, time has been kind to *The X-Files*. For most of its run, it had a fearsomely high level of creativity, and the vast majority of the episodes remain satisfyingly spooky viewing. **WS**

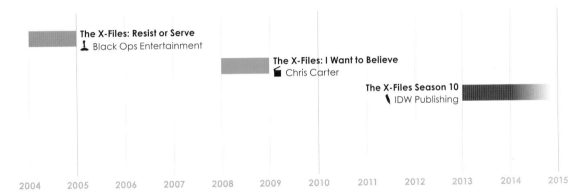

The X-Files: Resist or Serve
Black Ops Entertainment

The X-Files: I Want to Believe
Chris Carter

The X-Files Season 10
IDW Publishing

2004 2005 2006 2007 2008 2009 2010 2011 2012 2013 2014 2015

the x-files universe

Dana Scully **Monica Reyes** **Fox Mulder** **Alex Krycek** **John Doggett**

Fox Mulder is an FBI Special Agent haunted by his sister's disappearance, which he believes was the work of aliens. He is assigned to the Bureau's "X-Files" — cases dealing with the paranormal, UFOs and conspiracies — and partnered with skeptic Dana Scully.

Through their investigations, Mulder makes contact with the informant "Deep Throat." He tells Mulder that the U.S. government is aware of the existence of aliens and there is a conspiracy to keep the truth from the population. When Mulder discovers a human cloning experiment involving an alien virus, Deep Throat is killed, the X-Files closed and Mulder and Scully reassigned.

Mulder continues to unofficially investigate the paranormal and is assigned a new partner, Alex

Krycek. But when Scully is kidnapped and apparently handed over to the aliens, Krycek is exposed as working for the conspirators and the X-Files are reopened.

Scully is later found, with no memory of her ordeal and a microchip implanted under her skin, which she has removed. Shortly after, Mulder's sister Samantha returns and is revealed to be a clone created as part of a scheme to develop an alien/human hybrid.

Later, the agents encounter a strange black oil that appears to infect and control people. Mulder travels to Russia to investigate this "Black Cancer," while Scully discovers that she has developed cancer as a result of having her chip removed. She has another one implanted and is eventually cured.

characters

- Dana Scully
- Alex Krycek
- Monica Reyes
- John Doggett
- Fox Mulder

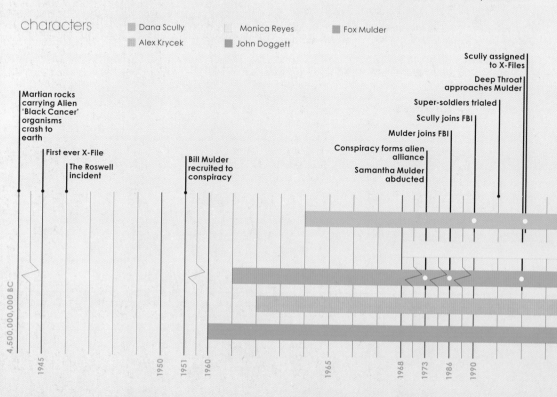

Scully assigned to X-Files

Deep Throat approaches Mulder

Super-soldiers trialed

Scully joins FBI

Mulder joins FBI

Conspiracy forms alien alliance

Samantha Mulder abducted

Martian rocks carrying Alien 'Black Cancer' organisms crash to earth

First ever X-File

The Roswell incident

Bill Mulder recruited to conspiracy

4,500,000,000 BC

1945 1950 1951 1960 1965 1968 1973 1986 1990

The agents then learn of a new type of oil that gestates an alien creature within a human. It transpires that the conspiracy has been negotiating with the aliens over their planned colonization of the Earth, while secretly working against them. Opposing both the aliens and the humans, alien rebels begin assassinating everyone involved in the conspiracy.

Mulder eventually uncovers the truth about his sister's disappearance, but is abducted while investigating a case. Scully joins forces with agent John Doggett to search for him and they find his corpse. However, an alien virus is keeping him alive and he is soon cured. He returns to work unofficially, but is fired soon after.

The agents — reluctantly working with Krycek again — discover that alien "Super-Soldiers" are being used to replace high-ranking people within the government and FBI as part of their invasion plan. The duplicitous Krycek is eventually killed.

Mulder goes into hiding and Scully is re-assigned, while Doggett and agent Monica Reyes continue to investigate the X-Files. Mulder is caught breaking into a government facility and put on trial, before escaping. Mulder and Scully go on the run knowing that the aliens have set a date for colonization: December 22, 2012.

In 2008 the FBI call off their manhunt for Mulder in return for his help on a case. Mulder and Scully can get on with their lives, but the threat of invasion lingers … **WS**

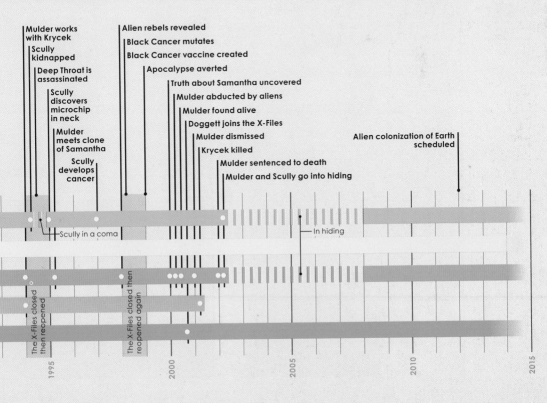

Mulder works with Krycek
Scully kidnapped
Deep Throat is assassinated
Scully discovers microchip in neck
Mulder meets clone of Samantha
Scully develops cancer

Alien rebels revealed
Black Cancer mutates
Black Cancer vaccine created
Apocalypse averted
Truth about Samantha uncovered
Mulder abducted by aliens
Mulder found alive
Doggett joins the X-Files
Mulder dismissed
Krycek killed
Mulder sentenced to death
Mulder and Scully go into hiding

Alien colonization of Earth scheduled

Scully in a coma

In hiding

The X-Files closed then reopened

The X-Files closed then reopened again

1995

2000

2005

2010

2015

The X-Files
(1993–2002)

The X-Files
(1998)

The Lone Gunmen
(2001)

**The X-Files: Resist
or Serve**
(2004)

**The X-Files: I Want
to Believe**
(2008)

An early publicity shot of David Duchovny and Gillian Anderson for *The X-Files* television series.

When pitching the idea for the *The X-Files*, Chris Carter told Fox executives: "There's nothing scary on network television any more. Let's do a scary show."

(L–R) FBI agents Brad D. Follmer (Cary Elwes), Alvin Kersh (James Pickens Jr.), Walter Skinner (Mitch Pileggi), Monica Reyes (Annabeth Gish), John Doggett (Robert Patrick) and Dana Scully (Gillian Anderson).

Dana Scully (Gillian Anderson) in *The X-Files* movie, in which she and Mulder investigated the conspiracy surrounding the alien attempt to colonize Earth.

The first movie received mixed reviews. Although it had a standalone story from the TV show, many critics found the plot confusing.

Zuleikha Robinson as Yves Adele Harlow in *The Lone Gunmen*, the short-lived spin-off series.

Released three years after the end of the TV series, *The X-Files: Resist or Serve* was set during the show's seventh season.

In *The X-Files: I Want to Believe*, Fox Mulder (David Duchovny) comes out of hiding to help the FBI investigate a case.

The X-Files: I Want to Believe had a self-contained story, rather than focusing on the conspiracy arc as the first film did.

Billy Connolly plays a former priest who claims that God is sending him visions of crimes in *The X-Files: I Want to Believe*.

babylon 5 1993

Babylon 5: The Gathering

Babylon 5

Babylon 5

Voices

Babylon 5 Wars

In the Beginning

Babylon 5 was a model of serialized storytelling and a watershed in genre broadcasting.

The title refers to a 5-mile (8-km) long commercial and diplomatic space station hub in neutral deep space, run by Commander Jeffrey Sinclair. Created in the 23rd century to foster peaceful relations between alien races, it eventually forms the base for an alliance in an ancient war between the secretive Vorlons and the evil Shadows.

Writer Joseph Michael Straczynski — frustrated by what he saw as the stagnation of TV science fiction — developed *Babylon 5* in 1987 as a dystopian vision of the future with a single, over-arching story. He produced a "bible" that charted the whole plot and provided stories for each character and various "trap doors" that gave an insurance policy against actors moving on. He found this hard to sell at a time when most U.S. TV series were comprised of standalone episodes with very little carryover from one installment to the next. The first two-hour pilot did not air until 1993, but its success led to five seasons between 1994 and 1998. Straczynski wrote 92 of the 110 episodes.

The series began at the same time as *Star Trek: Deep Space Nine*. Comparisons between the two were inevitable, but the similarities were superficial — *Babylon 5*'s ensemble was larger, its backdrop wider and it gave greater prominence to alien characters. Whereas *Star Trek* still relied on scale models, *Babylon 5* was the first show to ditch them completely — instead using CGI to create space scenes with, first, Foundation Imaging and then Netter Digital. Straczynski was also an early user of the internet to talk to fans — a practice that has since become *de rigueur* for SF makers.

The first series consisted mainly of stand-alone episodes, but each of them was littered with hints of things to come. Most of the preformances were workmanlike rather than outstanding, although the relationship between Peter Jurasik's Centauri ambassador Londo Molari and the Narn ambassador G'Kar, played by Andreas Katsulas, was complex and nuanced and underpinned the emotional narrative throughout each season, reaching the heights of tragedy in the season two episode "The Coming of the Shadows."

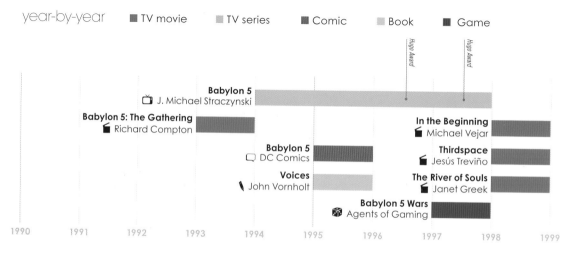

year-by-year ■ TV movie ■ TV series ■ Comic ■ Book ■ Game

Babylon 5
J. Michael Straczynski

Babylon 5: The Gathering
Richard Compton

Babylon 5
DC Comics

Voices
John Vornholt

Babylon 5 Wars
Agents of Gaming

In the Beginning
Michael Vejar

Thirdspace
Jesús Treviño

The River of Souls
Janet Greek

Hugo Award Hugo Award

1990 1991 1992 1993 1994 1995 1996 1997 1998 1999

Thirdspace

The River of Souls

Crusade

A Call to Arms

The Legend of the Rangers: To Live and Die in Starlight

The Lost Tales

By the third season in 1995, Straczynski began to bring the early plot threads together as the Shadow War begins. The love story between Commander Sheridan, played by Bruce Boxleitner, and the Minbari ambassador Delenn, played by Mira Furlan, had also taken on galactic significance as the former's role as pseudo-messiah came to the fore.

Babylon 5 was always intended to run over five seasons, but its finances were never secure. When Warner Brothers refused to be drawn on future funding, Straczynski moved chunks of the story into two TV movies and crammed much of the fifth season's planned storyline into season four, making the product seem rushed. Consequently, when TNT stepped in to save the series, the final episodes lacked narrative drive and the denouement was disappointing.

Although Straczynski was unable to avoid all the SF clichés he had sought to escape, and always had a tendency toward mawkish grandstanding, his writing achievement is still impressive and the slew of awards, including Emmys and Hugos, bear witness to Babylon 5's innovation and influence.

Unfortunately, the novels and comics that appeared as spin-offs during the original TV run failed to capture the public imagination and sold poorly. Three television movies broadcast in 1998 — In the Beginning, Thirdspace and River of Souls — also underperformed. A fourth, A Call to Arms (1999), formed the prologue to Crusade. This spin-off series, set after the events of season five, attracted so few viewers that it was cancelled barely halfway through its first season.

Straczynski has since attempted several times to reinvigorate the franchise. Among his efforts have been another TV movie for The Sci-Fi Channel in 2002, a proposed movie for theatrical release entitled "The Memory of Shadows" in 2005 that fell through, and the direct-to-DVD Lost Tales series in 2007.

Babylon 5 showed that SF could appeal to a mature audience. For all its faults, it helped rejuvenate a stagnant genre, and paved the way for shows such as Lost, Firefly and the Battlestar Galactica reboot. It also added impetus to the revival of long-form narrative, serialized television. **MMo**

■ Movie

Crusade
J. Michael Straczynski

A Call to Arms
Mike Vejar

The Legend of the Rangers: To Live and Die in Starlight
Michael Vejar

The Lost Tales
J. Michael Straczynski

1999 2000 2001 2002 2003 2004 2005 2006 2007 2008

babylon 5 universe

Delenn **G'Kar** **Londo Mollari** **John Sheridan**

Created to promote peaceful interstellar relations following the Earth–Minbari War, the Babylon station was to be built in neutral space. The first three stations were sabotaged and Babylon 4 disappeared without a trace. The fifth, however, was successfully completed.

Earth President Luis Santiago is assassinated amid rising tensions and rebellion on Mars. Ten years after the sudden surrender of the Minbari forces on the eve of victory against Earth, Babylon 5's commander Jeffrey Sinclair discovers that he himself is the reincarnated soul of Valen, one of the greatest Minbari leaders. Babylon 4 suddenly reappears.

Minbari ambassador Delenn is transformed into a Minbari-human hybrid. The Narn attack their former oppressors, the Centauri, but the mysterious Mr. Morden arrives on Babylon 5 and brokers an agreement with Centauri Ambassador Londo Mollari.

Captain John Sheridan takes command of Babylon 5 as William Clark becomes President of Earth Alliance.

Clark — who was involved in Santiago's death and runs Nightwatch, a group that weeds out traitors in Earth colonies — heads an authoritarian regime.

Babylon 5 becomes a refuge for human telepaths from the malevolent Psi Corps. Narn ambassador G'Kar discovers that an ancient enemy, the Shadows, may be returning. Londo has unknowingly formed an alliance with them through Morden. When the Centauri Emperor dies, his insane nephew, Cartagia, succeeds him and bombs the Narn into submission. Having emerged from her chrysalis, Delenn begins a courtship with Sheridan, who learns what happened to his wife on an expedition to the Shadow homeworld of Z'ha'dum, as well as about war between the Shadows and the Vorlons. While saving Sheridan's life, Vorlon ambassador Kosh enlists the aid of Babylon 5 in the struggle against the Shadows.

With the help of the Psi Corps and recovered Shadow technology, Clark declares martial law.

characters

■ Delenn ▪ G'Kar ▪ Londo Mollari ■ John Sheridan

Sheridan learns of the Shadows

Centauri smuggling ring exposed

Narn-Centauri war

Cartagia Centauri Emperor

Londo meets with Morden

Sheridan takes command

Babylon program begins

Delenn declines leadership of Minbari Grey Council

Delenn begins transformation

Earth Minbari War

Babylon 4 vanishes

Babylon 5 online

Mars Colony revolt

Narn Base destroyed by Shadows

President Santiago killed

2245 2250 2254 2256 2058 JUNE JULY DEC 2259 JAN APR SEP

Babylon 5 declares independence and defeats an attempt by Earth to retake it with the help of the Minbari. G'Kar and Sheridan rid the station of Nightwatch and the Narn take control of security. As Morden and the Shadows tighten their grip on the Centauri, war breaks out between the Shadows and the Interstellar Alliance. Kosh is assassinated after an attack on the Shadows. Sinclair returns to find Babylon 4 and takes it 1,000 years into the past as a base in the first Minbari–Shadow war. Having undergone the same metamorphosis as Delenn, he is revealed to actually be Valen, rather than a reincarnation.

Sheridan's wife, presumed dead, appears. In thrall to the Shadows, she takes Sheridan to Z'ha'dum but he crashes his ship into their city and jumps into a deep pit to his apparent death. During a fight with Shadow vessels, Babylon 5's security chief Garibaldi goes missing and, in a secret facility on Mars, he is conditioned by the Psi Corps to spy for them.

The Vorlons attack Shadow planets. Londo has Cartagia killed. The Alliance recruits the "First Ones" to combat the Shadows and the Vorlons. Sheridan returns to the station from Z'ha'dum. The Vorlons, the Shadows and the First Ones depart the galaxy.

Minbar is gripped by civil war between the Warrior and Religious castes, which is ended by Delenn.

The Shadows are defeated, and Garibaldi goes to work on Mars. He betrays Sheridan but is then freed from Psi Corps control and helps Sheridan escape. Clark is ousted and commits suicide. Sheridan becomes president of an Interstellar Alliance.

The Drakh manipulate the Centauri into igniting a war against the Alliance. Londo becomes Emperor but remains under Drakh control. He is killed by G'Kar. Nineteen years later, following a war between the telepaths and the Psi Corps, the First Ones return to take Sheridan on a journey beyond the end of the galaxy as Babylon 5 is finally destroyed. **MMo**

Lyta Alexander returns
Winter exposed as spy

Narn surrender to Centauri
Sheridan saved by Kosh

Nightwatch attempt to take over Babylon 5

Babylon 5 declares independence

Morden kills Kosh | Babylon 4 stolen

End of the Shadow War

Assassination of Cartagia
Londo Prime Minister

Sheridan returns from the dead

Sheridan destroys city on Z'ha'dum

Sheridan's fleet arrives at Earth
President Clark commits suicide

Delenn announces Interstellar Alliance

Sheridan and Delenn are married

Interstellar Alliance declares war on the Centauri Republic

The Centauri surrender
Londo made Emperor

Babylon 5 destroyed

Sheridan begins to die

Londo and G'Kar kill each other

NOV | DEC | 2260 APRIL | AUG | DEC | 2061 JAN | NOV | JULY | 2278 | 2281

Babylon 5
(1994–98)

The fictional Babylon 5 is set in Epsilon Eridani, 10 light years away from Earth and our closest neighboring planetary system.

Chief of Security Michael Garibaldi was played by Jerry Doyle.

CONFIDENCE 95.9/23

Claudia Christian played Susan Ivanova in the first four series of *Babylon 5*.

Delenn, before she is transformed into a Human-Minbari hybrid.

G'Kar (Andreas Katsulas) hates his former colonial masters, the Centauri.

(L–R): Londo Mollari (Peter Jurasik), Vir Cotto (Stephen Furst) and G'Kar (Andreas Katsulas).

Bruce Boxleitner played John Sheridan in series 2–5.

The Babylon 5 space station is one of the safest places in a war-torn galaxy.

stargate 1994

Stargate

Stargate

Stargate: Rebellion

Stargate

Stargate: Retaliation

Stargate SG-1

There's something irresistibly fascinating about a story that combines the ancient, enigmatic and unknowable Pyramids of Giza with alien technology so advanced that it can whisk human beings away to another planet. The concept plays upon Erich Von Daniken's theory in his controversial book *Chariots Of The Gods* — much mined by science fiction writers — that aliens helped to build human civilization. It is also a gloriously cheesy B-movie idea. Except that *Stargate* wasn't actually a B-movie. Made for $55 million in 1994, the film was a surprisingly serious adventure that depicted its ridiculous premise as a life-or-death action drama. Audiences were understandably left perplexed, even if they were fascinated by the concept.

The story sees James Spader's geeky Dr. Daniel Jackson enlisted by the U.S. Air Force to decrypt a mysterious symbol in some Ancient Egyptian ruins. Discovered alongside the ruins was a giant metal ring that no Ancient Egyptian could possibly have manufactured: clearly alien technology. With its last cartouche deciphered by Jackson, the ring soon reveals its purpose as a "Stargate" to another world. Once powered up, it opens a wormhole. A team is assembled to find out where it goes, Jackson included.

Kurt Russell played the colonel in charge of the mission to explore the desert planet the Stargate connected to. Naturally, given that the film was written by Dean Devlin and Roland Emmerich (never men to hold back their destructive urges on celluloid), things soon start exploding as battles break out between the Earthlings and the natives of the planet Abydos, led by their bizarre Egyptian-style "god," Ra (Jaye Davidson). And alas, this was *Stargate*'s main flaw: the sense of wonder at the beginning, as Dr. Jackson walked through the Stargate and arrived in the unknown world beyond, was completely let down by the square-jawed machismo of the soldiers who later turned the film into a beat-'em-up cliché.

Stargate received a mixed reception, although it did do well at the box office. Audiences loved the visuals, especially the Stargate itself: a beautiful ring with a shimmering, water-like center that produced the wormhole to connect two worlds. But Russell's stoic performance and the film's overblown ending failed to hit their marks, making *Stargate* nothing more than a brilliant idea with poor execution.

The movie was planned as a trilogy, but as Devlin and Emmerich moved on to develop *Independence Day*, this fell by the wayside. They sold the rights to

year-by-year ■ Movie ■ Video game ■ Book ■ Comic ■ TV series

Stargate
Roland Emmerich

Stargate
Acclaim

Stargate: Rebellion
Bill McCay

1990 1991 1992 1993 1994 1995 1996

Stargate:
Retribution

Stargate SG-1

Stargate:
Reconnaissance

Stargate:
Resistance

Stargate SG-1:
The First
Amendment

Stargate SG-1:
The Morpheus
Factor

M.G.M., who then did something truly unexpected and turned it into a television series. The subsequent show went on to become Guinness World Records' longest-running consecutive science fiction series of all time (note the word "consecutive" that separates it from the on-and-off run of *Doctor Who*).

Jonathan Glassner and Brad Wright, who had worked together on *The Outer Limits* for M.G.M., started developing the new series after separately approaching M.G.M. to ask to work on it. It was renamed *Stargate SG-1* to separate it from the film ("SG-1" being the name of the team of adventurers the viewers would follow during the series). The showrunners decided to use some of the characters from the movie, picking up the action one year on from the end of the film. The pilot, "Children of the Gods," helpfully went to great lengths to explain the concept for anyone who hadn't seen the film.

To replace Kurt Russell as O'Neil — now O'Neill — the showrunners chose former *MacGyver* star Richard Dean Anderson, who wisely asked if he could display more humor than Russell's version of the character. This resulted in his Colonel Jack O'Neill becoming the droll, wisecracking heart of the television show, with his quips and one-liners regularly stealing the limelight.

Alongside him, Michael Shanks was cast as Dr. Daniel Jackson: "The perfect imitation of James Spader," according to Brad Wright, although Shanks stamped his own persona on the role as the years rolled on (and his eventual non-Spader haircut, which happened between seasons two and three, seemed to change the character completely). Rounding off the SG-1 team were Amanda Tapping as Major Samantha Carter and the imposing Christopher Judge as Teal'c, an alien known as a "Jaffa" who used to serve an evil race known as the Goa'uld (of which the movie's Ra was one). Finally, there was former *Twin Peaks* star Don S. Davis playing George Hammond, the long-suffering general in charge of this troublesome team.

The show started filming in Vancouver in February 1997. The first feature-length episode aired on Showtime on July 27. This first season of 22 episodes was a mixed bag; as with many series, the writing team took a while to settle in and find the feel of their show. This led to such ill-advised episodes as "Brief Candle," in which O'Neill aged rapidly courtesy of some truly excruciating latex makeup, or "The Broca Divide," which saw the SG-1 team mutating into animalistic versions of themselves. Luckily,

Stargate: Infinity

Stargate SG-1

Stargate: Atlantis

Stargate: Atlantis — Rising

Stargate: Atlantis

Stargate: The Ark of Truth

however, things improved massively toward the end of the year. The season finale "Within The Serpent's Grasp" provided the perfect mixture of drama, action and humor as SG-1 battled to save the Earth from the Goa'uld.

Stargate SG-1 ended up airing for an extraordinary 10 seasons, from 1997 to 2007. The U.S. Air Force were so fond of it that they provided assistance on scripts, checking them for mistakes — the show had a high military content, being set at Cheyenne Mountain Air Force Base. The real-life complex received so many questions from fans about the show that they actually labeled a security door "Stargate Command."

As the series progressed, there were cast changes. Shanks left the show at the end of season five and was replaced by Corin Nemec, before returning in season seven to the delight of fans. In later seasons, Farscape's Ben Browder and Claudia Black joined the cast. Anderson reduced his role on the show after choosing to spend more time with his family (he remained an executive producer), while Davis was replaced by Beau Bridges. By the time Stargate SG-1 had reached its 200th episode, the show's momentum had slowed down enough for the plug to be pulled. The final episode aired on March 13, 2007.

In 2004 Stargate Atlantis was commissioned to run alongside SG-1. A new team, led by Torri Higginson as Dr. Elizabeth Weir, found themselves stranded in another galaxy with no clear way to get home after an attack on their base (similar to Star Trek: Voyager). Stargate Atlantis lasted a healthy five seasons, although it didn't receive quite the acclaim that its predecessor managed. The fact that its cast would leap through a Stargate and — even in this new galaxy — find themselves on a planet that looked like a Canadian forest had become a running joke.

What the show lost in dynamism it made up for with its cast, however, with David Hewlett's bickering Dr. Rodney McKay and Joe Flanigan's heroic Colonel John Sheppard providing the humor and charisma that Anderson brought to SG-1. Later additions, such as future Conan/Game Of Thrones star Jason Momoa as warrior Ronan Dex, also helped to perk things up.

Although Atlantis trundled on after SG-1's cancellation, the original team reassembled in films Stargate: The Ark of Truth and Stargate: Continuum, both released direct to DVD in 2008. They each helped to wrap up story arcs that had been intended for the show's eleventh season, and Continuum, which shot a sequence on the Arctic Ice Cap in Alaska, was

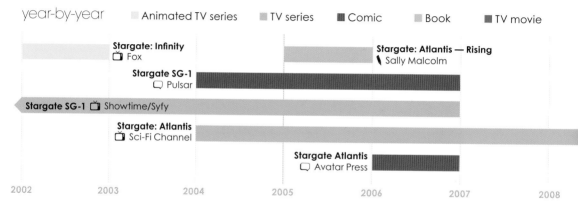

year-by-year ■ Animated TV series ■ TV series ■ Comic ■ Book ■ TV movie

Stargate: Infinity
📺 Fox

Stargate: Atlantis — Rising
📖 Sally Malcolm

Stargate SG-1
📖 Pulsar

Stargate SG-1 📺 Showtime/Syfy

Stargate: Atlantis
📺 Sci-Fi Channel

Stargate Atlantis
📖 Avatar Press

2002 2003 2004 2005 2006 2007 2008

Stargate: Continuum

Stargate SG-1: Gift of the Gods

Stargate Universe

Stargate SG-1: Unleashed

considered for a Guinness World Record for the "Most Northerly Film Shoot."

When *Atlantis* was cancelled in 2009, a last-ditch attempt to keep *Stargate* on screens resulted in the unusually bleak *Stargate Universe*, which premiered on October 2 the same year on SyFy. Heavily influenced by the new, gritty *Battlestar Galactica*, this series took a far darker approach — touching on *Star Trek: Voyager*'s themes, with a group of humans trapped billions of light years from home on a ship named *Destiny*. Created by *Stargate* stalwarts Brad Wright and Robert C. Cooper, the show's biggest star was Robert Carlyle, whose argumentative and often downright nasty character, Dr. Nicholas Rush, brought the kind of realism and tension to the *Stargate* franchise that had hitherto been missing.

During its first season *Stargate Universe* was almost a trial to watch, as characters struggled to find food, water and even keep the oxygen working on their ship. Their constant arguments and life-or-death dramas threatened to become wearing, although light relief was provided by David Blue as the *Destiny*'s resident wisecracking geek, Eli Wallace. Thankfully, as the series continued into season two, the crew's plight became a gripping, complex emotional drama that

introduced some genuinely brilliant ideas, such as the audacious "Common Descent," in which the *Destiny* team discovered a race descended from themselves, 2,000 years in the past.

Although the quality of the scripts improved, the ratings weren't high enough to appease Syfy, who seemed to be expecting a *Battlestar Galactica*-sized hit. They pulled the plug on the series and the final episode — a cruel cliffhanger — aired on May 9, 2011. When *Universe* ended, 17 seasons of *Stargate* were over, and U.S. television suddenly had no space-set shows for the first time since *Star Trek: The Next Generation* began airing in 1987.

A few *SG-1* and *Atlantis* cast members have since joined together to record some Big Finish audiobooks, but on the small screen, at least, the franchise is dead. For a while it looked as though there would be a *Stargate Atlantis* film, but with the death of *Universe*, that died too. Devlin briefly discussed making a sequel to the original movie back in 2006 and has teased fans with hints ever since, but no new *Stargate* film is forthcoming. However, after one blockbuster movie and 354 television episodes, *Stargate* has, without a doubt, staked its rightful claim as one of the biggest science fiction franchises in history. **JN**

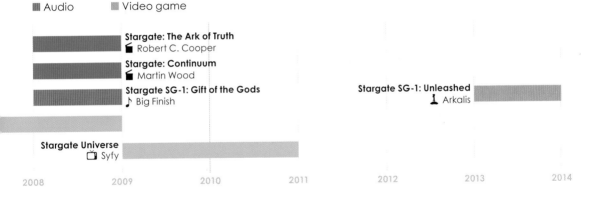

■ Audio ■ Video game

Stargate: The Ark of Truth
🎬 Robert C. Cooper

Stargate: Continuum
🎬 Martin Wood

Stargate SG-1: Gift of the Gods
♪ Big Finish

Stargate SG-1: Unleashed
👤 Arkalis

Stargate Universe
📺 Syfy

2008 2009 2010 2011 2012 2013 2014

stargate universe

Daniel Jackson **Jack O'Neill** **Teal'C** **George Hammond** **Sam Carter** **Elizabeth Weir**

In 1928 a strange, otherworldly device is discovered in Egypt: a giant metal ring carved with mysterious symbols. Fast forward to 1994 and controversial archaeologist Dr. Daniel Jackson is approached for his help with translating the symbols. The reluctant Jackson agrees and is surprised to discover that the artifact in question is being held in an underground Air Force base. His translation of the markings leads to the discovery that the giant ring is actually a technological device that connects worlds together via a wormhole.

The Air Force puts together a team, led by Colonel Jack O'Neill, to go through the Stargate. Jackson joins them as a linguist. After traveling through the gate they arrive on the planet of Abydos, where the citizens are controlled by the oppressive, god-like being known as Ra.

Ra threatens Earth using an atomic bomb the soldiers brought with them through the gate. After inciting the locals to rise up and fight their "god," O'Neill manages to get the bomb onto Ra's departing ship and explodes it. The Abydonians are free. After

falling in love with a local named Sha're, Jackson opts to stay on the planet while O'Neill returns to Earth.

One year later, the Air Force base holding the now mothballed Stargate comes under attack when the gate suddenly flares into life. An alien named Apophis, later identified as a Goa'uld — a parasitic alien that can possess its host — kidnaps a soldier and declares war on Earth. After further study it becomes apparent that the Stargate is merely one small part of a massive system of gates spread throughout the galaxy, built by a race known as the Ancients.

O'Neill contacts Jackson on Abydos and Apophis pays the planet a visit soon after. He kidnaps Jackson's wife Sha're and turns her into a Goa'uld. Jackson returns home, desperate for revenge. The U.S. military, realizing the threat from this alien race, starts a top-secret project at Stargate Command in Cheyenne Mountain, Colorado. They set up a collection of SG teams and start exploring the galaxy using the gates.

The most important team is SG-1, which comprises O'Neill, Jackson, Major Sam Carter and a former

characters

■ Daniel Jackson ■ Jack O'Neill ■ Teal'C ■ George Hammond ■ Sam Carter

Stargates built

Ra arrives on Earth

SG-1 time travel to overthrow Ra

SG-1 time travel to bury Stargate

Stargate discovered

Stargate powered up

Ra encountered

Sam Carter joins Stargate team

Stargate Program proper started

Prehistory 9,177 BC 3,000 BC 2,995 BC 1928 1942 1957 1965 1968 1970 1993 1995

Goa'uld slave named Teal'c, whose knowledge of his ex-masters is invaluable. SG-1 visit planet after planet, encountering numerous other alien races, including the Ancients themselves. After years of confrontations the Goa'uld are finally beaten back, but their threat is soon replaced by the mechanical life forms known as Replicators. Thankfully, after many skirmishes, they are finally eradicated from the galaxy by a superweapon.

Jackson discovers the Ancient city of Atlantis in the distant Pegasus Galaxy and Stargate Command sends a team led by Dr. Elizabeth Weir to explore it and establish a base. The team comes under attack from a race called the Wraith, who are just as threatening as the Goa'uld; in fact, the Wraith were the reason the Ancients abandoned the base many thousands of years before. Finding themselves cut off from Earth, the Atlantis team spends several years battling the Wraith, exploring their surroundings and forming alliances with aliens in the vicinity. Eventually managing to communicate with Earth again, the team defeat the Wraith and find their way back home.

By now there are Stargate bases across the galaxy. After the Icarus base is attacked by a group of mercenaries, the Icarus team use their Stargate to escape and land on a spaceship named *Destiny* traveling through deep, distant space. The ship was built by the Ancients and is unfit for human habitation, but the survivors have no choice but to adapt to their new surroundings. They can communicate with Stargate Command thanks to special stones that allow them to "body swap" with people back there. But they're still on their own, and although the ship is ostensibly led by the gruff Colonel Everett Young, the genius scientist Dr. Nicholas Rush constantly challenges him for power.

The last we hear of the *Destiny* is in 2011, when the crew are put into stasis to help them pass a three-year, faster-than-light journey to another Stargate. There aren't enough stasis pods for the entire crew, so Eli Wallace stays awake to watch over his friends and colleagues. The ship journeys on through empty space and as far as we know Eli still holds vigil. **JN**

■ Elizabeth Weir

Replicator attack on Earth

Atlantis presumed discovered

Elizabeth Weir placed in command

Atlantis actually discovered

George Hammond dies

Elizabeth Weir dies

Atlantis crew arrive home

Icarus base crew stranded on the *Destiny*

Destiny crew put in stasis

2000

2005

2010

Stargate
(1995)

Stargate SG-1
(1997–2007)

Stargate: Atlantis
(2004–09)

Daniel Jackson (James Spader) prepares to pass through the Stargate for the first time in the **Stargate** movie.

The Stargate is discovered in 1920s Egypt.

Jackson makes friends with the local wildlife on Abydos.

Christopher Judge as Teal'c in "Serpent's Song," an episode from season two of **Stargate SG-1**.

The Stargate springs into life at the Cheyenne Mountain military base in **SG-1**. In the original *Stargate* movie it was housed at Creek Mountain.

The Unas is a humanoid alien race that possess regenerative abilities. They first appeared in the **SG-1** episode "Thor's Hammer."

Samantha Carter (Amanda Tapping) with Thor of Asgard, whom she described upon meeting as looking like a "Roswell gray."

The Wraith Commander (Scott Heindl) launches an attack in **Stargate: Atlantis**.

neon genesis evangelion 1995

Neon Genesis
Evangelion

Neon Genesis
Evangelion

Evangelion:
Death and
Rebirth

The End of
Evangelion

Neon Genesis
Evangelion

Neon Genesis
Evangelion:
Angelic Days

In the early 1990s Japanese animation studio Gainax faced a problem. Their movie *Royal Space Force: The Wings of Honnêamise* (1987) had been a critical and commercial success, but despite its reception and the moderate success of other projects, the studio was struggling to find its place. Founded by a small group of fans and animators, it lacked the financial weight and standing to get its proposed *Royal Space Force* sequel into production, leaving director and animator Hideaki Anno without a project. Anno instead agreed to a collaboration with Japanese music and TV publisher King Records, who promised to find him a time slot for a 26-part series. Borrowing themes from the aborted *Honnêamise* sequel and taking motifs from his favorite anime series, he created *Neon Genesis Evangelion* (Japanese title: *Shin Seiki Evangerion*, literally "Gospel of a New Century").

Neon Genesis Evangelion's story is one of a truly cataclysmic global scale, but told from a series of small, personal perspectives. In the year 2000 the Earth is hit by what becomes known as "The Second Impact," believed by the general public to be a large meteor strike, which destroys Antarctica and triggers a globally devastating chain of tsunamis, floods and earthquakes, leading to political instability and economic chaos. As the world starts to rebuild itself the mysterious organization NERV rises to prominence.

Fifteen years later Shinji Ikari — the show's 14-year-old protagonist — arrives in Tokyo-3, a heavily fortified city built by NERV, which is attacked by a terrifying creature known as an Angel. As conventional military forces try to hold it back, Shinji is taken by Misato Katsuragi to NERV HQ, where he is met by his cold and distant father, Gendo Ikari, whom he has not seen for years. Gendo orders Shinji to pilot Eva Unit-01, a giant biomechanical robot built to defend Earth from the Angels. Shinji initially refuses, but is coerced into taking the controls and defeats the rampaging Angel. The rest of the series follows Shinji and his fellow teenage pilots Rei Ayanami and Asuka Langley Soryu as they attempt to hold off the powerful Angels while dealing with their own emotional issues and working out what exactly NERV's plans are for the human race.

year-by-year ■ Manga ■ Animated TV series ■ Animated movie ■ Video game

Neon Genesis Evangelion
▢ Kadokawa Shoten

Neon Genesis Evangelion
▢ TV Tokyo, Animax

Neon Genesis Evangelion
♟ Bandai

Evangelion: Death and Rebirth
🎞 Hideaki Anno, Masayuki, Kazuya Tsurumaki

The End of Evangelion
🎞 Kazuya Tsurumaki, Hideaki Anno

1990 1995 2000

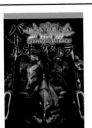

Neon Genesis Evangelion: The Shinji Ikari Raising Project

Evangelion: 1.0 You Are (Not) Alone

Neon Genesis Evangelion: Battle Orchestra

Neon Genesis Evangelion: Campus Apocalypse

Evangelion: 2.0 You Can (Not) Advance

Evangelion: 3.0 You Can (Not) Redo

Neon Genesis Evangelion was unique at the time for its combination of high school relationship drama, philosophical questions and exciting battles between giant robots and the bizarre and terrifying Angels. The character of Shinji split opinion between fans, with some finding his reluctance to fight infuriating and others relating instantly to his angst-ridden persona. It was Shinji's reluctance and continuous doubt that made Neon Genesis Evangelion unique. Although earlier shows like Mobile Suit Gundam (1979) had touched on the issue, Neon Genesis Evangelion never shied away from questioning whether children would actually want to risk their lives, and whether it was morally right for them to be made to do so.

Although popular, Neon Genesis Evangelion faced its fair share of production issues. Lack of money, tough deadlines and attempts at censorship from the TV network meant that episodes were frequently rushed. The result was a shift in tone from episode 16 onwards, as Anno felt the need to concentrate more on the overall story and less on individual characters. Things came to a head in the

final two episodes, when Anno realized he could not create the ending he had envisioned and instead was forced to deliver a chaotic finale that confused and angered many of the show's fans. Luckily, this was not to be the end of the story. Following the show's success he was allowed to re-animate and re-edit the final four episodes into two feature-length films, Death and Rebirth (1997) and The End of Evangelion (1997).

However, Gainax was now presented with a fresh problem. The franchise had become massively popular, spawning numerous manga spin offs and thousands of toys, but the nature of the finale meant that there was no chance of a sequel. The answer was, of course, to tell the whole story again. In 2006 Evangelion: 1.0 You Are (Not) Alone was released, the first in a series of high budget feature films. Although this first installment stayed faithful to the original story, the second and third installments — Evangelion: 2.0 You Can (Not) Advance (2009) and Evangelion: 3.0 You Can (Not) Redo (2013) — started to radically change the plot, hinting at yet another re-telling of the story's finale for the fourth and final movie. **TM**

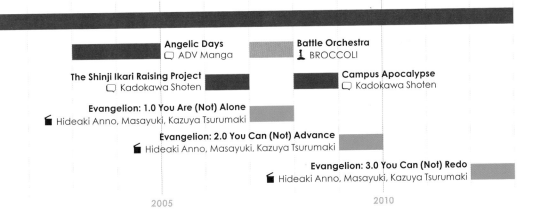

Angelic Days
ADV Manga

Battle Orchestra
BROCCOLI

The Shinji Ikari Raising Project
Kadokawa Shoten

Campus Apocalypse
Kadokawa Shoten

Evangelion: 1.0 You Are (Not) Alone
Hideaki Anno, Masayuki, Kazuya Tsurumaki

Evangelion: 2.0 You Can (Not) Advance
Hideaki Anno, Masayuki, Kazuya Tsurumaki

Evangelion: 3.0 You Can (Not) Redo
Hideaki Anno, Masayuki, Kazuya Tsurumaki

2005

2010

joss whedon 1995

Waterworld — Alien Resurrection — Titan AE — X-Men — Atlantis: The Lost Empire — Fray — Firefly — Astonishing X-Men

"I kept telling my mom that reading comic books would pay off," Joss Whedon told *The Guardian* newspaper after *Marvel's The Avengers* had become the third biggest-grossing movie of all time. It's a quintessential Whedon quote; witty, self-effacing and fanboyish. He is the geek who inherited the Earth, then demanded that the Earth have a big, super-powered party.

Both Whedon's father, Tom, and grandfather, John, were TV comedy scriptwriters. He was slightly embarrassed by the kind of shows his dad wrote (such as *The Golden Girls*). "I think my father's best work was probably done at our dinner table," he once said. "I loved just being around someone who was that funny."

He grew up in New York with two older brothers who were "bigger and meaner," escaping into the world of comic books. His parents had divorced by the time he was 10 and his mother reared him on a diet of British TV shows such as *Monty Python's Flying Circus*. His anglicization continued when his mother, a history teacher, moved to Britain for two years, and Whedon attended Winchester College.

His father, meanwhile, remarried and Joss' two half-brothers would both grow up to be serial collaborators of his: Jed Whedon co-wrote *Doctor Horrible's Sing-Along Blog* and was a writer/producer on *Marvel's Agents of S.H.I.E.L.D.*, while Zack also helped out on *Doctor Horrible* and has written some *Serenity* comics.

Joss Whedon began his writing career, ironically, on exactly the type of show his father used to write: *Roseanne*. He found the experience a mind-numbing grind, detesting the fact that his words were often changed out of all recognition. His first movie experience was even worse when an unsympathetic director misunderstood the inherent irony of *Buffy the Vampire Slayer* and created a vapid turkey. This was followed by a period as a successful (though largely uncredited) script doctor on films such as *Speed* and — his first foray in science fiction — *Waterworld*. Whedon was also one of an army of writers on *Toy Story*: "I think we wrote a gag each," he joked. His big break came when Warner Bros finally allowed him to do *Buffy* his way, on television. "As far as I am concerned," he told *Entertainment Weekly*, "the first episode of *Buffy* was the beginning of my career. It was the first time I told a story from start to finish the way I wanted."

Although *Buffy* was primarily a fantasy, the series did feature some science fiction elements. These included a cyborg soldier, an alien and a robot double — the Buffybot.

The success of *Buffy* gained Whedon further offers of movie work, and *Alien Resurrection* (1997) was his first full-on science fiction work. Sadly it was an inauspicious debut in the genre. Once again the director — in this case French weirdmeister Jean-Pierre Jeunet — had a different vision from the writer, and the film was an unsatisfying mishmash of whimsy

year-by-year ■ Movie ■ TV series ■ Comic ■ Online

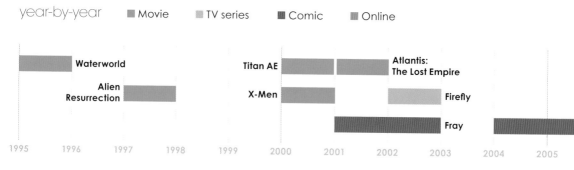

$69.6M
Alien Resurrection
(1997)

$30.5M
Serenity
(2005)

$1.51B
Marvel's The Avengers
(2012)

Serenity

Serenity:
Those Left
Behind

Dr. Horrible's
Sing Along
Blog

Dollhouse

Marvel's
The Avengers

Agents of
S.H.I.E.L.D.

and horror, although a scene featuring a cloned Ripley torching a room full of her predecessors is a highlight that is classic Whedon.

On TV, however, the cult hits flowed: *Firefly*, *Dollhouse* and *Buffy* spinoff *Angel*. All were loved intensely if not widely (the ax never seemed far from a Whedon show). Empowered female characters abounded; Whedon says that people who want to know why should meet his mother. *Firefly* was Whedon's spaceship show, but avoided the military emphasis that normally characterizes the genre, instead taking its cue from Westerns, with a crew of opportunist frontiersmen and women. Although it was cancelled tragically early, fan support helped secure a movie coda — *Serenity*, which, like Whedon's TV shows, was adored by fans and critics, who didn't, unfortunately, mass up to a particularly large audience.

Dollhouse was met with less enthusiasm, possibly because its central concept — operatives who are given new personalities each week — disguised a complex, constantly-evolving back plot of betrayal and intrigue that made it easy for casual viewers to miss the point.

The TV shows also gave Whedon the opportunity to flex his directing muscles and even indulge his music-writing abilities. Yes, he's a talented musician too, writing all the songs in the *Buffy* episode "Once More, With Feeling" and the *Dr. Horrible's Sing-Along Blog* web series about an aspiring supervillain. He

even managed to find the time to fit in some comic book scripting — a run on *Astonishing X-Men* is particularly well regarded, although he acquired a dubious reputation for missing deadlines.

Not that that stopped Marvel from giving him *The Avengers* movie to play with — both as writer and director — elevating Whedon to a whole new level of acclaim. The movie grossed $1.51 billion worldwide, and became the third-highest-grossing film of all time. The spin-off TV series he created, *Marvel's Agents of S.H.I.E.L.D.*, initially had a more lukewarm reception, partly for its lack of superhero action, but opinion began to swing back in its favor as the first season progressed.

Whedon is married to architect Kai Cole who designed their Mediterranean-style Santa Monica home to include an amphitheater where, since the late 1990s, Whedon has hosted impromptu Sunday afternoon gatherings of cast members from his shows to perform Shakespeare plays. The house ended up starring in Whedon's own theatrically released movie version of *Much Ado About Nothing* (2012).

Whedon productions might be crowd-pleasers but they are also quietly intelligent and slyly subversive. He says: "I hate it when people talk about *Buffy* as being campy. I hate camp. I don't enjoy dumb TV." And then in a swipe at the producer of such shows as *Charlie's Angels* and *Beverly Hills 90210*, he adds: "I believe Aaron Spelling has single-handedly lowered SAT scores." **DG**

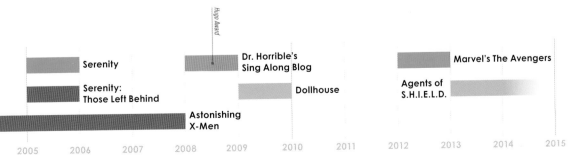

Waterworld
(1995)

Alien Resurrection
(1997)

Titan AE
(2000)

Firefly
(2002)

Dollhouse
(2009–10)

**Marvel's The
Avengers** (2012)

**Agents of
S.H.I.E.L.D.**
(2013–present)

A scene from **Waterworld**, the script of which was honed by Whedon.

Kevin Costner in **Waterworld**.

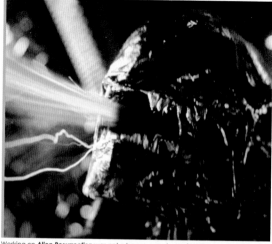

Working on **Alien Resurrection** was not a happy experience for Whedon. He later said of his time on the film: "[It] was, I thought, the lowest I could ever feel."

A frame from **Titan AE**, the animated post-apocalyptic science fiction adventure film co-written by Joss Whedon.

In **Alien Resurrection**, Sigourney Weaver plays a clone of Ellen Ripley, her character from the previous three *Alien* movies.

Nathan Fillion (L) and Adam Baldwin were among **Firefly**'s nine ever-presents.

Firefly stalwarts (L–R) Adam Baldwin, Alan Tudyk, Nathan Fillion and Gina Torres.

Eliza Dushku in **Dollhouse**.

(L–R) Black Widow, Thor, Captain America, Hawkeye, Iron Man and The Hulk in Marvel's **The Avengers**.

Joss Whedon regarded Mark Ruffalo's portrayal of The Hulk as definitive.

Chloe Bennet (L) and J. August Richards as two of Marvel's **Agents of S.H.I.E.L.D.**

sliders 1995

Sliders Sliders

Parallel universes have been a part of the fantasy arena since early myth, and have cropped up on U.S. television since the 1960s — the 1967 *Star Trek* episode "Mirror, Mirror" is a notable example. However, they have never been as widespread as they became during the 1990s' science fiction/fantasy TV revival, spearheaded by such shows as *Buffy the Vampire Slayer*. Eventually entire series would revolve around the concept, most notably *Sliders*, which lasted for five seasons and 88 episodes, first on Fox and later on the Sci-Fi Channel.

Created by Robert K. Weiss, producer of *The Blues Brothers*, and Tracy Tormé, it told of a physics graduate, Quinn Mallory (played by Jerry O'Connell), who discovers a method of "sliding" through wormhole-like vortices to parallel Earths. Together with three companions, including his college mentor and a professional singer who happened to be passing when the vortex first opened, he's now trapped in a seemingly endless cascade of alternative realities, hoping each time he makes another "slide" it will be back to his own world, "Earth Prime." The end result was a show not unlike *Quantum Leap* or *The Time Tunnel*, with each episode seeing the group arrive in a new scenario, where they learn the differences between that parallel world and ours, then race to a preset vortex opening in preparation for their next slide.

In the first season, most slides revealed alternative worlds with "what-if?" scenarios — what if men were "the weaker sex" and women held all positions of power? What if the 1967 Summer of Love had never ended? But things changed as the show developed. The second season introduced a recurring villain in the form of the divergent human species called the Kromaggs, who use sliding tech to conquer alternate Earths or to rob them of resources and people.

The third season moved production from Vancouver to Los Angeles, and saw the action quotient ramped up, with many episodes blatantly based on such topical hit movies as *Species* and *Twister*. During this period both John Rhys-Davies, who played mentor figure Professor Maximillian Jones, and co-creator Tracy Tormé expressed dissatisfaction with these developments and left the show. Fox eventually cancelled production.

It was a new incarnation of *Sliders* that was picked up by the Sci-Fi Channel for season four: now only two members of the original cast remained, and a return to Earth Prime found it had fallen to a Kromagg invasion, and revealed that somewhere among the worlds there might be an effective weapon against them. Sci-Fi would eventually fund a fifth series too, but, unable to meet Jerry O'Connell's financial demands, produced a complicated scenario involving merged personalities and a largely new cast. It ended on a cliffhanger, with Rembrandt "Cryin' Man" Brown (Cleavant Derricks) — the only remaining member of the original cast — returning to Earth Prime carrying a virus fatal to Kromaggs only. Whether he succeeds, and whether the genocide of that entire species is justified, is left for the viewer to decide. **MB**

year-by-year ■ TV series

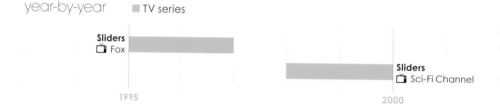

Sliders
Fox

Sliders
Sci-Fi Channel

1995 2000

3rd rock from the sun 1996

3rd Rock from
the Sun

3rd Rock from
the Sun

"It's actually about nothing," *3rd Rock* star Jane Curtin told *The New York Times* shortly after the show premiered in 1996. She wasn't, however, being critical. After decades of U.S. sitcoms growing ever more worthy and dramatic (stand up *M*A*S*H*) *3rd Rock* was a return to gloriously vacuous fun. Indeed, *The New York Times*' own TV reviewer called it, "brilliantly idiotic, a daffy pastiche of farce, burlesque and satire."

3rd Rock from the Sun was the brainchild of husband-and-wife writing team Bonnie and Terry Turner, previously best known for the *Wayne's World* films and *The Brady Bunch Movie*, so searing social commentary and gritty human drama were never on their radar. *3rd Rock* was a science fiction sitcom painted in the broadest strokes, with a simple cliché at its heart, stretched to breathtakingly ridiculous lengths. A group of aliens with no understanding of human emotions, who've learned most of what they know about the planet from intercepted TV transmissions, come to Earth on a research mission, posing as a family called the Solomons (their name taken from a passing truck).

Hilariously, the pecking order of the aliens is inverted in their Earth guises. Dick Solomon looks like the head of the family but is actually the most immature. Tommy is the expedition leader but trapped in the body of a teenage boy, forced to go to school. Sally was a male who lost some undefined contest and ended up as the female. And Harry? Well Harry seems to be borderline idiot savant in both alien and Earth form, which in sitcom terms means the

one who can deliver the weirdest gags. (In case you hadn't noticed, that means the men were called Tom, Dick and Harry.)

In the role of Dick, movie star John Lithgow (*2010, Footloose, Harry and the Hendersons*) unleashed his inner Robin Williams. Employed as a lecturer at Pendleton State University, Dick develops a crush on a fellow academic, Mary Albright (Curtin) and takes "What is this thing you call love?" to ludicrous extremes in a loud, brash theatrical performance that set the tone for the rest of the cast, especially Kristen Johnston as an ubervamp who turns her sexuality into a weapon. Only future movie star Joseph Gordon Levitt as Tommy plays things anywhere near straight (his running gag being that he's the least sexy one).

The first two seasons were massive hits, critically and in the ratings. Subtle it wasn't (108 of the 139 episodes had "Dick" in the title, and the double entendre was clearly always intended), but consistently funny it certainly was. This was a gags-per-minute show. It was also at the spearhead of a new brand of "meta" comedy, with movie pastiches (*Apocalypse Now, Chinatown*) and geeky in-jokes (when William Shatner guest stars, there's a reference to the fact that Lithgow played the same role in the *Twilight Zone* movie that Shatner had in the series) that foreshadow *The Big Bang Theory* and *Community*. (*Big Bang Theory*'s opening credits are a virtual rip-off of *3rd Rock*'s dancing planets.)

More sitcom than SF, *3rd Rock from the Sun* used geekiness to deliver big laughs and big audiences. **DG**

year-by-year　■ TV series　■ Book

3rd Rock from the Sun
📺 Sci-Fi Channel

3rd Rock from the Sun
\ Terry Turner, Bonnie Turner

1995

2000

resident evil 1996

Resident Evil

Resident Evil

The Umbrella Conspiracy

Resident Evil: Code Veronica

Resident Evil

Resident Evil (GameCube remake)

Resident Evil: Apocalypse

Resident Evil 4

In 1989, audiences in Japan were spooked by a modest home-grown horror movie called *Sweet Home*. Right alongside it, games studio Capcom released on Famicom, the Japanese arm of the Nintendo Entertainment System, a tie-in game that rapidly inspired one of the world's biggest entertainment franchises.

Players controlled five characters as they explored a haunted mansion, solving puzzles and slowly uncovering the grisly history of the family who once lived there. If a character died, they were gone for good (which also changed the ending), adding a palpable sense of tension. It was one of those rare games that spawns a whole genre — in this case, survival horror.

Capcom later capitalized on this success with a new product that was originally intended as a remake, but which became a brand new title — *Biohazard* in Japan; *Resident Evil* in the West. It adopted many of *Sweet Home*'s core mechanics and utilized a sinister mansion setting (this time crawling with zombies). It first went on sale in 1996.

A deep backstory about corporate greed and genetic experimentation was slowly revealed to the player, further transforming the zombie into an SF rather than a fantasy creature. Fixed camera angles gave the game a cinematic feel, and subtle but effective sound design kept the player paranoid about what might be lurking just out of sight. The game had a beautifully balanced item management element that meant ammo and healing herbs were resources to be treasured and expended with the utmost care. In a stroke of cruel genius, Capcom also tied the save game option into this system, forcing players to be painstakingly tactical. Above all, it is generally agreed that *Resident Evil* was the first videogame that was truly terrifying.

Less than two years later, *Resident Evil 2* appeared on the Sony PlayStation. It was bigger, better and slicker than its predecessor in almost every respect. Although some complaints were reasonably leveled at the clunky controls and cringe-worthy voice acting, it was a solid commercial and critical success that swelled the young franchise's global fanbase.

Resident Evil 3: Nemesis (1999) used the classic horror motif of the unstoppable pursuer, the titular Nemesis, which hunts protagonist Jill Valentine through a ruined Raccoon City. Smaller in scope than *Resident Evil 2*, in some ways it failed to live up to the extraordinary reputation of the series, but unfortunately worse was yet to come.

Resident Evil 4 did not arrive for another 10 games and six years, during which time Capcom experimented fairly heavily and not always to great effect. Two ill-advised shooter games were joined by an unfortunate foray into the handheld market, and

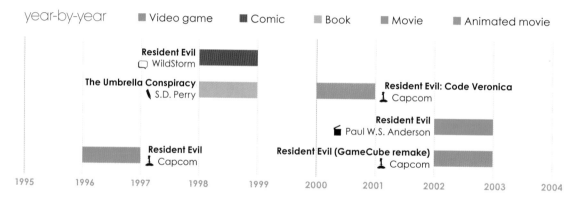

year-by-year ■ Video game ■ Comic ■ Book ■ Movie ■ Animated movie

Resident Evil
◻ WildStorm

The Umbrella Conspiracy
❧ S.D. Perry

Resident Evil: Code Veronica
⚖ Capcom

Resident Evil
❦ Paul W.S. Anderson

Resident Evil
⚖ Capcom

Resident Evil (GameCube remake)
⚖ Capcom

1995 1996 1997 1998 1999 2000 2001 2002 2003 2004

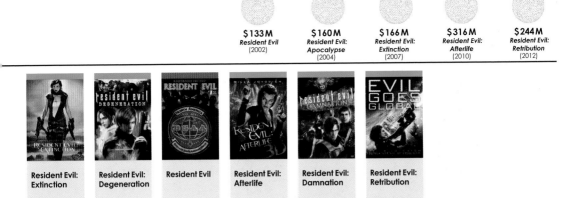

$133M
Resident Evil
(2002)

$160M
*Resident Evil:
Apocalypse*
(2004)

$166M
*Resident Evil:
Extinction*
(2007)

$316M
*Resident Evil:
Afterlife*
(2010)

$244M
*Resident Evil:
Retribution*
(2012)

**Resident Evil:
Extinction**

**Resident Evil:
Degeneration**

Resident Evil

**Resident Evil:
Afterlife**

**Resident Evil:
Damnation**

**Resident Evil:
Retribution**

all three are easily forgotten. *Resident Evil: Outbreak* took the bold step of incorporating online play, but this was an area in which home consoles struggled — *Outbreak* was a disappointment.

Bright spots did emerge, such as *Resident Evil: Code Veronica* on SEGA Dreamcast, and the series' convoluted tale about the evil Umbrella corporation continued to evolve, but overall the franchise had lost both focus and momentum.

The burden was eased via a whole different medium; in 2002 *Resident Evil*, the first live action film, hit cinemas worldwide. Produced by Constantin Film, it starred *The Fifth Element*'s Milla Jovovich and was written and directed by her future husband, Paul W.S. Anderson. Critical reaction was mixed, but it was a box office hit and spawned four sequels, each of which has made a bigger profit than the original.

The fourth *Resident Evil* game had a long and troubled gestation. One proposed version was well underway before being scrapped, although it later found new life as another Capcom hit, *Devil May Cry*. Three further versions were proposed and worked on, only to be cancelled.

Resident Evil 4 was finally released on GameCube in 2005. Characterized by a bold reinvention of some of the series' core mechanics and a much greater focus on action than horror, it was something of a gamble, but it paid off handsomely, reigniting interest

in the franchise and swiftly becoming one of the best-selling titles on the console. It was also hugely influential in both the survival horror and third-person shooter genres, inspiring such big name projects as *Gears of War* (2006), *Dead Space* (2008) and *Batman: Arkham Asylum* (2009).

In 2009, after several faltering side projects, *Resident Evil 5* was launched with considerable marketing fanfare, but produced only lukewarm press reaction. Very much a continuation of *Resident Evil 4*, it had some of the most impressive visuals of any game to date, and introduced strong co-op for the first time. Although there was by now a growing sense that *Resident Evil* had lost sight of what made it great in the first place, this game went on to outsell all four of its predecessors.

Resident Evil 6 (2012, Xbox 360 and PS3) was, once again, heavily focused on action, with co-op and multiplayer features. Even Capcom was forced to admit that it had essentially abandoned the genre it created, vaguely describing RE6 as "dramatic horror" instead. After a strong start (4.9 million copies worldwide) sales slowed considerably and Capcom was forced to admit that the game would not meet its targets. Although a seventh incarnation seems inevitable, it remains to be seen whether it will continue along its current lines or revert to the old spirit of survival horror. **TMa**

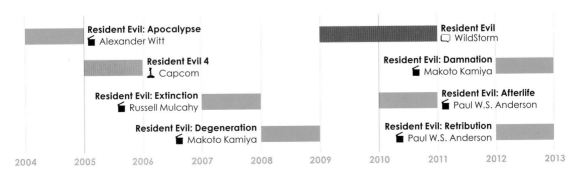

Resident Evil: Apocalypse
Alexander Witt

Resident Evil 4
Capcom

Resident Evil: Extinction
Russell Mulcahy

Resident Evil: Degeneration
Makoto Kamiya

Resident Evil
WildStorm

Resident Evil: Damnation
Makoto Kamiya

Resident Evil: Afterlife
Paul W.S. Anderson

Resident Evil: Retribution
Paul W.S. Anderson

2004 2005 2006 2007 2008 2009 2010 2011 2012 2013

resident evil universe

Albert Wesker

Chris Redfield

Jill Valentine

Lord Oswald E. Spencer

William Birkin

Ada Wong

Leon Kennedy

In 1968 Lord Oswald E. Spencer, James Marcus and Brandon Bailey discover the mutagenic Progenitor virus and then set up the Umbrella Corporation.

Spencer wants to destroy the world and rebuild it in his own image — and so Project Wesker is born. Hundreds of children of parents with above average intelligence are kidnapped, brainwashed, given new identities (always with the surname Wesker) and injected with a prototype t-Virus. Most of them die, but the survivors are sent out into the world.

Spencer builds a laboratory in the Arklay Mountains. In 1977, 17 years old and ignorant of his origins, Albert Wesker joins Umbrella as a researcher and befriends a young colleague, William Birkin. By 1981, t-Virus research has created the first of the zombies with which Spencer plans to wipe out all life on Earth.

In 1988, Spencer orders Wesker and Birkin to assassinate Professor Marcus, a co-founder of

Umbrella and their former mentor. Three years later, Wesker transfers to Umbrella's Intelligence Bureau, partly in order to determine Spencer's true motives. Birkin remains a company man and works on a new strain, the g-Virus, in a lab beneath Raccoon City.

Eight years later, Wesker sets up the Raccoon City Police Department Special Tactics And Rescue Service (STARS), in which he works under cover to investigate strange events in the Arklay Mountains.

The attempt on Marcus' life hadn't gone as planned — the Professor's broken body merged with a modified leech to form a creature that releases the t-Virus into Spencer's mansion.

STARS Bravo team flies out to investigate mysterious deaths near the mansion, but its helicopter crashes. Together, sole survivor Rebecca Chambers and death row prisoner Billy Coen fight their way through Bio Organic Weapons (BOWs) and defeat Marcus.

characters

- Albert Wesker
- Chris Redfield
- Jill Valentine
- Lord Oswald E. Spencer
- William Birkin
- Ada Wong
- Leon Kennedy

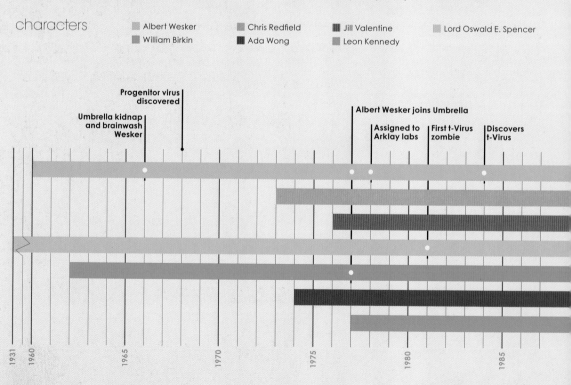

The STARS Alpha team goes in search of the Bravo team, and four of them — Jill Valentine, Chris Redfield, Albert Wesker and Barry Burton — stumble across Spencer's BOW-infested mansion. Jill and Chris discover Wesker's evil purpose but he escapes them.

Back at Umbrella, Birkin is making progress with the g-Virus, but has secretly made contact with the U.S. military requesting extraction from the corporation. Before he can leave, the Alpha Team, commanded by HUNK, bursts in and demands that he surrender his research. Birkin refuses, and is cut down by gunfire. In his dying moments, he injects himself with g-Virus and mutates into a huge creature known as "G." He chases HUNK's team through the sewers and kills them, but meanwhile accidentally passes the t-Virus to rats which then spread it throughout the city.

Jill Valentine is trapped in the city, and is chased by the tyrant Nemesis. She defeats him, but is infected with t-Virus. Ada Wong (a spy), Claire Redfield (Chris' sister) and Leon Kennedy (a cop) defeat the mutated Birkin creature and a tyrant called Mr. X before escaping the doomed metropolis.

Jill finds a cure for the virus. Nemesis is killed by a huge rail cannon, and Jill escapes in a helicopter. Raccoon City is nuked by Umbrella.

In 2004, the U.S. President's daughter is kidnapped by Los Illuminados, a Spanish cult that controls Las Plagas, a parasitic organism. On a rescue mission, Leon and Ada defeat Wesker, but cannot prevent him from acquiring a sample of La Plaga.

Five years later, Wesker has killed his old boss Spencer and, having refined La Plaga into an even deadlier virus, unleashes it on the African country of Kijuju. Sent there to investigate, Chris Redfield defeats hundreds of infected locals and then kills Wesker by trapping his mutated form in lava. **TMa**

Doctor Marcus assassinated

Wesker resigns from Umbrella

STARS formed by Wesker

Arklay Mansion/Raccoon City incident, Wesker becomes Tyrant

Jill Valentine hunted by Nemesis and infected

President's daughter kidnapped by Los Iluminados

Wesker learns of his origins, experiments on Jill Valentine.

Spencer killed by Wesker

African Outbreak

Wesker killed

Jill rescued

1990 1995 2000 2005 2010 2015

Resident Evil
(1996)

Resident Evil
(2002)

Resident Evil
(GameCube
remake)
(2002)

Resident Evil:
Apocalypse
(2004)

Resident Evil 4
(2005)

Resident Evil:
Extinction
(2007)

Resident Evil:
Degeneration
(2008)

Resident Evil:
Retribution
(2012)

The original *Resident Evil* game was strictly third-person action.

The *Resident Evil* movies are set in a post-apocalyptic world full of zombies.

One of the game's "leapers," as rendered in the first *Resident Evil* movie.

A zombie bars the way in *Resident Evil*, the 2002 Gamecube remake of the original 1996 video game.

Director Alexander Witt storyboarding his *Resident Evil: Apocalypse*.

Later installments of the game series moved away from survival horror to a third-person shooter mechanic, much to fans' annoyance.

Milla Jovovich in *Resident Evil: Extinction*, the third movie in the live-action series.

In *Resident Evil: Degeneration* humans at Harvardville Airport take refuge from zombies.

Roger Craig Smith as Curtis Miller in *Resident Evil: Degeneration*. He later became the voice of Sonic the Hegehog.

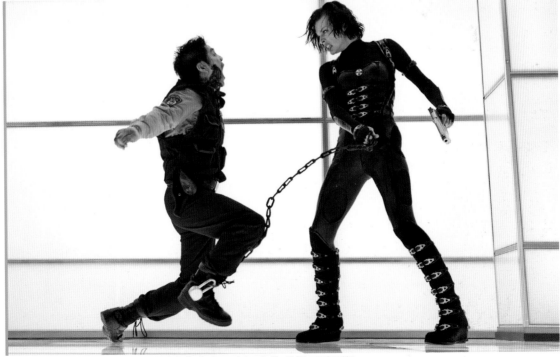

Much of Milla Jovovich's career has now been dominated by the five-movie long *Resident Evil* theater franchise.

independence day 1996

Independence
Day

Independence
Day U.K.

Independence
Day

Independence
Day

Independence
Day: Silent Zone

Independence
Day: War in the
Desert

German-born director Roland Emmerich and actor turned writer-producer Dean Devlin first worked together on science fiction thriller *Moon 44* (1999). They went on to form a production partnership, collaborating on action thriller *Universal Soldier* (1992) and space adventure *Stargate* (1994). Their biggest success came with *Independence Day* (1996).

This film depicts a deadly alien attack on Earth, as gargantuan flying saucers devastate cities worldwide. It's up to a plucky band of heroes — including U.S. President Bill Pullman and daredevil pilot Will Smith — to mount a desperate counterattack on July 4, the Independence Day holiday.

Harking back to 1950s' science fiction B-movies, *Independence Day* cashed in on the mid-1990s' popularity of SF. The film owed much to *Childhood's End* by Arthur C. Clarke and *The X-Files*, but its biggest influence was disaster-movie producer Irwin Allen.

The man behind 1970s' Hollywood epics *The Towering Inferno*, *Earthquake* and *The Poseidon Adventure*, Allen specialized in assembling large casts for tales that pitched ordinary people against exceptional circumstances. Emmerich and Devlin followed this recipe to the letter to produce a broad, manipulative but earnestly played film that combined melodrama with ultra-patriotism. All this was

combined with fast-paced action and breathtaking sequences of city destruction that raised the bar for what a Hollywood blockbuster could do onscreen.

Despite being released in the post-*Jurassic Park* era of increasingly dominant CGI, *Independence Day* was one of the last blockbusters to use largely traditional effects. Apart from the aliens' beam of destruction, everything was achieved with models; digital methods were used only to composite the various elements together

The relatively slim budget — $75 million at a time when blockbusters were regularly costing more than $100 million — meant that effects shots were not always as slick or polished as they could have been, but audiences didn't mind.

The film grossed more than $300 million in the United States alone and unleashed a stream of imitators, from CGI-assisted disaster movie *Dante's Peak* to patriotic SF adventure *Armageddon*. Even more than *Jurassic Park*, *Independence Day* proved that effects and spectacle could be just as important a draw as stars or directors.

As for Emmerich and Devlin, their attempt to repeat *Independence Day*'s success with a 1998 remake of *Godzilla* fell flat. In 2000 they dissolved their business partnership and went their separate ways. **SB**

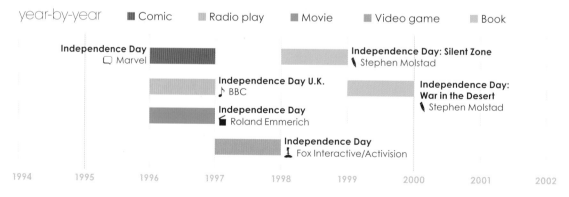

year-by-year ■ Comic ■ Radio play ■ Movie ■ Video game ■ Book

Independence Day
◻ Marvel

Independence Day U.K.
♪ BBC

Independence Day
🎬 Roland Emmerich

Independence Day
🎮 Fox Interactive/Activision

Independence Day: Silent Zone
🖋 Stephen Molstad

**Independence Day:
War in the Desert**
🖋 Stephen Molstad

1994 1995 1996 1997 1998 1999 2000 2001 2002

open your eyes 1997

Open Your Eyes

Vanilla Sky

For most of its length, *Open Your Eyes* (*Abre los ojos*) is a psycho-thriller, narrated by an unreliable antihero who is caught between two women with overlapping, interchanging identities. The SF material is mainly confined to the denouement, which functionally "explains" the story in a way that anticipated the coming wave of reality-bending SF thrillers.

Soon after its release in Spanish, the English-language rights to the story were snapped up by Tom Cruise, who produced and starred in the Hollywood remake, *Vanilla Sky*. Both versions work well; if the remake is in any way inferior, it is in its sometimes slavish faithfulness to the original.

In both films, a handsome, charming womanizer, (Eduardo Noriega in the original, Cruise in the remake) is in a casual — he thinks! — relationship with a glamorous girlfriend (Najwa Nimri, Cameron Diaz). Then the man is smitten overnight with his best friend's friend, played in both versions by Penélope Cruz. But come the morning, the womanizer can't resist a friendly-seeming invitation from the girl he jilted, who tries to kill him in a car crash.

The man survives, but is emasculated by his broken face. He must wear an inhuman mask, reminiscent of that of the faceless girl in the French horror *Les yeux sans visage* (Eyes Without a Face, 1960). As both the Spanish and the U.S. film become a twisty fable, so the disfigured "beast" is granted miraculous second chances. The Cruz character takes him back (or does she?). A marvellous new surgical technique restores his face (or does it?). Later revelations involve cryogenics, virtual simulations and a leap of faith down a skyscraper.

The males in the Spanish version are everyday horny youths, while Cruz performs ethereally in a Madrid park as a white-faced harlequin, openly inviting male fantasies. The remake moves the story to New York, matures the players, and makes the man heir to a multimedia empire. His "reality" is skewed by boardroom paranoia and the sounds and images of Hollywood's dream factory. At times, this element feels excessively elaborate in contrast to the directness of the original.

Of course, the greatest baggage in the remake comes with Tom Cruise. Some reviewers wrote off *Vanilla Sky* as a narcissistic star vehicle, snorting at Cruise's trademark roster of cocky grins, and ignoring his much more interesting acting when his character loses control. (In one scene he wails "What the fuck is happening?" as the woman he's in bed with transforms into someone else beneath him.) However, the remake is stolen by Diaz, pathetic and terrifying as the enraged wronged girlfriend — though in the tradition of *Fatal Attraction*, her legitimate claims on our sympathy are conveniently forgotten at the end.

Open Your Eyes was directed by Alejandro Amenábar, who then went to Hollywood to make the ghost story *The Others* (2001), another film with a trick ending. *Vanilla Sky* reunited Cruise and director Cameron Crowe after *Jerry Maguire* (1996). **AO**

year-by-year ■ Movie

Open Your Eyes
◤ Alejandro Amenábar

Vanilla Sky
◤ Cameron Crowe

1996　　1997　　1998　　1999　　2000　　2001　　2002　　2003

the fifth element 1997

The Fifth Element

The Fifth Element

NYR: New York Race

Directed by Frenchman Luc Besson, *The Fifth Element* is among the most influential European science fiction movies. A French production for Gaumont, the action begins in Egypt in 1914 as aliens recover an ancient weapon designed to combat the "Great Evil." When this threat appears in the 23rd century, the weapon manifests itself as Leelo, an attractive young woman who escapes into New York and falls into Korban Dallas' flying taxi. On learning of her significance, Dallas goes with Leelo to meet the keeper of four stones that will defend Earth from attack, but which are also being sought by ruthless industrialist Jean-Baptiste Emanuel Zorg.

The movie was based on "Zaltman Bleros," a sprawling science fiction story that Besson wrote at age 16. After directing *La Femme Nikita* (1990), Besson turned the tale into a 400-page screenplay and then with help from Hollywood screenwriter Robert Kamen broke it down into two stories. Besson next wrote and directed *Léon: The Professional* (1994), which was so successful that backers who had previously been reluctant to back his new project came flocking to him.

For preproduction design of *The Fifth Element*, Besson hired renowned French artists Moebius (Jean Giraud) and Jean-Claude Mézières. Costumes were commissioned from leading couturier Jean Paul Gaultier. When it came to casting, Besson discussed the role of Dallas with Bruce Willis, but eventually decided against a big name. Willis, however, insisted that he should be involved. Besson then personally auditioned 300 of the 8,000 contenders for the role of Leelo, which he eventually awarded to Ukrainian-born model Milla Jovovich.

Gary Oldman, with whom Besson had worked on *Léon*, reportedly agreed to star without reading the script, whereas comedian Chris Tucker was an unusual choice for the flamboyant and exuberant radio DJ Ruby Rodd. The film is also replete with cameos by, among others, British hip-hop singer Tricky, *Beverly Hills 90210* star Luke Perry and British comedian Lee Evans.

Filming began in 1996 in the Mauritanian desert, then moved to Britain's Pinewood Studios, where it was the largest production ever, occupying nine of its 12 sound stages. Principal photography lasted 109 days and ended with the largest indoor explosion ever created as the space liner's foyer set was blown up on Pinewood's 007 soundstage. Covered by 12 separate cameras, it took five minutes to put out the resulting fire.

The visual FX — produced by James Cameron's Digital Domain in Los Angeles — combined 24 scale models with computer generated effects.

With a cast of more than 1,000, *The Fifth Element* was the most expensive European film ever made at the time, but it went on to make more than three times its $90million budget.

Novelized in 1997 by Terry Bisson, the film has inspired two video games — *The Fifth Element* (1998) and *NYR: New York Race* (2001). In 2004, Moebius and writer Alexandro Jodorowsky lost in their bid to sue Besson and the Gaumont studio for $20 million, claiming the film plagiarized their comic book series *L'Incal*. Besson has repeatedly denied that there is any truth in rumors that the second half of the script he wrote with Kamen, reportedly entitled "Mr. Shadow," will become a sequel to *The Fifth Element*. **MMo**

year-by-year ■ Movie ■ Video game

The Fifth Element
🎬 Luc Besson

The Fifth Element
🎮 Activision

NYR: New York Race
🎮 Wanadoo Edition

1995 2000 2005 2010 2015

futurama 1999

| Futurama | Futurama Comics | Futurama | Bender's Big Score | The Beast with a Billion Backs | Futurama | Bender's Game | Into the Wild Green Yonder |

The international success of *The Simpsons* made it natural that Fox Television would look to creator Matt Groening for another series. In 1998 he pitched *Futurama* to the studio. Developed by Groening and David X. Cohen (a *Simpsons*' writer/producer), *Futurama* is very different in style and tone from Bart and co., with no regular child characters and a darker humor. Also, it is set 1,000 years in the future.

Adapting the Wellsian "sleeper awakes" idea, *Futurama* concerns underachieving pizza delivery boy Philip J. Fry, who is accidentally frozen on New Year's Eve 1999 and emerges a millennium later into a world of robots, spaceships, aliens and pretty much every other science fiction theme, convention and icon imaginable.

Fry lands a job with interstellar delivery service Planet Express, owned by his great (x30) nephew, geriatric mad scientist Professor Hubert Farnsworth. His colleagues include a one-eyed, no-nonsense alien (later revealed to be a mutant human) named Leela, with whom Fry has an intermittent, largely unfulfilled romance; wealthy bimbo Amy Wong; Jamaican bureaucrat Hermes Conrad; put-upon crustacean physician Dr. Zoidberg and hard-drinking, chain-smoking, whore-mongering robot Bender, who becomes Fry's roommate.

Bender quickly became the series' star, but *Futurama* still functioned as an ensemble sitcom. The show's format allowed the characters to visit any type of planet required for narrative reasons as well as exploring a 31st-century Earth on which aliens and robots are commonplace. Regular supporting characters include starship captain Zapp Branigan, his long-suffering first mate Kif and malevolent alien newsreader Morbo.

Futurama is both a satire on our own time and an evocation of the jet-pack, streamlined future which science fiction once promised but reality never delivered. A trend for preserving the heads of past celebrities allowed several famous people to play themselves (and explained why the President of Earth in 3000 is Richard Nixon). Guest stars in this format included Stephen Hawking, Al Gore and Leonard Nimoy. The last named voiced his own head in several episodes including the Nebula award-winning "Where No Fan Has Gone Before."

Fox was never happy with *Futurama*'s adult content or Groening's level of control, and the studio allowed the series to end after four seasons. Three years later, Comedy Central revived the show, first with DVD movies, then with two fully-fledged seasons. *Futurama* was finally cancelled in 2013. **MJS**

year-by-year　　■ Animated TV series　　■ Comic　　■ Video game　　■ Animated movie

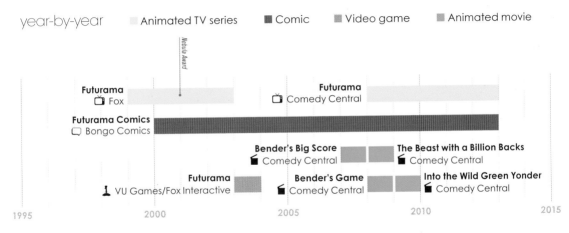

1995　　2000　　2005　　2010　　2015

farscape 1999

Farscape

House of
Cards

Farscape
Magazine

Farscape:
The Game

Farscape:
War Torn

The
Peacekeeper
Wars

Farscape

U.S. TV has a problem with science fiction. Not the soft stuff, of course — shows set on present-day Earth with aliens or time travel are common. But deep-space shows are rare, and invariably short-lived. Aside from the *Star Trek* franchise, there have only been a few real successes. This is one of the most surprising of them.

Farscape seemed designed to fail. It was almost entirely studio-based; the aliens were created by the Jim Henson Creature Shop, which guaranteed quality, but led to the belief that the show was merely Muppets In Space; and the humor was, to put it mildly, crude. And yet it worked.

Originally conceived by Rockne S. O'Bannon and Brian Henson under the woeful title "Space Chase," it went into production in 1999. Airing on Australia's Channel Nine Network, the Sci-Fi Channel (now SyFy) in the United States and BBC2 in Britain, it had a slow start, but quickly gathered a loyal fanbase.

Inspired chiefly by *Star Trek* with a dash of Buck Rogers, the first season saw John Crichton — a 20th-century astronaut blasted to the other side of the galaxy — pursued by fascistic Captain Crais. Then came Scorpius, a grotesque alien genius obsessed with the secrets in Crichton's head and determined to discover them by any means necessary.

The press eventually caught on to the fact that, whereas *Star Trek* was increasingly stiff, *Farscape* was wild and sexy. Ben Browder gave a lovable performance as Crichton, and there was the sense that the show might do something insane. Across its four seasons the show produced a cartoon episode, an episode where the characters went on an adventure while hung over, and featured multiple incidences of inter-species sex. More interestingly, it explored mental illness and took the SF cliché of a character being cloned and ran with it, exploring what that might mean psychologically and emotionally.

Conceived as a five-year arc, fans were overjoyed when it was announced that Sci-Fi had ordered both seasons four and five, guaranteeing them a proper ending. However, for reasons that have never quite been explained (but were perhaps down to a change of management at the station), the show was axed midway through the fourth season. The cast, crew and fans were devastated.

Thankfully, that was not the end. After much fan campaigning, a mini-series, *Farscape: The Peacekeeper Wars*, was filmed in 2004 and wrapped up the show's ongoing storylines effectively.

Since then, space-set SF has continued to dwindle on U.S. television. The only major success has been the revival of *Battlestar Galactica*. Recently, however, another new show featuring a cast of weird alien characters and some wild adventures completed its first season. It is called *Defiance*. Its creator? Rockne S. O'Bannon. **WS**

year-by-year ■ TV series ■ Book ■ Magazine ■ Video game ■ Comic

Farscape
Nine Network

House of Cards
Keith R.A. DeCandido

Farscape Magazine
Titan Magazines

Farscape: The Game
Crucial Entertainment

Farscape: War Torn
Wildstorm

The Peacekeeper Wars
Sci-Fi Channel

Farscape
BOOM!

2000 2005 2010

darwin's radio 1999

Darwin's Radio

Darwin's Children

Occasionally, an established science fiction author produces a novel that is so different from his or her previous output that it seems like a renunciation of the work that preceded it. A case in point is Greg Bear's *Darwin's Radio*, which tells of an evolutionary jump caused by the emergence of a virus, SHEVA, that activates redundant human DNA and thus creates a new species almost overnight.

The plot — like that of Marvel's *The X-Men* — is concerned mainly with humanity's reaction to its potential replacements. A sequel, *Darwin's Children* (2003), picked up on these themes, showing the nascent Shevan species, whose members take the very human characteristics of intense cooperation and deep communication to what may be regarded either as the next evolutionary level or as the undesirable extreme, and end up corralled in concentration camps. The story here concerns one couple's struggle to prevent their Shevan child from being taken away to such a collective.

When Bear followed up these novels with the near-future *Quantico* (2005) — a tale of FBI agents in pursuit of bio-hackers who create real rather than computer viruses — it seemed that an author previously associated with hard SF and space opera was moving into Michael Crichton territory. In truth, it is simply proof of Bear's versatility.

Born in 1951 in San Diego, California, Bear sold his first story to Robert Lowndes' *Famous Science Fiction* when he was just 15 years old. His first novel,

Hegira, appeared in 1979. In the mid-1980s, he began to emerge as a major force. *Eon* (1985), the first of his *Way* novels, offers up an asteroid starship that appears to come from humankind's future and, like Doctor Who's TARDIS, is bigger inside than outside.

The Forge of God (1987) is an ambitious invasion tale that proposes a solution to the Fermi paradox and in which noisy young civilizations get snuffed out by self-replicating machines. Both *Blood Music* (1985) and *Queen of Angels* (1991) deal with the ways in which nanotechnology might transform the Earth. *Moving Mars* (1993) portrays the Red Planet as a colonial world that wants to break free from Earth's influence.

In the 21st century, Bear's most notable works have included *City at the End of Time* (2008), a dying Earth tale that cuts between present-day Seattle and the far future, and *Hull Zero Three* (2010), which is set aboard a generation starship where things have gone badly awry.

A longtime SF fan who was involved in the foundation of the San Diego Comic Con, Bear has never been snobbish about working in other people's fictional universes, having written *Star Trek*, *Star Wars* and *Foundation* novels and a follow-up to Sir Arthur Conan Doyle's *The Lost World*.

Greg Bear has also worked as an artist and was a founding member of the Association of Science Fiction Artists (ASFA). Between 1983 and 1999, he served on the now defunct Citizens' Advisory Council on National Space Policy. **JW**

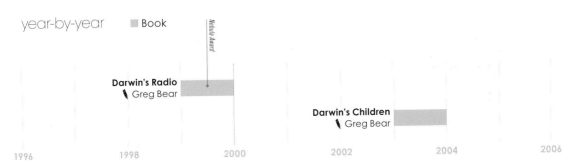

year-by-year ▪ Book

Nebula Award

Darwin's Radio
Greg Bear

Darwin's Children
Greg Bear

1996　　1998　　2000　　2002　　2004　　2006

the matrix 1999

The Matrix

The Matrix
Comics

The Matrix
Reloaded

The Matrix
Revolutions

Enter the Matrix

The Animatrix

Few science fiction properties have arrived with quite as much impact as *The Matrix* — siblings Andy and Lana Wachowski's rich stew of a sci-fi adventure film series, combining goth fashion, Hong Kong wire-fu and a Philip K. Dick-style "Everything You Think You Know Is False" premise. Even fewer have then disappeared again so quickly.

The original film grossed more than $460 million worldwide and won four Academy Awards. Two sequel theatrical movies and a direct-to-video animated short film anthology, filling in background information, followed in 2003; all were hits, and both features appeared in that year's Top 10 Box Office hit list. But the law of diminishing returns soon set in — too many fights! Too much grey-green! Audiences became exhausted, baffled and ultimately vaguely disappointed by the way such an initially enthralling storyline had played out. We have seen no important new Matrix material since.

Still, *The Matrix* trilogy is now regarded as a core cyberpunk text, loaded with the high tech/low life feel of novels such as William Gibson's *Neuromancer*. It layers multiple dystopian SF and mythological themes in a story that references *The Wizard of Oz*, *Alice's Adventures in Wonderland*, "the doors of perception"

from William Blake (and, later, Aldous Huxley), assorted Japanese anime properties including *Ghost in the Shell* and the martial arts films of John Woo. Its key stylistic innovation — "bullet time," a visual effect in which a shot proceeds in slow motion while the camera moves around and through the action at normal speed — became much imitated in other movies and in video games and is now part of the language of film.

An additional hook, of course, was the way *The Matrix* heaved with Biblical imagery, from Neo's death and resurrection to Trinity's name. In this reading, Morpheus is like a Gnostic Satan, rebelling against an insane God and one of the few who know that what appears to us as "the world" is actually Hell.

Above all, what captured the public imagination was the key conceit at *The Matrix*'s heart. It's a question we've all asked: what if the entire world was just a giant put-up job, designed to fool us?

The Matrix tells of a normal-looking 1999 in which hip computer hacker Thomas Anderson, code-name Neo (Keanu Reeves) discovers that his entire world is nothing but a highly sophisticated computer simulation, populated by the avatars of sleeping people and assorted sentient computer programs.

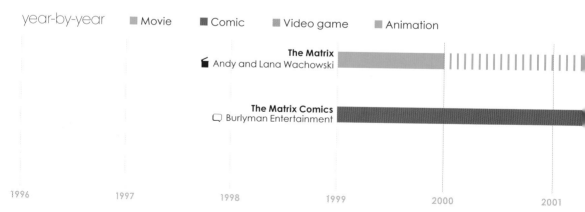

year-by-year ■ Movie ■ Comic ■ Video game ■ Animation

The Matrix
Andy and Lana Wachowski

The Matrix Comics
Burlyman Entertainment

1996 1997 1998 1999 2000 2001

$657 M
The Matrix
(1999)

$953 M
The Matrix
Reloaded
(2003)

$549 M
The Matrix
Revolutions
(2003)

The Matrix Online

The real human population, it turns out, actually slumbers in pods in some far-future year — evidence suggests it is around 2699 — where they are used as bioelectric batteries by a new machine species that has rebelled against its creators and taken over the world. That the amount of bioelectricity emitted by humans would hardly make them worth harvesting has long seemed one of the plot's key weaknesses — but not if you assume that the machines have other motives. Either this is pure revenge — press people into service as they once did us — or they actually have our best interests at heart, and are deliberately keeping us inert but safe until something better can be found. In such speculation lies the power of *The Matrix* — the movie encourages discussion.

Meanwhile, we learn of a small pocket of human resistance, centered on a single free city called Zion, that holds out against the machines in dark imitation of Asterix's Gaulish village; soon the rebel soldiers there have recruited Neo to their cause. Neo may well be "the One" who, prophecy says, will free the world, and his battle now ranges through both reality — once he has awoken and been freed from his pod — and this vast simulation called "The Matrix" in which his realization that things are not real allows him apparent superpowers. Of course, the machines mean to stop him, as so do assorted rogue programs within the Matrix, not least the megalomaniacal Agent Smith, who appears as a super-powered and self-replicating parody of an FBI man. When Smith starts to gain in-Matrix powers that might eclipse Neo's own, the battle-lines become even more complicated.

The central question — "What if the world were a simulation?" — has been asked again and again throughout history, by writers including Plato in "The Allegory of the Cave in *Republic* (circa 380 BCE) and René Descartes in the "evil demon" section of *Meditations on First Philosophy* (1641). What makes *The Matrix* so remarkable is that no other series (other than perhaps *Star Wars*) has brought to such vibrant, visual life so many of the other concerns and tropes of literary science fiction.

But where George Lucas blended the works of Isaac Asimov and Frank Herbert, the Wachowskis reference darker creations by Gibson, Philip K. Dick, Harlan Ellison and Thomas Pynchon. Although SF ideas keep coming as the series progresses, nothing in either sequel matches the core realization moments of the first film, when Neo starts to figure out "how deep the rabbit hole goes." **PM**

The Matrix Revolutions
Andy and Lana Wachowski

The Matrix Reloaded
Andy and Lana Wachowski

Enter the Matrix
Atari

The Matrix Online
Sega

The Animatrix
Various Artists

2001 2002 2003 2004 2005 2006

the matrix universe

Neo Morpheus Trinity

In a world that looks very like our own, computer programer Thomas Anderson is secretly super-hacker "Neo." Having stumbled across the enigmatic phrase "the Matrix" he is contacted by another hacker, "Trinity," who tells him a man called Morpheus has the answers. Neo is soon arrested by mysterious Agent Smith and his black-suited associates, but he eventually meets Morpheus, who shows him the unpalatable truth of the world. Neo now awakens, naked and defenseless, in a liquid-filled pod, just one of billions of people connected by cables to a giant machine. He is rescued by Morpheus and brought aboard a bizarre flying ship, the *Nebuchadnezzar*.

Morpheus explains that he is from Zion, the last free human city in the real world, where people long ago lost a war against intelligent machines. Now the machines draw energy from their defeated enemies, who are plugged into a giant fictional simulation of the Earth of 1999 called "the Matrix" — Neo's world — while their bodies are harvested for bioelectricity. People are born, live and die in pods. Morpheus and his crew are a small guerrilla force, fighting back by unplugging enslaved humans.

The rebels can hack into the Matrix and so re-enter its simulated reality, where their knowledge of its true nature allows them to manipulate the simulation's physical laws, giving them superhuman capabilities. The Agents, meanwhile, are human-looking sentient programs, designed to defend the Matrix.

Neo joins the rebels and proves so adept at virtual combat that Morpheus starts to believes he is "the One" who will end the war.

Within the Matrix, Morpheus, Neo and Trinity — revealed to be a dangerous, dark-haired woman — visit the Oracle, a prophet who predicted the arrival of the One. But now a huge battle breaks out within the Matrix between the rebels and numerous Agents. Morpheus lets himself be captured so Neo and the others can escape. Cypher, one of Morpheus' crew, betrays the rest of them to the Agents in exchange for a safe return to a comfortable, simulated life.

Morpheus is interrogated by the Agents who are desperate to gain access to Zion's main computer. Neo mounts a rescue mission; Trinity reluctantly joins him. Morpheus is saved, but as Trinity and Morpheus exit the Matrix, Neo is captured and killed by Smith,

characters ■ Neo ■ Morpheus ■ Trinity

The *Nebuchednezzar* built

Robot B166ER kills two humans

Robot backlash

Machine City Zero One founded

A.I. programs evolve

Zero One destroys world economy

Zero One refused entry to UN

Machine war begins

Sun blocked off

Machines victorious

The first Matrix fails

First "The One"

First Zion resistance movement

2065 2070 2075 2080 2085 2090 2095 2100 2105 2150 2199

while — in the real world — *Nebuchadnezzar* is surrounded by snake-like "Sentinel machines." A kiss from Trinity, who says the Oracle told her she would fall in love with the One, resurrects Neo who now exhibits new powers. He kills Smith and leaves the Matrix. The ship destroys the Sentinels.

Six months later, Neo and Trinity are lovers. The machines have discovered the underground location of Zion and Sentinels are tunneling toward it. Neo sets out to uncover the Source of the Matrix by finding the Keymaker, a sentient program that is being held prisoner by the Merovingian, an obsolete program that provides a safe haven for similar types. Soon Neo is again face to face with Smith, who claims that he too has gone rogue, and can now clone himself.

Neo meets the Architect, the program that created the Matrix, who explains that Neo has a choice: return to the Source to reboot the Matrix and pick survivors to repopulate the about-to-be-crushed Zion, or crash the Matrix and kill everyone connected to it.

Neo, however, decides to do neither, using his in-Matrix superpowers to save Trinity instead, catching her as she falls from a building and restarting her stalled heart, then disabling the Sentinels that attempt to overrun *Nebuchadnezzar*. The efforts put Neo in a coma, while his Matrix self explores a limbo between the Matrix and the Machine City; there he learns that Smith intends to destroy both the Matrix and the real world, and realizes the only way to stop him is through a truce with Machine City. Neo travels there with Trinity, who is soon killed, and enters the City to confront the "Deus Ex Machina," the leader of the machines, saying he will stop Smith in exchange for peace. The machine leader accepts, and Zion is saved.

Helping Neo re-enter the Matrix, the machines watch as he finds that Smith has assimilated all its inhabitants. Smith has inherited Oracle's precog power, and claims to have foreseen his own victory, but — after a mighty battle — Neo tricks Smith into assimilating him. The machine leader now sends a massive burst of energy into Neo's body in the real world, causing all the Smiths in the Matrix to be destroyed. Neo's body is carried away by the machines while — in a rebooted Matrix — the Architect and the Oracle agree that all humans who want to leave the Matrix can do so. **PM**

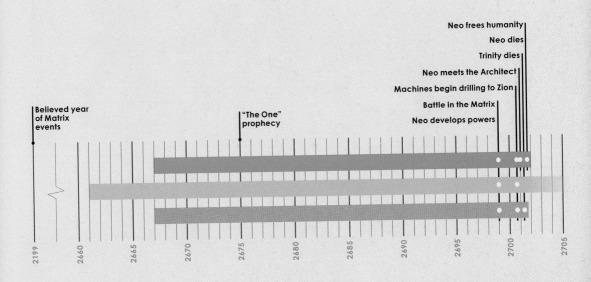

Neo frees humanity
Neo dies
Trinity dies
Neo meets the Architect
Machines begin drilling to Zion
Battle in the Matrix
Neo develops powers

Believed year of Matrix events

"The One" prophecy

2199 2660 2665 2670 2675 2680 2685 2690 2695 2700 2705

The Matrix
(1999)

The Matrix Reloaded
(2003)

The Matrix Revolutions
(2003)

Laurence Fishburne (L) as Morpheus with Keanu Reeves (Neo) in *The Matrix*.

The hideous reality of the situation: humans being farmed in pods for their bioelectricity.

Neo's powers allow him to see his world as it really is, composed of computer code.

The innovative "Bullet time" effect made heavy use of Greenscreen techniques.

Carrie-Anne Moss as Trinity in *The Matrix*.

In this scene from *The Matrix Reloaded*, Carrie-Anne Moss was replaced by her stunt double Debbie Evans.

In *The Matrix Reloaded*, the Twins (played by Neil and Adrian Rayment) are henchmen of the Merovingian. They can become ethereal and move through solid objects.

Agent Smith undergoes transformation in *The Matrix Revolutions* (2003).

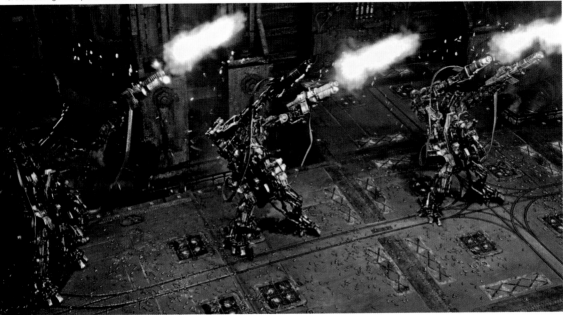

Armored personnel units (APUs) in *The Matrix Revolutions*.

the league of extraordinary gentlemen

The League of Extraordinary Gentlemen

The League of Extraordinary Gentlemen: Volume Two

The League of Extraordinary Gentlemen

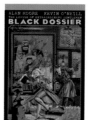

The League of Extraordinary Gentlemen: The Black Dossier

The League of Extraordinary Gentlemen: Century 1910

The League of Extraordinary Gentlemen: Century 1969

The League of Extraordinary Gentlemen began as part of Wildstorm publishers' America's Best Comics (ABC) series. It marked the return to mainstream comics of writer Alan Moore after the completion of his Jack the Ripper graphic novel *From Hell*.

With illustrator Kevin O'Neill, Moore used classic fictional adventure characters from the Victorian era as prototypes for modern superheroes. Such crossovers had previously been made by Phillip José Farmer in the Wold Newton stories and by Kim Newman in his *Anno Dracula* series.

The first *League* story teamed Captain Nemo, Allan Quatermain, Dr. Jekyll and Mr. Hyde, the Invisible Man and Mina Murray (from Bram Stoker's *Dracula*) in a rousing pulp adventure that blended aspects of steampunk with a satirical slant on the treatment of violence, sexuality and race in Victorian pulp fiction. This use of other writers' characters goes deeper than many readers realize. Every one is from a pre-existing work of fiction.

The second six-issue *League* series pitched the characters against the Martians from H.G. Wells' *The War of the Worlds* and combined brilliantly handled action with an even more darkly satirical tone. Sadly, the 2003 movie adaptation directed by

Stephen Norrington and starring Sean Connery as Quatermain was a mechanical, blandly-produced mess that lacked the distinctive flavor of the original series and prompted a lawsuit by two Hollywood screenwriters who claimed that the script infringed the copyright of a screenplay of theirs and alleged that Moore had written the comic series merely as a smoke screen to hide the plagiarism.

The case was settled out of court, but the process soured Moore's relationship with Hollywood. The writer was already at loggerheads with DC Comics, which had taken over Wildstorm shortly after the first *League* appeared, and with which he had originally fallen out over the rights to *The Watchmen* series. After a further disagreement in 2005 over the film adaptation of his graphic novel *V for Vendetta*, Moore and O'Neill took *The League of Extraordinary Gentlemen* out of the DC stable and offered it to independent publishers.

The final *League* volume released by DC, *The Black Dossier*, was much delayed both by production issues and by concerns over the fact that Moore had shifted the *League*'s story forward to the 1950s and was now dealing with fictional characters still under copyright — most contentiously Graham Greene's Harry Lime and Ian Fleming's James Bond.

year-by-year ■ Comic ■ Movie ■ Graphic novel

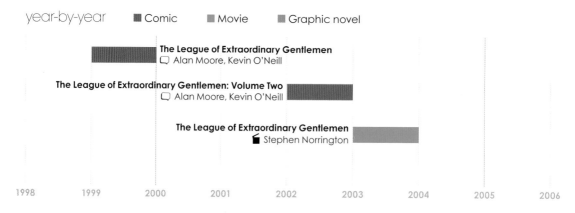

The League of Extraordinary Gentlemen
☐ Alan Moore, Kevin O'Neill

The League of Extraordinary Gentlemen: Volume Two
☐ Alan Moore, Kevin O'Neill

The League of Extraordinary Gentlemen
🔖 Stephen Norrington

1998 1999 2000 2001 2002 2003 2004 2005 2006

The League of
Extraordinary
Gentlemen:
Century 2009

Nemo:
Heart of Ice

Planned as a lavish outsized edition but ultimately downgraded to a standard graphic novel format, *The Black Dossier* initially could not be distributed outside the United States for fear of problems with some notoriously litigious authors and their agents. A mixture of pulp thriller and dense sourcebook, the story used in-depth illustrated text segments to explore the history of the *League*'s world. The central action was a chase through a bleak Britain shortly after the fall of Big Brother, the ruler in George Orwell's *Nineteen Eighty-Four*. More sexually explicit and violent than its predecessors, *The Black Dossier* was demonstrably hostile toward the cultural attitudes that had replaced the Victorian world of the original *League*.

These ideas were further explored in the following series, *The League of Extraordinary Gentlemen: Century*. This sprawling, ambitious trilogy of interconnected stories across one hundred years — set in 1910, 1969 and 2009 — sent the saga even further into the darkness and functioned as a savage satire on what Moore evidently regarded as the chronic decline of Western culture.

The stories in *Century* were every bit as inventive as those in previous *League* publications, and contained extensive allusions to a wide range of

other works, including Bertolt Brecht's *The Threepenny Opera* and Nicolas Roeg's 1960s' cult movie *Performance*. However, the density of such references gradually overwhelmed the narrative, and the anger behind the stories caused the *League* to become increasingly didactic. The hectoring tone was particularly grating in the 2009 volume, in which the antichrist is revealed (although never named) as a twisted version of Harry Potter, the wizard hero of the children's fantasy novels by J.K. Rowling.

In view of the decline in the quality of *The League of Extraordinary Gentlemen*, it came as something of a surprise when in 2013 a pilot episode was commissioned for a U.S. TV adaptation. Meanwhile Moore and O'Neill embarked on a side project — *Nemo: Heart of Ice*. This *League*-world story told of an encounter between Janni — the daughter of Jules Verne's submariner, who had first appeared in *Century 1910* — and the creatures of H.P. Lovecraft's Cthulhu mythos. It tapped back into the lighter, more action-based tone of the original *League* miniseries. Its favorable critical reception prompted an announcement by Moore that he and O'Neill would continue with the saga "for as long as they had stories to tell." **SB**

The League of Extraordinary Gentlemen: The Black Dossier
☐ Alan Moore, Kevin O'Neill

The League of Extraordinary
Gentlemen: Century 1910
☐ Alan Moore, Kevin O'Neill

The League of Extraordinary
Gentlemen: Century 1969
☐ Alan Moore, Kevin O'Neill

The League of Extraordinary Gentlemen: Century 2009
☐ Alan Moore, Kevin O'Neill

Nemo: Heart of Ice
☐ Alan Moore, Kevin O'Neill

2006 2007 2008 2009 2010 2011 2012 2013 2014

the league of extraordinary gentlemen

Orlando

Allan Quatermain

Mina Harker

Prince Dakkar/ Captain Nemo

Dr. Jekyll/ Mr. Hyde

Hawley Griffin

Janni Dakkar

In 1898, Mina Harker (née Murray), survivor of an attack by Count Dracula, is hired by British Intelligence to assemble a motley group of freaks and monsters that will be led by M, the head of the Secret Service.

Consisting of science-pirate Captain Nemo, faded big-game hunter Allan Quatermain, weak-willed scientist Dr. Henry Jekyll (alongside his monstrous alter-ego Edward Hyde) and Hawley Griffin, the Invisible Man, the group is assigned to defeat the plans of the Limehouse, London-based Asian crime lord known only as "the Doctor." Retrieving a stolen consignment of the anti-gravity mineral Cavorite from Limehouse, the team discovers too late that the enigmatic M is actually secretive crime lord James Moriarty, who needs the Cavorite to power his own advanced airship and bomb Limehouse into the ground. A massive confrontation occurs, during which Moriarty is killed and his airship destroyed.

Soon after, the Martians invade England. Nemo is betrayed to the Martians by Griffin but keeps fighting the invaders. Mina and Allan recover a secret package from reclusive scientist Dr. Moreau. Griffin is murdered by Mr. Hyde, who himself is killed by the Martians before they are defeated with germ warfare. Nemo quits the League.

Reunited in 1899, Mina and Allan face surreal horrors in Massachusetts, then visit Africa where the Pool of Life and Fire makes them immortal. Allan fakes his own death and assumes the identity of his son. A new League is formed with members including master-thief Raffles, immortal gender-changing warrior Orlando and psychic Joseph Karnacki.

In 1910, Karnacki's visions put the League on the trail of occultist Oliver Haddo, who may be attempting to create a magical Moon Child and thereby bring about the end of the world. Nemo's daughter Janni

characters

- Orlando
- Prince Dakkar/Captain Nemo
- Hawley Griffin
- Allan Quatermain
- Dr. Jekyll/Mr. Hyde
- Janni Dakkar
- Mina Harker

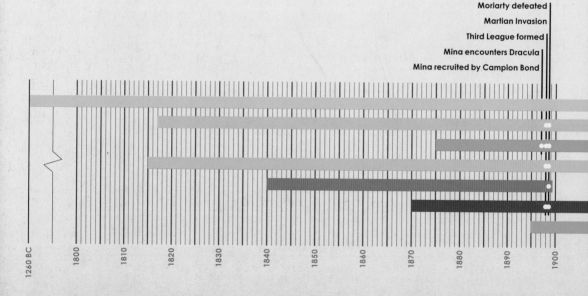

Moriarty defeated
Martian Invasion
Third League formed
Mina encounters Dracula
Mina recruited by Campion Bond

1260 BC 1800 1810 1820 1830 1840 1850 1860 1870 1880 1890 1900

runs away from Lincoln Island to London, where she is raped and then takes terrible vengeance with the aid of her father's submarine, *Nautillus*.

In 1925, Janni — now captain of the *Nautillus* — carries out a daring raid on wealthy tycoon Charles Foster Kane before following the trail of her father's 1894 expedition to Antarctica. Kane hires three inventors to hunt down the *Nautillus*, and their pursuit ends at the sinister alien city on the far side of the frozen Mountains of Madness. Many die, but Janni returns to the submarine and continues her travels.

In 1958, after the collapse of Britain's totalitarian IngSoc government and the death of its leader, Big Brother, Mina and Allan return to London to steal the Black Dossier. As they flee with this collection of intelligence on League members, they are pursued by Bulldog Drummond, Emma Night and a womanizing MI5 agent known as Jimmy. Mina and Allan narrowly

escape capture, and having discovered the truth about the death of Big Brother they return to the magical realm known as the Blazing World.

In 1969 Mina, Allan and Orlando return to Britain to fight Haddo, who stays alive by taking over the bodies of his followers. The three thwart an attack on Terner, a rock musician, but Haddo takes control of a teacher at a school for wizards. Mina is imprisoned in a lunatic asylum; Allan becomes a drug addict.

In 2009, Haddo's antichrist has already been born. Orlando returns to London and frees Mina; together they find the Moon Child among the ruins of a magical school that he destroyed after Haddo tried to control him. In the final battle, Allan tries to help his friends but is killed before forces from the Blazing World deal with the Moon Child once and for all. Allan is buried in Africa, and Mina and Orlando join forces in a new, all-female version of the League. **SB**

Source of Eternal Life discovered

Quatermain takes on identity of his son

Orlando meets Mina Harker

Nemo dies on Lincoln Island

Oliver Haddo begins quest to create Moon Child

Black Nautillus attacks Thames Docks

Janni Dakkar raids Charles Foster Kane

Black Dossier stolen

Oliver Haddo defeated

Mina committed to an asylum

Moon Child defeated

Quatermain killed

1900　1910　1920　1930　1940　1950　1960　1970　1980　1990　2000　2010

The League of
Extraordinary
Gentlemen
(1991–2000)

The League of
Extraordinary
Gentlemen:
Volume Two
(2002–03)

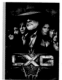

The League of
Extraordinary
Gentlemen
(2003)

The League of
Extraordinary
Gentlemen:
Century 2009
(2012)

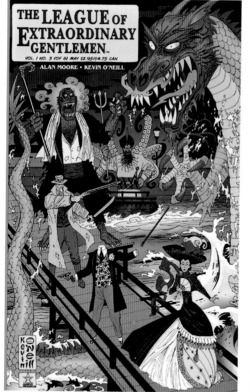

The cover of issue 3 of *The League of Extraordinary Gentlemen*, in which the League meet the crime lord Fu Manchu.

Volume Two sees the League battle Tripods, the Martian fighting machines from H. G. Wells' *The War of the Worlds*.

Jason Flemyng as Mr. Hyde. Flemyng wore a prosthetic suit to play the character — according to Steve Johnson, whose special effects company designed it, "The area around his mouth is the only thing that actually was his own skin."

(L–R) Dorian Gray (Stuart Townsend), Allan Quatermain (Sean Connery), Tom Sawyer (Shane West), Captain Nemo (Naseeruddin Shah), Rodney Skinner (Tony Curran) and Mina Murray (Peta Wilson).

(L–R) Captain Nemo (Naseeruddin Shah), Dorian Gray (Stuart Townsend) and Allan Quatermain (Sean Connery) in a scene from the movie.

Mina Murray (Peta Wilson) survived Dracula but picked up some of his bad habits.

Orlando as depicted in *The League of Extraordinary Gentlemen: Century 2009*.

20th century boys 1999

20th Century Boys

21st Century Boys

20th Century
Boys Part 1:
Beginning of
the End

20th Century
Boys Part 2:
The Last Hope

20th Century
Boys Part 3:
The Last Chapter–
Our Flag

Created by Naoki Urasawa and named after a pop song by T-Rex, *20th Century Boys* initially ran in the pages of the weekly *Big Comic Spirits* from 1999 to 2006. The premise involves a group of childhood friends reuniting as adults to try to stop a cult leader called Friend from taking over the world. At the center of the group is Kenji Endo, who once dreamed of being a rock star but wound up working in a convenience store while looking after his young niece, Kanna, whose mother vanished. When Kenji was a boy, he and a group of friends wrote a fictional story called "The Book of Prophecy" that foretold a lethal virus outbreak, terrorist bombings, a giant robot stomping through Tokyo and the end of the world. Years later when Kenji and his friends have drifted apart and the story has long since been lost, the events they imagined start to happen.

Against a background of classic science fiction motifs such as flying saucers and giant robots, the story deals with the loss of innocence and the compromises of adulthood.

20th Century Boys was not Urasawa's first hit series. His dark thriller *Monster* — which started in 1994 and concerned a manipulative serial killer — won several major manga awards and was adapted into an anime series by Madhouse Studios.

20th Century Boys made the leap to the big screen, spawning a live-action trilogy directed by Yukihiko Tsutsumi that was released in Japan in 2008 and 2009. The first instalment, *20th Century Boys 1: Beginning of the End*, topped the box office chart for two weeks and took $35.9 million to became the year's tenth biggest film in Japan. *20th Century Boys 2: The Last Hope* again topped the charts for two weeks and came in at #21 for 2009, and *20th Century Boys 3: The Last Chapter – Our Flag* held on to the top spot for six consecutive weeks and was number nine for the year. Critical reaction was mixed, with *Variety* describing the first film as "entertaining if not entirely satisfying" and many critics noting the problems Tsutsumi faced in trying to condense the manga's complex plot into the trilogy's seven-hour running time. The films were released in the West and the manga has been translated into several languages, including an English version published by VIZ Media. In Japan, the manga serialization was collected in 22 volumes and proved hugely popular — in the month of the release of the second film, *20th Century Boys* outsold the record-setting series *One Piece*. Urasawa has released an album, *Half Century Man*, under the name Bob Lennon that includes "Kenji's Song" from the films. **DWe**

year-by-year　■ Manga　■ Movie

20th Century Boys
Naoki Urasawa

21st Century Boys
Naoki Urasawa

20th Century Boys Part 1: Beginning of the End
Yukihiko Tsutsumi

20th Century Boys Part 2: The Last Hope
Yukihiko Tsutsumi

20th Century Boys Part 3: The Last Chapter – Our Flag
Yukihiko Tsutsumi

1995　　2000　　2005　　2010　　2015

danny boyle 1999

| Alien Love Triangle | 28 Days Later | Sunshine | 28 Weeks Later | Frankenstein |

One of the leading British directors of the late 20th and early 21st centuries, Danny Boyle has covered such diverse and disparate genres as thriller, family-friendly and science fiction.

Boyle began his artistic career directing for the stage, but by 1987 he had moved to television. Over the next seven years he worked on numerous series and one-off dramas, including the satirical *For the Greater Good* (1991) and episodes of *Inspector Morse* (1990 and 1992). His big break came in 1994 when he directed the Hitchcockian thriller *Shallow Grave*. The film was a cult hit, but its achievements were dwarfed in 1996 by *Trainspotting*. This intense, inventive story of drug addiction captured the cultural zeitgeist and launched the Hollywood careers of both Boyle and its star, Ewan McGregor.

Boyle then turned down an offer from 20th Century Fox to direct *Alien Resurrection* (1997). Instead he directed *A Life Less Ordinary* (1997) and then made his first sortie into science fiction with *Alien Love Triangle* (1999). This 30-minute four-hander with Kenneth Branagh, Alice Connor, Courteney Cox and Heather Graham was intended as part of a trilogy of short films, but the other two works were never made. He followed these with *The Beach* (2000), based on the novel by Alex Garland, which depicts a utopian/dystopian paradise on an Earth that could for all intents and purposes be another world entirely. As the film progresses, its increasingly psychedelic elements move it further into the realm of trippy, post-William Gibson, reality-altering possibilities.

Boyle's first full-length science fiction film was *28 Days Later* (2002), a horror story in which a mystery virus has turned the population of Britain into mindless, bloodthirsty killers. This low-budget take on the zombie genre that had usually been the domain of U.S. filmmakers was a critical and commercial success.

The director again worked on a smaller scale with the whimsical *Millions* (2004) before taking on his most ambitious project yet, the Garland-scripted science fiction thriller *Sunshine* (2007) about an international team of scientists and engineers on a mission to reignite the dying sun. It was based as much as possible on science fact and was informed by Brian Cox, Professor of Particle Physics and Astronomy at the University of Manchester. A difficult shoot resulted in an uneven blend of *Event Horizon* (1997) and *Solaris* (1997). Citing earlier directors such as Stanley Kubrick, who decided that one science fiction film (*2001: A Space Odyssey*) was enough, Boyle said: "I would never go back into space."

So far Boyle has kept his word, but following his Oscar success with *Slumdog Millionaire* (2008) he returned to science fiction when he tackled one of its cornerstones in his 2011 stage production of *Frankenstein* at the National Theatre in London.

With survival drama *127 Hours* (2010), his triumphant direction of the opening ceremony of the London 2012 Olympics, and the twist-filled psychological thriller *Trance* (2013), Danny Boyle has returned time and again to his main concern: the humanity of people in desperate circumstances. **SW**

year-by-year ■ Movie ■ Play

| | Alien Love Triangle | | Sunshine | | Frankenstein |

28 Days Later

28 Weeks Later

1995 2000 2005 2010 2015

dark angel 2000

Dark Angel

Dark Angel: Before the Dawn

Dark Angel: Skin Game

Dark Angel: After the Dark

Lasting for 43 episodes over two seasons, the teen-orientated, near-future dystopian cyberpunk adventure show *Dark Angel* told of a ruined United States in which genetically enhanced X-5 super-soldiers hide out from government agents in a just-better-than third world Seattle, and attempt to piece together the mysteries of their past.

Max Guevara (19-year-old Jessica Alba in her first major role) had fled with 11 other prototype super-solders from Manticore, a top-secret government outfit. Soon after their escape, a cyber-terrorist electromagnetic pulse attack on the United States destroyed communications networks and plunged the country into chaos. Max now works as a motorbike messenger, seeks out her missing siblings, dodges Manticore agents and fights corruption.

Dark Angel's first season juggled assorted mysteries — various X-5s come into Max's life, and power struggles within Manticore loom large — with girl-finding-her-way-in-the-world heartbreak, plus assorted stand-alone adventures where an essentially kind-hearted Max helps people in trouble.

In the less-well-liked second season Max combats the Conclave — a millennia-old "Breeding Cult" that produces telekinetics and other superhumans more powerful than the X-5s — and Manticore-developed transgenics now freed from their facilities.

It turns out Manticore was created by renegades within the cult and was perhaps not as evil as had at first been thought. The truth was due to emerge later, but it never did because the series was spiked before production began on the projected third season.

Dark Angel is notable as the project that made Alba's name and as the only TV outing for its co-creator, Oscar-winning filmmaker James Cameron. It is not without its flaws — too many monsters-of-the-week, a one-dimensional sub-Buffy supporting cast, and occasionally awkward line deliveries, not least by the still-inexperienced Alba — but it is a show to like, and some are obsessed by it.

In time the creators of *Cybersix* — an early 1990s' Argentine comic book, later made into an unsuccessful live action TV series and then a more popular animated one — brought a lawsuit against Cameron for plagiarism; the case was eventually dropped. Although the two works have some superficial similarities — evil scientists, escaped female super-soldiers lying low, nocturnal battles with other on-the-run superhumans — the stories develop in rather different ways: *Dark Angel* lacks *Cybersix*'s techno-vampire aspects, for instance. And, indeed, it has been persuasively suggested that the Robert Heinlein novel *Friday* is at least as likely a source for *Dark Angel* as the South American publication. **GH**

year-by-year ■ TV series ■ Book

Dark Angel
🖳 James Cameron, Charles H. Eglee

Dark Angel: Before the Dawn
❧ Max Allan Collins

Dark Angel: Skin Game
❧ Max Allan Collins

Dark Angel: After the Dark
❧ Max Allan Collins

2000 2005 2010 2015

m. night shyamalan 2000

Unbreakable

Signs

The Happening

After Earth

There have been few more meteoric rises and falls from grace than that of Indian-American writer/director M. Night Shyamalan, whose first major film was a commercial and critical smash hit, but whose subsequent career has been a succession of minor disappointments and yet has so far featured no complete box office disasters.

Born in India in 1970 to a Hindu father and a Tamil mother, and brought up in Philadelphia, Pennsylvania — the setting for many of his films — Manoj Shyamalan (known as "Night") made dozens of short Super-8 films in his teens. He shot his semi-autobiographical first feature while at New York University's Tisch School of the Arts, and his second a few years later; both were extremely low budget, but played at film festivals and had some critical success.

After co-scripting She's All That and Stuart Little (both 1999), Shyamalan moved into the genres with which he has become most associated — stylish, deliberately paced, somewhat sentimental science fiction, fantasy and horror mysteries, each culminating with a twist that invites audiences to reassess everything they've seen. The Sixth Sense (1999) — with Bruce Willis as a troubled child psychologist whose latest patient claims he can see ghosts — was an immediate success and was nominated for six Academy Awards including Best Picture. It marked Shyamalan as a talent to watch. The quieter follow-up — Unbreakable (2000), also with Willis — found an audience too. This was a realistic, downbeat take on the superhero story.

Signs (2002), with Mel Gibson, was a similarly twisty entry to the alien invasion genre, whereas The Village (2004) had some of the feel of Arthur Miller's play The Crucible, telling of a 19th-century community in the woods terrorized by dangerous creatures. All four of these films had a steady pace, flirted with silliness and relied for much of their impact on a late twist. They were all commercially successful, but reviews were rapidly cooling .

When Lady in the Water (2006) opened to a dire critical reception, it seemed like the wheels were starting to come off. Shyamalan's next effort, The Happening (2008), a sort of ecological-cum-supernatural disaster film, made money but received similarly scathing notices. The Last Airbender (2010), based on an animated children's cartoon series, got an even worse mauling — it won five Razzie Awards — although a strong overseas performance made it a fair-sized commercial hit.

Fearing that Shyamalan had become box-office poison, the producers of After Earth (2013) played down the name of its director and promoted it on that of its star, Will Smith. Again it was panned, but again it made money. M. Night Shyamalan was thus in an unusual position: a distinctive director, with his own style and sensibility, once critically loved, now critically reviled, who finds it difficult to make a film that doesn't make money. His current project, Labor of Love, again with Bruce Willis, is scheduled for release in 2015 — if it is like one of his plots, it will be a succès d'estime and lose a fortune. **MB**

year-by-year ■ Movie

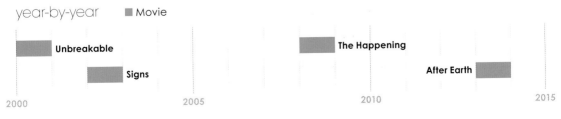

Unbreakable

Signs

The Happening

After Earth

2000　　　　2005　　　　2010　　　　2015

riddick 2000

Pitch Black

Pitch Black

The Chronicles
of Riddick

The Chronicles
of Riddick

The Chronicles
of Riddick:
Dark Fury

The Chronicles
of Riddick:
Escape from
Butcher Bay

An imposing, morally ambiguous killer with augmented eyes that give him the ability to see in the dark, Richard B. Riddick (Vin Diesel) first appeared in *Pitch Black* (2000), a modestly budgeted, visually stylish mix of action and science fiction horror directed by David Twohy.

With echoes of Isaac Asimov's "Nightfall," the story concerns events following a spacecraft crash on an alien planet that is lit almost permanently by a collection of suns. The survivors discover a race of monstrous light-sensitive creatures lurking in the shadows. During a year-long solar eclipse, the creatures go on the rampage and the survivors have to put their trust in Riddick.

With the mood of a bleak, violent Western, Twohy's rewrite of the original script by Jim and Keith Wheat featured strong female characters and cunning plot twists, especially when dealing with Riddick and his lawman adversary (Cole Hauser). Twohy combined this with sharp suspense and well-crafted digital effects in the monster sequences, resulting in a memorable and inventive thrill ride.

The production process was far from smooth — at one point the film was in danger of being released straight to DVD — but ultimately a theatrical release

was secured and *Pitch Black* went on to become an unexpected sleeper hit. With Diesel subsequently achieving major box office success with the action thriller *The Fast and the Furious* (2001), another outing for Riddick was suddenly on the table.

Resisting pressure to repeat the *Pitch Black* formula, Diesel and Twohy instead aimed for an ambitious epic that would, according to Diesel, be to *Pitch Black* what J.R.R. Tolkien's novel *The Hobbit* had been to *The Lord of the Rings*.

Expectations were high for *The Chronicles of Riddick*, and its 2004 release was backed up with both the animated prequel *Dark Fury* and the computer game *Escape from Butcher Bay*. Unfortunately the $100 million sequel was a garbled and over-designed mess that lacked *Pitch Black*'s elegant pulp nastiness.

Whereas the first film largely took the utilitarian, gritty SF world of Ridley Scott's *Alien* as its template, *The Chronicles of Riddick* veered wildly into a lurid, extravagant style reminiscent of David Lynch's flawed 1984 movie adaptation of *Dune*. Despite attempts to maintain continuity, the sequel felt more like a misconceived bid to craft a science fiction equivalent of classic fantasy hero Conan.

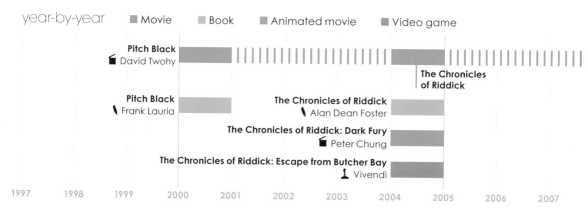

The Chronicles of Riddick: Assault on Dark Athena

Riddick

Riddick: Blindsided

Only a short interlude on a prison planet with lethal daylight brought back any good memories of the original film — the rest was all stodgy action and tangled mythology, with Riddick a chosen one with a hidden destiny pitched against the cartoonish evil of the Necromonger Army.

The Chronicles of Riddick acquired a few cult followers, but not enough to permit another sequel. With Diesel's star power apparently waning, any further adventures for Riddick seemed unlikely.

Then, in exchange for getting back the character rights to Riddick from Universal Pictures, Diesel returned to *The Fast and the Furious* franchise in 2009. The resulting films became massive successes, and Diesel's reclaimed box office clout meant he was eventually able to reteam with Twohy for a third time.

Riddick (2013) aimed to recapture the hard-boiled attitude of *Pitch Black* by replacing the mythology and toned-down violence of *Chronicles* with much swearing, gore and female nudity.

Although the small-scale plot followed on from *Chronicles*, *Riddick* was a predominantly self-contained SF action thriller in which the hero is betrayed and left for dead on an alien world. He fights lethal wildlife and two bands of mercenaries.

Independently financed and shot on a relatively slim budget of $35 million, Riddick pulled off some impressive visuals, especially in its largely dialogue-free opening half hour. Certain sequences captured the same visceral pulp thrills as *Pitch Black*, but that film's creative characterization was entirely absent, with both mercenary teams largely populated by unlikable two-dimensional cyphers. The treatment of female characters was especially bad, with *Battlestar Galactica* remake star Katee Sackhoff in a thankless role as a clichéd lesbian sharpshooter who finds herself "turned straight" by Riddick.

The film was a slick but unmemorable remix of *Pitch Black*. Although Diesel remained an intimidating screen presence, Riddick failed to win over the critics and only just made back its production budget at the U.S. box office. However, the film did well in overseas territories, and also managed a successful home video debut in early 2014.

Thanks to this, Diesel was able to announce soon after that a further adventure was entering development. As this volume went to press it was unclear whether the provisionally entitled *Riddick 4* would be small-scale like the original or a *Chronicles*-like attempt at a blockbuster. **SB**

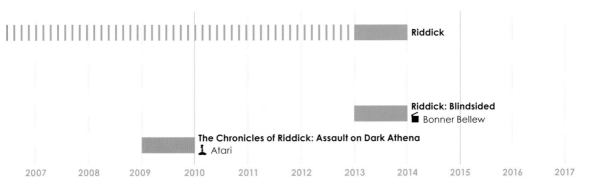

Riddick

Riddick: Blindsided
Bonner Bellew

The Chronicles of Riddick: Assault on Dark Athena
Atari

2007 2008 2009 2010 2011 2012 2013 2014 2015 2016 2017

Pitch Black
(2000)

**The Chronicles
of Riddick**
(2004)

Riddick
(2013)

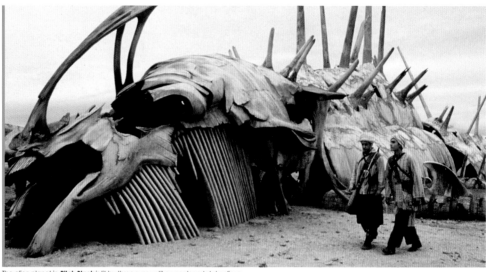
The alien planet in *Pitch Black* is lit by three suns until a year-long total eclipse.

Claudia Black as Sharon "Shazza" Montgomery in *Pitch Black*.

Thandie Newton (L) and Karl Urban in *The Chronicles of Riddick*.

Lavish, computer-generated "virtual sets" had become an everyday tool of SF by the time of *The Chronicles of Riddick*.

Vin Diesel flies into action in *The Chronicles*.

In *Riddick*, our hero is accompanied by an alien jackal.

The makers of *Riddick* made significant reductions in the wardrobe budget.

halo 2001

Halo:
Combat
Evolved

Halo:
The Fall of
Reach

Halo:
The Flood

Halo 2

Halo:
Ghosts of
Onyx

Halo 3

Halo:
Contact
Harvest

Halo:
Cole Protocol

Most SF franchises have developed from movies, but *Halo* is a series of video games that has produced sales to date of more than $4.38 billion and spawned a host of spin-off comics, novels, figurines, webisodes and even a TV series produced by Steven Spielberg.

When Microsoft entered the games console market, it needed a "killer app" that would help shift its hardware. It turned to Bungie Software Products Corporation, a small Chicago-based developer known for its first-person shooter *Marathon* and its real-time strategy title, *Myth*.

In 1999 Bungie unveiled *Halo*, a third-person shooter. The game's aesthetics and impressive scope brought it lots of attention — and in the summer of 2000 Microsoft shocked the industry by announcing that it had acquired Bungie, and that *Halo* would become a first-person shooter, appearing exclusively at launch on the Xbox.

Set in the 26th century, *Halo* tells the story of a lone soldier, Master Chief Petty Officer John-117, a cybernetically-enhanced SPARTAN II commando, who embarks on an epic battle with an alien alliance called the Covenant, which is intent on the destruction of humankind.

The game is notable for its production design and settings — the action takes place on a "Halo," a *Ringworld*-style alien installation. However, it is in fact a superweapon, capable of wreaking galaxy-wide destruction. It transpires, in *Halo*'s complex backstory, that it was built to stem the spread of the Flood, a dangerous parasitical lifeform. *Halo: Combat Evolved* launched with the Xbox in 2001 to great acclaim, and went on to sell more than 6.4 million copies.

In 2004 *Halo 2* continued the story, with the player alternating between John-117 and an alien character called the Arbiter, a disgraced Elite Covenant commander sent on a mission to kill heretics within the alliance. The tale flip-flops between the two, until they eventually meet in the tentacled grip of Gravemind, leader of the Flood. Despite an ever-more confusing storyline and abrupt, anticlimactic ending, the game was critically acclaimed and sold 8.5 million units.

By this stage, the *Halo* brand had come to the attention of Hollywood. With Peter Jackson on board as executive producer, Neil Blomkamp as director and a script by Alex Garland, things looked positive. To fulfil Microsoft's demands, 20th Century Fox and Universal partnered to finance the film, but money issues intervened and the project eventually stalled.

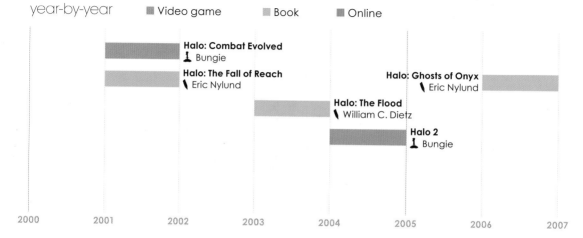

year-by-year ■ Video game ■ Book ■ Online

Halo: Combat Evolved
⚊ Bungie

Halo: The Fall of Reach
Eric Nylund

Halo: The Flood
William C. Dietz

Halo 2
Bungie

Halo: Ghosts of Onyx
Eric Nylund

2000 2001 2002 2003 2004 2005 2006 2007

| Halo Wars | Halo 3: ODST | Halo: Reach | The Forerunner Saga | Kilo-Five Trilogy | Halo: Legends | Halo 4: Forward Unto Dawn | Halo 4 |

The third installment debuted on Xbox 360 in 2007 and invited players to "Finish the fight." It earned Microsoft $170 million on launch day and $300 million by the end of the first week.

The new generation of hardware enabled Bungie to create a richer gaming experience, with enhanced graphics and a huge library of dialogue, including performances from Rob Perlman, Nathan Fillion, Katee Sackhoff and Terence Stamp.

The series continued in 2009 with *Halo Wars*, a spin-off real-time strategy (RTS) game developed by Ensemble Studios and set in the same universe 21 years before the events of *Halo: Combat Evolved*. It sold 2.3 million copies.

Bungie's next installment was another prequel, *Halo 3: ODST* (Orbital Drop Shock Troopers). Set in New Mombasa during the events of *Halo 2*, the game is played in flashback sequences, as players discover the fates of their team mates. It sold 6 million units, but it wasn't really what the fans wanted; the buzz was already beginning for the new "true" Halo game, *Halo: Reach*.

Here, Planet Reach is the main base for Earth's military forces, which come under attack from the invading Covenant. The player takes the role of Noble Six, a SPARTAN-III supersoldier, part of the remaining Noble Team. The Covenant are on Reach looking for secret information, and the team must transport an artificial intelligence named Cortana back to the cruiser *Pillar of Autumn* — thus segueing into the events of *Halo: Combat Evolved*.

Halo: Reach took $200 million on its first day and went on to sell nearly 10 million copies.

After being involved with the *Halo* franchise for more than a decade, Bungie finally decided it was time to create a new IP, the open-world first-person shooter *Destiny*. However, keen to keep the *Halo* brand alive, Microsoft formed its own internal development studio, 343 Industries.

Launched in 2012, *Halo 4* explored the Forerunner race, creators of the Halo superweapons. With day-one sales of 3.1 million units, it beat the biggest opening in U.S. box office history, *Harry Potter and the Deathly Hallows: Part 2*, taking $220 million.

The series plunders ideas from all manner of sources, but like *Star Wars*, *Warhammer 40,000* and *Avatar*, it melds them into a coherent new whole, rich with its own mythology and with a vast story arc spanning the ages. It is not high art, but it is engaging, action-packed and frequently awe-inspiring. **SJ**

Halo 3
♟ Bungie

Halo: Contact Harvest
❦ Joseph Staten

Halo: Cole Protocol
❦ Tobias S. Buckell

Halo Wars
♟ Ensemble Studios

Halo 3: ODST
♟ Bungie

Halo: Reach
♟ Bungie

The Forerunner Saga
❦ Greg Bear

Kilo-Five Trilogy
❦ Karen Traviss

Halo: Legends
@ Halo Waypoint

Halo 4: Forward Unto Dawn
@ Machinima Prime

Halo 4
♟ 343 Industries

| 2007 | 2008 | 2009 | 2010 | 2011 | 2012 | 2013 | 2014 |

halo universe

Mendicant
Bias AI

The Didact

John-117/
Master Chief

Halsey

One hundred thousand years before the first Halo device is found, a race called the Forerunners ruled a galaxy-wide empire until they were overwhelmed by the Flood, a parasitic species. The Forerunners built the Ark, which in turn created seven Halo rings capable of destroying all sentient life in the galaxy, depriving the Flood of its prey. When the Halo array was activated, the Forerunners disappeared.

Over time, the legend of the Forerunners helped to forge the Covenant, a theocratic alliance of alien races. Comprised of eight main species, and ruled by the High Prophets, the Covenant worships the Forerunners and seeks out the artifacts of this vanished race.

By the 22nd century, humankind is colonizing the solar system, but disputes between various social and political factions prompt the creation of a powerful military force, the United Nations Space Command (UNSC). At the turn of the 24th century, the first faster-than-light colony ships enable expansion beyond the solar system. To help quell colonial uprisings, the SPARTAN-II project is born, which aims to create cybernetically enhanced supersoldiers.

In 2525, contact is made between the Covenant and colonists on planet Harvest. The aliens believe that Harvest has Forerunner artifacts, but when they capture them they discover that they are human-made. The Covenant realizes that humans are "living Forerunners," but decides to keep the discovery secret and declares a holy war on all humans.

Within a decade, the human species has retreated to the UNSC's base on planet Reach. When the Covenant attacks Reach, Master Chief John-117 and Cortana, an artificial intelligence that resides in his suit, escape in a spaceship that crash-lands on one of the Halo installations.

Master Chief and Cortana round up the remaining UNSC forces and rescue Captain Jacob Keyes from the Covenant. Keyes tells Master Chief to get to the Halo's control room, but on the way they find that the Covenant has unwittingly released remnants of the Flood that were incarcerated on the ring.

The AI discovers the true destructive purpose of the Halo, so Master Chief, instead of activating it, as he had at first intended, blows it up, then makes his escape and returns home.

characters

■ Mendicant Bias AI ■ The Didact ■ John-117/Master Chief ■ Halsey

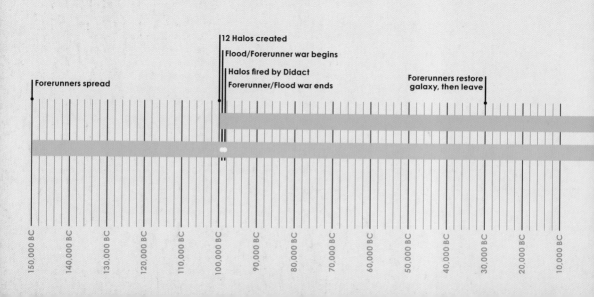

12 Halos created

Flood/Forerunner war begins

Halos fired by Didact
Forerunner/Flood war ends

Forerunners restore
galaxy, then leave

Forerunners spread

150,000 BC · 140,000 BC · 130,000 BC · 120,000 BC · 110,000 BC · 100,000 BC · 90,000 BC · 80,000 BC · 70,000 BC · 60,000 BC · 50,000 BC · 40,000 BC · 30,000 BC · 20,000 BC · 10,000 BC

The Covenant begins an invasion of Earth. Most of its fleet is scattered by UNSC forces, but a solitary cruiser remains carrying the High Prophet of Regret. Master Chief pursues him into space, where he finds another Halo installation. He leaves his team to find the key while he continues the chase.

A Covenant Elite commander who has destroyed a Halo is demoted to "Arbiter" and sent on a mission to kill a Covenant heretic. The Arbiter is betrayed and pushed into the tentacles of Gravemind — leader of the Flood — where he encounters Master Chief, who has also been captured. Gravemind suggests that the three of them form an alliance.

Discord within the Covenant sparks a civil war in which the betrayed Elites side with the UNSC. The High Prophet of Truth orders the Halo to be activated, and while Master Chief and his crew prevent its detonation, a failsafe protocol puts all the remaining Halos on standby, awaiting a signal from the Ark.

Rejoining the battle above Earth, Master Chief crash-lands in Africa, near the site of a Forerunner artifact. The High Prophet of Truth opens a slipspace portal to the Ark.

Together with a band of UNSC and Elite forces, Master Chief and the Arbiter follow the High Prophet; so too do Gravemind and the Flood. Gravemind betrays Master Chief and the Arbiter but they manage to escape the Flood forces.

Master Chief destroys the Ark and a new Halo, but the resulting shockwave causes a tear in slipspace that destroys his ship. The Arbiter crash-lands on Earth, while Master Chief and Cortana are left floating through space.

Four years later, Cortana awakens the Master Chief from cryo-sleep as they approach Requiem, a Forerunner planet. A Dyson sphere holds the Didact, a Forerunner warrior who controls a race of Prometheans — "composed" digital humans who are impervious to the Flood.

The Didact is released and, after journeying to a Halo ring, heads for Earth. Master Chief and Cortana follow, enter the Didact's ship and defeat him before he can "compose" the planet's population. Master Chief destroys the Didact's ship with a nuclear bomb and is saved by Cortana, who generates a hard light shield before disappearing forever. **SJ**

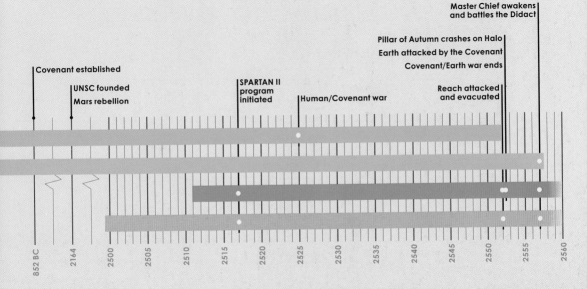

Master Chief awakens
and battles the Didact

Pillar of Autumn crashes on Halo
Earth attacked by the Covenant
Covenant/Earth war ends

Covenant established

UNSC founded

Mars rebellion

SPARTAN II
program
initiated

Human/Covenant war

Reach attacked
and evacuated

852 BC 2164 2500 2505 2510 2515 2520 2525 2530 2535 2540 2545 2550 2555 2560

Halo 3
(2007)

Halo: Reach
(2010)

Halo 4
(2012)

In **Halo 3** players take the role of the Master Chief, a cybernetically enhanced supersoldier, as he battles the Covenant.

Halo 3 grossed $300 million in its first week and more than one million people played the game on Xbox Live in the first 20 hours of its release.

Halo 3 was heralded an overwhelming success by critics.

Halo: Reach grossed $200 million on its launch day.

Halo: Reach was developed as a prequel to the original game trilogy, set in the year 2552 during the events of the novel *Halo: The Fall of Reach*. Players assume the role of Noble Six, a member of an elite supersoldier squad.

Tom Hoggins of *The Daily Telegraph* described **Halo: Reach** as a "blistering, breathless crescendo to a decade's worth of work."

The design for **Halo 4**'s Cortana was based on the Ancient Egyptian Queen Nefertiti.

28 days later 2002

28 Days Later

28 Weeks Later

28 Days Later:
The Aftermath

28 Days Later

28 Days Later is a British apocalypse horror film, directed by Danny (*Trainspotting*) Boyle and scripted by Alex Garland, author of *The Beach*. It fuses John Wyndham's *The Day of the Triffids* with the zombie tradition exemplified by George A. Romero in *Dawn of the Dead* (1978).

The film opens with protagonist Jim (Cillian Murphy) awaking from a coma in a deserted hospital. Outside, central London is silent and seemingly deserted. The empty city is powerfully envisioned. Some images seem impossible — how could the filmmakers have shot London landmarks for real in daylight with not a bystander in sight? (In fact, the scenes were shot at dawn.) One of those rare SF films that do not depend on special effects, *28 Days Later* is lent an expressionist quality by cinematographer Anthony Dod Mantle's use of digital video.

Britain has been all but wiped out by a human-made plague that turns people into mindless, shrieking killers. Boyle said he was influenced by stories of so-called "road rage" and other new ways of going berserk. The conventions in *28 Days Later* are similar to those of zombie films, although the Infected don't lurch, they sprint. If they don't rip you apart, then their bites or blood will make you one of them in seconds. In the most harrowing scene, one of the most lovable characters is infected, and has barely a moment to blurt goodbye.

After Jim and his surrogate family of survivors escape to the country, the final act of the movie involves a meeting with a group of soldiers, led by Christopher Eccleston, who have escaped the plague and are combating its spread. But their methods are monstrous — the treatment is almost as bad as the condition it purports to cure. Such nightmarish escapes from danger into worse trouble are an apocalypse tale tradition — there are similar plot turns in *Triffids* and in Romero's films.

A late twist suggests that the disaster is confined to Britain, leaving the rest of the world unaffected. This idea was developed in the sequel, *28 Weeks Later*, with a different cast and Juan Carlos Fresnadillo (*Intacto*) as director, although Boyle and Garland had producer credits. This film has the United States resettling British refugees in London after the Infected have supposedly burned themselves out. When the plague starts again, the U.S. response is to annihilate Infected and civilians together. This has been taken as a commentary on the real-life War on Terror. Fresnadillo also turns the family (a positive motif in the first film) into a nightmare, as an infected father played by Robert Carlyle hunts his children.

There were two print spin-offs from the films. *28 Days Later: The Aftermath*, a graphic novel, follows the fortunes of other characters when the original plague breaks out. The subsequent 24-issue comic book series (called simply *28 Days Later*) brings back a character from the first film, who must return to Britain and face the Infected again. It was later reprinted as a series of six collections. **AO**

firefly 2002

Firefly

Serenity

Serenity:
Those Left Behind

Serenity:
Better Days

Serenity:
Float Out

In 2002, while overseeing *Buffy the Vampire Slayer* and its spin-off *Angel*, writer/director/producer Joss Whedon was inspired by reading *The Killer Angels* (1974), Michael Shaara's novel about the Battle of Gettysburg, to pitch a proposal for a TV series that fused science fiction with elements of the traditional Western genre. Whedon wanted to tell the story of members of the losing side in a conflict who had survived on the edge of civilization, but place the action in an extraterrestiral setting. The result was *Firefly*, which Whedon summarized as being about "nine people looking into the blackness of space and seeing nine different things."

The nine were the crew and passengers of the Firefly-class starship *Serenity*, captained by Malcolm ("Mal") Reynolds (Nathan Fillion). Mal and second-in-command Zoe (Gina Torres) fought for the losing Browncoats in the Unification War against the Alliance worlds. They and their crew have subsequently struggled to survive in outlying worlds that resemble the Wild West.

Serenity's pilot (and Zoe's husband) is Wash (Alan Tudyk), its mechanic is Kaylee (Jewel Staite); muscle is provided by Jayne Cobb (Adam Baldwin). Diplomacy — and other services — are handled by Inara (Morena Baccarin), a "companion" or escort. In the original series pilot, *Serenity* takes on three passengers — Shepherd Book (Ron Glass), a pastor, and Simon and River Tam (Sean Maher and Summer Glau), a brother and sister on the run from the Alliance.

Firefly was constantly beset by production problems. Executives at the Fox network, concerned about the lack of action and the dark portrayal of Mal, rejected the pilot, so Whedon and co-writer Tim Minear quickly produced another one in which the crew pulled off a daring heist and Mal had a sunnier disposition. This got them the go-ahead, but there were further conflicts to come. Fox broadcast episodes out of production order and regularly rescheduled *Firefly* in order to accommodate various sporting events. Never really given a chance, the series was cancelled in December 2002 after only 14 episodes.

It was on DVD that the series really connected with a strong audience. Sales of the complete box set sold in sufficient numbers to convince Universal Pictures that they should acquire film rights. The crew would fly one last time on the big screen in *Serenity*, written and directed by Whedon, which was released in 2005. The series cast reprised their roles in a movie that tied up *Firefly*'s loose ends and revealed the true nature of the Alliance experiments on River. *Serenity* was well received by critics but narrowly failed to make a profit.

Although several comic books co-written by Whedon continued the *Firefly* story, no further screen adventures were commissioned. This was lamented by a legion of devoted fans who regarded the spiking of the series as one of the great missed opportunities of science fiction television. **MW**

year-by-year ▓ TV series ▓ Movie ▓ Comic

Firefly
▢ Fox

Serenity
▮ Joss Whedon

Serenity: Those Left Behind
▢ Dark Horse

Serenity: Better Days
▢ Dark Horse

Serenity: Float Out
▢ Dark Horse

2000 2005 2010 2015

the walking dead 2003

The Walking Dead

The Walking Dead

Rise of the Governor

The Road to Woodbury

The Walking Dead

The Fall of the Governor

Robert Kirkman's comic, *The Walking Dead*, was a crucial part of a new zombie wave that emerged at the turn of the century. Mankind has always been fascinated by stories of the apocalypse, and with the first few years of the 21st century offering terrorist attacks, mindless consumerism and natural disasters on an unprecedented scale, the possibility of the end of everyday life and an uncertain future once again made zombies as pointed a metaphor as they had been for civil liberties in the 1930s and for paranoia in the 1960s.

With its realistic, harsh and detailed black and white artwork *The Walking Dead* is a distinct and beautiful graphic novel, despite the presence of death seemingly on every page. The tone is determinedly adult and is an emotionally and physically brutal read, the punishing experience forcing the reader to empathize with the story's survivors. A sense of doom hangs over humanity's efforts to reclaim their lives. The zombie hordes fade into the background as the survivors become their own worst enemy, struggling for land, safety, supplies and facing the prospect of being the final generation. And this is the comic's power, its harrowing examination of group dynamics in a truly grim post-apocalyptic setting. It certainly found an audience — a consistent bestseller, Kirkman claims he will push the series at least as far as issue #300.

Away from the printed page, in 2011 a TV adaptation was shepherded to the small screen by Frank Darabont and Gale Anne Hurd, the former stepping further into apocalypse on a grand scale after the stunning Stephen King horror *The Mist*. American Movie Classics (AMC) broadcast the show, taking a bold step into genre television and mirroring HBO's success with *True Blood* and *Game of Thrones*. *The Walking Dead* was an instant hit and the biggest, most expansive showcase yet for zombies.

The series maintains the grimy, dirty and mature content of the comic, and has perfectly realized key moments and characters. The original ingredients are all there but the adaptation has also branched off in directions of its own. It is not in thrall to the comic and has proved this on numerous occasions, not least with the unexpected deaths of fan-favorite characters.

The Walking Dead may be the most harrowing, intelligent and comprehensive study of zombies we have yet seen. **SW**

year-by-year ■ Comic ■ TV series ■ Book ■ Video game

The Walking Dead
▢ Image Comics

The Walking Dead
▢ AMC

The Road to Woodbury

Rise of the Governor
Robert Kirkman, Jay Bonansinga

The Fall of the Governor

The Walking Dead
Telltale Games

2000 2005 2010 2015

steamboy 2004

Steamboy

Steamboy

It's London in 1866, and in the shadow of Crystal Palace, a troop of British police officers runs pell-mell from an army of "Steam Troopers" — clanking figures in steam-powered armor. Above the action, an obsequious flunky of the American O'Hara foundation flogs these weapons of mass destruction to foreign buyers. The foundation's teen heiress, called (what else?) Scarlett, storms out, demanding to know what's happening. "Something in the way of a war with Britain," the flunky answers reluctantly, "combined with a product demonstration." The girl surveys the smoking carnage. "Don't lose," she says.

Seventeen years after Katsuhiro Otomo transformed attitudes to anime with *Akira*, *Steamboy* marked his embracing of steampunk. Otomo had dipped his toe into the subgenre before, with "Cannon Fodder," his segment of the anime anthology, *Memories* (1995), which he set in a city of hissing pipes and giant cannons. But *Steamboy* is full-on, classic Otomo cinematic bombast. Possessed of similarly jaw-dropping sequences to *Akira*, *Steamboy* opens in a retro-techno Manchester where paper-boys shout "Ground-up bones found in bread!" Soon after, there's a titanic chase featuring a motorized unicycle and a monster locomotive. Later, a pre-Wright Brothers flying soldier smashes into London's Great Exhibition blowing it sky high ... And so it goes on.

Steamboy is mostly magnificent, but is tripped up by Otomo's expressed desire to create a movie as "one big scene, with no divisions." The plots of both *Akira* and *Steamboy* dissolve into continuous spectacle, but whereas the former's apocalypse remains truly astonishing to the last moment, *Steamboy*'s finale runs out of drama and indeed steam, leading to a numbing crescendo of destruction.

Anime's previous steampunk yardstick had been Hayao Miyazaki's *Castle in the Sky* (1986), which Otomo acknowledges in *Steamboy*'s climactic vision of a massive fortress floating over Victorian London, giving it the kind of treatment usually meted out to Tokyo by Godzilla. In their retro-styling, both anime films draw on the Fleischers' action-packed *Superman* cartoons of the 1940s.

Together with Miyazaki's earlier effort, *Steamboy* demonstrates the spread of steampunk beyond Europe and America. In the main, Japanese audiences seem to prefer their steampunk mixed with fantasy: indeed, one of the most successful manga/anime franchises of the 2000s was *Fullmetal Alchemist*, set in a world looking like Europe circa 1900, where robotics and alchemy go hand-in-hand. Otomo, however, follows the European steampunk mode, festishizing thrusting pistons and the jetting steam of machinery, rather than providing any mystical explanation for the way his devices operate.

Still one of the most expensive Japanese animated movies to date, *Steamboy* was internationally released in a shorter dubbed version, cutting much of the wonderful vision of industrial Manchester. There was also talk of a sequel, and even a *Steamgirl* spin-off, but nothing emerged apart from a Japanese-language PlayStation 2 video game. **AO**

year-by-year ■ Anime ■ Video game

Steamboy
🎬 Katsuhiro Otomo

Steamboy
⚲ Bandai

2000 2005 2010 2015

lost 2004

Lost

No show since the turn of the century had divided audiences as much as this mystery-drama-adventure-science-fiction saga. Part *Robinson Crusoe*, part *Twin Peaks* (1990), *Lost* follows what happens to the passengers of Oceanic flight 815 after it crashes down on an island somewhere in the Pacific Ocean. The pilot episode begins moments after the crash and throws the viewer straight into the ensuing chaos and confusion. One by one we meet the key players as they come to terms with their new life on the island. By the end of episode two not only are they struggling to survive in harsh conditions, but they have also discovered a polar bear and a 16-year old radio transmission emitting from the island. This, truly, is just the start of what's in store.

Uncanny happenings aside, central to *Lost* are the characters and their relationships. The brilliant idea, deftly woven into each episode, is the way flashbacks are used to provide details of characters' lives before the crash. We learn about Jack's career as a surgeon, Kate's criminal past, Locke's hidden secret and how and why these people were brought together.

Originally conceived as a cross between *Lord of the Flies* and *Gilligan's Island*, and heavily influenced by *The Twilight Zone*, the pilot was initially written by Jeffrey Lieber before J.J. Abrams was brought on to develop the project. The eventual two-part pilot was one of the most expensive TV episodes ever given the green light and featured Hollywood-style production values despite a relatively unknown cast.

Season one is a voyage of discovery revolving around a sinister "smoke monster" and Locke's attempts to uncover and gain entrance to a mysterious hatch. Series two focuses on the survivor's struggle with the island's other inhabitants, the "Others," while also introducing the device of a button that must be pushed every 108 minutes to prevent the destruction of the island. Despite hinting at supernatural occurrences and a clash of faith and science, it was not until the third series that the show made a genuine commitment to science fiction, when the critically acclaimed episode "Flashes Before Your Eyes" twists the established formula by revealing Desmond's flashback, in fact, to be time travel. From here the less-grounded elements of the show took flight, resulting in possession, immortality, a hydrogen bomb, and at one point the island changing its location due to an ancient device. New characters are introduced and by season six the flashbacks/flash-forwards have become flash-sideways and the mythology of the island gives way to spirituality. The show becomes increasingly high concept but suffers only when it overlooks the characters in favor of obfuscation.

Over six seasons *Lost* introduced new characters, killing off fan-favorites, and delivering killer twists. What do the numbers mean? Who is Jacob? Is the island some form of purgatory? Will Jack and Kate ever get together? Will Sawyer and Kate ever get together? By the time it ended many questions had been answered but others left ambiguous. The characters are asked, did you really want to leave the island? While at the same time the audience is asked, do you really want to know all the answers? **SW**

year-by-year ■ TV series

Lost
☐ ABC

2000 2005 2010 2015

neill blomkamp 2004

TETRA VAAL

A NEILL BLOMKAMP MOVIE

ALIVE JOBURG

DISTRICT 9

MATT DAMON JODIE FOSTER
ELYSIUM
FROM THE DIRECTOR OF DISTRICT 9
AUGUST

Tetra Vaal Alive in Joburg District 9 Elysium

A writer, director and visual effects animator who cut his teeth on short films and commercials, South African-born Neill Blomkamp burst onto the science fiction scene in 2009 with *District 9*. This satirical blockbuster earned immense critical praise and immediately established him as a fine director of large-scale but independently minded pictures.

His first foray into science fiction filmmaking had come in 2004 when he directed the short film *Tetra Vaal*, a fake advertisement for a robotic law enforcement officer. The following year he created, alongside his wife, Terri Tatchell, the short *Alive in Joburg*. Both short films featured high-end digital effects that blended seamlessly with documentary-style footage of Johannesburg.

Alive in Joburg caught the eye of Peter Jackson, who attached Blomkamp as the director of his *Halo* feature film, based on the popular video game series. A troublesome co-production between Universal and 20th Century Fox, *Halo* eventually disappeared into a development black hole.

With the support of Jackson, Blomkamp set about adapting *Alive in Joburg* into a full-length feature. The result was *District 9*, a thinly-veiled study of apartheid that sees aliens on Earth shunted into ghettos. Its blend of allegory, action and comedy took audiences by surprise, making over $200 million worldwide and even garnering an Academy Award nomination for Best Film.

District 9 was followed in 2013 by *Elysium*, a big budget summer blockbuster with socio-political concerns. Matt Damon plays Max Da Costa, a factory worker who lives on a ravaged Earth in the ruins of Los Angeles in the year 2154. It's a dystopian vision where the majority of humanity lives in poverty, while the wealthy have retreated to a man-made space station called *Elysium*. Suffering radiation poisoning, Max has five days to break in to Elysium to get treatment, his actions simultaneously threatening to break down the barriers of inequality. Reuniting with his *District 9* star, Sharlto Copley, *Elysium* also saw Blomkamp working with designer Syd Mead, one of the giants of science fiction cinema, who contributed original artwork.

Both *District 9* and *Elysium* exist in impressively fleshed-out and lived-in worlds. Favoring the grime and grit of realism over the polished sheen of more traditional Hollywood science fiction, Blomkamp fashions environments, stories and characters that are relatable and all the more meaningful for it.

Science fiction serves Blomkamp's aim to explore themes, not to preach or chastise but to make one think, in doing so creating an intellectual science fiction for the masses. "The way I look at the world is already almost the science fiction version of it. You have areas in the First World co-existing at the exact same minute as poverty-stricken kids in India are lying under concrete by the side of a sewer."

In 2013 he began preproduction on *Chappie*, a science fiction comedy once again starring his childhood friend Sharlto Copley. And like *District 9*, *Chappie* is also based on one of Blomkamp's short films — in this case, his debut *Tetra Vaal*. **SW**

year-by-year ■ Movie

Tetra Vaal

Alive in Joburg

District 9

Elysium

2000 2005 2010 2015

christopher nolan 2005

| Batman Begins | The Prestige | The Dark Knight | Inception | The Dark Knight Rises | Man of Steel | Interstellar |

An Anglo-American filmmaker with a darkly serious worldview and a love of complex narrative structures, Christopher Nolan started making films from the age of seven, and by his twenties was able to self-finance his micro-budgeted debut feature *Following* (1998) by working in London as a freelance cameraman.

His second film, *Memento* (2000), a thriller told in reverse chronological order, netted him widespread acclaim and an Oscar nomination for Best Screenplay, whereas his follow-up *Insomnia* (2002) showed he could be a reliable director of mainstream Hollywood thrillers.

Nolan's next step was to take control of the then-dormant *Batman* movie franchise, shifting the tone far from the gothic camp of previous films. Closer in execution to the first two X-Men movies, *Batman Begins* (2005) rebooted the saga with an origin story and treated the entire Bat-mythos with a far more grounded sense of realism. The film was a massive box-office hit, and was critical in heralding a vogue for more faithful superhero adaptations.

Nolan's next undertaking was an ambitious adaptation of Christopher Priest's award-winning science fiction mystery novel, *The Prestige* (2006), a Victorian tale of the rivalry between two magicians.

A second *Batman* movie, *The Dark Knight* (2008), shifted Nolan's industry status to a different level. Darker and bleaker than its predecessor, its box-office success gave Nolan the freedom to embark upon a project he had been developing for years.

A bizarre science fiction heist thriller, *Inception* (2010) is centered on the work of "extractors," who perform corporate espionage by infiltrating the subconscious of their targets. It was a risky big-budget concept in a market where recognizable franchises had become the standard, yet it became a massive hit, earning almost $70 million in profits.

He concluded his *Batman* saga with *The Dark Knight Rises* in 2012, which failed to receive the critical adulation of its predecessor, the film shifting more toward the brighter Marvel approach to their superheroes seen that year in *The Avengers*. It was nevertheless a global hit, and saw Nolan eschewing the popular 3D format in favor of shooting 72 minutes of the movie on super-sized IMAX film.

Only a post-*Avengers* Joss Whedon could match Nolan in terms of power and influence in Hollywood, and as one of the few big-budget filmmakers capable of making an original project into a worldwide commercial hit. After declaring he was moving on from the *Batman* franchise, Nolan's next project was the science fiction movie *Interstellar* (2014), an ambitious tale about a team of space travelers who pass through a wormhole.

Nolan's presence was felt in the *Superman* reboot *Man of Steel* (2013) — he produced the film and was involved with story development — while his *Batman* movies continue to provide a stylistic template for Warner Bros. and their plans for a shared D.C. Comics movie universe to match that of Marvel. **SB**

year-by-year ■ Movie

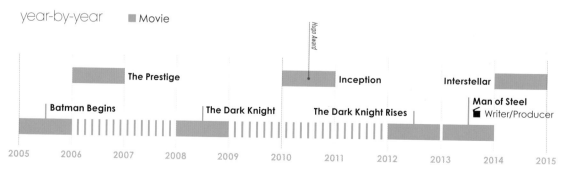

Hugo Award

The Prestige

Inception

Interstellar

Batman Begins

The Dark Knight

The Dark Knight Rises

Man of Steel
■ Writer/Producer

2005 2006 2007 2008 2009 2010 2011 2012 2013 2014 2015

the road 2006

The Road **The Road**

Cormac McCarthy's reputation as one of the 20th century's great literary novelists was already established before the publication of *The Road* in 2006. Between 1965 and 1985 McCarthy published five novels, of which *Blood Meridian* remains the most widely celebrated, marking his territory in the Southern Gothic style and dark, brooding reworkings of the Western genre. *All the Pretty Horses* (1992) introduced an amount of romanticism to McCarthy's fiction, and its success launched him to new levels of recognition. *No Country For Old Men*, published in 2006 and adapted as the Oscar-winning movie of the same title in 2007, confirmed McCarthy as a leading American novelist.

The Road is a prime example of good science fiction written by a "mainstream" author, and this foray into the metaphorical and symbolic language of the genre marked a departure in McCarthy's work, away from the realism of his first nine novels. However, although *The Road* can be read in relation to the science fiction genre, it is better understood as a continuation of McCarthy's thematic and stylistic interests. Russell Hoban's *Riddley Walker*, Stephen King's *The Stand*, the "cosy catastrophe" novels of John Wyndham and *The Earth Abides* by George R. Stewart all share the imaginative space of the post-apocalypse with *The Road*, but there is no indication that any source beyond McCarthy's own imagination has influenced the work. When interviewed, McCarthy claimed the inspiration came from a journey to El Paso, Texas in 2003 with his then young son, and the worries of all fathers about the future and safety of their children.

A man and boy, both nameless, travel by foot across a brutal, unforgiving post-apocalyptic America. The cause of the apocalypse is never specified, but there are signs of nuclear holocaust and/or environmental collapse. McCarthy's intense prose takes the reader deep inside the thoughts and memories of the man, blending the character's internal monologue with descriptions of the shattered landscape and the events of their journey. The few other humans they encounter have been reduced to cannibalism, and the man and boy's survival turns on a revolver carrying only two bullets, and a shopping cart collecting their meager possessions. Threaded through their journey is the man's recollections of his wife, who deserted the man and boy in the early stages of the unfolding apocalypse.

Interpreted literally, *The Road* is a bleak story that offers little hope for the future. McCarthy's own statements about the novel's genesis also suggest that the novel can be read as a study of anxiety, depression and fear, the events of the apocalypse providing a metaphor for a mind defeated by its own fears and neuroses.

An allegorical reading of *The Road* reveals a symbolic history of human civilization, each cannibal group encountered by the man and boy representing a stage in human development — from early tribal structures to the capitalist system of the 20th century. It is testament to McCarthy's mastery of the form that such diverse readings of the novel are possible, and *The Road* rightly won its author the Pulitzer prize for fiction in 2007.

A movie adaptation of the novel, directed by John Hillcoat and starring Viggo Mortensen as the father and Kodi Smit-McPhee as the son, was released in 2009 to critical acclaim. **DGW**

year-by-year ■ Book ■ Movie

The Road
❧ Cormac McCarthy

The Road
🎬 John Hillcoat

2005 2006 2007 2008 2009 2010 2011 2012 2013 2014 2015

jericho 2006

Jericho

Jericho

Jericho

Most post-apocalyptic films and TV shows start with a disaster that destroys civilization (zombies, a plague, aliens or whatever) and then move on from there. In that regard, *Jericho* is no different; what distinguishes the CBS series is that it proceeds in an unusually quiet, introspective way.

Originally conceived by Jonathan Steinberg and Josh Schaer as a film, the idea quickly grew into something that would better suit an ongoing series. Director Jon Turteltaub, producer Carol Barbee and screenwriter Stephen Chbosky came on board and shaped the show into an intriguing — and occasionally irritating — blend of action adventure and small-town soap opera.

The pilot episode follows Jake Green (Skeet Ulrich) as he returns home after a five-year absence. As he is reunited with his family and friends we discover a little of what made him leave in the first place — and then nearby Denver is destroyed in a nuclear explosion. With communications down, the focus switches to the town's internal struggles as the characters try to cope with the crisis. Was the explosion an attack or an accident? No one knows — except, perhaps, for mysterious newcomer Robert Hawkins (Lennie James). We soon learn that it wasn't just Denver that was hit — 23 U.S. cities have been annihilated.

Exciting stuff? Well, kind of. Both admirably and frustratingly, the focus is always on Jericho's citizens. The viewer may have been more interested in who nuked the United States, but the show, at least at first, focused on the on-off love affair of Jake's younger brother Eric and local bar owner Mary Bailey.

Thankfully, *Jericho* soon found its feet. It became clear that although Jake was the audience's viewpoint character, Hawkins was the real reason to watch. Was he behind the bombings, or trying to stop them?

Alas, despite building a significant cult following, *Jericho* was axed after a single season. The fans revolted, as fans are wont to do, and organized a massive shipments of nuts (in reference to a quote from Jake in the season one finale) to be delivered to the CBS offices. In what was becoming an increasingly prevalent scenario, eventually the network relented under public pressure and commissioned a second run of seven episodes, with the suggestion that a third (and further) seasons might be in the cards if it was a hit.

But it wasn't a hit. The first episode of the second season scored the lowest viewing figures to date for the series. Still, season two felt like it had been made with closure, rather than continuation, in mind. Although the conclusion of the run left room for the story to continue, most of the outstanding questions had been answered satisfactorily.

Despite its double death, *Jericho* hasn't quite faded away. There were rumors of a movie version in 2009, and IDW Publishing produced comics telling the projected story of seasons three and four. Most intriguingly, Netflix — on which *Jericho* is available and has achieved good viewing figures — is rumored to be considering a third season of the show. No matter what the future may hold, *Jericho* remains, like Coleridge's poem "Kubla Khan," a work that is described as unfinished but which feels like a whole. **WS**

year-by-year ■ TV series ■ Comic

Jericho
☐ CBS

Jericho
◻ IDW Comics

Jericho
◻ IDW Comics

2005 2006 2007 2008 2009 2010 2011 2012 2013 2014 2015

lauren beukes 2006

URBO:
The Adventures
of Pax Afrika

Moxyland

Zoo City

All the Pretty
Ponies

The Shining Girls

In 2011, South African novelist Lauren Beukes won the Arthur C. Clarke Award for her second novel, *Zoo City*. As she stepped up to the podium to take the applause of London's SF literary great and good, she looked genuinely shocked at what had just occurred.

Yet this wasn't a case of the Clarke judges, long noted for making left-field choices, choosing an outlier. Fusing elements of cyberpunk and magical realism in an alternate Johannesburg, *Zoo City* not only fully deserved the praise it received, but it followed on from an accomplished debut, the Cape Town-set *Moxyland* (2008), a dystopian cyberpunk novel praised by, among others, William Gibson.

In the wake of the award, a bidding war ensued for the rights to Beukes' third novel, *The Shining Girls*, the tale of a girl who survives a vicious assault by a time-traveling hobo serial killer and sets out to track down her attacker. Set largely in the Chicago of the 1990s and heavily marketed as a crime thriller rather than SF or fantasy, the novel appeared in 2013 and catapulted Beukes into the mainstream. Stephen King gave his terse approval — "clever story, smart prose" — for a book built on the kind of scenario the horror maestro might have come up with himself.

In dealing with violence against women, *The Shining Girls* reflects recurring social themes in Beukes' work. Born in Johannesburg in 1976, when apartheid was still in place, she worked for a decade as a journalist, twice winning awards for her work as a columnist. Her nonfiction collection of brief biographies, *Maverick: Extraordinary Women from South Africa's Past* (2005), for example, included appreciations of Africa's first black movie star, Dolly Rathebe, and Glenda Kemp, a snake-dancing stripper who outraged (white) South African sensibilities in the 1970s.

Beukes has worked extensively in television. As head writer for production company Clockwork Zoo, she was one of the team that created *URBO: The Adventures of Pax Afrika*, an animated SF series chronicling the lives of teenagers in dystopian iKapa City (Cape Town). She also wrote for the animated series *Florrie's Dragons* and *Mouk* and for *ZA News*, a *Spitting Image*-style topical satire. *Glitterboys & Ganglands*, her documentary about the Miss Gay Western Cape competition, was shown at festivals around the world and took the award for best LGBT film at the San Diego Black Film Festival.

Her novelistic success resulted in offers to write for comics. "All the Pretty Ponies" appeared in Vertigo's *Strange Adventures*, whereas "The Hidden Kingdom" was commissioned for *Fairest*, a spin-off from Bill Willingham's *Fables* series.

As this volume went to press, Beukes was at work on a new novel, the Detroit-set *Broken Monsters*, which she says is "about the subconscious of cities — ghosts and dreams" and a film script for an adaptation of *Zoo City*. *The Shining Girls* has been optioned for TV by MRC and Leonardo DiCaprio's Appian Way.

Lauren Beukes currently lives in Cape Town with her husband, television director Matthew Brown, and their daughter. **JW**

year-by-year ■ TV series ■ Book ■ Comic

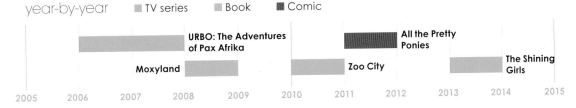

URBO: The Adventures
of Pax Afrika

Moxyland

Zoo City

All the Pretty
Ponies

The Shining
Girls

2005 2006 2007 2008 2009 2010 2011 2012 2013 2014 2015

the 99 2006

The 99 The 99: Origins The 99: New Blood JLA/The 99 The 99: Timelost The 99: Beginnings The 99

The 99 are a team of Islamic superheroes in a comic of the same name created by Kuwaiti psychologist Dr. Naif al-Mutawa and published by his Teshkeel Comics.

The series soon gained worldwide exposure. Teshkeel established a relationship with DC Comics for North American sales and *The 99* was also successful in India and Indonesia. In 2007, it was named by *Forbes Magazine* as one of the top 20 global trends.

Al-Mutawa founded his company as a response to the terrorist attacks on U.S. targets on September 11, 2001; his stated aim was to "take back Islam" from "militants who had taken it hostage."

Following the Mongol invasion of Baghdad in 1258, the books in its Great Library are destroyed by being thrown into the river. Ninety-nine mystical Noor stones are used to collect the vanished wisdom of the library and are then scattered throughout the world, to be found, centuries later, by the series' heroes.

Granted special powers by the stones, the youngsters must fight evil in the form of Osama bin-Laden-like villain Rughal and his minions.

The 99 are led by Dr. Ramzi, an older, Professor X-like figure, and come from a variety of backgrounds, including the Middle East, North America and Europe. They include the burka-clad Batina the Hidden and Saudi Arabian Hulk-like hero Jabbar the Powerful.

Al-Mutawa was inspired in part by his experience treating victims of political torture. In an open letter to his own children, he wrote: "I worked with disappointed children trapped in the minds of men who grew up to idolize a leader, to see that leader as a hero and then be tortured by him. I started to think very seriously about who your heroes were going to be."

Although *The 99* is not the only Islamic superhero comic, such publications are rare. AK Comics of Egypt produces a series created by Ayman Kandeel featuring four superheroes who fight to maintain a fragile peace in a future Middle East. There was also a short-lived comic, *The Adventures of Iman*, whose titular hero was described as "the first Muslim girl superhero." It was created by Palestinian Rima Khoreibi and self-published in Dubai.

The 99 featured in DC Comics' crossover miniseries *Justice League of America* and then expanded into television, where it became an animated series produced by Endemol (creators of *Big Brother*). (The only comparable development is on Pakistani television, where *Burka Avenger* — created by Asian pop star Haroon — features Jiya, who fights for women's rights and education for all.)

Teshkeel Comics grew into the Teshkeel Media Group and created The 99 Village, a series-based theme park in Kuwait with more than 20 rides, including the roller coaster Jabbar's Rollin' Adventure. Plans for further such developments have been announced. The franchise has since also branched into interactive online games. It remains unrivaled in its depictions of Muslims in comics. **LT**

year-by-year ■ Comic ■ Animated TV series

The 99
☐ Teshkeel

The 99: Origins
☐ Teshkeel

The 99: New Blood
☐ Teshkeel

JLA/The 99
☐ Teshkeel

The 99: Timelost
☐ Teshkeel

The 99: Beginnings
☐ Teshkeel

The 99
☐ Endemol

2005 2006 2007 2008 2009 2010 2011 2012 2013 2014 2015

primeval 2007

Primeval

The Shadow
of the Jaguar

The Lost
Island

Extinction
Event

Fire & Water

Totally
Primeval

Primeval:
New World

With a revived *Doctor Who* (2005) producing a hit for BBC Television, British commercial rival ITV was keen to develop its own Saturday evening adventure drama. Debuting in 2007, *Primeval* was a potent mix of time travel and dinosaurs, featuring an ensemble cast and cutting-edge computer-generated effects.

The development of *Primeval* preceded *Doctor Who*'s most recent iteration. Writer Adrian Hodges and producer Tim Haines of independent production company Impossible Pictures had developed the concept with the BBC prior to 2005. Haines had created *Walking with Dinosaurs* (1999), which combined a wildlife documentary approach to prehistory with CGI and animatronic dinosaurs. Similar techniques were proposed for a time-travel drama, but the BBC declined to take it forward. ITV1 was more enthusiastic, and *Primeval* premiered in January 2007.

The story concerns a group of scientists coopted by the British Home Office to investigate the emergence of temporal anomalies around the country. These anomalies lead to different time zones and allow creatures from the past and the future to break through. The team is tasked to return them all to their own time before the portals seal.

The group is led by Professor Nick Cutter (Douglas Henshall), lab technician Stephen Hart (James Murray), zookeeper Abbie Maitland (former pop singer Hannah Spearritt) and paleontology student Connor Temple (Andrew Lee Potts). The work of the team is overseen by civil servants Claudia Brown (Lucy Brown) and James Lester (Ben Miller).

Strong ensemble relationships, a subsidiary story arc concerning Cutter's missing wife Helen (Juliet Aubrey) within a wider conspiracy, entertaining effects and creature-of-the-week adventure plots secured good ratings for *Primeval* throughout two series in 2007 and 2008. In a temporal twist cliffhanger, Claudia is removed from time, returning in season two as Jenny Lewis (still played by Brown).

Henshall and Brown left during season three; the former was replaced by Jason Flemyng as policeman Danny Quinn. Ratings declined, and in June 2009 it was reported that ITV had cancelled the series. A reprieve came in the form of a multi-channel finance deal. Fourth and fifth seasons were shown jointly by ITV1 and cable channel Watch during 2011. The cast was joined by Ciaran MacMenamin, replacing Danny as team leader Matt Anderson, Ruth Kearney as Jess Parker, and *Star Trek: Deep Space Nine* actor Alexander Siddig as mysterious entrepreneur Philip Burton.

Season five premiered on Watch, followed by showings on ITV1, but the popularity of the series had waned. The final episode recorded a viewing figure of 1.7 million viewers and *Primeval* was not renewed.

But the series was not yet extinct. In 2011 Haines and Impossible Pictures struck a co-production deal with Canadian broadcaster Space to produce *Primeval: New World*, a Canadian set spin-off with a new cast. Links were maintained to the British original with guest appearances by Potts as Connor. The series debuted in October 2012 but was cancelled after one season of 13 episodes due to poor ratings. **MW**

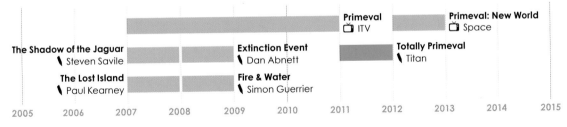

year-by-year ■ TV series ■ Book ■ Magazine

	Primeval ⃞ ITV		Primeval: New World ⃞ Space
The Shadow of the Jaguar ＼ Steven Savile		Extinction Event ＼ Dan Abnett	Totally Primeval ＼ Titan
The Lost Island ＼ Paul Kearney		Fire & Water ＼ Simon Guerrier	

2005 2006 2007 2008 2009 2010 2011 2012 2013 2014 2015

mass effect 2007

Mass Effect: Revelation | **Mass Effect** | **Mass Effect: Ascension** | **Mass Effect 2** | **Mass Effect: Retribution** | **Mass Effect: Deception** | **Mass Effect 3** | **Mass Effect: Paragon Lost**

When *Mass Effect* was first announced, gamers reacted with an enthusiasm that bordered on hysteria. Developer BioWare had spent more than a decade creating role-playing video games that were renowned for their character development, tough moral choices and epic narratives. They were usually in licensed settings such as *Dungeons & Dragons* and *Star Wars*, but here for the first time the company created a vast, brand new science fiction universe.

In *Mass Effect*, players take on the persona of Commander Shepard. They can define Shepard's gender, backstory, physical appearance and combat class. Throughout the game, they can also choose conversational options that change the course of the story and earn "Paragon" points for politeness or "Renegade" points for ruthlessness.

They command the SSV *Normandy*, a powerful military spacecraft, and can explore worlds in the galaxy, completing missions and recruiting companions with an unusual degree of freedom for a game. This, combined with an exceptionally detailed hard science fiction setting, captured players' imaginations and made *Mass Effect* one of the most successful new IP launches in videogaming history.

Another trademark BioWare feature, the ability to romance other characters in the game, caused some controversy. After many hours of building an in-game relationship it was possible to see a short, modest sex scene. Some critics denounced this as an example of

children being exposed to explicit content. Despite or perhaps because of this, a sequel was inevitable.

Mass Effect 2 (2010) continued the original story. It gave players the option to transfer their saved files, thus recognizing decisions they had made in the first game and preserving their version of Shepard. Few other franchises offered such possibilities.

The combat (one of the weaker areas of the original game) was improved significantly, as was the clunky inventory system, and many popular characters made welcome reappearances. *Mass Effect 2* sold more than two million units in its first week, and the Xbox 360 version achieved the third highest ever aggregated review score.

When *Mass Effect 3* was released in 2012, BioWare revealed that Shepard's story would be concluded at the end of the game, leading to rampant speculation. Again, player saves could be transferred from *Mass Effect 2*; among a host of improvements and new features was an excellent multiplayer mode. However, it was the game's three possible endings that garnered the strongest reaction. Many players felt disappointed or even betrayed by the conclusion of a story that they had grown to feel they owned. In truth, no possible number of endings could have satisfied every player. Although this was a disappointingly negative note on which to end Shepard's legend, it was nevertheless a fascinating statement about the nature and power of interactive entertainment. **TMa**

bioshock 2007

Bioshock

Bioshock 2

Bioshock Infinite

In 1999, the Irrational Games studio released *System Shock 2* to immediate critical acclaim. A tense science fiction horror title, it was lauded for its combination of first-person shooter gameplay, free exploration, RPG elements and intelligent story. Players could approach challenges in a flexible manner, using a variety of weapons and special powers. It was ahead of its time but, despite winning seven Game of the Year awards, sales were poor.

Rumors of a sequel persisted for nearly a decade, at the end of which Irrational released *BioShock*, a spiritual successor to its fan favorite. With gameplay based heavily on that of *System Shock 2*, the story was inspired by Ayn Rand's Objectivism philosophy, Orwell's *Nineteen Eighty-Four*, and *Logan's Run*. In an industry dominated by populist sport and military franchises, *BioShock* was an audacious gamble — it didn't even include a multiplayer mode, widely considered to be a minimum requirement for a first-person shooter. However, its heavy investment in storytelling — led by influential games designer Ken Levine — proved to be a mark of things to come in videogaming.

It is set in 1960, in an underwater city named Rapture which was intended to be a haven for the cream of society but became a decaying dystopic nightmare largely through the influence of ADAM, a powerful and addictive gene-altering substance that grants incredible powers, but can also twist the user's body and mind beyond repair. An art deco aesthetic and wonderfully atmospheric soundtrack helped to conjure up an extraordinarily immersive experience.

BioShock made an immediate and lasting impression. It got perfect review scores from *Eurogamer*, *IGN* and *1UP*, and is still the fifth highest-ranking Xbox 360 game of all time according to GameRankings.com.

When the sequel arrived in 2010 it was developed by a different studio, 2K Marin. Although not a disaster by any means, it also took place in Rapture and fans found little new to marvel at in the setting, which had been such a crucial part of the first game's impact. A strong ending was hidden behind hours and hours of overly familiar gameplay, and precious development resources were expended on a mediocre multiplayer feature. Although moderately successful, *BioShock 2* failed to live up to the promise of the original.

BioShock Infinite (2013) was unquestionably one of the most eagerly-awaited video games of all time, introducing a brand new setting, story and cast of characters. This time the action takes place in the floating city of Columbia in 1912, a time of bright-eyed American optimism and prosperity. Ostensibly idyllic, it soon becomes clear that this marvel of engineering is built on foundations of institutionalized prejudice and hatred. The player (as mercenary Booker DeWitt) must rescue a young woman named Elizabeth, deal with both the violently elitist Founder forces and the revolutionary Vox Populi, and get out while the going is good. Press reaction was predictably ecstatic, and perfect scores poured in.

In the years between *BioShock* and *BioShock Infinite*, the games industry had matured and its products had become a valid subject for serious intellectual consideration. *BioShock Infinite*'s complex themes and ambitious narrative meant that one of its greatest legacies was the role it played in developing intelligent debate about the future of interactive entertainment — a discussion that its predecessor had helped to start. **TMa**

year-by-year ■ Video game

Bioshock 🡇 2K Games	**Bioshock 2** 🡇 2K Games	**Bioshock Infinite** 🡇 2K Games

2005 2006 2007 2008 2009 2010 2011 2012 2013 2014 2015

the hunger games 2008

The Hunger Games

Catching Fire

Mockingjay

The Hunger Games

Catching Fire

Mockingjay: Part One

In *The Hunger Games*, teens kill teens in contests mounted by an evil regime in a future setting reminiscent of ancient Rome. Suzanne Collins' bestselling book and its sequels — *Catching Fire* (2009) and *Mockingjay* (2010) — are narrated by 16-year-old Katniss Everdeen, who is played in the 2012 film version by Jennifer Lawrence, previously a tough girl in the non-SF *Winter's Bone* (2010).

Critics objected that *The Hunger Games* lacked originality — the idea of people entering or being forced to enter violent death-games had featured in Koushun Takami's *Battle Royale* (novel 1999, film 2001) and in two SF novellas by Stephen King under his "Richard Bachman" pseudonym: *The Long Walk* (1979) and *The Running Man* (1982). The sport of human-hunting had been treated by Richard Connell in *The Most Dangerous Game* (1924; first filmed 1932) and by Peter Watkins in his pseudo-documentary *Punishment Park* (1971).

Such comparisons did nothing to damage *The Hunger Games*, because there was more to it than the sum of its parts. Its scenario had an immediate, visceral force that was especially exciting and accessible to young readers. The lead character gave the story a compelling voice that turned the violence into a drama to care about. The vivid Katniss is a brave huntress, smart in survival, gauche in relationships, untrained in the politics of celebrity and death.

Overall the film is more faithful to the novel than many movie adapations of literary works. Collins co-wrote the screenplay with Billy Ray and director Gary Ross. In it Katniss lives in poverty-stricken District Twelve, a rusty, neo-Depression province. When her younger sister is selected by lottery to take part in the games, she frantically volunteers to replace her. (The heroine's protectiveness of younger characters often feels motherly, although she swears never to have children of her own.)

Katniss and fellow tribute Peeta (Josh Hutcherson in the film) are taken to the Capitol, which in the movie resembles Oz and is populated by people in outlandish wigs. Once the games commence, the film rattles rather artlessly through the story's incidents, telescoping the practicalities of survival (in the book, Katniss almost dies of thirst) to get to the next fight. The film uses fast-cut elisions for violence, in the same way as comics leave room for imagination between frames.

The course of the fights is influenced by members of the audience who support one or another of the participants and arrange for them to receive assistance if they approve of their performance so far. When Katniss enters the arena with Peeta, she is challenged to create a crowd-pleasing love story, a task that requires her to gloss over all her unexplored feelings and insecurities.

This theme of performance resurfaces in the later books, in which Katniss is exploited for PR purposes by the wicked regime and its enemies. Finally the games spill into the "real" world as war begins. The books culminate in levels of violence that make those in *Battle Royale* pale into insignificance and reject the cosiness of the traditional Hollywood happy ending. **AO**

year-by-year ■ Book ■ Movie

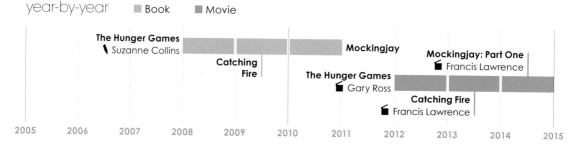

fringe 2008

Fringe

Fringe

Fringe: Tales from the Fringe

Beyond the Fringe

September's Notebook – The Bishop Paradox

The Zodiac Paradox

The Burning Man

Sins of the Father

Created by J.J. Abrams (*Alias, Lost, Star Trek*) with Roberto Orci and Alex Kurtzman (both *Star Trek* and *Star Trek: Into Darkness*), *Fringe* ran on Fox for 100 episodes over five seasons (2008–2013).

FBI Special Agent Olivia Dunham (Anna Torv) works for Fringe Division, which investigates bizarre occurrences. Dr. Walter Bishop (John Noble), his son Peter (Joshua Jackson) and Agent Astrid Farnsworth (Jasika Nicole) make up the rest of the team, with support from Director Phillip Broyles (Lance Reddick). One notable recurring cast member was Dr. William Bell, played by Leonard Nimoy.

In its first season, *Fringe* had much in common with *The X-Files* and *Psi Factor: Chronicles of the Paranormal*, especially its investigative and monster-of-the-week elements. (In a wry nod at the former, a senator tells Broyles: "The old 'X' designation and your fringe investigations have been indulgences in the federal budget for over half a century.") The writers stated that they worked the procedural aspect into the show because it was a feature of so many other popular programs. Later the *Fringe* mythology developed, deepening the texture of the series but making it less accessible to new viewers. Procedural and monster-of-the-week aspects diminished. The fifth season was effectively one long story.

At the core of *Fringe* was the notion of parallel universes. Many of the events portrayed seemed unconnected at first, but were ultimately shown to be all connected to a central clash between our universe and one other. Throughout there was also a group of mysterious, bald beings, the Observers, watching everything. These creatures were only lightly explored in the first season, but became important later.

The first two series were set mainly in our "prime" world, but in the third season the first eight episodes alternated between this world, where Olivia's doppelgänger had infiltrated Fringe Division, and the alternate universe, where the real Olivia was trapped. Peter sacrificed himself to connect the two universes and resolve the conflict at the end of the third season.

During season three, Fox moved *Fringe* to the "death slot" — 9 p.m. on Fridays. Ratings fell, but the series was renewed for a fourth season. This was set in 2036 in a third alternate timeline where the Peter in both universes had died in childhood, and the Peter from the original timeline was drawn in. The fifth season — set in the future of that alternate timeline — was just 13 episodes long, not the usual 22. Knowing it was the final season enabled the program's makers to give *Fringe* the proper ending they had planned for it — something of a luxury in TV science fiction. **MM**

year-by-year ■ TV series ■ Comic ■ Book

Fringe
📺 Fox

Fringe
▢ Wildstorm Comics

Fringe: Tales from the Fringe
▢ Wildstorm Comics

Beyond the Fringe
▢ DC Comics

September's Notebook – The Bishop Paradox
❧ Tara Bennett, Paul Terry

The Zodiac Paradox
❧ Christa Faust

The Burning Man
❧ Christa Faust

Sins of the Father
❧ Christa Faust

2005 2006 2007 2008 2009 2010 2011 2012 2013 2014 2015

wall-e 2008

Wall-E

In *2001: A Space Odyssey*, director Stanley Kubrick made it impossible for SF fans to hear "The Blue Danube" without thinking of outer space. Pixar's animated film, *Wall-E*, is more populist. It opens to starfields accompanied by a corny showtune, "Put on Your Sunday Clothes" from *Hello Dolly!* The song echoes around a dust-blown, desolate planet Earth, covered with dunes and towers of garbage; and around the artificial intelligence of Wall-E, a rusty little square robot who chatters to himself in quizzical whines and bleeps. He patiently tidies humanity's mess and builds a museum on the side, treasuring lightbulbs, Rubik's Cubes and sporks, and looking wistfully to the heavens, from which descends another robot, Eve, all gleaming white curves and looping flight. She's seeking a sign of plant life — when Wall-E provides it, they're both snatched into space. The rest of the film takes place on a generational spaceship for humanity's descendants, who have devolved into blobby butterballs, their world an endless theme park. Many SF robots gain humanity; Wall-E gives it back to the humans, disrupting their routines and reopening their eyes. Much of the film is staged and shaped like a musical, with Wall-E the clown out of step, like the bobbing baby mushroom in *Fantasia*. (The DVD edition has a spinoff cartoon, *BURN-E*, about a hapless robot on the periphery of Wall-E's story.)

Wall-E is one of very few Hollywood SF animated films. Notably, much of it doesn't look very "cartoony," but resembles the increasingly virtual effects films of the time (*Avatar*; the *Star Wars*' prequels). Pixar had

deftly handled SF themes in *Toy Story*, with its Philip K. Dick-style story arc about Buzz Lightyear, a space hero who's really just a toy. Interestingly, SF writers had previously imagined the cartoon medium carrying the heritage of a vanished humanity. In Arthur C. Clarke's 1949 story "History Lesson," Venusians mistake a Disney cartoon film for a historical document. Howard Waldrop's "Heirs of the Perisphere" (1985) imagines robot versions of Mickey, Donald and Goofy wandering a seemingly dead world.

More direct antecedents of Wall-E include R2D2 — the mostly wordless first act of the film was influenced by the evocative early scenes in *Star Wars*, where the little droid trundles round the dunes of Tatooine. (Sound designer Ben Burtt gave both robots their voices.) *Wall-E*'s image of a mechanical, supposedly lifeless automaton nurturing the Earth's last plant recalls the mute, stumpy droid Dewey — named for another Disney cartoon duck! — tending a forest in space in *Silent Running* (1972). The Japanese animator Hayao Miyazaki used a similar image in his steampunk cartoon, *Laputa — Castle in the Sky* (1986).

Wall-E won the Best Animation Oscar and made half a billion dollars at the world box-office. On a tide of acclaim, its director Andrew Stanton, who'd helmed Pixar's sea adventure *Finding Nemo* (2003), went on to the live-action *John Carter* (2012). This film — based on Edgar Rice Burroughs' planetary romances and described by the *Guardian* as "giant, suffocating doughy feast of boredom" — was a commercial belly flop. **AO**

year-by-year ■ Movie

Hugo Award

Wall-E
Andrew Stanton

2005 2006 2007 2008 2009 2010 2011 2012 2013

avatar 2009

Avatar

Avatar: A
Confidential Report
on the Biological
and Social History
of Pandora

James Cameron's
Avatar: The Game

Weeks before the release of James Cameron's *Avatar*, IMAX cinemas screened a 15-minute press preview that outlined the story. It showed the hero — wheelchair-bound ex-marine Jake Sully (Sam Worthington) — on Pandora, where trees are super-skyscrapers, waterfalls evaporate off floating mountains and blue-skinned hordes fly monsters into battle.

By the standards of print fantasy, Pandora was all quite pedestrian, but as a big-screen science fiction creation, it was as audacious as Skull Island had been in the first *King Kong* 76 years previously. When *Avatar* opened, the fantastical yardstick was Peter Jackson's *The Lord of the Rings* trilogy, but Cameron's film used CG landscapes, performance capture technology and 3D to even greater effect. *Avatar* is truly a landmark in the development of on-screen SF.

In a laboratory, Jake projects his mind into a genetically customized alien body that can tolerate the planet's poisonous atmosphere. His new form is 10 feet (3 m) tall, has blue skin, cat's eyes and a fetching tail. After being paralyzed for so long, Jake wiggles his toes, sits up to find that his human world has shrunk, then pelts out onto the Pandora landscape.

In the wild, Jake faces Jurassic-sized versions of rhinos and lions. Then a beautiful and bestial native humanoid, a Na'vi (Zoe Saldana, the rebooted Uhura in *Star Trek*), leads him through a luminous fairyland where he tames a pterodactyl monster on the brink of a bottomless chasm.

It's hard to think of another film with images that so perfectly evoke lurid fantasy book covers. Indeed, *Avatar* is a distillation of all the dreams of pulp novelists, book- and album-cover illustrators, comic-strip artists, animators and game designers.

The script is not without inanities, but these were exaggerated by critics angry at *Avatar*'s hype and rumored budget of $500 million, even though that is not a lot when compared with the movie's eventual global takings of close to $3 billion. Although it is undeniable that there are some ghastly info-dumps and dialogue, the film is unfailingly bold in positioning humanity (and specifically an Americanized humanity) as the villain. This is a post-colonialist, post-Iraq blockbuster. The story's call to open one's mind to new realities is sometimes corny but always sincere.

Like *Star Trek* and *Star Wars*, *Avatar* is regarded by some as a Western in extra-terrestrial makeup. Many pundits dubbed it "Dances with Smurfs," in disparaging reference to Kevin Costner's go-native blockbuster *Dances with Wolves* (1990). Indeed, *Avatar* has bow-and-arrow battles, although its combatants leap and plunge between earth and sky, overwhelming humanity's death machines in the gripping finale. But the movie returns us to the heady, sublime pulp territory which Cameron has made definitively his own, and to to which he has already returned. *Avatar*'s two sequels are far into production. **AO**

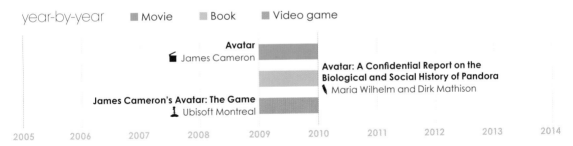

year-by-year　　■ Movie　　■ Book　　■ Video game

Avatar
🎬 James Cameron

Avatar: A Confidential Report on the
Biological and Social History of Pandora
🖉 Maria Wilhelm and Dirk Mathison

James Cameron's Avatar: The Game
⚊ Ubisoft Montreal

2005　　2006　　2007　　2008　　2009　　2010　　2011　　2012　　2013　　2014

famous spaceships

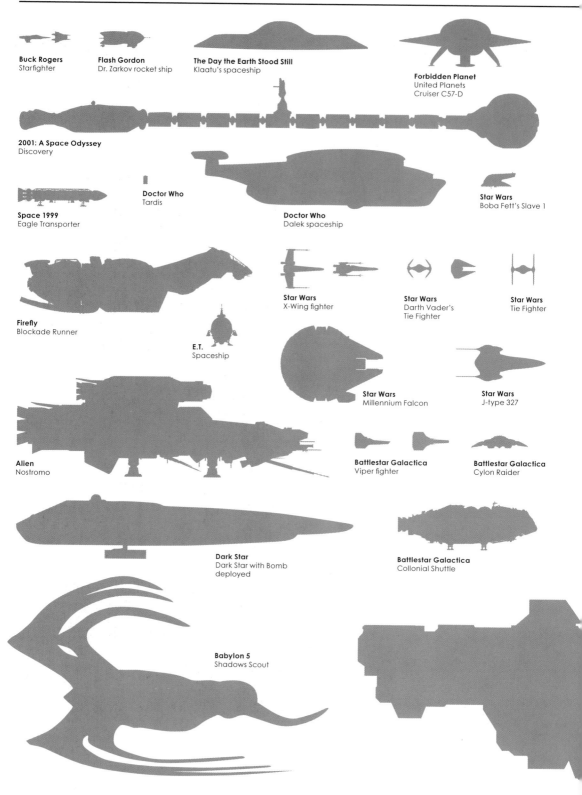

Buck Rogers
Starfighter

Flash Gordon
Dr. Zarkov rocket ship

The Day the Earth Stood Still
Klaatu's spaceship

Forbidden Planet
United Planets
Cruiser C57-D

2001: A Space Odyssey
Discovery

Space 1999
Eagle Transporter

Doctor Who
Tardis

Doctor Who
Dalek spaceship

Star Wars
Boba Fett's Slave 1

Firefly
Blockade Runner

E.T.
Spaceship

Star Wars
X-Wing fighter

Star Wars
Darth Vader's
Tie Fighter

Star Wars
Tie Fighter

Star Wars
Millennium Falcon

Star Wars
J-type 327

Alien
Nostromo

Battlestar Galactica
Viper fighter

Battlestar Galactica
Cylon Raider

Dark Star
Dark Star with Bomb
deployed

Battlestar Galactica
Collonial Shuttle

Babylon 5
Shadows Scout

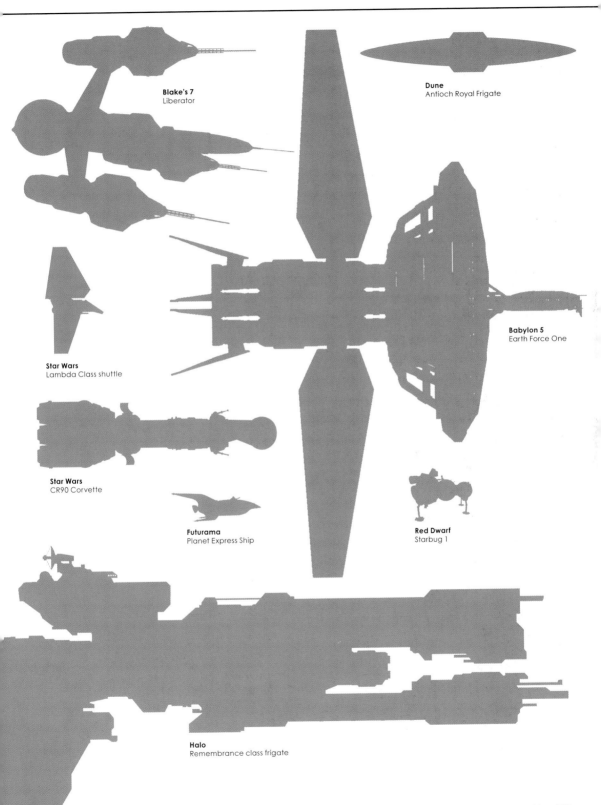

Blake's 7
Liberator

Dune
Antioch Royal Frigate

Star Wars
Lambda Class shuttle

Babylon 5
Earth Force One

Star Wars
CR90 Corvette

Futurama
Planet Express Ship

Red Dwarf
Starbug 1

Halo
Remembrance class frigate

famous spaceships continued

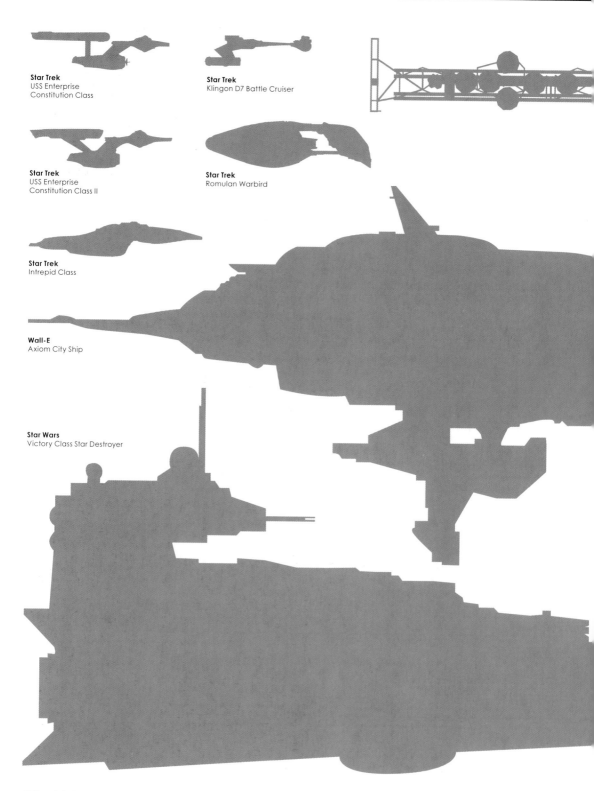

Star Trek
USS Enterprise
Constitution Class

Star Trek
Klingon D7 Battle Cruiser

Star Trek
USS Enterprise
Constitution Class II

Star Trek
Romulan Warbird

Star Trek
Intrepid Class

Wall-E
Axiom City Ship

Star Wars
Victory Class Star Destroyer

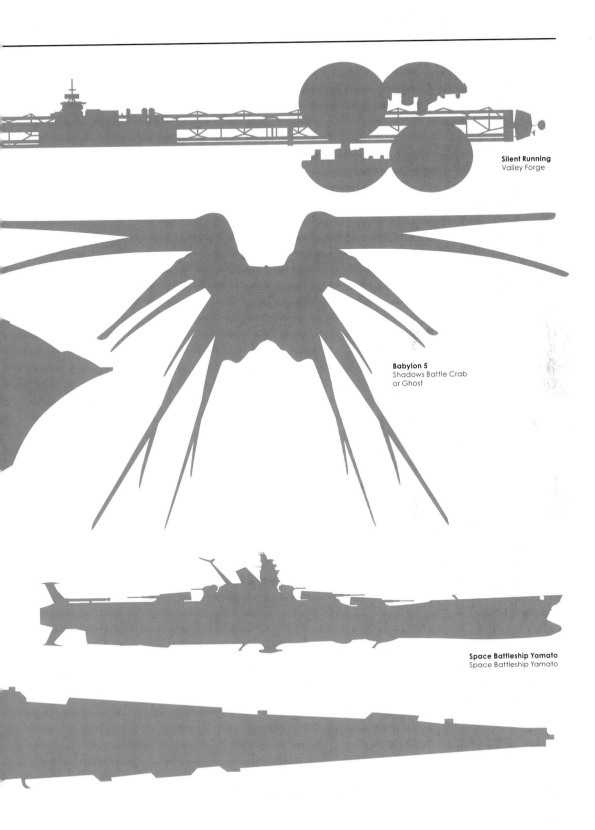

Silent Running
Valley Forge

Babylon 5
Shadows Battle Crab
or Ghost

Space Battleship Yamato
Space Battleship Yamato

the science fiction chronology

Doctor Who p.216

Transformers p.386

The X-Files p.452

2001: A Space Odyssey p.136

Halo p.512

The Hitchhiker's Guide to the Galaxy p.330

Valérian et Laureline p.264

Frankenstein p.18

The Beginning of Time

The Big Bang (c. 14,000,000,000 BC)

4,500,000,000 BC

4,000,000 BC

150,000 BC

Neolithic Era (c. 10,200–4,500 BC)

980 AD

1770

1800

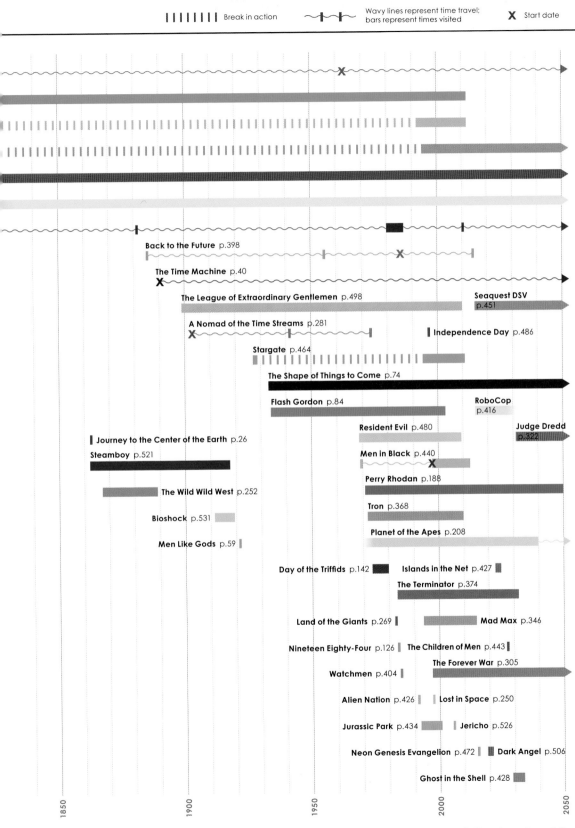

| | | | | | | | | Break in action Wavy lines represent time travel; bars represent times visited X Start date

Back to the Future p.398

The Time Machine p.40

The League of Extraordinary Gentlemen p.498

Seaquest DSV p.451

A Nomad of the Time Streams p.281

Independence Day p.486

Stargate p.464

The Shape of Things to Come p.74

Flash Gordon p.84

RoboCop p.416

Resident Evil p.480

Judge Dredd p.322

Journey to the Center of the Earth p.26

Men in Black p.440

Steamboy p.521

Perry Rhodan p.188

The Wild Wild West p.252

Tron p.368

Bioshock p.531

Planet of the Apes p.208

Men Like Gods p.59

Day of the Triffids p.142 Islands in the Net p.427

The Terminator p.374

Land of the Giants p.269 Mad Max p.346

Nineteen Eighty-Four p.126 The Children of Men p.443

The Forever War p.305

Watchmen p.404

Alien Nation p.426 Lost in Space p.250

Jurassic Park p.434 Jericho p.526

Neon Genesis Evangelion p.472 Dark Angel p.506

Ghost in the Shell p.428

1850 1900 1950 2000 2050

the science fiction chronology continued

Doctor Who p.216

Star Trek p.240

Alien p.352

2001: A Space Odyssey p.136

Halo p.512

The Hitchhiker's Guide to the Galaxy p.330

Valérian et Laureline p.264

The Jetsons p.202

The Time Machine p.40

Seaquest DSV p.451

Ender's Game p.320

Logan's Run p.263

Avatar p.535

The Shape of Things to Come p.74

Mass Effect p.530

Judge Dredd p.322

Babylon 5 p.458

Space Battleship Yamato p.304

Perry Rhodan p.188

Planet of the Apes p.208

The Forever War p.305

2050

2100

2150

2200

2250

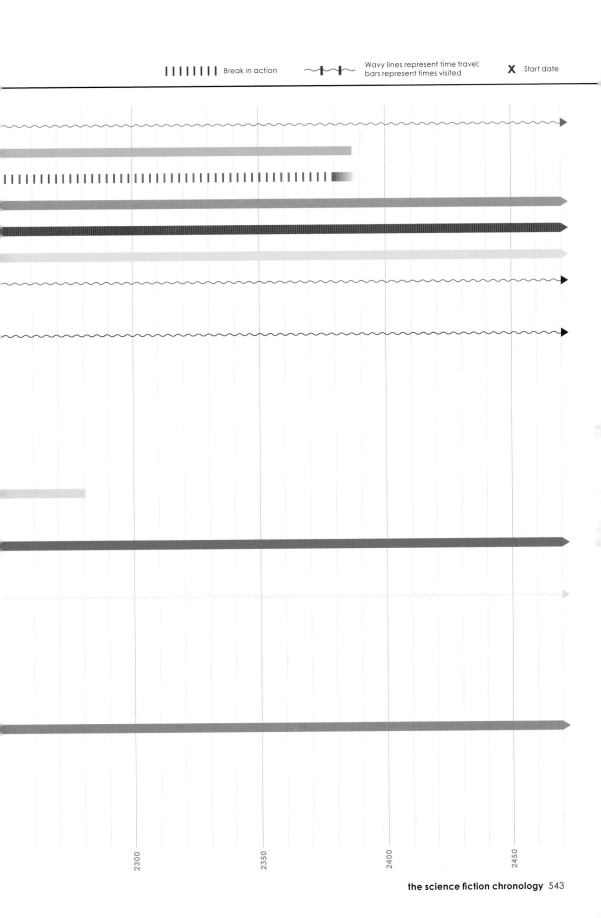

2300

2350

2400

2450

Doctor Who p.216

2001: A Space Odyssey p.136

Halo p.512

The Hitchhiker's Guide to the Galaxy p.330

Valérian et Laureline p.264

Brave New World p.72

The Time Machine p.40

Perry Rhodan p.188

Planet of the Apes p.208

The Forever War p.305

2500

2550

2600

2650

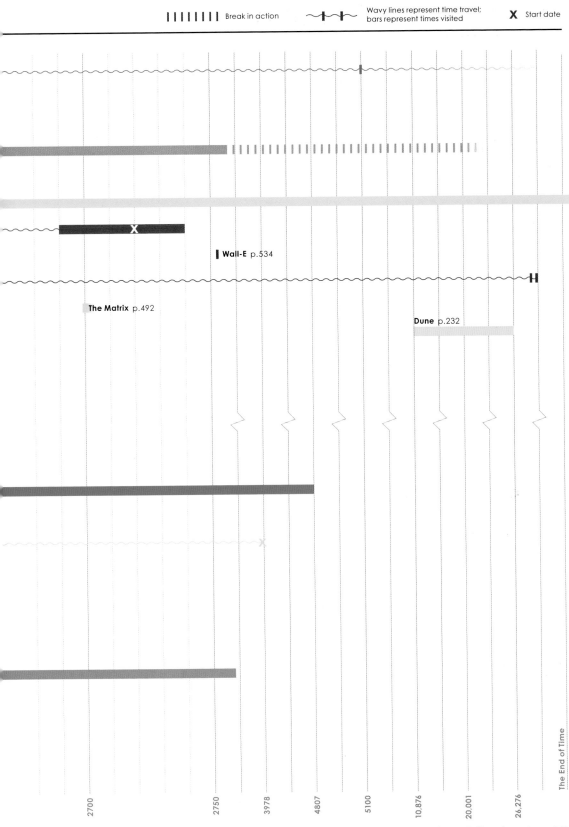

Wall-E p.534

The Matrix p.492

Dune p.232

The End of Time

2700

2750

3978

4807

5100

10,876

20,001

26,276

genre definitions

There are as many genres of science fiction as there are of popular music. And, like music, science fiction can be divided up in a multiplicity of ways. How this division falls is almost entirely dependent on the observer. Science fiction shares much of its makeup with the genres of fantasy, horror and crime, and the boundaries between them can sometimes be hard to unpick. For example, *The X-Files* is predominantly science fiction, but it is also horror and fantasy, and shares some of crime fiction's narrative mechanisms. Furthermore, it fits into a number of subgenres in each of those genres.

However you choose to apportion science fiction, you will find that many individual properties fit into other genres, and into many subgenres. Sometimes, there are even subsubgenres. It can get complicated very quickly, so we've decided upon the following definitions for this book. Badges denoting the subgenres that apply to a property can be found at the top left of each entry. In the name of comprehensiveness, we have mentioned a few additional subgenres in certain entries that we have chosen not to use as discreet categories in their own right. Out in the wider world, there are other subgenres and other definitions of our subgenres, depending on interpretation. You have been warned.

Alien Invasion Earth is invaded by aliens, usually extraterrestrial, sometimes extradimensional, occasionally from some other time. Sometimes such fiction deals with postconquest scenarios. Despite its bombastic premise, Alien Invasion can cross over with a great many subtler subgenres.

Alternative Worlds Fiction that depicts worlds similar to, but not the same as, our own. In some fictions the alternative world is the focus of the story, but often multiple variant realities exist side by side, and travel and interaction between these worlds is a key component of the drama.

Apocalyptic Fiction Stories that deal with large-scale, civilization-challenging destruction. At its basest form, the destruction is merely a means to entertainment. Includes the subgenre Cosy Catastrophe.

Creature Feature Science fiction concerned with giant monsters, often created through the agent of spurious science — especially "magic atomics" or, latterly, "magic D.N.A."

Cyberpunk Stories that concern the impact of emergent informational technologies on a broad societal basis. Often set in a dystopian, corporate future. Shares some tropes, especially in characterization, with hard-boiled crime fiction. Later subgenres nanopunk and biopunk are mostly similar in tone and intent, but focus on nanotechnology and biotechnology respectively.

Dystopian Fiction Scenarios where society has become terminally corrupt, unfair and/or clings on to a barely functional existence in the wake of some catastrophe. Often intended as a warning.

Eco SF Green issues and concern for the environment, either on Earth or on an alien world, predominate. Also includes those narratives that expend much effort on the detailing of future or alien ecology.

Erotic SF Science fiction that has an overtly sexual content.

Future History As sprawling in scope as Space Opera, future history takes in hundreds, if not thousands, of years of mankind's future development. However, the timespan is usually longer and the intellectual content stronger.

Ghost in the Machine Blanket term of our own devising to cover all fiction primarily dealing with robotic, cyborg or artificial intelligence characters.

Hard SF For many, the very definition of science fiction. Narratives are concerned primarily with the exploration of advanced, actual scientific concepts, speculation on the future of the same, and with the resultant technology. Characterization and literary styling can suffer. Also known as/closely related to "Engineering SF."

Lost Worlds Stories that deal with uncharted pockets of the Earth's surface where prehistoric creatures survive.

Literary SF Science fiction where great attention is paid to literary styling and the narrative effects of literary fiction.

Military SF Concerned almost entirely with military characters, settings and action. Usually with a right wing bent, but can be utilized for an opposing, anti-war stance.

Planetary Romance Features a planet as its primary venue, and has a plot that revolves to a significant degree around the nature of that planet. A subgenre of Science Fantasy.

Post-Apocalyptic SF Stories concerning survival in a post-apocalyptic setting.

Science Fantasy Science fiction that has a liberal blending of fantasy, either in terms of supernatural content or through featuring tropes regarded as belonging primarily to fantasy. Formerly this included such sword and sorcery trappings as dragons, wizards, magic and slave-girls in distress, but nowadays it can equally refer to "urban fantasy" conventions included in a predominantly science-fictional setting. Includes the subgenre Planetary Romance.

SF Comedy Subgenre in which science fiction is used to comedic effect. In some instances this can be a shallow reading of the genre concerning only its trappings, in others the subject matter of science fiction itself becomes a source of comedy. Also includes the more seriously intentioned SF Satire.

SF Horror Science fiction with a pronounced horror content, whether in terms of simple visceral spectacle or deeper subject matter. Contains the subgenres Cosmic Horror and Gothic Science Fiction.

Soft SF Science fiction that is far more interested in future peoples and societies or the effects of future technology on peoples and societies than the science or technology itself. Also known as Social SF.

Space Exploration Details the mechanics and difficulties of travel between the planets of the solar system and/or the further stars, and what is encountered there. Examples set later in the timeline of mankind's diaspora might involve contact with and/or exploitation of alien species, and the ethical concerns this raises.

Space Opera Stories that deal with sweeping, galactic conflicts set against backdrops of polyracial empires, often over lengthy book/movie cycles. Science here takes a backseat to romantic spectacle.

Space Western Either a direct importation of the Western to a nominally science fictional setting — up to and including space cowboys — or science fiction that makes use of many of the Western's low-tech, frontier tropes.

Speculative Fiction Arguably suitable as an alternative label for all science fiction, in our case speculative fiction covers that SF which is predominantly concerned with "What If?" scenarios. It tends to be more nuanced and ambiguous than many other subgenres, although it draws heavily on the tropes of both Hard and Soft SF, it is more philosophically inclined, up to and including speculation on religious matters. Speculative science fiction

is usually of a high literary standard, and is therefore often co-opted by mainstream writers who, disdainful of SF, want to define their forays into science fiction as separate to it.
The borderland subgenres Slipstream and Magic Realism overlap with Speculative Fiction to a certain extent.

Spy-Fi Espionage thrillers that feature impossible technologies. The Techno-Thriller genre — closely related to science fiction — can often be fitted into this category.

Steampunk A loose group of splintered subgenres that cross genre boundaries, taking in equal amounts of science fiction, fantasy and horror. All, however, place fantastical, impossible technologies based on outmoded engineering principles into historical or pseudo-historical settings.

Superhero Fiction Cross-genre fiction wherein individuals are granted fantastic powers. Those featured in this book have mainly received their powers for spurious scientific reasons. Such adventures borrow heavily from all fantastical genre fiction, including fantasy and horror, and as such popular superheroes tend to take part in virtually all the genres listed here at some point in their careers.

Techno-Thriller Subgenre of contemporary thriller fiction that shades into science fiction to a lesser or greater degree, but in the main the science fiction component is restricted to "tomorrow's-technology" macguffins. Primary characteristics are that it is takes place within a recognizable, modern or barely-future setting, and that the "techno" aspect is peripheral to the narrative, even while its existence may be the driver for action. Similar to Spy-Fi.

The Unexplained Events of a paranormal or supernatural nature approached scientifically or set in a science fictional setting. Closely related to Horror.

The Uninvited Stories in which aliens are among us, malign or benign, moving covertly or in very small numbers. Outright invasion is not the intent, or has yet to occur.

Time Travel Tales that involve travel through time into the past or the future. Common tropes include paradoxes (such as the grandfather paradox), time loops, time police, time tourism and cognitive estrangement.

Unreality Such fiction as deals with the seeming unravelling of consensus reality. Blends into surrealism or fantasy, and often includes unreliable narrators and inconstant narrative.

Utopian Fiction Stories in which an idealistic society is depicted, often in detail, usually as travelogue featuring a visiting outsider. Most often employed as a vehicle for political manifesto.

Voyages Extraordinaires Extraordinary voyages to little understood areas of the Earth. The direct precursor to the Lost World subgenre, and, to a certain extent, in as much as we are experiencing speculative exploration of the unknown, to the Space Exploration subgenre. When the world was less well-mapped, such journeys could take place to any corner of the globe, but after circa 1950 this subgenre became restricted to oceanic adventures. The term was originally coined by French author Jules Verne.

Zombie Apocalypse Stories in which the Earth is overrun by zombies, an event which can be an allegory or metaphor for some pressing contemporary concern. Narratives are often hopeless, with the surviving protagonists dying horribly one by one. A subgenre of Post-Apocalyptic and Apocalyptic Fiction, but prevalent enough throughout the 1990s and early 21st century to deserve its own category. Always bloody, sometimes tense, often puerile.

contributors

Matt Bielby (MB) has been writing about science fiction for 20 years, and has edited a number of magazines on the subject, including *SFX* and *Death Ray*. "The first SF book I remember reading was *Islands in the Sky* by Arthur C. Clarke," he says. "It's today little known, and his take on a Heinlein Juvenile, but as a realistic, low-key tale of space station life it's quietly unbeatable. Or so memory has it!"

Saxon Bullock (SB) first got into professional journalism via a series of happy accidents, and has since notched up 13 years of writing about science fiction, films, books and comics. A regular contributor to *SFX* magazine, he's currently based in Manchester, UK, and divides his time between freelance publishing work, writing novels and trying not to spend too much money on comic books.

Dave Golder (DG) has loved being scared and seduced by sci-fi ever since screaming his head off in a push chair outside Debenhams in Staines at the age of four (he was convinced the mannequins were Autons). He was one of the launch team on *SFX* magazine, which he then edited for ten years. Even now he hangs round the office; he has nothing better to do having never followed Shatner's advice to get a life.

Guy Haley (GH) is a science fiction writer and journalist. He has worked on the magazines *SFX*, *White Dwarf* and *Death Ray*, and is the author of *Reality 36*, *Omega Point*, *Champion of Mars*, *Crash* and numerous works for the Black Library. He works and drinks to equal excess, has four brothers, a young son, a fierce Nordic wife and a giant dog. When not writing, he wanders the countryside pretending to be Aragorn.

Thom Hutchinson (TH) is a freelance critic and script editor. A former staff writer on the magazines *Death Ray* and *Filmstar*, he has also edited dozens of history books, written travel podcasts and programmed for the Bath Film Festival. On television, he has script-edited *Monroe*, *Lewis*, *Marple* and *Poirot*. If you squint, you might spot him playing a Menoptra in Mark Gatiss' *An Adventure in Space and Time*. He can be found on Twitter @unthom.

Steve Jarratt (SJ) is a long-time videogame and technology journalist, and has been into SF and special effects since watching Gerry Anderson TV shows as a kid. He's launched a range of magazines including *Edge*, *T3* and official titles for Sony and Nintendo, and received the GMA Games Media Legend award in 2008. Steve is currently working on a spectacular movie script that he'll probably never finish.

Stephen La Riviere (SLR) is a documentary maker and writer with an unhealthy obsession with Gerry and Sylvia Anderson's puppet shows of the 1960s. His book *Filmed in Supermarionation*, which charts the rise and fall of their studio, has been published in America and Japan. Recently he has produced a documentary film version of the book. Other TV-related credits include documentaries on *The Saint*, *The Persuaders*, *Danger U.X.B.* and *Upstairs Downstairs*.

Russell Lewin (RL) is originally from Newcastle upon Tyne, where his first taste of journalism was at the local *Herald & Post* newspaper. He moved to London in the mid 1990s to work for Capital Radio, then made his way into magazines and had six years at *FHM*, four as production editor. He now lives in Bath and works at Future Publishing editing and sub-editing various SF and horror-related magazines.

Paul Marland (PM) writes about food, comic books and science fiction, amongst other interests. "Re-watching *The Matrix* films reminded me how much food is in them," he says. "They're constantly going on about noodles, steaks, dessert, breakfast, spoons … It might be the most foodie SF film ever — or would be, if *Soylent Green* didn't exist. Of course, the chatty main course from *Hitchhiker's* is also pretty memorable."

Tim Maughan (TM) is a science fiction author and freelance writer originally from the UK. In 2011 he released the critically acclaimed *Paintwork*, a collection of three near future stories dealing with the roles of art, celebrity and globalization, and his story "Limited Edition" was shortlisted for the British Science Fiction Association 2012 award. He is also a regular contributor to *Medium*, *Tor*, and *New Scientist*'s *Arc* magazine.

Tom Mayo (TMa) has worked for *SFX* magazine, the SCI FI channel, Electronic Arts and Activision. He once gave Ray Harryhausen a birthday card, fought with Buffy's stunt double and tried to make Sigourney Weaver laugh (it didn't work). Not all on the same day, of course. That would have been quite a day. He is currently a computer game designer living in Cambridge.

Miriam McDonald (MM) is a professional magazine journalist who has contributed to a wide range of publications, including the science fiction magazines *SFX* (since 1998) and *Death Ray*. She enjoys silent and classic films, vintage science fiction and crime novels, beer and knitting, and considers her pattern for a knitted werewolf balaclava one of her best pieces of work. She aspires to be a mad cat lady.

Michael Molcher (MMo) was raised on a diet of *Transformers*, Denis Gifford books, Lego and *2000 AD*, which has understandably warped him for life, but has also enabled him with the skills to write authoritatively about comics for *SFX*, *Comic Heroes*, *2000 AD* and the *Judge Dredd Megazine*. He has amazing facial hair.

Jayne Nelson (JN) is the Editor of *ODEON Magazine*, a former columnist with *SFX* magazine and has consulted on film and television projects with the BBC, Channel Four, Channel Five and Sky, as well as making numerous radio appearances. An experienced writer and sub-editor, her work has appeared in *Total Film*, *Sky Movies Magazine*, *DVD & Blu-ray Review*, *Judge Dredd Megazine* and many more. She regularly contributes to sfx.co.uk and culttvtimes.com.

Steve O'Brien (SOB) started his SF life editing the *Doctor Who* fanzines *Peladon* and *Purple Haze*, before becoming Reviews Editor on Cult TV. He then spent seven years on *SFX* before joining the short-lived *Filmstar* magazine as News Editor. He writes about film and television for, among others, *SFX*, *Total Film*, *Empire* and the Cineworld magazine and website. He can also be spotted as an occasional talking head on various SF-themed documentaries.

Andrew Osmond (AO) is a writer specializing in fantasy media and animation. Born in Wales, he lives in Berkshire, and can be frequently found in Tokyo. He's the author of *100 Animated Feature Films*, *BFI Film Classics: Spirited Away* and *Satoshi Kon: The Illusionist* (about the animation director). He writes for *SFX*, *Sight and Sound*, *Neo*, *Empire* and other magazines.

Will Salmon (WS) is a Bath-based freelance journalist and editor. A regular contributor to *SFX* and *Comic Heroes*, he edited the *SFX Book of Game Of Thrones*, *The A-Z of Zombies* and *Comic Heroes Presents ... Superheroes*. He writes about new music for *Clash* magazine and can usually be found surrounded by stacks of vinyl. His debut comic strip, *The Carers*, was recently published in the *Dead Roots* anthology.

Cavan Scott (CS) is the co-author of the Sunday Times Top Ten Bestseller *Who-ology: The Official Doctor Who Miscellany*. The writer of over 50 books and audio-dramas, he regularly writes for such magazines as *SFX*, *Comic Heroes* and *Doctor Who Magazine*. You can find him at www.cavanscott.com.

M.J. Simpson (MJS) co-founded *SFX* and has also written for *Fangoria*, *Video Watchdog*, *Psychotronic Video*, *Starburst*, *Shivers*, *Book and Magazine Collector*, *New Scientist*, *Total Film* and many other magazines. His books include

Urban Terrors: New British Horror Cinema and an award-winning biography of Douglas Adams. A former stand-up comic, he occasionally acts in low-budget movies. By day he works in the Marketing Division of the University of Leicester.

Lavie Tidhar (LT) is the World Fantasy Award winning author of *Osama, The Violent Century* and *The Bookman Histories* trilogy and many other works. He also won the British Fantasy Award for Best Novella, for *Gorel & The Pot-Bellied God*, and was nominated variously for a BSFA, Campbell, Swturgeon and Sidewise awards. He grew up on a kibbutz in Israel and in South Africa but currently resides in London.

Calum Waddell (CW) is a PhD student in film and philosophy who has also written about sci-fi and horror for a decade. A regular contributor to *SFX, Sci Fi Now* and other genre magazines, his books include *Jack Hill: The Exploitation and Blaxploitation Master* and *Taboo Breakers*. In addition, Waddell produces and directs and DVD interviews and documentaries for companies such as Arrow Video, 88 Films, Synapse and Grindhouse. His current pet project is a documentary on Scream Queens.

Damien Walter (DW) is a writer, *Guardian* columnist and journalist with bylines for *Wired UK, SFX, Aeon* magazine and *IO9*. His fiction has been published in the Hugo award winning *Electric Velocipede*, broadcast on BBC Radio and won grant funding from Arts Council England. He is a graduate of the Clarion writers workshop at UC San Diego.

Simon Ward (SW) is a writer and editor working at Titan Books in London. He is the author of three novels, has won awards for his short story work, and has written extensively on cinema and graphic novels. His work includes essays on horror, animation and psychological drama, and for *The Greatest Movies You'll Never See* he produced articles on David Lynch's *Ronnie Rocket*, Tim Burton's *Superman Lives*, and others.

David West (DWe) has followed a simple creed for most of his life — the person who dies with the most comics wins. When not re-reading Jack Kirby stories or *Calvin & Hobbes* strips, David watches too much anime, which he claims is work for *NEO Magazine*, and interviews comic creators for *SFX* and *Comic Heroes*. The opening theme song to *Battle Of The Planets* still brings a lump to his throat.

Jonathan Wright (JW) is a journalist and editor who has contributed to *SFX* since 1998, interviewing the likes of Michael Moorcock, Ursula K. Le Guin, Terry Pratchett, China Miéville and Lauren Beukes for the magazine. He's also the publisher of the *Adventure Rocketship!* series of themed anthologies. He lives in Bristol with his wife, Chloe, and two children, Sam and Isabelle. He's fond of cycling, Leeds United and the films of Powell and Pressburger.

Mark Wright (MW) has been an author and journalist for over ten years, and has written for many brands including *Doctor Who, The Sarah Jane Adventures, Highlander, Blake's 7* and *Pathfinder*. With Cavan Scott he is the best-selling author of *Who-ology*, is a regular contributor to *Doctor Who Magazine* and produces the audio series *Graceless* and *Vienna* for Big Finish Productions. Mark's award-winning stage play, *Looking for Vi*, was a finalist at the Off Cut Festival 2011 and was adapted in 2013 into a short film starring Josie Lawrence. He lives in West Yorkshire with his family.

Pat Wright (PW) is an intermittent contributor to British and American movie magazines. Under a variety of disguises, Pat has appeared on screens both large and small and even occasionally been paid. Previous employment opportunities have included drummer in an unsuccessful punk band, manager of an unsuccessful football club, promoter of an unsuccessful wrestling circuit and sole employee of a spectacularly unsuccessful children's entertainment agency.

index

Page numbers in **bold** refer to illustrations.

index continued

picture credits

Every effort has been made to credit the copyright holders of the images used in this book. We apologize for any unintentional omissions or errors and would be pleased to insert the appropriate acknowledgement to any companies or individuals in any subsequent editions of the work.

KEY
Thumbnail images: numbered, left to right or top to bottom (1), (2), (3), (4), (5), (6), (7), (8)
Image-only pages: top = t / bottom = b / left = l / right = r / center = c / top left = tl / top right = tr / center top = ct / center bottom = cb / center left = cl / center right = cr / center left top = clt / center left bottom = clb / center right top = crt / center right bottom = crb / bottom left = bl / bottom right = br

2 REX / Moviestore Collection 6 British Film Institute / Lucasfilm 16 UNIVERSAL / THE KOBAL COLLECTION 18 (1) Colburn & Bently, 1831 (2) Edison Manufacturing Company (3) Universal Pictures (4) Universal Pictures (5) Universal Pictures (6) Universal Pictures (7) Universal Pictures (8) Universal Pictures 19 (1) Universal Pictures (2) Warner Bros. (3) Hammer Film Productions (4) Hammer Film Productions (5) Columbia Pictures / Hammer Film Productions (4) Hammer Film Productions / Universal International Pictures (5) Hammer Film Productions (6) Gruskoff / Venture Films / Crossbow Productions / Jouer Limited (7) TriStar Pictures / American Zoetrope (8) National Theatre, London 20 (1) REX / Moviestore Collection (2) REX / Moviestore Collection (3) REX / Moviestore Collection (4) REX / Moviestore Collection (5) REX / ITV 22 (1) Edison Manufacturing Company (2) Universal Pictures (3) Universal Pictures (4) Universal Pictures (5) Hammer Film Productions (6) Gruskoff / Venture Films / Crossbow Productions / Jouer Limited (7) TriStar Pictures / American Zoetrope (8) National Theatre, London tl EDISON / THE KOBAL COLLECTION tr UNIVERSAL / THE KOBAL COLLECTION c REX / Moviestore Collection bl UNIVERSAL / THE KOBAL COLLECTION 23 tl HAMMER / THE KOBAL COLLECTION tr 20TH CENTURY FOX / THE KOBAL COLLECTIO bl REX / Moviestore Collection br REX / Donald Cooper 24 (1) Hetzel (2) Hetzel (3) Hetzel (4) Hetzel (5) Hetzel (6) Hetzel (7) Hetzel (8) Hetzel 25 (1) Hetzel (2) Hetzel (3) Hetzel (4) Hetzel (5) Hetzel (6) Hetzel (7) Hetzel (8) Hetzel 26 (1) Hetzel (2) Twentieth Century-Fox (3) Filmation (4) Rick Wakeman / A&M (5) Air Programs International (6) Almena Films (7) Golan-Globus Productions (8) BRB Internacional S.A. 27 (1) Columbia Pictures Television / High Productions (2) Bedtime Primetime Classics / Blye Migicovsky / Phoenix Animation Studios (3) Alien Voices (4) Hallmarka Entertainment / USA Network (5) La Fabrique / Tele Images Creation / France 3 / EM.TV & Merchandise AG (6) New Line Cinema / Walden Media (7) RHI Entertainment / Reunion Pictures / Journey Films (8) The Asylum 28 (1) Hetzel (2) Twentieth Century-Fox (3) New Line Cinema / Walden Media tl © adoc-photos / Corbis tr Time & Life Pictures / Getty Images cr Time & Life Pictures / Getty Images b 20TH CENTURY FOX / THE KOBAL COLLECTION 29 t NEW LINE CINEMA / THE KOBAL COLLECTION cl NEW LINE CINEMA / THE KOBAL COLLECTION cr REX / Moviestore b NEW LINE CINEMA / THE KOBAL COLLECTION 30 (1) Hetzel (2) Hetzel (3) American Mutoscope & Biograph (4) Williamson Submarine Film Corporation (5) Metro-Goldwyn-Mayer (MGM) (6) Classics Illustrated (7) Walt Disney Productions (8) Ameran Films 31 (1) Albina Productions S.a.r.l. / Cameroons Development / Cité Films / Copercines, Cooperativa Cinematográfica / Filmes Cinematografica / Office de Radiodiffusion Télévision Française (ORTF) (2) Daw Books (3) ZSRR (4) Frederick S. Pierce Company / Village Roadshow Pictures (5) America's Best Comics (6) Kheops Studio (7) Hallmark Entertainment / Silverstar Ltd. / Larry Levinson Productions (in association with) RTL Television Germany / Living Films (8) New Line Cinema / Contrafilm 32 (1) Hetzel (2) Metro-Goldwyn-Mayer (MGM) (3) Walt Disney Productions (4) Ameran Films (5) New Line Cinema / Contrafilm tl © Blue Lantern Studio / Corbis tr Mary Evans Picture Library bl Mary Evans Picture Library cr MGM / THE KOBAL COLLECTION br MGM / THE KOBAL COLLECTION 33 t REX / Everett Collection cl REX / Everett Collection cr COLUMBIA / THE KOBAL COLLECTION bl COLUMBIA / THE KOBAL COLLECTION br NEW LINE CINEMA / THE KOBAL COLLECTION 34 (1) Breslau, S. Schottlaender (2) Breslau Schottlaender (3) L. Voss (4) Felber (5) Leipzig : B. Elischer Nachfolger (6) Leipzig : B. Elischer Nachfolger (7) Charles L. Webster and Co. (8) Fox Film Corporation (3) Vanderbilt Theatre (4) Paramount Pictures (5) Chuck Jones Enterprises / Warner Bros. Television (6) Rosemont Productions / Walt Disney Television 36 (1) William Heinemann (2) William Heinemann (3) C. Arthur Pearson (4) Harper and Brothers (5) Harper and Brothers (6) George Newnes Limited (7) Macmillan & Co (8) Chapman & Hall, Ltd. 37 (1) Macmillan & Co (2) George Bell and Sons (3) Thomas Nelson and Sons (4) Cassell and Company, Ltd (5) Jonathan Cape (6) Hutchinson (7) London Film Productions (8) Chatto & Windus 38 (1) Universal International Pictures (2) Paramount Pictures (3) George Pal Productions / Galaxy Films Inc. (4) Ameran Films (5) American International Pictures (AIP) / Cinema 77 / Major Productions / Winters Hollywood Entertainment Holdings Corporation (6) Columbia Pictures Corporation / Global Entertainment Productions GmbH & Company Medien KG (7) Warner Bros. / DreamWorks SKG / Parkes / MacDonald Productions (8) Paramount Pictures / DreamWorks SKG / Amblin Entertainment/Cruise / Wagner Productions t REX / Moviestore Collection cl REX / Everett Collection cr REX / Everett Collection bl REX / Everett Collection br REX / SNAP 39 t REX / c.Columbia / Everett cr REX / c.Warner Br / Everett cr REX / c.Warner Br / Everett br REX / c.Paramount / Everett 40 (1) William Heinemann (2) Piper (3) Classics Illustrated (4) George Pal Productions / Galaxy Films Inc. (5) Orion Pictures Corporation / Warner Bros. (6) Dell Publishing (7) HarperCollins (8) Warner Bros. / DreamWorks SKG / Parkes / MacDonald Productions (4) Arnold Leibovit Entertainment 41 (1) William Heinemann (2) Paramount Pictures (3) Lynn-Romero Productions / Premiere Productions (4) Hemisphere Pictures (5) Cinematográfica Calderón S.A. (6) Four Associates Ltd. (7) American International Pictures (AIP) / Cinema 77 / Major Productions / Winters Hollywood Entertainment Holdings Corporation (8) New Line Cinema 42 (1) Harper and Brothers (2) Paramount Pictures (3) Classics Illustrated (4) TM & © 2014 Marvel Entertainment, LLC (5) Jeff Wayne / Columbia / CBS Records (6) CRL Group 43 (1) Hometown Films / Paramount Television / Ten Four / Triumph (2) Rage Software (3) The Asylum (4) Paramount Pictures / DreamWorks SKG / Amblin Entertainment / Cruise / Wagner Productions (5) Dark Horse (6) Anthill Productions 44 (1) Evolution Records (2) Paramount Pictures (3) TM & © 2014 Marvel Entertainment, LLC (4) The Asylum(5) Paramount Pictures / DreamWorks SKG / Amblin Entertainment / Cruise / Wagner Productions tl THE KOBAL COLLECTION tr British Film Institute cl NY Daily News via Getty Images cr PARAMOUNT / THE KOBAL COLLECTION bl PARAMOUNT / THE KOBAL COLLECTION br TM & © 2014 Marvel Entertainment, LLC 45 tl THE ASYLUM / THE KOBAL COLLECTION tr DREAMWORKS / PARAMOUNT / THE KOBAL COLLECTION / COOPER, ANDREW cl DREAMWORKS / PARAMOUNT / THE KOBAL COLLECTION / MASI, FRANK b DREAMWORKS / PARAMOUNT / THE KOBAL COLLECTION 46 (1) Star-Film (2) Pathé Frères 47 (1) Verlag Benjamin Harz 48 (1) S.C. Brown, Langham & Co. (2) TM & © 2014 Marvel Entertainment, LLC (3) DC (4) Dynamite Comics 49 (1) Popular Publications (2) Popular Publications (3) Popular Publications (4) QMG Magazine Corporation (5) Experimenter Publishing Company (6) TM & © 2014 Marvel Entertainment, LLC (7) The Asylum (8) Walt Disney Pictures 50 (1) Hodder & Stoughton 50 (2) Hodder & Stoughton (3) First National Pictures (4) Hutchinson & Co (5) Irwin Allen Productions (6) Harmony Gold (7) A&E Television Networks / BBC / RTL (8) The Asylum 51 (1) Popular Publications (2) National Film Corporation of America (3) A. C. McClurg (4) Metro-Goldwyn-Mayer (5) Dell Comics (6) Ballantine Books (7) Warner Bros. (8) Walt Disney 52 (1) The Vagrant (2) Nth Dimension Media (3) Nth Dimension Media (4) Experimenter Publishing Company (5) Nth Dimension Media (6) Nth Dimension Media (7) Nth Dimension Media(8) Nth Dimension Media 53 (1) Nth Dimension Media (2) Nth Dimension Media (3) Charles D. Hornig (4) The Galleon (5) Dell Magazines (6) Visionary Publishing Company (7) Nth Dimension Media (8) Arkham House 54 tl H. P. Lovecraft tr REX / Zach Zito / Everett cl AIP / THE KOBAL COLLECTION cr AIP / THE KOBAL COLLECTION c. Empire / Everett / REX tl RE-ANIMATOR / WILDSTREET / THE KOBAL COLLECTION 55 tr EMPIRE / THE KOBAL COLLECTION cr NEW LINE / THE KOBAL COLLECTION bl NEW LINE / THE KOBAL COLLECTION / HARVEY, S br Movie Poster Database 56 LONDON FILMS / UNITED ARTISTS / THE KOBAL COLLECTION 58 (1) U.S. Works Project Administration (2) Fr.Borovy Praha (3) Praha, Aventinum (4) Praha: Aventinum (5) Praha: Aventinum (6) Ceskoslovensky Spisovatel (7) Fr. Borovy Praha 59 (1) Cassell and Company 60 (1) Experimenter Publishing Company (2) Experimenter Publishing Company (3) Experimenter Publishing Company (4) Experimenter Publishing Company (5) Experimenter Publishing Company (6) Experimenter Publishing Company 61 (1) Experimenter Publishing Company (2) Experimenter Publishing Company (3) Experimenter Publishing Company (4) Experimenter Publishing Company 62 (1) Experimenter Publishing Company (2) Experimenter Publishing Company (3) Experimenter Publishing Company tl Experimenter Publishing Company tr Experimenter Publishing Companycr Experimenter Publishing Company b Experimenter Publishing Company 63 tl Experimenter Publishing Company tr Experimenter Publishing Company cr Experimenter Publishing Company bl Experimenter Publishing Company br Experimenter Publishing Company 64 (1) Universum Film (2) August Scherl (3) Ikuei Shuppan, Kodansha (4) Giorgio Moroder (5) Piccadilly Theatre (6) Madhouse / Tezuka Productions 65 (1) F.W. Murnau Foundation (2) F.W.M.S. / Transit Film / Eureka Entertainment Ltd. (3) The M Machine / OWSLA 66 tl UFA / THE KOBAL COLLECTION tr UFA / THE KOBAL COLLECTION cr UFA / THE KOBAL COLLECTION bl UFA / THE KOBAL COLLECTION 67 tl UFA / THE KOBAL COLLECTION / VON HARBOU, HORST tr UFA / THE KOBAL COLLECTION / VON HARBOU, HORST tr British Film Institute cl UFA / THE KOBAL COLLECTION / VON HARBOU, HORST cr BANDAI / TOHO / TEZUKA / THE KOBAL COLLECTION bl REX / Moviestore Collection br BANDAI / TOHO / TEZUKA / THE KOBAL COLLECTION 68 (1) Experimenter Publishing Company (2) National Newspaper Service Syndicate (3) CBS (4) Universal Pictures (5) ABC (6) Universal Studios (7) TSR (8) Dynamite Entertainment 69 (1) The Adjutant (2) Pyramid Books (3) Galaxy Publishing (4) Galaxy Publishing (5) Pyramid Books (7) Pyramid Books 70 (1) Ballantine Books (2) Dell Magazines (3) Dell Magazines (4) Dell Magazines (5) Dell Magazines (6) Dell Magazines (7) Dell Magazines (8) Dell Magazines (1) Methuen (2) Methuen (3) Methuen (4) Dodd, Mead 72 (1) Chatto & Windus (2) CBS (3) Chatto & Windus (4) Universal TV (5) Dan Wigutow Productions / HOF

Productions / Michael R. Joyce Productions / USA Networks Studios / Universal Television Entertainment **74 (1)** Hutchinson **(2)** London Film Productions **(3)** CFI Investments / SOTTC Film Productions Ltd. **76 (1)** London Film Productions **tl** British Film Institute **tr** British Film Institute **cr** LONDON FILMS / UNITED ARTISTS / THE KOBAL COLLECTION **b** LONDON FILMS / UNITED ARTISTS / THE KOBAL COLLECTION **77 t** REX / ITV **cl** LONDON FILMS / UNITED ARTISTS / THE KOBAL COLLECTION **bl** LONDON FILMS / UNITED ARTISTS / THE KOBAL COLLECTION **br** British Film Institute **78 (1)** RKO Radio Pictures **(2)** RKO Radio Pictures **(3)** John Beck / RKO General Pictures / Toho Company / Universal International Pictures **(4)** Videocraft, Toei Animation **(5)** Rankin / Bass Productions / Toho Company **(6)** Dino De Laurentiis Company **(7)** De Laurentiis Entertainment Group (DEG) **(8)** L.A. Animation / Lana Productions **79 (1)** BKN International **(2)** Dark Horse **(3)** BKN International / Warner Home Video **(4)** Pocket Star **(5)** Universal Pictures / Wing Nut Films **(6)** Pocket Star **(7)** Regent Theatre, Melbourne **80 (1)** RKO Radio Pictures **(2)** John Beck / RKO General Pictures / Toho Company / Universal International Pictures **(3)** Rankin / Bass Productions / Toho Company **(4)** Dino De Laurentiis Company **(5)** Universal Pictures / Wing Nut Films **tl** RKO / THE KOBAL COLLECTION **tr** RKO / THE KOBAL COLLECTION **cl** RKO / THE KOBAL COLLECTION **cr** RKO / THE KOBAL COLLECTION **bl** RKO / THE KOBAL COLLECTION **br** TOHO / THE KOBAL COLLECTION **81 tl** RANKIN-BASS-TOHO / THE KOBAL COLLECTION **tr** PARAMOUNT / THE KOBAL COLLECTION **cl** UNIVERSAL / WING NUT FILMS / THE KOBAL COLLECTION **cr** UNIVERSAL / WING NUT FILMS / THE KOBAL COLLECTION **bl** UNIVERSAL / WING NUT FILMS / THE KOBAL COLLECTION **br** UNIVERSAL / WING NUT FILMS / THE KOBAL COLLECTION **82 (1)** Experimenter Publishing Company **(2)** Dell Magazines **(3)** Dell Magazines **(4)** Dell Magazines **(5)** H-K Publications **(6)** Dell Magazines **(7)** Fantasy Press **(8)** Fantasy Press **83 (1)** Fantasy Press **(2)** Fantasy Press **(3)** Fantasy Press **(4)** Fantasy Press **(5)** Vector Enterprises **(6)** EE Doc Smith MK Company / Kodansha / MK Productions Ltd. / Mad House / Toho Company **(7)** MK Productions **(8)** Eternity **84 (1)** Reproduced with the kind permission of King Features Syndicate **(2)** Universal Pictures; Reproduced with the kind permission of King Features Syndicate **(3)** Grosset & Dunlap; Reproduced with the kind permission of King Features Syndicate **(4)** Universal Pictures; Reproduced with the kind permission of King Features Syndicate **(5)** Universal Pictures; Reproduced with the kind permission of King Features Syndicate **(6)** Inter-Continental Film Productions / Interwest / La Telediffusion / Luedecker Productions; Reproduced with the kind permission of King Features Syndicate **(8)** Avon; Reproduced with the kind permission of King Features Syndicate **85 (1)** Avon; Reproduced with the kind permission of King Features Syndicate **(2)** Filmation Associates / King Features Syndicate; Reproduced with the kind permission of King Features Syndicate **(3)** Starling Films / Dino De Laurentiis Company; Reproduced with the kind permission of King Features Syndicate **(4)** Filmation; Reproduced with the kind permission of King Features Syndicate **(5)** Marvel Productions; Reproduced with the kind permission of King Features Syndicate **(7)** Marvel; Reproduced with the kind permission of King Features Syndicate **(8)** Dynamite Entertainment; Reproduced with the kind permission of King Features Syndicate **86 (1)** Reproduced with the kind permission of King Features Syndicate **(2)** Reproduced with the kind permission of King Features Syndicate **(3)** Reproduced with the kind permission of King Features Syndicate **(4)** Reproduced with the kind permission of King Features Syndicate **(5)** Reproduced with the kind permission of King Features Syndicate **88 (1)** Reproduced with the kind permission of King Features Syndicate **(2)** Universal Pictures; Reproduced with the kind permission of King Features Syndicate **(3)** Universal Pictures; Reproduced with the kind permission of King Features Syndicate **(4)** Inter-Continental Film Productions / Interwest / La Telediffusion / Luedecker Productions; Reproduced with the kind permission of King Features Syndicate **(5)** Filmation Associates / King Features Syndicate; Reproduced with the kind permission of King Features Syndicate **(6)** Starling Films / Dino De Laurentiis Company; Reproduced with the kind permission of King Features Syndicate **(7)** Flash Films / Reunion Pictures; Reproduced with the kind permission of King Features Syndicate **tl** Reproduced with the kind permission of King Features Syndicate **tr** REX / Moviestore Collection; Reproduced with the kind permission of King Features Syndicate **cl** UNIVERSAL / THE KOBAL COLLECTION; Reproduced with the kind permission of King Features Syndicate **cr** REX / PF / Everett; Reproduced with the kind permission of King Features Syndicate **bl** REX / Everett Collection; Reproduced with the kind permission of King Features Syndicate **br** REX / Everett Collection; Reproduced with the kind permission of King Features Syndicate **89 t** British Film Institute; Reproduced with the kind permission of King Features Syndicate **bl** British Film Institute; Reproduced with the kind permission of King Features Syndicate **cr** UNIVERSAL / THE KOBAL COLLECTION; Reproduced with the kind permission of King Features Syndicate **br** REX / Snap Stills; Reproduced with the kind permission of King Features Syndicate **90 (1)** Pendulum Publications **(2)** Nova Publications **(3)** Berkley **(4)** Charles Partington **(5)** Gollancz **(6)** www.newworlds.co.uk **(7)** **91 (1)** Dell Magazines **(2)** Popular Publications **(3)** Ballantine Books **(4)** Galaxy Publishing **(5)** Galaxy Publishing **(6)** Random House **(7)** St. Martin's Press **(8)** HarperVoyager **92 (1)** DC Comics **(2)** DC Comics **(3)** DC Comics **(4)** Fleischer Studios / Famous Studios **(5)** Columbia Pictures Corporation **(6)** DC Comics **(7)** DC Comics **(8)** Dovemead Films / Film Export A.G. / International Film Production **93 (1)** Dovemead Films / Film Export A.G. / International Film Production **(2)** Dovemead Films / Cantharus Productions **(3)** DC Comics **(4)** Cannon Films / Warner Bros. / Golan-Globus Productions / London-Cannon Films **(5)** Warner Bros. Television **(6)** Tollin / Robbins Productions / Millar Gough Ink / Warner Bros. Television / DC Comics / DC Entertainment / Smallville **(3)** Films / Smallville Films **(7)** Warner Bros. / DC Comics **(8)** Warner Bros. **94 (1)** Dovemead Films / Film Export A.G. / International Film Production **(2)** Dovemead Films / Film Export A.G. / International Film Production **(3)** Dovemead Films / Film Export A.G. / International Film Production **(4)** Artistry Limited / Investors In Industry PLC / Robert Fleming Leasing Limited / St. Michael Finance Limited **96 (1)** DC Comics **(2)** Fleischer Studios / Famous Studios **(3)** DC Comics **(4)** Dovemead Films / Film Export A.G. / International Film Production **(5)** DC Comics / Warner Bros. **(6)** Tollin / Robbins Productions / Millar Gough Ink / Warner Bros. Television / DC Comics / DC Entertainment / Smallville **(3)** Films / Smallville Films **(7)** Warner Bros. / DC Comics **(8)** Warner Bros. **tl** REX / Everett Collection **tr** DC Comics **cr** REX / Courtesy Everett Collection **b** REX / Everett Collection **97 tl** REX / c.Warners / Everett **tr** REX / Moviestore Collection **cl** REX / c.CWNetwork / Everett **cr** REX / Snap Stills **bl** REX / c.CWNetwork / Everett **br** REX / c.Warner Br / Everett **98 (1)** Dell Magazines **(2)** RKO **(3)** Starstream **(4)** Bantam **(5)** Universal Pictures / Turman-Foster Company **(6)** Dark Horse **99 (1)** Dark Horse **(2)** Dark Horse **(3)** Computer Artwork **(4)** Dark Horse **(5)** Wyrm Publishing **(6)** Morgan Creek Productions / Universal Pictures / Strike Entertainment **100 (1)** RKO **(2)** Universal Pictures / Turman-Foster Company **(3)** Morgan Creek Productions / Universal Pictures / Strike Entertainment **tl** RKO / THE KOBAL COLLECTION **tr** RKO / THE KOBAL COLLECTION **cl** RKO / THE KOBAL COLLECTION **cr** REX / Moviestore Collection **b** UNIVERSAL / THE KOBAL COLLECTION **101 tl** UNIVERSAL / THE KOBAL COLLECTION **tr** UNIVERSAL / THE KOBAL COLLECTION **c** STRIKE ENTERTAINMENT / THE KOBAL COLLECTION **br** REX / Moviestore Collection **102 (1)** John Lane **(2)** The Bodley Head **(3)** The Bodley Head **(4)** Avon **(5)** Collins **103 (1)** Dell Magazines **(2)** Scribner's **(3)** George Pal Productions **(4)** G. P. Putnam's Sons **(5)** G. P. Putnam's Sons **(6)** G. P. Putnam's Sons **(7)** G. P. Putnam's Sons **(8)** G. P. Putnam's Sons **104 (1)** DC Comics **(2)** DC Comics **(3)** 20th Century Fox Television / Greenway Productions **(4)** DC Comics **(5)** DC Comics **(6)** DC Comics **(7)** Warner Bros. / DC Comics **(8)** Warner Bros. / DC Comics **105 (1)** Warner Bros. / DC Comics **(2)** DC Comics **(3)** Warner Bros. / DC Comics **(4)** DC Comics **(5)** DC Comics **(6)** Warner Bros. / DC Comics **(7)** DC Comics **(8)** Warner Bros. / DC Comics **106 (1)** DC Comics **(2)** DC Comics **(3)** DC Comics **(4)** DC Comics **(5)** DC Comics **(6)** DC Comics **(7)** DC Comics **(8)** DC Comics **107 (1)** DC Comics **(2)** DC Comics **108 (1)** DC Comics **(2)** 20th Century Fox Television / Greenway Productions **(3)** DC Comics **(4)** Warner Bros. / DC Comics **(5)** Warner Bros. / DC Comics **(6)** Warner Bros. / DC Comics **(7)** Warner Bros. / DC Comics **(8)** Warner Bros. / DC Comics **tl** DC Comics **tr** REX / SNAP **cr** WARNER BROS / DC COMICS / THE KOBAL COLLECTION **bl** DC Comics **br** REX / SNAP **109 tl** REX / SNAP **tr** REX / Moviestore Collection **cl** REX / Everett Collection **cr** WARNER BROS. / D.C. COMICS / THE KOBAL COLLECTION / JAMES, DAVID **bl** British Film Institute © 2005 Warner Bros. Entertainment Inc. **br** REX / c.Warner Br / Everett **110 tl** REX / c.20thC.Fox / Everett **tr** REX / Moviestore Collection **cr** REX / c.Warner Br / Everett **bl** DC Comics **br** WARNER BROS / THE KOBAL COLLECTION **111 tl** WARNER BROS / DC COMICS / THE KOBAL COLLECTION **tr** REX / Warner Bro / Everett **cl** REX / c.Warner Br / Everett **cr** REX / Moviestore Collection **bl** British Film Institute © 2005 Warner Bros. Ent. **br** REX / c.Warner Br / Everett **112 (1)** Experimenter Publishing Company **(2)** Dell Magazines **(3)** Gnome Press **(4)** Gnome Press **(5)** Bantam Books **(6)** Doubleday **(7)** Paramount Pictures / Century Associates **(8)** Doubleday **113 (1)** Popular Publications **(2)** Dell Magazines **(3)** Gnome Press **(4)** Doubleday **(5)** Doubleday **(6)** Doubleday **(7)** Doubleday **(8)** Twentieth Century Fox Film Corporation **114 (1)** Dell Magazines **(2)** Twentieth Century Fox Film Corporation **(3)** Lux Radio Theater **(4)** Twentieth Century Fox Film Corporation **115 (1)** TM & © 2014 Marvel Entertainment, LLC **(2)** TM & © 2014 Marvel Entertainment, LLC **(3)** TM & © 2014 Marvel Entertainment, LLC **(4)** DC Comics **(5)** DC Comics **(6)** DC Comics **(7)** DC Comics **(8)** DC Comics **116 (1)** TM & © 2014 Marvel Entertainment, LLC **(2)** TM & © 2014 Marvel Entertainment, LLC **(3)** TM & © 2014 Marvel Entertainment, LLC **(4)** TM & © 2014 Marvel Entertainment, LLC **(5)** TM & © 2014 Marvel Entertainment, LLC **(6)** TM & © 2014 Marvel Entertainment, LLC **(7)** TM & © 2014 Marvel Entertainment, LLC **(8)** FWE Picture Company / POW! Entertainment **117 (1)** Nth Dimension Media **(2)** Dell Magazines **(3)** Michael Joseph **(4)** Michael Joseph **(5)** Eyre & Spottiswoode **(6)** Hodder and Stoughton **(7)** Simon Pulse **(8)** Dutton **118 (1)** Dell Magazines **(2)** Dell Magazines **(3)** Gnome Press **(4)** Gnome Press **(5)** Gnome Press **(6)** Doubleday **(7)** Doubleday **(8)** Doubleday **119 (1)** Tor **(2)** Doubleday **(3)** Ace Books **(4)** Ace Books **(5)** Ace Books **(6)** Harper Prism **(7)** Harper Prism **(8)** Harper Prism **120 (1)** Condé Nast Publications **(2)** Arkham House **(3)** Doubleday **(4)** Doubleday **(5)** Ballantine Books **(6)** Universal International Pictures **(7)** Ballantine Books **(8)** Doubleday **121 (1)** Simon & Schuster **(2)** Cayuga Productions / Columbia Broadcasting System **(3)** Alfred A. Knopf **(4)** Alfred A. Knopf **(5)** Walt Disney Productions / Bryna Productions **(6)** Alfred A. Knopf **(7)** Alberta Filmworks / Atlantis Films / Ellipse Programme / Granada Television **(8)** William Morrow and Company **122 (1)** Universal International Pictures **(2)** Anglo Enterprises / Vineyard Film Ltd. **(3)** SKM **(4)** Charles Fries Productions / Stonehenge Productions / BBC / Polytel

International Film **tl** REX / Everett Collection **tr** REX / Moviestore Collection **cl** UNIVERSAL / THE KOBAL COLLECTION **cr** British Film Institute **bl** ANGLO ENTERPRISE / VINEYARD / THE KOBAL COLLECTION **br** ANGLO ENTERPRISE / VINEYARD / THE KOBAL COLLECTION **123 tl** ANGLO ENTERPRISE / VINEYARD / THE KOBAL COLLECTION **tr** REX / Moviestore Collection **cl** REX / Moviestore **br** CHARLES FRIES PRODS / THE KOBAL COLLECTION **124 (1)** Dell Magazines **(2)** Ballantine Books **(3)** NAL / Signet **(4)** Metro-Goldwyn-Mayer / Stanley Kubrick Productions **(5)** Gollancz **(6)** Granada Publishing Ltd. **(7)** Voyager Books **(8)** Voyager Books **125 (1)** Nowa **(2)** Czytelnik **(3)** Iskry **(4)** Iskry **(5)** MON, Walker **(6)** Wydawnictwo Literackie **(7)** Czytelnik **(8)** WL **126 (1)** Secker and Warburg **(2)** BBC **(3)** Columbia Pictures Corporation / Holiday Film Productions Ltd. **(4)** David Bowie / RCA **(5)** Umbrella-Rosenblum Films Production / Virgin **(6)** Embassy International Pictures **(7)** DC Comics **(8)** BBC **127 (1)** Daiei Studios **(2)** Toho Film (Eiga) Co. Ltd. **(3)** Tsuburaya Productions **(4)** Toho Company / Tsuburaya Productions **(5)** Tsuburaya Productions **(6)** Tsuburaya Productions **(7)** Tokyo Broadcasting System / Tsuburaya Productions **128** © Photos 12 / Alamy **130 (1)** IPC Magazines **(2)** © REBELLION A / S, ALL RIGHTS RESERVED. **(3)** IPC Magazines **(4)** Virgin Interactive, Electronic Arts **(5)** BBC **(6)** Fleetway **131 (1)** Netter Digital Animation **(2)** Spaceship Away **(3)** Liquid Comics **132 tl** Reproduced with kind permission of the Dan Dare Corporation Limited **tr** Reproduced with kind permission of the Dan Dare Corporation Limited **crf** Reproduced with kind permission of the Dan Dare Corporation Limited **crb** 2000 AD ARTWORK © REBELLION A / S, ALL RIGHTS RESERVED; Reproduced with kind permission of the Dan Dare Corporation Limited **b** 2000 AD ARTWORK © REBELLION A / S, ALL RIGHTS RESERVED; Reproduced with kind permission of the Dan Dare Corporation Limited **133 tl** Reproduced with kind permission of the Dan Dare Corporation Limited **tr** Reproduced with kind permission of the Dan Dare Corporation Limited **cl** Reproduced with kind permission of the Dan Dare Corporation Limited **c** Reproduced with kind permission of the Dan Dare Corporation Limited **cr** Reproduced with kind permission of the Dan Dare Corporation Limited **bl** Reproduced with kind permission of the Dan Dare Corporation Limited **br** Reproduced with kind permission of the Dan Dare Corporation Limited **134 (1)** Spilogale, Inc. **(2)** Gold Medal **(3)** Gold Medal **(4)** Cayuga Productions / Columbia Broadcasting System **(5)** Paramount Television **(6)** American Broadcasting Company / Dan Curtis Productions **(7)** ABC Circle Films **(8)** Viking Press **135 (1)** JTE Multimedia **(2)** Charles Scribner's Sons **(3)** Dell **(4)** Spilogale, Inc. **(5)** Holt, Rinehart and Winston **(6)** Delacorte Press **(7)** Delacorte Press **(8)** Delacorte Press **136 (1)** Avon Publications **(2)** Experimenter Publishing Company **(3)** Metro-Goldwyn-Mayer / Stanley Kubrick Productions **(4)** New American Library **(5)** Signet **(6)** Granada Publishing Ltd. **137 (1)** Metro-Goldwyn-Mayer **(2)** Del Rey **(3)** Voyager Books **(4)** Voyager Books **(5)** Del Rey **(6)** Del Rey **138 (1)** Metro-Goldwyn-Mayer / Stanley Kubrick Productions **(2)** Metro-Goldwyn-Mayer / Stanley Kubrick Productions **(3)** Metro-Goldwyn-Mayer / Stanley Kubrick Productions **(4)** Metro-Goldwyn-Mayer / Stanley Kubrick Productions **140 (1)** Metro-Goldwyn-Mayer / Stanley Kubrick Productions **(2)** Metro-Goldwyn-Mayer **tl** REX / Moviestore Collection **tr** REX / c.MGM / Everett **cr** MGM / THE KOBAL COLLECTION **bl** MGM / THE KOBAL COLLECTION **141 tl** MGM / UA / THE KOBAL COLLECTION **tr** MGM / UA / THE KOBAL COLLECTION **cl** MGM / THE KOBAL COLLECTION **b** MGM / THE KOBAL COLLECTION **142 (1)** Michael Joseph **(2)** BBC **(3)** Allied Artists Pictures / Security Pictures Ltd. **(4)** BBC **(5)** Australian Broadcasting Corporation / BBC / RCTV Inc. **(6)** Hodder & Stoughton **143 (1)** Power **(1)** Michael Joseph **(2)** Allied Artists Pictures / Security Pictures Ltd. **(3)** Australian Broadcasting Corporation / BBC / RCTV Inc. **(4)** Power Ent. **144 tl** Power Ent. **tr** © AF archive / Alamy **cl** REX / SNAP **cr** Copyright © BBC Photo Library **bl** Copyright © BBC Photo Library **145 tl** Power Ent. **tr** REX / James Boardman **cl** Power Ent. **cr** Power Ent. **b** Power Ent. **146 (1)** Kobunsha, Kodansha **(2)** MBS Productions **(3)** Mushi Production **(4)** Tezuka Production Company Ltd. **(5)** Tezuka Production Company Ltd. **(6)** Tezuka Productions / Sony Pictures Television **(7)** Shogakukan **(8)** Imagi Animation Studios / Imagi Crystal / Tezuka Production Company Ltd. **147 (1)** Shasta Publishers **(2)** Universal International Pictures **(3)** Best Brains / Universal Pictures **148 (1)** Fiction House **(2)** Ace Books **(3)** Ace Books **(4)** Putnam **(5)** Ballantine Books **(6)** Ace Books **(7)** Doubleday **(8)** Doubleday **149 (1)** Pyramid Books **(2)** Doubleday **(3)** Doubleday **(4)** Doubleday **(5)** Doubleday **(6)** Bantam Books **(7)** Timescape Books / Simon & Schuster **(8)** Arbor House **150 (1)** Ladd Company / Shaw Brothers / Warner Bros. **(2)** Carolco Pictures **(3)** Allegro Films / Fries Film Group / Fuji Eight Company Ltd. / The Movie Network / Super Ecran / Triumph Films **(4)** Twentieth Century Fox Film Corporation / DreamWorks SKG **(5)** Paramount Pictures / DreamWorks SKG **(6)** Warner Independent Pictures / Thousand Words **(7)** Total Recall / Original Film / Prime Focus / Rekall Productions **tl** REX / c.Warner Br / Everett **tr** REX / SNAP **cl** REX / Everett Collection **crf** REX / SNAP **crb** REX / Moviestore Collection **bl** REX / Moviestore Collection **br** REX / Moviestore Collection **151 tl** REX / Moviestore Collection **tr** REX / Moviestore Collection **cl** REX / Moviestore Collection **cr** REX / Snap Stills **br** REX / Snap Stills **152 (1)** Galaxy Publishing **(2)** Shasta Publishers **(3)** Meulenhoff **(4)** Galaxy Publishing **(5)** Signet **(6)** Dell Magazine **(7)** Berkley Books **153 (1)** Galaxy Publishing **(2)** Faber and Faber **(3)** Gnome Press **(4)** Ballantine Books **(5)** Signet **(6)** Faber and Faber **(7)** Penguin Books **(8)** Penguin Books **154 (1)** Universal International Pictures **(2)** Universal International Pictures **(3)** Universal International Pictures **(4)** Universal International Pictures **(5)** Ivan Tors Productions **(6)** Universal International Pictures **155 (1)** Paramount Pictures **(2)** Universal International Pictures **(3)** CBS Productions / United Artists Television / ZIV Television Programs **(4)** Bruce Lansbury Productions / Douglas S. Cramer Company / Warner Bros. Television **(5)** Harve Bennett Productions / Universal TV **(6)** Universal TV **156 (1)** Universal International Pictures **(2)** Universal International Pictures **(3)** Universal International Pictures **(4)** Ivan Tors Productions **(5)** Universal International Pictures **(6)** Bruce Lansbury Productions / Douglas S. Cramer Company / Warner Bros. Television **(7)** Harve Bennett Productions / Universal TV **tl** UNIVERSAL / THE KOBAL COLLECTION **tr** REX / Moviestore Collection **cl** REX / Courtesy Everett Collection **cr** REX / Moviestore Collection **bl** REX / Everett Collection **br** REX / SNAP **157 tl** REX / Moviestore Collection **tr** REX / Everett Collection **cl** REX / Everett Collection **cr** MCA TV / THE KOBAL COLLECTION **br** REX / Moviestore Collection **158 (1)** BBC **(2)** BBC **(3)** Exclusive / Hammer Film Productions **(4)** Hammer Film Productions **(5)** BBC **(6)** Hammer Film Productions **(7)** Euston Films / Thames Television **(8)** BBC **159 (1)** Gold Medal **(2)** Produzioni La Regina / Associated Producers **(3)** Walter Seltzer Productions **(4)** Eclipse Comics **(5)** Warner Bros. / Village Roadshow Pictures **(6)** Vertigo / DC Comics **(7)** The Asylum **160 (1)** Toho Film (Eiga) Co. Ltd. **(2)** Toho Company **(3)** John Beck / RKO General Pictures / Toho Company / Universal International Pictures **(4)** Toho Company **(5)** Hanna-Barbera Productions / Benedict Pictures Corp. / Toho Company **(6)** Toho Company / Toho Eizo Co. **(7)** Centropolis Film Productions / Fried Films / Independent Pictures (II) / Toho Film (Eiga) Co. Ltd. / TriStar Pictures **(8)** Toho Film (Eiga) Co. Ltd. / C.P. International / Zazou / napalm FiLMS **161 (1)** Nova Publications **(2)** Faber and Faber **(3)** Carroll & Graf Publishers **(4)** Spilogale Inc. **(5)** Hearst **(6)** Weidenfeld & Nicolson **(7)** Random House **(8)** Jonathan Cape **162 (1)** Crownpoint Publications **(2)** Thomas Y. Crowell Company **(3)** Avon **(4)** Ballantine Books **(5)** Sphere **(6)** Charles Scribner's Sons **(7)** Bantam Books **(8)** EOS Books **163 (1)** Galaxy Publishing **(2)** Ace Books **(3)** Doubleday **(4)** Avon **(5)** Doubleday **(6)** Spilogale Inc. **(7)** Spilogale Inc. **(8)** Babylonian Productions / Warner Bros. Television **164 (1)** Eyre & Spottiswoode **(2)** Allied Artists Pictures / Walter Wanger Productions **(3)** Solofilm **(4)** Dorset Productions / Robert H. Solo Productions / Warner Bros. **(5)** Warner Bros. / Village Roadshow Pictures / Silver Pictures / Vertigo Entertainment **(6)** The Asylum **165 (1)** Nova Publications **(2)** Gollancz **(3)** Gollancz **(4)** Jonathan Cape **(5)** Jonathan Cape **(6)** Jonathan Cape **(7)** Flamingo London **(8)** Flamingo London **166 (1)** Metro-Goldwyn-Mayer **(2)** Metro-Goldwyn-Mayer **167 (1)** Playboy **(2)** Twentieth Century Fox Film Corporation **(3)** Associated Producers **(4)** Lippert Films **(5)** SLM Production Group / Brooksfilms **168 (1)** Dell Comics **(2)** Pyramid Books **(3)** Walker **(4)** Galaxy Publishing **(5)** Davis Publications **(6)** Rebellion **(7)** Tor Books **(8)** Gollancz **169 (1)** Michael Joseph **(2)** Metro-Goldwyn-Mayer **(3)** Lawrence P. Bachmann Productions / Metro-Goldwyn-Mayer **(4)** BBC **(5)** Universal Pictures / Alphaville Films **(6)** BBC **170 (1)** Nova Publications **(2)** Mayflower Books Ltd **(3)** Allison & Busby **(4)** DAW **(5)** Fontana **(6)** Granada **(7)** Orion Books / Millenium **(8)** Pyr **171 (1)** ACT-Moscow **(2)** ACT-Moscow **(3)** ACT-Moscow **(4)** ACT-Moscow **(5)** ACT-Moscow **(6)** ACT-Moscow **(7)** ACT-Moscow **(8)** ACT-Moscow **172 (1)** Spilogale Inc. **(2)** G. P. Putnam's Sons **(3)** Avalon Hill **(4)** Radio Shack / Tandy Corporation **(5)** Bandai Visual Company / Nippon Sunrise / Studio Nue **(6)** TriStar Pictures / Touchstone Pictures / Big Bug Pictures **(7)** Dark Horse **(8)** Avalon Hill **173 (1)** Adelaide Productions **(2)** Startroop Pictures Inc. / Tippett Studio **(3)** Mongoose Publishing **(4)** Sony Pictures Home Entertainment / ApolloMovie Beteiligungs / Bold Films / Film Afrika Worldwide **(5)** Spectre Media **(6)** Sola Digital Arts / Stage 6 Films **174 (1)** Cayuga Productions / Columbia Broadcasting System **(2)** Dell Comics **(3)** Gold Key **(4)** Warner Bros. **(5)** Atlantis Films / Columbia Broadcasting System / London Film Productions / MGM Television / Persistence of Vision Films **(6)** NOW Comics **175 (1)** O'Hara-Horowitz Productions **(2)** MJF Books **(3)** MJF Books **(4)** New Line Television / Spirit Dance Entertainment / Trilogy Entertainment Group / Joshmax Productions Services **(5)** Walker & Co. **(6)** Tor Books **176 (1)** Cayuga Productions / Columbia Broadcasting System **(2)** Gold Key **(3)** Warner Bros. **t** REX / c.Everett Collection **cl** REX / c.Everett Collection **cr** REX / c.Everett Collection **bl** REX / c.Everett Collection **br** Gold Key **177 tl** WARNER BROS / THE KOBAL COLLECTION **tr** WARNER BROS / THE KOBAL COLLECTION **cl** WARNER BROS / THE KOBAL COLLECTION **b** WARNER BROS / THE KOBAL COLLECTION **178 (1)** Irwin Allen Productions **(2)** Twentieth Century Fox Film Corporation / Windsor Productions **(3)** Irwin Allen Productions **(4)** Irwin Allen Productions / 20th Century Fox Television **(5)** 20th Century Fox Television / Columbia Broadcasting System / Irwin Allen Productions **(6)** 20th Century Fox Television / Irwin Allen Productions / Kent Productions **179 (1)** 20th Century Fox Television / Irwin Allen Productions / Kent Productions **(2)** Kent Productions / Motion Pictures International / Warner Bros. Television **(3)** 20th Century Fox Television / Irwin Allen Productions **(4)** Irwin Allen Productions / Warner Bros. Television **(5)** Warner Bros. **180 (1)** Irwin Allen Productions **(2)** Twentieth Century Fox Film Corporation / Windsor Productions **(3)** Irwin Allen Productions **(4)** 20th Century Fox Television / Columbia Broadcasting System / Irwin Allen Productions **(5)** 20th Century Fox Television / Irwin Allen Productions / Kent Productions **(6)** Warner Bros. **tl** REX / Moviestore Collection **tr** 20TH CENTURY FOX / THE KOBAL COLLECTION **cr** REX / Moviestore Collection **b** 20TH CENTURY FOX / THE KOBAL COLLECTION **181 tl** British Film Institute **tr** 20TH CENTURY FOX / CBS TELEVISION / THE KOBAL COLLECTION **cl** British Film Institute **cr** REX / Moviestore Collection **bl** WARNER BROS / THE KOBAL COLLECTION **br** WARNER BROS / THE KOBAL

COLLECTION **182 (1)** AP Films / Incorporated Television Company **(2)** AP Films / Associated Television / Incorporated Television Company **(3)** AP Films / Associated Television **(4)** AP Films / Associated Television **(5)** Century 21 Television / Incorporated Television Company **(6)** Century21 Television / Incorporated Television Company **(7)** Century 21 Television **(8)** Century 21 Television / Incorporated Television Company **183 (1)** Century 21 Television **(2)** Incorporated Television Company **(3)** Group 3 / Incorporated Television Company / RAI Radiotelevisione Italiana **(4)** Anderson Burr Pictures / London Weekend Television **(5)** Virgin **(6)** Grove Television Enterprises / Mentorn **(7)** CPI / Cosgrove Hall Films / Gerry Anderson Productions **(8)** Indestructible Production Company **184 (1)** AP Films / Incorporated Television Company **(2)** AP Films / Associated Television / Incorporated Television Company **(3)** AP Films / Associated Television **(4)** AP Films / Associated Television **(5)** Century 21 Television / Incorporated Television Company **(6)** Grove Television Enterprises / Mentorn **(7)** Century 21 Television / Incorporated Television Company **tl** REX / ITV **tr** GTV ARCHIVE **cl** REX / ITV **cr** REX / ITV **b** REX / ITV **185 tl** REX / Granada International **tr** REX / Granada International **cl** Grove Television Enterprises / Mentorn; photo supplied by Stephen La Riviere **cr** Grove Television Enterprises / Mentorn; photo supplied by Stephen La Riviere **bl** GTV ARCHIVE **br** REX / ITV **186 tl** GTV ARCHIVE **tr** REX / ITV **cl** REX / ITV **cr** REX / ITV **b** REX / ITV **187 tl** REX / ITV **tr** REX / ITV **cl** REX / ITV **cr** REX / ITV **bl** REX / ITV **br** REX / Granada International **188 (1)** Pabel-Moewig Verlag **(2)** Aitor Films / Constantin Film Produktion / Produzioni Europee Associati / Theumer Film / Tritone Cinematografica **(3)** Ace Books **(4)** Master Publications **(5)** Christopher Franke / Sonic Images **(6)** Vector Enterprises **189 (1)** Fan Pro **(2)** Perry Rhodan Digital **190 (1)** Pabel-Moewig Verlag **(2)** Pabel-Moewig Verlag **(3)** Pabel-Moewig Verlag **192 (1)** MON, Walker **(2)** Iz Sobraniya Gosteleradio / Studio "Orlenok", Central Television USSR **(3)** Creative Unit of Writers & Cinema Workers / Kinostudiya "Mosfilm" / Unit Four **(4)** Twentieth Century Fox Film Corporation / Lightstorm Entertainment **194 (1)** Creative Unit of Writers & Cinema Workers / Kinostudiya "Mosfilm" / Unit Four **(2)** Twentieth Century Fox Film Corporation / Lightstorm Entertainment **t** British Film Institute **cl** British Film Institute **cr** British Film Institute **bl** British Film Institute **br** REX / c.20thC.Fox / Everett **195 tl** British Film Institute **tr** British Film Institute **cl** British Film Institute **cr** REX / Moviestore Collection **br** REX / Moviestore **196 (1)** University of Utah English Department **(2)** Ace Books **(3)** Ace Books **(4)** Panther **(5)** Ace Books **(6)** Experimenter Publishing Co. **(7)** Doubleday **(8)** Doubleday **197 (1)** Harper & Row **(2)** Galaxy Publishing **(3)** Delacorte Press **(4)** Harper and Row **(5)** Spilogale Inc. **(6)** HarperCollins **(7)** Harcourt **(8)** Harcourt **198 (1)** TM & © 2014 Marvel Entertainment, LLC **(2)** TM & © 2014 Marvel Entertainment, LLC **(3)** Krantz Films / Marvel Enterprises **(4)** TM & © 2014 Marvel Entertainment, LLC **(5)** TM & © 2014 Marvel Entertainment, LLC **(6)** TM & © 2014 Marvel Entertainment, LLC **(7)** Charles Fries Productions / Dan Goodman Productions **(8)** TM & © 2014 Marvel Entertainment, LLC **199 (1)** New World Entertainment Films / Genesis Entertainment / Marvel Enterprises / Marvel Productions / TMS Entertainment **(2)** Columbia Pictures Corporation / Marvel Enterprises / Laura Ziskin Productions **(3)** Columbia Pictures Corporation / Marvel Enterprises / Laura Ziskin Productions **(4)** Columbia Pictures Corporation / Marvel Enterprises / Laura Ziskin Productions **(5)** TM & © 2014 Marvel Entertainment, LLC **(6)** Columbia Pictures / Marvel Entertainment / Laura Ziskin Productions **(7)** Film Roman Productions / Marvel Animation **(8)** TM & © 2014 Marvel Entertainment, LLC **200 (1)** TM & © 2014 Marvel Entertainment, LLC **(2)** Charles Fries Productions / Dan Goodman Productions **(3)** New World Entertainment Films / Genesis Entertainment / Marvel Enterprises / Marvel Productions / TMS Entertainment **(4)** Columbia Pictures Corporation / Marvel Enterprises / Laura Ziskin Productions **(5)** Columbia Pictures Corporation / Marvel Enterprises / Laura Ziskin Productions **(6)** Columbia Pictures Corporation / Marvel Enterprises / Laura Ziskin Productions **(7)** Columbia Pictures / Marvel Entertainment / Laura Ziskin Productions **tl** TM & © 2014 Marvel Entertainment, LLC **tr** TM & © 2014 Marvel Entertainment, LLC **cl** REX / Moviestore Collection **cr** COLUMBIA / MARVEL / THE KOBAL COLLECTION **bl** REX / Moviestore Collection **br** COLUMBIA / MARVEL / THE KOBAL COLLECTION **201 t** REX / Moviestore Collection **cl** REX / Moviestore Collection **cr** REX / Snap Stills **bl** COLUMBIA PICTURES / THE KOBAL COLLECTION **br** REX / Snap Stills **202 (1)** Hanna-Barbera Productions / Screen Gems **(2)** Gold Key **(3)** Charlton **(4)** Hanna-Barbera Productions / Wang Film Production Company / Cuckoo's Nest Studios **(5)** Hanna-Barbera Productions / Wang Film Production Company / Cuckoo's Nest Studios **(6)** Harvey Comics **(7)** Archie Comics **(8)** DC Comics **203 (1)** Argos Films **(2)** Universal Pictures / Atlas Entertainment / Classico **204 (1)** William Heinemann **(2)** Warner Bros. / Hawk Films **205 (1)** V Magazine **(2)** Editions Eric Losfeld **(3)** Dino de Laurentiis Cinematografica / Marianne Productions **(4)** Kesselring **(5)** Horay **(6)** Albin Michel **(7)** Raimund Theater **206 (1)** Ace Books **(2)** Ace Books **(3)** Ace Books **(4)** Doubleday **(5)** Signet Books **(6)** Bantam Books **(7)** Byron Preiss Visual Publications **(8)** Magnus Books **207 (1)** Villa Di Stefano / Daystar Productions / United Artists Television **(2)** Milton Bradley **(3)** Dell Comics **(4)** DC Comics **(5)** Alliance Atlantis Communications / Atlantis Films / Showtime Networks / Trilogy Entertainment Group **208 (1)** Le Cercle du Nouveau Livre **(2)** APJAC Productions / Twentieth Century Fox Film Corporation **(3)** Akita Shoten **(4)** Twentieth Century Fox Film Corporation / APJAC Productions **(5)** Gold Key **(6)** Twentieth Century Fox Film Corporation / APJAC Productions **209 (1)** Manga Tengoku Zōkan **(2)** Twentieth Century Fox Film Corporation / APJAC Productions **(3)** Twentieth Century Fox Film Corporation / APJAC Productions **(4)** 20th Century Fox Television **(5)** TM & © 2014 Marvel Entertainment, LLC **(6)** DePatie-Freleng Enterprises / Twentieth Century Fox Film Corporation **210 (1)** Adventure Comics **(2)** Twentieth Century Fox Film Corporation / The Zanuck Company / Tim Burton Productions **(3)** Fox Interactive **(4)** Dark Horse **(5)** HarperCollins **(6)** HarperCollins **211 (1)** Mr. Comics **(2)** Twentieth Century Fox Film Corporation / Chernin Entertainment / Dune Entertainment III **(3)** Boom! Studios **(4)** Archaia **(5)** Chernin Entertainment **212 (1)** APJAC Productions / Twentieth Century Fox Film Corporation **(2)** APJAC Productions / Twentieth Century Fox Film Corporation **(3)** APJAC Productions / Twentieth Century Fox Film Corporation **(4)** APJAC Productions / Twentieth Century Fox Film Corporation **(5)** APJAC Productions / Twentieth Century Fox Film Corporation **214 (1)** APJAC Productions / Twentieth Century Fox Film Corporation **(2)** Twentieth Century Fox Film Corporation / APJAC Productions **(3)** Twentieth Century Fox Film Corporation / APJAC Productions **(4)** TM & © 2014 Marvel Entertainment, LLC **(5)** Twentieth Century Fox Film Corporation / The Zanuck Company / Tim Burton Productions **(6)** Twentieth Century Fox Film Corporation / Chernin Entertainment / Dune Entertainment III **t** 20TH CENTURY FOX / THE KOBAL COLLECTION **cl** 20TH CENTURY FOX / THE KOBAL COLLECTION **cr** REX / Moviestore Collection **bl** 20TH CENTURY FOX / APJAC / THE KOBAL COLLECTION **br** 20TH CENTURY FOX / THE KOBAL COLLECTION **215 tl** TM & © 2014 Marvel Entertainment, LLC **tr** TM & © 2014 Marvel Entertainment, LLC **cl** 20TH CENTURY / ZANUCK CO / THE KOBAL COLLECTION **cr** REX / c.20thC.Fox / Everett **b** REX / c.20thC.Fox / Everett **216 (1)** BBC **(2)** Armada Books **AARU** Productions **(3)** Amicus Productions **(4)** Frederick Muller **(5)** Target Books **AARU** Productions / British Lion Films / Amicus Productions **217 (1)** Target Books **(2)** Adelphi Theatre **(3)** Newman **(4)** TM & © 2014 Marvel Entertainment, LLC **(5)** BBC **(6)** BBC **218 (1)** Virgin Publishing **(2)** Universal TV / BBC Worldwide / 20th Century Fox Television / Fox Network / Universal Studios **(3)** BBC **(4)** BBC **(5)** Big Finish **(6)** BBC **219 (1)** BBC **(2)** BBC **220 (1)** BBC **(2)** BBC **(3)** BBC **(4)** BBC **(5)** BBC **(6)** BBC **(7)** BBC **(8)** BBC **221 (1)** BBC **(2)** BBC **(3)** BBC **(4)** BBC **222 (1)** BBC **(2)** AARU Productions / Amicus Productions **(3)** British Lion Films / Amicus Productions **t** REX / Everett **cl** REX / Associated Newspapers **cr** REX / Moviestore Collection **bl** REX / KEITH BUTLER **223 tl** REX / South West News Service **tr** REX / Huw John **cl** REX / Huw John **bl** REX **br** REX / Beretta / Sims **224 t** British Film Institute **cl** Copyright © BBC Photo Library **cr** Copyright © BBC Photo Library **bl** Copyright © BBC Photo Library **br** Copyright © BBC Photo Library **225 tl** Copyright © BBC Photo Library **tr** Copyright © BBC Photo Library **bl** REX / PETER BROOKER **br** REX **226 (1)** TM & © 2014 Marvel Entertainment, LLC **(2)** TM & © 2014 Marvel Entertainment, LLC **(3)** TM & © 2014 Marvel Entertainment, LLC **(4)** TM & © 2014 Marvel Entertainment, LLC **(5)** TM & © 2014 Marvel Entertainment, LLC **(6)** TM & © 2014 Marvel Entertainment, LLC **(7)** TM & © 2014 Marvel Entertainment, LLC **(8)** TM & © 2014 Marvel Entertainment, LLC **227 (1)** Twentieth Century Fox Film Corporation / Marvel Enterprises **(2)** Twentieth Century Fox Film Corporation / Marvel Enterprises **(3)** TM & © 2014 Marvel Entertainment, LLC **(4)** Twentieth Century Fox Film Corporation / Marvel Enterprises **(5)** Twentieth Century Fox Film Corporation / Marvel Enterprises **(6)** TM & © 2014 Marvel Entertainment, LLC **(7)** TM & © 2014 Marvel Entertainment, LLC **(8)** Twentieth Century Fox Film Corporation / Marvel Enterprises **228 (1)** TM & © 2014 Marvel Entertainment, LLC **(2)** Twentieth Century Fox Film Corporation / Marvel Enterprises **(3)** Twentieth Century Fox Film Corporation / Marvel Enterprises **(4)** Twentieth Century Fox Film Corporation / Marvel Enterprises **(5)** Twentieth Century Fox Film Corporation / Marvel Enterprises **(6)** Twentieth Century Fox Film Corporation / Marvel Enterprises **(7)** TM & © 2014 Marvel Entertainment, LLC **(8)** Twentieth Century Fox Film Corporation / Marvel Enterprises **tl** TM & © 2014 Marvel Entertainment, LLC **tr** 20TH CENTURY FOX / MARVEL ENT GROUP / THE KOBAL COLLECTION / DORY, ATTILA **cl** 20TH CENTURY FOX / THE KOBAL COLLECTION **cr** 20TH CENTURY FOX / MARVEL ENTERTAINMENT / THE KOBAL COLLECTION / ISRAELSON, NELS **bl** 20TH CENTURY FOX / THE KOBAL COLLECTION **br** 20TH CENTURY FOX / THE KOBAL COLLECTION **229 tl** REX / Moviestore Collection **tr** 20TH CENTURY FOX / MARVEL / THE KOBAL COLLECTION **cl** 20TH CENTURY FOX / MARVEL / THE KOBAL COLLECTION **cr** TM & © 2014 Marvel Entertainment, LLC **br** TWENTIETH CENTURY FOX FILM / THE KOBAL COLLECTION **230 (1)** Experimenter Publishing Co. **(2)** Michael Joseph **(3)** Thames Television **(4)** Thames Television **(5)** Methuen Publishing Ltd **(6)** Thames Television **(7)** BBC **231 (1)** Gold Medal Books **(2)** British Lion Film Corporation / Cinema **(5)** **(3)** David Gerber Productions / MGM Television **232 (1)** Dell Magazines **(2)** Dell Magazines **(3)** Chilton Books **(4)** Galaxy Publishing **(5)** Putnam Publishing **(6)** Putnam Publishing **(7)** Avalon Hill **(8)** Putnam Publishing **233 (1)** G. P. Putnam's Sons **(2)** De Laurentiis **(3)** G. P. Putnam's Sons **(4)** Virgin Interactive **(5)** Bantam Spectra **(6)** Evision / New Amsterdam Entertainment **(7)** Bantam Spectra **(8)** Blixa Film Produktion GmbH & Co. KG / Hallmark Entertainment / New Amsterdam Entertainment / TTP Film Distributions II LLC **234 (1)** De Laurentiis **(2)** Blixa Film Produktion GmbH & Co. KG / Hallmark Entertainment / New Amsterdam Entertainment / TTP Film Distributions II LLC **(3)** De Laurentiis **(4)** De Laurentiis **236 (1)** De Laurentiis **t** UNIVERSAL / THE KOBAL COLLECTION **cl** British Film Institute **cr** REX / c.Universal / Everett **bl** REX / c.Universal / Everett **br** REX / Moviestore Collection **237 tl** REX / c.Universal / Everett **tr** REX / Moviestore Collection **cl** REX / Moviestore Collection **b** UNIVERSAL / THE KOBAL COLLECTION **238 (1)** Desilu Productions **(2)** Desilu Productions **(3)** Desilu Productions / Norway Corporation

picture credits continued

/ Paramount Television **(4)** Jeffrey Hayes Productions / Universal TV **(5)** Norway Productions / Warner Bros. Television **(6)** Filmation Associates / Norway Productions / Paramount Television **(7)** Paramount Pictures / Century Associates **(8)** Paramount Pictures **239 (1)** Paramount Pictures / Cinema Group Ventures **(2)** Paramount Pictures / Industrial Light & Magic **(3)** Paramount Television **(4)** Paramount Pictures **(5)** Paramount Pictures **(6)** Alliance Atlantis / Tribune Entertainment / Roddenberry-Kirschner Productions **(7)** Tribune Entertainment / MBR Productions, Inc. / Fireworks Entertainment **240 (1)** Desilu Productions **(2)** Desilu Productions **(3)** Desilu Productions / Norway Corporation **(4)** Paramount Television **(4)** Bantam Books **(5)** Bantam Books **(6)** For-Play Manufacturing **(7)** Filmation Associates / Norway Productions / Paramount Television **(8)** Ballantine Books **241 (1)** Paramount Pictures / Century Associates **(2)** Pocket Books **(3)** Paramount Pictures **(4)** Paramount Pictures / Cinema Group Ventures **(5)** Paramount Pictures / Industrial Light & Magic **(6)** DC Comics **(7)** Paramount Television **(8)** Pocket Books **242 (1)** Paramount Pictures **(2)** Paramount Pictures **(3)** Paramount Television **(4)** Pocket Books **(5)** Paramount Pictures **(6)** Paramount Television / United Paramount Network **(7)** Pocket Books **(8)** Paramount Pictures **243 (1)** Pocket Books **(2)** Paramount Pictures **(3)** Paramount Television **(4)** Pocket Books **(5)** Paramount Pictures **(6)** Paramount Pictures / Spyglass Entertainment / Bad Robot **(7)** Paramount Pictures / Skydance Productions / Bad Robot **244 (1)** Desilu Productions / Norway Corporation / Paramount Television **(2)** Desilu Productions / Norway Corporation / Paramount Television **(3)** Paramount Television **(4)** Paramount Television **(5)** Paramount Television / United Paramount Network **246 (1)** Desilu Productions / Norway Corporation / Paramount Television **(2)** Filmation Associates / Norway Productions / Paramount Television **(3)** Paramount Pictures / Century Associates **(4)** TM & © 2014 Marvel Entertainment, LLC **(5)** Paramount Pictures **(6)** Interplay **(7)** Paramount Pictures / Spyglass Entertainment / Bad Robot **tl** PARAMOUNT TELEVISION / THE KOBAL COLLECTION **tr** PARAMOUNT TV / THE KOBAL COLLECTION **c** PARAMOUNT / THE KOBAL COLLECTION **bl** PARAMOUNT / THE KOBAL COLLECTION **br** TM & © 2014 Marvel Entertainment, LLC **247 tl** PARAMOUNT / THE KOBAL COLLECTION **tr** Interplay **cl** REX / c.Paramount / Everett **cr** PARAMOUNT / BAD ROBOT / THE KOBAL COLLECTION **b** REX **c.**Paramount / Everett **248 tl** PARAMOUNT TV / THE KOBAL COLLECTION / YARISH, MICHAEL **tr** PARAMOUNT / BAD ROBOT / THE KOBAL COLLECTION **cr** PARAMOUNT TV / THE KOBAL COLLECTION **bl** PARAMOUNT / BAD ROBOT / THE KOBAL COLLECTION **249 tl** PARAMOUNT TV / THE KOBAL COLLECTION **tr** PARAMOUNT / THE KOBAL COLLECTION **cl** PARAMOUNT TELEVISION / THE KOBAL COLLECTION **bl** PARAMOUNT / THE KOBAL COLLECTION **br** PARAMOUNT TV / THE KOBAL COLLECTION **250 (1)** 20th Century Fox Television / Columbia Broadcasting System / Irwin Allen Productions **(2)** Milton Bradley **(3)** Pyramid Books **(4)** Filmation Associates / Hanna-Barbera Productions **(5)** Innovation **(6)** New Line Cinema / Saltire Entertainment / Irwin Allen Productions / Prelude Pictures **(7)** Fox Television Studios / Regency Television / Warner Bros. Television **(8)** Bubblehead Publishing, Inc. **251 (1)** Kadokawa Shoten Publishing Co., Ltd. **(2)** Toei Company **(3)** Fuji Television Network / Kyodo Television **(4)** Kadokawa Haruki **(5)** Mad House / Happinet Pictures / Kadokawa Pictures / Kadokawa Shoten Publishing Co. / Memory Tech / Q-Tec / Toki wo Kakeru Shôjo Seisaku Iinkai 2006 **(6)** Aniplex / Epic Records / Style Jam / Voice & Heart **252 (1)** Bruce Lansbury Productions / Columbia Broadcasting System / Michael Garrison Productions **(2)** Gold Key **(3)** Transogram **(4)** Columbia Broadcasting System **(5)** Columbia Broadcasting System **(6)** Millennium **(7)** Peters Entertainment / Sonnenfeld Josephson Worldwide Entertainment / Todman, Simon, LeMasters Productions / Warner Bros. **(8)** Southpeak **253 (1)** Nova Publications **(2)** Berkley Books **(3)** DAW Books **(4)** Dell Magazines **(5)** Tor Books **(6)** Tor Books **(7)** Dell Magazines **(8)** Tor Books **254 (1)** Galaxy Publishing **(2)** Galaxy Publishing **(3)** Putnam Publishing Group **(4)** Galaxy Publishing **(5)** Berkley Books **(6)** SFBC **(7)** Putnam Publishing Group **(8)** Alliance Atlantis Communications / Tasman Films / Box TV **255 (1)** Spilogale Inc. **(2)** DC Comics **(3)** Carolco Pictures **(4)** Alliance Atlantis Communications / PolyGram Television / Pro **(7)** **(5)** Dynamite **(6)** Total Recall / Original Film / Prime Focus / Rekall Productions **256 (1)** Berkley Books **(2)** Universal Pictures **(3)** Putnam **(4)** Berkley Books **257 (1)** Nova Publications **(2)** Faber and Faber **(3)** Faber and Faber **(4)** Faber and Faber **(5)** Faber and Faber **(6)** Scribner **(7)** Doubleday **(8)** Gollancz **258 (1)** Nova Publications **(2)** Pocket Books**(3)** Doubleday **(4)** Night Shade Books **(5)** St Martins Pr **(6)** Gollancz **(7)** Gollancz **(8)** Gollancz **259 (1)** Nova Publications **(2)** Doubleday **(3)** G. P. Putnam's Sons **(4)** Metro-Goldwyn-Mayer **260 (1)** New Worlds **(2)** Allison & Busby **(3)** New English Library **261 (1)** Everyman Films / Incorporated Television Company **(2)** Edu-Ware **(3)** DC Comics **(4)** TM & © 2014 Marvel Entertainment, LLC **(5)** Granada International / ITV Productions / Out of Africa Entertainment **262 (1)** Knight Books **(2)** Macmillan **(3)** Hamish Hamilton **(4)** Boy Scouts of America **(5)** **(7)** Network / BBC / Fremantle International Inc. **(6)** BBC **(7)** Red Shift **(8)** Dutton **263 (1)** Dial Press **(2)** Metro-Goldwyn-Mayer **(3)** Bantam Books **(4)** Goff-Roberts-Steiner Productions / MGM Television **(5)** TM & © 2014 Marvel Entertainment, LLC **(6)** Bantam Books **(7)** Malibu **(8)** Bluewater **264 (1)** Dargaud **(2)** Dargaud **(3)** Dargaud **(4)** Dargaud **(5)** Dargaud **(6)** Dargaud **(7)** Dargaud **(8)** Dargaud **265 (1)** Dargaud **(2)** Dargaud **(3)** Dargaud **(4)** Dargaud **(5)** Dargaud **(6)** Dargaud **(7)** EuropaCorp / Dargaud Marina / France 3 / Satelight / Spectra Animation **(8)** Dargaud **266 (1)** Dargaud **(2)** Dargaud **268 (1)** Dell Magazines **(2)** Dell Magazines **(3)** Ballantine Books **(4)** Ballantine Books **(5)** Ballantine Books **(6)** Del Rey **(7)** Del Rey Books **(8)** Corgi **269 (1)** 20th Century Fox Television / Irwin Allen Productions / Kent Productions **(2)** Gold Key **(3)** Ideal **(4)** Pyramid Books **(5)** Pyramid Books **(6)** Pyramid Books **270 (1)** Doubleday **(2)** Ladd Company / Shaw Brothers / Warner Bros. **(3)** TM & © 2014 Marvel Entertainment, LLC **(4)** Orion **(5)** Orion **(6)** Westwood Studios **(7)** Orion **(8)** BOOM! Studios **271 (1)** Faber and Faber **(2)** Pete Townshend / Atlantic **(3)** Dial Books **(4)** Warner Bros. **272 (1)** Dell Magazines **(2)** Spilogale Inc. **(3)** Ballantine Books **(4)** Doubleday **(5)** Spilogale Inc. **(6)** Fawcett Gold Medal **(7)** Dell Magazines **(8)** Berkley Books **273 (1)** Ace Books **(2)** Penny Publications **(3)** Spilogale Inc. **(4)** Spilogale Inc. **(5)** Tor Books **(6)** Arkham House **(7)** Arkham House **(8)** Starz Productions / Nice Guy Productions / Industry Entertainment **274 (1)** Nova Publications **(2)** LQ / JAF **(3)** Peacock Press **(4)** Experimenter Publishing Company **(5)** St Martins Pr **275 (1)** Alfred A. Knopf **(2)** Playboy **(3)** Metro-Goldwyn-Mayer **(4)** The Ladd Company / Warner Bros. **(5)** TriStar Pictures / Delphi III Productions **(6)** Alfred A. Knopf **(7)** Fredrick **(8)** A.S. Films / Scott Free Productions / Traveler's Rest Films **276** British Film Institute / Lucasfilm **278 (1)** Ballantine Books **(2)** Phantasia Press **(3)** Tsunami Games **(4)** Tsunami Games **(5)** Del Rey **(6)** Tor Books **(7)** Tor Books **(8)** Tor Books **279 (1)** Berkley Books **(2)** Charles Scribner's Sons **(3)** Simon & Schuster **(4)** Timescape Books **(5)** Arrow **(6)** Pocket Books **(7)** Tor Books **(8)** Tor Books **280 (1)** American Zoetrope / Warner Bros. **(2)** Paperback Library **(3)** American Zoetrope / Warner Bros. **(4)** American Zoetrope / Warner Bros. **281 (1)** Ace Books **(2)** Doubleday **(3)** Granada **282 (1)** Universal TV **(2)** Columbia Pictures Corporation **(3)** Universal Pictures / Amblin Entertainment **(4)** Warner Bros. **(5)** Amblin Entertainment / Universal TV **(6)** Universal Pictures / Amblin Entertainment **(7)** Universal Pictures / Amblin Entertainment **(8)** Amblin Entertainment / Universal TV **283 (1)** Columbia Pictures Corporation / Amblin Entertainment **(2)** Paramount Pictures / DreamWorks SKG **(3)** Warner Bros. / DreamWorks SKG / Amblin Entertainment / Stanley Kubrick Productions **(4)** Twentieth Century Fox Film Corporation / DreamWorks SKG **(5)** DreamWorks Television **(6)** Paramount Pictures / DreamWorks SKG / Amblin Entertainment / Cruise / Wagner Productions **(7)** Paramount Pictures **(8)** DreamWorks Television / TNT Originals / Invasion Productions **284 (1)** Columbia Pictures Corporation **(2)** Universal Pictures / Amblin Entertainment **(3)** Universal Pictures / Amblin Entertainment **(4)** Warner Bros. / DreamWorks SKG / Amblin Entertainment / Stanley Kubrick Productions **(5)** Twentieth Century Fox Film Corporation / DreamWorks SKG **(6)** DreamWorks Television **(7)** Paramount Pictures / DreamWorks SKG / Amblin Entertainment / Cruise / Wagner Productions **(8)** DreamWorks Television / TNT Originals / Invasion Productions **tl** COLUMBIA / THE KOBAL COLLECTION **tr** AMBLIN / UNIVERSAL / THE KOBAL COLLECTION **cl** UNIVERSAL / THE KOBAL COLLECTION / MC BROOM, BRUCE **cr** AMBLIN / UNIVERSAL / THE KOBAL COLLECTION **bl** UNIVERSAL / THE KOBAL COLLECTION **br** AMBLIN / UNIVERSAL / THE KOBAL COLLECTION / CLOSE, MURRAY **285 t** AMBLIN / DREAMWORKS / WB / THE KOBAL COLLECTION / JAMES, DAVID **cl** DREAMWORKS LLC / THE KOBAL COLLECTION / JAMES, DAVID **cbl** 20TH CENTURY FOX / DREAMWORKS / THE KOBAL COLLECTION **cbr** USA FILMS / THE KOBAL COLLECTION / ZENUK, ALAN **bl** DREAMWORKS / PARAMOUNT / THE KOBAL COLLECTION / MASI, FRANK **br** DREAMWORKS TV / THE KOBAL COLLECTION **286 (1)** American Zoetrope / Warner Bros. **(2)** Lucasfilm / Twentieth Century Fox Film Corporation **(3)** Lucasfilm **(4)** Lucasfilm **(5)** Korty Films / Lucasfilm **(6)** Nelvana / Lucasfilm **(7)** Lucasfilm **(8)** Nelvana, Lucasfilm **287 (1)** Universal Pictures / Lucasfilm **(2)** Three D D D Productions / Eastman Kodak Company / Lucasfilm / MKD Productions / Walt Disney Imagineering **(3)** LucasArts **(4)** Lucasfilm **(5)** Lucasfilm**(6)** Cartoon Network / Lucasfilm / Rough Draft Studios **(7)** Lucasfilm **(8)** CGCG / Lucasfilm **288 (1)** Tatsunoko Productions Company **(2)** Tatsunoko Productions Company **(3)** Gallerie International Films Ltd. **(4)** Tatsunoko Productions Company **(5)** Sparklin' Entertainment **(6)** Saban Entertainment / Tatsunoko Productions Company **(7)** Tatsunoko Productions Company **(8)** Nikkatsu **289 (1)** Random House **(2)** Fadsin Cinema Associates / Palomar Pictures **(3)** Edgar J. Scherick Associates **(4)** Edgar J. Scherick Associates / Taft Entertainment Television **(5)** Edgar J. Scherick Associates / Victor Television Productions Inc. **(6)** Paramount Pictures / DreamWorks **290 (1)** Warner Paperback Library **(2)** Universal TV **(3)** Warner Paperback Library **(4)** Harve Bennett Productions / Silverton Productions / Universal TV **(5)** Charlton Comics **(6)** Harve Bennett Productions / Universal TV **(7)** Charlton Comics **(8)** NBC Universal Television / Universal Media Studios **291 (1)** Universal Pictures / Trumbull / Gruskoff Productions **(2)** Scholastic **292 (1)** Universal TV **(2)** Glen A. Larson Productions / Universal TV **(3)** Universal TV **(4)** Glen A. Larson Productions / Universal TV **(5)** Glen A. Larson Productions / Universal TV **(6)** 20th Century Fox Television / Glen A. Larson Productions **293 (1)** Glen A. Larson Productions / The Kushner-Locke Company / 20th Century Fox Television **(2)** 20th Century Fox Television / Glen A. Larson Productions **(3)** Alliance Atlantis Communications / Crescent Entertainment / Glen A. Larson Productions / Tribune Entertainment **(4)** MCA Television / Sterling Pacific Films / Universal TV **(5)** Glen A. Larson Productions / Universal TV **294 (1)** Glen A. Larson Productions / Universal TV **(2)** Glen A. Larson Productions / Universal TV **(3)** Universal TV **(4)** Glen A. Larson Productions / Universal TV **(5)** 20th Century Fox Television / Glen A. Larson Productions **(6)** Glen A. Larson Productions / The Kushner-Locke Company / 20th Century Fox Television **tl** GLEN A LARSON PRODS / UNIVERSAL TV / THE KOBAL COLLECTION **tr** UNIVERSAL TV / THE KOBAL COLLECTION **cl** ABC-TV / THE KOBAL COLLECTION **bl** UNIVERSAL TV / THE KOBAL COLLECTION **br** REX / Universal / Everett **295 tl** UNIVERSAL TV / THE KOBAL COLLECTION **tr** THE KOBAL COLLECTION **b** REX / Everett Collection **296 (1)** Argos Films **(2)** Télécip / TF1

Films Production **(3)** Col.Ima.Son / Films A2 **297 (1)** MGM **(2)** Bantam Books **(3)** American International Pictures / The Aubrey Company **(4)** Ballantine Books **(5)** MGM Television **298 (1)** Jack H. Harris Enterprises / University of Southern California **(2)** AVCO Embassy Pictures / International Film Investors / Goldcrest Films International **(3)** Universal Pictures / Turman-Foster Company **(4)** Columbia Pictures Corporation **(5)** Cinema Group Ventures / New Pictures **(6)** New World Pictures / Sequoia Productions **299 (1)** Alive Films / Larry Franco Productions **(2)** Warner Bros. **(3)** Universal Pictures **(4)** Paramount Pictures / Rysher Entertainment **(5)** Screen Gems **300 (1)** Jack H. Harris Enterprises / University of Southern California **(2)** AVCO Embassy Pictures / International Film Investors / Goldcrest Films International **(3)** Universal Pictures / Turman-Foster Company **(4)** Columbia Pictures Corporation **(5)** Alive Films / Larry Franco Productions **(6)** Warner Bros. **(7)** Paramount Pictures / Rysher Entertainment **(8)** Screen Gems **tl** JACK H. HARRIS ENTERPRISES / THE KOBAL COLLECTION **cl** JACK H. HARRIS ENTERPRISES / THE KOBAL COLLECTION **cr** AVCO EMBASSY / THE KOBAL COLLECTION **bl** AVCO EMBASSY / THE KOBAL COLLECTION **br** UNIVERSAL / THE KOBAL COLLECTION **301 tl** UNIVERSAL / THE KOBAL COLLECTION **tr** WARNER BROS / CANAL PLUS / REGENCY / ALCOR / THE KOBAL COLLECTION **cl** COLUMBIA / THE KOBAL COLLECTION **bl** PARAMOUNT / THE KOBAL COLLECTION **br** STORM KING / THE KOBAL COLLECTION / JACOBS, NEIL **302 (1)** Les Humanoïdes Associés **(2)** HM Communications / Metal Mammoth, Inc **(3)** Columbia Pictures Corporation **(4)** CinéGroupe / Helkon Media AG / Das Werk / Trixter Film / Artisan Film **(5)** Gathering of Developers **(6)** Sega / Capcom **303 (1)** Humanoids Publishing **(2)** BNP Paribas Fortis Film Fund / WE Productions **304 (1)** Office Academy **(2)** Akita Shoken **(3)** Asahi Sonorama **(4)** Office Academy **(5)** Academy Productions **(6)** Claster Television Productions / Sunwagon Productions **(7)** Academy Productions **(8)** AIC / Xebec **305 (1)** St. Martin's Press **(2)** Ace Books **(3)** Ace Books **(4)** Avon Books **(5)** Tor Books **306 (1)** BBC **(2)** Futura Publications **(3)** Futura Publications **(4)** BBC **307 (1)** Brain Storm Comix **(2)** Galaxy Press **(3)** Valkyrie Press **(4)** Dark Horse **(5)** Big Finish Productions **308 (1)** Rebellion **(2)** Rebellion **(3)** Rebellion **(4)** Virgin Games **(5)** Rebellion **(6)** Hollywood Pictures / Cinergi Pictures Entertainment **309 (1)** Rebellion **(2)** Rebellion **(3)** Evolved Games **(4)** Rebellion **(5)** DNA Films / IM Global / Peach Trees / Reliance / Rena Film **(6)** Rebellion **310 (1)** Lucasfilm / Twentieth Century Fox Film Corporation **(2)** TM & © 2014 Marvel Entertainment, LLC **(3)** Lucasfilm **(4)** National Public Radio / National Public Radio **(5)** Parker Brothers **311 (1)** Lucasfilm **(2)** Lucasfilm **(3)** Korty Films / Lucasfilm **(4)** Dark Horse **(5)** Bantam Spectra **(6)** LucasArts **312 (1)** Bantam Spectra **(2)** Lucasfilm **(3)** Lucasfilm **(4)** Cartoon Network / Lucasfilm / Rough Draft Studios **(5)** Bioware / LucasArts **(6)** Eidos Interactive / LucasArts **313 (1)** Lucasfilm **(2)** CGCG / Lucasfilm **(3)** Lucasfilm **(4)** Disney / Lucasfilm **314 (1)** Lucasfilm **(2)** Lucasfilm **(3)** Lucasfilm **(4)** Lucasfilm **(5)** Lucasfilm **(6)** Lucasfilm **315 (1)** Lucasfilm **(2)** Lucasfilm **(3)** Lucasfilm **(4)** Lucasfilm **316 (1)** Lucasfilm / Twentieth Century Fox Film Corporation **(2)** Lucasfilm **(3)** Lucasfilm **tl** LUCASFILM / 20TH CENTURY FOX / THE KOBAL COLLECTION **tr** LUCASFILM / 20TH CENTURY FOX / THE KOBAL COLLECTION **ctl** LUCASFILM / 20TH CENTURY FOX / THE KOBAL COLLECTION **cbl** LUCASFILM / 20TH CENTURY FOX / THE KOBAL COLLECTION **cr** LUCASFILM / 20TH CENTURY FOX / THE KOBAL COLLECTION **317 tl** LUCASFILM / 20TH CENTURY FOX / THE KOBAL COLLECTION **tr** LUCASFILM / 20TH CENTURY FOX / THE KOBAL COLLECTION **cl** LUCASFILM / 20TH CENTURY FOX / THE KOBAL COLLECTION **bl** LUCASFILM / 20TH CENTURY FOX / THE KOBAL COLLECTION **br** LUCASFILM / 20TH CENTURY FOX / THE KOBAL COLLECTION **318 (1)** Lucasfilm **(2)** Lucasfilm **(3)** Lucasfilm **(4)** Lucasfilm **t** LUCASFILM / THE KOBAL COLLECTION **cl** LUCASFILM / THE KOBAL COLLECTION / HAMSHERE, KEITH **b** LUCASFILM / THE KOBAL COLLECTION **319 tl** LUCASFILM / 20TH CENTURY FOX / THE KOBAL COLLECTION **tr** LUCASFILM / 20TH CENTURY FOX / THE KOBAL COLLECTION **cl** LUCASFILM / 20TH CENTURY FOX / THE KOBAL COLLECTION **cr** LUCASFILM / 20TH CENTURY FOX / THE KOBAL COLLECTION **b** LUCASFILM / THE KOBAL COLLECTION **320 (1)** Dell Magazines **(2)** Tor Books **(3)** Tor Books **(4)** Tor Books **(5)** Tor Books **(6)** Tor Books **(7)** TM & © 2014 Marvel Entertainment, LLC **(8)** Summit Entertainment **321 (1)** Columbia Pictures Corporation **(2)** Delacorte Press **(3)** TM & © 2014 Marvel Entertainment, LLC **322 (1)** © REBELLION A / S, ALL RIGHTS RESERVED **(2)** © REBELLION A / S, ALL RIGHTS RESERVED **(3)** Games Workshop **(4)** Melbourne House **(5)** © REBELLION A / S, ALL RIGHTS RESERVED **(6)** DC Comics / Rebellion **(7)** Virgin Books **(8)** DC Comics / Rebellion **323 (1)** Hollywood Pictures / Cinergi Pictures Entertainment **(2)** © REBELLION A / S, ALL RIGHTS RESERVED **(3)** © REBELLION A / S, ALL RIGHTS RESERVED **(4)** DC Comics / Rebellion **(5)** Big Finish **(6)** Black Flame **(7)** © REBELLION A / S, ALL RIGHTS RESERVED **(8)** DNA Films / IM Global / Peach Trees / Reliance / Rena Film **324 (1)** © REBELLION A / S, ALL RIGHTS RESERVED **(2)** © REBELLION A / S, ALL RIGHTS RESERVED **(3)** © REBELLION A / S, ALL RIGHTS RESERVED **(4)** © REBELLION A / S, ALL RIGHTS RESERVED **(5)** © REBELLION A / S, ALL RIGHTS RESERVED **(6)** © REBELLION A / S, ALL RIGHTS RESERVED **(7)** © REBELLION A / S, ALL RIGHTS RESERVED **(8)** © REBELLION A / S, ALL RIGHTS RESERVED **326 (1)** © REBELLION A / S, ALL RIGHTS RESERVED **(2)** Hollywood Pictures / Cinergi Pictures Entertainment **(3)** DNA Films / IM Global / Peach Trees / Reliance / Rena Film **(4)** © REBELLION A / S, ALL RIGHTS RESERVED **tl** JUDGE DREDD®JUDGE DREDD IS A REGISTERED TRADEMARK, © REBELLION A / S, ALL RIGHTS RESERVED **tr** JUDGE DREDD®JUDGE DREDD IS A REGISTERED TRADEMARK, © REBELLION A / S, ALL RIGHTS RESERVED **cr** JUDGE DREDD®JUDGE DREDD IS A REGISTERED TRADEMARK, © REBELLION A / S, ALL RIGHTS RESERVED **b** CINERGI PICTURES / THE KOBAL COLLECTION / BLANSHARD, RICHARD (N) **327 t** REX / Moviestore Collection **cl** REX / Moviestore Collection **cr** DNA FILMS / THE KOBAL COLLECTION **bl** REX / c.Lions Gate / Everett **br** JUDGE DREDD®JUDGE DREDD IS A REGISTERED TRADEMARK, © REBELLION A / S, ALL RIGHTS RESERVED **IDW** Publishing **328 (1)** St. Martin's Press **(2)** Ballantine Books **(3)** Del Rey Books **(4)** Ballantine Books **(5)** Absolute Magnitude **(6)** Legend **(7)** Legend **(8)** Tor Books **329 (1)** BBC **(2)** TM & © 2014 Marvel Entertainment, LLC **(3)** BBC **(4)** BBC **(5)** BBC **(6)** BBC **(7)** Big Finish Productions **330 (1)** BBC **(2)** Pan Books **(3)** Original Records **(4)** Pan Books **(5)** Original Records **(6)** BBC **(7)** Pan Books **(8)** Pan Books **331 (1)** Infocom **(2)** Fontana Press **(3)** Harmony Books **(4)** DC Comics **(5)** Touchstone Pictures / Spyglass Entertainment **(6)** Penguin Books **332 (1)** Touchstone Pictures / Spyglass Entertainment **(2)** Touchstone Pictures / Spyglass Entertainment **(3)** Touchstone Pictures / Spyglass Entertainment **(4)** Touchstone Pictures / Spyglass Entertainment **(5)** Touchstone Pictures / Spyglass Entertainment **334 (1)** BBC **(2)** BBC **(3)** Infocom **(4)** Touchstone Pictures / Spyglass Entertainment **tl** Copyright © BBC Photo Library **tr** Copyright © BBC Photo Library **cl** Copyright © BBC Photo Library **cr** Infocom **b** Infocom **335 t** REX / Snap Stills **cl** REX / Snap Stills **cr** REX / c.Touchstone / Everett **b** TOUCHSTONE / SPYGLASS ENTERTAINMENT / THE KOBAL COLLECTION **br** TOUCHSTONE / SPYGLASS ENTERTAINMENT / THE KOBAL COLLECTION **336 (1)** Glen A. Larson Productions / Universal TV **(2)** Glen A. Larson Productions / Universal TV **(3)** Futura **(4)** Glen A. Larson Productions / Universal TV **(5)** TM & © 2014 Marvel Entertainment, LLC **(6)** Glen A. Larson Productions / Universal TV **(7)** Universal TV **(8)** Maximum Press **337 (1)** R&D TV / Sky TV / USA Cable Entertainment **(2)** Universal Interactive **(3)** Sci Fi Channel **(4)** Tor Books **(5)** Dynamite Comics **(6)** David Eick Productions / R&D TV **(7)** Sci Fi Channel **338 tl** GLEN A LARSON PRODS / UNIVERSAL TV / THE KOBAL COLLECTION **tr** REX / Moviestore Collection **cr** REX / Moviestore Collection **bl** GLEN A LARSON PRODS / UNIVERSAL TV / THE KOBAL COLLECTION **br** REX / Moviestore Collection **339 tl** TM & © 2014 Marvel Entertainment, LLC **tc** TM & © 2014 Marvel Entertainment, LLC **tr** SCI-FI CHANNEL / THE KOBAL COLLECTION **cl** SCI-FI CHANNEL / THE KOBAL COLLECTION **b** NBCU Photo Bank via Getty Images **340 (1)** Xenogen Production **(2)** New World Pictures **(3)** New World Pictures **(4)** AVCO Embassy Pictures / International Film Investors / Goldcrest Films International **(5)** New World Pictures **(6)** Hemdale Film / Pacific Western / Euro Film Funding **(7)** Twentieth Century Fox Film Corporation **(8)** American Entertainment Partners II L.P. / Twentieth Century Fox Film Corporation **341 (1)** Twentieth Century Fox Film Corporation **(2)** Carolco Pictures / Pacific Western **(3)** Lightstorm Entertainment **(4)** Plume **(5)** Cameron / Eglee Productions **(6)** 20th Century Fox Television **(7)** Twentieth Century Fox Film Corporation / Lightstorm Entertainment **(8)** Cameron / Eglee Productions **342 (1)** AVCO Embassy Pictures / International Film Investors / Goldcrest Films International **(2)** Hemdale Film / Pacific Western / Euro Film Funding **(3)** Twentieth Century Fox Film Corporation **(4)** American Entertainment Partners II L.P. / Twentieth Century Fox Film Corporation **(5)** Twentieth Century Fox Film Corporation **(6)** Carolco Pictures / Pacific Western **(7)** Twentieth Century Fox Film Corporation / Lightstorm Entertainment **(8)** Twentieth Century Fox Film Corporation **tl** REX / c.Everett Collection **tr** ORION / THE KOBAL COLLECTION **cl** 20TH CENTURY FOX / THE KOBAL COLLECTION **cr** 20TH CENTURY FOX / THE KOBAL COLLECTION **bl** REX / Moviestore Collection **br** REX / Everett Collection **343 tl** REX / SNAP **tr** CAROLCO / THE KOBAL COLLECTION **cl** REX / Moviestore Collection **cr** REX / c.20thC.Fox / Everett **br** REX / c.20thC.Fox / Everett **344 (1)** Henderson Productions / Miller-Milkis Productions / Paramount Television **(2)** Hanna-Barbera Productions / Ruby-Spears Productions / Paramount Television **(3)** NBC Studios / Nomadic Pictures / Once Upon a Time Films **345 (1)** Science Fiction World **346 (1)** Kennedy Miller Productions / Crossroads / Mad Max Films **(2)** Kennedy Miller Productions **(3)** Kennedy Miller Productions **(4)** Mindscape **(5)** Avalanche Studios **(6)** Kennedy Miller Productions / Village Roadshow Pictures **348 (1)** Kennedy Miller Productions **(2)** Kennedy Miller Productions **350 (1)** Kennedy Miller Productions / Crossroads / Mad Max Films **(2)** Kennedy Miller Productions **(3)** Kennedy Miller Productions **(4)** Mindscape **tl** REX / Moviestore Collection **tr** MAD MAX / THE KOBAL COLLECTION **cl** REX / American International / Everett **crt** REX / Moviestore Collection **crb** REX / c.American Int / Everett **bl** MAD MAX / THE KOBAL COLLECTION **br** WARNER BROS / THE KOBAL COLLECTION **351 tl** REX / Moviestore Collection **tr** REX / Moviestore Collection **cl** WARNER BROS / THE KOBAL COLLECTION **cr** WARNER BROS / THE KOBAL COLLECTION **br** Mindscape **352 (1)** Brandywine Productions / Twentieth Century-Fox Productions **(2)** 20th Century Fox **(3)** Argus Press, Amsoft, Concept Software **(4)** Twentieth Century Fox Film Corporation / Brandywine Productions / SLM Production Group **(5)** Activision **(6)** Dark Horse **353 (1)** Konami **(2)** Dark Horse **(3)** Twentieth Century Fox Film Corporation / Brandywine Productions **(4)** Sega **(5)** Bantam Books **(6)** Capcom **354 (1)** Probe Entertainment **(2)** Brandywine Productions / Twentieth Century Fox Film Corporation **(3)** Twentieth Century Fox Film Corporation **(4)** Twentieth Century Fox Film Corporation **(5)** Rebellion **(6)** Twentieth Century Fox **355 (1)** Gearbox Software **356 (1)** Twentieth Century Fox **(2)** Twentieth Century Fox **(3)** Brandywine Productions / Twentieth Century-Fox Productions **(4)** Brandywine Productions / Twentieth Century-Fox Productions **(5)** Twentieth Century Fox Film Corporation / Brandywine Productions **(6)** Twentieth Century Fox Film Corporation / Brandywine Productions / SLM Production Group

picture credits continued

358 (1) Brandywine Productions / Twentieth Century-Fox Productions **(2)** Twentieth Century Fox Film Corporation / Brandywine Productions / SLM Production Group **(3)** Twentieth Century Fox Film Corporation / Brandywine Productions **(4)** Twentieth Century Fox Film Corporation **(5)** Twentieth Century Fox **tl** British Film Institute **tr** REX / c.20thC.Fox / Everett **cl** 20TH CENTURY FOX / THE KOBAL COLLECTION **cr** 20TH CENTURY FOX / THE KOBAL COLLECTION **bl** REX / SNAP **br** 20TH CENTURY FOX / THE KOBAL COLLECTION **359 tl** 20TH CENTURY FOX / THE KOBAL COLLECTION **tr** REX / c.20thC.Fox / Everett **cr** REX / Moviestore Collection **bl** REX / c.20thC.Fox / Everett **br** REX / c.20thC.Fox / Everett **360 (1)** Associated Television / Colour Productions **(2)** Virgin Books **(3)** Big Finish Productions **361 (1)** DAW Books **(1)** Tokuma Shoten **(2)** Hakuhodo / Nibariki / Tokuma Shoten / Topcraft **(3)** Khara Corporation / Studio Ghibli **364 (1)** TTA Press **365 (1)** Universal Pictures / Amblin Entertainment **(2)** Berkley Books **(3)** Atari **(4)** Berkley Books **366 (1)** Kodansha **(2)** TMS Entertainment **(3)** Taito **(4)** Epic Comics **(5)** Dark Horse **(6)** Bandai **367 (1)** St. Martin's Press **(2)** Applause Records **(3)** Warner Bros. **368 (1)** Walt Disney Productions **(2)** Del Rey **(3)** Bally Midway **(4)** Slave Labor Graphics **(5)** Walt Disney Pictures **(6)** TM & © 2014 Marvel Entertainment, LLC **(7)** Disney Interactive **(8)** Walt Disney Television Animation **369 (1)** Montcalm Publishing **(2)** Blueway Books **(3)** Doubleday **(4)** Bantam Books **(5)** Headline Book Publishing **(6)** Bantam Books **(7)** HarperCollins **370 (1)** Reagan Arthur Books **(2)** Penny Publications **(3)** Bantam Books **(4)** Tig Productions / Warner Bros. **371 (1)** Ace Books **372 (1)** Kenneth Johnson Productions / Warner Bros. Television **(2)** Blatt-Singer Productions / Warner Bros. Television **(3)** Warner Bros. Television **(4)** Pinnacle Books **(5)** DC Comics **(6)** The Scott Peters Company / HDFilms / Warner Bros. Television / Visitors Films **373 (1)** Ace Books **(2)** Doubleday **(3)** Bantam Books **(4)** Voyager **(5)** Eos **(6)** Eos **(7)** Eos **(8)** HarperCollins **374 (1)** Hemdale Film / Pacific Western / Euro Film Funding / Cinema 84 **(2)** Now Comics **(3)** Dark Horse **(4)** Bethesda **(5)** Carolco Pictures / Pacific Western **(6)** Midway **375 (1)** Dark Horse **(2)** Bethesda **(3)** Bethesda **(4)** Malibu Comics **(5)** Landmark Entertainment Group / Lightstorm Entertainment / MCA Planning and Development / Universal Creative / Universal Studios Recreation Group **(6)** Bethesda **376 (1)** DC Comics **(2)** HarperEntertainment / Gollancz S.F. **(3)** i Books **(4)** C-2 Pictures / Intermedia Films / IMF / Mostow / Lieberman Productions **(5)** Dynamite **(6)** Bartleby Company / C-2 Pictures / Warner Bros. Television / The Halcyon Company / Sarah Connor Pictures / Syfy **377 (1)** The Halcyon Company **(2)** Dynamite **378 (1)** Hemdale Film / Pacific Western / Euro Film Funding / Cinema 84 **(2)** Carolco Pictures / Pacific Western **(3)** Hemdale Film / Pacific Western / Euro Film Funding / Cinema 84 **(4)** The Halcyon Company **(5)** The Halcyon Company **380 (1)** Hemdale Film / Pacific Western / Euro Film Funding / Cinema 84 **(2)** Midway **(3)** Carolco Pictures / Pacific Western **(4)** Landmark Entertainment Group / Lightstorm Entertainment / MCA Planning and Development / Universal Creative / Universal Studios Recreation Group **(5)** Bartleby Company / C-2 Pictures / Warner Bros. Television / The Halcyon Company / Sarah Connor Pictures / Syfy **(6)** The Halcyon Company **tl** REX / Moviestore Collection **tr** REX / Moviestore Collection **cl** Midway **cr** REX / Moviestore Collection **b** CAROLCO / THE KOBAL COLLECTION **381 tl** REX / Moviestore **tr** REX / c.Warner Br / Everett **cl** REX / c.Warner Br / Everett **cr** REX / c.Warner Br / Everett HALCYON COMPANY, THE / THE KOBAL COLLECTION **br** REX / c.20thC.Fox / Everett **382 tl** REX / c.Warner Br / Everett **tr** REX / c.Warner Br / Everett **b** British Film Institute **383 tl** REX / Snap Stills **tr** REX / Snap Stills **cl** HALCYON COMPANY, THE / THE KOBAL COLLECTION **bl** REX / Courtesy Everett Collection **br** HALCYON COMPANY, THE / THE KOBAL COLLECTION **384 (1)** Shueisha **(2)** Toei Animation Company **(3)** Bird Studios / Toei Animation Company **(4)** Toei Animation Company **(5)** Toei Animation Company **(6)** Toei Animation Company **(7)** Twentieth Century Fox Film Corporation **(8)** Toei Animation Company **385 (1)** Ace Books **(2)** Victor Gollancz Ltd **(3)** Victor Gollancz Ltd **(4)** Mediagenic **(5)** Epic Comics **386 (1)** Hasbro **(2)** Hasbro **(3)** TM & © 2014 Marvel Entertainment, LLC **(4)** Sunbow Productions / Marvel Productions / Hasbro **(5)** Toei Animation **(6)** TM & © 2014 Marvel Entertainment, LLC **(7)** Hasbro **(8)** Hasbro **387 (1)** Hasbro **(2)** Titan / IDW **(3)** DreamWorks SKG / Paramount Pictures / Hasbro **(4)** DreamWorks SKG / Paramount Pictures / Hasbro **(5)** Activision **(6)** Paramount Pictures / Hasbro **(7)** Hasbro **(8)** Paramount Pictures / Hasbro **388 (1)** Hasbro **(2)** Hasbro **(3)** Hasbro **390 (1)** Hasbro **(2)** TM & © 2014 Marvel Entertainment, LLC **(3)** Sunbow Productions / Marvel Productions / Hasbro **(4)** Hasbro **(5)** DreamWorks SKG / Paramount Pictures / Hasbro **(6)** DreamWorks SKG / Paramount Pictures / Hasbro **(7)** Activision **(8)** Paramount Pictures / Hasbro **tl** Hasbro **tr** Hasbro **clt** TM & © 2014 Marvel Entertainment, LLC **clb** Hasbro **cr** Sunbow Productions / Marvel Productions / Hasbro **bl** DREAMWORKS / THE KOBAL COLLECTION **br** DREAMWORKS / THE KOBAL COLLECTION **391 cl** PARAMOUNT PICTURES / THE KOBAL COLLECTION **tr** PARAMOUNT PICTURES / THE KOBAL COLLECTION **cl** PARAMOUNT PICTURES / THE KOBAL COLLECTION **cr** Activision **b** REX / Moviestore Collection **392 (1)** Hemdale Film / Pacific Western / Euro Film Funding **(2)** Twentieth Century Fox Film Corporation **(3)** American Entertainment Partners II L.P. / Twentieth Century Fox Film Corporation **(4)** Twentieth Century Fox Film Corporation **(5)** Universal Pictures **(6)** Carolco Pictures / Pacific Western **(7)** Paramount Pictures / Polygram Filmed Entertainment / Cloud Nine Entertainment **(8)** Touchstone Pictures / Jerry Bruckheimer Films **393 (1)** Mutual Film Company / Universal Pictures / Dark Horse Entertainment / Valhalla Motion Pictures **(2)** Paramount Pictures / Nickelodeon Movies / Valhalla Motion Pictures / Pacific Western **(3)** C-2 Pictures / Intermedia Films / IMF / Mostow / Lieberman Productions **(4)** Paramount Pictures / Lakeshore Entertainment / Valhalla Motion Pictures / MTV / Colossal Pictures **(5)** Circle of Confusion / Valhalla Motion Pictures / Darkwoods Productions / AMC Studios **394 (1)** Hemdale Film / Pacific Western / Euro Film Funding **(2)** Twentieth Century Fox Film Corporation **(3)** Twentieth Century Fox Film Corporation **(4)** Carolco Pictures / Pacific Western **(5)** Touchstone Pictures / Jerry Bruckheimer Films **(6)** C-2 Pictures / Intermedia Films / IMF / Mostow / Lieberman Productions **(7)** Paramount Pictures / Lakeshore Entertainment / Valhalla Motion Pictures / MTV / Colossal Pictures **tl** CAROLCO / THE KOBAL COLLECTION / ROSENTHAL, ZADE **tr** 20TH CENTURY FOX / THE KOBAL COLLECTION **c** 20TH CENTURY FOX / THE KOBAL COLLECTION **bl** 20TH CENTURY FOX / THE KOBAL COLLECTION **br** 20TH CENTURY FOX / THE KOBAL COLLECTION **395 tl** CAROLCO / THE KOBAL COLLECTION **tr** C-2 PICTURES / WARNER BROS. / THE KOBAL COLLECTION **c** TOUCHSTONE / THE KOBAL COLLECTION / MASI, FRANK **br** PARAMOUNT PICTURES / MTV FILMS / THE KOBAL COLLECTION / BOLAND, JASIN **396 (1)** FASA Corporation **(2)** FASA Corporation **(3)** FASA Corporation **(4)** Westwood Studios, Infocom **(5)** FASA Corporation **(6)** Malibu Comics **(7)** Day One Studios, Microsoft **(8)** Pirahna Games, Infinite Games **397 (1)** McClelland and Stewart **(2)** McClelland and Stewart **(3)** McClelland and Stewart **(4)** Random House **(5)** www.wattpad.com / happyzombie **(6)** Bloomsbury Publishing **398 (1)** Universal Pictures / Amblin Entertainment **(2)** Corgi **(3)** Electric Dreams **(4)** Universal Pictures / Amblin Entertainment **(5)** Headline Book Publishing **(6)** LJN **(7)** Universal Pictures / Amblin Entertainment **(8)** Berkley Books **399 (1)** Data East **(2)** Harvey **(3)** Image Works **(4)** Universal Cartoon Studios / BIG Pictures / Amblin Television / Colossal Pictures **(5)** Toshiba **(6)** Telltale **400 (1)** Universal Pictures / Amblin Entertainment **(2)** Universal Pictures / Amblin Entertainment / U-Drive Productions **(3)** Universal Pictures / Amblin Entertainment / U-Drive Productions **(4)** Universal Cartoon Studios / BIG Pictures / Amblin Television / Colossal Pictures **t** REX / Snap Stills **cl** REX / Moviestore Collection **crt** REX / Everett Collection **crb** AMBLIN / UNIVERSAL / THE KOBAL COLLECTION **bl** REX / c.Universal / Everett **br** AMBLIN / UNIVERSAL / THE KOBAL COLLECTION **401 tl** REX / Universal / Everett **tr** AMBLIN / UNIVERSAL / THE KOBAL COLLECTION **crlt** British Film Institute **crb** British Film Institute **bl** British Film Institute **br** Universal Cartoon Studios / BIG Pictures / Amblin Television / Colossal Pictures **402 (1)** Embassy International Pictures **403 (1)** Ace Books **(2)** Arkham House **(3)** Subterranean Press **(4)** Subterranean Press **(5)** Titan Books **404 (1)** DC Comics **(2)** DC Comics **(3)** Cruel & Unusual Films **(4)** Warner Bros / Paramount Pictures / DC Comics **(5)** Warner Bros. **(6)** Warner Bros. **405 (1)** Paramount Pictures / DC Comics / Reel FX Creative Studios / Warner Bros. **(2)** Glu Mobile **(3)** DC Comics **406 (1)** DC Comics **(2)** Warner Bros / Paramount Pictures / DC Comics **t** WARNER BROS / DC COMICS / THE KOBAL COLLECTION **ct** WARNER BROS / DC COMICS / THE KOBAL COLLECTION **cb** WARNER BROS / DC COMICS / THE KOBAL COLLECTION **b** WARNER BROS / DC COMICS / THE KOBAL COLLECTION **407 tl** WARNER BROS / DC COMICS / THE KOBAL COLLECTION **tr** WARNER BROS / DC COMICS / THE KOBAL COLLECTION **cl** WARNER BROS / DC COMICS / THE KOBAL COLLECTION **br** WARNER BROS / DC COMICS / THE KOBAL COLLECTION **408 (1)** Games Workshop **(2)** Games Workshop **(3)** Black Library **(4)** Games Workshop **(5)** THQ **(6)** Boom! Studios **409 (1)** THQ **(2)** Good Story Productions / Codex Pictures / POP6 **410 (1)** Amercent Films / American Entertainment Partners L.P. / Davis Entertainment / Lawrence Gordon Productions / Silver Pictures / Twentieth Century Fox Film Corporation **(2)** Activision **(3)** Dark Horse **(4)** Dark Horse **(5)** Davis Entertainment / Lawrence Gordon Productions / Silver Pictures / Twentieth Century Fox Film Corporation **(6)** Dark Horse **(7)** DC Comics **(8)** Dark Horse **411 (1)** Dark Horse **(2)** Dark Horse **(3)** Fox Interactive **(4)** Sierra **(5)** Twentieth Century Fox Film Corporation / Davis Entertainment / Brandywine Productions **(6)** Sierra **(7)** Twentieth Century Fox Film Corporation / Davis Entertainment / Brandywine Productions **(8)** Twentieth Century Fox Film Corporation / Troublemaker Studios / Davis Entertainment **412 (1)** Amercent Films / American Entertainment Partners L.P. / Davis Entertainment / Lawrence Gordon Productions / Silver Pictures / Twentieth Century Fox Film Corporation **(2)** Davis Entertainment / Lawrence Gordon Productions / Silver Pictures / Twentieth Century Fox Film Corporation **(3)** Twentieth Century Fox Film Corporation / Davis Entertainment / Brandywine Productions **(4)** Twentieth Century Fox Film Corporation / Davis Entertainment / Brandywine Productions **tl** 20TH CENTURY FOX / THE KOBAL COLLECTION **cl** 20TH CENTURY FOX / THE KOBAL COLLECTION / ROSENTHAL, ZADE **bl** 20TH CENTURY FOX / THE KOBAL COLLECTION **413 tl** 20TH CENTURY FOX / THE KOBAL COLLECTION / VOLLMER, JURGEN **tr** 20TH CENTURY FOX / THE KOBAL COLLECTION **cr** 20TH CENTURY FOX / THE KOBAL COLLECTION **br** 20TH CENTURY FOX / THE KOBAL COLLECTION **414 (1)** Orion Pictures **(2)** Carolco Pictures **(3)** TriStar Pictures / Touchstone Pictures / Big Bug Pictures **(4)** Columbia Pictures Corporation / Global Entertainment Productions GmbH & Company Medien KG **415 (1)** Macmillan **(2)** Macmillan **(3)** Orbit Books **(4)** Orbit Books **(5)** Orbit Books **(6)** Orbit Books **(7)** Little, Brown and Company **(8)** Orbit Books **416 (1)** Orion Pictures **(2)** Marvel Productions / Orion Television Entertainment **(3)** Data East **(4)** Orion Pictures / Tobor Productions **(5)** Ocean / Data East **(6)** TM & © 2014 Marvel Entertainment, LLC **(7)** Dark Horse **(8)** Orion Pictures **417 (1)** Ocean **(2)** Virgin Games USA **(3)** Robocop Productions Ltd. / Rysher Entertainment / Skyvision Entertainment

(4) Orion Pictures / MGM (5) Robocop Productions Ltd. (6) Avatar Press (7) MGM / Columbia Pictures / Strike Entertainment 418 (1) Orion Pictures (2) Orion Pictures (3) Orion Pictures (4) Orion Pictures 420 (1) Orion Pictures (2) Marvel Productions / Orion Television Entertainment (3) Orion Pictures (4) Avatar Press (5) Boom! Studios (6) MGM / Columbia Pictures / Strike Entertainment tl REX / Moviestore Collection tr REX / Moviestore Collection cl Marvel Productions / Orion Television Entertainment bl REX / Moviestore Collection 421 tl REX / Moviestore Collection tr Boom! Studios cl REX / Moviestore Collection bl Avatar Press br REX / Snap Stills 422 (1) BBC / Grant Naylor Productions / Paul Jackson Productions (2) Penguin Books (3) Roc (4) Viking Books (5) Viking Books (6) BBC Worldwide / Grant Naylor Productions / UK Gold Services 423 (1) BBC / Grant Naylor Productions / Paul Jackson Productions 424 (1) BBC / Grant Naylor Productions / Paul Jackson Productions (2) BBC Worldwide / Grant Naylor Productions / UK Gold Services (3) BBC / Grant Naylor Productions / Paul Jackson Productions tl Copyright © BBC Photo Library tr Copyright © BBC Photo Library cl Copyright © BBC Photo Library cr Copyright © BBC Photo Library b Copyright © BBC Photo Library 425 t British Film Institute c British Film Institute bl REX / Mark Campbell br REX / Rory Gilder 426 (1) American Entertainment Partners II L.P. / Twentieth Century Fox Film Corporation (2) 20th Century Fox Television / Kenneth Johnson Productions (3) Malibu Comics (4) Foxstar Productions / Kenneth Johnson Productions / Twentieth Century Fox Film Corporation (5) 20th Century Fox Television (6) 20th Century Fox Television / National Studios Inc. (7) 20th Century Fox Television (8) 20th Century Fox Television / Kenneth Johnson Productions 427 (1) Arbor House 428 (1) Kodansha (2) Bandai Visual Company / Kodansha / Production I.G. (3) THQ (4) Kodansha (5) Bandai Visual Company / DENTSU Music And Entertainment / Kodansha / Kôkaku Kidôtai Seisaku Iinkai / Production I.G. (6) Kodansha (7) Production I.G (8) Bandai Visual Company / DENTSU Music And Entertainment / ITNDDTD / Kodansha / Production I.G. 429 (1) Bandai (2) Kôkaku Kidôtai Seisaku Iinkai / Production I.G (3) Production I.G (4) Kôkaku Kidôtai Seisaku Iinkai / Production I.G. (5) Bandai Visual Company / Manga Video / Production I.G. (6) Bandai Visual Company / Kodansha / Production I.G. / Toho 430 (1) Bandai Visual Company / Kodansha / Production I.G. (2) Bandai Visual Company / DENTSU Music And Entertainment / ITNDDTD / Kodansha / Production I.G. tl BANDAI / KODANSHA / PRODUCTION IG / THE KOBAL COLLECTION tr REX / Moviestore Collection clt REX / Moviestore Collection clb REX / Moviestore Collection cr BANDAI / KODANSHA / PRODUCTION IG / THE KOBAL COLLECTION bl REX / Moviestore Collection 431 tl REX / c.Dreamworks / Everett tr BANDAI / BUENA VISTA / STUDIO GHIBLI / THE KOBAL COLLECTION cl REX / Moviestore Collection crt BANDAI / BUENA VISTA / STUDIO GHIBLI / THE KOBAL COLLECTION crb REX / Moviestore Collection bl REX / c.Dreamworks / Everett br BANDAI / BUENA VISTA / STUDIO GHIBLI / THE KOBAL COLLECTION 432 WARNER BROS / THE KOBAL COLLECTION 434 (1) Alfred A. Knopf (2) Universal Pictures / Amblin Entertainment (3) Topps Comics(4) Ocean (5) Alfred A. Knopf (6) Universal Pictures / Amblin Entertainment 435 (1) Random House (2) Universal Pictures / Amblin Entertainment (3) IDW Publishing (4) Telltale Games (5) Amblin Entertainment / Legendary Pictures / Universal Pictures 436 (1) Universal Pictures / Amblin Entertainment (2) Topps Comics (3) Universal Pictures / Amblin Entertainment (4) Universal Pictures / Amblin Entertainment tl c.Universal / Everett tr REX / Moviestore Collection c REX / Moviestore Collection bl Topps Comics 437 t REX / Everett Collection cl REX / Moviestore Collection cr REX / Moviestore Collection bl REX / Moviestore Collection br REX / Moviestore Collection 438 tl REX / c.Universal / Everett tr REX / c.MCA / Everett cr AMBLIN / UNIVERSAL / THE KOBAL COLLECTION b REX / Moviestore Collection 439 t AMBLIN / UNIVERSAL / THE KOBAL COLLECTION cl AMBLIN / UNIVERSAL / THE KOBAL COLLECTION cr AMBLIN / UNIVERSAL / THE KOBAL COLLECTION b REX / Moviestore Collection 440 (1) Aircel (2) Aircel (3) Columbia Pictures Corporation / Amblin Entertainment (4) Amblin Entertainment / Columbia TriStar Television / Adelaide Productions (5) TM & © 2014 Marvel Entertainment, LLC (6) TM & © 2014 Marvel Entertainment, LLC (7) Columbia Pictures Corporation / Amblin Entertainment (8) Columbia Pictures Corporation / Amblin Entertainment 441 (1) Centropolis Film Productions / Overseas FilmGroup (2) StudioCanal / Carolco Pictures / IndieProd Company Productions (3) Canal+ / Centropolis Film Productions (4) Twentieth Century Fox Film Corporation / Centropolis Entertainment (5) 20th Century Fox Television / Centropolis Television (6) Centropolis Film Productions / Fried Films / Independent Pictures / Toho Film (Eiga) Co. Ltd. / TriStar Pictures (7) Twentieth Century Fox Film Corporation / Centropolis Entertainment / Lions Gate Films / Mark Gordon Productions (8) Columbia Pictures / Centropolis Entertainment / Farewell Productions / The Mark Gordon Company 442 (1) HarperCollins (2) HarperCollins (3) Sovereign Media (4) Spilogale Inc. (5) Tor Books (6) Penny Publications (7) Penny Publications (8) Corgi 443 (1) Faber & Faber (2) Universal Pictures / Strike Entertainment 444 (1) Warner Bros. / Icon Entertainment International (2) Touchstone Pictures / Jerry Bruckheimer Films (3) Bad Robot / Touchstone Television / ABC Studios (4) Paramount Pictures / Bad Robot (5) Bad Robot / Warner Bros. Television / FB 2 Films / Fringe Element Films (6) Paramount Pictures / Spyglass Entertainment / Bad Robot / Mavrocine (7) Paramount Pictures / Amblin Entertainment / Bad Robot / K / O Camera Toys (8) Kripke Enterprises / Bad Robot / Warner Bros. Television 445 (1) Bonanza Productions / Bad Robot / Warner Bros. Television (2) Paramount Pictures / Skydance Productions (3) Frequency Films / Bad Robot / Warner Bros. Television (4) Canongate Books Ltd (5) Bad Robot / Esperanto Filmoj / Warner Bros. Television 446 (1) Warner Bros. / Icon Entertainment International (2) Bad Robot / Touchstone Television / ABC Studios (3) Paramount Pictures / Bad Robot (4) Bad Robot / Warner Bros. Television / FB 2 Films / Fringe Element Films (5) Paramount Pictures / Spyglass Entertainment (6) Paramount Pictures / Amblin Entertainment / Bad Robot / K / O Camera Toys (7) Bonanza Productions / Bad Robot / Warner Bros. Television (8) Paramount Pictures / Skydance Productions tl REX / Moviestore Collection tr REX / c.ABC Inc / Everett cl REX / c.ABC Inc / Everett crt REX / Moviestore Collection crb REX / c.20thC.Fox / Everett b REX / Moviestore 447 t PARAMOUNT PICTURES / THE KOBAL COLLECTION cl REX / c.20thC.Fox / Everett crt REX / c.20thC.Fox / Everett crb REX / Moviestore Collection bl PARAMOUNT PICTURES / THE KOBAL COLLECTION br REX / Moviestore Collection 448 (1) Toei Company (2) MMPR Productions Inc. / Renaissance-Atlantic Films / Saban Entertainment / Toei Company (3) Saban Entertainment / Toei Company / Twentieth Century Fox Film Corporation (4) TM & © 2014 Marvel Entertainment, LLC (5) Saban Entertainment / Toei Company / Twentieth Century Fox Film Corporation (6) ABC Family Worldwide / BVS Entertainment Inc. / BVS International N.V. / Renaissance-Atlantic Films / Toei Company / Village Roadshow KP Productions (7) Disney Interactive Studios (8) Marvista Entertainment / SCG Power Rangers / Saban Brands 449 (1) Id Software (2) Id Software (3) Id Software (4) Id Software (5) Id Software (6) Fantasy Flight Games (7) Id Software, Nerve Software (8) John Wells Productions / Di Bonaventura Pictures / Doom Productions / Stillking Films / Babelsberg Film / Reaper Productions / Distant Planet Productions 450 (1) HarperCollins (2) HarperCollins (3) HarperCollins 451 (1) Amblin Entertainment / Universal TV (2) Ace Books (3) Millennium (4) Nemesis (5) Malibu 452 (1) Ten Thirteen Productions / 20th Century Fox Television / X-F Productions (2) Titan Books (3) Topps Comics (4) Twentieth Century Fox Film Corporation / Ten Thirteen Productions (5) HyperBole Studios (6) 20th Century Fox Television / Millennium Canadian Productions Ltd. / Ten Thirteen Productions 453 (1) Black Ops Entertainment (2) Twentieth Century Fox Film Corporation / Ten Thirteen Productions (3) IDW Publishing 454 (1) Ten Thirteen Productions / 20th Century Fox Television / X-F Productions (2) Ten Thirteen Productions / 20th Century Fox Television / X-F Productions (3) Ten Thirteen Productions / 20th Century Fox Television / X-F Productions (4) Ten Thirteen Productions / 20th Century Fox Television / X-F Productions (5) Ten Thirteen Productions / 20th Century Fox Television / X-F Productions 456 (1) Ten Thirteen Productions / 20th Century Fox Television / X-F Productions (2) Twentieth Century Fox Film Corporation / Ten Thirteen Productions (3) 20th Century Fox Television / Millennium Canadian Productions Ltd. / Ten Thirteen Productions (4) Black Ops Entertainment (5) Twentieth Century Fox Film Corporation / Ten Thirteen Productions tl REX / SNAP tr © Photos 12 / Alamy c REX / Snap Stills bl REX / Moviestore Collection brt REX / Moviestore Collection br REX / c. 20thC.Fox / Everett 457 tl Black Ops Entertainment tr REX / c.20thC.Fox / Everett cl REX / c.20thC.Fox / Everett b REX / Moviestore Collection 458 (1) Babylonian Productions / Rattlesnake Productions / Synthetic Worlds (2) Babylonian Productions / Warner Bros. Television (3) DC Comics (4) Del Rey Books (5) Agents of Gaming (6) Babylonian Productions / Turner Network Television 459 (1) Babylonian Productions / Turner Network Television (2) Babylonian Productions / Turner Network Television (3) Babylonian Productions / Warner Bros. Television (4) Babylonian Productions / Turner Network Television (5) Babylonian Productions / Legendary Films Inc. / Sci-Fi Channel, The (6) Lost Tales Films / NS Pictures / Warner Bros. Entertainment 460 (1) Babylonian Productions / Warner Bros. Television (2) Babylonian Productions / Warner Bros. Television (3) Babylonian Productions / Warner Bros. Television (4) Babylonian Productions / Warner Bros. Television 462 (1) Babylonian Productions / Warner Bros. Television t NASA / JPL-Caltech cl WARNER BROS TV / THE KOBAL COLLECTION cr WARNER BROS TV / THE KOBAL COLLECTION b TVB218BC 463 tl WARNER BROS TV / THE KOBAL COLLECTION tr REX / Moviestore Collection cl REX / Moviestore Collection b REX / Marmor / Everett 464 (1) Canal+ / Centropolis Film Productions (2) Centropolis Film Productions 465 (1) Roc (2) Penguin Putnam Inc USA (3) Roc (4) Roc (5) Roc (6) Roc 466 (1) 4 Kids Entertainment / DiC Enterprises (2) Pulsar (3) Acme Shark / MGM Television / Pegasus Productions (4) Fandemonium Books (5) Avatar Press (6) MGM / Kawoosh! Productions DTV I 467 (1) MGM / Kawoosh! Productions DTV II / Acme Shark (2) Big Finish (3) MGM Television / Syfy (4) Arkalis 468 (1) MGM Television / Double Secret Productions (2) MGM Television / Double Secret Productions (3) MGM Television / Double Secret Productions (4) MGM Television / Double Secret Productions (5) MGM Television / Double Secret Productions (6) Acme Shark / MGM Television / Pegasus Productions 470 (1) Canal+ / Centropolis Film Productions (2) MGM Television / Double Secret Productions (3) Acme Shark / MGM Television / Pegasus Productions t © Photos 12 / Alamy c © Photos 12 / Alamy bl REX / Everett Collection br © AF archive / Alamy 471 tl DOUBLE SECRET / GEKKO / STARGATE SG-1 / THE KOBAL COLLECTION tr DOUBLE SECRET / GEKKO / STARGATE SG-1 / THE KOBAL COLLECTION cr © Photos 12 / Alamy br REX / c.Sci-Fi / Everett 472 (1) Kadokawa Shoten (2) Gainax / NAS / TV Tokyo / Tatsunoko Productions Company (3) Gainax / Kadokawa Shoten Publishing Co. / Production I.G. / Project Eva / Sega / TV Tokyo / Toei Company (4) Gainax / Kadokawa Shoten Publishing Co. / Movic / Production I.G. / Project Eva / Sega / Star Child Recording / TV

picture credits continued

Tokyo / Toei Animation **(5)** Bandai **(6)** ADV Manga **473 (1)** Kadokawa Shoten **(2)** Gainax / Khara Corporation **(3)** BROCCOLI **(4)** Kadokawa Shoten **(5)** FUNimation Entertainment / Gainax / Khara Corporation / Studio Khara Digital-bu **(6)** Gainax / Khara Corporation **474 (1)** Universal Pictures / Gordon Company / Davis Entertainment / Licht / Mueller Film Corporation **(2)** Brandywine Productions / Twentieth Century Fox Film Corporation **(3)** David Kirschner Productions / Fox Animation Studios / Twentieth Century Fox Film Corporation **(4)** Twentieth Century Fox Film Corporation / Marvel Enterprises / Donners' Company / Bad Hat Harry Productions **(5)** Walt Disney Pictures **(6)** Dark Horse **(7)** Mutant Enemy / 20th Century Fox Television **(8)** TM & © 2014 Marvel Entertainment, LLC **475 (1)** Universal Pictures / Barry Mendel Productions **(2)** Dark Horse **(3)** Mutant Enemy / 20th Century Fox Television / Boston Diva Productions **(5)** Marvel Studios / Paramount Pictures **(6)** Mutant Enemy / Marvel Television / ABC Studios **476 (1)** Universal Pictures / Gordon Company / Davis Entertainment / Licht / Mueller Film Corporation **(2)** Brandywine Productions / Twentieth Century Fox Film Corporation **(3)** David Kirschner Productions / Fox Animation Studios / Twentieth Century Fox Film Corporation **(4)** Mutant Enemy / 20th Century Fox Television **(5)** 20th Century Fox Television / Boston Diva Productions **(6)** Marvel Studios / Paramount Pictures **(7)** Mutant Enemy / Marvel Television / ABC Studios **tl** REX / Moviestore Collection **tr** UNIVERSAL / THE KOBAL COLLECTION **cl** REX / c. 20thC.Fox / Everett **cr** REX / Moviestore Collection **bl** REX / c.20thC.Fox / Everett **477 br** REX / Snap Stills **tl** REX / c.20thC.Fox / Everett **tr** REX / c. 20thC.Fox / Everett **c** REX /c. W.Disney / Everett **bl** REX / c. W.Disney / Everett **br** ABC STUDIOS / MARVEL TELEVISION / THE KOBAL COLLECTION **478 (1)** St. Clare Entertainment / Studios USA Television / Universal TV **(2)** St. Clare Entertainment / Studios USA Television / Universal TV **479 (1)** Carsey-Werner Company / YBYL Productions **(2)** HarperCollins **480 (1)** Capcom **(2)** WildStorm **(3)** Pocket Books **(4)** Capcom **(5)** Constantin Film Produktion / Davis-Films / Impact Pictures / New Legacy **(6)** Capcom **(7)** Constantin Film Ltd. / Impact Pictures **(8)** Capcom **481 (1)** Resident Evil Productions / Constantin Film Produktion / Davis-Films / Impact Pictures **(2)** Capcom Company / Resident Evil CG Film Partners / Sony Pictures Entertainment **(3)** WildStorm **(4)** Constantin Film Produktion / Davis-Films / Impact Pictures **(5)** Capcom Company / Digital Frontier / Sony Pictures Entertainment **(6)** Constantin Film International / Davis Films / Impact Pictures / Capcom Company **482 (1)** Capcom **(2)** Capcom **(3)** Capcom **(4)** Capcom **(5)** Capcom **(6)** Capcom **(7)** Capcom **484 (1)** Capcom **(2)** Constantin Film Produktion / Davis-Films / Impact Pictures / New Legacy **(3)** Capcom **(4)** Constantin Film Ltd. / Impact Pictures **(5)** Capcom **(6)** Resident Evil Productions / Constantin Film Produktion / Davis-Films / Impact Pictures **(7)** Capcom Company / Resident Evil CG Film Partners / Sony Pictures Entertainment **(8)** Constantin Film International / Davis Films / Impact Pictures / Capcom Company **tl** Capcom **tr** REX / Moviestore Collection **ctl** NEW LEGACY / THE KOBAL COLLECTION **ctr** Capcom **cb** DAVIS FILMS / THE KOBAL COLLECTION / BOLAND, JASIN **b** Capcom **485 tl** Motion Picture Photography © 2007 Constantin Film International GmbH. All Rights Reserved. **tr** REX / c.Sony Pics / Everett **cr** REX / c.Sony Pics / Everett **b** © 2011 Davis Films / Impact Pictures (RE5) Inc. and Constantin Film International GmbH. **486 (1)** TM & © 2014 Marvel Entertainment, LLC **(2)** BBC **(3)** Twentieth Century Fox Film Corporation / Centropolis Entertainment **(4)** Fox Interactive / Activision **(5)** HarperEntertainment **(6)** HarperPaperbacks **487 (1)** Canal+ España / Las Producciones del Escorpión S.L. / Les Films Alain Sarde / Lucky Red / Sogetel **(2)** Paramount Pictures / Cruise / Wagner Productions / Vinyl Films **488 (1)** Gaumont **(2)** Activision **(2)** Wanadoo Edition **489 (1)** The Curiosity Company / 20th Century Fox Television **(2)** Bongo Comics **489 (3)** VU Games / Fox Interactive **(4)** The Curiosity Company / 20th Century Fox Television **(5)** The Curiosity Company / 20th Century Fox Television **(6)** The Curiosity Company / 20th Century Fox Television **(7)** The Curiosity Company / 20th Century Fox Television **(8)** The Curiosity Company / 20th Century Fox Television **490 (1)** Jim Henson Productions / Hallmark Entertainment / Nine Network Australia / The Sci-Fi Channel **(2)** Tor Books **(3)** Titan Magazines **(4)** Crucial Entertainment **(5)** WildStorm **(6)** The Jim Henson Company **(7)** Boom! Studios **491 (1)** Del Rey **(2)** Del Rey **492 (1)** Warner Bros. / Village Roadshow Pictures / Groucho II Film Partnership / Silver Pictures **(2)** Burlyman Entertainment **(3)** Warner Bros. / Village Roadshow Pictures / Silver Pictures / NPV Entertainment / Heineken Branded Entertainment **(4)** Warner Bros. / Village Roadshow Pictures / NPV Entertainment / Silver Pictures **(5)** Atari **(6)** Warner Bros. / Silver Pictures / Village Roadshow Pictures **493 (1)** Sega **494 (1)** Warner Bros. / Village Roadshow Pictures / Groucho II Film Partnership / Silver Pictures **(2)** Warner Bros. / Village Roadshow Pictures / Groucho II Film Partnership / Silver Pictures **(3)** Warner Bros. / Village Roadshow Pictures / Groucho II Film Partnership / Silver Pictures **496 (1)** Warner Bros. / Village Roadshow Pictures / Groucho II Film Partnership / Silver Pictures **(2)** Warner Bros. / Village Roadshow Pictures / Silver Pictures / NPV Entertainment / Heineken Branded Entertainment **(3)** Warner Bros. / Village Roadshow Pictures / NPV Entertainment / Silver Pictures **tl** REX / Moviestore Collection **tr** WARNER BROS / THE KOBAL COLLECTION / AAVATSMARK, ERIK **c** WARNER BROS / THE KOBAL COLLECTION **b** REX / Everett Collection **497 tl** REX / Moviestore Collection **tr** REX / Simon Rosbers **cl** WARNER BROS / THE KOBAL COLLECTION **cr** REX / Snap Stills **b** REX / Snap Stills **498 (1)** DC Comics **(2)** DC Comics **(3)** Angry Films / International Production Company / JD Productions / Mediastream Dritte Film GmbH & Co. Beteiligungs KG / Twentieth Century Fox Film Corporation **(4)** DC Comics **(5)** Top Shelf Productions / Knockabout Comics **(6)** Top Shelf Productions / Knockabout Comics **499 (1)** Top Shelf Productions / Knockabout Comics **(2)** Top Shelf Productions / Knockabout Comics **500 (1)** DC Comics **(2)** DC Comics **(3)** DC Comics **(4)** DC Comics **(5)** DC Comics **(6)** DC Comics **(7)** DC Comics **502 (1)** DC Comics **(2)** DC Comics **(3)** Angry Films / International Production Company / JD Productions / Mediastream Dritte Film GmbH & Co. Beteiligungs KG / Twentieth Century Fox Film Corporation **(4)** Top Shelf Productions / Knockabout Comics **tl** DC Comics **tr** DC Comics **b** © AF archive / Alamy **503 t** © AF archive / Alamy **cl** © AF archive / Alamy **bl** © AF archive / Alamy **br** © Alan Moore and Kevin O'Neill **504 (1)** Shogakukan **(2)** Shogakukan **(3)** Cine Bazar / Dentsu / NTV / Office Crescendo / Shogakukan / Toho Company / VAP / Yomiuri Newspaper Company / YTV / d-rights **(4)** Cine Bazar / Dentsu / NTV / Office Crescendo / Shogakukan / Toho Company / VAP / Yomiuri Newspaper Company / YTV / d-rights **505 (1)** Figment Films **(2)** DNA Films / British Film Council **(3)** DNA Films / Ingenious Film Partners / Moving Picture Company / UK Film Council **(4)** Fox Atomic / DNA Films / UK Film Council / Figment Films / SOGECINE / Koan Films **(5)** National Theatre **506 (1)** Cameron / Eglee Productions / 20th Century Fox Television **(2)** Del Rey **(3)** Del Rey **(4)** Del Rey **507 (1)** Limited Edition Productions Inc. **(2)** Touchstone Pictures / Blinding Edge Pictures / Kennedy / The Marshall Company **(3)** Twentieth Century Fox Film Corporation / UTV Motion Pictures / Spyglass Entertainment / Blinding Edge Pictures / Dune Entertainment **(4)** Columbia Pictures / Overbrook Entertainment / Blinding Edge Pictures **508 (1)** Polygram Filmed Entertainment / Interscope Communications **(2)** Saint Martin's Press **(3)** Universal Pictures / Radar Pictures / One Race Productions / Primal Foe Productions **(4)** Del Rey Books **(5)** Universal Pictures **(6)** Vivendi **509 (1)** Atari **(2)** One Race Productions / Radar Pictures / Riddick Canada Productions **(3)** One Race Productions / Radar Pictures / Riddick Canada Productions **510 (1)** Polygram Filmed Entertainment / Interscope Communications **(2)** Universal Pictures / Radar Pictures / One Race Productions / Primal Foe Productions **(3)** One Race Productions / Radar Pictures / Riddick Canada Productions **s** GRAMERCY PICTURES / THE KOBAL COLLECTION / BARNES, SEAN **cl** GRAMERCY PICTURES / THE KOBAL COLLECTION / BARNES, SEAN **cr** UNIVERSAL / THE KOBAL COLLECTION / LEDERER, JOSEPH **b** UNIVERSAL / THE KOBAL COLLECTION / LEDERER, JOSEPH **511 t** UNIVERSAL / THE KOBAL COLLECTION / LEDERER, JOSEPH **cl** ONE RACE PRODUCTIONS / THE KOBAL COLLECTION **br** ONE RACE PRODUCTIONS / THE KOBAL COLLECTION **512 (1)** Bungie **(2)** Del Rey Books **(3)** Del Rey Books **(4)** Bungie **(5)** Tor Books **(6)** Bungie **(7)** Tor Books **(8)** Tor Books **513 (1)** Ensemble Studios **(2)** Bungie **(3)** Bungie **(4)** Tor Books **(5)** Tor Books **(6)** Halo Waypoint **(7)** Machinima Prime **(8)** 343 Industries **514 (1)** Bungie **(2)** Bungie **(3)** Bungie **(4)** Bungie **516 (1)** Bungie **(2)** Bungie **(3)** 343 Industries **t** Bungie **c** Bungie **bl** Bungie **br** Bungie **517 t** Bungie **cl** Bungie **br** 343 Industries **518 (1)** DNA Films / British Film Council **(2)** Fox Atomic / DNA Films / UK Film Council / Figment Films / SOGECINE / Koan Films **(3)** Fox Atomic Comics **(4)** Boom! Studios **519 (1)** Mutant Enemy / 20th Century Fox Television **(2)** Universal Pictures / Barry Mendel Productions **(3)** Dark Horse **(4)** Dark Horse **(5)** Dark Horse **520 (1)** Image Comics **(2)** AMC / Circle of Confusion / Valhalla Motion Pictures / Darkwoods Productions **(3)** St. Martin's Press **(4)** St. Martin's Press **(5)** Telltale Games **(6)** St. Martin's Press **521 (1)** Bandai Visual Company / Steamboy Committee / Studio 4°C / Sunrise VAP **(2)** Bandai **522 (1)** Bad Robot / Touchstone Television / ABC Studios **523 (1)** Triton Films **(2)** Spy Films **(3)** TriStar Pictures / Block / Hanson / WingNut Films **(4)** TriStar Pictures / Media Rights Capital / QED International / Alpha Core / Simon Kinberg Productions / Sony Pictures Entertainment **524 (1)** Warner Bros. / Syncopy / DC Comics / Patalex III Productions Limited **(2)** Touchstone Pictures / Warner Bros. / Newmarket Productions / Syncopy **(3)** Warner Bros. / Legendary Pictures / Syncopy / DC Comics **(4)** Warner Bros. / Legendary Pictures / Syncopy **(5)** Warner Bros. / Legendary Pictures / DC Entertainment / Syncopy **(6)** Warner Bros. / Legendary Pictures / Syncopy **(7)** Warner Bros. / Legendary Pictures / Lynda Obst Productions / Paramount Pictures / Syncopy / Warner Bros. **525 (1)** Alfred A. Knopf **(2)** Dimension Films / 2929 Productions / Nick Wechsler Productions / Chockstone Productions **526 (1)** CBS Paramount Network Television / Junction Entertainment **(2)** IDW Publishing **(3)** IDW Publishing **527 (1)** Clockwork Zoo **(2)** Angry Robot **(3)** Angry Robot **(4)** Vertigo **(5)** Harper **528 (1)** Teshkeel **(2)** Teshkeel **(3)** Teshkeel **(5)** Teshkeel **(6)** Teshkeel **(7)** Endemol Productions UK **529 (1)** ITV Productions / Impossible Pictures / M6 Films / Pro 7 / Treasure Entertainment **(2)** Titan Books Ltd **(3)** Titan Books Ltd **(4)** Titan Books Ltd **(5)** Titan Books Ltd **(6)** Titan **(7)** Bell Broadcast and New Media Fund / Omni Film Productions **530 (1)** Del Rey Books **(2)** Microsoft Games **(3)** Del Rey Books **(4)** Electronic Arts **(5)** Del Rey Books **(6)** Del Rey Books **(7)** Electronic Arts **(8)** Bioware / Electronic Arts / FUNimation Entertainment / Production I.G. / T.O. Entertainment **531 (1)** 2K Games **(2)** 2K Games **(3)** 2K Games **532 (1)** Scholastic Press **(2)** Scholastic Press **(3)** Scholastic Press **(4)** Lionsgate / Color Force **(5)** Lionsgate / Color Force **533 (1)** Bad Robot / Warner Bros. Television / FB2 Films / Fringe Element Films **(2)** WildStorm **(3)** WildStorm **(4)** DC Comics **(5)** Insight Editions **(6)** Titan Books **(7)** Titan Books **(8)** Titan Books **534 (1)** Pixar Animation Studios / Walt Disney Pictures **535 (1)** Twentieth Century Fox Film Corporation / Dune Entertainment / Ingenious Film Partners / Lightstorm Entertainment **(2)** It Books **(3)** Ubisoft Montreal